THE JUDGEMENT OF PARIS

The
JUDGEMENT
of
PARIS

Manet, Meissonier and an
Artistic Revolution

ROSS KING

Chatto & Windus
LONDON

Published by Chatto & Windus 2006

2 4 6 8 10 9 7 5 3 1

Art Credits

Corbis: pages 3, 12, 14, 20, 24, 61, 66, 83, 87, 102, 110, 149, 173, 212, 244, 276, 294, 299, 304, 306, 308; plates 2B
and 8A. The Bridgeman Art Library: pages 5, 53, 76, 93, 106, 118, 135, 141, 143, 165, 166, 177, 193, 200, 215, 218,
237, 313, 361 (both images); plates 1A, 1B, 2A, 3A, 3B, 4A, 4B, 5A, 5B, 6A, 7A, 7B, 8B. The Fogg Museum at
Harvard University: page 33. The Metropolitan Museum of Art: page 41 and
plate 6B. The Art Institute of Chicago: page 19. Ross King: page 374.

First published in Great Britain in 2006 by
Chatto & Windus
Random House, 20 Vauxhall Bridge Road
London SW1V 2SA

Random House Australia (Pty) Limited
20 Alfred Street, Milsons Point, Sydney,
New South Wales 2061, Australia

Random House New Zealand Limited
18 Poland Road, Glenfield,
Auckland 10, New Zealand

Random House (Pty) Limited
Isle of Houghton, Corner of Boundary Road & Carse O'Gowrie,
Houghton 2198, South Africa

The Random House Group Limited Reg. No. 954009
www.randomhouse.co.uk

A CIP catalogue record for this book is available from the British Library

ISBN 9780701176839 (from Jan 2007)
ISBN 07011 7683 0

Papers used by Random House are natural,
recyclable products made from wood grown in sustainable forests;
the manufacturing processes conform to the environmental
regulations of the country of origin

Printed and bound in Great Britain by Wm. Clowes Ltd, Beccles, Suffolk

For my three sisters
Karen, Maureen, and Wendy

In this bitch of a life, one can never be too well armed.
—Édouard Manet

CONTENTS

List of Illustrations xi

Chapter One: Chez Meissonier 1

Chapter Two: Modern Life 13

Chapter Three: The Lure of Perfection 26

Chapter Four: Mademoiselle V. 36

Chapter Five: Dreams of Genius 43

Chapter Six: Youthful Daring 48

Chapter Seven: A Baffling Maze of Canvas 56

Chapter Eight: The Salon of Venus 73

Chapter Nine: The Tempest of Fools 81

Chapter Ten: Famous Victories 92

Chapter Eleven: Young France 101

Chapter Twelve: Deliberations 113

Chapter Thirteen: Room M 121

Chapter Fourteen: Plein Air 132

Chapter Fifteen: A Beastly Slop 144

Chapter Sixteen: The Apostle of Ugliness 151

Chapter Seventeen: Maître Velázquez 159

Chapter Eighteen: The Jury of Assassins 167

Chapter Nineteen: Monet or Manet? 175

Chapter Twenty: A Flash of Swords 184

Chapter Twenty-one: Marvels, Wonders and Miracles 192

Chapter Twenty-two: Funeral for a Friend 206

Chapter Twenty-three: Manoeuvres 217

Chapter Twenty-four: A Salon of Newcomers 227

Chapter Twenty-five: Au Bord de la Mer 233

Chapter Twenty-six: Mademoiselle Berthe 241

Chapter Twenty-seven: Flying Gallops 248

Chapter Twenty-eight: The Wild Boar of the Batignolles 257

Chapter Twenty-nine: Vaulting Ambitions 265

Chapter Thirty: The Prussian Terror 272

Chapter Thirty-one: The Last Days of Paris 281

Chapter Thirty-two: A Carnival of Blood 293

Chapter Thirty-three: Days of Hardship 310

Chapter Thirty-four: The Apples of Discord 318

Chapter Thirty-five: A Ring of Gold 327

Chapter Thirty-six: Pure Haarlem Beer 332

Chapter Thirty-seven: Beyond Perfection 342

Chapter Thirty-eight: The Liberation of Paris 349

Epilogue: Finishing Touches 362

Political Timeline 375

Acknowledgements 379

Notes 381

Bibliography 423

Index 437

LIST OF ILLUSTRATIONS

Ernest Meissonier	3
The Brawl (Meissonier)	5
The Grande Maison	12
Édouard Manet	14
The Absinthe Drinker (Manet)	19
Théophile Gautier	20
Boulevard Saint-Michel	24
The Comte de Nieuwerkerke (J-A-D Ingres)	33
The Judgment of Paris (Marcantonio Raimondi after Raphael)	41
Study for *Music in the Tuileries* (Manet)	53
James McNeill Whistler	61
Emperor Napoleon III	66
The Palais des Champs-Élysées	76
Gustave Courbet	83
The White Girl (James McNeill Whistler)	87
Polichinelle (Meissonier)	93
Eugène Delacroix	102
Study of Victorine Meurent (Manet)	106
Nadar	110
Drawing of Manet (Edgar Degas)	118
Lithograph of *The Races at Longchamp* (Manet)	135
Meissonier and family	141
The Studio (Charles Meissonier)	143
Claude Monet	149
Menippus (Diego Velázquez)	165
Beggar in a Cloak (Manet)	166
Émile Zola	173
Paul Cézanne and Camille Pissarro	177
The Universal Exposition of 1867	193

Émile Zola pamphlet on Édouard Manet 200
Charles Baudelaire 212
Lithograph of *The Execution of Maximilian* (Manet) 215
Study of horses in motion (Meissonier) 218
The Luncheon (Manet) 237
Berthe Morisot 244
Otto von Bismarck 276
Rue Castiglione during the siege of Paris, 1871 294
Adolphe Thiers 299
The Vendôme Column 304
Statue of Napoleon from the Vendôme Column 306
The Hôtel de Ville, burned during the Commune 308
The Barricade (Manet) 313
The Monet Family in Their Garden at Argenteuil (Manet) 361
Manet Painting in Monet's Garden (Monet) 361
Marble statue of Ernest Meissonier 374

Colour Plates (following page 226)

1A. *Remembrance of Civil War* (Ernest Meissonier)
1B. *Liberty Leading the People* (Eugène Delacroix)
2A. *The Emperor Napoleon III at the Battle of Solferino*
 (Ernest Meissonier)
2B. *The Campaign of France* (Ernest Meissonier)
3A. *Music in the Tuileries* (Édouard Manet)
3B. *A Burial at Ornans* (Gustave Courbet)
4A. *The Birth of Venus* (Alexandre Cabanel)
4B. *Olympia* (Édouard Manet)
5A. *Le Déjeuner sur l'herbe* (Claude Monet)
5B. *Le Déjeuner sur l'herbe*, originally entitled *Le Bain*
 (Édouard Manet)
6A. *The Races at Longchamp* (Édouard Manet)

6B. *Friedland* (Ernest Meissonier)

7A. *The Siege of Paris* (Ernest Meissonier)

7B. *The Railway* (Édouard Manet)

8A. *Le Bon Bock* (Édouard Manet)

8B. *Bathers at La Grenouillère* (Claude Monet)

Chez Meissonier

O NE GLOOMY JANUARY day in 1863, Jean-Louis-Ernest Meissonier, the world's wealthiest and most celebrated painter, dressed himself in the costume of Napoleon Bonaparte and, despite the snowfall, climbed onto the rooftop balcony of his mansion in Poissy.

A town with a population of a little more than 3,000, Poissy lay eleven miles north-west of Paris, on the south bank of an oxbow in the River Seine and on the railway line running from the Gare Saint-Lazare to the Normandy coast.[1] It boasted a twelfth-century church, an equally ancient bridge, and a weekly cattle market that supplied the butcher shops of Paris and, every Tuesday, left the medieval streets steaming with manure. There was little else in Poissy except for the ancient priory of Saint-Louis, a walled convent that had once been home to an order of Dominican nuns. The nuns had been evicted during the French Revolution and the convent's buildings either demolished or sold to private buyers. But inside the enclosure remained an enormous, spired church almost a hundred yards in length and, close by, a grandiose house with clusters of balconies, dormer windows and pink-bricked chimneys: a building sometimes known as the Grande Maison.

Ernest Meissonier* had occupied the Grande Maison for most of the previous

*Most Frenchmen during the nineteenth century were christened with three hyphenated names. As in Meissonier's case, the first two were usually either biblical or the names of saints, and generally speaking the third was that used in social relations. Meissonier, for example, signed both his letters and paintings "E. Meissonier" or sometimes simply with the

two decades. In his forty-eighth year he was short, arrogant and densely bearded: "ugly, little and mean," one observer put it, "rather a scrap of a man."[2] A friend described him as looking like a professor of gymnastics,[3] and indeed the burly Meissonier was an eager and accomplished athlete, often rising before dawn to rampage through the countryside on horseback, swim in the Seine, or launch himself at an opponent, fencing sword in hand. Only after an hour or two of these exertions would he retire, sometimes still shod in his riding boots, to a studio in the Grande Maison where he spent ten or twelve hours each day crafting on his easel the wonders of precision and meticulousness that had made both his reputation and his fortune.[4]

To overstate either Meissonier's reputation or his fortune would have been difficult in the year 1863. "At no period," a contemporary claimed, "can we point to a French painter to whom such high distinctions were awarded, whose works were so eagerly sought after, whose material interests were so guaranteed by the high prices offered for every production of his brush."[5] No artist in France could command Meissonier's extravagant prices or excite so much public attention. Each year at the Paris Salon—the annual art exhibition in the Palais des Champs-Élysées—the space before Meissonier's paintings grew so thick with spectators that a special policeman was needed to regulate the masses as they pressed forward to inspect his latest success.[6] Collected by wealthy connoisseurs such as James de Rothschild and the Duc d'Aumale, these paintings proved such lucrative investments that Meissonier's signature was said to be worth that of the Bank of France.[7] "The prices of his works," noted one awestruck art critic, "have attained formidable proportions, never before known."[8]

Meissonier's success in the auction rooms was accompanied by a chorus of critical praise and—even more unusual for an art world riven by savage rivalries and piffling jealousies—the respect and admiration of his peers. "He is the incontestable master of our epoch," declared Eugène Delacroix, who predicted to the poet Charles Baudelaire that "amongst all of us, surely it is he who is most certain to survive!"[9] Another of Meissonier's friends, the writer Alexandre Dumas *fils*, called him "*the* painter of France."[10] He was simply, as a newspaper breathlessly reported, "the most renowned artist of our time."[11]

monogram "EM." Other painters were considerably more ambiguous. Jean-Auguste-Dominique Ingres was known as "Dominique" to many of his contemporaries, though often he inscribed his letters and paintings "J. Ingres." Such was the respect he inspired that in his lifetime he came to be known simply as "Monsieur Ingres."

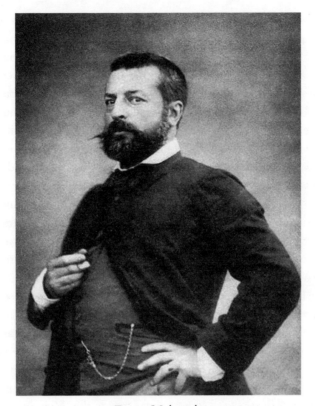

Ernest Meissonier

From his vantage point at the top of his mansion this most renowned artist could have seen all that his tremendous success had bought him. A stable housed his eight horses and a coach house his fleet of carriages, which included expensive landaus, berlines, and victorias. He even owned the fastest vehicle on the road, a mail coach. All were decorated, in one of his typically lordly gestures, with a crest that bore his most fitting motto: *Omnia labor*, or "Everything by work." A greenhouse, a saddlery, an English garden, a photographic workshop, a duck pond, lodgings for his coachman and groom, and a meadow planted with cherry trees—all were ranged across a patch of land sloping down to the embankments of the Seine, where his two yachts were moored. A dozen miles upstream, in the Rue des Pyramides, a fashionable street within steps of both the Jardin des Tuileries and the Louvre, he maintained his Paris apartment.[12]

The Grande Maison itself stood between the convent's Gothic church and the remains of its ancient cloister. Meissonier had purchased the pink-bricked

eighteenth-century orangery, which was sometimes known as Le Pavillon Rose, in 1846. In the ensuing years he had spent hundreds of thousands of francs on its expansion and refurbishment in order to create a splendid palace for himself and his family. A turret had been built above an adjoining cottage to house an enormous cistern that provided the Grande Maison with running water, which was pumped through the house and garden by means of a steam engine. The house also boasted a luxurious water closet and, to warm it in winter, a central heating system. A billiard room was available for Meissonier's rare moments away from his easel.

Yet despite these modern conveniences, the Grande Maison was really intended to be an exquisite antiquarian daydream. "My house and my temperament belong to another age," Meissonier once said.[13] He did not feel at home or at ease in the nineteenth century. He spoke unashamedly of the "good old days," by which he meant the eighteenth century and even earlier. He detested the sight of railway stations, cast-iron bridges, modern architecture and recent fashions such as frock coats and top hats. He did not like how people sat cross-legged and read newspapers and cheap pamphlets instead of leather-bound books. And so from the outside his house—all gables, pitched roofs and leaded windows—was a vision of eighteenth-century elegance and tranquillity, while on the inside the rooms were decorated in the style of Louis XV, with expensive tapestries, armoires, embroidered fauteuils, and carved wooden balustrades.

The Grande Maison included not one but, most unusually, two large studios in which Meissonier could paint his masterpieces. The *atelier d'hiver*, or "winter workshop," featuring bay windows and a large fireplace, was on the top floor of the house, while at ground level, overlooking the garden, he had built a glass-roofed annexe known as the *atelier d'été*, or "summer workshop." Both abounded with the tools of his trade: canvases, brushes and easels, but also musical instruments, suits of armour, bridles and harnesses, plumed helmets, and an assortment of halberds, rapiers and muskets—enough weaponry, it was said, to equip a company of mercenaries. For Meissonier's paintings were, like his house, recherché figments of an antiquarian imagination. He specialised in scenes from seventeenth- and eighteenth-century life, portraying an ever-growing cast of silk-coated and lace-ruffed gentlemen—what he called his *bonshommes*, or "goodfellows"—playing chess, smoking pipes, reading books, sitting before easels or double basses, or posing in the uniforms of musketeers or halberdiers. These musicians and bookworms striking their quiet and reflective poses in serene, softly lit interiors, all executed in microscopic detail, bore uncanny similarities to the work of Jan Vermeer, an artist whose rediscovery in

the 1860s owed much to the ravenous taste for Meissonier—and one whose tremendous current popularity approaches the enthusiastic esteem in which Meissonier himself was held in mid-nineteenth-century France.

Typical of Meissonier's work was one of his most recent creations, *Halt at an Inn*, owned by the Duc de Morny, a wealthy art collector and the illegitimate half-brother of the French Emperor, Napoleon III. Completed in 1862, it featured three eighteenth-century cavaliers in tricorn hats being served drinks on horseback outside a half-timbered rural tavern: a charming vignette of the days of old, without a railway train or top hat in sight. Meissonier's most famous painting, though, was *The Brawl*, a somewhat less decorous scene depicting a fight in a tavern between two men dressed—as usual—in opulent eighteenth-century attire. Awarded the Grand Medal of Honour at the Salon of 1855, it was owned by Queen Victoria, whose husband and consort, Prince Albert, had prized Meissonier above all other artists. At the height of the Crimean War, Napoleon III had purchased the work from Meissonier for 25,000 francs—eight times the annual salary of an average factory worker—and presented it as a gift to his ally across the Channel.

"If I had not been a painter," Meissonier once declared, "I should have liked to be a historian. I don't think any other subject could be so interesting as history."[14] He was not alone in his veneration of the past. The mid-nineteenth century was an age of rapid technological development that had witnessed the

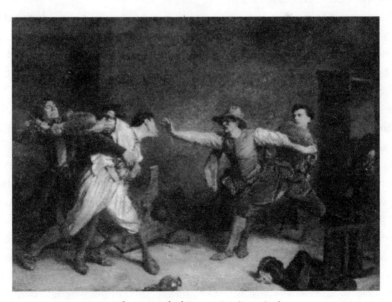

The Brawl *(Ernest Meissonier)*

invention of photography, the electric motor and the steam-powered locomo-tive. Yet it was also an age fascinated by, and obsessed with, the past. The nov-elist Gustave Flaubert regarded this keen sense of history as a completely new phenomenon—as yet another of the century's many bold inventions. "The historical sense dates from only yesterday," he wrote to a friend in 1860, "and it is perhaps one of the nineteenth century's finest achievements."[15] Visions of the past were everywhere in France. Fashions at the court of Napoleon III aped those of previous centuries, with men wearing bicorn hats, knee breeches and silk stockings. The country's best-known architect, Eugène-Emmanuel Viollet-le-Duc, had spent his career busily returning old churches and cathe-drals to their medieval splendour. By 1863 he was creating a fairy-tale castle for the emperor at Pierrefonds, a knights-in-armour reverie of portcullises, round towers and cobbled courtyards.

This sense of nostalgia predisposed the French public towards Meissonier's paintings, which were celebrated by the country's greatest art critic, Théophile Gautier, as "a complete resurrection of the life of bygone days."[16] Meissonier's wistful visions appealed to exactly the same population that had made *The Three Musketeers* by Alexandre Dumas *père*, first published in 1844, the most commercially successful book in nineteenth-century France.[17] Indeed, with their cavaliers decked out in ostrich plumes, doublets and wide-topped boots, many of Meissonier's paintings could easily have served as illustrations from the works of Dumas, a friend of the painter who, before his bankruptcy, had lived in equally splendid style in his "Château de Monte Cristo," a domed and turreted folly at Marly-le-Roi, a few miles upstream from Meissonier. Both men excelled at depicting scenes of chivalry and masculine adventure against a backdrop of pre-Revolutionary and pre-industrial France—the period before King Louis XVI was marched to the steps of the guillotine and the old social relations were destroyed, in the decades that followed, by new economic forces of finance and industry.[18] "The age of chivalry is gone," wrote Edmund Burke, a fierce critic of the French Revolution who lamented the loss, after 1789, of "manly sentiment and heroic enterprise."[19] But the age of chivalry had not entirely vanished in France: by the middle of the nineteenth century it lingered eloquently in Dumas's novels, in Viollet-le-Duc's spires and towers, and in Meissonier's jewel-like "musketeer" paintings.

Still, the subject matter of Meissonier's works accounted only partly for their extraordinary success. What astounded the critics and the public alike was his mastery of fine detail and almost inconceivably punctilious craftsmanship. "It is impossible to comprehend that our clumsy hands could achieve such a de-gree of delicacy," enthused Gautier.[20] Meissonier's paintings, most of which

were small in size, rewarded the closest and most prolonged observation. After purchasing one of his works, the English art critic John Ruskin would examine it at length under a magnifying glass, marvelling at Meissonier's manual dexterity and eye for fascinating minutiae. A critic once joked that Meissonier was capable of putting the Prophets of the Sistine Chapel on the setting of a ring.[21] No one in the history of art, it was said, ever possessed such a superlative and unerring touch with his brush. "The finest Flemish painters, the most meticulous Dutch," claimed Gautier, "are slovenly and heavy next to Meissonier."[22]

Despite his great success, Meissonier was not, however, immune to criticism. By 1863 an undertone of murmuring had begun to accompany his seemingly endless parade of chess players and musketeers. The art critic Paul de Saint-Victor had bemoaned this seemingly limited repertoire, complaining that Meissonier's *bonshommes*, however well executed, did little more than read, write and puff their pipes. Another critic, Paul Mantz, inquired: "Would it be too demanding to ask this talented artist to renew his choice of subjects a little?"[23]

Most critical of all, though, was Meissonier himself. His minute paintings of eighteenth-century officers and gentlemen may have brought him wealth and fame, but for all of that he claimed to despise them as beneath his talents. "Nothing can express adequately my horror at going about making *bonshommes* for a living!" he declared.[24] These elegant little paintings were not, he insisted, the true expression of his genius. Posterity would celebrate him, he believed, for something quite different.

"An artist cannot be hampered by family cares," Meissonier once wrote. "He must be free, able to devote himself entirely to his work."[25] Yet Meissonier seemed always to have been hampered by family cares. His father, Charles, had been a successful businessman, the proprietor of a factory in Saint-Denis, north of Paris, that produced dyes for the textile industry. Though possessed of an artistic temperament—he played the flute, sang ballads and danced the quadrille at parties—Charles Meissonier did not contemplate with enthusiasm the prospect of a painter in the family. He was a strict, practical man who subscribed to the theory that children should be toughened up by means of exposure to the cold. And, not unnaturally, he expected Ernest, the eldest of his two sons, to follow him into the dye business. When young Ernest indicated his distaste for such a career, relations between father and son deteriorated, all the more so after Madame Meissonier died and Charles had a liaison, and subsequently a daughter, with a laundress, whom he duly married. Ernest was then sent, at age seventeen, to work in a chemist's shop in the Rue des Lombards. His days were spent preparing bandages and sweeping the floor, while at night

he sketched in secret and dreamed of launching his artistic career. Only a dogged show of determination and a threat to run away to Naples convinced Charles Meissonier to apprentice his son to Léon Cogniet, a well-known history painter who had studied in Rome and received important public commissions such as a mural for the ceiling of a gallery in the Louvre.

Meissonier had proved a precocious talent. A fellow artist later observed that he seemed to have been born a master, free from the clumsiness and uncertainty that marked the early careers of other artists.[26] The talented young Meissonier set his sights high, aiming to become a history painter like Cogniet, who had first made his name in 1817 with a sandal-and-toga scene entitled *Helen Delivered by Her Brothers Castor and Pollux*. The depiction of these grand historical scenes was believed to be the most noble task a painter could set for himself in the nineteenth century. History painting occupied the summit in the strict hierarchy endorsed by the Académie des Beaux-Arts, the prestigious institution charged with shaping the destiny of French art. Landscapes, portraits and still lifes were all thought inferior because, unlike history paintings, they could not impart moral precepts to the spectator—and the teaching of moral lessons was, for most members of the Académie, the whole point of a work of art. The ideal painting, according to this wisdom, was one in which well-known characters from the Bible, national history or classical mythology performed heroic deeds and, in so doing, provided cogent moral inspiration for the viewers. One of the most celebrated examples was Jacques-Louis David's *The Oath of the Horatii*, painted in Rome in 1784, a thirteen-foot-wide canvas featuring a band of toga-clad brothers pledging an oath to their father to defend Rome against its enemies.

The young Meissonier had begun a number of these high-minded paintings, including *The Siege of Calais* and *Peter the Hermit Preaching the Crusade*—works that were intended, he later wrote, "to express great thoughts, devotion, noble examples."[27] But his style of painting was to change, and instead of executing these grand visions with their lofty moral lessons he soon found himself illustrating books and dashing off more modest scenes that were exported to America and brought him five francs per square metre.

The main reason for this less exalted style was that in 1838, at the age of twenty-three, Meissonier had married a rather austere Protestant woman from Strasbourg named Emma Steinheil, the sister of one of his artistic companions. His father then presented him with a set of silver cutlery, paid a year's rent on his lodgings, and promptly terminated his slender allowance. "It is now quite evident that you want nothing further from me," Charles Meissonier announced. "When people set up house together they must consider themselves capable of providing for themselves."[28]

Two children were born in due course, Thérèse and Charles. On the birth registration of his daughter, born in 1840, Meissonier boldly declared his occupation as "painter of history."[29] But grandiose history paintings—no matter how revered by the members of the Académie des Beaux-Arts—did not sell as readily as smaller canvases such as landscapes or portraits, which fitted more easily onto the walls of Paris apartments. So the saints, heroes and angels disappeared from Meissonier's easel and the little *bonshommes*, the products of economic necessity, began appearing under his brush. He quickly became known as the "French Metsu," a reference to the seventeeth-century Dutch painter Gabriel Metsu, who specialised in miniature scenes of bourgeois domestic life.[30] By 1863 Meissonier had been producing his charming little paintings, and enjoying his extravagant success, for more than two decades. "I resigned myself to their creation," he later wrote wistfully of his *bonshommes*, "dreaming the while of other things."[31]

Meissonier was dreaming of these other things, presumably, on that winter day in 1863 when, dressed in the cocked hat and grey riding coat of Napoleon, he climbed to the top of the Grande Maison.

Outside on his balcony, Meissonier swung into a saddle cinched to a wooden horse and, in imitation of the famous gesture, tucked one hand inside the grey riding coat. Then, examining his reflection in a mirror, he took up his paint-brush and, as the snow drifted down from the winter sky, began painting his own sombre image on the wooden panel placed on the easel before him—a study for a historical work, then well under way, called *1814: The Campaign of France*.[32]

"On how many nights did Napoleon haunt me in my sleep!" Meissonier once declared.[33] He had been born, ironically enough, in 1815, the year of Waterloo. More than four decades after Napoleon's death on Saint-Helena, his legend was still very much alive, not least thanks to vigorous promotion by his nephew, Napoleon III, who came to power in 1848. Each year on the fifth of May, the anniversary of his death, a Mass was performed in the chapel of the Invalides and wreaths were laid at the foot of the Vendôme Column. Each year on the fifteenth of August, the anniversary of his birth, a national holiday was observed: soldiers paraded in the Place de la Concorde, clowns frolicked along the Champs-Élysées, fireworks crackled overhead, and more wreaths appeared at the base of the Vendôme Column.

Everywhere in Paris, it seemed, Napoleon was venerated. Brought back from Saint-Helena with much pomp in 1840, his bones resided in a magnificent porphyry tomb beneath the dome of the Invalides. His statues presided over the

city from atop the Vendôme Column and the Arc de Triomphe, while streets and bridges, such as Rivoli, Wagram and Austerlitz, bore the names of his military victories. He was the subject of numerous biographies, and the biggest-selling book in France after *The Three Musketeers* was Adolphe Thiers's *History of the Consulate and the Empire of France under Napoleon*, of which twenty volumes had been churned out between 1845 and 1862.[34] Napoleon was also kept alive in novels by Stendhal and Balzac, and in poems by Victor Hugo. Béranger celebrated his name in patriotic songs, and Berlioz composed a cantata, *The Fifth of May*, in his honour. His valet, his secretary, his doctor, his chamberlain, and his wife's lady-in-waiting—all wrote about him at length in their memoirs. His sword from the Battle of Austerlitz and the harness of his favourite horse, Marengo, were cherished as holy relics. The Château de Malmaison, his house near Paris, had been turned into a museum dedicated to his legend, and all over France willows grew from cuttings taken from the tree that had sheltered his tomb on Saint-Helena.

Napoleon was also an inspiration for artists. "The life of Napoleon is our country's epic for all the arts," announced Delacroix, whose father had served as Napoleon's Foreign Minister.[35] No figure except Christ had been so ubiquitous in French art. Every episode in his career was commemorated in paint. The Paris Salons teemed with military imagery as his exploits from Italy to Egypt were illustrated in scores of paintings and lithographs. At one Salon, nine different canvases showed the Battle of Wagram; another boasted eighteen of Austerlitz. His coronation as Emperor had been memorialised by Jacques-Louis David, his windswept tomb on Saint-Helena by Horace Vernet, who reverentially draped his canvas in black when he exhibited the painting. In 1855 Vernet, perhaps the greatest of all the battle painters, was paid 50,000 francs for a canvas of Napoleon surrounded by his marshals and generals on the field of battle. But even this gargantuan sum was dwarfed when, five years later, a wealthy banker named Gaston Delahante commissioned his own Napoleonic scene for 85,000 francs. The subject was to be Napoleon's last days as Emperor. The painter was to be Meissonier.

The saddle on which Meissonier posed for *The Campaign of France*, his commission from Delahante, was completely authentic. It had been lent to him by one of Napoleon's nephews, Prince Napoleon-Jérôme. The riding coat was likewise authentic, or nearly so: Meissonier had borrowed the original from the Musée des Souverains, where various Napoleonic relics were housed, and then had it copied by a tailor, stitch by stitch, right down to its frays and creases. He had been donning this coat and climbing into the saddle for much of the previous year, making endless studies of the way in which, for instance, the coat

draped over the crupper of the wooden horse or—as on that snowy afternoon—how the winter light fell across his face.

Meissonier had selected himself as the model for Napoleon because he believed his own short, powerful physique perfectly matched the Emperor's. "I have exactly his thighs!" he boasted one hot summer day when a visiting art critic discovered him wearing the grey riding coat and perspiring heavily as he painted his self-portrait.[36] Another visitor, the playwright Émile Augier, was treated to an even more arresting sight. Meissonier had taken to making sketches of himself in the nude, the better to portray, he believed, the physique of the Emperor on horseback. He was in this compromising state when Augier surprised him in his studio, naked but for a *suspensoir*, a truss used to support the scrotum in cases of hernia and gonorrhea. Augier inquired whether the bandage meant Meissonier was suffering from a medical condition, to which the artist enthusiastically replied: "No, but you see the Emperor wore a *suspensoir*."[37]

The subject to be rendered with such historical accuracy—right down to the *suspensoir*—was Napoleon's retreat across France in the early months of 1814, in the face of a massive attack by the British, Prussian, Austrian, Swedish and Russian armies. The episode would end with the invasion of Paris and Napoleon's abdication and subsequent exile on Elba. These events were recounted in comprehensive detail in the seventeenth volume of Thiers's best-selling *History*, which had been published in 1860, the year Meissonier received his commission from Delahante. Meissonier kept this book beside his pillow and on occasion played *boules* and discussed politics and history with the short, bespectacled Thiers, a regular visitor to the Grande Maison. Thiers had been Minister of the Interior under King Louis-Philippe, and in this capacity he arranged for the return of Napoleon's body from Saint-Helena and oversaw the installation of the statue on the Vendôme Column. His greatest tribute to Napoleon, though, was his *History*, in volume seventeen of which he reserved the highest praise for the bravura with which the doomed Emperor conducted himself in the face of the invading armies. In a desperate war against an enemy outnumbering his own troops by as much as five to one, Napoleon "added to all the brilliance, daring and fertility of resource exhibited on his former campaigns," Thiers contended, "one quality that he had still to display—and which he then displayed even to a miracle—unchangeable constancy in misfortune."[38]

Meissonier hoped to capture precisely this aspect of Napoleon's character: his admirable courage in the face of staggering adversity. "All have lost faith in him," Meissonier wrote of the episode. "Doubt has come. He alone believes that all is not yet lost."[39] *The Campaign of France* would depict the Emperor,

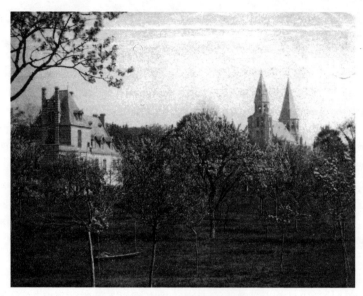

The Grande Maison

the great and tragic genius celebrated by Thiers for the originality and grandeur of his "astonishing deeds."[40] Meissonier showed him astride his white charger and at the head of the exhausted Grande Armée, grimly leading his weary soldiers through snowy wastes to engage their formidable enemy in a last, desperate struggle. Grand in manner and noble in subject, it would be exactly the sort of work he had dreamed of painting as a young man in Cogniet's studio.

Modern Life

As Meissonier worked on *The Campaign of France*, a short distance away in Paris, in a small studio in the Batignolles district, another artist was preparing a painting of a quite different sort. Édouard Manet, at thirty-one, was seventeen years younger than Meissonier. He lived in a three-room apartment in the Rue de l'Hôtel-de-Ville and did his painting in his studio nearby in the Rue Guyot. "Bohemian life," wrote Henri Murger, "is possible nowhere but in Paris,"[1] and nowhere in Paris was bohemian life more possible—in the early 1860s at least—than in the Batignolles. A mile north of the Seine, this lively working-class neighbourhood had low rents, open-air cafés, immigrants from Poland and Germany, and an itinerant population of ragpickers, gypsies, artists and writers. By no means was it Paris's cleanest or most peaceful enclave. At its heart was France's busiest railway station. Each year millions of passengers poured through the Gare Saint-Lazare on excursions to Rouen, Le Havre or more local destinations such as Asnières or Argenteuil. From the railway tracks, which ran north into the industrial suburb of Clichy, came the stink of burning coal, showers of sparks and cinders, and constant whistle blasts that a friend of Manet once described as sounding like the "piercing shrieks of women being violated."[2]

The dandyish Manet looked more than a little incongruous in the bustle and smoke of the Batignolles. His usual costume consisted of a top hat, frock coat, gloves of yellow suede, a walking stick and, according to a friend, "intentionally gaudy trousers."[3] If Meissonier was pugnacious and arrogant, Manet, a handsome young man with reddish-blond hair, was the personification of charm. Witty and sociable, he possessed both an infectious humour and a bold

streak of independence that made him a natural leader among younger artists. One of them, an Italian named Giuseppe De Nittis, claimed to love him for his "sunny soul," adding: "No one has ever been kinder, more courageous, or more dependable."[4] Another friend, the poet Théodore de Banville, even paid homage in verse to Manet's numerous allurements:

> The laughing, blond Manet,
> Emanating grace,
> Gay, subtle and charming,
> With the beard of an Apollo,
> Had from head to toe
> The appearance of a gentleman.[5]

The "laughing, blond Manet" was indeed every inch a gentleman. He had been born and raised in more prestigious surroundings than the Batignolles, at

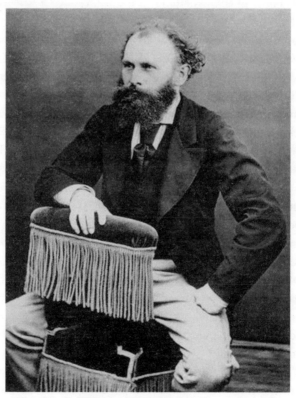

Édouard Manet (Nadar)

his parents' home on the Left Bank of the Seine, in the aristocratic Faubourg Saint-Germain. The house stood across the street from the government's official art school, the École des Beaux-Arts, and across the river from the Louvre, the former royal palace that had served since 1793 as a national art museum. As a boy, Manet had been taken on regular visits to the Louvre by his maternal uncle, Colonel Edmond Fournier, a military man with an artistic bent. Fittingly for someone raised in such an environment, he had decided at a young age that he would become a painter. His father had other ideas. Auguste Manet was the son of the former mayor of Gennevilliers, a small town on the Seine where a street had been christened with the family name. Auguste, a lawyer, had served as the principal private secretary to the Minister of Justice and, after 1841, as a magistrate. He drew a comfortable salary of 20,000 francs per year presiding over cases involving paternity suits, contested wills and violations of copyright. His wife, Édouard's mother, came with an even more impressive pedigree. The daughter of a diplomat, she was the goddaughter of one of Napoleon's generals, Jean-Baptiste Bernadotte, who later fought against the Emperor in the 1814 campaign and four years later became King Karl XIV of Sweden.

Young men with such commendable forebears did not become painters, or so Auguste Manet believed. Instead, he had in mind for his eldest son a career in law. Alas, young Édouard had failed to distinguish himself at school, except in gymnastics, in which he excelled, and penmanship, where he was judged particularly atrocious. He passed his baccalauréat, in the end, only because his father knew the school's director.[6]

With careers in law and art both pre-empted, Édouard had set his sights on the French Navy. This plan too seemed doomed when he failed the entrance examination for the naval academy: "a waste of time," his examiner had gloomily observed after surveying the result of his test.[7] However, in 1847 a law was passed guaranteeing admission to the academy to anyone who spent eighteen months on board a naval vessel. Manet therefore went off to Brazil on board the *Havre and Guadeloupe*, which weighed anchor in December 1848; but by the time the vessel returned to France six months later the seventeen-year-old sailor possessed no further appetite for the high seas. Within the year, his father finally having relented, he began his training as an artist. He had no wish to enter the prestigious École des Beaux-Arts, where originality and individuality were discouraged, and where students learned anatomy and geometry but not, bizarrely, how to paint. Manet began his studies, instead, in the studio near the Place Pigalle of a young painter named Thomas Couture. Known for encouraging spontaneity and self-expression

among his students, the thirty-four-year-old Couture nonetheless had an unimpeachable artistic pedigree: he was a graduate of the École des Beaux-Arts, a former winner of the Prix de Rome—the highest prize available to students at the École—and a member of the Legion of Honour. He had also executed the portrait of, among others, Frédéric Chopin. Auguste Manet must have regarded him as a respectable member of what was otherwise, in his opinion, a fairly disreputable profession.

Manet was treading a similar path to that of Ernest Meissonier, who had likewise shunned the École des Beaux-Arts in favour of studying in the workshop of a respected painter. But there the similarities ended. Meissonier had exposed his first painting at the Paris Salon, a juried exhibition, at the astonishingly youthful age of nineteen, claiming his first medal six years later. Édouard Manet, on the other hand, appeared to be far less precocious, clashing frequently with Couture, a notably generous and broad-minded teacher who nonetheless believed his pupil to be fit only for drawing caricatures. According to legend, Couture told Manet that he would never be anything more than the "Daumier of your time," a reference to Honoré Daumier, an artist known much better for his barbed political cartoons than for his paintings.[8] Manet nevertheless remained under Couture's tutelage for almost six years, during which time he spent many hours copying prints and paintings in the Louvre, including works by Diego Velázquez—a particular favourite—and Giulio Romano. He had been intoxicated by the art of previous centuries, and at various times he made visits to Venice, Florence, Rome, Amsterdam, Vienna and Prague, making sketches in their churches and museums. He took three trips to Italy, where he copied, among other masterpieces, Raphael's frescoes in the Vatican Apartments and, in the Uffizi in Florence, Titian's *Venus of Urbino*.[9] Inspired by these journeys, he planned canvases showing biblical and mythological characters, such as Moses, Venus and a heroine from Greek legend, Danaë—exactly the sort of works commended by the Académie des Beaux-Arts.

Manet had befriended Charles Baudelaire, a poet who had become notorious with the publication in 1857 of *Les Fleurs du mal*. Together they frequented the Café Tortoni, which stood on the corner of the Boulevard des Italiens and the Rue Taitbout, a temptingly short stroll from Manet's studio in the Batignolles. Manet also took a mistress at this time, a blonde Dutchwoman named Suzanne Leenhoff. Two years his senior, Suzanne had given him piano lessons for a few months in 1851 before becoming pregnant and then giving birth, in January 1852, to a boy of mysterious paternity who was christened Léon-Édouard Koëlla.[10] Whether or not he was the father, by the late 1850s Manet was living

with both Suzanne and her child, who masqueraded in public as her younger brother. Showing a touching domestic regard that belied his more bohemian pursuits, Manet took Léon for walks through the Batignolles each Thursday and Sunday.

Not until 1859, when he was twenty-seven years old, did Manet feel himself ready to launch his career at the Paris Salon, or "The Exhibition of Living Artists," as it was more properly called. This government-sponsored exhibition was known as the "Salon" since for many years after its inauguration in 1673 it had taken place in the Salon Carré, or Square Room, of the Louvre. By 1855 it had moved to the more capacious but less regal surroundings of the Palais des Champs-Élysées, a cast-iron exhibition hall (formerly known as the Palais de l'Industrie) whose floral arrangements and indoor lake and waterfall could not disguise the fact that, when not hosting the Salon, it accommodated equestrian competitions and agricultural trade fairs.

The Salon was a rare venue for artists to expose their wares to the public and—like Meissonier, its biggest star—to make their reputations. One of the greatest spectacles in Europe, it was an even more popular attraction, in terms of the crowds it drew, than public executions. Opening to the public in the first week of May and running for some six weeks, it featured thousands of works of art specially—and sometimes controversially—chosen by a Selection Committee. Admission on most afternoons was only a franc, which placed it within easy reach of virtually every Parisian, considering the wage of the lowest-paid workers, such as milliners and washerwomen, averaged three to four francs a day. Those unwilling or unable to pay could visit on Sundays, when admission was free and the Palais des Champs-Élysées thronged with as many as 50,000 visitors—five times the number that had gathered in 1857 to watch the blade of the guillotine descend on the neck of a priest named Verger who had murdered the Archbishop of Paris. In some years, as many as a million people visited the Salon during its six-week run, meaning crowds averaged more than 23,000 people a day.*

*To put these figures into context, the most well-attended art exhibition in the year 2003 was *Leonardo da Vinci: Master Draftsman*, at the Metropolitan Museum of Art in New York. Over the course of a nine-week run, the show drew an average of 6,863 visitors each day, with an overall total of 401,004. *El Greco*, likewise at the Metropolitan Museum of Art, averaged 6,897 per day during its three-month run in 2003–4, ultimately attracting 574,381 visitors. The top-ranked exhibition of 2002, *Van Gogh and Gauguin*, at the Van Gogh Museum in Amsterdam, drew 6,719 per day for four months, with a final attendance of 739,117.

For this great exhibiton in 1859 Manet had submitted, not one of his Renaissance-inspired mythological canvases, but *The Absinthe Drinker*, the model for which was a rag-and-bone man named Collardet whom he had met one day while sketching in the Louvre. The presence in the Louvre of a rag-and-bone man testified to how interest in fine arts crossed all social boundaries in Paris, and how in some years a million people—out of a city of only 1.7 million—could visit the Salon. Yet Manet did not depict Collardet as a connoisseur of art. He posed him beside an overturned bottle with a glass of absinthe at his elbow, a stovepipe hat perched on his head. The result was a modern-day Parisian, a rough-looking drunkard such as one might have seen after dark in the Batignolles.

Absinthe was a greenish alcoholic beverage so popular with Parisians that they spoke of the "green hour" in the early evening when they sat imbibing it in cafés. However, besides being seventy-five per cent proof, the drink was flavoured with wormwood, a herb whose toxic properties caused hallucinations, birth defects, insanity and, according to the authorities, rampant criminality. Manet's solitary figure loitering menacingly among the shadows must have seemed an all-too-graphic illustration of the consequences of its consumption. At least as unsettling as the subject matter, though, was the style of the work. Two years earlier a critic had praised Meissonier for painting his *bonshommes* so realistically that their lips appeared to move.[11] Such mind-boggling manual dexterity and painstaking dedication to minutiae were entirely absent from Manet's work. He applied his paint thickly and in broad brushstrokes, suppressing finer details such as the facial features of his reeling drunkard and taking instead a more abstract approach to visual effects. Ushered into Manet's studio, Couture ventured the opinion that his former student had produced only "insanity."[12] The jury for the 1859 Salon was no more impressed, promptly rejecting the work. It appeared to them not only to lack any sort of finesse but also to celebrate the same debauched low life as the poems in Baudelaire's *Les Fleurs du mal*, one of which, "The Wine of the Ragpickers," recounted the antics of a drunken rag-and-bone man as he staggered through "the mired labyrinth of some old slum / Where crawling multitudes ferment their scum."[13]

At the next Salon, in 1861, Manet submitted, and had accepted, two canvases, both less controversial in theme if not in technique: *The Spanish Singer*, showing a model in Spanish costume seated on a bench and playing a guitar; and a portrait of his mother and father, the latter of whom had by this time been paralysed and robbed of his speech by a stroke (a tragedy alluded to in the grim, downcast expressions of both his parents). The two paintings received contrasting receptions when they were placed on show with almost 1,300 others. While *Portrait of M. and Mme. Manet* was roasted by the critics—one

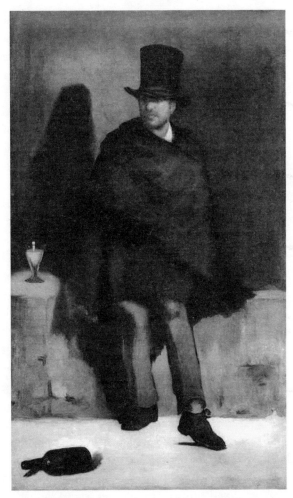

The Absinthe Drinker *(Édouard Manet)*

wrote that the artist's parents "must often have rued the day when a brush was put into the hands of this merciless portraitist"[14]—his guitar-strumming Spaniard, inspired by Velázquez, caught the eye of Théophile Gautier, the friend and admirer of Meissonier.

The fifty-year-old Gautier, who smoked a hookah and favoured wide-brimmed hats and dramatic capes, was a scourge of bourgeois respectability and a champion of such rebels as Hugo, Delacroix and Baudelaire, the latter of whom had dedicated *Les Fleurs du mal* to him. Generous and sociable, he entertained every Thursday evening at his riverfront house in Neuilly-sur-Seine,

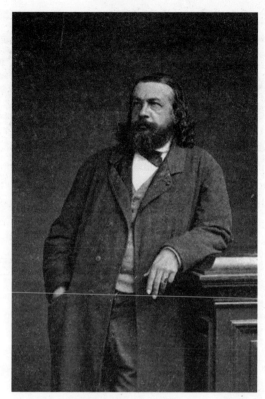

Théophile Gautier (Nadar)

a pleasant suburb to which luminaries such as Gustave Flaubert would go to recline on Oriental cushions among their host's collection of cats, books and cuckoo clocks. A poet and novelist in his own right, he had become, in the words of a fellow critic, "the most authoritative and popular writer in the field of art criticism."[15] A favourable word from Gautier could make the reputation of a painter, with the result that the flamboyantly attired critic was daily bombarded with letters from artists pleading for reviews.

"*Caramba!*" wrote Gautier in *Le Moniteur universel*, the official government newspaper, after seeing Manet's *The Spanish Singer*. "There is a great deal of talent in this life-sized figure, which is painted broadly in true colours and with a bold brush."[16] This seal of approval meant the canvas was singled out for public attention, soon becoming so popular with Salon-goers that it was placed in a more conspicuous location. An award even came Manet's way: an Honourable Mention. Still more gratifying, perhaps, was its reception by other young artists, who were intrigued by its vigorous brushwork, its sharp contrasts of black and white, and a

slightly slapdash appearance that seemed to oppose the highly polished, highly de-
tailed style of so many other Salon paintings. *The Spanish Singer* was painted in
such a "strange new fashion," according to one of them, that it "caused many
painters' eyes to open and their jaws to drop."[17] Though he had yet to sell a single
painting, Manet, at the age of twenty-nine, seemed emphatically to have arrived.

Édouard Manet's forebears on his father's side had been, if not quite aristo-
crats, then at least respectable members of the gentry. In the middle of the
eighteenth century, Augustin-François Manet, the painter's great-great-
grandfather, had been the local squire in Gennevilliers, a town on the Seine a
few miles north-west of Paris. His son Clément, Manet's great-grandfather,
had served King Louis XVI as treasurer for the Bureau des Finances for
Alençon, north of Le Mans. Shrewdly switching sides after King Louis lost his
head, he swore the civic oath, gobbled up even more land in Gennevilliers, and
in 1795 became the town's mayor. His son, likewise named Clément, followed
in his footsteps, serving his own term as mayor from 1808 to 1814.

Fifty years on, the family fortune consisted of two hundred acres of land in
the suburbs of Gennevilliers and neighbouring Asnières-sur-Seine, together
with a house in Gennevilliers where the family spent part of every summer in
order to escape the heat of Paris. Édouard Manet became an heir to this size-
able estate in the year following his victorious Salon: still disabled by his
stroke, Auguste Manet died in September 1862, at the age of sixty-six.[18]
Édouard was due to receive a third of the legacy, splitting with his two
younger brothers, Gustave and Eugène, the proceeds of lands worth as much
as 800,000 francs—a huge fortune—if sold on the open market.[19]

These ancestral acres lay fewer than five miles from Manet's modest studio in
the Batignolles. Asnières and Gennevilliers were within easy reach of Paris by
train, the former only a ten-minute ride from the Gare Saint-Lazare. Gennevil-
liers was a mile or so to its north, on a low-lying plain whose rich soil, fertilised
by sewage from Paris, allowed numerous market gardens to grow vegetables
for the dinner tables of the capital. Since the arrival of the railway in Asnières in
1851, however, another industry had developed. The Seine was two hundred
yards wide at Asnières and, as such, perfect for sailing and rowing. A sailing
club, Le Cercle de la Voile, had been founded, and on weekends during the
summer Parisians descended on Asnières in the thousands to rent rowboats,
swim in the river, picnic on the bank, or avail themselves of attractions such as
the Restaurant de Paris, which served food and drinks on a large terrace over-
looking the river. These crowds were tempted, according to a novel of the day,
"by the idea of a day in the country and a drink of claret in a cabaret."[20]

Édouard Manet had arrived among this brigade of daytrippers one day in the late summer or early autumn of 1862, around the time of his father's death. He was in the company of a friend named Antonin Proust, the son of a politician and a fellow pupil from Couture's studio. More than thirty years later, Proust was to remember how the two young men had sunned themselves on the riverbank, watching skiffs furrowing the Seine and, in the distance, female bathers disporting in the shallows. Their talk turned naturally enough to painting, in particular to the nude. Nudes always attracted a great deal of attention at the Salon. Few things impressed the critics more than a well-turned heroic male nude, the execution of which, in the style of either the Ancients or the masters of the Italian Renaissance, made the strictest trial of an artist's abilities. Even more highly prized by the critics were female nudes.[21] Such paintings were venerated so highly by the Académie des Beaux-Arts that painters referred to a nude study as an *académie*.[22]

Female nudes were not meant to titillate the viewer with their sensuality but to give physical form to abstractions such as ideal beauty or chaste love. What could happen if an artist strayed from portraying this ideal of beauty or virtue in favour of a more unvarnished illustration of the unclad female form had been demonstrated by French art's greatest *bête noire*, a blustering, bellicose painter named Gustave Courbet. A self-proclaimed socialist and revolutionary who had founded a school of painting he called Realism, Courbet had exhibited at the Salon of 1853 a canvas called *The Bathers*, which featured two young ladies in the woods, one sitting half-undressed beside a stream, the other presenting to the spectator, as she stepped naked from the water, copious layers of fat and a bountiful posterior. The critics were disgusted by such a show of lumpy female flesh; even Delacroix lamented Courbet's "abominable vulgarity" in depicting what he called "a fat bourgeoise."[23] The canvas was swiftly removed from view by a police inspector, but not before the Emperor Napoleon III was rumoured to have struck it a sharp blow with his riding crop.

So far in his career Manet had not sent a nude, either male or female, to the Salon. But the sight of Parisians taking a dip in the Seine reminded him of Titian's *Le Concert champêtre* in the Louvre, a painting that featured two women and two men in a rural landscape, the women nude, the men fully clothed.[24] Proust remembered how Manet stared at the bodies of the women leaving the water before remarking: "It seems that I must paint a nude. Very well, I shall paint one."[25] However, he explained to Proust that his own painting would include "people like those you see down there"—modern-day Parisians instead of the elegant sixteenth-century Venetians of Titian's work. "The public will

rip me to shreds," he mused philosophically, "but they can say what they like." Whereupon, according to Proust, the young artist gave his top hat a quick brush and clambered to his feet.[26]

The notion of painting modern-day Parisians was a relatively new one, though as long ago as 1824 the novelist Stendhal had urged artists to depict "the men of today and not those who probably never existed in those heroic times so distant from us."[27] This imperative had been adopted more recently by Manet's teacher, Thomas Couture. Though his own most famous work was *The Romans of the Decadence*, a historical tableau showing the moral decline of the Roman Empire, Couture had urged his students to take their subjects from nineteenth-century France. "I did not make you study the Old Masters so that you would always follow trodden paths," he told his pupils before exhorting them to represent such contemporary sights as workmen, public holidays and examples of modern technology such as locomotives. Artists of the Renaissance did not paint such sights, he pointed out, for the sole reason that in those days they did not exist.[28]

Visions of the past may have abounded in France, but so too did unmistakable signs of the present, of a world that over the past few decades had been dramatically transformed through technology and invention. "Everything advances, expands and increases around us," wrote the photographer and traveller Maxime du Camp in 1858. "Science produces marvels, industry accomplishes miracles."[29] By the early 1860s, France was criss-crossed by 6,000 miles of railway track and 55,000 miles of telegraph wire. Over the previous ten years, eighty-five miles of wide new streets—made out of macadam and asphalt instead of cobblestones— had been laid in Paris under the guidance of Baron Georges Haussmann, the Prefect of the Seine. In 1863 a three-wheeled wagon powered by an internal combustion engine, the invention of an engineer named Lenoir, rode these boulevards on a fifteen-mile return journey to Joinville-le-Pont. Those witnessing this triumphant progression must truly have believed themselves to be living in what a German critic, writing of Paris, would later call the "capital of the nineteenth century."[30]

While Ernest Meissonier shunned this audacious new world by retreating into an eighteenth-century idyll of periwigs and cavaliers, not everyone remained convinced of the suitability of such a response. Du Camp, for one, found absurd the fact that, in an age of electricity and steam, artists were still producing mythological scenes featuring Venus and Bacchus. In a similar spirit, Baudelaire had written a treatise entitled *The Painter of Modern Life* in which he encouraged artists to abandon "the dress of the past" and take their subjects from modern life instead. He called on painters to embrace what he

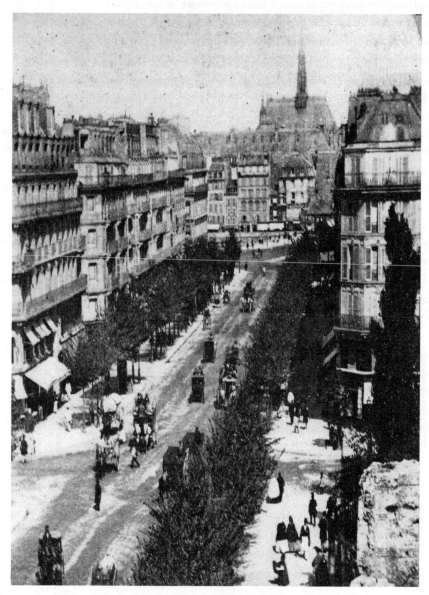

The Boulevard Saint-Michel, designed by Baron Haussmann

christened *la modernité*, by which he meant the fleeting and seemingly trivial world of contemporary life. Like Couture, he believed the task of an artist was not to regurgitate the forms of past centuries but to produce visions of this modern world—crowds, street scenes, vignettes of middle-class life—in all their splendour and all their ugliness.[31]

With his devotion to the art of previous centuries, Édouard Manet may have seemed an unlikely convert to this cause. The inspiration for his early paintings came mostly from Old Masters he had sketched in the Louvre and the Uffizi rather than from the everyday life he saw along the boulevards of Paris or in the cafés of Asnières. *Fishing at Saint-Ouen*, begun about 1860, was set on the banks of the Seine a mile or so downstream from Asnières, in the industrial suburb of Saint-Ouen; modelled on a work by Peter Paul Rubens, however, it showed not modern-day factory workers or boisterous holidaymakers but a couple in seventeenth-century dress posing beside the river. Still, Manet had begun paying heed to the advice of Baudelaire and Couture with canvases such as *The Absinthe Drinker* and *The Old Musician*. The latter canvas, painted in 1862, portrayed a number of indigents from the Batignolles, including a violinist from a gypsy colony—though even in this work Manet had borrowed some of his poses directly from paintings in the Louvre.

Determined to capture another scene from modern life, Manet began a canvas called *Le Bain*, or "The Bath," soon after his return from Asnières. A nude scene of modern-day Parisians, *Le Bain* would be, in its own way, as striking a vision of modernity as Haussmann's boulevards or Lenoir's gasoline-powered engine.

CHAPTER THREE

The Lure of Perfection

IF SOMETHING WAS worth doing, Ernest Meissonier always maintained, it was worth doing properly. He had been conscientious even as a child, showing remarkable patience in tasks like blacking his boots or, when put to work in the chemist's shop, tying up parcels of medicine for customers.[1] He applied the same exacting standards to his paintings, each of which took months, if not years, of concentrated effort. "Although I work under great pressure from all sides," he claimed, "I am always altering. I am never satisfied."[2] Because he often spent one day scraping away the paint he had spent the previous day laboriously applying, he referred to his works-in-progress as "Penelope's webs," an allusion to how each night Odysseus's wife Penelope would unravel the shroud she was weaving on her loom for Laertes, her father-in-law. Sometimes Meissonier did not even bother to scrape away the offending part of the work; he simply repainted the entire canvas, often so many times that the finished product was merely the uppermost layer of a series of palimpsests. "Perfection," he claimed, "lures one on."[3]

Meissonier always spent many months researching his subject, finding out, for example, the precise sort of coats or breeches worn at the court of Louis XV, then hunting for them in rag fairs and market stalls or, failing that, having them specially sewn by tailors. Historical authenticity was taken very seriously in the nineteenth century, not just by Meissonier but also by other artists who likewise went to great lengths to ensure the authenticity of their works. When Théodore Géricault began his masterpiece, The Raft of the "Medusa"—a huge canvas depicting survivors of a notorious shipwreck—he had shown exceptional diligence. Starting work in 1818, two years after the event, he pored

over published accounts of the ill-fated voyage, interviewed a number of sur-
vivors, employed some of them as models, and studied corpses in a hospital
morgue. He even hired the carpenter of the *Medusa* to build him an exact
replica of the raft. The resulting canvas was shockingly grisly and violent—
but accurate in its every gory detail.*

This kind of historical reconstruction had always been Meissonier's stock-
in-trade. Recently he had spent more than three years on a painting that was a
mere thirty inches wide by seventeen inches high: *The Emperor Napoleon III at
the Battle of Solferino* (plate 2A). The work, a battle scene, had been some-
thing of a departure for the painter of *bonshommes* and musketeers. Marking
the new direction in Meissonier's career, it took as its subject a victorious battle
fought by the French against the Austrians in 1859, when the Emperor
Napoleon III, together with Victor Emmanuel II, King of Piedmont and Sar-
dinia, tried to oust the Habsburgs from their territories in northern Italy.
When hostilities commenced early in the summer of 1859, Meissonier had re-
ceived a commission from the government to illustrate several scenes from the
campaign. He set off for the front in Lombardy, taking with him a servant, two
horses and a supply of pencils and paints. Arriving in time to witness a bloody
battle fought outside the village of Solferino, he made numerous on-the-spot
sketches of the action, barely escaping with his life after several bullets
whizzed past his head when he accidentally strayed into the thick of the action
in his quest for a good vantage point.

Meissonier's studies for *The Battle of Solferino* had continued long after the
war ended. At the army camp in Vincennes, east of Paris, he painted further
sketches of soldiers, and at the Château de Fontainebleau he did portrait stud-
ies of both Napoleon III—who was going to be the focus of the scene—and
his horse, Buckingham. He even made a return trip to Solferino, a year after
the battle, to make still more studies of the bleak, dusty landscape. The paint-
ing was accepted by the judges, sight unseen, for the Salon of 1861, where
Meissonier had been hoping to show the critics that he had risen above his

*This is not to say that the historical record was never traduced in nineteenth-century
French art, especially when political reputations were at stake. Baron Gros's *Napoleon at
the Battle of Arcola* (1797) shows Bonaparte heroically leading his troops across a bridge,
under fire from the Austrians, whereas in actual fact he fell off the bridge and into the river.
And Jacques-Louis David's *The Coronation of Napoleon* (1805–8) includes the emperor's
mother Letizia, who in reality had stayed away from the ceremony because of her dislike
of her daughter-in-law, Joséphine.

lucrative "musketeer style" to paint something more ambitious in conception. It failed to materialise: the master was still perfecting the work in his studio. Nor did it appear the following year, as announced, at the Universal Exposition in London. Meissonier would not complete the painting until January of 1863, almost four years after his first expedition to Solferino.

The Campaign of France, commissioned while *The Battle of Solferino* was still on his easel, required equally prolonged and unstinting researches. Starting work in 1860, he consulted Adolphe Thiers, both in person and in print. He interviewed survivors of the 1814 campaign, such as the Duc de Mortemart, one of Napoleon's generals. He also consulted Napoleon's valet, an old man named Hubert. He made a special journey to Chantilly to see Napoleon's groom, Pillardeau, whose home was a bizarre shrine dedicated to the memory of Napoleon and the Grande Armée, complete with papier mâché replicas of the kind of bread eaten by the soldiers. Meissonier thereby became an expert on every aspect of Napoleon's life, from how he changed his breeches every day because he soiled them with snuff, to how he undressed himself—for reasons of modesty—only in total darkness.[4]

Meissonier did not begin the actual painting of any of his works until he had first made numerous preparatory sketches and studies. And he did not begin these until he had worked out the composition of the painting in the most elaborate detail, usually by means of a three-dimensional scale model of the scene. A number of painters had resorted to this strategy, from Michelangelo, who made wax figurines of many of the characters he painted, to the eighteenth-century English landscapist Thomas Gainsborough, who fashioned tabletop models with sand, moss, twigs, bits of mirror for water or sky, and miniature horses and cows. But Meissonier, as ever, took matters a step or two farther. Thus, for *The Campaign of France* he sculpted in wax a series of highly detailed models, some six to eight inches high, of Napoleon and his generals, as well as the horses on which they sat. These models he then arranged in his studio on a wooden platform four feet square. He also made models of tumbrils and wagons, which he proceeded to drag across a muddy landscape—carefully moulded from clay spread on top of the platform—to create the furrowed road along which Napoleon trekked with his generals. He prided himself on these creations, considering himself, according to a friend, "by turns tailor, saddler, joiner, cabinetmaker."[5]

Absolutely nothing was left to chance or imagination; everything had to be rigorously and impeccably correct. Meissonier had faced a problem, though, with his *tableau vivant* for *The Campaign of France*. Despite the presence of Napoleon and his generals, this new painting was conceived as, first and fore-

most, a snowscape: a panorama in which the Grande Armée plods across a vast expanse of snow beneath a leaden sky.[6] And since Meissonier would not paint anything without first having the correct specimen before his eyes, he had naturally found himself in need of snow. So across the expanse of fur-rowed clay he had sprinkled handfuls of finely granulated sugar and, to give his snow its glitter, pinches of salt. With a shod hoof, likewise executed in miniature, he then meticulously pressed the imprints of the horses' feet. The leadership of the Grande Armée was thereby devised in perfect effigy against a snowy landscape.

"What an effect of snow I obtained!" Meissonier had proudly declared when the model was finished.[7] Unfortunately, the sugar soon attracted the attention of bees from a neighbour's hive, forcing him to replace it with flour—which merely served to bring on another invasion of unwanted guests: "The mice came and ravaged my battlefield," he lamented.[8] At which point Meissonier decided to stage *The Campaign of France* on a larger scale, in the grounds of his house at Poissy.

Work on this full-scale mock-up had begun around the summer of 1861, with elaborate plans and preparations more typical of staging an opera than painting a picture. Models were hired, costumes sewn, and a white horse, a double for Napoleon's charger, brought to Poissy from the stables of Napoleon III. Then, to simulate snow, vast quantities of flour were raked across the grounds of the Grande Maison—so much that at the end of each day Meissonier's models and their horses needed to be de-whitened by a team of servants.[9] Meanwhile the escort of generals posed on horseback. The model serving for Marshal Ney—riding immediately behind Napoleon—wore his coat draped over his shoulders like a cape, a sartorial detail Meissonier had picked up from a chance encounter in a train carriage with a medic who had served under Marshal Ney at the Battle of Leipzig in 1813. The coat itself was authentic, since Meissonier had borrowed it, along with the rest of the uni-form, from Marshal Ney's son.[10] The model serving for Napoleon was, of course, Meissonier himself.[11]

The seasons changed and, as winter arrived, Meissonier had awaited a fall of real snow. When at last it came, he set busily to work. The team of servants was ordered to trample the ground and drag heavy carts back and forth through the mud, carving out deep ruts.[12] The models were once more made to pose on horseback, "notwithstanding the bitterly cold weather."[13] Meissonier made sketches hurriedly for fear of a thaw destroying his wintry scene or an outbreak of bright sunlight interfering with the cheerless grey sky he had planned for the painting. For reasons of speed he engaged another model to

assume the part of Napoleon and sit astride the white charger; but unfortu-
nately the man proved unequal to the task. "He was a stout young man," Meis-
sonier's son Charles, then eighteen, later remembered, "and the riding coat
was too small for the big fellow, while the hat fell over his eyes."[14] Once again,
therefore, Meissonier donned the riding coat and swung into the saddle. At this
point, out of doors in the frigid weather, he really began to suffer for his art.
Concerned friends suggested that he abandon the park for the warmth and
comfort of his studio, but Meissonier objected that in order to capture the cor-
rect light and atmosphere he needed to see his models set against a backdrop of
cloud and snow.

Despite his two commodious ateliers, Meissonier was no stranger to working
at his easel in the open air. Most painters contented themselves with painting
outdoor scenes in the comfort of their studios. Even Géricault—otherwise so
concerned with authenticity—had the replica of the *Medusa*'s raft constructed
inside his studio, not under the open skies.[15] But such an approach was not
good enough for Meissonier. He was determined that the light and shadows in
his paintings should be the result of a close and protracted observation of the
landscape. "Outdoor light!" he once boasted. "I was the first to paint it!"[16] The
claim is exaggerated, but he had worked *en plein air* ("in the open air") ever
since he was a young man, with his easel becoming a familiar landmark along
the riverbank in Poissy.

Meissonier was something of a pioneer in this respect, since *plein-air* painting
was still relatively new in France. By the 1830s a group of French painters,
mainly landscapists inspired by the examples of the English artists John
Constable and J. M. W. Turner—the latter of whom had been making outdoor
paintings from a boat floating on the Thames—took their canvases out of their
studios and onto riverbanks and meadows in order to record their perceptions of
the French landscape. One of them, Camille Corot, the most talented and versa-
tile landscapist in France, regarded *plein-air* studies as essential for capturing the
fugitive effects of light and colour. Each summer he criss-crossed France with his
easel, immortalising the Forest of Fontainebleau, the sweeping plains of Picardy,
and the misty, tree-lined ponds (known ever since as "the ponds of Corot") in
Ville-d'Avray, his adopted home near Paris. A friend from Meissonier's student
days, Charles-François Daubigny, was also among this vanguard, purchasing a
boat, christened *Le Botin*, with which he plied both the Seine and the Oise.[17]

Such artistic forays into the countryside had been made easier by the inven-
tion, in 1824, of metal tubes for oil paints, which replaced the messy and awk-
ward pig bladders in which artists of previous generations had kept their
paints; and by the introduction of collapsible three-legged stools and portable

easels, both of which could be carried into the countryside by the artist.[18] Yet despite these conveniences, *plein-air* painters still suffered from logistical difficulties and even occupational hazards created by the vagaries of the weather. Meissonier found himself risking frostbite as he made his outdoor studies for *The Campaign of France*. "The cold was intense," Charles Meissonier later reported. "My father's feet froze in the iron stirrups. We were obliged to place foot-warmers under them, and to put near him a chafing dish over which he occasionally held his hands."[19] Meissonier may have been prepared for these hardships, strangely enough, thanks to his own father's decree that children should be toughened up by means of exposure to the elements: denied the luxury of a winter coat in his youth, Meissonier used to walk to school with roasted chestnuts, purchased from a street vendor, crammed into his pockets for warmth. Only at the age of nineteen, when he was commissoned to paint a pair of watercolour portraits for ninety francs, did he finally have the means to buy himself a warm cloak.[20]

After all of these discomforts and exertions, *The Campaign of France* was nearing completion by January of 1863. Meissonier had been hoping to show both it and *The Battle of Solferino* at the Salon of 1863, due to open to the public in May. But even as he was preparing to submit the two works he believed would force a reappraisal of his talents, an unexpected event suddenly cast a shadow over his plans.

Under the ancien régime, the fine arts had been the business of cardinals and kings. Since the French Revolution, the politicians had taken charge. Under Napoleon III, a special section of the Ministry of State known as the Ministry of the Imperial House and the Fine Arts had been given jurisdiction over artistic matters. The tasks of training young artists, organising exhibitions, commissioning works for churches and other public buildings—all became the responsibility of this Ministry, which was headquartered in the Louvre. Not the least among its duties was the administration of the Salon. To that end, each Salon year, usually in January, the Ministry published what was known as the *règlement*, an official set of rules and regulations stipulating the conditions under which artists submitted their works to the Salon's jury, the composition of which was detailed in the document. The artists were informed, for example, by what date they needed to send their paintings or sculptures to the Palais des Champs-Élysées for judging, how many works they could enter into the competition, and how the Selection Committee—composed of separate juries for the different visual arts—would be formed.

The author of this important document, for the previous fourteen years, had

been a suave but ruthless aristocrat named Alfred-Émilien O'Hara, the Comte de Nieuwerkerke. Occupying majestic apartments in the Louvre, where he entertained lavishly amid his collection of antique armour and Italian art, Nieuwerkerke cut an impressive dash through both the Parisian art world and the Imperial court. Despite his Irish surname, he was a Continental blueblood who could claim descent from both the House of Orange in Holland and the House of Bourbon in France. Born in Paris in 1811, the young Émilien had begun his career in the military, training as an officer at the cavalry school in Saumur; but a six-month visit to Italy in 1834 convinced him to try his hand at sculpture. He began studying under Carlo Marochetti—an Italian who had worked on the Arc de Triomphe—and regularly exhibiting at the Salon, to no particular acclaim, works such as his bronze sculptures of René Descartes and Napoleon I. An urbane *séducteur* with a thick mane of hair, a well-groomed beard and, according to one admirer, eyes of "silky blue,"[21] Nieuwerkerke really made his reputation when he took as his mistress Princess Mathilde, the niece of Napoleon Bonaparte and the cousin of the Emperor Napoleon III.

Following vigorous promotion by Princess Mathilde, who was the daughter of one of Napoleon's younger brothers, Nieuwerkerke had been appointed Directeur-Général des Musées in 1849. In this capacity he was given charge of a number of museums, including the Louvre and the Luxembourg, the latter of which had been founded in 1818 in order to exhibit works by living artists. Most important from the point of view of painters and sculptors, Nieuwerkerke oversaw the Salon. He had therefore become by far the most powerful figure in the French art world.[22]

Nieuwerkerke concerned himself, naturally enough, with upholding what he regarded as the highest artistic and moral standards. He wanted both to encourage history painting and to discourage Realism, the new movement, led by Courbet, whose followers had abandoned noble and elevated subjects in order to depict gritty scenes featuring peasants and prostitutes. "This is the painting of democrats," sniffed the debonair Nieuwerkerke, "of men who don't change their underwear."[23] In order to achieve his lofty aims for French art, he had already forced through a number of reforms, such as taking the decision in 1855 that the Salon should instead be held only biennially in order to give artists more time to complete and display paintings of the highest merit. Then in 1857 he decreed that the painting jury should no longer be made up, as previously, by painters elected by their peers. Instead, the only men eligible to serve would be members of the Académie des Beaux-Arts, the self-perpetuating élite of forty "immortals" whose duty it was to guide and protect French art. With these wise and venerable men acting as gatekeepers, Nieuwerkerke believed, only works of

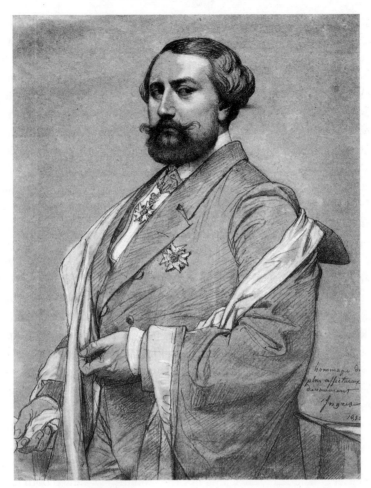

The Comte de Nieuwerkerke (Jean-Auguste-Dominique Ingres)

the most compelling aesthetic and moral standards would be permitted into the artistic *sanctum sanctorum* that was the Paris Salon.

Then in 1863 Nieuwerkerke introduced yet another reform. Whereas previously artists had been allowed to submit an unlimited number of works to the jury, the latest regulations stated that they could submit no more than three. Nieuwerkerke's reasoning was that artists had been sending as many as eight or ten rather inferior works, in the hope of having at least one or two accepted, instead of concentrating their efforts on a true masterpiece—a large and heroic history painting, for instance—that would take its honoured place in the pantheon of French art.

Nieuwerkerke's previous reforms had not been popular with large numbers of artists. The fact that the Salon was held only every two years meant that an artist whose offerings were rejected from one particular Salon would face, in effect, a four-year exile from the Palais des Champs-Élysées. Furthermore, many artists were displeased by the complete domination of the juries by members of the Académie, most of whom had made their reputations in the dim and distant past, usually with grand history paintings. The majority of them were only too happy to enforce Nieuwerkerke's ideals and exclude from show "the painting of democrats." Indeed, these judges had rejected so many artists from the 1859 Salon—Édouard Manet among them—that Nieuwerkerke's soirées in his Louvre apartments were interrupted by mobs of painters chanting protests beneath his windows.

Not surprisingly, a large group of artists also objected to Nieuwerkerke's change to the rules for the 1863 Salon. Ten days after the publication of the regulations, on January 25, a letter with a signed petition was sent to the Minister of State, the Comte de Walewski, who was Nieuwerkerke's superior as well as an illegitimate son of Napoleon Bonaparte.[24] The letter complained that the new proviso was prejudicial to the fortunes of French artists. It argued that the Salon was intended to operate as a kind of shop window for collectors, and so exhibition in the Palais des Champs-Élysées was absolutely vital to the economic well-being of artists. Nieuwerkerke's new regulations left them, however, with an even poorer chance of having their wares displayed. "A measure that would result in making it impossible for us to present to the public the fruit of our work," the petition read, "would go, it seems to us, precisely against the spirit that presided over the creation of the Salon."[25]

This letter concluded with a hope that the Comte de Walewski would "do the right thing with a complaint which is, for us, of such a high interest."[26] Six sheets of paper adorned with 182 signatures were attached. Many of the most prominent and successful artists in France had added their names, including both Delacroix and Jean-Auguste-Dominique Ingres, bitter professional rivals who usually disagreed on everything. Also signing the petition were a pair of accomplished landscape painters, Camille Corot and Eugène Isabey, the latter of whom had once been court painter to King Louis-Philippe. However, the signature boldly leading the charge, the one scrawled with a thick-nibbed pen at the top of the first page, was that of Ernest Meissonier.

Meissonier and Nieuwerkerke knew one another well. Meissonier had attended the soirées hosted by Princess Mathilde on Sunday evenings at her mansion in the Rue de Courcelles, and he and Nieuwerkerke shared a number of friends, such as Théophile Gautier. In 1855, moreover, Nieuwerkerke had

been Vice-President of the International Awards Jury when it presented Meis-
sonier with the Grand Medal of Honour at the Universal Exposition in Paris.
For these and other reasons, Nieuwerkerke might have expected Meissonier, of
all people, to support his latest reform. After all, Meissonier was guaranteed a
place at every Salon since he was classified as *hors concours* ("outside the com-
petition"). This distinction, given only to those who had received three major
awards at previous Salons, meant he was not required to submit his work to the
jury for inspection. Nor was he guilty of the practice that Nieuwerkerke
wished to snuff out—that of dashing off half-finished paintings and hoping
that one or two of them might slip past the jury. Meissonier sought, indeed, the
same high standards of morality and aesthetic purity as Nieuwerkerke: he re-
garded mediocre artists, he once said, as "national scourges."[27]

At issue for all of the petitioners, however, was the right of artists to exhibit
their works to the public. And Meissonier ardently believed in this right—or,
at any rate, he believed in his right to exhibit his own work in the Palais des
Champs-Élysées in whatever quantities he desired. He had shown five paint-
ings in 1861, while the Salons of 1855 and 1857 had each featured nine of his
works. Under Nieuwerkerke's new *règlement*, he would be allowed to show
only three of his works every two years. For an artist possessing Meissonier's
large and enthusiastic following, this new regulation would make for a disap-
pointingly slender offering to his public. He therefore dedicated the full weight
and authority of his name to overturning Nieuwerkerke's new rule. Given the
prominent position of his signature, he may well have assisted with the argu-
ment and wording of the letter itself.

Whatever his involvement in the composition of the appeal to the Comte de
Walewski, Meissonier soon took a much more drastic step than simply signing
the petition. He let it be known that should Nieuwerkerke's new reform not be
struck down, he would personally lead a boycott of the 1863 Salon.

CHAPTER FOUR

Mademoiselle V.

AMONG THE 182 artists who signed the petition to the Minister of State was Édouard Manet. His name appeared three quarters of the way down the first page, the eighteenth signature on the list. It was included together with those of several friends, including a shy and diminutive painter called Henri Fantin-Latour, a Belgian named Alfred Stevens, and Félix Bracquemond, an engraver. Like many of the others on the petition, Manet's name was not one that the Comte de Nieuwerkerke would necessarily have recognised, beyond, perhaps, his vague awareness that Manet's style of painting—at least, in a work of Realism such as *The Absinthe Drinker*—veered dangerously towards the kind of art that the Directeur-Général was hoping to exclude from future Salons.

Unlike Ernest Meissonier, Manet had no plans to boycott the 1863 Salon should the petition fail. Still at the beginning of his career, he could ill afford to pass on the opportunity to show the best of his work to the public. Therefore, at the same time that he added his signature to the list he was preparing for submission to the jury, whose deadline was the first of April, the three paintings allowed to him by the new regulations. He had completed more than twenty works since the previous Salon in 1861 but seems to have known exactly which three pieces he would send to the jury.[1] Two of them would be Spanish-themed canvases along the lines of his previous success, *The Spanish Singer*. The third would be *Le Bain*, the nude scene inspired by his trip to Asnières with Antonin Proust.

Manet had decided that his new canvas should be a tableau of young people bathing and picnicking beside the water. He would feature two men dressed in

modern costumes as well as a young woman—his nude figure—reposing on the ground. On the few occasions when he required a nude model, Manet had turned to his mistress, Suzanne Leenhoff. In about 1860 she had posed for a work called *Nymph and Satyr*, which featured her sitting beside a woodland stream, her hair unfastened and her clothing discarded beside her.[2] For *Le Bain* (plate 5B), however, Manet decided to use a different model, a nineteen-year-old redhead named Victorine Meurent. The daughter of an engraver, Victorine came from a working-class district in the east end of Paris, where she was baptised, in February 1844, in the church of Saint-Élisabeth. By 1863 she was living in an apartment in the Latin Quarter, near the Sorbonne, some two miles from Manet's studio in the Batignolles. Manet probably met her through his former teacher, since she had begun modelling in Couture's studio in 1861 for a wage of twenty-five francs per month.[3] She would have been what was known as a *modèle-occasionnel*, someone who posed for whomever she could, either on short contracts or for a few francs a sitting, at the same time that she supplemented this slender income with other low-paid work.[4]

Little seemed to distinguish Victorine, her looks included, from the scores of other young women who hovered on the margins of Parisian artistic life. Nicknamed *La Crevette* ("The Shrimp") because of her short stature, she was nothing like the exotically beautiful women favoured by members of the Académie des Beaux-Arts. Her face was round and expressionless, her eyes hooded, her nose blunt above a small mouth, her limbs short, her trunk fleshy. Manet nonetheless seems to have been captivated by her appearance, or at least by the visual possibilities of dressing her in exotic costumes and placing her in beguiling poses. He first used her, in the spring or summer of 1862, for a painting called *The Street Singer*, in which, holding a guitar and a bunch of cherries, she fixes the viewer with her gaze as—in a gesture both challenging and suggestive—she raises two cherries to her lips. Next he hired her for *Young Woman Reclining in a Spanish Costume*, a work of mild eroticism that saw her stretched out on an upholstered divan in a black bolero. Finally, she had posed as a female matador for a third canvas, a strange bullfight scene called *Mlle V . . . in the Costume of an Espada* that Manet was planning to send to the 1863 Salon.

These paintings had all seen Victorine fixing the viewer with an arrestingly direct gaze and—in the latter two at least—cross-dressing in a manner evoking the morally dubious world of gaslit boulevards and women of easy virtue that an 1855 play by Alexandre Dumas *fils* had christened *le demi-monde*. If, however, these three paintings seemed risqué, *Le Bain*, in which Victorine posed for Manet for the first time in the nude, would be all the more so.

For a period of at least several weeks during the autumn of 1862, Victorine

had regularly found herself making the two-mile journey to Manet's studio, possibly travelling on one of the horse-drawn omnibuses, nicknamed *Batignol-laises*, that linked the Batignolles with the centre of Paris. Many of these omnibuses were driven, oddly enough, by male models who had retired from the business, which meant that Parisians of Manet's day were transported around the city by men who had once posed as valiant biblical heroes or the vindictive deities of classical mythology.[5] Models lived a hard life in Paris. During the eighteenth century, posing for artists had been, at least for male models, a quite respectable occupation. Those who worked for members of the prestigious Académie Royale de la Peinture et de la Sculpture had worn royal livery, carried swords, lived in the Louvre and, when they retired, received generous pensions.[6] By the middle of the nineteenth century, however, models enjoyed a much less exalted status. Even the most successful earned well under 1,000 francs per year, or only a half to a third of the average factory worker's annual salary. Their earnings were little better than those of Paris's lowest-paid workers, such as ragpickers, cobblers, washerwomen and milliners.

Female models were paid even less than men. Couture, for instance, offered his male models nineteen francs per week,[7] compared to the twenty-five that Victorine, when she posed for his students, received per month. Moral squeamishness about women removing their clothes meant they were barred from posing at the École des Beaux-Arts, where wages for models were higher than in private studios.[8] Indeed, such shame and ill repute attached itself to the profession of *modèle-femme* that many women were reluctant to admit their vocation. "She follows it on the sly," one writer claimed of the typical female model. "She does laundry, she embroiders, she works in a boutique, but she is never a model!"[9] Female bodies may have been celebrated in paintings as incarnations of ideal beauty, but their flesh-and-blood prototypes, at two francs per sitting, were treated with considerably less esteem.

The behaviour of models was a common source of worry and complaint for artists. "When I start something," Manet once told a friend, "I always tremble to think that models will let me down, or that I won't see them as often as I would like, or that the next time will be under conditions I don't like."[10] However, he seems to have had no trouble with Victorine, who proved herself exemplary—patient, obedient, uncomplaining and not given to idle chitchat.[11] Arriving at the studio, she would have been carefully positioned into the prescribed stance—that of a young woman reclining on the grass after having taken her bath in the river. Seated on the floor with her right leg retracted and her right elbow bent and supported by one knee, she would cup her chin with her right hand and turn her head to the right to gaze at Manet as he stood be-

hind his easel. This pose was not especially uncomfortable in an age when many artists were obliged to suspend from the ceilings of their workshops systems of rings and pulleys for the models to use in maintaining their balance or supporting their limbs as they struck the required heroic postures. Even so, she would have held the position for long periods at a stretch, suffering the strains—and the tedium—that were the occupational hazards of the model.

Though *Le Bain* was an outdoor scene, Victorine was not obliged to pose anywhere other than in Manet's studio. Manet was not given to erecting his easel on riverbanks or mountains, like Meissonier, and painting *en plein air*. His works were the products, on the contrary, of visits to museums and print shops rather than of any kind of face-to-face communion with nature: the external world was always mediated, for Manet, by other works of art. Moreover, unlike Meissonier, he did not concern himself with realistically transcribing nature or ensuring that the flesh tones of his subjects correctly matched their outdoor setting. He may have made a few preliminary on-the-spot sketches of trees on the Île Saint-Ouen, the location on the Seine, near Asnières, sometimes identified as the setting for *Le Bain*. However, the stream and saplings of his riverscape were inspired more by another work of art—Titian's *Jupiter and Antiope*, which he had copied in the Louvre—than by any actual foliage in Asnières or Saint-Ouen.[12]

Manet used two further models for *Le Bain*. The pose for one of the young men seated beside Victorine was struck by his brother Gustave, while that for the other by Suzanne Leenhoff's twenty-one-year-old brother Ferdinand, an aspiring sculptor and engraver who had followed his sister to Paris in order to study art.[13] In the background, Manet included a fourth figure, a young woman in a white negligee wading in the shallows of the river, a much less detailed figure for whom Victorine may also have posed.

Manet's earlier bathing scene, *Nymph and Satyr*, had featured Suzanne Leenhoff preserving her modesty through the strategic disposition of her limbs while turning her gaze unflinchingly to the viewer. The picture resembled works known to Manet from his studies in the Louvre and elsewhere, especially *Susannah and the Elders* by Rubens, an engraving of which was in the Louvre's Print Room. For *Nymph and Satyr* he transcribed the pose of Rubens's Susannah virtually line for line, albeit reversing the image, a trick frequently used by artists to disguise their borrowings.

This entire formula—a woodland stream, a seated nude, a bold gaze, an echo of an Old Master painting—was rehearsed again as Manet painted *Le Bain*. He did not select the positions of his models at random. The pose of Gustave, placed to Victorine's right, was particularly interesting. Manet

instructed him to recline as if on a sloping patch of ground, bending his right leg slightly, supporting the weight of his body on his left elbow, and extending his right arm towards Victorine. This posture was an exact copy—albeit in reverse—of one of the most famous images in the history of art: that of Adam in Michelangelo's *Creation of Adam* on the vault of the Sistine Chapel. Though Manet was familiar with this fresco from his visit to Rome, Gustave's recumbent pose in *Le Bain* was not actually borrowed directly from Michelangelo, but rather from Michelangelo's young admirer and rival, Raphael, who had reversed the famous image and placed it in one of his own works, *The Judgement of Paris*. Dating from about 1518, *The Judgement of Paris* was a drawing specially executed by Raphael for engraving by Marcantonio Raimondi—an engraving that Manet knew from his foraging in the Print Room of the Louvre. Besides the central scene showing Paris choosing which of the three goddesses, Juno, Minerva or Venus, was the most beautiful,* the engraving included a small vignette of three nude figures—two bearded river gods and a water nymph—seated on the reedy ground beside a stream. For the pose of one of these river gods, Raphael carefully reversed the image of Michelangelo's Adam.

Manet's newfound devotion to painting scenes of contemporary life did not mean that he had jettisoned his regard for—and his imitations of—the art of previous centuries. If Raphael borrowed an image from Michelangelo and then transposed it, Manet, at least in the case of *Le Bain*, did not even bother with the transposition: he simply appropriated the poses of these three figures in the engraving and arranged his models into their exact attitudes. Victorine was therefore given the role of the water nymph, Gustave and Ferdinand those of the river gods. Still, his painting was not a mere line-by-line reproduction of the figures in the Raimondi engraving. In keeping with his desire to capture something of the roisterous spirit of the Asnières daytrippers, he wittily updated Raphael's scene. Thus while Victorine, like the water nymph, appeared in the nude, her male companions were turned out resplendently in black frock coats, fob-chains and bright cravats—the very height of Second Empire fashion. Gustave even wore a bohemian hat on his head and held a cane (instead of the river god's trident of reeds) in his hand. In place of the plumed helmet and shield abandoned on the ground in *The Judgement of*

*Paris chose Venus. All three of the goddesses bribed him, but Venus won the day—and set in motion the events leading to the Trojan War—with her promise to give Paris the world's most beautiful woman, Helen of Troy.

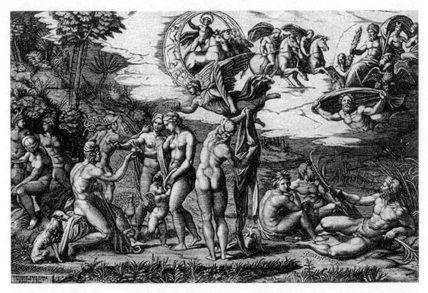

The Judgement of Paris *(Marcantonio Raimondi engraving after Raphael)*

Paris, Manet added a wickerwork picnic basket with its debris of bread and fruit, together with a jumble of discarded clothing: a blue polka-dot dress and a beribboned straw hat.

Le Bain was therefore, despite its origins in a Renaissance print, a daringly modern scene not unlike the works of Realism painted by Courbet. It was, in many ways, a defiant painting. Manet had copied or adapted numerous Old Masters, but never had he given his source such an audacious spin. He was not simply copying Raphael—he was cheekily reworking him, turning a mythological scene from one of the most celebrated engravings of the Renaissance into a tableau of somewhat vulgar Parisian holidaymakers in whom the morally fastidious might detect indecent undertones.

Manet's painting therefore marked an assault on the bastions of nineteenth-century art. Raphael was revered above all other painters by the conservative members of the Académie des Beaux-Arts, most of whom viewed his achievement as the pinnacle of artistic perfection. His paintings were a vital part of the pedagogical programme at the École des Beaux-Arts, where copies of fifty-two images from his most celebrated frescoes were permanently on display for the edification of students.[14] Those fortunate enough to win the Prix de Rome were sent forth from Paris to spend five years absorbing the artistic style of the Italian Renaissance by making further copies of masterpieces by Raphael and

other artists such as Michelangelo.* Of all Raphael's admirers in France, by far the greatest was Ingres, who claimed he endeavoured always to follow the path of the Renaissance master. Raphael, he once proclaimed, was not a man but "a god come down to earth."[15]

With its clever refashioning of Raphael, *Le Bain* was not a work guaranteed to please Ingres. Indeed, Manet can hardly have been entirely optimistic about his chances for success with so brazen a painting.

*The Prix de Rome was founded in 1663, during the reign of Louis XIV. There were competitions in painting, sculpture, architecture, etching and, after 1803, musical composition. The winners, determined by the members of the Institut de France, were sent to Rome to study at the Académie de France, which had been founded in 1666.

CHAPTER FIVE

Dreams of Genius

E RNEST MEISSONIER HAD signed his name on the petition to the
Comte de Nieuwerkerke, with a certain amount of pretension and pride,
as "E. Meissonier, Membre de l'Institut." He had been elected to a chair in the
Institut de France a little more than a year earlier, in the autumn of 1861, when
the members of the Académie des Beaux-Arts voted for him to join their ranks.
For Meissonier, already dripping with medals and bristling with ribbons, in-
cluding that of the Legion of Honour, membership in the Institut was the lat-
est and undoubtedly the greatest honour so far bestowed on him.*

Yet Meissonier's consecration by the French artistic establishment was not
without incident. His election to the Académie had actually succeeded only
on the second attempt, since in 1860 he was defeated for a vacant chair when
the members of the Académie instead cast their votes for Émile Signol, a
former student at the École des Beaux-Arts who had won the Prix de Rome
in 1830 with a weighty scene from classical mythology entitled *Meleager
Taking Up Arms Once More at the Insistence of His Wife*. Though Signol was

*The Académie des Beaux-Arts was one of the branches of the Institut de France, which
had been founded in 1795 to bring together five separate academies of learning: the
Académie Française, the Académie des Inscriptions et Belles-Lettres, the Académie des
Sciences, the Académie des Sciences Morales et Politiques, and the Académie des Beaux-
Arts. The forty members of the Académie des Beaux-Arts were made up from 14 painters,
8 sculptors, 8 architects, 4 engravers and 6 composers (one of whom, since 1856, was
Hector Berlioz).

a comparatively youthful fifty-eight, many members of the Académie were, quite literally, men from a different age, ten of the fourteen painters having been born in the eighteenth century. Their average age was sixty-eight, with the venerable and vituperative Ingres their elder statesman at eighty. A good number had spent large chunks of their careers on ladders and scaffolds, like Michelangelo and Raphael, executing murals on the walls and ceilings of churches and government buildings. In nineteenth-century France, murals were still what they had been during the Italian Renaissance, the most exalted form of painting. Their difficulty of execution as well as their obvious grandeur of design—what one writer called their "gravity" and "elevation"—made works painted on walls and vaults far more prestigious than oil paintings done on canvas.[1] "It's to the decoration of churches," Ingres had once declared, "of public palaces, of halls of justice, that art must dedicate itself. That is its true and unique goal."[2] Or as Géricault more bluntly expressed it: "Real painting means working with buckets of colour on hundred-foot walls."[3]

The career of Meissonier did not come close to matching this profile. He had not studied at the École des Beaux-Arts; he had not competed for, much less won, the Prix de Rome; he had not spent years honing his skills in Rome; he had not worked in fresco; and his little *bonshommes* and cavaliers, however popular with the public, hardly answered the Académie's call for classical subjects of profound moral earnestness. His artistic compass was orientated towards the north, to the work of the Flemish and Dutch painters of the seventeenth and eighteenth centuries. Meissonier's candidacy in 1861—when his main rival was sixty-six-year-old Nicolas-Auguste Hesse, yet another alumnus of the École des Beaux-Arts and winner of the Prix de Rome—must therefore have seemed no more likely to succeed than his bid the year before.

Any artist failing to conform to the standards of the Académie could be sure of a rough ride whenever the votes were cast to elect a new member of this self-perpetuating élite. A case in point had been the fate of Delacroix, the leading exponent of Romanticism. A movement specialising in depictions of storms and massacres, Romanticism produced canvases that were a far cry from the staid forms and austere style favoured by most painters in the Académie. Ingres had derided Delacroix as a "drunken broom," a reference to how he subordinated fine detail to bright colour and emotional effect. This challenge to the artistic orthodoxy meant Delacroix was elected only at the seventh attempt, having been rejected a total of six times between 1839, when his name was first put forward, and 1857, when he finally claimed his chair at the age of fifty-nine.

Meissonier was good friends with Delacroix, who used to visit the Grande Maison, together with Adolphe Thiers, for games of *boules*.[4] Meissonier was also a

great admirer of Delacroix's work, claiming never to pass through the Gallery of Apollo in the Louvre, on whose ceiling his friend had painted *Apollo Slaying Python*, without doffing his hat as a mark of respect for what he called a "dream of genius."[5] Delacroix may have seemed an unlikely artistic ideal for Meissonier, since the shipwrecks and slaughters of Delacroix's paintings were the antithesis of Meissonier's sedate, well-dressed *bonshommes*. Yet Meissonier was also capable of producing the kind of violent and impassioned scenes of revolutions and massacres for which Romanticism was both renowned and reviled. He had witnessed bloodshed at close hand long before the Battle of Solferino, since in 1848 he saw active service as a captain in the National Guard, the citizen militia that was the duty of every able-bodied man between twenty and fifty-five. He fought on the side of the newly formed republican government during the "June Days," an insurrection in Paris by thousands of unemployed workers in June 1848. Stationed near the Hôtel de Ville, Meissonier witnessed, he later recalled, "all the horror of such warfare. I saw the defenders shot down, hurled out of windows, the ground strewn with corpses, the earth red with blood." In the end, some 1,500 men died on the barricades or in reprisals afterwards. Meissonier was chilled by the words of an officer in command of the National Guard who, when asked if all the men shot without trial were guilty, casually replied: "I can assure you that not more than a quarter of them were innocent."[6]

With the "terrible impression" of this spectacle still fresh in his mind, Meissonier had painted a harrowing vision of the tragic aftermath of civil strife—a work that in its shock tactics and ghastly realism was different from anything else in his body of work. A remarkable painting, *Remembrance of Civil War* (plate 1A) was an unblenching piece of pictorial reportage that showed dead bodies heaped together beneath a shattered barricade. Shown at the Salon two years later, it attracted admiring reviews but also attention from the political authorities, who had it removed from the wall before the exhibition closed. However, the canvas made a deep impression on Delacroix, the "master of massacres" to whom Meissonier gave a watercolour study for the work. "I experienced one of the greatest pleasures of my life in making him a present of it," he later remembered.[7]

Meissonier could therefore count on the vote of Delacroix, who had supported him in 1860, noting afterwards in his journal that "the insipid Signol," a "nurseling of the École," had been chosen in favour of Meissonier because the other members were "shuddering at the idea that an original talent should enter the Académie."[8] Meissonier probably also enjoyed the support of his old teacher, Cogniet, another close friend of Delacroix who had been elected to his own chair in 1849 following important public commissions for both the Louvre

and the Palace of Versailles. Few other painters were prepared to endorse Meissonier, though, and his election in 1861 was achieved, after three rounds of voting, thanks to support from various of the sculptors, architects, engravers and musicians in the Académie—men whose prejudices were considerably less intractable than those of the painters.[9]

Meissonier's election was explained in a number of newspapers as having been a concession by the Académie to his tremendous public appeal. Many of these same papers celebrated his election as a victory for youth—Meissonier was forty-six at the time—over "the old Académie" with its "mongrel Raphaelism" (as Delacroix called it) and uncompromising reverence for Rome.[10] Certainly the robust painter, with his fondness for athletics, cut a conspicuous figure among the more elderly members of the Académie. "I was still vain enough of my youth," Meissonier later claimed, "to go running up the staircase of the Institut two steps at a time, and to jump seven or eight on my way down."[11]

And yet Meissonier, with his lofty dreams of majestic historical scenes, did not intend to go completely against the grain of the Académie. Therefore, in 1861, in his letter of application to the Académie, he had promised to reward its members for their votes "with new efforts and works perhaps more worthy of its attention."[12] He pledged to leave behind his *bonshommes*, in other words, and devote himself to elevated pictorial ventures with which he hoped to enhance both his own reputation and the grandeur of French art. If the members of the Académie wished to see this change with their own eyes, he had informed them, they were welcome to visit his picture dealer Francis Petit, in whose gallery in the Rue Saint-Georges he had temporarily put on display (though it was still only half-finished) *The Battle of Solferino*.

If most members of the Académie had been unpersuaded by Meissonier's claims in 1861—*The Battle of Solferino*, at two and a half feet wide, did not quite answer their demands for *grande peinture*—they remained equally unconvinced, in 1863, by his threatened boycott. The vast majority of them declined to sign the petition to Nieuwerkerke to which he so prominently attached his name, two exceptions being Delacroix and Ingres.[13] The third exception was Jacques-Raymond Brascassat, who had been elected to the Académie in 1846. A successful animal painter, Brascassat earned his keep by visiting the country homes of wealthy aristocrats and painting portraits of their prize cattle—canvases that inevitably lacked the moral gravity of those produced by most of his colleagues. But the names of the other eleven painters in the Académie signally failed to appear among the 182 names, no doubt because most of them shared the same lofty goals for French art as Nieuwerkerke.

* * *

The petition was delivered to the Comte de Walewski by two artists selected by their peers. One of the delegates was Gustave Doré, a thirty-one-year-old painter and illustrator; the other was Édouard Manet. The choice of Manet as an artistic ambassador to the Minister of State showed both his strong commitment to the cause and the level of faith placed in him by the other artists, Meissonier no doubt among them. At thirty-one, he was clearly regarded by his peers as something of a bellwether in political activism as well as in artistic innovation.

The fifty-two-year-old Walewski received the two men, the *Courrier artistique* reported, "with the greatest affability."[14] The son of Napoleon's Polish mistress Maria Walewska, he had once enjoyed something of an artistic career. He had collaborated with Alexandre Dumas *père* on a wildly successful play, *Mademoiselle de Belle-Isle*, and in 1840 his own work, *L'École du monde*, was produced at the Théâtre-Française. But Walewski had found himself saddled with cumbrous political obligations when his cousin, Napoleon III, came to power. Therefore, however affably he received Manet and Doré, he had no wish to involve himself in a dispute with disgruntled artists. He simply turned for advice to Nieuwerkerke, who urged him to ignore the petition even though its signatories included, he conceded in a scribbled note, "a small number of artists having considerable merit"[15]—a reference to the three most celebrated artists on the petition, Meissonier, Delacroix and Ingres. Walewski duly accepted this advice, and the *Chronique des arts* was soon reporting that the regulations for the 1863 Salon would go into effect with no modifications whatsoever: artists would be allowed to submit no more than three works.

Nieuwerkerke had called Meissonier's bluff. However, the painter's threat was not idly made. He had boycotted a previous Salon, that of 1847, in protest against the severity of the jury, which a year earlier had accepted fewer than half of the submissions, and which for the previous decade had systematically been excluding the work of landscapists such as Théodore Rousseau and Jean-François Millet.[16] The boycott had been a noble gesture on the part of Meissonier, a painter who had never had one of his paintings turned down by a jury. In 1863 he evidently still felt as strongly about a painter's right to exhibit at the Salon. He therefore declared that he would send nothing at all to the Palais des Champs-Élysées. The world would be forced to wait two more years for a glimpse of Meissonier's new style of painting. For the first time since 1847 the Salon would open without a contribution from France's most popular and acclaimed painter.

Youthful Daring

WHILE MEISSONIER WAS announcing his intention to boycott the Salon, Manet was doing everything in his power to ensure that his own paintings would be on the walls of the Palais des Champs-Élysées when its doors opened to the public in May. In what amounted to a campaign to generate publicity for himself in the run-up to the Salon, he arranged for an exhibition of fourteen of his canvases at the beginning of March, exactly a month before the painting jury was due to assess the submissions to the Salon. He no doubt reasoned that favourable attention from critics and the public would convince the jury to accept his three paintings for exhibition.[1]

More than one hundred private galleries operated in Paris in the early 1860s; many of them displayed canvases for sale in their windows or hosted small exhibitions of artists both living and dead.[2] Such venues—part of the city's vibrant visual culture—represented an opportunity for artists to show their wares outside the Salon. These exhibitions did not generate nearly the same widespread critical and public attention as the Salon, but art critics occasionally reviewed them, and the public, peering through the window, could enjoy a free show and become familiar with an artist's name and work. The most popular and famous of these galleries was that of Adolphe Goupil, against whose windows the crowds pressed themselves in order to enjoy displays of engravings, photographic reproductions of Old Masters, and original paintings by modern artists, all of which were offered for sale. The enormous success of Jean-Léon Gérôme—a painter who was perhaps second only to Meissonier in terms of the prices he could command—was due in no small part to the fact that his

works were always displayed in Goupil's windows, either in the original or in reproduction.[3]

The Galerie Martinet, though new, was beginning to rival that of Goupil in terms of its prestige. It was owned by a fifty-three-year-old named Louis Martinet, the son of a Corsican architect. Martinet had enjoyed a highly successful career as a painter and, more especially, as an engraver. In 1857 he was elected to the Académie des Beaux-Arts, one of only four engravers in the country to enjoy such a privilege. After an eye infection forced him to abandon this career, he opened a gallery in the Boulevard des Italiens, where in 1860, determined to give a wider exposure to artists, he showed a number of paintings controversially rejected from the 1859 Salon. Martinet was interested in discovering and promoting new talent, and in 1861 Édouard Manet's *The Spanish Singer* had caught his eye at the Salon. In September 1861 he therefore showed two of Manet's works, *Boy with Cherries* and *The Reader*, alongside works by Courbet and Daubigny. Neither painting was sold, but *Boy with Cherries* attracted the attention of none other than Adolphe Goupil, who offered to put the work on display in his own gallery in the Boulevard Montmartre. Encouraged by this success, early in 1863 Manet had begun arranging for another showing in the Boulevard des Italiens, this time a one-man exhibition.

By the time his exhibition opened, Manet had virtually completed *Le Bain* following at least four months of work. The canvas had proved as defiant in execution as it had been in conception, since he continued to experiment with the "strange new fashion" that had so astonished onlookers at the 1861 Salon. Manet may have taken the poses for *Le Bain* from Raphael's *The Judgment of Paris*, but his admiration for the Old Masters did not extend to their intricately modulated painting techniques. In working towards a new style better suited to capturing the energy and spirit of the modern age, he abandoned chiaroscuro, a technique perfected by Leonardo da Vinci and exploited by successful Salon painters as part of their stock-in-trade. The art of chiaroscuro (Italian for "clear" and "dark") involved giving the appearance of depth and relief to a painting by means of carefully graduated contrasts of light and shade. These soft and subtle nuances in the tonal range may have been adequate for portraying winged angels and toga-clad heroes, but ordinary Parisians on a day's outing to Asnières required, Manet seems to have decided, quite a different treatment. He therefore did away with most of his half-tones—the transitions between highlights and shadows—such that his figures, particularly the nude Victorine, looked harshly lit. In contrast to her counterpart in *The Judgment of Paris*, where the contours of the water

nymph's body were suggested through skilful hatching, Victorine appeared strangely two-dimensional.

Manet also explored his new style by experimenting with his canvases themselves. Since an optical illusion makes light colours advance and dark ones recede, most artists painted on a dark undercoat in order to enhance the impression of depth and, therefore, the "realistic" appearance of their chosen scene. This undercoat, sometimes referred to as *la sauce* ("gravy"), was a translucent mixture of linseed oil, turpentine and often bitumen, a tarry hydrocarbon made from distilling crude oil and used in, among other things, the production of asphalt. Manet had abandoned these dark undercoats after *The Absinthe Drinker*, working instead on canvases treated with off-white primers. This lighter ground gave *Le Bain* a greater luminosity—desirable in an outdoor scene—but at the expense of the appearance of spatial recession that could be achieved by a painter working on a darker undercoat. Manet was not interested, however, in such illusions of depth, or in creating on his canvas a wholly persuasive fictional space. Painting had other purposes, he clearly believed, than such clever trickery.

He further broke with artistic tradition as he worked on *Le Bain*, once again in a way that seemed designed to shatter the centuries-old obsession with perspectival space. Painters were usually trained to create a subtle relief on the surface of their canvases by applying their darks and lights in contrasting styles. Dark colours, such as those used for shadows, were spread very thin while highlights were "loaded" or "impasted"—applied, that is, in thick layers. This procedure was employed, together with the darker undercoat, to devise a subtle illusion whereby the whites would advance and the darks retreat. Yet Manet boldly disregarded this practice in *Le Bain*, loading his dark colours—the blacks of the men's coats—as well as the lights. Though a few other painters, such as Géricault and Courbet, had already experimented with this technique, the boldness of Manet's application witnessed his pursuit of a new direction in art.[4]

Le Bain was completed in good time for Manet to send it for appraisal to the Palais des Champs-Élysées. His other two entries were *Mlle V . . . in the Costume of an Espada* and yet another Spanish-style portrait, *Young Man in the Costume of a Majo*. This latter work, painted early in 1863, featured as its model not a real-life *majo*, or Spanish dandy, but the youngest of Manet's two brothers, twenty-seven-year-old Gustave, who posed for him in a bolero and white sash taken from Manet's trunkful of Andalusian costumes—an exotic costume for a young man who was, in fact, a lawyer. By the time the three

canvases went before the jury, however, Manet's new style of painting had begun receiving a truly ominous reception.

A one-man exhibition at the Galerie Martinet was a great honour for Manet, and he offered to public view some of the finest paintings he had completed over the previous few years, including *The Street Singer*—his first painting of Victorine Meurent—and a number of Spanish-flavored works, including another portrait of Victorine, *Young Woman Reclining in a Spanish Costume*. He also showed, for the first time in public, *Music in the Tuileries* (plate 3A), a scene, painted in 1860, of a dense mob of Parisians, including Baudelaire and Gautier, leisurely disporting themselves among the chairs and trees of the Jardin des Tuileries. In the finest tradition of Renaissance frescoists such as Perugino and Raphael, Manet had included his own self-portrait: a bearded and frock-coated figure standing on the left.

As a bid to garner public attention, the exhibition was a success. As a bid to sway votes on the painting jury, however, it was a disaster. Manet did receive one good notice, that of a young critic named Ernest Chesneau, a great enthusiast for Meissonier as well as a pioneer in the study of Japanese art. Writing in *L'Artiste*, he observed that Manet's work generally provoked more condemnation than sympathy. "Nonetheless, I confess that a certain amount of youthful daring is not unpalatable," he went on, "and that, even if I willingly grant that Manet still lacks much to justify his audacity, I do not despair of seeing him triumph over ignorance to become a fine painter."[5] Other reviews were less inclined to indulge Manet's youthful daring. The critic for the *Gazette des Beaux-Arts*, Paul Mantz, a republican who supported Delacroix and Romanticism, was someone from whom Manet might have expected a few words of praise and encouragement. But Mantz was thoroughly unimpressed by the fourteen canvases, calling Manet a "Parisian Spaniard," denouncing his work as "unhealthy," and declaring that he would by no means "plead Monsieur Manet's case" before the Salon jury.[6]

More was to come as Paul Bins, the Comte de Saint-Victor, reviewed the exhibition for *La Presse*, a mass-market daily newspaper with a circulation of some 30,000. Though this paper, edited by a dandyish impresario named Arsène Houssaye, was generally liberal in outlook, the thirty-six-year-old Saint-Victor was a venomous reactionary, with even his friends accusing him of "boorish intolerance" in matters of art.[7] True to form, he dismissed Manet in a few words: "Goya gone native in the depths of the Mexican pampas."[8]

Worse still, however, was the response of the public. One of Manet's friends

would later write that all "original" works of art were fated to suffer the gibes and taunts of "bourgeois imbeciles."[9] Many Parisians were as hostile and intolerant in matters of artistic taste as the disdainful Saint-Victor, and paintings not meeting with their approval sometimes risked being shown the business end of a riding-crop or walking-stick (as Courbet had discovered in 1853). Occasionally even the artists themselves came in for rough treatment. At the Salon of 1828, Delacroix's *Death of Sardanapalus* aroused such widespread revulsion with its brilliant colours and wild sensuality that one visitor threatened to put a stop to the painter's controversial career by amputating his hands.[10]

For several weeks in March, the Galerie Martinet witnessed similarly unruly scenes as indignant visitors threatened violence to Manet's canvases. Most offensive to their sensibilities was *Music in the Tuileries*, a chaotic-looking blaze of figures painted with a smeary lack of fine detail. Inauspiciously enough, it shared many of the same hallmarks as *Le Bain*, such as an off-white undercoat, impasted shadows and a lack of chiaroscuro—all of which made it drastically dissimilar in style to most of the works put on show in the Palais des Champs-Élysées.

The viewing public was accustomed to standing close to paintings, studying them minutely and marvelling over the delicacy of the handiwork. The work of a master like Meissonier even repaid, as John Ruskin would discover, the scrutiny of a magnifying glass. But Manet's apparently clumsy brushstrokes and lack of clarity in *Music in the Tuileries* did not lend themselves to this sort of appreciation. The work looked lackadaisical and incomplete because in places the undercoat of white primer and the weave of the canvas could clearly be seen. Elsewhere the marks of the paintbrush were visible. Most other painters used thin glazes and fine brushes made from sable to cover their traces, in effect brushing themselves—their labours and their personalities—out of their works. Manet, however, exploited the properties of his paints to reveal the nature of his workmanship. The vast majority of pigments sold in France were no longer mixed with linseed oil, which yellowed with age, but rather with poppy oil, whose use resulted in more buttery, textured pigments than the smooth ones produced by mixtures of linseed oil. Painters using pigments bound in poppy oil therefore needed to work harder to eliminate the bristle-marks from their canvases, though a number of them, notably Delacroix and Couture, had begun leaving behind the visible sign of the brush as a kind of signature of their individuality and workmanship.[11] They were following in the tradition of painters of the Italian Renaissance such as Leonardo and Titian, some of whose works show how they even smeared paint with their fingertips. But by the nineteenth century this seemingly spontaneous approach—and the hand of the individual artist—had largely disappeared because of an insistence on a more burnished appearance.

Study for Music in the Tuileries *(Édouard Manet)*

From close range, therefore, *Music in the Tuileries* simply looked absurd to spectators in the Galerie Martinet, a half-completed sketch masquerading as a finished product. The subject matter of *Music in the Tuileries* seems to have been equally repellent. It did not shock in the same way as, for instance, *The Death of Sardanapalus*, a scene of orgy and murder inspired by one of Lord Byron's plays. But Parisians accustomed to paintings featuring models in historical dress—the Roman togas and plumed helmets of David and Ingres, the Louis XV costumes of Meissonier—found themselves confronted, to their surprise, by a canvas showing a cast of characters dressed much like themselves.

Top hats and frock coats were by 1863 a distinctly modern costume. The top hat had been invented in 1797 by the London haberdasher John Hetherington, who caused a riot when he stepped outside with one perched on his head: children screamed, women fainted, the arm of an errand boy was broken, and Hetherington was hauled before the courts to explain the meaning of his alarming new invention. Sixty years on, these fears had been conquered and the top hat was omnipresent on the heads of both the bourgeois and the aristocrat, worn, like the equally ubiquitous frock coat, for both business and pleasure. While the dress of men in previous centuries had been designed to indicate ranks or professions, by the middle of the nineteenth century—especially after the reign of King Louis-Philippe, the "Citizen King" who

wore a bowler hat and carried a rolled-up umbrella—almost all men in Paris dressed identically in sober black clothes as a kind of sartorial recognition of their equality.[12] As early as 1846 Baudelaire had been interested in the black frock coat as a worthy subject for artists, urging them to abandon the exotic fripperies of historical paintings and to concentrate instead on this modern-day uniform of the bourgeois age (this despite the fact that he himself was a famous dandy who favoured resplendent dress and spent two hours each day making his toilet).[13] The same argument was made by the novelist and art critic Jules Champfleury. This "supreme pontiff of Realism," as he was known, ordered artists to discard the costumes of Greece and the Renaissance and consider a "serious representation of present-day personalities, the derbies, the black dress-coats, the polished shoes or the peasants' clogs."[14]

Since Baudelaire and Champfleury both appear in *Music in the Tuileries*, the painting might be understood as a kind of artistic manifesto or, at the very least, as Manet's experimental response to the entreaties of these two friends as well as to Couture's demands for scenes of modern life. However, modern-day dress was still a controversial topic for a painting. The subject of one of Manet's other figures in *Music in the Tuileries*, Théophile Gautier, was far more dubious about the value of commemorating top hats and frock coats in paint, or indeed of representing scenes of contemporary life through any means whatsoever.[15] Often seen sporting bright caftans and a fez, the long-haired Gautier despised bourgeois clothing, regarding it as unworthy of art since the sheer mundaneness of frock coats quashed the possibility of presenting visions of nobility or heroism. And Gautier believed, like many of his contemporaries, that these beautifully idealised visions were the highest and most proper subjects for art. Manet's depiction of humdrum everyday fashion therefore seemed a deliberate and provocative contrast to the signatures of masculine heroism—togas, helmets, swords—so familiar from the canvases and murals sanctioned by the Académie and put on show at each Salon. Nothing heroic or morally uplifting could be seen in *Music in the Tuileries*, merely an ill-defined mob of Parisians loitering and gossiping in a park.

Given the hostile reactions of both the newspapers and the visitors to the Galerie Martinet, Manet cannot have been surprised that his works failed to elicit commercial attention. Yet when Martinet inquired as to the price of one of the works, *Boy with a Sword*, he responded quickly. "I would like <u>one thousand francs</u> for it," he wrote with stern emphasis, before adding: "but I authorise you, <u>if you see fit</u>, to let it go for eight hundred."[16] Nonetheless, the painting languished on the wall of Martinet's gallery, and Manet would make, in the end, not a single sale from the exhibition.

One of Manet's few consolations at this time was the support from a fellow artist. Though seriously ill with tuberculosis, Delacroix left his home in the Rue de Furstemberg to pay a visit to the Galerie Martinet. He and Manet had met as early as 1857, the year of Delacroix's election to the Académie. Two years later, as a member of the painting jury, he had voted for *The Absinthe Drinker*, an endorsement from which Manet took much consolation. In 1863 Delacroix remained a fierce champion of the younger painter. Appalled by the rude comments and contumelious scenes around the paintings, he loudly proclaimed as he left the Galerie Martinet: "I regret having been unable to defend this man."[17]

Delacroix's spirited advocacy aside, Manet's exhibition had undermined some of the reputation he had built for himself two years earlier with *The Spanish Singer*. This failure obviously did not bode well for the Salon of 1863. His strategy in showing his canvases seemed dismally to have backfired.

A Baffling Maze of Canvas

Although his paintings were not destined to appear at the Salon of 1863, Ernest Meissonier would at least make his presence felt in another important way. His election to the Académie des Beaux-Arts had given him the privilege of serving on the painting jury. He would therefore be one of the men charged with reviewing several thousand works of art and deciding which among them were worthy of exposure in the Palais des Champs-Élysées.

The deadline for submissions was the first of April, a month before the Salon was due to open. Frenetic scenes always took place in the studios of Paris in the days preceding the deadline as artists worked desperately to put the finishing brushstrokes on their works, many of which arrived at the Palais des Champs-Élysées—the 250-yard-long cast-iron exhibition hall where the judging took place—with the paint still wet to the touch. Transporting a work of art to the hall, especially a piece of sculpture or a large canvas, posed logistical difficulties. The more affluent artists hired porters to convey them, while the rest were forced to do the job themselves, pushing handcarts and wheelbarrows through the streets. Masterpieces of painting and sculpture were thereby exposed to the elements, the perils of cobblestones, and the curious glances of passers-by, who occasionally witnessed amusing spectacles, such as the exertions of the Swiss sculptor James Pradier, who often gave his work finishing touches with a hammer and chisel while it was en route. Onlookers in 1855 would have witnessed the arresting sight of Jean-Léon Gérôme's *The Age of Augustus*, a gargantuan painting thirty-three feet long by twenty-three feet high, making its stately progress through the streets.

In the run-up to the 1863 deadline, the Champs-Élysées and surrounding av-
enues and bridges grew thick with swaying trolleys and wobbling carts as the
artists descended on the Palais des Champs-Élysées to have their works regis-
tered and measured. Despite Nieuwerkerke's new regulations, some 5,000 works
of art—paintings, sculptures, engravings and photographs—were submitted to
the Selection Committee, which began its deliberations on the second of April.
The process of judging was, as always, an arduous one. The works were ranged
around the Palais des Champs-Élysées in alphabetical order according to the
artists' surnames, creating what one writer called a "baffling maze of canvas."[1]
The jurors were obliged to tramp around the hall—and through the warren of
upstairs rooms into which the overflow spilled—to view the works one at a time,
separated from the canvases they were appraising by a white rope held by two at-
tendants. Votes for and against each work were taken by a show of hands, with a
simple majority prevailing. The chairman of the jury was armed with a little bell,
which he rang each time the jurors turned their attention to a new work, whose
fate was carefully recorded by a secretary. Canvases receiving unanimous favour
from the jurors were awarded a "number one" ranking, which gave them the
privilege of hanging "on the line" at the Salon, that is, at the ideal viewing height.
Those turned down by the jury, on the other hand, were carried away ("like
corpses after a battle," as a commentator put it)[2] by white-coated attendants and
then—most humiliatingly—stamped on the back with a red R that stood for *re-
fusé*: "rejected." This symbol was the kiss of death to a work, not only ruling it
out of the Salon but also hampering any chance of its selling to a private buyer.

The painting jury for the 1863 Salon faced a daunting prospect as its delibera-
tions began. The annual equestrian exhibition due to be held at the Palais des
Champs-Élysées during the latter half of April gave the jurors a mere ten days to
evaluate all of the submissions. At least five hundred works therefore needed to
be appraised every day, and given that the judges spent six-hour days in the Palais
des Champs-Élysées, more than eighty pieces passed before their eyes each
hour—with the result that most works received less than a minute of attention.
Paintings on which artists had spent months or even years were declined, in other
words, on the basis of an assessment, made by a team of dazed and exhausted
jurors, that lasted no more than a few seconds.[3]

The *règlement* did provide a slim chance for reprieve: at the end of the judg-
ing a special session called the *repêchage*, or "fishing again," was convened,
when the jury took a second look at the *refusés* in order to reconsider their ver-
dicts. As well, each of the jurors had the right of a "charity" pick—a work
that, no matter how unworthy in the eyes of his colleagues, would be accepted

without quibble. Still, an artist enjoyed only a fifty–fifty chance of having his work accepted.

The odds against the artists appeared to become even more unfavourable when, as judging for the Salon of 1863 commenced, Nieuwerkerke urged the jury to treat the submissions severely.[4] Given the composition of the jury, most of whose members shared Nieuwerkerke's elevated objectives, this imperative was hardly necessary. Those eligible to serve on the jury included six former winners of the Prix de Rome as well as one runner-up for the prize, Victor Schnetz, a seventy-six-year-old who, in a long and distinguished career, had served as Director of both the École des Beaux-Arts and the Académie de France in Rome, the two main training grounds for French artists.[5] However, the physical rigours involved in judging so many works, together with the advanced age of many members of the Académie, prevented a number of those eligible for service, including Schnetz, from appearing at the Palais des Champs-Élysées on April 2. All told, Ingres, Delacroix, Cogniet, Schnetz and Hippolyte Flandrin—a friend and former pupil of Ingres—declined to accept their places, while another member of the Académie, the battle painter Horace Vernet, had died in January at the age of seventy-three. To Manet, anxiously awaiting news of the deliberations, the absence of a strong supporter like Delacroix was a cause for serious concern. He even went so far as to exhort Delacroix to attend the voting sessions, but the older artist was simply too ill to participate.[6]

The jury was therefore reduced to eight members, with the votaries of Raphael and Rome well-represented among them.* Indeed, one of their number, seventy-seven-year-old Jean Alaux, even went by the nickname "The Roman." François Heim, another septuagenarian veteran of the controversial 1859 jury, epitomised the majority. A renowned history painter, he had won the Prix de Rome fifty-six years earlier, in 1807, for *Theseus and the Minotaur*. After five years of studies in Rome he had returned to Paris to teach at the École des Beaux-Arts and to paint ceiling murals for the Louvre. Manet could not have expected him to provide a friendly reception for a work such as *Le Bain*. Nor could he count on encouragement from Émile Signol, a famously intolerant conservative who could be outraged by the sight in a painting of "a certain red."[7] Another juror, a seventy-seven-year-old named François Picot,

*The remaining jurors were Jean Alaux, Jacques-Raymond Brascassat, Auguste Couder, Émile Signol, François Heim, Joseph Robert-Fleury, François Picot and Ernest Meissonier.

was bound to be equally intransigent. A sensation thirty years earlier at the Salon of 1833 with allegorical paintings such as *Cybele Protects the Towns of Stabiae, Herculaneum, Pompeii and Resina from Vesuvius*, he had distinguished himself by repeatedly voting against the inclusion in the Salon of Gustave Courbet and other proponents of Realism.

Ernest Meissonier was the one member of the jury from whom Manet may have hoped for some support. They had been allies in the fight against Nieuwerkerke's new regulations, and Meissonier enjoyed a close friendship with Manet's strongest advocate, Delacroix. Moreover, on the 1863 jury he found himself among a group of *académiciens* who, on two separate occasions within the previous three years, had voted against exalting him to their ranks.

"I flatter myself that I can be of use there," Delacroix had written in 1857 regarding his own presence on the Salon jury, "because I shall be nearly alone in my opinion."[8] On his own first stint on the jury, Meissonier must likewise have resigned himself to holding the minority opinion. Most interested observers could reasonably have concluded that he was the ideal candidate to assume the mantle of the ailing Delacroix and vote for the artists who dwelt beyond the charmed circle of the École des Beaux-Arts.

Meissonier's presence notwithstanding, the results of the jury's deliberations were, perhaps, only too predictable. On April 5, three days into the judging, rumours about widespread rejections made the rounds of the cafés and studios of Paris. When the results were announced a week later, stories of a massacre in the Palais des Champs-Élysées were brutally confirmed: only 2,217 works were accepted out of the more than 5,000 submitted, a failure rate of almost sixty per cent. Of the 3,000 artists who had submitted work, only 988 heard good news.

Among the more than 2,000 *refusés* were a number of well-known painters. Foremost among them were the landscapists Antoine Chintreuil, an exhibitor since 1847, and Johan Barthold Jongkind, a forty-four-year-old Dutch painter whose work had been awarded a gold medal in 1852. In another surprise, more than forty students and former students of Léon Cogniet—Meissonier's old teacher and a fellow member of the Académie—were also given the thumbs-down. Among their number was one of the rising stars of French art, Amand Gautier, a thirty-seven-year-old painter and engraver who had won great plaudits at the Salon of 1857 for *The Madwomen of La Salpêtrière*—a study of lunatics in a Paris asylum—and again in 1861 for a portrait of his friend and former roommate, Paul Gachet, a doctor specialising in psychiatry and homeopathy.[9]

As for Manet, he received the same bad news as the more than 2,000 other *refusés*. A letter on notepaper headed "Ministry of State," and signed with a flourish by Nieuwerkerke, tersely explained how the Directeur regretted that

his three works "were not admitted by the jury." There was no explanation for the rejection: the artist was simply told that he had to reclaim his work from the Palais des Champs-Élysées "without delay."[10]

The jury's wholesale rejections spurred into action groups of artists who had already been mobilised several months earlier by the campaign against Nieuwerkerke. They did not on this occasion muster on the steps of the Institut de France, as they had done four years earlier, or protest noisily beneath Nieuwerkerke's windows in the Louvre. Instead, in the days that followed many of them gathered to drown their sorrows and discuss strategy in the Café de Bade, close to the Galerie Martinet in the Boulevard des Italiens.

A number of the 12,000 cafés in Paris had become important forums for artistic life. Cafés offered to painters and writers a bohemian atmosphere of pipesmoke, *bonhomie*, and drinks that tasted, in the words of one habitué, like a mixture of cheap mouthwash and soot.[11] Manet had been a regular at the Café de Bade for the previous eight or nine years, spending each evening there before making his way home to Suzanne, Léon and what passed for his domestic obligations. The café offered a slightly raffish clientele of men-about-town, prostitutes and devotees of *le whist*, a card game recently imported from England. It had become the preferred hangout of a group of young artists who abandoned their former haunt on the Left Bank, the Café Molière, to enjoy its hospitality. Included among them were Fantin-Latour and his close friend, the painter and engraver Alphonse Legros; a young art critic named Zacharie Astruc; and, whenever he was in Paris, a twenty-nine-year-old expatriate American named James McNeill Whistler.

Manet and "Jemmie" Whistler had met in March, following an introduction by Fantin-Latour. With his monocle, sarcastic wit and rebellious streak, not to mention an inheritance stingily doled out by a widowed mother, Whistler resembled a transatlantic version of Manet—though his *bon mots* and "amazing power of anecdote" (as one admiring witness reported) exceeded even Manet's sparkling repartee.[12] The son of an engineer who built a 420-mile railway from Moscow to Saint Petersburg for Czar Nicholas I, Whistler was a former West Point cadet who had been expelled by the academy's commandant, a despairing Robert E. Lee, for incompetence and insubordination. He had fetched up in Paris in 1855, at the age of twenty-one, determined to make a living as a painter. Like Manet, he saw his offering for the Salon of 1859, *At the Piano*, rejected by that year's painting jury, but since then a limited amount of success had come his way in London. He had sent to the 1863 Salon, however, a painting already rejected by the Royal Academy in London. That Whistler was still alive to show the painting was something of a minor miracle in itself.

James McNeill Whistler (Nadar)

Called *The White Girl*, the seven-foot-high canvas had been responsible for giving him a dose of lead poisoning after he used copious amounts of lead white, a toxic pigment, in its creation.* He had subsequently spent time recuperating from the illness in Biarritz, on the south-west coast of France. There he had nearly been drowned when a fifteen-foot-high wave swept him out to sea as he studied the breakers for his latest work, *The Blue Wave: Biarritz*.

Both Whistler and Fantin-Latour found themselves excluded from the 1863

*Lead-based paints were responsible for poisoning many artists over the centuries. One of the symptoms of lead poisoning—spasmodic pains in the stomach—came to be known as "painter's colic." Besides Whistler, a second artist poisoned by his pigments was Vincent Van Gogh. Another symptom of lead poisoning, a swelling of the retina that creates the illusion that objects are encircled by halos, seems to have had repercussions for Van Gogh's painting as well as his health.

Salon along with Manet, Whistler's *The White Girl* adding to its catalogue of misfortunes the inglorious red stamp of the Salon jury. Though Whistler left for Amsterdam in April to make a study of Dutch painting, many other rejectees gathered in the Café de Bade, in the days after the jury's decisions were announced, to plot their response. Among their number, it seems, was Louis Martinet, who, undaunted by the poor reception given Manet's works a month earlier, offered to show some of the refused works in his gallery. The *Courrier artistique* reported the project on April 15, three days after the jury's decisions were made public. Martinet immediately received a letter from Whistler (who was being kept abreast of developments by the faithful Fantin-Latour) authorising him to fetch *The White Girl* from the Palais des Champs-Élysées.[13] Manet, too, undoubtedly began preparations for another showing of his work, including *Le Bain*, at the Galerie Martinet—a small compensation for his exclusion from the Salon.

These plans were suddenly and dramatically altered, however, when word of rampant discontent among the artists reached the ears of someone far more powerful than Louis Martinet. Exactly a week after the controversial decisions were announced, Emperor Napoleon III, worried about the level of the complaints, decided to investigate. On April 22, therefore, he made his way to the Palais des Champs-Élysées to inspect the rejected paintings for himself.

Charles-Louis-Napoleon Bonaparte had been born in Paris on April 20, 1808, in a mansion in the Rue Cerutti (now the Rue Laffitte). His was a dizzying genealogy. His mother was Hortense de Beauharnais, the daughter of the Empress Joséphine and the stepdaughter of Napoleon.* His father, at least on paper, was Louis Bonaparte, Napoleon's brother and the King of Holland from 1806 until his abdication in 1810. However, the marriage between Louis and Hortense was so unhappy ("Never was there so gloomy a ceremony," wrote Louis of his own wedding)[14] that the child's true paternity was the object of much speculation. Candidates ranged from an admiral in charge of the Dutch navy, to various equerries and chamberlains, and even to Napoleon himself, who was rumoured to have nourished a soft spot for his stepdaughter.[15]

The child, known as Louis-Napoleon, was so feeble at birth that he was

*Hortense-Eugénie de Beauharnais, born in 1783, was the daughter of Vicomte Alexandre de Beauharnais and Marie-Josèphe-Rose Tascher de La Pagerie, i.e. Joséphine. Joséphine separated from Vicomte de Beauharnais in 1785, nine years before he was guillotined. In 1796 she married Napoleon Bonaparte, from whom she was divorced in 1810.

bathed in wine and then wrapped in cotton wool. For several years there-
after, disappointed at having given birth to a boy, Hortense dressed him as a
girl, an inauspicious start in life for someone whose horoscope proclaimed
that he would wear the imperial crown of France. Still, greatness was im-
pressed upon the child from an early age. An imperial decree gave him, at the
age of two, the title of "Prince Louis-Napoleon," and he received regular
visits from his uncle the Emperor. One of his most vivid early memories, in-
deed, was of Napoleon picking him up by his head.[16]

After Waterloo, the young prince, then aged seven, was exiled with his
mother to a castle in Switzerland, where they were put under the surveillance
of the British, French, Austrian, Russian and Prussian ambassadors. This ex-
ile was to last for many years, during which time the sickly child became a
vigorous young man who fought by the side of Italian revolutionaries in
Rome and conducted multiple love affairs in Switzerland. In London, work-
ing in the British Museum, he penned a political treatise, *Ideas of Napoleon-
ism*, which he published in 1839. These musings were no idle occupation, for
in 1832 the possibility of the young prince fulfilling the prediction of his
horoscope and seizing the French throne had unexpectedly presented itself.
Napoleon's only legitimate son, the Duc de Reichstadt—the so-called
Napoleon II—died of tuberculosis in Vienna, leaving Louis-Napoleon as the
dynastic heir.* He duly set about making plans to oust King Louis-Philippe,
but an unsuccessful coup attempt in 1836 ended with his arrest, imprisonment
and then another exile as he was sent to America aboard a French warship. In
New York City he proved a great social success, meeting Washington Irving
and impressing the locals with his wax-tipped moustache, a sight virtually
unknown in America.

Four years later, in August 1840, Louis-Napoleon made a second attempt to
reclaim what he regarded as his birthright. By this time he was living in Lon-
don, in a mansion in Carlton Gardens staffed by seventeen fervent Bona-
partists. In a daring bit of bluff, he and his band of fifty-six conspirators—his
domestic servants among them—donned military uniforms, chartered a

*Napoleon-Francis-Joseph-Charles Bonaparte, the Duc de Reichstadt, known as "The
Young Eagle," had been born in 1811, the son of Napoleon and Marie Louise, the Arch-
duchess of Austria, whom the Emperor had married following his divorce from Joséphine.
Napoleon abdicated in his favour in 1814, which made him, at the age of three, Emperor
Napoleon II. Events, however, conspired to keep this title from being anything more than
nominal, and he spent most of his short life in exile in Vienna.

Thames pleasure boat named the *Edinburgh Castle*, and made for the French coast. On board were nine horses, two carriages, several crates of wine, and a tame vulture bought at Gravesend to improvise as an eagle, the totem of the Bonaparte family. This ragtag expeditionary force landed at Boulogne-sur-Mer but beat a hasty retreat when the presence on French soil of the Bonaparte heir failed to incite a popular uprising against the King. When the landing craft capsized in the Channel, the invasion ended with Louis-Napoleon clinging to a buoy and awaiting his rescue, which came in the form of the French National Guard. Fished from the waves, he was arrested and then sentenced to life imprisonment in the fortress at Ham, a medieval château in northern France. There he spent the next six years. His confinement does not seem to have been onerous, since he found opportunities to author a treatise on sugar beets, hatch a scheme to dig a canal across Nicaragua, and carry on a liaison with a ginger-haired laundress named Alexandrine Vergeot, who ironed the uniforms of the prison's officers and lived in the gatekeeper's house. He gave her lessons in grammar and spelling; she returned the favour with two children, both of whom, confusingly, were named Alexandre-Louis.

Louis-Napoleon escaped from Ham in 1846 by donning the uniform of a workman and casually strolling through the front gate with a plank of wood balanced on his shoulder. He then returned to England, where he served briefly as a special constable at the Marlborough Street police station and dallied with his latest mistress, Lizzie Howard, the daughter of a Brighton bootmaker. Soon, however, Louis-Napoleon's destiny drew nigh. His chance came in 1848, the "Year of Revolution," when an economic downturn and widespread crop failures, combined with demands for more liberal governments, triggered riots and revolutions across much of Europe. In February, following pitched battles in the streets of Paris, King Louis-Philippe abdicated his throne, fleeing to England as his Bonapartist rival crossed the Channel in the opposite direction. In December of that year, with a majority of four million votes, Louis-Napoleon was elected President of the Second Republic, and the former prisoner of Ham found himself enjoying the splendours of the Élysée Palace. Three years later, anticipating the end of his four-year term as President, he consolidated and increased his powers in a bloody coup d'état. In an operation code-named "Rubicon," he dissolved the Constituent Assembly, imprisoned many of his opponents (including Adolphe Thiers), and sent the army into the streets of Paris, where 400 people were killed in violent skirmishes. One year later, on December 2, 1852, he proclaimed himself Emperor Napoleon III.

The Second Empire was one of the gaudiest and most vainglorious eras in

the history of France. The years since Louis-Napoleon came to power had witnessed unprecedented economic expansion and commercial prosperity. Industry flourished, foreign trade tripled, household incomes increased by more than fifty per cent, and credit grew with the establishment of new financial institutions. Grand projects were undertaken, such as the building of the new sewers and boulevards in Paris and the laying of thousands of miles of railway and telegraph lines. Louis-Napoleon was making the country live up to his vision of "Napoleonism," which, he had written, "is not an idea of war, but a social, industrial, commercial and humanitarian idea."[17] Louis-Napoleon may have disliked wars, but he had nonetheless involved France in the Crimean War, which ended in 1856, and in the war against Austria in Lombardy in 1859. The year 1859 also witnessed French military expeditions to Syria and Cochin-China, in the latter of which the Emperor's troops occupied the capital, Saigon. In the following year, French troops invaded Peking and burned the Summer Palace.

His swashbuckling career notwithstanding, Napoleon III was a less than prepossessing character. He looked, to Théophile Gautier, like "a ringmaster who has been sacked for getting drunk," while one of his generals claimed he had the appearance of a "melancholy parrot."[18] The urbane aristocrat Charles Greville, meeting him in London, found him "vulgar-looking, without the slightest resemblance to his imperial uncle."[19] In fact, the only thing that he seemed to have shared with Napoleon was a short stature: he was only 5 feet 5 inches tall. A reserved and thoughtful man with a waxed moustache, a pointed beard and hooded eyes, he possessed an air of inscrutability. It was said that he knew five languages and could be silent in all of them. Prince Richard von Metternich, the Austrian ambassador, called him the "Sphinx of the Tuileries."[20] But most of his opponents were guilty of underestimating his abilities, and by the 1860s he had become, as an English newspaper admitted, "the foremost man of all this world."[21]

On April 22, in the midst of the judging controversy, Emperor Napoleon left the Palais des Tuileries, which sat beside the Louvre, for the short journey to the Palais des Champs-Élysées. Despite having been a popular target for assassination (in 1858, most notoriously, an Italian named Orsini had thrown three bombs at his carriage as he arrived at the opera for a performance of *William Tell*), he was accompanied only by a single equerry. Arriving at the exhibition hall, he demanded to be shown examples of both accepted and rejected works, some forty of which were duly exposed to him, in the absence of Nieuwerkerke and the jury, by the team of white-coated attendants.

Charles-Louis-Napoléon Bonaparte, Napoleon III (Nadar)

His uncongenial reaction to Courbet's *Bathers* a decade earlier notwithstanding, Louis-Napoleon had virtually no interest in painting. One of his wife's ladies-in-waiting claimed that art was "a subject strangely foreign to his natural faculties."[22] And a good friend from his days in London, the Earl of Malmesbury, was shocked, during a visit to Paris in 1862, at his ignorance about even the most famous painters.[23] At the Palais des Champs-Élysées, however, the Emperor managed to sustain his interest and restrain his riding crop. For more issues were at stake, he knew, than simply the fortunes of a band of disgruntled artists.

Since his coup d'état, Napoleon III had been, for all intents and purposes, the absolute ruler of France. He commanded both the Army and the Navy, and he alone could promulgate laws, declare wars and conclude treaties. He appointed all of his Ministers, who were accountable to him alone and not to the Legislative Assembly, a body (elected through universal male suffrage) that sat for

only three months of the year.* This autocracy was sustained by a good deal of censorship and repression. Trial by jury had been eliminated, and under the Law of General Security, passed in 1858, anyone suspected of plotting against the government could be arrested and deported without trial. The *Marseillaise* was banned (the Emperor did not want its patriotic strains stirring the blood of French republicans) and in fact singing songs of any sort was banned in all cafés and taverns, which faced closure if they threatened to become hotbeds of dissent. There was no freedom of assembly, and organisations perceived as hostile to the government were proscribed and suppressed. Nor, of course, was there any freedom of the press. So draconian were the restrictions on newspapers during the Second Empire that a satirical pamphlet reported that any journalist wanting to publish an article of any sort "should hand himself in to the authorities twenty-four hours in advance."[24] Images were likewise censored, since a law of 1852 required all prints to be submitted, before they could be sold or exhibited to the public, to the Dépôt Légal, where they were carefully scrutinised for subversive messages. Books, likewise, could not be published without a licence from the police, and the works of many authors were outright banned. Among the proscribed writers was Victor Hugo, a former supporter of Louis-Napoleon who had turned against him and, in 1852, evaded arrest and fled to the island of Jersey, from where he derided the Emperor as a "disgusting dwarf."

The Emperor had been especially mindful of dissent in the spring of 1863, since he had called an election, the first in France for eight years, for the end of May. The Minister of the Interior, the Comte de Persigny—the prime strategist in Louis-Napoleon's two failed coup attempts†—was busy squelching the opposition press in the run-up to this election, in which the republicans in Paris, led by Adolphe Thiers, looked poised to increase the number of their seats in the Legislative Assembly. To make matters worse, this election would

*To avoid confusion, I will refer to the Corps Législatif—as this body was known—as the "Legislative Assembly," as opposed to the Constituent Assembly of the Second Republic and the National Assembly of the Third Republic.

†For his part in the 1840 Boulogne expedition, Jean-Gilbert-Victor Fialin, the Comte (and later Duc) de Persigny, was imprisoned at Versailles, where he wrote a treatise called *On the Purpose and Permanent Use of the Pyramids*. This work, published in 1845, advanced the theory that the ancient Egyptians had constructed the pyramids in order to stop the Nile from clogging up with silt.

be fought against the background of an unpopular war in which the Emperor had embroiled himself in Mexico.

Louis-Napoleon had declared war on Mexico in 1862, seeking to remove from power the government of Benito Juárez, a popular lawyer and liberal reformer. A Zapotec Indian who had once worked in a cigar factory in New Orleans, Juárez had swiftly alienated Catholics in Europe, soon after coming to power in 1861, by confiscating Church lands and expelling monks and nuns from their convents. He further infuriated the European powers by suspending payment of Mexico's foreign debts, which, in the case of France, amounted to twenty million pesos. With America embroiled in its Civil War, the Emperor saw an opportunity and a reason to flex his muscles and invade the North American continent. Claiming that he was "rescuing a whole continent from anarchy and misery,"[25] he dispatched 3,000 French soldiers with orders to capture Mexico City and replace Juárez with a Catholic monarch. The French promptly suffered defeat at Puebla on May 5 (the famous "Cinco de Mayo"), a stunning rout that the French press were banned from reporting. Thirty thousand more troops were then shipped across the Atlantic. All of them had reached Mexican soil by early 1863, and in the middle of March Puebla, sixty-five miles from Mexico City, was again under siege. Even the Emperor's strongest supporters had doubts about the Mexican enterprise.[26] By the third week in April, Louis-Napoleon was anxious for news to pacify his critics and trumpet a French victory before the election.

The man who visited the Palais des Champs-Élysées on April 22 was thus, despite his wide-ranging powers, not invulnerable. Nor was he deaf to protests and complaints. Despite the absolutist nature of his régime, he was keenly attentive to public opinion, knowing that his authority ultimately rested not on the might of the army but on the will of the people who had endorsed his rule. He once wrote that the best government was one in which the leader ruled "according to the will of all."[27] He seems to have sensed that the discontent among the artists might spread, like dissent over his Mexican adventure, into a wider critique of his régime. In any case, artists protesting that their right to exhibit had been infringed must have borne, in Louis-Napoleon's ears, uncomfortable parallels to opposition complaints about the government's wider violations of personal liberties.

The Emperor viewed the works with his riding crop in hand, occasionally halting the proceedings to express his astonishment at the jury's severity.[28] Not the least of his amazements was the sight of one of his own commissions among the rejected works, paintings of the *Four Seasons* done for the Salon de l'Impératrice in the Élysée Palace. The artist for this commission was Paul-César Gariot, a fifty-two-year-old painter who had been awarded a medal at

the 1843 Salon. The Emperor may have viewed the rejection of these four paintings as a comment on his own artistic taste. Nor would he have been amused to see among the *refusés* a portrait of his wife painted by a female artist named Hortense Bourgeois.

In an obvious rebuke to the jury, the Emperor concluded his visit by ordering the purchase for himself of one of the rejected works, a still life of game birds by Eugène-Édouard Salingre. Then, returning to the Palais des Tuileries, he sent for Nieuwerkerke. When the Directeur could be found in neither his offices nor his apartments—rumour had it he was in hiding—Louis-Napoleon seems to have turned for advice to one of his relations, a member of the imperial court named Albert Lezay-Marnésia, who served as a chamberlain to the Empress Eugénie.[29] More important for Louis-Napoleon, the forty-four-year-old Lezay-Marnésia was an artist who had trained under Thomas Couture. Whether alone or with a few other close advisers, he seems to have dissuaded the Emperor from acting on his first impulse, which was to order the jury to reconsider their verdicts—a command guaranteed to cause the Selection Committee to resign en masse and mire the Emperor in further controversy. What Lezay-Marnésia proposed instead was that a separate exhibition of the refused works be mounted in the Palais des Champs-Élysées, allowing the public to decide if the jury had indeed been overly harsh—or if, on the other hand, its assessments had been only too reliable.

Louis-Napoleon was nothing if not a shrewd politician. His decree to let the people decide had pleasingly democratic overtones in the weeks before an election, providing a riposte to those who complained about the illiberal nature of his régime. But other motives might also have been behind the decree. "One of the first duties of a sovereign," he once claimed, "is to amuse his subjects of all ranks in the social scale."[30] If his subjects could be entertained, he reasoned, then perhaps they would fail to notice or to care about the fact that most of their liberties had vanished. This was the man, after all, who had suppressed an insurrection in Algeria in 1856 by sending the magician Robert-Houdin to Algiers to bamboozle the locals with his repertoire of amazing tricks, including his famous "bullet catch" routine. And what worked on unruly Algerians would likewise, Louis-Napoleon hoped, work for the unruly French. As a correspondent for *The Athenaeum*, an English journal, noted in 1862: "So long as Parisians are amused, there is less probability of their thoughts dwelling on political slavery."[31] The people of Paris were accordingly treated during the years of the Second Empire to endless military parades, illuminations and fireworks, gala opera performances, state balls in the Tuileries, grand openings of new parks and boulevards, and public beheadings such as that in the Place de la Roquette of the would-be assassin Orsini.[32]

The Emperor no doubt realised that Lezay-Marnésia's suggestion for an alternative exhibition would provide yet another distracting spectacle for the public in the weeks before the May elections. In any case, two days after his visit to the Palais des Champs-Élysées the government's official newspaper, *Le Moniteur universel*, carried the following announcement:

> Numerous complaints have reached the ear of the Emperor on the subject of works of art which have been refused by the Salon jury. His Majesty, wishing to let the public judge the legitimacy of these complaints, has decided that the rejected works of art are to be exhibited in another part of the Palais des Champs-Élysées. This exhibition will be voluntary, and artists who may not wish to participate need only inform the administration, which will return their works to them.[33]

The Salon des Refusés—as this impending exhibition soon came to be called—was scheduled to open on May 15, a fortnight after the official Salon commenced at the start of the month. So, provided Manet elected not to reclaim it from the Palais des Champs-Élysées, *Le Bain* would be seen by the public after all.

Napoleon III's decision to exhibit in the Palais des Champs-Élysées the works rejected by the 1863 Selection Committee was met, at first, with a flurry of excitement. A week after the announcement, the art critic Ernest Chesneau wrote that Parisians interested in artistic matters had "received this ruling with real joy."[34] No less joyous were the rejected artists themselves. "It's delightful, it's delightful for us, this business of the rejects' exhibition!" Whistler wrote excitedly to Fantin-Latour from Amsterdam, where he had been marvelling over Rembrandt's *Night Watch* and purchasing shedloads of blue-and-white porcelain for his house in London.[35] At the Café de Bade, Whistler's Paris friends were busy mobilising themselves. Zacharie Astruc, the journalist and critic, made plans to publish a daily newspaper in which he would herald the virtues of Manet and others of his friends while savaging the works in the official Salon; and schemes for a book declaiming the artistic genius of the rejected artists were set in motion by Fernand Desnoyers, a poet and art critic.

The bulk of the leadership in preparing for the Salon des Refusés was assumed, however, not by the eager young artists and writers in the Café de Bade but by a more prominent and seasoned team of painters centred around forty-nine-year-old Antoine Chintreuil, the veteran landscapist. Chintreuil was a protégé of Camille Corot, who urged his students to seek a spontaneous and personal response to the landscape. "We must never forget to envelop reality

in the atmosphere it first had when it burst upon our view," Corot once wrote. "Whatever the sight, whatever the object, the artist must submit to the first impression."[36] Chintreuil specialised in these "first impressions" of the effects of sunlight on fields and meadows near Septeuil, some thirty miles west of Paris, where he had become the leading light in a group of landscapists known as the École de Septeuil. Though several of his works had been purchased by the government in the 1850s, all three of his offerings for the 1863 Salon were turned down. Having suffered poverty and rejection from the Salon in his early days (when he had been obliged to work as a bookseller to make ends meet), Chintreuil wished neither to repeat the unpleasant experience nor see the younger generation share it. Therefore, with his friend Jean Desbrosses, another member of the Septeuil group, he formed a committee of eight men, the *Comité de salut des refusés*, to assist the rejected artists. The centre of their operations was the studio of Jean Desbrosses in the Rue de Seine—ironically, just around the corner from the Institut de France.

One of the Committee's first tasks was to prepare a catalogue listing the works of the rejected artists that would be on show. Hardly had this started, though, than the enthusiasm of many of the rejected artists rapidly began to wane. Letting the public decide the merits of the works—the public that had so recently ridiculed Manet's works in the Galerie Martinet—did not seem, on reflection, quite so appealing an idea after all. Many artists soon thought better of showing their work, and within a few days more than 600 paintings were quietly reclaimed from the Palais des Champs-Élysées. So many of the rejected paintings were removed that, as the expatriate English poet and art critic Philip Hamerton ruefully observed, it would become "impossible to determine, in any satisfactory manner, how far the jury has acted justly towards the refused artists as a body."[37] One of the artists who withdrew his work was a twenty-two-year-old former pupil of Émile Signol named Pierre-Auguste Renoir. A former painter in a porcelain factory, Renoir redeemed his canvas, a mythological scene featuring a nymph and a faun, so as to avoid enraging his mentor at the École des Beaux-Arts. Rumoured to have been the most inflexible member of the jury, Signol would hardly have looked kindly upon the sight of his former student flouting the jury's authority in this rebel Salon.

Also contemplating the recovery of his works was Fantin-Latour. But as he prepared to fetch his two canvases, a sinew-stiffening letter arrived from Amsterdam: "Certainly you must send my picture there!" Whistler urged him. "And yours too! It would be madness to withdraw them . . ."[38] And so Fantin-Latour, like Whistler, permitted his paintings—one of which was entitled *Fairyland*—to risk its fortunes in the Salon des Refusés.

Manet no doubt also had conflicting ideas regarding the proper course of action to take. To exhibit in the Salon des Refusés was to risk not only public derision—which, thanks to *Music in the Tuileries*, he knew only too well—but also the wrath of the Académie, whose judgment and authority the exhibition put into question. He had little desire to alienate the members of the Académie since he was no less hungry than anyone else for official recognition. And he would much rather have competed for medals against established artists than have been forced to enter the Palais des Champs-Élysées through the back door, where his works would inevitably be hung alongside the amateurish productions of anonymous painters. The jury's decisions may have been harsh in many cases, but for every Chintreuil or Jongkind unjustly excluded from the Salon there were bound to be numerous dabblers whom the jury had quite rightly refused. Rumours were circulating, in fact, that all of the best artists had withdrawn their work from the Salon des Refusés, thereby turning it into an arena for only the most laughably incompetent. Equally concerning was the fact that the jury had authority over hanging the paintings in the Salon des Refusés—a task that would unavoidably become an exercise in self-justification whereby the vengeful jurors took care to hang the worst pictures in the most conspicuous places.

In the end, Manet reasoned that any exposure was better than none. After all, as the petition to the Comte de Walewski had argued three months earlier—and as Manet no doubt had explained to Walewski when they met in person—exhibitions such as the Salon served the essential function of introducing an artist and his work to a public that would not otherwise know about him. For Manet, of all painters, to refuse to exhibit his work would have been hypocrisy. And so the deadline of May 7 passed without his reclaiming his three canvases from the Palais des Champs-Élysées. *Le Bain* would go on show, for better or worse, with all of the other works in the Salon des Refusés.

The Salon of Venus

T HE PARIS SALON, as the novelist and theatre critic Jules Janin once claimed, was "the event of the year," an occasion always preceded by "two months of feverish exhilaration."[1] Besides exhilaration, the Salons were also heralded by hard work and careful organisation. The exhibition hall that hosted, among other attractions, expositions of cheeses, pigs and poultry needed to be transformed for the display of thousands of works of art. The mess from the recent equestrian exhibition had to be scrubbed from the floor, blinds fitted on the windows, thousands of paintings hung on the walls, the statues trundled into position, buffet luncheons arranged, the catalogue printed, the medals for the Awards Ceremony ordered, the diploma for the Grand Medal of Honour engraved, and dozens of guards hired to both keep watch over the paintings and discourage the pickpockets for whom Salon crowds were a lively source of income. Decisions even had to be made regarding which beggars would be allowed to work the grounds of the Palais des Champs-Élysées.

Since 1852 most of these tasks had fallen, not to Nieuwerkerke himself, but to his harassed deputy, a forty-three-year-old named Philippe de Chennevières-Pointel, who described the weeks before the Salon's opening as a time of "unspeakable anxiety and fatigue."[2] The Marquis de Chennevières was a former law student who had travelled in Italy and published short stories and poems under a variety of pseudonyms before starting work, at the age of twenty-six, in the Louvre, which he called "that holy house."[3] The Palais des Champs-Élysées, on the other hand, Chennevières did not regard as being quite so divine. Ironically, he entertained ambiguous feelings about the virtues of such a large and popular

exhibition to which hundreds of thousands of visitors of every social description flocked to gawp at whatever was put on show. In many ways, he deplored the success of the venture over which he had charge. The enormous crowds at the Salon did not suggest to him that Parisians were a cultivated people with an insatiable appetite for the fine arts. They told him, instead, that the fine arts must have debased themselves in order to appeal to the vulgar tastes of the ignorant masses.

Raised among fervent royalists and Catholics as the stepson of a Norman aristocrat, Chennevières was a political conservative who despised both democracy and the common man. "Democracy has always horrified me," he once wrote, "and I see in it only principles that are corrosive and destructive for every society."[4] Seventy years after the French Revolution, he harked back nostalgically to the institutions of the ancien régime, claiming that the aristocracy, "in which the sound and strong head directs and contains the tail, is worth more than democracy, where the insolent and churlish tail drags along the weak and diminished head."[5] Chennevières's fellow Norman, Gustave Flaubert, a friend of Nieuwerkerke, had coined the word *democrasserie* (*crasse* meaning both "filth" and "dirty trick") to describe the way in which democracy led, in his opinion, to a lowering of artistic standards. Chennevières likewise detested the effects of democracy on the arts, where the tail, in his opinion, was threatening to wag the dog. He had little use for most modern art, dismissing the work of Courbet and other Realists as "democratic painting" and maintaining that Honoré Daumier (a friend of Meissonier from their student days on the Île Saint-Louis) should have his paints and brushes confiscated.[6] He was nostalgic for the time when the Salon had been an exclusive preserve where members of the Académie Royale de la Peinture et de la Sculpture, founded by Louis XIV in 1648, showed examples of their recent work. But after the French Revolution, the Académie Royale had been abolished and the Salon thrown open to all artists who could impress the jury. And while Manet and others found the juries too draconian in preventing the exposure of their work, Chennevières, like many conservatives, bemoaned what he regarded as the aesthetic free-for-all and galloping commercialisation of the Salon.

Indeed, by the middle of the nineteenth century the Salon had become, in the eyes of many of its critics, little more than a marketplace for which commodities—such as easel paintings for the walls of middle-class apartments—were manufactured by the thousand. Chennevières's reservations about this commercialisation were expressed by Ingres, another archconservative, who fulminated against this "bazaar" in which business ruled

instead of art: "Artists are driven to exhibit there," he wrote, "by the attractions of profit, the desire to get themselves noticed at any price, by the supposed good fortune of an eccentric subject capable of producing an effect and leading to an advantageous sale."[7] In this view, little difference existed between the paintings shown at the Palais des Champs-Élysées and the expositions of cheeses or pigs that followed them. Both were commodities produced for no other purpose than a profitable commercial transaction. And the visitors to this bazaar were to be treated, in 1863, to a strange new variety of art.

The 1863 Salon opened, with even more than the usual excitement and anticipation, on the first of May, a Friday. The Palais des Champs-Élysées grew as crowded as ever as thousands of visitors poured through the enormous, flag-stoned entrance hall and made their way up the monumental staircases to the rooms on the first floor. Negotiating one's way through a 250-yard-long exhibition hall in which more than two thousand works of art were on display in a maze of rooms and indoor courtyards and gardens was a daunting task, but Chennevières and his helpers had tried to guide visitors through the labyrinth. The enormous exhibition hall had been partitioned, as usual, into several dozen rooms, each of which featured a letter of the alphabet above its door. Paintings by artists whose surnames began with A were hung in the first room, those with B in the next room, and so forth, allowing Salon-goers to make their way unerringly from A through Z.

Once inside each room, however, visitors were confronted by a disorderly confusion of paintings stacked on all four walls from floor to ceiling; some rooms were home to as many as two hundred canvases. These works were hung together in a promiscuous jumbling of styles and genres that witnessed, for example, portraits of pious Christian martyrs occupying space beside lubricious depictions of red-blooded satyrs or the undraped habitués of Turkish baths. Huge canvases were suspended next to tiny portraits, with almost every inch of wall space occupied. Viewing conditions were far from ideal. Paintings that had been "skyed"—that is, hung high on the wall—could not be appreciated without either sore necks or telescopic aids to vision, while the space in front of works by the most famous artists always grew dense with spectators jostling one another for a better view. "They come as they would to a pantomime or a circus," the philosopher Hippolyte Taine complained of these hordes.[8] In order to find their way through this maze—and also to help themselves form opinions on what they had seen—visitors could purchase the numerous guides, known as *salons*, that were written for newspapers of every description by the hundred art critics who stalked Paris.[9]

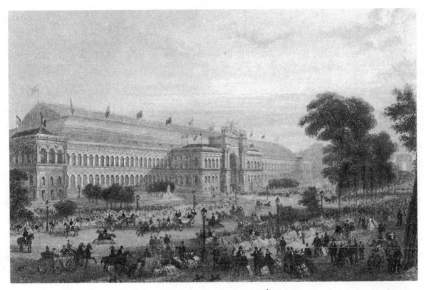

The Palais des Champs-Élysées

The Salon of 1863 had any number of eye-catching works on show. One of the most popular paintings—and what would become one of the most celebrated paintings of the nineteenth century—was *The Prisoner* by Jean-Léon Gérôme. A perennial favourite with the public if not always with the critics, Gérôme was, at the age of thirty-nine, one of France's most successful painters. He specialised in exceptionally detailed, delicately erotic scenes from ancient Greece and Rome as well as from modern-day Egypt and the Holy Land, through which he had travelled on several occasions. His patrons occupied the very highest levels of French society. His *Greek Interior*, a brothel scene shown at the Salon of 1850, had been bought by the Emperor's cousin, Prince Napoleon-Jérôme, who then hired him to add to the décor of his spectacularly tasteless Paris mansion, the Villa Diomède. No sooner were these murals finished than the painter of belly dancers and snake charmers received a commission from Pope Pius IX to decorate the interior of His Holiness's private railway carriage.

The Prisoner added further to Gérôme's reputation. An Oriental scene, it depicted a handcuffed prisoner in white robes lying crosswise in a boat rowed along the Nile at sundown as one of the turbaned captors taunted him with a song. Oozing with the placid exoticism and technical virtuosity that was Gérôme's trademark, it had caught the eye of an American collector named Edward Matthews, who tried unsuccessfully to buy it for 30,000 francs. A

smallish painting only eighteen inches high by thirty-two inches wide, it received the sort of elbow-jogging, neck-craning attention usually accorded the works of Meissonier, with Gérôme boasting that it was "admired by both connoisseurs and idiots."[10]

No Salon was complete without its share of controversial canvases, works that appalled the critics, scandalised the public and, of course, sucked enormous crowds into the Palais des Champs-Élysées. The Salon of 1863 did not fail to deliver. On show in Room M, for example—the room from which both Manet and Meissonier were so conspicuously absent—was Jean-François Millet's *Man with a Hoe*. This work depicted exactly what its title described: a peasant leaning wearily on his hoe before his furrow in the middle of a rocky field. The canvas was typical of Millet, a forty-nine-year-old painter of rustic scenes of toiling peasants. With its celebration of the worker, *Man with a Hoe* was precisely the sort of work that Nieuwerkerke and Chennevières denounced as "democratic painting." Many Salon critics found the painting repellent on aesthetic grounds, mocking the farm worker's ugliness and nicknaming him "Dumolard," a reference to Martin Dumolard, a grotesque-looking peasant from the village of Montluel, near Lyon, who had been beheaded a year earlier after a court found him guilty of the brutal murders of as many as twenty-five women.

Far more controversial even than Millet's homely peasant was the beautiful woman on show in Room C. The Salons positively teemed with painted female flesh at a time, ironically, when actual female flesh was a forbidden sight in Paris. Women were not permitted on the top floor of omnibuses in case they exposed an ankle or calf as they climbed or descended the steps; and the sexes were strictly prohibited from mingling—thanks to barriers, signposts and uniformed inspectors—at the various bathing spots along the Seine. Women were expected to cover themselves in shifts as they entered the water; even men were liable to arrest if they bathed without tops. The Salon, however, lifted a curtain to expose a fantasyland where, uninhibited by these stringent regulations, men and women frolicked together in stark-naked abandon. Mythological scenes graced by exquisite female nudes were therefore mainstays of the Salon, and never more so than in 1863. So many depictions of Venus (always a popular subject for a nude) appeared on the walls of the Palais des Champs-Élysées in 1863 that Théophile Gautier dubbed it the "Salon des Vénus."[11]

The clear winner among these goddesses, in terms of its crowd-pulling prowess, was Alexandre Cabanel's *The Birth of Venus* (plate 4A). The red-bearded Cabanel, who favoured velvet jackets and flowing cravats, was one of the brightest stars in the artistic empyrean. A native of Montpellier, he had studied at the École des Beaux-Arts under François Picot and carried away the

Prix de Rome in 1845. After his studies in Italy he returned to Paris to paint a number of prestigious commissions, including work in the Hôtel de Ville. A Salon favourite since 1843, when he showed his first work at the tender age of twenty, he had thrilled the crowds two years earlier with *Nymph Abducted by a Faun*, a risqué mythological fantasy featuring a milk-white female nude swooning in the hairy grasp of a leering faun.

The Birth of Venus dropped another depth charge of refined concupiscence into the Palais des Champs-Élysées. Supposedly showing Venus stirring to life on the waves, Cabanel's canvas presented its viewers with the arresting spectacle of a young nude with opulent contours and come-hither eyes lolling deliciously on her back. Paul Mantz, the critic for the *Gazettes des Beaux-Arts*, found her "wanton and lascivious" but declared she was, for all that, "harmonious and pure."[12] Yet not everyone agreed that Cabanel's Venus was altogether untainted by belowstairs passion. Mythological trappings and allusive names provided a flimsy pretext for acre upon acre of painted female flesh. But no amount of mythologising—no hastily painted togas or garlands of laurel leaves—could save a painter if his work was thought to dwell on the brute senses rather than trying to capture the abstract ideals of beauty or virtue. For instance, Flaubert's friend Maxime du Camp believed a painted nude should exude no more carnality than a mathematical equation. "The naked body is an abstract being," he confidently declared.[13] And the flawless curves and powder-puff complexion of Cabanel's Venus could violate this proposition as easily as the lumpy flesh of one of Courbet's bathers.[14]

As it transpired, du Camp, like many other critics, was aghast at Cabanel's *The Birth of Venus*. He was no prude, having darkened the doors of brothels from Paris to Cairo.[15] But when he looked at the painting du Camp saw not a philosophical meditation on beauty or truth but, rather, a sensual young woman "revealing herself" in a most immodest fashion—someone whose true milieu was not the mists of antiquity but the gaslights of modern Paris. She was such a creature, he claimed with a hypocritical and insincere horror, as one might encounter "at a ball, at that moment of intoxication that music, perfume and dancing create."[16] Many other critics were equally convinced of Cabanel's immoral designs. Arthur Stevens, a Belgian art dealer, found the work little more than pornographic fodder for dirty old men and adolescents, while Millet, smarting from criticism of his own work, would denounce Cabanel's "indecent" painting as a "frank and direct appeal to the passions of bankers and stockbrokers."[17] The republican art critic Théophile Thoré predicted an even more disreputable market for the work: it would be turned into coloured lithographs, he claimed, to decorate the boudoirs of low-class prostitutes in the Rue Bréda.[18]

These critics were therefore divided over whether Cabanel's Venus was really a high-class courtesan or a low-rent prostitute, but all agreed that the painting addressed itself to the base physical senses rather than the nobler passions of the soul—and none believed that the mythological allusion in the title in any way excused this transgression.

Cabanel did have his supporters, a band of critics and connoisseurs soon dubbed *les Cabanellistes*. One of them writing under the name Claude Vignon (the pseudonym of a woman, Noémie Cadiot) compared the painting favourably with the works of Raphael and Correggio, arguing that Cabanel's Venus exemplified "ideal beauty embodied in a woman."[19] Others simply showed their unashamed appreciation of the work's blatant eroticism. The critic for the monthly *Revue des races latines* exulted that the painting portrayed "everything the imagination can dream of," while the expatriate Englishman Philip Hamerton drooled over the way the limbs of this "wildly voluptuous" goddess participated in "a kind of rhythmical, musical motion."[20]

Cabanel also had another advocate. Emperor Napoleon III was a noted voluptuary who had enjoyed the attentions of numerous mistresses both before and after his marriage to Eugénie de Montijo ten years earlier. Among their ranks had been an Italian countess, Virginia di Castiglione, and Marianne de Walewska, the wife of his cousin, the Minister of State. His sexual appetite was said to be insatiable. Rumour had it that each evening a different woman was brought to the Palais des Tuileries, undressed in an anteroom, and escorted to the bed of His Imperial Majesty, who would exert himself until (in the words of one of these bedmates) "the wax on the ends of his moustache melts, causing them to droop."[21] Whatever the truth of these stories, in the spring of 1863 he was certainly enjoying a dalliance with a twenty-three-year-old former dressmaker and circus rider named Justine Leboeuf, who called herself Marguerite Bellanger, dressed in men's clothes and lived in the house in which he had installed her in the pleasant suburb of Passy.

If many art critics bewailed the sight of prostitutes on either the Rue Bréda or the walls of the Salon, the Emperor himself took, on both counts, a more progressive view. Prostitution during the Second Empire was not simply tolerated by his régime, it was also legalised.[22] Some 5,000 prostitutes had been registered at the Prefecture of Police in Paris in an attempt by the government to regulate and control the sex trade both in brothels—of which there were 190 operating legally—and on streets such as the Rue Bréda, where women were permitted to ply for business during certain prescribed hours. In addition to these registered prostitutes, Paris had as many as 120,000 *filles insoumises*, or "unruly women," unregistered streetwalkers who operated outside the official

sanctions. This was a staggering statistic even in a city with a population in the early 1860s of 1.7 million, for it meant that more than thirteen per cent of the entire population of Paris worked in prostitution.

Critics of the Emperor claimed that such rampant prostitution had less to do with either economic conditions or biological urges than with a government desire to quell dissent: prostitution, they argued, was a means of placating social unrest, functioning (like religion) as a kind of opiate of the people. One of the régime's fiercest critics, the socialist Pierre-Joseph Proudhon, accused the Emperor of establishing a "pornocracy," with prostitutes operating as his "instruments of despotism."[23] Whether or not this was truly the case, one fact was certain: the Second Empire came into being thanks in part to the very direct help of one courtesan in particular, Lizzie Howard, the bootmaker's daughter who conquered London society, won Louis-Napoleon's heart and, in 1851, supported his regime by lending him 800,000 francs with which he was able to entertain (and to bribe) important members of the French military.[24] To the disgust of Proudhon and others, Miss Howard had been rewarded for this and other services with the title of Comtesse de Beauregard. By 1863 she had retired, at the age of forty, to a life of modest luxury at Versailles.

If the Emperor took a forbearing attitude towards prostitution, he was likewise unperturbed by nudity in art, his supposed treatment of Courbet's *Bathers* notwithstanding. Though he knew next to nothing about art, Cabanel's was, however, a name with which he could conjure. In 1861 he had purchased *Nymph Abducted by a Faun*, and two years later he again showed his appreciation for Cabanel's aphrodisiac style by buying *The Birth of Venus* for 15,000 francs (with some press reports excitedly putting the price as high as 40,000 francs). This evenhandedness was typical of Louis-Napoleon: having purchased one of the *refusés*, the still life by Salingre, he promptly acquired the most conspicuous painting in the official Salon.

The Emperor's appreciation of Cabanel's work was no doubt rooted in its sensual qualities rather than any perceived reflections of "ideal beauty." Whatever his reasons, though, word of this acquisition, as well as the controversy over its supposed celebration of the pleasures of physicality, made the painting by far the most popular exhibit at the Salon of 1863 and Cabanel one of the most famous names in French art.

The Tempest of Fools

T HE NUMEROUS DUTIES of the Marquis de Chennevières did not extend themselves, in 1863, to making arrangements for the Salon des Refusés, which was to be held in an annexe of the Palais des Champs-Élysées. Nor was any money for organising or publicising this counter-exhibition forthcoming from the government. Chennevières and Nieuwerkerke, like most members of the Selection Committee, were desperate for this rival exhibition to fail: a popular and critical success would deal a heavy blow to their authority and prestige.

The task of advertising the show and printing a catalogue therefore fell to Antoine Chintreuil and his small group, who had three weeks to prepare everything. They placed notices in many newspapers, including *La Presse* and *Le Siècle*, both announcing the forthcoming Salon des Refusés and canvassing participating artists for information about themselves and their works. The catalogue was put together, a short preface stated, "with notes hastily collected from all over the place," and was rushed on the eve of the exhibition to a printer in the Rue des Grands-Augustins, a short distance from the Committee's headquarters in the studio of Jean Desbrosses.[1] Starved of government funds, the Committee had been fortunate to find a patron in the Marquis de Laqueuille, a wealthy aristocrat who was the proprietor of a journal called *Les Beaux-Arts*.[2] Sympathetic to the plight of the rejected artists, Laqueuille edited the catalogue, found the printer for it, and met all the bills out of his own pocket. Miraculously, copies were ready when the Salon des Refusés opened its doors on May 15. However, unlike those for the official Salon, catalogues for the Salon des Refusés could not be sold inside the Palais

des Champs-Élysées—yet one more obstruction placed in the way of the rejected artists. Laqueuille therefore provided one more service, arranging for hawkers to sell the catalogue in the street outside the exhibition.

The Catalogue of Works of Painting, Sculpture, Engraving, Lithography and Architecture Refused by the Jury of 1863 and Exhibited, by the Decision of His Majesty the Emperor, in the Salon Annexe in the Palais des Champs-Élysées ran to eighty pages. It listed 781 works of art by 366 painters, 64 sculptors, and a handful of architects and engravers. However, more works than these would actually go on show in this "annexe" to the regular Salon. Chintreuil and his friends admitted in their preface that the catalogue "could not be made as complete as the committee wished" due to difficulties in contacting a number of the exhibiting artists. For example, one of the painters they had trouble tracking down was a virtually unknown thirty-three-year-old landscapist named Camille Pissarro; his surname was misspelled "Pissaro" and his forename left blank. Another exhibitor unknown to the committee—indeed, unknown to almost everyone in Paris—was a young friend of Pissarro named Paul Cézanne; he received no mention at all in the catalogue.

The catalogue of *refusés* was incomplete for another reason as well. Of the more than 2,000 artists rejected from the Salon, fewer than 500 elected to show their work in the Salon des Refusés. In their catalogue, Chintreuil and his committee expressed their "major regret" about the many artists who had withdrawn work—including almost 2,000 paintings—from the show. Their unwillingness to participate, wrote Chintreuil, deprived both the public and the critics of seeing a truly representative sample of the sort of work that had inspired this unparalleled counter-exhibition in the first place.

One artist who had not voluntarily withdrawn his painting, but who nonetheless failed to appear among the other *refusés*, was Gustave Courbet. This most infamous artist enjoyed the unique distinction in 1863 of having been rejected from both the regular Salon and the Salon des Refusés. Then aged forty-four, he had been the maverick of French art for more than a dozen years, constantly embroiling himself in controversy and acrimony. Throughout his turbulent life he seems faithfully to have followed advice given to him at a tender age by his grandfather: "Shout loud and march straight ahead."[3]

Courbet, like both Manet and Meissonier, had taken a career path that eschewed the École des Beaux-Arts in favour of independent study and periods of heedless bohemianism. The son of a prosperous vintner and landowner near Ornans, in farming country near the French–Swiss border, he had entered the seminary in Ornans at the age of twelve but divulged such monstrously precocious sins in the confessional that none of the priests would

grant him absolution. His career in the priesthood thus nipped in the bud, he moved to Paris some years later to study law, though most of his time was spent sketching Old Masters in the Louvre or warming the benches of various beerhouses. Largely self-taught as a painter, he did not enjoy early acclaim: all but three of the twenty-four paintings he sent to the Salons between 1841 and 1847 were refused, largely at the insistence of François Picot. Typically, his first Salon painting, in 1844, was a self-portrait. Few painters had ever done as many portraits of themselves as the narcissistic Courbet, who remained his own favourite subject even as, by the 1860s, his fondness for beer and cider meant that the dark-haired, high-cheekboned good looks of his youth had given way to ruddy-faced corpulence.

Success had finally come Courbet's way at the Salon of 1849 with *After Dinner at Ornans*, an atmospheric interior scene that won him a handful of good reviews, a Salon medal, and a feast in his honour in his home town. But the barbed comment of one reviewer—"No one could drag art into the gutter

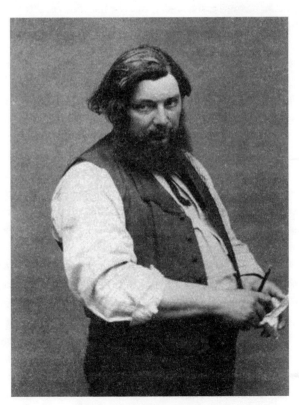

Gustave Courbet (Nadar)

with greater technical virtuosity"[4]—typified the reluctant admiration that many people felt for the talented but undisciplined Courbet, who, in works such as *A Burial at Ornans*, *The Stonebreakers* and *The Bathers*, used vast canvases to depict, not gods and heroes, but ordinary farmers, peasants and prostitutes. So notorious had his canvases become by the middle of the 1850s, not just in France but in Europe as a whole, that a prominent notice in a casino in Frankfurt stated that "Monsieur Courbet's pictures must not be discussed in this club."[5]

Yet by the early 1860s Courbet finally seemed to have watered down his beer. He had enjoyed a highly successful Salon in 1861 with uncontroversial and widely acclaimed scenes of hunters, stags and foxes. Enthusiastic words of praise came from Théophile Gautier, while an admiring Chennevières—who had hitherto shown scant regard for the beer-swilling socialist—tried unsuccessfully to purchase one of the works, *Fighting Stags*, for the State. A Legion of Honour was even mooted, a decoration that Courbet, the maturing rebel, secretly craved. However, this accolade never materialised, leaving Courbet to believe, rightly or wrongly, that the Emperor had personally vetoed it. In true Courbet fashion, he decided to exact a pitiless revenge.

Courbet had spent the latter half of 1862 and the first few months of 1863 in Saintes, north of Bordeaux, on an estate called Rochemont that belonged to a young art collector and republican named Étienne Baudry. His absence from Paris meant that he missed the excitement over both the petition to Walewski and the announcement of the Salon des Refusés. Still, he made the most of his days at Rochemont, conducting an affair with the wife of a draper and astounding the locals with his capacity for drink. On one memorable occasion he was said to have downed, before dinner, six bottles of wine and a bowl of coffee half-filled with cognac.[6] He managed to produce a number of paintings, mainly of flowers, though he also began work on a canvas of quite a different sort. *Return from the Conference*, which depicted seven drunken priests staggering back home from an assembly, was deliberately intended to shock and offend. After sending the provocative work to the Salon jury in April, Courbet had relishingly predicted to a friend that, if this work were selected, "there will be an uproar. I expect that so audacious a painting has never been seen."[7]

Courbet need hardly have worried about his painting slipping past the Selection Committee. Two of his works were indeed selected for the Salon, *Fox Hunt* and a portrait of Laure Borreau, his mistress in Saintes. His inebriated priests, however, stood no chance. "I painted the picture so it would be refused," he boasted to a friend after the deliberations were announced in April, adding triumphantly: "I have succeeded."[8] Not only was the work rejected

from the Salon, it was likewise banned by the government from the Salon des Refusés. "I have been accused of immorality," he complained with crocodile tears in a letter to *Le Figaro*.[9] As a protest against this censorship, he promptly put the painting on show in his Left Bank studio. Here, he claimed, large crowds flocked to admire the canvas, giving him the inspiration for a plan to embark with his controversial painting on a one-man tour of the great cities of Europe, starting with London.

Courbet was a relentless braggart and self-publicist; he was, in his own words, "the most arrogant man in the world."[10] His style was every bit as bold as he claimed, with textured layers of paint, muddy colours, eccentric perspectives, and unusual and often unsettlingly vulgar subjects that were a world away from the pleasingly anodyne and effortlessly burnished scenes of contemporaries like Gérôme and Cabanel. Few painters could match his flair for ruggedly realistic scenes that, at its best, produced masterpieces of almost primeval beauty such as *A Burial at Ornans* (plate 3B), a striking panorama of black-clad mourners gathered for a rural funeral (in fact, that of his beloved grandfather). Still, Courbet was wrong about one thing: *Return from the Conference* was not the most audacious painting ever seen in France. That honour belonged to the work, catalogued number 363, on show in the last room of the Salon des Refusés.

Despite the absence of Courbet's *Return from the Conference*, the 7,000 people who poured into the Palais des Champs-Élysées on Friday, May 15, the opening day of the Salon des Refusés, had no shortage of scandalous and amusing works to view. Most of them came fully expecting to be shocked and entertained by an exhibition of the most freakish art. Their appetite for the event had been whetted by the newspapers, which gave widespread coverage to the opening of what they variously dubbed the "Salon of the Vanquished," the "Salon of the Pariahs," the "Salon of the Banished," and the "Salon of the Heretics."[11] One newspaper even christened it the "Salon of the Comics," guaranteeing its readers a rare glimpse of incompetent artistic drolleries: "No, nothing is more comic, nothing is more grotesque, nothing is more ridiculous than these works."[12]

If Hippolyte Taine lamented that the regular Salons were treated by spectators as circuses or pantomimes, how much worse was the frame of mind of the typical visitors to the Salon des Refusés, who were described by a friend of Manet's as "an ignorant goggle-eyed rabble."[13] One visitor, the English poet Philip Hamerton, wrote disapprovingly that spectators were forced "to abandon all hope of getting into that serious state of mind which is necessary to a fair comparison of works of art. That threshold once past, the gravest visitors

burst into peals of laughter."[14] The laughter was so loud, in fact, that visitors at the door cursed the slowness of the turnstiles in their eagerness to join the fun. "People entered as if to Madame Tussaud's Chamber of Horrors in London," sighed the rejected painter Charles Cazin.[15] Five days after the exhibition opened, Manet's friend Zacharie Astruc complained that serious art-lovers who dared set foot in the Salon des Refusés needed to be "extra strong to keep erect beneath the tempest of fools, who rain down here by the million and scoff at everything in the most outrageous fashion."[16]

Several paintings attracted especially clamorous attention from this tempest of fools, among them Whistler's *The White Girl*. This work displayed a young redhead—in fact, Whistler's Irish mistress Joanna Hiffernan—dressed in white and standing on a bearskin rug. Its real subject, though, was colour and form. Whistler was less concerned about executing a true-to-life portrait than he was about using his model and her wardrobe to investigate the optical effects of different shades of white; he would eventually rename the canvas *Symphony in White, No. 1*. Such subtle explorations were lost, however, on the crowds in the Palais des Champs-Élysées. Hamerton claimed that everyone catching sight of the canvas—himself included—"stopped instantly, struck with amazement. This for two or three seconds, then they always looked at each other and laughed."[17] *The White Girl* nevertheless received a number of positive reviews, all of them dutifully scissored from the papers by Fantin-Latour and posted to Whistler's address in London. *Le Boulevard*, for example, called the work "a piece of painting of indisputable beauty," while in *Le Figaro* Arthur Stevens, the critic who accused Cabanel of immorality, wrote: "I recognise in this work an artist of great purity."[18] Better yet, Whistler's painting soon enjoyed an enviable word-of-mouth reputation, with both Baudelaire and Courbet singing its praises and Arsène Houssaye, editor of *La Presse*, making inquiries about purchasing it for himself. Houssaye was an influential figure in the Paris art world, having formerly served as both director of the Théâtre-Français and editor of the *Revue de Paris* at the time when it serialised *Madame Bovary*. Back home in Chelsea, Whistler was beside himself with delight.

Édouard Manet's paintings, *Le Bain* in particular, attracted even more attention than *The White Girl*. His three works were conspicuously featured in the last of the twelve rooms that made up the Salon des Refusés. Manet's cousin Ambroise Adam, a sixty-three-year-old lawyer, summed up the painter's ambiguous feelings about both this prominence and the Salon des Refusés more generally: "The poor boy has one of the best positions, but would rather have had a less good one in the real Salon."[19] This eye-catching location was accounted for in part because

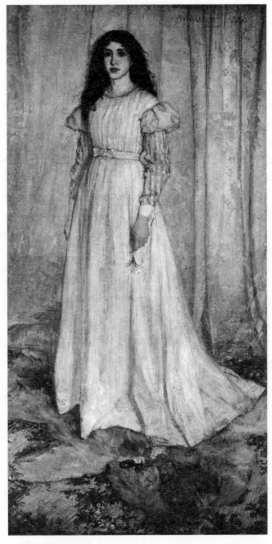

The White Girl *(James McNeill Whistler)*

of the monumental size of *Le Bain* but also because the Selection Committee, which oversaw the hanging, suspected the painting of being ripe for public ridicule. Their intuition was quickly proved correct as the hilarity and hostility that had greeted Manet's work in the Galerie Martinet was reprised two months later. *Le Bain* raised, one of Manet's friends wrote, "a veritable clamour of condemnation."[20] Spectators astonished and amused by the puzzling scene of Victorine Meurent sitting naked on the grass between two men in modern dress

quickly dubbed the work *Le Déjeuner sur l'herbe*, or "The Luncheon on the Grass," a name by which even Manet himself began referring to the painting.

"Never was such insane laughter better deserved," one critic observed of these scenes of gleeful mockery before Manet's canvases.[21] Many critics viewed his bewildering work with varying degrees of animosity and incredulity. A number of them faulted his technique, pointing out how the work lacked the subtle gradations of tone and careful definitions of relief that were the bread and butter of students at the École des Beaux-Arts. His palette "misses the nuances," complained one. Another quipped that the brushwork was so lacking in finesse that it could have been done with a floor mop.[22] Others found the human figures poorly executed and utterly unconvincing: "Manet's figures make us automatically think of the marionettes on the Champs-Élysées."[23]

A good many critics also expressed their troubled mystification over what exactly Manet had intended to depict. "A commonplace woman of the *demimonde*, as naked as can be, lolls shamelessly between two dandies dressed to the nines," wrote one named Louis Étienne, who added: "This is a young man's practical joke, a shameful open sore not worth exhibiting this way."[24] The idea that Manet's painting was some sort of jest—a perverse burlesque perpetrated by a rebellious young artist laughing up his sleeve at the audience—was widespread. Few were prepared to accept that the artist could have created such a bizarre scene in good faith. Jules-Antoine Castagnary, for instance, claimed to see in the work, besides an incompetent application of paint, a "lack of conviction and sincerity."[25]

This review by Castagnary, in *L'Artiste*, would have been dismaying for Manet given that the thirty-three-year-old critic was a supporter of Courbet and the more adventuresome brands of modern painting. Furthermore, *L'Artiste* had contributed one of the few good reviews to Manet's show in the Galerie Martinet. The author of the review on that occasion, Ernest Chesneau, the man who had praised Manet's "youthful daring," likewise expressed his reservations about *Le Bain*. Writing in *Le Constitutionnel*, a daily newspaper with a circulation of 30,000, he chided the painter on moral grounds: "We cannot find it altogether chaste," he wrote, "to show seated in the woods, surrounded by students in overcoats, a young woman clad in nothing but the shade of the trees."[26]

Chesneau's prudish comment was one of the few moralistic objections to Manet's work, which attracted far less spleen on this count than Cabanel's more flagrantly sexual *Birth of Venus*.[27] Most people did not object to Victorine's nudity, for Salon-goers were perfectly accustomed to seeing nudity on the walls, even if the nudes were usually of beautiful women rather than, as one critic wrote of Victorine, "the ideal of ugliness."[28] Nor did they seem un-

duly troubled by the possibility (if indeed it occurred to them) that Victorine was meant to personify a prostitute, a state of affairs hinted at by the presence in the foreground of a frog (*grenouille* was a slang term for a prostitute in the 1860s).[29] Cabanel's wanton Venus, not Victorine with her love handles and pasty skin, was widely regarded to have been the morally precarious *fille de joie* inside the Palais des Champs-Élysées. Victorine may well have been intended by Manet to represent a streetwalker from the Rue Bréda—but, seated naked beside her picnic basket, she was regarded by the public more as a source of mirth than of danger.

Disquiet over Manet's painting was expressed, instead, over the fact that Victorine's companions were dressed, as Hamerton distastefully observed, in "horrible modern French clothing."[30] The critic and Vermeer collector Théophile Thoré admonished Manet for creating such an "absurd composition" in which the clothed and unclothed mingled together: "The nude does not have a good figure, unfortunately, and one cannot imagine anything uglier than the man stretched out next to her, who hasn't even the presence of mind to remove his horrid ring-shaped cap. It is the contrast of a creature so inappropriate in a pastoral scene with this undraped bather that is shocking."[31]

The clothes, therefore, more than the nudity, were what shocked. Victorine's naked body, unsightly as it was for anyone weaned on the scrumptious nudes of Ingres or Cabanel, caused far less horror than the strange hat perched on Gustave Manet's head or the fact that the two men were wearing dark overcoats in a forest glade. To an audience habituated to the exotic Oriental costumes of Gérôme or the olden-days aristocratic fashions of Meissonier, these two boorish-looking students in their Left Bank apparel were an unhappily discrepant sight. The ambrosial world of nymphs and shepherds had been gate-crashed, it seemed, by a pair of vulgar Asnières daytrippers.

Yet for all the criticism, Manet's work received a number of favourable notices—some of them composed, albeit, by his friends.[32] His strongest supporter was Zacharie Astruc, whose daily newspaper shouted his genius from the rooftops, declaring him "one of the greatest artistic characters of the time" and lauding his "brilliance" and "inspiration."[33] Other writers saw in Manet the future of French art. "Manet, I hope, will one day become a master," wrote a critic using the name Capitaine Pompilius. "He has the sincerity, the conviction, the strength, the universality—that is to say, the stuff of great art."[34] Another glowing review came from a twenty-three-year-old named Édouard Lockroy, an ardent republican who made a bold prediction: "Manet will triumph some day, we have no doubt, over all the obstacles he encounters, and we shall be the first to applaud his success."[35]

All told, in the annals of French art criticism, Manet had actually escaped rather lightly. Vicious reviews were all too frequent in nineteenth-century France; no one was immune from the venomous quills of the critics. Ingres, for example, had been the recipient of dozens of poisonous reviews throughout his career. His *Grande Odalisque*, exhibited at the Salon of 1819, attracted such hateful notices (the critics had seized on the fact that the reclining woman had three vertebrae too many) that he was moved to lament how his work had become "so much prey for ravenous dogs."[36] Fifteen years later, at the Salon of 1834, his *Martyrdom of Saint-Symphorian* was assailed so fiercely that he shut his studio, left Paris for the next seven years, and for more than two decades refused to exhibit at the Salon. His long-awaited return, in 1855, was promptly met with a review of unbridled malevolence: "Before this antiquated and non-majestic painting," a critic for *Le Figaro* informed his readers, "my nostrils are invaded by whiffs of warm, sour and nauseating air . . . I'm sorry to say this to delicate readers, but it's like the taste of a sick man's handkerchief."[37] Delacroix fared no better. His *Massacre of Chios* had been treated to unanimously hostile reviews at the Salon of 1824, where it was mocked as "the massacre of painting."[38] Worst of all, though, was the fate of Baron Gros, a talented student of Jacques-Louis David. *Hercules and Diomedes* received such merciless reviews at the 1835 Salon that Gros drowned himself in a tributary of the Seine.

Manet was not the only *refusé* spared, for the most part, the wrath of the critics, many of whom sheathed their daggers as they surveyed the rest of the exhibition, which was not the critical catastrophe for which the members of the Selection Committee had been hoping. Though far from impressed by the exhibition, Charles Brun claimed that at least the paintings were not as dreadful a sight as the sneering crowds standing in front of them.[39] Chesneau even questioned the extent of this mockery, pointing out that while the majority of those who came to the Salon des Refusés found all of the paintings equally bad, some visitors, at least, shook their heads and questioned the harshness of the jury.[40] Other writers took the jury itself sternly to task. In *Le Figaro*, a critic calling himself Monsieur de Cupidon wrote that if one entered the Salon des Refusés with a smile, one departed feeling "serious, anxious and disturbed" at the injustices perpetrated against the *refusés*, who, he noticed, "bore their name proudly."[41] The journalist and art critic Théodore Pelloquet likewise bearded the jury. He wrote in his bi-weekly review that the Salon des Refusés included some fifty paintings that were superior to the standard of the canvases accepted by the Selection Committee for the official Salon. "If we add to this figure those paintings which their authors withdrew," he further noted, "the Institut's

inadequacy at continuing in its present role is beyond debate."[42]

Pelloquet raised a question that had been on the lips of many people even before the Salon des Refusés opened its doors: given their controversial performance, should the members of the Académie des Beaux-Arts continue to staff the Selection Committee? Was this team of eminent painters really to be trusted with their hands on the rudder of French art?

From the works on show in the Salon des Refusés, educated observers, not least the artists themselves, could see that the jury was systematically barring from the Salon a particular style of painting in favour of the sort of art practised by many of its own members and taught at the École des Beaux-Arts. The difference was one of both subject matter and technique. Many of the *refusés* had favoured landscapes, while the jury instinctively sanctioned historical or mythological works from which moral lessons could be extracted. And whereas the jury preferred the smooth finish seen in the works of Gérôme and Cabanel, where all marks of the brush were deftly effaced, the canvases of many of the *refusés*, Manet's included, featured a skimpiness of detail that aimed for an overall aesthetic impact—what Corot called the "first impression"—rather than an exactingly precise depiction of minutiae.

One of the most perceptive art critics, Théophile Thoré, summed up the aims of many of these rejected painters: "Instead of seeking what the connoisseurs of classic art call 'finish,' they aspire to create an effect through a striking harmony, without concern for either correct lines or meticulous detail."[43] This battle—between "finishers" and "sketchers"—was ultimately one, Thoré claimed, between "conservatives and innovators, tradition and originality."[44] If the conservatives held the bastion of the Institut de France, the innovators were grouping together and organising themselves outside its walls, whether in Jean Desbrosses's studio or the Café de Bade. Those who pushed through the turnstiles of the Palais des Champs-Élysées amid peals of laughter may have little suspected it at the time, but they had seen, Thoré and many others believed, the future of painting.

Famous Victories

ERNEST MEISSONIER HAD a passion, amounting almost to a mania, for sketching and drawing. His rare moments away from his easel were spent doodling on scraps of paper. As a young man he scribbled pencil drawings as he sat biding his time in the anterooms of book publishers; and after his election to the Institut de France he sketched his colleagues as they sat snoozing beside him at meetings. His mania was so pronounced that his handiwork sometimes spilled over from his paper onto anything within reach of his pencil or brush. His friend Philippe Burty, a frequent guest at the Grande Maison, observed how Meissonier "sometimes amused himself by tracing large, rather audacious drawings on the walls of the stairway and corridors leading to his studio."[1] Two of these capricious sketches were comical versions of Polichinelle, the anarchic figure from the Italian commedia dell'arte that he had also created—while in the grip of a similar spasm of doodling—on the door of a friend, the courtesan Madame Sabatier.

Meissonier's idle sketches were not limited to doors or stairwells. Another friend, Charles Yriarte, art critic for *Le Figaro*, passing through Poissy on his way to pay his respects at the Grande Maison, was once surprised by the sight of a life-size Napoleonic soldier sketched in charcoal on a newly whitewashed wall beside the Seine. "The perfect anatomical accuracy and boldness of the execution, the style of the costume as well as something indescribable," concluded Yriarte, "revealed the master as a great decorator."[2] Even Meissonier's graffiti were masterpieces of detail and execution.

Yriarte attributed this curious obsession to Meissonier's restless inability to put down his pencil or brush and stop working. Another friend, the Russian

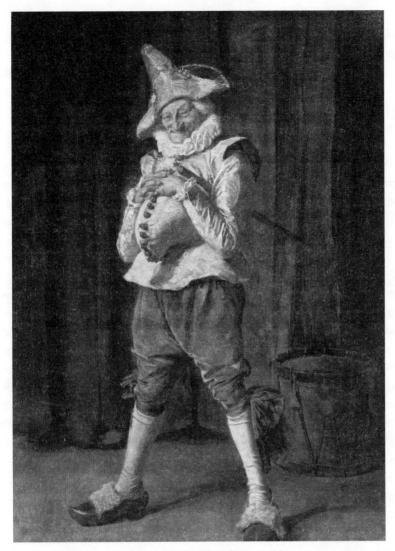

Polichinelle *(Ernest Meissonier)*

painter Vassílí Verestchagín, claimed—stretching the facts only slightly—that Meissonier "never knew any rest or holiday" and "worked unceasingly all the 365 days of the year."[3] This dedication to his work inevitably meant that Meissonier led an increasingly retired life as he shut himself away in his studio in Poissy. His life at the Grande Maison was peaceable, disciplined and salubrious. An early riser, he would breakfast alone with a book at his elbow: heavyweight literature such as leather-bound editions of Shakespeare, Corneille, Molière

and Homer. Having finished eating, he would speak to the groom and, at six thirty, rouse his nineteen-year-old son Charles from his bed for a ride on horseback along the riverbank or into the Forest of Saint-Germain.

Meissonier was a great lover and tireless painter of horses: there was in a horse, he said, "enough to study all one's life."[4] Of the eight horses in his stable, his two favourites were a grey named Bachelier and a mare, Lady Coningham, which had been his mount at the Battle of Solferino. Also present for these early-morning excursions through the countryside were Meissonier's greyhounds, several of which had been given to him by his friend Alexandre Dumas *fils*.[5] So devoted was Meissonier to these dogs that he included greyhounds on the coat of arms he painted onto the doors of his fleet of expensive carriages. These elegant vehicles were sometimes used by Meissonier to ferry his family on fifty-mile excursions through the countryside to Auvers-sur-Oise, a town north of Paris to which his friend Daubigny had recently moved.

Besides horses, greyhounds and fashionable carriages, Meissonier also had a passion for boats. A flotilla of skiffs, cutters and yachts was moored on his stretch of the riverfront; two of them, the *Charles* and the *Thérèse*, were named for his children. Dressed in a pilot coat and sou'wester, he often took them onto the river, with his children and their friends serving as his crewmates. The Seine at Poissy was more peaceful than at Asnières or Argenteuil, disturbed only by anglers in their skiffs or the occasional barge making its way upstream towards Paris. Meissonier would scud along the channels between the islands in the river, downstream past the Île-de-Villennes or upstream to where reflections of the twelfth-century bridge and a riverside inn, L'Esturgeon, shimmered in the water. The voyage finished, Meissonier would strike the sail and carry the rigging back to the house, looking, according to a friend, like an "Icelandic fisherman."[6] He then sometimes started painting in his studio while still wearing his pilot coat.

Following his disheartening experiences on the painting jury, Meissonier was more inclined than ever to forgo the bright lights of Paris in favour of his rural idyll in Poissy. The artistic controversies that culminated in the institution of the Salon des Refusés had marked a low point in his brilliant career. The failed campaign against Nieuwerkerke; the boycott of the Salon that prevented him from showcasing his new artistic direction; the subsequent eclipse of this boycott by the publicity surrounding the announcement of the Salon des Refusés; the contentious decisions of the jury of which he had been a member—all represented frustrating setbacks in a year he had hoped would witness the further exaltation of his reputation.

These experiences had not dented Meissonier's aspirations to aesthetic grandeur, however, and he was still determined to fulfil his pledge to the

Académie des Beaux-Arts to produce what he called "works perhaps more wor-
thy of its attention." To that end, by June 1863 a new painting was on his easel.
Like *The Campaign of France*, it would be an epic scene from the life of
Napoleon, a canvas—grand in manner and monumental in subject—that he
hoped would become his masterpiece. It would feature all his familiar hallmarks,
including the same scrupulous enthusiasm for history and obsessive attention to
detail. It would also be by far the largest he had ever attempted. His biggest
painting so far, *The Campaign of France*, had measured a modest two and a half
feet wide. Attempting to cast off his reputation for miniatures, he envisaged a
canvas eight feet wide by four and a half feet high. These dimensions may have
paled beside the largest paintings of the century, such as Gérôme's colossal *Age
of Augustus*, with its thirty-three-foot span. But they marked an eye-catching es-
calation for the man Gautier once called the "painter of Lilliput."

The new painting in question was to be entitled *1807: Friedland*. Instead of
showing Napoleon on the brink of defeat, as in *The Campaign of France*, Meis-
sonier chose a different moment in French fortunes—the aftermath of a battle
that Adolphe Thiers had called "a splendid victory."[7] The Battle of Friedland
had been fought in eastern Prussia on June 14, 1807. Eighteen months earlier,
Napoleon and the Grande Armée had defeated a combined force of Austrians
and Russians at Austerlitz; less than a year later, in October 1806, the Prussians
had been routed at Jena. The victorious Grande Armée then marched eastwards
through the ensuing winter, capturing Prussian fortresses and bent on subduing
Russia, France's last enemy on the Continent. Meeting a force of 60,000 Rus-
sians at the village of Friedland, on the River Alle, Napoleon won a victory so
stunningly swift and decisive that Czar Alexander I had no option but to sue for
peace. In an eighteen-month military expedition even more impressive, Thiers
claimed, than the campaigns of Alexander the Great, Napoleon had made him-
self the master of an entire continent. "Never had greater lustre surrounded
the person and the name of Napoleon," wrote Thiers, for whom—as for
Meissonier—Friedland marked the Empire's glittering summit.[8]

Meissonier was no stranger to the horrors of warfare. He had been in the
thick of the carnage in the June Days and at Solferino, where conquest was
achieved, he wrote, in a grim chaos of "broken weapons, shattered limbs,
pools of blood."[9] As a student of history, he knew the Battle of Friedland had
been equally horrific, with the French gun crews suffering massive casualties
(Delacroix's older brother among them) before utterly destroying the Russian
cavalry. But just as *The Battle of Solferino* had soft-pedalled the violence of
warfare, so too would *Friedland* downplay the terrible gore of Napoleon's
great victory. Meissonier planned to depict a happier aftermath: the moment

when Napoleon's cavalry saluted him, as he sat astride his white charger on the morning after the battle, with cries of *"Vive l'Empereur!"*[10]

The painting was therefore to be a patriotic scene celebrating both the genius of Napoleon and the supremacy of the French military. It would give Meissonier plenty of opportunities to paint, over and over again, what had become his two favourite subjects: soldiers and horses. The first studies for the work were made as early as the summer of 1863. The Battle of Friedland had taken place in the middle of June, and so precise was Meissonier that he never worked on *plein-air* studies except during the same season, and preferably the same month, that his painting was set—"the light and shadows," he once told a friend, "could not otherwise be the same."[11] And so when they were not escorting him on early-morning gallops through the countryside near Poissy, his beloved horses Bachelier and Lady Coningham were serving him as models for the brave warhorses of the Grande Armée.

Meissonier was not alone in his passion for horses: they were one of the great enthusiasms of the age. The annual equestrian competition at the Palais des Champs-Élysées, which featured leaping and pirouetting stallions, rivalled the Salon for popularity. Horse racing was equally in demand. The French Oaks, the Prix de l'Empereur and the Poule d'Essai des Poulains (the French 2,000 Guineas) were highlights of both the social and sporting calendars. In 1857 a new racecourse, the Hippodrome de Longchamp, opened on a large plain west of the Bois de Boulogne, with grandstands for 100,000 racegoers. The course was administered by Le Jockey-Club, whose wealthy members, when not gambling, carousing and setting new trends in men's fashion, oversaw the improvement of French bloodlines. By 1863 several successful new types of horse, including the Anglo-Arab, had been bred, and legends of the track born, such as Mademoiselle de Chantilly, a filly who in 1858 crossed the Channel to win the City and Suburban Handicap at Epsom.

Two weeks after the Salon des Refusés opened, on May 31, a Sunday, *les turfistes* enjoyed a new attraction when the Grand Prix de Paris, a race for three-year-old colts and fillies, was run for the first time. Sponsored by five rail companies, it was held at Longchamp with a purse of 100,000 francs. The favourite, a French colt named Le Toucques, was cheered on by, among others, Emperor Napoleon. A victory over the English contender, The Ranger, would see voters swept to the ballot boxes, the Emperor hoped, on a surge of patriotism—for May 31 was also the first day of the 1863 election. Alas for Louis-Napoleon, The Ranger spoiled the party, taking victory by a length. Worse still, good news had not arrived from Mexico on time for polling day,

since word of the French victory at Puebla, where the Juáristas had finally been defeated on May 7, did not reach Paris until ten days after the election.

At least the outcome of the Grand Prix de Paris, unlike that of the election, had not been decided in advance. Unsurprisingly, the Emperor won a handy majority, receiving seventy-three per cent of the more than 5 million votes, with his candidates claiming 250 of 282 seats in the Legislative Assembly. Of course, these elections had not exactly been free and fair. They featured vandalised posters, vote-rigging, stuffed ballot boxes, and legal intimidation and physical threats against opposition candidates; and even under universal manhood suffrage only a quarter of the French population had the right to vote.[12] Yet despite his seemingly overwhelming victory, the 1863 election left the Emperor with a good deal to ponder. Not one of his candidates had been returned in Paris, where almost two thirds of the electorate had rejected his rule: 150,000 people voted against his government compared to only 82,000 in favour. Republicans claimed eight of the nine Parisian seats in the Legislative Assembly. Among their number was Adolphe Thiers, who, despite being the torchbearer for Napoleon—Karl Marx derided him as Napoleon's "historical shoe-black"[13]—was one of Louis-Napoleon's fiercest and most articulate critics.

The Emperor responded to this débâcle with a number of measures designed to appease the disgruntled Parisians. He dismissed the Comte de Persigny, his pompous and inept Minister of the Interior, hitherto his most faithful and fanatical supporter, and replaced him with a sixty-two-year-old lawyer named Paul Boudet. He also brought into his cabinet a number of moderate reformers, such as the respected historian Jean-Victor Duruy, a well-known republican. Then, in keeping with his dictum that a sovereign's first duty was to "amuse his subjects of all ranks," he promulgated a number of decrees regarding the arts. The first, announced on June 22, was that in 1867 Paris would host a Universal Exposition, a six-month-long festival of arts and industry. Two days later, *Le Moniteur universel* published a number of announcements about the Salon, the first of which stated that henceforth it would be held annually instead of biennially. Furthermore, evidently having decided that his decree to "let the public judge" had been a success, the Emperor declared that in 1864 the Salon des Refusés would be repeated. Lastly, the paper reported that the Emperor had promoted the Comte de Nieuwerkerke to the post of Superintendent of Fine Arts. Whereupon, suffering from arthritis, neuralgia and haemorrhoids, Louis-Napoleon departed with his mistress, Marguerite Bellanger, for the reviving mineral baths of Vichy.

The office of Superintendent of Fine Arts had been specially created for Nieuwerkerke at the behest of his mistress, Princess Mathilde. Commanding a

considerable annual salary of 60,000 francs, this post invested Nieuwerkerke with even more sweeping powers over the government's fine arts policy. With the blessing of the Emperor, he immediately set about making further reforms to the Salon. The first was unveiled six weeks later, at the beginning of August, while Louis-Napoleon was still in Vichy. Dramatically scrapping the terms of his 1857 regulations, which had turned the Selection Committee over to the members of the Académie, Nieuwerkerke announced that, beginning in 1864, three quarters of the seats on the jury would be elected by artists, with the remainder appointed by the government—which meant, in effect, by Nieuwerkerke himself.

On the face of it, this reform looked remarkably progressive, since it would give the artists the right to choose who sat in judgment over their work. No longer would arch-conservatives like François Picot or "the insipid Signol," or any of the Académie's other hidebound exponents of "mongrel Raphaelism," automatically qualify for seats on the Selection Committee. Such a reform would never have been implemented had not the public and the critics, as well as the Emperor himself, recognised the blinkered intransigence at work in the jury's decisions.

Yet Nieuwerkerke, a conservative for whom "democrat" was a term of abuse, did not wish to see a complete liberalisation of the Selection Committee. Indeed, nothing could have been more distasteful to him. Crucially, therefore, the jury would not be elected by universal suffrage; the announcement in *Le Moniteur universel* stressed that those entitled to cast their votes would be limited to "the painters who had been awarded medals."[14] This important qualification meant that the vast majority of French artists—including all but a handful of those who had exhibited in the Salon des Refusés—would not actually have a vote. The Selection Committee would be elected, rather, by an élite of artists who had been rewarded for their efforts by previous Selection Committees—a group that the progressive critic Jules-Antoine Castagnary denounced as "an intolerant and jealous aristocracy."[15] There was therefore no guarantee that the jury for 1864 would be any less narrowminded than that for 1863. In the Selection Committee no less than in the elections for the Legislative Assembly, the appearance of democratic fair play was belied by strategic rigging of the votes.

Nieuwerkerke was not finished with his reforms, however. He next turned his attentions to the École des Beaux-Arts and, three months later, in November, issued in the name of the Emperor a decree that drastically reorganised its teaching and administration.[16] Hitherto the École, though officially under the

government's jurisdiction, was for all intents and purposes run by the Académie, whose members appointed its faculty (usually themselves) and adjudicated prizes such as the Prix de Rome, which always went to the students who best conformed to their own artistic ideals. The decree of November 13 changed all of that, as Nieuwerkerke took the administration of the École back into the hands of the government through the creation of a supervisory body whose members would be appointed by the government. More deleterious to the prestige of the Académie than the August decree, this reform effectively wiped out the virtually monopolistic control its members had exerted over the training and education of French artists. The blow was especially devastating coming as it did so soon after the Académie had seen its authority challenged by the inauguration of the Salon des Refusés. A small consolation for the members of the Académie was that one of their own, the history painter Joseph-Nicolas Robert-Fleury, was named Director of the École.

Yet another blow was to come. Hitherto painting had not formed part of the school's curriculum, with students receiving lessons in drawing only. This lack of practical instruction in how to paint was the result of a bias against colour on the part of the Neoclassicists in the Académie: Ingres had once famously declared that thirty years was needed to learn to draw but only three days to learn to paint. Nieuwerkerke, however, decided that the time had come for colour to enter the École, and so in November he appointed three artists to instruct students in painting techniques: Gérôme, Cabanel and a fifty-two-year-old former student of François Picot and winner of the Prix de Rome named Isidore Pils.[17] Cabanel's appointment capped what had been, for him, a remarkable year. Not only had he scored a triumph with *The Birth of Venus*, but at the end of the summer he had been elected to fill the chair in the Institut made vacant by the death earlier in the year of Horace Vernet, the battle painter.

Before the summer of 1863 was out, another chair in the Institut had suddenly become vacant. The health of Delacroix had continued to decline throughout the spring and into the summer. After falling ill at the end of May while at his small house in Champrosay, near Fontainebleau, the painter had been taken back to his home in Paris, where, knowing the end was nigh, he wrote his will and began sharing out his possessions. By the middle of July he was spitting blood, and a month later, on August 13, he passed away at the age of sixty-five. Even at the end, he had been filled with loathing for the members of the Académie with whom he had locked horns on so many occasions. A few days before his death one of his fellow members arrived at his house to inquire about his health. "Haven't these people caused me enough trouble,"

Delacroix complained, "haven't they insulted me enough, haven't they made me suffer enough?"[18]

In fact, the Académie had one last insult in store. Elected soon afterwards to Delacroix's chair in the Institut was, not a Romantic or a Realist, but Nicolas-Auguste Hesse, the former winner of the Prix de Rome whom Meissonier had narrowly defeated two years earlier. An artist more different from Delacroix would have been difficult to imagine.

Young France

EUGÈNE DELACROIX WAS buried in the cemetery of Père-Lachaise on August 17, 1863, two days after the birthday of Napoleon Bonaparte was celebrated in Paris with gambolling clowns and great bursts of fireworks. The funeral service took place in the church of Saint-Germain-des-Prés, a short distance from Delacroix's house and studio. Among the pallbearers were Nieuwerkerke and the painter Hippolyte Flandrin, whose frescoes adorned the ancient church, festooned for the occasion in black. Funeral orations were delivered by the sculptor François Jouffroy, president of the Académie des Beaux-Arts, and by Paul Huet, a landscapist who declared in his speech that Delacroix had been "one of a small number of artists who characterise an epoch."[1]

Delacroix's funeral signalled, in many ways, the end of this epoch. The ceremony marked both the waning of an artistic movement, Romanticism, and the passing of the fabled "Generation of 1830."[2] The representatives of this generation of Romantics—Gautier, Hugo, Alphonse de Lamartine—had come of age against the backdrop of the Revolution of 1830, when the ultra-conservative King Charles X was deposed, following three days of fighting in the streets of Paris, in favour of the more liberal monarchy of King Louis-Philippe, a distant relative.* These events had been immortalised by Delacroix

*Charles X had abdicated in favour of his grandson, the Comte de Chambord, but the Chamber of Deputies refused to confirm Chambord, declaring the throne vacant and offering it instead to the more liberal Duc d'Orléans, who reigned as Louis-Philippe, King of the French. Louis-Philippe's claim on the throne had been based on the fact that he was

in *Liberty Leading the People* (plate 1B), first shown at the Salon of 1831. Slight and genteel, Delacroix had been too alarmed by the sight of the rough-looking rabble to do battle on the barricades himself, but he did not hesitate to portray himself in the work as a stalwart citizen wearing a top hat, clutching a rifle in his hands, and standing shoulder to shoulder with the bare-breasted figure of Liberty.

By the time of Delacroix's death, many of the other poets and prophets of 1830 had begun vanishing into the shades. Still, he had no shortage of mourners, and the reporter for *Le Temps* spoke of a "considerable attendance" in the church.[3] Ernest Meissonier was naturally present, wearing the green tailcoat of the Institut as he followed the hearse towards the cemetery.

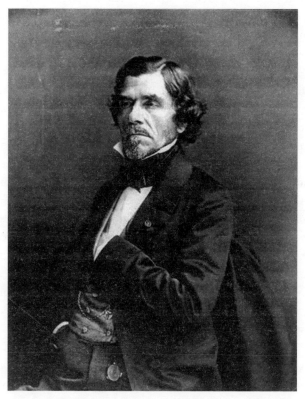

Eugène Delacroix (Nadar)

the great-great-great-grandson of Philippe I of Orléans (1640–1701), the son of King Louis XIII (r. 1610–43) and younger brother of Louis XIV.

Besides being a close friend of Delacroix, he had been profoundly affected by both the events of 1830 and the works of the painters, poets and playwrights of Delacroix's generation. He had been fifteen years old, boarding at a school in Thiais, ten miles south of Paris, when the fighting erupted on the barricades. The sound of the fusillades in the distance pitched him into such "an extraordinary state of effervescence," he later remembered, that he and three friends tried to escape from the school and make their way to Paris to join the fray.[4] Collared by the headmaster, the young Meissonier earned for his political zeal a box on the ear and a stint in solitary confinement. For the rest of his schooldays he indulged his revolutionary instincts by reading in secret the works of Victor Hugo and Alfred de Vigny, as well as the writings of two men who would later become close friends, Gautier and Lamartine—all members of the Generation of 1830, or what Gautier called "Young France."[5]

Gautier, too, was present at Père-Lachaise for the funeral of his old friend, as was Delacroix's fellow *boules* player, Adolphe Thiers. Also at the graveside was Charles Baudelaire, who cut a ghastly appearance. Though only forty-two, he was in dire straits both financially and physically—dunned by creditors, addicted to opium, and so wasted by syphilis that vanity compelled him to rouge his cheeks. Fresher faces, though, were in the crowd, representatives of a small group that might have been called the "Generation of 1863." Arriving in the company of Baudelaire was the painter Henri Fantin-Latour, whose studio was around the corner from where Baudelaire lived near the Gare Saint-Lazare. Also in Baudelaire's company was Édouard Manet, the widely acknowledged leader of this new generation who had come to mourn the man who, had he lived, seems certain to have become his most powerful champion.

Soon after the funeral, Fantin-Latour would begin his next painting, *Homage to Delacroix*. It would feature portraits of a select group of the painter's self-proclaimed admirers—including Manet, Baudelaire, Whistler and Fantin-Latour himself—grouped around a gold-framed painting of their master. The torch of 1830 was being passed into the hands, Fantin-Latour implied, of a new generation of rebels and romantics.

In the weeks following the Salon des Refusés, Manet had been tending to various aspects of family business. Chief among his concerns was part of his late father's legacy, the 200 acres of land near Asnières and Gennevilliers. Fifteen acres of this patrimony were sold in August, fetching 60,000 francs, of which Manet's share was to be 10,000 francs, or what amounted to a comfortable income for one year.[6] This would be the only money that he received in 1863 since, notwithstanding his reputation among the cognoscenti, he had yet to sell

a single painting. Despite its clutch of good notices, *Le Déjeuner sur l'herbe* had been returned unsold to his studio.

By the time of Delacroix's funeral, Manet had started work on a number of new paintings. His two Spanish canvases, overshadowed by *Le Déjeuner sur l'herbe*, had failed to attract much notice at the Salon des Refusés. Even so, in looking for a new subject he had reached once again into his trunk of Andalusian costumes and begun another scene redolent of Spain. *Incident in a Bull Ring* would include a bull and several toreros doing battle in the background, while the foreground would feature the "incident" referred to in the title—a dead matador lying prone on his back and oozing a small pool of blood.

Work on *Incident in a Bull Ring* did not progress smoothly. Manet made a number of changes to his composition before setting it aside and starting work on quite a different canvas. His inspiration came, as was so often the case, from a previous painting. Visiting Florence on a tour through Italy in 1853, he had been entranced in the Uffizi by Titian's *Venus of Urbino*, a painting later described by Mark Twain as "the foulest, the vilest, the obscenest picture the world possesses."[7] Painted for the Duke of Urbino in 1538, the *Venus of Urbino* depicts a nude woman reclining horizontally on a divan as she fixes the beholder with an inviting gaze and places her left hand lightly across her pubic region in a gesture suggesting either modesty or—so Twain pretended to believe—masturbation.

Paintings of Venus concealing her privates with either a hand or another obstacle to sight (such as the conveniently placed tresses of golden hair in Sandro Botticelli's *Birth of Venus*) were a genre known during the Middle Ages and Renaissance as *Venus Pudica*, "shameful" or "shamefaced" Venus. The genre may have had precedents in illustrations of the Expulsion from the Garden of Eden that showed the naked Eve covering her breasts and genitals out of shame (which is precisely how Michelangelo, obedient to this tradition, portrayed her on the vault of the Sistine Chapel). The link between female genitalia and shame has actually been inscribed in language, since the word *pudenda* comes from the Latin *pudere*, to be ashamed. However, Titian appears to have subverted the genre of *Venus Pudica*, since his Venus with her bold gaze and seductive manner is anything but shamefaced.

Manet, then twenty-one years old, clearly relished Titian's clever sabotage of artistic tradition. The entire painting, as he undoubtedly recognised, was wonderfully ambiguous. Was the woman truly a goddess, as the title suggested? Was she a loyal and loving wife, as indicated by her sleeping lapdog (a symbol of fidelity) and the servant and child rummaging through the marriage

chests in the background? Or was she, as her enchanting gaze and the inscrutable gesture with her hand seemed to imply, a Venetian courtesan?

Ever the diligent student, Manet had made a colour sketch of the painting, which he unearthed a decade later as he began his own version of the scene. However, Titian's *Venus of Urbino* was not the only inspiration for his new work. Recumbent female nudes were commonplace in French art, with Ingres and Cabanel probably the most famous practitioners by 1863. But Manet may have been moved to paint his own version by the example of one painter in particular. Throughout his career, Delacroix had painted numerous naked odalisques draped enticingly across unmade divans, as in *Woman with a Parrot* in 1827 and *Odalisque Reclining on a Divan* from a year later. Delacroix had been very much on Manet's mind during the spring and summer months of 1863, and this new work, comparable in subject matter to the odalisque paintings, came to serve as his own "homage to Delacroix."

Manet needed a model for his new painting, so Victorine Meurent once again found herself making the journey across Paris to remove her clothing in Manet's studio. She must have known of the controversy and ridicule aroused by *Le Déjeuner sur l'herbe*; perhaps she even visited the Salon des Refusés and witnessed for herself the convulsions of hilarity and abuse. If so, she was evidently undaunted by both the laughter of the Salon-goers and the barbs of the critic who had mocked her as the "ideal of ugliness." Whatever the case, she agreed to a pose considerably more sexually provocative than the one she had struck for Manet almost a year earlier.

Manet began work by making a number of sketches of Victorine reclining naked on a daybed. One was painted with a brush in black ink; another in a sepia wash heightened with colour; two more were done in red chalk, the medium favoured by Renaissance artists such as Leonardo and Michelangelo. Victorine's pose for this new painting was more comfortable than the one she had been required to hold for *Le Déjeuner sur l'herbe*. For the sketches in red chalk, probably Manet's first studies, she reposed on a large pillow, her right hand touching her breastbone and her right leg bent slightly to hide her genitals. Manet changed her pose for the other sketches, placing her in a revealing position more akin to that demonstrated in the *Venus of Urbino*: legs outstretched and crossed at the ankles, eyes fixed on the beholder, left hand covering the "shameful" privates.

Manet may also have made other images of Victorine. Painters had been supplementing their drawings with photographs ever since Louis Daguerre, twenty-five years earlier, had created the first workable camera. A writer in an

Study of Victorine Meurent for Olympia *(Édouard Manet)*

1856 issue of *La Lumière*, a journal dedicated to photography, noted the "intimate association of photography with art."[8] By the 1860s more than three hundred professional photographers were working in Paris, and a great many of their clients were painters for whom they did nude studies. Indeed, as many as forty per cent of all photographs registered at the Dépôt Légal were asserted to be *académies* done for painters—photographs of nude (usually female) models posing on *chaises longues* amid paraphernalia such as lyres, shields, plumed helmets, and antique vases and busts.[9]

Even the most renowned painters of the day availed themselves of this new technology. In the 1850s Delacroix had collaborated with the photographer Eugène Durieu, who took pictures of nude models that Delacroix proceeded to turn into his paintings of odalisques. Other painters, such as Gérôme, had female models shot for them by Nadar, the most renowned photographer of the day. Born Gaspard-Félix Tournachon, Nadar was a printer and caricaturist (his pseudonym came from the expression *tourne à dard*, meaning "bitter sting") who had also published a novel and spent time in a debtors' prison. At the age of thirty-three, in 1853, he had turned his considerable energies to photography, taking portraits of many artists and writers and then, in 1861, a series of eerie-looking pictures of Paris's new sewer system and water mains. An intimate of Baudelaire, by the early 1860s he was also friends with Manet, whom he photographed on several occasions. No photographs of Victorine, by Nadar or anyone else, have come to light, but she may well have appeared before his camera, either in Manet's studio or in Nadar's own workshop in the Boulevard des Capucines.[10]

Victorine was not the only woman to pose for Manet's new painting. He planned to include in the work, as a counterpart to the servant in the background of the *Venus of Urbino*, a black maid. Since it was commonly believed, as Flaubert wryly observed, that black women were "more amorous than white women,"[11] negresses were often included in scenes of bathers or brothels in order to heighten the eroticism. Manet planned to portray a black maid, fully dressed, presenting her supine mistress with a large bouquet of flowers. For his model he chose a twenty-four-year-old named Laure, whom he described as "a very beautiful negress."[12] Manet painted a sketch of Laure on a small canvas less than two feet square, depicting her in a madras, or headscarf, and wearing pearl earrings as well as a necklace of precious stones and a pale dress that set off her dark complexion. As a warm-up for the oil painting, he next completed a watercolour sketch of the entire scene, showing Victorine, pale and slender, wearing nothing but a pair of gold slippers and a keepsake bracelet as Laure approaches her with an armful of flowers in a paper wrapping.

When, in the late summer of 1863, Manet was ready to paint the work in oil, he chose a canvas six feet wide by some four feet high—smaller than the showstopping grandeur of *Le Déjeuner sur l'herbe* but still large enough to command attention in the Salon. Difficulties soon arose, chief among them Victorine's face, which Manet was forced to scrape down and repaint several times.[13] He also experimented with Laure's figure, providing her with, on second thought, more generous curves, repainting her dress at least once and omitting the jewelled necklace. Finally, at the end of his labours he added, almost as an afterthought, a touch absent from his earlier sketches: in place of the lapdog curled at the feet of Titian's Venus he substituted a black cat with an arched back and erect tail. Like the frog in *Le Déjeuner sur l'herbe*, the animal might have been intended as a visual pun, for *les chattes* was a slang term for both female genitalia and prostitutes.[14]

Manet scarcely needed to add the black cat in order to suggest exactly what was happening in his scene. Victorine was clearly cast in the role of a prostitute receiving a gift of flowers from an admiring customer. She was not, however, a prostitute like the lower-class "unruly woman" hinted at in *Le Déjeuner sur l'herbe*, but rather what was known legally as a *fille de maison*. A prostitute of somewhat higher standing, the *fille de maison* worked in a brothel, entertained a better class of client, and often adopted for herself an exotic name such as Arthémise, Octavie or Olympe. Manet even called his painting *Olympe* ("Olympia"), thereby leaving little doubt about how the reclining young woman earned her living. The name may have been a direct allusion to the courtesan Olympe in Alexander Dumas *fils*'s novel *La Dame aux camélias*,

first published in 1848 and turned into a popular stage play four years later. Another courtesan with the alias Olympe had appeared in 1855 in Émile Augier's *Le Mariage d'Olympe*.[15]

Depicting a courtesan in so unmistakable a fashion was a bold and provocative move on Manet's part considering how Alexandre Cabanel, only a few months earlier, had taken such a battering from the critics who accused his Venus of looking like a prostitute from the Rue Bréda. Prostitution may have been legal in the streets and brothels of Paris, but it was still very far from being acceptable on the walls of the Salon. And while Cabanel had at least executed his work with an unimpeachable technique, Manet applied his paint to the canvas with the same supposed lack of control and finish that had put one critic in mind of a floor mop. As in *Le Déjeuner sur l'herbe*, he painted Victorine's face, torso and limbs with none of the sculptural three-dimensionality and careful modulations of colour to which Salon-goers were accustomed. Instead, using sharp contrasts of colour, he created her body through a series of flat planes, producing a two-dimensional image that almost served to make the canvas seem a parody of Titian's curvilinear *Venus of Urbino*.

Part of Manet's inspiration for this technique probably came from photography. Painters had almost always required a muted light in which to work. The ideal studio was lit by a large north-facing window that diffused the sunlight and allowed the painter to see—and to capture in pigment—the softest and subtlest tones. Photographers, however, worked under quite different conditions. Anyone hoping to produce a photograph in the middle of the nineteenth century needed bright illumination since the first chemical emulsions were stubbornly insensitive to light. In the days before the invention of flash powder (a mixture of potassium chloride and powdered magnesium first successfully employed in the 1880s), photographers were forced to turn on their sitters various forms of artificial light. Most of their pyrotechnic devices, such as "limelight," a sheet of lime heated with a hydrogen-oxygen torch, had provided a harsh, brilliant illumination that resulted in photographs with pronounced tonal contrasts.* Photographs therefore displayed far fewer varieties of tone than was found on canvases. If Victorine had indeed been

*Other light sources used by photographers in the middle decades of the nineteenth century included static electricity stored in Leyden jars (a method tried by William Henry Fox Talbot) and a piece of magnesium wire set alight with a candle. Photographers were forced to turn to such unreliable measures because lighting their studios with electricity was too expensive an option.

photographed by Nadar (who sometimes used battery-powered arc lamps to cast light on his subjects), the result would not have been dissimilar to the stark image Manet produced on his canvas, whose lack of detail, moreover, resembled the hazy images produced by photographers as a result of the long exposures required by paper-negative prints.[16]

Manet's peculiar rendering of Victorine reclining on her pillows probably had another source as well. Besides photography, his work owed a debt to Japanese woodcuts. In the years since the 1854 Treaty of Kanagawa ended Japan's two centuries of isolation and opened her ports to foreign trade, Oriental wood-block prints and other handcrafted artifacts such as painted fans and folding screens had begun making their way to Europe. Manet was not as devout a collector of such bric-à-brac as Whistler, who had been stockpiling Japanese artefacts since the early 1860s. Even so, he was a regular visitor at La Jonque Chinoise, a purveyor of Japanese art in the Rue de Rivoli, and one of his proudest possessions was a print of a sumo wrestler done by Kuniaki II. The disregard for linear perspective found in the woodblock prints of Japanese artists such as Hokusai, as well as their lack of subtle shadings of colour, clearly appealed to Manet, offering him a precedent for his own stylised representations.[17]

Work on this canvas was probably more or less complete by the first week of October in 1863. By dint of both its style and its subject, *Olympia* almost seemed calculated to raise the same wrathful response as *Le Déjeuner sur l'herbe*. Still, Manet had other matters to worry about by the time he finished his provocative new painting. At the age of thirty-one, he was about to get married.

Besides being a photographer, Nadar was also, even more wondrously, an aeronaut. In 1863 he founded the Société générale d'Aërostation et d'Autolocomotion Aérienne, started up a newspaper called *L'Aeronaute*, and constructed the world's largest hot-air balloon. The aeronautical possibilities of hydrogen balloons had captured the public imagination. A few months earlier, an unknown thirty-five-year-old named Jules Verne, a former law student, had published his first novel, *Five Weeks in a Balloon*, in which he imagined the voyage across Africa of three Englishmen in a giant hot-air balloon named the *Victoria*. The fictional *Victoria* had been inflated with 90,000 cubic feet of hydrogen, but Nadar's real-life balloon managed to outstrip even Verne's exuberant imagination. Christened *Le Géant*, it was borne aloft by 200,000 cubic feet of hydrogen, stood 180 feet tall, and used almost twelve miles of silk that two hundred women had required an entire month to sew together. Included in the wicker-work gondola, which was the size of a small cottage, were a photographic laboratory, a refreshment room, a lavatory and, for the amusement of the passengers, a billiard table.

Studio photograph of Nadar in a balloon

On October 4, a Sunday, more than 500,000 people—almost a third of the entire population of Paris—crowded onto the Champ-de-Mars and surrounding streets, and even onto nearby housetops, to witness the maiden voyage of this magnificent vessel. A military band played for two hours as the gondola was towed into place by four white horses and the balloon, which one journalist claimed looked like "an immense unripe orange,"[18] was inflated with gas. Twelve passengers besides Nadar then climbed aboard, including the art critic Paul de Saint-Victor. "*Lâchez tout!*" shouted "Captain" Nadar at five o'clock in the afternoon, and the gigantic balloon rose skywards, sailing north-east across a silent and awestuck Paris, passing over the Invalides and the Louvre before finally disappearing from view. But unlike the *Victoria*, which sailed all the way across Africa, *Le Géant* stayed airborne for only a couple of hours before a technical malfunction in a valve line forced Nadar to make a premature descent into a marsh near Meaux, some twenty-five miles away. By the time he

and his dozen passengers were rescued, the enterprising aeronaut was already making plans for a second voyage.

Two days after Nadar's spectacle, Manet and his mistress Suzanne Leenhoff made their own, less spectacular, departure from Paris. Manet's mother and two brothers had witnessed a marriage contract between him and Suzanne, who was then aged thirty-three. According to the terms of the contract, Manet would receive the 10,000-franc advance on his inheritance from the proceeds of selling the fifteen acres of family land in Gennevilliers. This sum would allow him officially to set up home with Suzanne and Léon. The contract stipulated, curiously, that these 10,000 francs would return to Manet's mother should he predecease her with no children of his own.[19] This rather mean-spirited provision, no doubt added at the insistence of Eugénie Manet, indicated that Léon, who would suffer under its application, was probably not Manet's flesh and blood. It also indicated how Eugénie—known to her children as "Manetmaman"—nourished a robust dislike for her prospective daughter-in-law, whose misfortune in giving birth out of wedlock she once referred to as a "crime" in need of "punishment."[20] Manet's joyful anticipation of his forthcoming marriage must have been tempered by the knowledge that, as long as Eugénie was alive, domestic tranquillity could not be guaranteed.

Family resentments and rivalries were set aside, temporarily at least, as the Manet family assembled for lunch in the Batignolles on October 6 to celebrate the impending nuptials. Present for the feast was Suzanne's brother Ferdinand—one of Manet's models for Le Déjeuner sur l'herbe—and her younger sister Martina, who had moved to Paris like her siblings, gallicised her name to Marthe, married the painter Jules Vibert, and given birth to two children. The forty-eight-year-old Vibert, a native of Lyon, was a considerably more successful painter than his soon-to-be brother-in-law. A former student of Paul Delaroche, he had entered the École des Beaux-Arts in 1839 and then exhibited regularly at the Salon—usually portraits and landscapes—since 1847.[21] Set against Vibert's worthy efforts, Manet's checkered artistic career must have seemed, to the extended Leenhoff family, rather scanty prospects on which to found a marriage.

When the meal was finished, Manet and Suzanne made their way to the Gare du Nord, from where they were waved off on the seven-hour train ride to Holland. The marriage, a civil ceremony, would be celebrated in Zaltbommel, Suzanne's home town, on October 28. Manet's experience of Suzanne's family was scarcely more congenial than hers of his. He found her father, the organist and choirmaster Carolus Antonius Leenhoff, then fifty-six, "a typical Dutch

bourgeois, sullen, fault-finding, thrifty, and incapable of understanding an artist."[22]

 If the newly married couple appeared to be dogged by problems with their in-laws, one person at least envied Manet his relationship. The raddled Baudelaire, who had neither met Suzanne nor even known of her existence, was surprised to learn of the wedding. Manet seems to have kept his domestic life a secret, for some reason, from even his closest friends. "Manet came round to tell me the most unexpected news," Baudelaire wrote to a mutual friend on the day Manet departed for Zaltbommel. "He leaves tonight for Holland, from where he will bring back his wife. He makes various excuses, however, since it seems his wife is beautiful, very kind, and a very great artist. So many treasures in a single female, isn't that quite monstrous?"[23]

Deliberations

THE HANDCARTS AND wheelbarrows laden with offerings for the 1864 Salon began rolling up before the Palais des Champs-Élysées on March 21. Besides having their submissions measured, catalogued and receipted, certain artists were allowed to cast their votes for the Selection Committee. The ballot boxes closed on April 2, the deadline for submitting works of art. Of the twelve seats available on the jury for painting, nine were to be elected by the group of artists who had either received medals at previous Salons or been privileged with induction into the Legion of Honour or the Académie des Beaux-Arts.

Given this constituency, the results showed a bias in favour of members of the Académie, a total of five of whom were elected. The painter polling the most votes was the seemingly unstoppable Cabanel, followed by Robert-Fleury and Ernest Meissonier. Other members elected included Léon Cogniet and Hippolyte Flandrin (both of whom had chosen not to serve in 1863), while nonmembers picked by their peers included Gérôme and Camille Corot. The election of the sixty-eight-year-old Corot must have encouraged the landscapists, the group most harshly treated by the 1863 Selection Committee. He was a mentor to both Antoine Chintreuil and another much less well-known participant in the Salon des Refusés, Camille Pissarro.

The election produced other results that looked favourable for the *refusés* of 1863. Émile Signol, the man blamed by many for the harshness of the previous painting jury's decisions, failed to get himself elected, as did three other well-known conservatives from the Académie: François Picot, François Heim and Auguste Couder. All four were apparently being punished for their deeds of a

year earlier. The backlash against the more intransigent *académiciens*, begun in many of the newspapers, seemed even to have spread into the ranks of this relatively conservative electorate of painters. Meissonier's tally of votes proved, on the other hand, that he was not held responsible for their sins.

Nieuwerkerke had been careful to reserve for himself the right to appoint a quarter of the Selection Committee. For the painting jury he selected one conservative, Paul de Saint-Victor,* whose narrow-mindedness was offset by the more benevolent Théophile Gautier, as well as by a third appointee, Auguste de Morny. The Duc de Morny (his title had been conferred two years earlier) was an inspired choice on the part of Nieuwerkerke—and an acknowledgment of just how determined he was to avoid the débâcle of the 1863 Salon.

After the Emperor, the fifty-three-year-old Morny was the most powerful man in France. He was in fact the illegitimate half-brother of Louis-Napoleon, the product of an affair between Hortense de Beauharnais and one of Napoleon's generals, the Comte de Flahaut. An adept and charismatic politician, he had been one of the architects of Louis-Napoleon's coup d'état and, since 1854, President of the Legislative Assembly. He was also a great patron of the arts, having amassed a large collection of paintings thanks to the fortune of his former mistress. Eclectic and venturesome in his aesthetic tastes, Morny had been among the first to purchase paintings by the landscapist Théodore Rousseau—whose work until then had regularly been rebuffed by Salon juries—and even Gustave Courbet. He also, naturally, collected Meissonier, six of whose finest works looked down from the walls of his splendid mansion beside the Champs-Élysées. But Morny's tastes for Meissonier's paintings showed his political as well as his aesthetic instincts.

Morny's appearance on the painting jury was nominally due to the fact that he knew his way around the auction rooms and art galleries of Paris. But he had almost certainly been put forward by Nieuwerkerke because of his brilliant political instincts. A master at blunting opposition to Louis-Napoleon in the Legislative Assembly, he was equally skilled at subtly shaping the careers—political as well as aesthetic—of the artists whom he collected. His purchase in 1852 of Courbet's *Young Ladies of the Village Giving Alms to a*

*The "boorishly intolerant" Saint-Victor was fit for service since he had wisely forgone a second voyage in Nadar's balloon, launched several weeks after the first one. This time, following a seventeen-hour flight, the vehicle had crash-landed near Hanover, resulting in two broken legs for Nadar and serious injuries for his wife Ernestine and a number of other passengers.

Cow Girl was a clever attempt to co-opt the radical impulses of Courbet, then at the height of his notoriety.[1] The effort proved unsuccessful, but Morny obtained better results with another painter whose uncompromising realism had been seen, in the early 1850s, as a plausible threat to Louis-Napoleon's régime.

Meissonier may have missed the Revolution of 1830, but he had managed a more active part in the turbulent events of 1848, when the Second Republic was declared after famine and riots forced the abdication of King Louis-Philippe. Meissonier's friend, the poet Lamartine, became Minister of Foreign Affairs and a member of the Executive Committee. At his insistence the thirty-three-year-old Meissonier—whom Lamartine recommended to the voters of Poissy as "a man of heart, an artist of genius, and a devoted patriot"[2]—ran for a seat in the Constituent Assembly. Though he lost the election, Meissonier served in the National Guard during the June Days, after which he painted his "terrible impression" of political violence, *Remembrance of Civil War*. His scene of corpses beneath a broken barricade was in many ways a companion piece to Delacroix's *Liberty Leading the People*, a painting deemed so subversive that for many years it was banned from public view. The authorities recognised that Meissonier's work likewise had the potential to inflame political passions. Sent to the Salon of 1850, it was removed from view before the exhibition closed, though not before a good deal of attention came its way from critics across the political spectrum, most of whom praised Meissonier's "omelette of men" (as one called it) for depicting the horrors of warfare with "the pitiless fidelity of the daguerrotype."[3] The man responsible for dozens of easygoing musketeers appeared to have been transformed into a painter whose shocking tableau delivered an uncustomary political and emotional charge.

Paintings with such sharp political edges had a grim resonance after Louis-Napoleon came to power. After his violent coup d'état in 1851 saw more than a hundred people shot dead in the streets of Paris, supporters of the new Emperor had reason to fear that Meissonier, a republican sympathiser, might create another such "omelette" with his brushes, conjuring vividly to life the men and women caught in the crossfire of Bonapartist guns. But Morny was careful to forestall any such work by assiduously courting Meissonier's favour, paying visits to his studio and purchasing from him works such as *Bravoes*, exhibited at the Salon of 1852.[4] He also commissioned Meissonier to paint a portrait of his mistress wearing a blue dress and holding a book.[5] The tactic succeeded. No more scenes of military gore came forth from Meissonier's easel; work resumed on the *bonshommes* and musketeers; and by 1859 Meissonier was celebrating in paint the Emperor's victory at Solferino. Such sly coercion on the part of Morny suggests that the members of the Académie would not have

heaped up their funeral pyre in so blundering a fashion, as they did in 1863, had he been in their midst.

Besides appointing the Duc de Morny to the painting jury, Nieuwerkerke took further precautions to make certain that the scandals of 1863 would not repeat themselves. The jurors were specifically instructed to take a more tolerant view of the works submitted. Any works not admitted to the Salon would simply be deemed "too weak to participate in the competition for rewards"[6] and go on show in another Salon des Refusés. This year, however, the administration of the Salon des Refusés was not to be entrusted to a band of private individuals, such as Chintreuil and his friends; it would be organised instead by Nieuwerkerke and Chennevières themselves.

One note of discord did manage to creep into Nieuwerkerke's harmonious arrangement when Meissonier—showing that he had not been entirely tamed—abruptly declined to serve on the jury. The reasons for his refusal are not known for certain, but a number of factors may have played their part in his decision. He may simply have balked at the physical and mental labours involved in judging at a time when he was preparing numerous studies for *Friedland*. "Besides taking up much precious time," he once wrote of his work on the Selection Committee, "it generally results in regret, reproaches, and very great fatigue."[7] Nieuwerkerke's dismissive response to the petition presented to the Comte de Walewski a year earlier may still have irked him, while his galling experience on the previous Salon jury and his failure to be awarded a professorship at the École des Beaux-Arts—a position which he coveted—could likewise have made him reluctant.

Meissonier was not one to forgive and forget a slight. According to a friend at the Institut de France, he enjoyed a well-deserved reputation among friends and enemies alike as "a very savage fellow" whose impulsive temper often "betrayed him into violent outbursts and an offensive show of contempt."[8] Another friend, Edmond de Goncourt, likewise noted Meissonier's flammable disposition, calling him a "maniac" who could be "as brutal as anything" if the moment moved him: "One never knows, coming to his house, if the door will be slammed in your face or if you will be crowned with roses."[9]

Though he refused jury duty, Meissonier's anger and churlishness were not extreme enough for him to continue his boycott of the Salon. He therefore agreed to send *The Campaign of France* and *The Battle of Solferino* to the Salon of 1864. His grand new style, after the delay of a year, would at long last make its début in public.

* * *

After the Selection Committee began its deliberations in April, the Marquis de Chennevières received a letter from an old acquaintance. Charles Baudelaire had reached a low ebb. In February 1864 he had published in *Le Figaro* a series of melancholy and ill-tempered prose poems entitled *The Spleen of Paris*, in one of which he declared himself "dissatisfied with everything."[10] In April he had departed on a train for Brussels, officially to deliver a series of lectures on Delacroix, Hugo, Gautier and Edgar Allan Poe, but also to find a publisher for his work and, even more pressing, to give the slip to his many creditors in Paris. Ill and penniless apart from money he had borrowed from Édouard Manet, he installed himself in the Hôtel du Grand Miroir, where his sole companion was a live bat. Here he spent his days composing his lectures, drinking Belgian beer (which he blamed for his constant diarrhoea) and making frequent excursions to the local pawnshop.

Yet Baudelaire was not thinking of his own sorry plight when he wrote to Chennevières. He was concerned that his friends Manet and Fantin-Latour should both receive a fair hearing from the painting jury and then advantageous positions for their paintings in the Salon. "You will see what marvellous talent is revealed in these paintings," he informed Chennevières before urging him to "do your best to place them well."[11] The entreaties of a figure as notorious as Baudelaire may have seemed unlikely to cut much ice with Chennevières, a staunch conservative; but many years earlier the pair had gone to school together at the Lycée Saint-Louis in Paris, from which, however, Baudelaire had been expelled, though not before distinguishing himself among his fellow pupils for his standoffishness and, as one of them later remembered, "the most brazenly immoral opinions, which went beyond what was tolerable."[12] Even so, Baudelaire thought it worthwhile writing to Chennevières (who a year earlier had sent him a copy of his latest volume of short stories) in order to try pulling a few strings for his younger friends.

Manet had sent two works to the Salon of 1864. Although *Olympia* had been completed as many as six months earlier, this latest painting of Victorine Meurent was not among them. The public ridicule to which *Music in the Tuileries* and *Le Déjeuner sur l'herbe* had been treated made him reluctant to open himself to further obloquy with what he must have realised was a daring work. Not knowing the composition of the Selection Committee at the time of the deadline for submissions meant, moreover, that he had cause to fear rejection from the main Salon and exile to the Salon des Refusés—a state of affairs he was unwilling to suffer for a second year in a row. *Olympia* therefore stayed in his studio while two other works were shipped to the Palais des Champs-Élysées.

The first of Manet's submissions was *Incident in a Bull Ring*, which he had

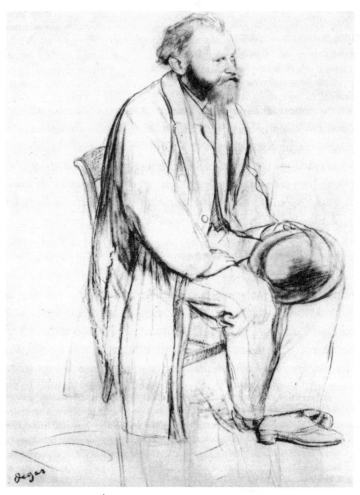

Édouard Manet (Edgar Degas)

managed to complete in spite of difficulties with the scene's perspective. The second, begun the previous November and painted on a canvas almost six feet high by five feet wide, was a biblical episode entitled *The Dead Christ with Angels*. Manet had painted a few religious scenes in his career, though these were done not out of any special feelings of piety or devotion so much as from a love of the works of Italian Renaissance artists like Titian and Tintoretto. Manet had a particular affection for Tintoretto, a sixteenth-century Venetian, sometimes known as Il Furioso, who was renowned for his *fa presto* ("work quickly") style of painting in which he applied his pigments with brush-popping vehemence. Tintoretto's *Self-Portrait*, which featured the mournful

face of the grey-bearded, baggy-eyed artist hovering against a pitch-dark background, was one of Manet's favourite paintings. He made a copy of the work in the Louvre and thereafter, as if paying court to a wise old sage, never failed to seek out the original on his visits to the museum.

Tintoretto was predominantly a religious artist who, among his many scenes from the New Testament, depicted several of the dead Christ. Likewise, Manet's *Dead Christ with Angels* depicts precisely what its title describes—the figure of the dead Christ slumped between two winged, female figures. One of the angels has lifted the muscular, half-naked body of the crucified Christ into a sitting position, while the other weeps as in a Lamentation or a Pietà. Still, despite its allusions to Tintoretto and other Renaissance painters, Manet's work included touches that were unconventional to the point of eccentricity: one of his angels sported orange robes and unfolded a pair of blue wings, while—strangest of all—Christ's loincloth was pink.*

The Dead Christ with Angels was idiosyncratic for reasons beyond its unique choices in colour. For some reason Manet placed the wound from the spear on Christ's left side rather than, as the Scriptures record, his right. Furthermore, an inscription in the foreground referred viewers to the verse in the Gospel of Saint John that recounts how the grief-stricken Mary Magdalene, having told the disciples that Christ's body is missing, returns to the tomb to see "two angels in white sitting where the body of Christ had lain." Yet Manet's work, with its curious disjunction between the text and the painting, cannot be taken for a straightforward presentation of the Resurrection, since the body of Christ, slumped lifelessly on the shroud, has neither gone missing from the tomb nor been resurrected. Was Manet simply confusing a Lamentation scene with a Resurrection? Or was he making a more abstruse and controversial point about religion and Christianity? The jurors would evidently have much to ponder.

Not surprisingly, the results of the judging in 1864 were radically different from those announced a year earlier. The percentage of *refusés* fell dramatically from sixty per cent to only thirty, meaning that seven works out of every ten were accepted. Many of the painters, such as Antoine Chintreuil, were as conspicuous by their acceptance in 1864 as they had been by their rejection the year before. In fact, one of Chintreuil's paintings admitted to the Salon, a landscape called *The Ruins: Sunset*, was even purchased by the government, a

*Manet would later retouch this pink loincloth, turning it white.

clear indication that Nieuwerkerke and the Emperor were attempting to make amends for the antics of the jurors in 1863.

The many painters hearing good news in 1864 included Fantin-Latour. Both of his works, including *Homage to Delacroix*, were accepted by the jury. Whistler, however, carelessly missed the deadline for submitting work to the Palais des Champs-Élysées. As for Manet, he saw both of his offerings approved. Evidently the jury had been undaunted by either the strange and difficult perspective of *Incident in a Bull Ring* or the obscure nature of the scene played out in *The Dead Christ with Angels*. When the Salon of 1864 opened on the first of May, his works were therefore displayed in Room M of the Palais des Champs-Élysées, together with the two paintings by Ernest Meissonier.

Room M

For the artists of Paris, the most important date in the social calendar always fell a day or two before the Salon opened to the public. *Le Jour du Vernissage*, or Varnishing Day, saw hundreds of painters descend on the Palais des Champs-Élysées to put the finishing touches on their works, filling the exhibition hall with the scraping of ladders and the penetrating stink of varnishes, turpentine and drying oils. Over the years, however, this technical exercise had become a social occasion when the exhibiting painters held court beneath their works with their wives and friends in attendance, together with crinoline-clad members of the *beau monde*, all gathered both to preview the paintings and witness a sort of fashion show. The event marked the first time the artists had seen their works in almost six weeks. It also marked the first time they were allowed to see where their paintings had been hung—and what last-minute touches with the paintbrush might improve their appearance.

Varnishing Day in 1864 brought into the Palais des Champs-Élysées, besides the usual congregation of painters and their friends, a trio of distinguished visitors. Emperor Napoleon arrived for a tour with his wife Eugénie and the Prince Imperial, his eight-year-old son Eugène-Louis-Jean-Joseph, known as Loulou. An English journalist among the entourage was unimpressed by the appearance of the Emperor, who had celebrated his fifty-sixth birthday a week earlier. The dandyish figure who cut a dash through London society in the 1830s had metamorphosed, he observed, into a "rotund, easy-looking little man who strolled about the Palais des Champs-Élysées with both hands, and his stick along with them, thrust into the side pockets of his overcoat."[1]

 The Emperor had both state and personal matters on his mind in the spring of 1864. Not only had his mistress Marguerite Bellanger given birth two months earlier to a child who she claimed was his son, but his latest inamorata, twenty-one-year-old Valentine Haussmann (daughter of Baron Georges Haussmann, the man responsible for Paris's grand new boulevards), had also become pregnant.[2] Not surprisingly, Louis-Napoleon's relations with his wife were strained by these latest affairs. The Empress had never reconciled herself to his serial adultery: "I have such a disgust for life," she once wrote to her sister after learning of yet another of his infidelities.[3] She had fallen ill in 1863 after learning about Marguerite Bellanger, cancelling many of her public engagements and dyeing her copper-coloured hair black as if in mourning—a change that was, one newspaper reported, "anything but becoming."[4]

 More than a decade after her marriage, the Empress was still deeply unpopular with many Parisians, due mainly to her supposedly unfettered extravagance. She was rumoured to sprinkle her hair each morning with 200 francs' worth of gold dust, while each pair of her underpants was said to cost 1,000 francs—the entire annual wage of the average construction worker. These stories may have been exaggerated, but entire rooms in the Tuileries were devoted to her collection of hats, shoes, gowns and furs; the latter included the skins of fourteen silver foxes and several chinchilla-lined silk bodices. And, as if determined to taunt fate, Eugénie had recently become obsessed with Marie-Antoinette, decorating her apartments in the Tuileries with furniture and other articles once owned by the late queen, a portrait of whom was suspended above her bed.

 Louis-Napoleon had greater worries, however, than his wife and his mistresses. His Mexican adventure, following various mischances, was reaching a critical stage. After his troops defeated Benito Juárez the previous May, he had set about establishing a pro-French, pro-Catholic monarchy in Mexico. Specifically, he was planning to install on the Mexican throne Maximilian von Habsburg, the Archduke of Austria and the younger brother of the Emperor Franz Josef.* The thirty-one-year-old Maximilian had required a good deal of persuasion before agreeing to the plan. With his wife Charlotte, the daughter of Leopold I, King of the Belgians, he had been enjoying a quiet life at the Castello

*There seems to have been no truth in the rumour, often repeated at the time, that Maximilian was actually the illegitimate son of the Duc de Reichstadt—the so-called Napoleon II—and therefore the grandson of Napoleon Bonaparte and a cousin of Napoleon III. Charlotte, for her part, did have French blood: she was the granddaughter of King Louis-Philippe.

di Miramare, the beautiful seaside mansion near Trieste where his days were spent indulging his passion for botany. Mexican monarchists had approached him as early as 1859, but he declined their offer and promptly departed on a plant-collecting expedition to the jungles of Brazil. Four years later, Emperor Napoleon had come calling. In October 1863, after much wavering, Maximilian agreed to accept the throne, only to suffer an attack of nerves and reject the offer five months later. Much diplomacy on the part of Louis-Napoleon, including a ball in Maximilian's honour at the Tuileries, convinced the reluctant Archduke, once again, to assent to the scheme. On April 14 he and Charlotte, a beautiful green-eyed brunette, had finally bidden farewell to their beloved Castello di Miramare and set sail for Mexico. Ominously, instead of reading books on Mexican affairs, Maximilian spent the voyage designing uniforms and medals for his army and composing a manual of court etiquette that stipulated, among other things, which waltzes and polkas would be played at his balls. His ship, the *Novara*, was due to arrive in Veracruz at the end of May.

The outcome of this Mexican enterprise was foremost in the Emperor's thoughts at the end of April. His plan to crown Maximilian could be jeopardised not only by Juárez and his fighters but also by the Americans, who viewed the French intervention in Mexico as a breach of the Monroe Doctrine of 1823, which stated that the whole of the Americas should be free from European interference. Fortunately for Louis-Napoleon, the American Civil War, then entering its fourth year, had turned into the longest and bloodiest war fought by any major power since 1815, keeping American troops preoccupied north of the Rio Grande. The war seemed destined to continue as the summer of 1864 approached, with the Confederates in a deadly struggle against the Union. Although officially neutral, the Emperor had been privately cheered a year earlier when the Army of Northern Virginia, led by the seemingly invincible Robert E. Lee, inflicted a blow to the North at the Battle of Chancellorsville. In further good news, a Confederate privateer named the C.S.S. *Alabama* had been wreaking havoc with Union shipping, capturing or destroying merchantmen in waters ranging from the Atlantic and the Gulf of Mexico to the East Indies.

All appeared to be unfolding according to the Emperor's plan. Even so, he may have learned from his friend Lord Malmesbury the portentous words of Giuseppe Garibaldi, the Italian patriot who in April 1864 was being fêted on his visit to London. At a dinner for Garibaldi in the London home of the Earl of Clanricarde, someone speculated that the career of Napoleon III had been even more successful than that of Napoleon I, to which, Malmesbury claimed, Garibaldi retorted: "We must wait for the end of the story."[5]

* * *

The Emperor was undoubtedly brought to Room M on Varnishing Day in 1864. Altogether, seven works in this room alone had either been commissioned by his government or would be purchased at his command after their appearance at the Salon. And he would have been eager to see one of his commissioned works in particular. Vain about his appearance, Louis-Napoleon had posed over the years for various busts and oil portraits. Most recently he had requested that Alexandre Cabanel execute his likeness, in part to erase from public memory the shifty-looking portrait by Hippolyte Flandrin shown at the Salon of 1863—a work the Emperor despised so much that he had tried to cancel the commission. He must therefore have been anxious to see his portrayal in Meissonier's *The Battle of Solferino*, for which both he and his horse Buckingham had posed several years earlier.

Though Meissonier was, along with Cabanel, one of the few artists whose name the Emperor would have recognised, Louis-Napoleon's opinion of the Solferino painting went unrecorded. The small size of the work—the Emperor, seated on Buckingham, was a mere two inches high—may well have failed to gratify the vainglorious instincts of a man who at that moment was making plans for an "Arc de Napoleon III," an awe-inspiring monument to be erected near the Place du Trône on the south-east edge of Paris. This arch was to feature twelve marble columns, larger-than-life bronze statues of warriors, and an enormous archway inscribed "To the Emperor Napoleon III, To the Armies of the Crimea, of Italy, of China, Cochin-China and Algeria, 1852–1862."*

The Empress Eugénie generally showed even less interest in art than did her husband. Manet's *Incident in a Bull Ring* may have caught her attention in Room M, though, since she was a great aficionado of her national sport. She had even attempted to introduce bullfighting into France, inviting a number of famous Spanish picadors to Versailles, the previous Christmas, to participate in a bizarre battle between bulls and boars—and thereby giving her enemies the chance to paint her as a pitiless degenerate.[6] No evidence confirms that she paid any attention to Manet's depiction of a bullfight, though her critics could have argued that the canvas's dead matador was a sight guaranteed to make her swoon with ecstasy.

With Varnishing Day over, the rest of Paris was permitted into the Salon. The first of May 1864 was a Sunday, when admission was free, and so the crowds

*This arch was duly finished, but it was demolished after 1870 and the Place du Trône was renamed the Place de la Nation.

pushing through the turnstiles were even larger than usual for an opening day. Though the previous year's favourite, Cabanel, was not exhibiting in 1864, plenty of other painters attracted admiring huddles. Gérôme scored another success with an Oriental scene, *Dance of the Almeh*, a small painting of a belly dancer before which, as Gautier observed in his favourable review of the work, "there was always a crowd."[7] Another popular Oriental scene came from the brush of a newcomer, a twenty-eight-year-old Dutch painter named Laurens Tadema (later to earn fame as Lawrence Alma-Tadema), whose *Pastimes in Ancient Egypt*, inspired by a wall painting in the British Museum, portrayed a group of ancient Egyptians amusing themselves with music and dance in an exotic-looking interior. Tadema's success with Salon-goers would be followed by a gold medal at the awards ceremony six weeks later—a huge honour for such a young artist.

But Room M was the main attraction in 1864. It included paintings by Jean-François Millet as well as one of the most arresting scenes in the entire exhibition, *Oedipus and the Sphinx* by Gustave Moreau, a thirty-eight-year-old former student of François Picot. Having taken some three years and thirty studies to complete, *Oedipus and the Sphinx* drew rave reviews from major critics such as Gautier, Saint-Victor and Maxime du Camp, all of whom heralded Moreau as a force to be reckoned with. "We welcome this new name," wrote a critic for *Le Temps*, "which represents unflagging effort and work, devotion to the Old Masters, and the knowledge and application of sound principles and traditions."[8] But most Salon-goers had flocked to Room M to see, for the first time in three years, the two new paintings by Meissonier.

The year 1864 marked Meissonier's thirtieth anniversary at the Salon: he had shown work at seventeen Salons since his début with *A Visit to the Burgomaster* in 1834. Yet he had not been looking forward to this new Salon with any special enthusiasm. Ever the perfectionist, he was suffering from self-doubts over *The Battle of Solferino*. Four years of hard work on this important commission had still, he feared, failed to capture the Emperor at his moment of glory. "It is really grievous for me, after so many years of work and effort," he wrote a few weeks before the Salon was opened, "at the moment when I thought I could count on what I had learned, to acknowledge that I have found myself powerless to succeed, as well as I could have wished, at the first thing that His Majesty asked of me."[9]

Meissonier did not specify precisely how *The Battle of Solferino* had failed, but critics also had their doubts about the painting. Many questioned its small size, which seemed inappropriate, even somewhat ludicrous, for a battle scene. A familiar sight at Salons, battle paintings were almost always sprawling

panoramas that covered half a wall and plunged the viewer into the thick of the action. Solferino certainly seemed to call for such treatment. The largest battle fought in Europe for almost fifty years, it had featured a front fifteen miles long, a quarter of a million soldiers, and as many as 40,000 casualties. In 1861, an artist named Adolphe Yvon tried to do justice to the battle with a painting that consumed more than 500 square feet of canvas and featured a fully life-size Napoleon III directing the action on a battlefield almost thirty feet across. Meissonier's painting was, by contrast, a dainty thirty *inches* wide. Paul de Saint-Victor protested at such an extreme economy of scale: "One doesn't use a microscope to paint three nations fighting at close quarters, as though it were a matter of observing amoebae battling each other in a drop of water."[10] Likewise, the critic for *Le Figaro* joked that it looked as if the French had gone to war against Lilliput, and a writer in *Le Nain Jaune* claimed to be reminded of the illustration on a box of chocolates.[11]

Its small size was not, in the eyes of other critics, the only problem with Meissonier's work. The presence on the Selection Committee of Camille Corot had ensured that the Salon of 1864, unlike that of 1863, showcased a good number of landscapes, not the least of which was Corot's own dreamy river view, *Memory of Mortefontaine*, which was immediately purchased by the government. A number of fine landscapes were on show in Room M, including the work of a twenty-three-year-old pupil of Corot named Berthe Morisot, who was making her Salon début with a woodland scene of sun-dappled greenery entitled *Old Path at Auvers*. Alas for Meissonier, the dusty, sunbaked Lombardian plain did not lend itself to a beautiful landscape. Critics seized on the apparent bleakness of the setting against which his battle unfolded. "The landscape seems to me the weakest part of the painting," a critic named Charles Clément complained in the *Journal des Débats*. "It is painted a disagreeable colour, harsh and meagre, and strewn with infelicitous details." The critic for *Les Beaux-Arts*—the journal owned by the Marquis de Laqueuille, the benefactor of the Salon des Refusés—likewise found the landscape hard, dry and lacking in warm tones, while the artificiality of both the sky and land reminded another of the efforts of a painter of porcelain.[12]

These negative reviews detonated in the pages of the newspapers with a disheartening regularity through the months of May and June, deepening Meissonier's conviction that his painting had miscarried and giving him, after thirty years of exhibitions, the novel experience of watching one of his paintings disappoint the critics. Fortunately, the griping reviews were offset by the applause for *The Campaign of France* (plate 2B), which the critics judged far more favourably. In fact, Meissonier's portrait of Napoleon Bonaparte was one of the

great successes of the Salon of 1864. Most critics rhapsodised over the grandeur and dignity with which Meissonier infused Napoleon as he and the doomed Grande Armée slogged their way through the snow. In offering a kind of moral lesson—courage and stoicism in the face of adversity—the painting answered the Académie's call for art to be patriotic, inspirational and heroic. Saint-Victor took the lead in a unanimous chorus of praise, poetically describing the image of Napoleon to his readers in *La Presse*: "His face is sublime with resigned despair. He feels that his genius is beaten but not dead. He sees his star fade in the dark sky."[13]

The most rapturous applause of all, though, came from Edmond About, an inexhaustible thirty-six-year-old journalist, playwright, pamphleteer and novelist whom the *Westminster Review* called "the literary grandson of Voltaire."[14] In 1864 About added to his ever-growing tally of works a volume of art criticism in which Meissonier played the role of conquering hero. "Never, I think," he wrote, "has Meissonier been better inspired than this year; never has he attempted such great things; never has his genius taken so high a flight."[15] He went on to scold those who complained about the small size of Meissonier's works, to stoutly (and almost uniquely) defend *The Battle of Solferino*, and to lambaste the judges for not decorating Meissonier with the Grand Medal of Honour. "Oh Frenchmen of Paris!" he lamented like a latter-day Jeremiah. "You do not deserve great artists, as you do not know how to reward them!"[16]

The measure of esteem that Manet had earned at the Salon des Refusés drained swiftly away as his two new works went on show at the 1864 Salon. Both canvases were roundly attacked by critics of almost every stripe, led by Théophile Gautier, whose normally charitable disposition deserted him when he found himself standing before *Incident in a Bull Ring* and *The Dead Christ with Angels*.

Manet must have entertained strong misgivings about *Incident in a Bull Ring*, a work that had given him much trouble. Even so, he could hardly have been prepared for such a critical mauling from Gautier, especially given the critic's enthusiasm for *The Spanish Singer* three years earlier. Manet may have hoped the painting's Spanish theme (which inspired a satirical journal to lampoon him as "Don Manet y Courbetos y Zurbarán de las Batignolas"[17]) might once again appeal to a Hispanophile like Gautier. However, Gautier could find nothing good to say about the work, denouncing it as "completely unintelligible" before describing to his readers the awkward and apparently nonsensical scene in which "a microscopic bull stands on its hind legs, astonished, in the middle of an arena spread with yellow sand."[18]

This "microscopic bull" was the source of much amusement to both the public and the critics alike, appearing to them a deplorably amateurish stab at conveying on canvas the recession of three-dimensional space in the bull ring—with the result that the bull, placed in the background, looked like it had shrunk. The journalist Hector de Callias, writing in *L'Artiste*, mocked how the matadors seemed to be laughing at "this little bull which they could crush under the heels of their pumps," while Edmond About joked that the dead toreador laid out in the foreground looked as if he had been "killed by a horned rat."[19] The painter and engraver Louis Leroy, writing in *Le Charivari*, a satirical journal that poured its rather sophomoric brand of scorn on hairstyles and fashions as well as art and literature, speculated that Manet had to be suffering from "an acute affliction of the retina" since "Nature could not appear this way without an aberration of the optic nerve." He went on to suggest that Manet should be placed in a special box in the Paris slaughterhouse until he learned the correct way to paint a bull.[20]

Manet's novel approach to linear perspective may have found such disfavour in part because Room M contained, a few feet away, a masterful example of how the impression of a receding three-dimensional space could be created. In a composition at once diabolically complex and exquisitely executed, Meissonier's *The Campaign of France* showed Napoleon and his generals riding diagonally across the picture plane, from left to right, in a flawless escalation of both scale and detail, leading from the soldiers at the periphery, along the orthogonals formed by the ruts in the snow, to Napoleon on his white charger at the very centre of the scene. Besides a convincing depth in the visual field, Meissonier achieved, through his flow of marching figures, one of the most satisfactory images of motion in the history of art. Next to such a master-class in perspective construction, Manet's awkward and implausible bullfight scene could hardly have been rated by the critics of the day as anything other than a dismal flop.

Worse still for Manet were the reviews accorded his second work, *The Dead Christ with Angels*. Gautier, once again, was appalled by the scene, calling Manet a "frightful Realist" and pointing out that his Christ was so filthy that "not even the Resurrection would cleanse him."[21] This portrayal of Christ— with, to all appearances, dirty hands and a grubby beard—offended most critics. "We have never seen such audaciously bad taste," thundered the critic for the *Gazette des Étrangers*, who complained how lampblack seemed to have been smeared on the face of "the most beautiful of men."[22] Another journal, *La Vie Parisienne*, jested that the painting was actually meant to portray "the poor miner rescued from a coal pit."[23]

These reviews were in many ways unfair to Manet. While Christ was usually portrayed by artists as the ideal man, paintings of the Crucifixion and, even more, the Entombment often emphasised his grotesque physical sufferings and horrific death with wincing particulars of torture, disfigurement and rigor mortis. One of the most famous images of the Entombment ever painted was that done in 1507 by Raphael, whose slit-eyed, gaping-mouthed Christ makes a no less unglamorous corpse than Manet's. The problem for Manet was that he had sailed, however unintentionally, into some very choppy theological waters. As the critic for *La Vie Parisienne* put it, Manet's Christ seemed to have been "painted for Monsieur Renan."[24]

The "Monsieur Renan" in question was, in 1864, the most controversial man in France, enjoying a reputation in France as the Church's most dangerous foe since Martin Luther. Born in 1823 to a Breton fisherman, Ernest Renan was a brilliant scholar of Hebrew who had studied for the priesthood before leaving the Church because of his disenchantment with its teachings. He spent a decade working at the Imperial Library, where he honed his knowledge of ancient languages and published translations of the Book of Job and the Song of Solomon before applying in 1859 for the chair of Hebrew and Chaldaic at the Collège de France (then known as the Collège Impérial). When the Roman Catholic Church opposed his candidacy, he was dispatched by Napoleon III, in a sort of compromise, on an archaeological expedition to the Middle East. There, in 1861, in a hut in Lebanon, he wrote *The Life of Jesus*, which interpreted the Bible in historical and scientific terms rather than theological ones. Crucially, Renan's Christ was a man, a mere mortal, rather than the Son of God. He appeared in *The Life of Jesus* as an itinerant Galilean preacher whose miracles, such as the raising of Lazarus, were tricks played on a credulous population. His supposed divinity owed itself to myths about the Resurrection spread by frenzied followers after his death (which Renan diagnosed, in his confident scientific spirit, as having been the result of a ruptured vessel in the heart). Returning to Paris with his manuscript, he assumed the vacant post at the Collège Impérial in 1862 and in the following year published his book— coincidentally, six weeks after the Salon des Refusés had opened. Within a few months *The Life of Jesus* had sold 60,000 copies, run through a dozen printings, and provoked so much outrage and indignation that Renan, at the insistence of conservative Catholics, was deprived of his academic position.

The rumpus caused by *The Life of Jesus* may well have motivated Manet to paint his *Dead Christ with Angels*, a work begun at the height of the storm. Whatever the case, a portrait of Christ painted by an artist with Manet's reputation was bound to draw fire at a time when orthodox opinion was so incensed

by Renan's own depiction of Christ. Moreover, Manet's presentation of the dead Christ as less than the *beau idéal*, with a sooty face and grimy hands, appeared to endorse Renan's conclusion that he was a man rather than a divinity.

The most contentious passages in *The Life of Jesus* came near the end, in a chapter entitled "Jesus in the Tomb," where Renan speculated that the Resurrection had not actually taken place. "Had Christ's body been taken away," he asked his readers, "or did enthusiasm, always credulous, create afterwards the group of narratives by which it was sought to establish faith in the Resurrection?" Renan inclined towards the latter, concluding that "the strong imagination of Mary Magdalene played an important part in this circumstance. Divine power of love! Sacred moments in which the passion of one possessed gave to the world a resuscitated God!"[25] The Resurrection was, in this view, a fabrication founded on the wishful thinking of an ex-prostitute unhinged by grief.

Manet's inclusion of the biblical verse recounting how Mary Magdalene had arrived at the tomb to see that Christ's body was missing could be taken as another approving nod at Renan's demolition of the Resurrection.[26] Still, a true attempt to quash all supernatural aspects of the Bible would surely not have included the brace of winged angels that feature so conspicuously in Manet's painting. Renan put no stock, naturally, in stories about angels materialising in Christ's tomb, since for him they were simply the figments of Mary Magdalene's overheated imagination. For Manet the "two angels in white" described in the Gospel of Saint John may have mutated into the blue-winged creatures in orange and black robes—but they are angels nonetheless. Their presence suggests that, whatever some of the critics believed, his work was actually influenced more by the canvases of Tintoretto than the pages of Renan.

Manet's reputation may have dipped somewhat with these two unpopular canvases. But Gautier, for one, suspected that more would be heard from Manet, who possessed, he allowed, "the true qualities of a painter." He also recognised that, whatever his poor reputation among most critics, Manet had his share of "fanatical" admirers: "Already some satellites are circling around this new star and describing orbits of which he is the centre."[27]

As he wrote these lines, Gautier may have been thinking of another painting in the Salon, Fantin-Latour's eight-foot-wide *Homage to Delacroix*, in which a ginger-bearded Manet, surrounded by friends and allies such as Baudelaire and Whistler, cut a conspicuous figure to the right of the framed portrait of Delacroix. The work was, besides a tribute to Delacroix, a celebration on canvas of prominent artists from the "Generation of 1863"—Manet, Whistler,

Legros, the engraver Félix Bracquemond, and Fantin-Latour himself, all vet-
erans of the Salon des Refusés. One by one through the early months of 1864
these artists and writers had come to Fantin-Latour's small studio in the Rue
Saint-Lazare, in front of the train station, to pose for the group portrait. Yet
despite the appearance of solidarity and earnest purposefulness that Fantin-
Latour conveyed, those of the Generation of 1863 shown in the painting had
largely left Paris by the time it was shown. Having missed the deadline for the
Salon, Whistler was a no-show in Paris in 1864; instead, he submitted two
works to the Royal Academy in London, receiving favourable reviews from
both *The Athenaeum* and *The Times*. He had in any case more or less perma-
nently relocated to London, to a house in Lindsey Row, Chelsea, which was
crammed with his collection of blue-and-white porcelain and Japanese fans.
Another painter, Alphonse Legros, had also moved to London, sharing
accommodation with Whistler for a few months before marrying an English-
woman in 1864. Baudelaire, of course, had left for Brussels and, despite his
complaints about living among "the stupidest race on earth,"[28] showed no sign
of returning to Paris.

Manet and Fantin-Latour, then, were left to hoist the standard in 1864. If
Manet's Salon had been underwhelming, Fantin-Latour was beginning to enjoy
some remarkable success. *Homage to Delacroix* proved so popular with Salon-
goers that it was bought for the very reputable sum of 2,000 francs by a
printseller named Ernest Gambart, who planned to have the image engraved and
then sold in his shop. His second painting, *Scene from Tannhäuser*, also sold for
2,000 francs, this time to Alexander Ionides, a London-based shipping merchant
and art collector. Nor were these sales the last of his triumphs. Fantin-Latour
also exhibited two of his flower paintings at the Royal Academy in London;
these, too, were purchased by Ionides.

Manet could only dream of such commercial success, and his two paintings
suffered a more forlorn fate. Reclaiming the pair of them from the Palais des
Champs-Élysées in June, he proceeded to take a knife to his much-derided *In-
cident in a Bull Ring*, cutting it into several pieces. He kept two fragments—the
dead toreador and the three bullfighters in the background—but destroyed the
remainder, including most of the "microscopic bull." *Dead Christ with Angels*
joined the several dozen other unsold canvases, including *Le Déjeuner sur
l'herbe*, that cluttered his studio in the Rue Guyot. Manet then vacated this stu-
dio for a few weeks in the summer of 1864. The notorious painter was taking
his family to the seaside.

Plein Air

BOULOGNE-SUR-MER WAS ON the English Channel, 135 miles north of Paris. A walled city of some 35,000 people, it featured a harbour bristling with masts, a wooden pier jutting into the waves, a cliff with Roman ruins, and the newly restored church of Notre-Dame, to which a miraculous image of the Virgin had brought pilgrims since the Middle Ages. The city was also famous as the site where Napoleon had made his preparations to invade Britain in 1804. On an eminence above the town a 170-foot-high pillar, the Colonne de la Grande Armée, was still topped by a statue of Napoleon. More recently, an invasion by a Bonaparte had come the other way: Louis-Napoleon had launched himself on France from this spot in his ill-fated expedition aboard the *Edinburgh Castle* in 1840.

Édouard Manet arrived in Boulogne in the second week of July. With him were his wife Suzanne, his godson Léon, his younger brother Gustave, a lawyer, as well as both his mother and his new mother-in-law. The extended family rented a small house in the Rue de l'Ancienne-Comédie, a short walk from the harbour, and partook of the delights of Boulogne by purchasing a one-month subscription to the Établissement des Bains. This was a grand new set of assembly rooms, opened a year earlier, that treated its guests to heated baths, an English garden, terraces overlooking the sea, billiard tables, a lawn for croquet (a game newly imported from England) and, in the evening, musical entertainment. It was, according to one enthusiastic newspaper report, "on a more splendid scale than any establishment of the same nature."[1]

Seaside resorts had become popular in France over the previous dozen years.[2] After the railway, which came to Boulogne in 1848, linked Paris with

what had then been a series of fishing villages on the coasts of Normandy and Picardy, middle-class Parisians found themselves able to spend a week or two each summer either under parasols on the beach or submerged in the waves. The beneficial effects of the seaside had been explained in 1861 by the historian Jules Michelet in *La Mer*, a book that claimed seabathing, in particular the infusion of salt through the skin, was excellent for the constitution; and a journal called *La Gazette des eaux*, published fortnightly, extolled the benefits of immersing oneself in water. The point was not to exercise oneself in the waves but to absorb (and even to drink) the brine. Some resorts, like the Établissement des Bains, offered indoor bathing facilities, complete with heated salt water, but more adventurous holidaymakers could brave the bathing machines. Drawn by horses and looking like privies on wheels, these contraptions conducted bathers chest-deep into the chilly waves, preserving their modesty, shielding them from the wind, and then transporting them safely back to shore.

The seaside was popular with painters as well as Parisian holidaymakers. Inspired by the example of English artists like J. M. W. Turner, a painter of Normandy seascapes by the early 1830s, many artists had arrived with their canvases and easels a good decade before the railway. In Honfleur, at the mouth of the Seine, a group of artists had begun congregating at the Auberge Saint-Siméon, an old farmhouse whose interior walls were scrawled with chalk-drawn caricatures by visiting painters; among those who came there to work were landscapists such as Daubigny and Corot. Twenty miles up the coast, at Étretat in Normandy, a hotel known as the Rendez-Vous des Artistes had attracted the custom of Delacroix and numerous other painters. "Parisian painters came to ask the beautiful cliffs of Étretat for inspiration," a writer named Morlent had observed in 1853, noting how their canvases never failed to find buyers, further spreading the fame of both artists and resorts alike.[3]

Like so many painters before him, Manet had travelled to Normandy for something more than dips in the ocean or games of croquet. He had gone to the seaside armed with an easel as early as 1853, when Thomas Couture arranged a walking and painting tour of the Normandy coast for his students. Eleven years later, he raised his easel beside the harbour and, though he had rarely worked *en plein air*, proceeded to paint a number of canvases during the spell of fine, dry weather. After the failure of his works at the Salon, he was determined to take inspiration not from Old Masters in the Louvre so much as from—as both Baudelaire and Couture had been exhorting—the everyday life that surrounded him.

To that end, even before the Salon of 1864 closed its doors Manet had started a painting based on a number of *plein air* sketches of "modern life."

On June 5, a Sunday, he had joined the more than 100,000 Parisians who made their way to the Hippodrome de Longchamp for the second running of the Grand Prix de Paris. "All Paris went out to see it and made a splendid show," the correspondent for *The Times* reported breathlessly at the sight of so many Parisians in resplendent attire streaming through the Bois de Boulogne in their stylish carriages. "Surely in no out-of-door spectacle in the world could such a show present itself."[4] Huge excitement had accompanied the race because Blair Athol, winner of the 1864 Epsom Derby in a record time, had come to challenge the local favourite, Vermouth, a bay with three white legs. Despite arriving in Paris only the evening before, Blair Athol was the favourite with the bookmakers, who chalked the latest odds—2 to 1 at post time—on blackboards set up around the Hippodrome. But Vermouth led from the start and never relinquished his lead, defeating the English champion by two full lengths. "The roar of huzzas rent the air," wrote the correspondent for *The Times*, who noted how Emperor Napoleon—never one to miss a grand occasion such as this—acknowledged the glorious victory with a bow from his private box. After endless cries of "*C'est magnifique!*" and "*Vive l'Empereur!*" as well as endless bottles of champagne, the ecstatic crowd wobbled home, clogging the Champs-Élysées with six lanes of fashionable broughams, barouches, spiders and tandems.

Manet had made pencil sketches of the scene at Longchamp that he then turned into a watercolour and, some time over the next few weeks, an oil painting called *The Races at Longchamp* (plate 6A).[5] Engravings of horse races featured in the pages of journals such as *La Chronique du turf* and *Le Sportsman*, but Manet added a new and striking aspect to the popular genre by showing the horses galloping straight at the viewer. As an action scene with a dramatic perspective, it was a bold composition for someone who had just failed so visibly with *Incident in a Bull Ring*. But the atmospheric perspective through which the background of hills and trees was devised, as well as the vanishing point created by the racetrack's guardrail, both provided the visual depth so notably lacking in the bullfight scene.

The composition was bold for another reason as well. If *The Races at Longchamp* was accepted for the next Salon, it would hang in the same room as whatever Meissonier chose to display. Meissonier's reputation as a painter of horses was, of course, without parallel. *The Battle of Solferino* may not have endeared itself to many critics, but no one could fault Meissonier's depiction of equine anatomy. As Théophile Gautier wrote, with this one work all previous painters of horses—Cuyp, Wouwermans, Horace Vernet—were "overcome in a single blow."[6] *The Campaign of France* had simply aggrandised this reputation.

Of course, Manet's painting was very different from anything Meissonier

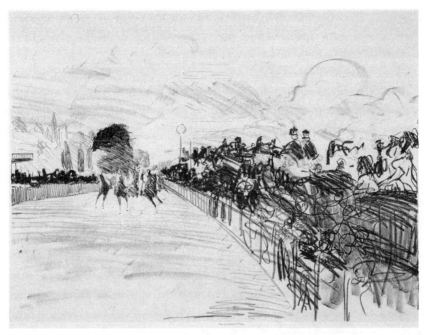

Lithograph of The Races at Longchamp *(Édouard Manet)*

would have done. Manet was not interested in recording for posterity the duel between Vermouth and Blair Athol, or even showing what the individual horses looked like. They were mere dabs of paint in the background—a few flying forelegs and a cloud of dust rather than the elegant, lifelike beasts at which Meissonier excelled. Manet was actually more interested in the racegoers than the racehorses, and accordingly he filled the left half of his canvas with members of the *beau monde* in modern dress—a crowd of Longchamp spectators with their top hats, crinolines and parasols. He even included a pair of coachmen in blue livery seated atop a landau with its hood folded back to reveal its passengers, a pair of ladies enjoying the spectacle from under their blue parasols. The result was a frieze of modern life not unlike *Music in the Tuileries.*

If *The Races at Longchamp* was stimulated in part by engravings in journals like *Le Sportsman*, a second of Manet's paintings from the summer of 1864 owed even more to the popular press. For the past few years a Confederate privateer, the C.S.S. *Alabama*, had been roaming the seas in search of Union merchant ships. All told, sixty-eight of these vessels had been sent to a watery doom, with a loss of six million dollars in Union trade revenues. By the spring of 1864, the

Alabama's deadly hunt had brought it into the waters of the English Channel. Then in June, a short time before Manet departed for Boulogne, the legendary privateer appeared in the French port of Cherbourg.

Through the spring of 1864, the Civil War had remained a grim battle of attrition. At the beginning of May, the Union General Ulysses S. Grant started his summer campaign by moving his 120,000-strong Army of the Potomac into central Virginia, where it engaged Robert E. Lee's numerically inferior forces in the Wilderness, a harsh terrain where more than 17,000 Union casualties were sustained. A few days later and ten miles to the south-east, in the Battle of Spotsylvania Court House, Lee again checked the Union advance, inflicting almost 20,000 casualties on the Army of the Potomac.

Meanwhile the war was being fought on other fronts. Gideon Welles, the U.S. Navy Secretary, had eight warships scouring the oceans for the *Alabama*, whose remarkable exploits had been splashed across the pages of British, French and American newspapers. On June 11, while patrolling the English Channel, one of these vessels, a sloop of war named the U.S.S. *Kearsarge*, received reports that a Confederate ship, soon confirmed to be the *Alabama*, had arrived in Cherbourg for the recoppering of its hull and the repairing of its boilers. Two days later, the *Kearsarge*, commanded by John Winslow, was sighted several miles off the coast of Cherbourg, where it waited for the *Alabama* to weigh anchor and enter the Channel. Battle was finally engaged on a Sunday morning, June 19, when the *Alabama*, though low on ammunition and still barely seaworthy, steamed out of Cherbourg, bravely living up to the motto on her great bronze wheel: *Aide-toi et Dieu t'aidera* ("God helps those who help themselves"). After a battle lasting ninety minutes—during which time the two warships fought starboard to starboard in increasingly diminishing circles while spectators gathered on high ground along the shore to watch—the *Alabama* was sunk by the superior firepower of the *Kearsarge*, which was outfitted with two 15,700-pound Dahlgren smoothbore cannons. Three French pilot boats and a British steam yacht named the *Deerhound* rescued Raphael Semmes, captain of the *Alabama*, and fifty of his crew. But the career of the great Confederate privateer was ended as the burning ship sank stern-first into the waves and then disappeared from sight.*

Even though French sympathies rested largely with the *Alabama*, the sea

*But not for all time: in 1984 the French Navy discovered the wreck of the *Alabama* six nautical miles off the coast of Cherbourg, at a depth of 185 feet.

battle created as much excitement in France as the victory of Vermouth at
Longchamp had two weeks earlier. Before the month of June was out, engrav-
ings of this naval battle had appeared in numerous French newspapers, includ-
ing *L'Universel* and *Le Monde illustré*. Within a few weeks, another view of the
engagement was also offered to the public. In the middle of July, a painting by
Manet entitled *The Battle of the U.S.S. "Kearsarge" and the C.S.S. "Alabama"*
went on show in the window of a shop in the Rue de Richelieu owned by the
publisher Alfred Cadart. Inspired by the engravings and news reports, Manet
had created his own version of the scene, one placing a French pilot boat in the
foreground and, beyond it, the *Alabama* swamped and smouldering in the
blue-green waves. Unlike *The Races at Longchamp*, the painting was not based
on either first-hand observation or *plein air* sketches, but it was animated, like
the racing scene, by both popular illustrations and public sentiment. In his
search for success and acclaim, Manet had left behind the corridors of the Lou-
vre and turned to the events—albeit quite extraordinary ones—that were oc-
curring in the world around him.

Manet arrived in Boulogne a day or two after the work went on show in
Cadart's shop and, setting up his easel in the harbour, began his seascapes.
One of these, *Departure of the Folkestone Boat*, featured a more modest vessel
than the *Alabama*, a steam packet that plied the Channel between England and
France. This work was probably not painted entirely out of doors, since Manet
placed the captain, in what would have been a flagrant breach of the rules, on
the boat's bridge, a detail indicating that he did not paint exactly what he saw
but rather cobbled the painting together from various of his sketches and mem-
ories. Another of his paintings, *Seascape at Boulogne*, featured a school of por-
poises in the foreground and a variety of ships and scudding sailboats in the
distance.

Still, the charms of working *en plein air* were not inexhaustible. And while
Boulogne had various attractions besides its harbour, its ships and the Étab-
lissement des Bains, Manet seems to have found its cultural allurements less
than stimulating. Within a few days of arriving in Boulogne he wrote to a
friend in Paris, the engraver Félix Bracquemond: "Although I'm enjoying my
seaside holiday, I miss our discussions on Art with a capital A, and besides
there's no Café de Bade here."[7] Desperate for news of friends such as Baude-
laire, he appealed to Bracquemond for the latest gossip.

Fortunately for Manet, his interest was piqued by the arrival in Boulogne of
the U.S.S. *Kearsarge*, which dropped anchor a short distance offshore and be-
gan playing host to numerous tourists. "The ship is pretty well crowded with a
fine lot of people," wrote one crewman, Marine Corporal Austin Quinby, in

his journal, "many of them from the country and have on their Sunday go-to-meeting clothes and are very nice looking."[8] Another observer, one of the *Kearsarge*'s coal-heavers, was less impressed with the visitors, recording that "they go up and down the decks chattering like so many monkeys, and they go through as many antics as I ever see a Clown go through in a circus."[9]

Manet was one of these visitors. Ferried out to the *Kearsarge* by a pilot boat, he went on board a day or two after arriving in Boulogne. He made sketches of the scene and then painted two impressions of the sloop as she lay at anchor: one an ink-and-watercolour, the other an oil painting entitled *The "Kearsarge" at Boulogne*. The latter included a sailboat navigating a foreground of choppy, aquamarine-tinted sea and, on the horizon line, several pilot boats nearing the *Kearsarge*, which was little more, in this view, than a menacing black silhouette. The painting also included a curious anomaly. The flags and streamers on the prow and masts of the *Kearsarge* blow in one direction while the sails on the boats billow the opposite way, offering more evidence that Manet was not painting exactly what he saw—and perhaps explaining why the young Édouard had proved such an abysmal recruit for the naval academy.

Manet's efforts by the seaside received encouragement when he learned that *The Battle of the U.S.S. "Kearsarge" and the C.S.S. "Alabama"* had received a good review from Philippe Burty in *La Presse*, the daily newspaper in whose pages Paul de Saint-Victor usually dripped his venom. The thirty-four-year-old Burty was a progressive art critic whose articles had appeared in, among other journals, the *Gazette des Beaux-Arts*.[10] During the late 1850s he had championed the art of etching, but more recently his attentions had turned to Oriental art: he would later coin the word *japonisme* to describe the craze for all things Japanese. Manet was well aware that Burty's words carried much weight. He went so far as to write Burty from Boulogne to thank him, expressing the hope that more such reviews would come his way. "I'm grateful to you," he wrote, "and hope the proverb 'one swallow doesn't make a summer' will not apply to us!"[11]

After several weeks in Boulogne, Manet finally returned with his family to Paris, bringing back with him on the train a collection of *plein-air* sketches and several completed canvases. He also returned with an apparent determination to steer his new course in art, painting popular, topical scenes without any of the learned and ironic allusions to the art of past centuries that undergirded works such as *Le Déjeuner sur l'herbe* and *Olympia*. In fact, one of his first paintings upon returning to Paris was of a bowl of fruit—pears from the orchard in Gennevilliers of his cousin, Jules De Jouy.

Manet made a change to his personal as well as his artistic life in 1864. Soon

after returning from the coast, he moved out of the three-room apartment in the Rue de l'Hôtel de Ville that for the past four years had been his home. With Suzanne and Léon, as well as Suzanne's grand piano, he took new lodgings in the Boulevard des Batignolles, still within short reach of the Gare Saint-Lazare, and still in the heart of the district. Once installed, he began making plans for an exhibition of his works that would reveal this new artistic direction.

"The painter's part is to come to the aid of history," Meissonier once wrote. "Thiers speaks of the flash of swords. The painter engraves that flash upon men's minds."[12]

Meissonier, in the summer of 1864, was still hard at work turning Adolphe Thiers's words—his description of Napoleon and his triumphant cuirassiers at the Battle of Friedland—into a painting. While Manet was able to illustrate the combat between the *Kearsarge* and the *Alabama* in four short weeks, Meissonier, typically, was taking far more time on his own battle scene. He made small oil sketches of everything from the hooves and haunches of the individual horses (the painting, like *The Campaign of France*, would feature more than a dozen of them) to tiny details such as the hat with which Napoleon salutes his troops.[13] He also began sculpting various of the horses in wax. These figurines, which stood some eight or nine inches high, were impressive works of art in themselves. Meissonier twisted wire frameworks into shape, then covered them with pellets of warm beeswax that he proceeded to model with his fingers. The features of the horses—the flared nostrils, the eyes, even the teeth—were next sculpted with minute precision, while small leather bridles were fashioned to fit over their heads. If Manet's horses in *The Races at Longchamp* were suggested by a few quick splodges of colour, the warhorses of the Grande Armée would take shape on Meissonier's easel only after being put through their paces in an endless series of models and prototypes. He was so laboriously precise that he forced one of his horses to hold an awkward position for such a long stretch that he completely exhausted the animal.[14]

These intricate preparations meant that *Friedland*, though keenly awaited by the public and the critics alike, would not be finished on time to appear at the Salon of 1865. However, Meissonier was also creating several other works, including a pair of small panel paintings—*Laughing Man* and *End of a Gambling Quarrel*—which marked the return of his musketeer style. The former work simply portrayed a man in seventeenth-century clothing (sword, sash, lace collar, wide-topped boots and wide-brimmed hat), the latter a pair of men in identical costume sprawled on the floor after having exchanged rapier

thrusts. This last scene was set in an elegant interior—enormous fireplace, tapestried wall, upholstered chairs—that looked like something out of the seventeenth century but was in fact a room in the Grande Maison. Meissonier's house, with its needlepoint tapestries, heavy antiques and acres of wood panelling, made a fitting backdrop to his musketeer paintings. Its rooms were works of art in themselves. "Some of the rooms are fit to be framed," enthused Gautier (whose own taste in interior decoration inclined towards Turkish sabres, cuckoo clocks and the various exotic curios brought back from his expeditions to Algeria).[15]

Meissonier was still crafting his musketeer paintings for the simple reason that he needed the money. He had been paid very large sums for *The Battle of Solferino* and *The Campaign of France*—25,000 and 85,000 francs respectively. But together the paintings had used up three or four years of work. With *Friedland* threatening to take equally long, he clearly needed other work to finance his ostentatious manner of living. Meissonier spent, on average, 60,000 francs per year. Most of these huge sums disappeared due to his passion for, as he put it, "piling stones on top of one another."[16] Construction bills for the Grande Maison and its assorted outbuildings had devoured hundreds of thousands of francs since the original structure had been purchased almost twenty years earlier for a modest 18,000 francs.[17] Meissonier was as much a perfectionist with his house as he was with his paintings: only the best materials and most exacting craftsmanship would do. And so just as he often scraped paint from a canvas, he forced his builders to knock down and rebuild any additions and alterations that failed to please him—often at great inconvenience and even greater expense. The accounts for the building works at the Grande Maison for the two years between 1854 and 1856—a dense manuscript of 837 pages—include the master mason's constant scribbled refrain, "change made by the owner."[18]

There seemed to be no limit to Meissonier's tinkering with his house. A set of iron tie-bars were sealed in the masonry three times before he was satisfied; the brickwork on the front of the house was removed and laid a second time when the alternating bands of pink and white failed to impress; and no sooner was the roof completed than Meissonier ordered its demolition because it did not, in his view, present the desired profile.[19] Even the most minor details were important to Meissonier, for his house was as essential as his paintings to what Gautier called his "resurrection of the life of bygone days." Wanting the Grande Maison to look from the outside like a steep-roofed Flemish house in an engraving by the seventeenth-century artist David Teniers the Younger, he went so far as to show the engraving to his perplexed workmen, ordering them to copy it.[20] Things were scarcely any easier on the inside. Balustrades for the staircase were carved and then recarved, and Meissonier finished decorating

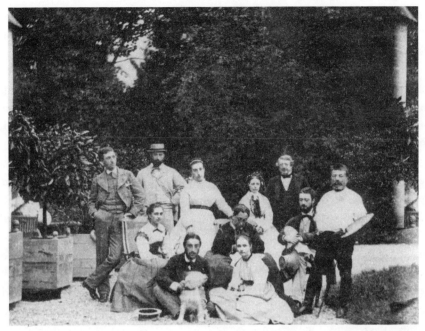

Ernest Meissonier and family in front of the Grande Maison. Seated in front:
Charles Meissonier and Jeanne Gros. Seated in second row: Emma
Meissonier (second from left) and Lucien Gros (third from left); standing:
Thérèse Meissonier (third from left) and Ernest Meissonier (far right).

his salon in sixteenth-century style—carved wood, a large fireplace—only to dismantle the entire room to create the illusion of a different century. "Each day, a new change," sighed Meissonier's friend Edmond de Goncourt.[21]

Not surprisingly, Meissonier's wife found these endless refurbishments no less exasperating than the builders did. "His poor wife," murmured Goncourt sympathetically in his journal. "He sends her to visit friends whenever he wants to make a change."[22] Since about 1860, Emma Meissonier had suffered bouts of poor health, in particular rheumatism and bronchitis, which at times kept her confined for long spells to her bedroom. These conditions may have been exacerbated—or even brought on—by the stress of her husband's incessant architectural experimentation. The situation was not helped by the fact that Meissonier was anything but a doting husband. "My art before all and above all!" he once pompously declared, adding: "In spite of my yearnings for deep affection, I am one of those who could have walked alone in the liberty of work and of creation. I could have forgone marriage."[23] He claimed, in fact,

that the true artist should never marry. "Painting is his mistress, and all others must inevitably flee before her."[24] Small wonder that as the years passed Emma became an invalid and a recluse.

In 1862 Meissonier had purchased another building in the abbey enclosure that he planned to turn into a residence for his son Charles, then aged eighteen. Formerly the house of the abbey's prioress, the building was dubbed "La Nouvelle Maison" even though it was actually older than many of the other buildings in the enclosure, including the Grande Maison itself. Meissonier once again hired an architect and set about remodelling and extending the structure such that its rows of dormer windows and alternating bands of pink and white brickwork would nicely complement his own residence.

Meissonier also designed, for the rear of the Nouvelle Maison, a glass-walled studio in which his son could paint. Charles was training to become an artist like his father. Meissonier did not run a studio or take students under his tutelage like Thomas Couture, whose pupils numbered in the dozens. But he did instruct a few hand-picked students. His son Charles was one pupil, along with Charles's best friend (and a Poissy neighbour) Lucien Gros, who in 1864 was nineteen years old. Charles was working at this time on a painting whose virtuoso brushwork and keen eye for detail proved that he had inherited his father's amazing precocity. Called *The Studio*, it showed the burly, bearded Meissonier toiling intently over a sketch in his workshop. This kind of tableau—an artist at his craft—was one much favoured by Meissonier himself.[25] Charles faithfully followed his father's style, even down to the inclusion of a painting-within-a-painting. He portrayed Meissonier standing at a table and jotting something on a piece of paper while wearing a pair of riding boots (evidently having dashed into the studio after a gallop through the countryside). The work gave a captivating glimpse inside the master's richly appointed studio, with its oak-beamed floor and Renaissance-style refectory table; most fascinating of all, though, he showed the unfinished *Friedland* perched on Meissonier's easel, awaiting further attentions. One can just make out on the right of the canvas the blurry mass of the charging cuirassiers. Charles included in the foreground a discarded envelope addressed to (lest there be doubts as to the subject's identity) "Monsieur Ernest Meissonier/ membre de l'Institut/Poissy."

Charles was clearly talented, but Meissonier, as both father and teacher, proved a stern and domineering taskmaster, forcing his son from his bed for jaunts on horseback at six o'clock in the morning and presiding over what Charles called "hair-pulling" lessons in the studio.[26] The young man confided in his journal that sometimes he felt like nothing more than the "second skin"

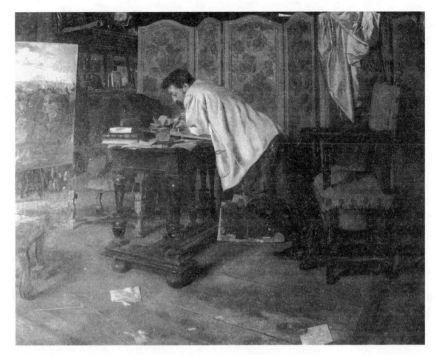

The Studio *(Charles Meissonier)*

of his father, whom he called *Le Patron* ("The Boss").[27] Charles nonetheless idolised Meissonier, seeking his approval not only through his art but by means of simple gestures such as bringing mushrooms back from his walks in the woods near Poissy. Meissonier loved mushrooms, even trying to propagate them in a special cellar, and so whenever Charles took a walk in the woods he kept an eye peeled for appetising fungi. "If I could please him with these," he wrote in his journal, "then he would at least see that while walking I thought of him."[28]

By the end of 1864, Charles possessed an even better opportunity to impress *Le Patron*. Having completed *The Studio*, he planned to send it to the Salon of 1865. At the age of twenty, he hoped to make his début in the same room as his father.

A Beastly Slop

IN NOVEMBER 1864, a thirty-six-year-old English painter named Dante Gabriel Rossetti, a friend of Whistler and Fantin-Latour, arrived in Paris for a short stay. Accompanied by his red-headed mistress and model, Fanny Cornforth, Rossetti rented a room in a hotel in the Rue Laffitte and then visited an exhibition of Delacroix's paintings and did the rounds of the china shops. He also visited one of Delacroix's favourite haunts, the Jardin des Plantes, a zoological garden on the Left Bank. Its collection of beasts was only slightly more impressive than Rossetti's own, since the painter's house in Chelsea was home to a kangaroo, a raccoon, several peacocks, a wallaby, a chameleon, a gazelle, a woodcock, various monkeys and parakeets, a raven, an armadillo and (until it died after eating Rossetti's cigars) a wombat.

Rossetti was the most notorious painter in England. He had been a founding member, in 1848, of the Pre-Raphaelite Brotherhood, a clutch of ambitious young artists who had challenged the stodgily conservative Royal Academy in London—the arbiter of taste in British art—with a misty-eyed medievalism and a supposed emulation of fourteenth-century Italian frescoists, such as Andrea Orcagna, who preceded the much-worshipped Raphael (hence "Pre-Raphaelite"). Appalled by the industrial age in which he lived, with its clouds of smoke and steam, Rossetti had fashioned in his paintings an enchanted world of languid angels and swooning, full-lipped maidens. Such works earned lacerating reviews, with his detractors castigating them as "revolting" and "disgusting," and filled with a "morbid infatuation."[1] These complaints about a seemingly decayed morality seemed to the critics to have been justified

when Rossetti's wife and student, Lizzie Siddal, overdosed on laudanum, probably a suicide, in 1862.

The work of Édouard Manet, however, was too much even for Rossetti. Taken by his friend Fantin-Latour to Manet's studio in the Rue Guyot, the English painter found himself appalled. "The new French school is simple putrescence and decomposition," he wrote home in disgust to his mother. "There is a man named Manet . . . whose pictures are for the most part mere scrawls, and who seems to be one of the lights of the school."[2] He was even more disobliging in a letter to a friend, Jane Morris, describing to her "a French idiot named Manet, who certainly must be the greatest and most conceited ass who ever lived."[3] Manet's canvases were fit for nothing, he told her, but the decoration of a lunatic asylum. To another friend, the poet Algernon Charles Swinburne, he concluded witheringly: "The whole of French art at present is a beastly slop and really makes one sick."[4] How very relieved he must have been that a busy schedule a year earlier had prevented him from travelling to Paris, as planned, to pose for Fantin-Latour's *Homage to Delacroix*, a canvas in which he would have been compelled to share space with the obnoxious Manet.

The regulations for the 1865 Salon appeared in *Le Moniteur universel* in early November, around the time of Rossetti's visit. They were composed, as ever, by Nieuwerkerke, who decided the Salon of 1864 had been successful enough that the modifications made to the Selection Committee a year earlier should remain in place. Once again, therefore, the qualifying artists would be allowed to cast their ballots to elect nine of the twelve members of the painting jury. The only change was that the Salon des Refusés would not be repeated in 1865. The moderate stance taken by the Selection Committee in 1864 meant that year's Salon des Refusés, deprived of figures like Édouard Manet, had been a far less controversial affair than the infamous "Salon of the Heretics." Only 286 artists had exhibited at the Salon des Refusés in 1864, compared to upwards of 500 a year earlier. Their offerings, meanwhile, had attracted far less attention and abuse than had Manet's work in the official Salon. The more liberal régime instituted by Nieuwerkerke had made the Salon des Refusés redundant.

The elections for the jury were held in March 1865. Predictably, the most notorious conservatives from the 1863 jury—Signol, Picot, Heim—were once again shut out by the electors, while Ingres received a paltry thirty-two votes. But the voting also produced a number of surprising results, since Léon Cogniet and Charles Gleyre both failed to poll enough votes automatically to qualify for service. Both were elected only as alternates, as was Ernest Meissonier.

Having come third in the balloting a year earlier, Meissonier, surprisingly, was placed only tenth in 1865, a diminished ranking that may have owed much to his refusal to take up his place on the 1864 jury. It was an unsatisfactory result for Meissonier, who this year was determined to serve, not least because his son Charles was submitting *The Studio*.

The clear victor, for a second year in a row, was Cabanel, followed by his fellow professor at the École des Beaux-Arts, Jean-Léon Gérôme; the Director of the École, Robert-Fleury; and Camille Corot. Along with them came four new painters who promised to change the face of the jury even more, among them a former student of Delacroix, Alexandre Bida, who favoured Oriental scenes and who, at forty-one, was one of the youngest painters to serve on the jury. The constitution of the painting jury had therefore altered remarkably since the hullabaloo only two years earlier. Gone were the preponderance of painters for whom classical history, ancient mythology and heroic nudity occupied the gleaming apogee of French art. In its place were landscapists, led by Corot, and Orientalists such as the enormously popular Gérôme.

Absent from the government appointees in 1865 was the Duc de Morny, whose shrewd guidance had made the previous Salon a success. Morny died on March 10, at the age of fifty-four, ten days before the paintings and statues were due to arrive at the doors of the Palais des Champs-Élysées. His death was officially blamed on pneumonia, though rumours quickly went around Paris that he had expired from a remedy given to him by his personal physician, an expatriate Irishman named Sir Joseph Olliffe. The son of an Irish merchant, Olliffe had risen in life to become a knight of the realm, a physician at the British Embassy in Paris, and an enormously wealthy speculator who in the early 1860s had helped turn the fishing village of Deauville into a fashionable seaside resort. Unfortunately, he was also a quack, and much of his huge fortune had come from prescribing arsenic pills to improve the complexions of well-to-do patients such as Morny. The pills may well have done wonders for skin tone, but they also produced—as Morny appears to have discovered to his cost—the most disagreeable side effects. Morny's death would be felt deeply not only on the painting jury, but also in the Legislative Assembly, the auction rooms and, perhaps most of all, in the fashionable Paris salons where he had ruled as the Second Empire's greatest social lion.

The loss of Morny's moderating influence was compensated for, in part, by the government's appointment of Théophile Gautier and then the announcement that Ernest Meissonier would serve on the painting jury after all, when one of the other jurors declined his post. And among the thousands of paintings

awaiting their attentions was the portrait of the nude Victorine Meurent posing as a prostitute. Manet had finally decided to send *Olympia* before the judges.

To the average Parisian, Manet must have seemed a connoisseur of punishment. When he showed his paintings at Louis Martinet's gallery in 1863, visitors had menaced his canvases with their walking sticks, creating a climate of hostility and mockery that led to even more public ridicule two months later at the Salon des Refusés. Yet after moving into his new lodgings he immediately began preparing for a second one-man show at the Galerie Martinet—an act that must have seemed either one of vainglorious self-confidence or a foolhardy taunting of fate.

Manet's exhibition opened in February, the month before judging was due to begin for the 1865 Salon. Among the eight works he sent to the gallery were two of his "modern life" *plein-air* paintings from the previous summer, *The Races at Longchamp* and *The "Kearsarge" at Boulogne*. He also included a fragment, the dead matador, amputated from his unsuccessful *Incident in a Bull Ring*, together with a number of still lifes of fish and fruit that he had painted in Boulogne. The eight canvases were more cordially received than his show two years earlier. This was due mainly to the fact that his still lifes were perfectly unobjectionable: his paintings of peonies, salmon and bunches of grapes were far less likely to inflame opinion than had most of his previous works. These simple images of fish and fruit spread on white tablecloths showed, Théophile Thoré claimed, "undeniably picturesque qualities."[5] Manet's comparative success seemed to be underscored by the fact that during the exhibition he sold an earlier still life, two flowers in a vase, to Chesneau, who had evidently responded favourably to his overtures. "Perhaps it will bring me luck," Manet wrote to Baudelaire of the sale.[6]

Manet dared to grow upbeat about his chances for the Salon. However, if his exhibition at the Galerie Martinet showcased his new artistic direction, his submissions to the 1865 Salon reverted to his more typical style. Despite the rough ride given *Dead Christ with Angels* a year earlier, he decided to offer another portrait of Christ, a canvas entitled *Jesus Mocked by the Soldiers*, painted early in 1865 with a well-known model named Janvier, a locksmith, posing in the title role. As so often in Manet's case, the work was inspired by a painting in the Louvre, this time Titian's *Christ Derided*. He portrayed Christ with his hands bound before him and the crown of thorns on his head as three Roman soldiers gathered around to taunt and threaten him. Once again his Christ—large feet, knobby knees, thin chest, plaintive expression—hardly cut a gallant

figure. Nor was Manet especially galvanised by the topic: "I think that's the last time I'll be going for that sort of subject," he wrote to Baudelaire after the piece was finished.[7]

If *Jesus Mocked by the Soldiers* seemed almost certain to annoy the critics, the decision to submit *Olympia* was even more recklessly daring. The fact that Manet had kept the work hidden in his studio for eighteen months indicates his reservations about showing it in public. Why he decided to launch it on the world in 1865 remains something of a mystery, though Léon Koëlla later claimed Baudelaire had urged Manet to send it to the Salon.[8] He may also have been persuaded by Zacharie Astruc, who seems to have given the work its title and then composed an execrable poem in its honour. Whoever was responsible, the strange gamble seemed initially to have paid off. Both paintings were accepted for the Salon—though a newspaper reported, ominously, that the jurors had rejected *Olympia* at first.[9] Still, Manet remained optimistic. "From what I hear, it won't be too bad a year," he wrote to Baudelaire on the eve of the Salon's opening.[10] The next day, his sanguinity at first seemed well founded when a number of people rushed over to congratulate him on his work. They were, he was told, the most superb seascapes.

Seascapes? Manet was confused. Taking himself to Room M, he soon discovered the source of the confusion: two canvases, *The Mouth of the Seine at Honfleur* and *The Pointe de la Hève at Low Tide*, signed by an unknown painter named Monet. Manet was indignant. "Who is this Monet," he demanded, "whose name sounds just like mine and who is taking advantage of my notoriety?"[11]

Claude Monet, at the age of twenty-four, was exhibiting at the Salon for the first time. He was a cocksure, competitive and rebellious young man of enormous ambition. The son of a grocer, he had earned a precocious fame in Le Havre, his home town, for his talents as a caricaturist before falling under the influence of the seascapist Eugène Boudin, the son of a ship's captain and Le Havre's most celebrated painter. After Boudin convinced him to give up caricatures for painting landscapes out of doors, Monet moved to Paris in 1859 to study at the Académie Suisse, a private art studio opened on the Île-de-la-Cité in about 1850 by a former artists' model named Suisse. Gustave Courbet, among others, had paid the small fee of ten francs per month required to study at the school, which offered male and female models, studio space and plenty of camaraderie, but no teachers or programme of study—a relaxed regime ideally suited to the rebellious temperament of the young Monet.

Monet's fledgling artistic career had been interrupted when he was drafted into the army in 1860. Most young Frenchmen dreaded military service and

Claude Monet

took every precaution—including bribery of the relevant officials—to avoid it. Not so, however, the plucky Monet. "The seven years of service that appalled so many," he later boasted, "were full of attraction to me."[12] He was sent to Algeria with the Zouaves, a division of the light infantry that took its name and exotic uniform—turban, baggy trousers, cutaway tunic—from an Algerian tribe. Here he savoured the light of the African sun and the colour of the desert, not to mention (so he later averred) the "crackling of gunpowder and the thrusts of the sabre."[13] But after little more than a year his military career ended amid the purple spots and fevered delirium of typhus. Obliged to return to France, he divided his time after his recuperation between his studies in Paris, where he entered the studio of Charles Gleyre, and painting expeditions to the Normandy coast, where he encountered his idol, Courbet.

By 1865 Monet was sharing an apartment in the Rue Furstemberg with Frédéric Bazille, a friend from Gleyre's studio. However, a month before the Salon opened he had departed with his paintbox and his eighteen-year-old

mistress, Camille Doncieux, for the village of Chailly-en-Bière, on the edge of the Forest of Fontainebleau, thirty-five miles south of Paris. The forest's rustic enchantments had been celebrated on canvas by Corot, who had painted there as early as 1822, as well as by Jean-François Millet and Théodore Rousseau, both permanent residents of the area by the late 1840s. Inspired in part by the example of their work, Monet was beginning an immensely bold pictorial enterprise, a twenty-foot-wide canvas onto which he planned to paint, in the open air, capturing the interplay of light and shade among the trees, a series of life-size figures in modern dress relaxing over a picnic lunch in the forest.

Monet hoped to have his mammoth new painting ready for the Salon of 1866. In the meantime, he had succeeded in his first attempt to show work at the Salon, since his two Normandy seascapes—one showing sailboats battling winds in rough, muddy waters off the coast of Honfleur, the second a foaming tide retreating from a rocky beach under a leaden sky—suitably impressed the jurors. Better still, the two works soon received exuberant praise from the public and critics alike. Paul Mantz, chief art critic for the *Gazette des Beaux-Arts* and one of the most fearsome reviewers in France, heaped compliments on *The Mouth of the Seine at Honfleur*, singling out its "taste for harmonious colours" and proclaiming it one of the finest seascapes seen at the Salon in recent years.[14]

A new star had been born—a star who, most irritatingly for Édouard Manet, shared four fifths of his surname. Manet may have been even more provoked had he known that Monet planned to call his huge new painting *Le Déjeuner sur l'herbe*. Zacharie Astruc, who knew both painters, volunteered to introduce Manet to the younger man. But Manet, waving his arm dismissively, stoutly refused the acquaintance.[15] For while his virtual namesake luxuriated in words of exorbitant praise, his own two Salon paintings were meeting with an altogether different fate.

The Apostle of Ugliness

"I WISH I HAD you here, my dear Baudelaire," Manet wrote to his friend, who was still in Brussels, shortly after the 1865 Salon opened. "Insults are beating down on me like hail. I've never been through anything like it."[1]

Charles Baudelaire was not the most sympathetic person to whom Manet might have turned. Never one to worry about either the critics or public opinion, Baudelaire thrived on controversy and notoriety. "I'd like to see the entire human race against me," he once wrote. Eager to produce an opprobrious reputation for himself and requite the morbid curiosity of the Belgians, he had recently begun spreading the rumour that he had murdered and then eaten his father. "I am swimming in dishonour like a fish in water," he was soon boasting in letters to friends back in Paris.[2]

Baudelaire could not therefore understand Manet's dismay over yet another vitriolic reception for his Salon paintings. As he put it in a letter to a friend, insults and injustice were "excellent things."[3] His response to Manet's plight was a stern letter urging his friend to call to mind artists such as Richard Wagner—an idol of Baudelaire's—who had been forced to contend with both a loutish public and the inane sniping of the critics. "Do you think you are the first man put in this predicament?" Baudelaire upbraided the disconsolate painter. "Are you a greater genius than Chateaubriand or Wagner? And did not people make fun of them? They did not die of it."[4]

Still, the boorish protests that drove Wagner's *Tannhäuser* from the Paris stage in 1861 could not compare to the unseemly hubbub that greeted Manet's work at the 1865 Salon, with *Olympia* (plate 4B) provoking an even more incredulous and fiercely hostile reaction than *Music in the Tuileries* or *Le Déjeuner sur l'herbe* had

two years earlier. "Never has a painting excited so much laughter, mockery and catcalls as this *Olympia*," wrote one critic in his review of the show.[5] On Sundays, when admission was free, immense crowds poured into Room M, preventing people from getting close to *Olympia* or even circulating through the rest of the room. An atmosphere of hysteria and even fear predominated. Some spectators collapsed in "epidemics of crazed laughter" while others, mainly women, turned their heads from the picture in fright. "Nothing can convey the visitors' initial astonishment," wrote the correspondent for *L'Époque*, "then their anger or fear."[6]

These rancorous attentions soon became too much for the Marquis de Chennevières. In the past, he and Nieuwerkerke had been forced to post guards in front of Ernest Meissonier's paintings to protect them from their crushes of admirers. At the 1865 Salon, Chennevières needed to deploy guards to protect *Olympia* from the malicious designs of indignant spectators. When even these precautions proved inadequate, the painting was removed from its original location and suspended high above the heads of the visitors—so high, in fact, that a critic for *Le Figaro* claimed that "you scarcely knew whether you were looking at a parcel of nude flesh or a bundle of laundry."[7] *Olympia* thereby completed exactly the opposite trajectory of *The Spanish Singer*, which had earned such admiration four years earlier that on Chennevière's commands it had been lowered to eye level.

Almost equal to the fury of the public was the loathing of the critics. Théophile Gautier, once again, could find nothing good to say about Manet's work, accusing the painter of deliberately courting controversy: "Here there is nothing, we are sorry to say," he wrote after casting a disdainful eye on *Olympia*, "but the desire to attract attention at any price." From the pages of *La Presse* Paul de Saint-Victor snorted: "Art sunk so low doesn't even deserve reproach." Other critics seized gleefully on the figure of Victorine, variously lampooning her as a "female gorilla," "a coal lady from the Batignolles," "a redhead of perfect ugliness," and "a corpse displayed in the Morgue . . . dead of yellow fever and already arrived at an advanced state of decomposition."[8]

The Morgue was one of Paris's more macabre sights, a special building on the south-east corner of the Île-de-la-Cité where unclaimed bodies, arranged naked on a counter and exposed to a stream of cold water to delay decomposition, could be viewed by family members searching for lost loved ones—or simply by curious members of the public wishing to enjoy cheap and lurid titillation. These same repellent fancies were being gratified, Saint-Victor distastefully observed, by Manet's *Olympia*, with Room M taking on, he claimed, the unwholesome and unedifying aspect of the Morgue.[9] Art had come a long distance from the days when painters had sought the *beau idéal* and concerned themselves with morally uplifting images.

If the public had found *Le Déjeuner sur l'herbe* merely ridiculous, a farcical jape that might, at its worst, bring a blush to the cheek of a young maiden, *Olympia* elicited far stronger responses. Along with their hysterical laughter, the onlookers exhibited, if the critic for *L'Époque* was correct, "anger and fear." For many Salon-goers in 1865, Victorine reclining on her bed was a threatening sight. Many people found her unspeakably and offensively ugly—a kind of female version of the cretinous-looking "Dumolard" in Millet's *Man with a Hoe.* One critic noted her "vicious strangeness," adding that she had "the sourness of someone prematurely aged." Another called her a "grotesque," while a third, in *Le Siècle*, proclaimed her "ugly" and "stupid" as well as cadaverous. Before the Salon was out, Victorine's supposedly repulsive demeanour had won for Manet the title "Apostle of Ugliness"[10]—the name by which Delacroix had once been known.

Victorine was thought filthy as well as ugly. The shadows on her hands and feet, crudely painted in comparison to the prevailing style, were mocked as the grime of the shop or factory, with some critics complaining, for instance, that she was "covered in coal"[11] and others making speculations about her working-class origins. With Victorine's dirtiness and ugliness came a horror of moral contamination. Not a few onlookers regarded the painting as a shameful obscenity that should never have been put on public view. "Why does one find these paintings in the galleries of the Palais des Champs-Élysées?" asked one exasperated critic.[12] Not that Manet had given Victorine a pose that was sexually alluring: *Olympia* rehashed none of the aphrodisiac expressions—bedroom eyes, emphatic breasts and buttocks—found in the nudes of Cabanel and Ingres. Much of the moral outrage and anxiety had to do, instead, with the position of Victorine's left hand, which to many spectators simply looked indecent. The customary *Venus Pudica* gesture appeared to have been transformed (as Twain thought it had been in Titian's *Venus of Urbino*) into an act of self-gratification. Various critics pointed out how Victorine's hand was, as one of them put it, "flexed in a sort of shameless contraction." One critic claimed that not all of her fingers were present and accounted for, suggesting a lewd act that he argued "cries out for examination by the inspectors of public health."[13]

Olympia therefore caused offence for various reasons, some having as much to do with aesthetics as with morality. But one issue in particular—a legal as well as moral one—may have created much of the horrified backlash against Manet's painting. At the exact time the 1865 Salon raged in the Palais des Champs-Élyseés, French politicians and the police were busy trying to quell the spread of pornography, or what one observer had called "the facility of the photographic art in representing scandalous situations."[14] A lucrative trade in

pornographic images had developed by the early 1850s as photographers who began their careers producing *académies* for painters soon branched out to supply a much wider market with what a book entitled *The Squalor of Paris* denounced as "cynical photographs boldly showing insolent details."[15] Moral outrage against this proliferating trade had been followed by legal sanctions as the Prefecture of Police established a special register to record the names of photographers and models arrested for producing these "street *académies*." Police crackdowns became ever more aggressive in the early 1860s, with 172 photographers and printsellers arrested in Paris between 1863 and 1865; those found guilty would spend as much as a year in prison. Even so, by 1865 the trade had grown so large that one police raid alone, on June 15, netted 15,000 pornographic images.

The 1865 Salon therefore took place against a background of police raids on suspected pornographers, angry petitions to the authorities (mainly by conservative Catholics), and heated debate on the floor of the Senate. This febrile atmosphere hardly made 1865 the most propitious time to unveil a work such as *Olympia*. The painting's nudity was far less explicit than photographs illicitly peddled in the streets and aimed unambiguously at scabrous tastes, but to many Salon-goers in 1865, *Olympia* must have appeared to owe as much to these street *académies*—many of which showed women reclining on curtained beds in exotic boudoirs—as it did to the *Venus of Urbino*.

Manet grew increasingly angry and depressed as one appalling review followed another, with *Jesus Mocked by the Soldiers* receiving a press almost as atrocious as *Olympia*. And if the reviews themselves were not bad enough, caricaturists such as Cham and Bertall had a field day parodying *Olympia* in the satirical journals.* Both ridiculed Victorine as a grubby-looking artisan with large feet and a homely grin, and both gave special prominence to the black cat with its suggestively erect tail. Bertall punningly christened the painting "Manette," a clever blending of "Manet" and "*minette*," which meant both "pussycat" and "young woman." Manet was mocked in the streets as well as in the newspapers. He became the butt of songs and jokes, "pursued as soon as he showed his face," according to one version of events, "by rumours and wisecracks, the passers-by in the street turning to laugh at the handsome fellow, so well dressed and correct, who painted such filth."[16]

Feelings ran so high that Manet even provoked fisticuffs. At the École des

*"Cham" was the pseudonym of Charles-Henri Amédée, the Comte de Noé, who had published his caricatures in *Le Charivari* since 1843; and "Bertall" was Charles-Albert Arnaux.

Beaux-Arts, where students were divided between admirers and detractors, discussions of *Olympia* frequently ended with exchanges of blows. One of these disputes was interrupted by the arrival of Jean-Léon Gérôme, who castigated his pupils not for fighting but for mentioning Manet's name. "Look here, gentlemen," he upbraided them, "why are you talking about Manet? You know quite well that it's forbidden."[17]

One evening in May, in order to forget his troubles for an hour or two, Manet braved the streets to go with Antonin Proust for an ice cream at the Café Imoda in the Rue Royale, a street of florists and other fine shops running south of the church of the Madeleine. When the waiter as a matter of habit brought over the newspapers, Manet snapped at him: "Who asked for the newspapers?" The papers were removed but Manet, his appetite ruined, left his ice cream melting on the table. "He drank a whole carafe of water," Proust remembered, "and then, after a long silence, we went back to his studio."[18] That Manet still had the will to face his easel was perhaps something of a miracle.

For those able to fight their way through the jeering mobs to see them, more than a hundred other paintings were hung on the walls of Room M. Gustave Moreau showed two works, *Medea and Jason* and *The Young Man and Death*, that evoked the same vaporous dreamworld with its air of cryptic menace as his *Oedipus and the Sphinx* from a year earlier. His continued popularity with the critics ensured him another medal.

Ernest Meissonier was likewise present in Room M. Newspapers such as *L'Artiste* had been reporting as late as April that he would be unveiling *Friedland* at the Salon of 1865,[19] but these forecasts were extremely optimistic given his working methods. In the end, the only appearance made by *Friedland* at that year's Salon was its fascinating cameo in Charles Meissonier's *The Studio*. If Charles's undeniable talent was not guarantee enough, the presence on the jury of *Le Patron* helped to secure his participation. Having reached the age of fifty in February, Meissonier appeared to be shaping the talents and nurturing the careers of a new generation of painters. Also accepted by the jury was a painting, likewise called *The Studio*, by Meissonier's other young pupil, the twenty-year-old Lucien Gros.

While Charles Meissonier included a portrait of his father in *The Studio*, Meissonier *père* returned the favour by exhibiting, in lieu of the unfinished *Friedland*, a work painted several years earlier called *The Etcher: Portrait of Charles Meissonier*, in which he showed his son, then about seventeen, at work on an etching. Meissonier had a particular interest in etchings, executing them throughout his career, and clearly he passed on his knowledge of the difficult

technique to his son. Etching is a form of engraving in which the surface of a copper plate is coated with a ground (often a mixture of wax, mastic and bitumen) onto which the artist traces his design using a steel needle. Hydrochloric acid is then applied to the surface, where it eats away at the copper exposed by the needle (the word etching comes from the Dutch *etsen*, "to eat") and leaves behind grooves, which in turn leave their imprints after the ground is removed, the plate inked, and the paper run through a printing press.

For *The Etcher*, Meissonier made this workmanlike procedure appear to be, despite its wax pastes and bottles of acid, a gentlemanly occupation. He depicted the young man seated in an upholstered chair before a sunlit window, smoking a cigarette and wearing an embroidered red dressing gown and slippers as he oversaw the biting of his plate. Set in Meissonier's studio, the scene included a canvas adorning an easel and, on the back wall, a tapestry featuring Apollo and his muses on Mount Parnassus. The presence in the painting of Apollo, the god of poetry and music as well as the leader of the Muses, seems to bode well for the career of the young etcher, as if Meissonier were predicting future triumphs for his talented son.

The Etcher glows with a sunlight that kindles on the open shutter on the left, spills through the mullioned window, defines Charles's face, and diffuses itself dimly throughout the room.[20] Such a poetic treatment of the fall of light might easily have come from the brush (and the camera obscura) of Jan Vermeer. *The Etcher*, in fact, bears such an uncanny similarity to a pair of works painted by Vermeer in 1668 and 1669, *The Astronomer* and *The Geographer*, that it is impossible to believe Meissonier did not know these two canvases, or at least engraved reproductions of them. In fact, the painting depicted by Vermeer in the background of *The Astronomer*, an illustration showing *The Finding of Moses*, also appears to be represented in Meissonier's *The Etcher*, further suggesting Meissonier's emulation of the Dutch painter's style.[21]

Whatever the case, the astonishing lesson in painting a fall of light conveyed in *The Etcher* only made Manet's apparently clumsy adumbration of Victorine's form—the shadows that reminded the reviewers of smudges of coal—look even more preposterously slipshod. Almost as impressive in this regard was Meissonier's second painting in Room M, *The End of a Gambling Quarrel*, which featured the two swordsmen sprawled on the floor. However, for the first time in his career Meissonier found his paintings eclipsed. A writer in *L'Artiste* once claimed that the priority of the crowds on entering the Salon was to locate Meissonier's paintings—and then to gain access to them through the vigorous use of their elbows.[22] In 1865, Room M was, as usual, the most popular destination in the Palais des Champs-Élysées, but the hordes, for once,

were not bent on planting themselves before Meissonier's works: they had come, rather, to laugh and jeer at *Olympia*. Anyone interested in admiring Meissonier's works—or those of the many other painters in Room M—had to contend with the carnival atmosphere created by the raucous crowds exclaiming over Manet's canvases.

Meissonier was further upstaged at the Salon when the Grand Medal of Honour was awarded to Alexandre Cabanel—whose career was truly going from strength to strength—for his portrait of Napoleon III. If Meissonier resented this rare experience of being overshadowed, he at least had the consolation of knowing his paintings could still command the highest prices of any living artist in France. His worth in the sale room was proven several weeks after the 1865 Salon opened, at one of the greatest auctions seen in Paris for a decade.

Paris had been abuzz with gossip since the death of the Duc de Morny in March. As insatiable in the boudoir as his half-brother the Emperor, Morny had taken as mistress the most famous courtesan in Paris, a dyed-blonde Englishwoman who went by the name Cora Pearl and lived in a mansion near the Champs-Élysées with a stable of sixty horses. He also enjoyed legions of other lovers, all of whom he was said to have photographed in the nude, with bouquets of flowers tastefully shielding their modesty. These mementoes were preserved on his bedside table in a casket that mysteriously vanished from sight after his death, supposedly into the clutches of an unscrupulous valet intent upon blackmailing the ladies involved. The casket with its pulse-quickening treasures—elegant *académies* which the pornographers of Paris could only dream of possessing—had yet to surface by the end of May. But other of Morny's treasures had come onto the market as his art collection went to auction.

Art auctions were a common occurrence in Paris in the 1860s, with as many as three taking place on any given day.[23] Attended by bankers, industrialists and aristocrats, who bought and sold paintings as investments, they were usually held at the Hôtel Drouot, the official auction house in Paris. Morny's auction was no ordinary enterprise, however. Held at his home in the Rond-Point des Champs-Élysées, it attracted a throng of the wealthy and the fashionable who gathered to bid for his treasures or simply to gape at the implausible opulence of his residence. Among the guests invited to the event were numerous well-heeled collectors as well as art critics like Paul Mantz and Théophile Thoré. Meissonier was also among the privileged invitees, and after witnessing the frantic bidding for his paintings the correspondent for *La Presse* promptly dubbed him "king of the sale."[24]

Of the six Meissonier paintings on the auction block, three were knocked down to Lord Hertford, the wealthy English aristocrat. At the age of sixty-five, Richard Seymour-Conway, the fourth Marquess of Hertford, had made himself proprietor of the finest private art collection in Europe. With an annual income of six million francs, mostly from his vast estates in Ireland, he had filled his Paris residences—an *hôtel* in the Rue Laffitte and a magnificent country house in the Bois de Boulogne—with a glorious hoard of French and Dutch art. Art was an obsession almost to the point of fetishism for Lord Hertford, a notorious miser whom an acquaintance called "a complete, absolute, unashamed monster."[25] He once proudly declared that "when I die I shall at least have the consolation of knowing that I have never rendered anyone a service."[26]

Lord Hertford already owned a number of paintings by Meissonier, one of a very select group of artists whose names graced his address book.[27] Among his collection was Meissonier's *Polichinelle*, which Madame Sabatier had cannily trimmed from the door of her apartment and sold in a time of financial need. At the Morny auction he added to his collection both *Halt at an Inn* and *Bravoes*, as well as *An Artist Showing His Work*, which had been painted in 1854 on a commission from Morny. Of the three, *Halt at an Inn*, at 36,000 francs, fetched the highest price, topping those paid at the auction for works by Gérôme (21,300 francs), Ingres (20,000 francs) and even by the eighteenth-century painter Jean-Honoré Fragonard, whose Rococo masterpiece *The Swing* went to Lord Hertford for 30,200 francs.[28] Still able to raise furious bidding and gasps of astonishment in the auction room, Meissonier's stock apparently remained as buoyant as ever. Indeed, the future in 1865 looked as bright for Meissonier as it looked bleak for Manet.

Maître Velázquez

THE EXCITEMENT CAUSED by the auction of the Duc de Morny's art collection was eclipsed, a few days later, by the third running of the Grand Prix de Paris. As in 1864, more than 100,000 people poured through the Arc de Triomphe and the Bois de Boulogne on their way to the Hippodrome de Longchamp. And, as in 1864, the winner of the Epsom Derby was again the favourite—only this time the Derby champion was a French horse named Gladiateur. Known as "The Avenger of Waterloo" for his stunning victory on English soil—where he also won the 2,000 Guineas at Newmarket— Gladiateur had returned to France covered in glory. At Longchamp he did not disappoint the wildly cheering crowds, outpacing his nearest competitor by three lengths. A few days later he was given a victory parade along the Champs-Élysées and his owner, Comte Frédéric de Lagrange, received a standing ovation in the Legislative Assembly.

Édouard Manet was not so depressed by his reception at the Salon that he be- grudged himself a trip to Longchamp to cheer Gladiateur on to victory. As in 1864, he began a work, *Women at the Races*, based on his studies of the crowds at Longchamp. Once again, he did not concern himself with the racehorses— Gladiateur does not even feature in the work—so much as with the spectators. He depicted a pair of women in bonnets and crinolines holding parasols over their heads as they stood beside an elegant carriage. Devastated by the reaction to *Olympia* and *Jesus Mocked by the Soldiers*, he had turned once more to the fashionable Parisian society of which he had become an observer.

Manet at this time decided on another palliative for his artistic ills: he was planning a trip to Spain. "I cannot wait to see all those wonderful things," he

wrote to Zacharie Astruc, "and go to *maître* Velázquez for advice."[1] He was hoping to travel with two friends, Jules Champfleury (the "supreme pontiff of Realism" whom he had portrayed in *Music in the Tuileries*) and the Belgian painter Alfred Stevens, "but they keep putting me off . . . Anyway, they're a bloody bore," he wrote in the middle of August to Astruc, a Hispanophile who would happily have accompanied him were his wife not expecting a baby.[2] Manet therefore decided to make the journey on his own, armed with a detailed twenty-page guide to Spain very helpfully prepared by Astruc, who advised his friend to take his own supply of tobacco, to travel second-class on the trains, to drink copious amounts of water to stave off the effects of the extreme heat, to sample Manzanilla (a dry sherry), and to avail himself of the pastries and coffee in the Café Suisse in Madrid. "Your itinerary seems excellent," Manet wrote gratefully to Astruc. "I'll follow it precisely."[3]

This pilgrimage to Spain was long overdue for someone so transfixed by Spanish art, particularly the work of Diego Velázquez. Manet had seen the nineteen alleged Velázquez paintings in the Louvre's Galerie Espagnole before it closed in 1849, and as a student of Couture he had copied other paintings in the Louvre attributed to Velázquez, such as *The Gathering of Gentlemen* and *Portrait of a Monk*. In 1862 he had done an engraving of *Philip IV as a Hunter*, and in the same year he made a copy of *The Infanta Margarita*, likewise in the Louvre. Yet most of these paintings were not actually by Velázquez. *The Gathering of Gentlemen* had been done by his son-in-law; *Portrait of a Monk* by an artist or artists unknown; and *The Infanta Margarita* by various of Velázquez's assistants. Almost none of the so-called Velázquez paintings in the Galerie Espagnole—the collection of Spanish art purchased by King Louis-Philippe—had in fact come from the brush of the master. Suspicions about the true authorship of these paintings—which seemed, to experts like Gautier, pale imitations of those in Madrid—had led to the truism that one needed to cross the Pyrenees in order fully to appreciate Velázquez.

Leaving behind Suzanne and the rest of his family, Manet departed from the Gare Montparnasse on August 25 for what was meant to be a month-long stay in Spain. The train took him via Bordeaux and Bayonne on a seventeen-hour journey to Irún, from where exactly one year earlier a new 300-mile railway line to Madrid had been inaugurated amid much fanfare. On the way he disembarked briefly at Burgos to see an El Greco in the cathedral, then at Valladolid (the city where Christopher Columbus had died), before arriving in Madrid amid "fatigue and problems"[4] and taking a room at the Grand Hôtel de Paris. Seeking out his idol Velázquez, he went each day to the Prado (then known as the Real Museo de Pintura y Escultura), where he signed his name

in the museum's visitors' book, emphatically recording his occupation as "*artiste*."

Founded by King Ferdinand VII in 1819 in order to house the royal collection (and in order, Ferdinand's detractors had sneered, that the walls of his palaces could be wallpapered), the Prado held the world's finest and most comprehensive collection of paintings by Velázquez, by far the most celebrated painter in Spain. Manet was able to see, by his own count, as many as forty of his canvases, including masterpieces such as *Las Meninas* (which he found "an extraordinary picture") and *The Fable of Arachne*, as well as portraits of various dwarfs and jesters at the Spanish royal court. He was intoxicated. "How I miss you here," he wrote to Fantin-Latour, "and how happy it would have made you to see Velázquez, who all by himself makes the journey worthwhile . . . He is the supreme artist. He didn't surprise me, he enchanted me." To Baudelaire he wrote: "I've really come to know Velázquez, and I tell you he's the greatest artist there has ever been," while a letter to Zacharie Astruc heartily declared: "He's the greatest artist of all. . . . I discovered in his work the fulfilment of my own ideals in painting, and the sight of those masterpieces gave me enormous hope and courage."[5]

Manet did not specify his "ideals in painting": presumably Astruc knew them only too well from their debates at the Café de Bade. But he was undoubtedly inspired by the Spaniard's application of paint in the thick impasto that a connoisseur, Edmond de Goncourt, once called Velázquez's "soft muddiness."[6] This slathering on the canvas of "muddy" paint, so radically different from the thin, smooth layerings of pigment advocated by teachers at the École des Beaux-Arts such as Gérôme and Cabanel, seemed to give Manet sanction for the sort of loose brushwork knocked, in the case of *Le Déjeuner sur l'herbe*, for looking like it was done with a floor mop. Manet was also no doubt impressed by how Velázquez was willing to sacrifice fine detail in his paintings for an overall effect—a style an admirer once claimed resulted in "distant blobs" that achieved "truth rather than likeness."[7] If, as Théophile Thoré claimed after the Salon des Refusés, a battle raged in Paris between the "sketchers" and the "finishers," Velázquez was surely the patron saint of the former.

Besides visiting the Prado, Manet also found time to attend a bullfight—an overdue experience, once again, given the fact that he had already painted and exhibited several bullfight scenes. As a painter of crowds, he was very much in his element among the throngs at the bull ring in Madrid. He was, if anything, even more impressed by the sight of this gory spectacle with its colourful matadors and passionately exultant aficionados than he was by anything Velázquez had painted. "The outstanding sight is the bullfight," he enthused in

a letter to Astruc. "I saw a magnificent one, and when I get back to Paris I plan to put a quick impression on canvas: the colourful crowd, the dramatic aspect as well, the picador and horse overturned, with the bull's horns plunging into them."[8] It was a courageous plan given that the critical jeering of *Incident in a Bull Ring* must still have been ringing in his ears.

Despite his love of Velázquez and the bull ring, Manet remained in Madrid for only a week. His reason for abbreviating his visit was quite simple: the food in Spain was not to his liking. "When you sit down at the table," he explained in a letter to Baudelaire, "you want to vomit rather than eat."[9] Not even the cuisine prepared in the Hôtel de Paris met his lofty standards. A young French visitor named Théodore Duret, having arrived in Madrid after a forty-hour journey by stagecoach, witnessed unpleasant scenes in the hotel's dining room as Manet, adopting the role of the rude Gallic snob, imperiously dismissed dish after dish ferried from the kitchen. When Duret, famished from his travels, eagerly tucked into everything placed before him, Manet took offence and stormed across the dining room to rebuke him: "So, is it to mock me, to make me look a fool, that you insist on eating this revolting food?"[10] Duret eventually managed to persuade the irate stranger that his only motive in eating his dinner was hunger, not ridicule or revenge. At this point they introduced themselves, and Duret found himself sharing his table with the painter, who explained by way of an apology that he had feared the mockery he was experiencing in the streets of Paris had pursued him to Madrid.

The twenty-seven-year-old Duret came from a wealthy family of cognac merchants based near Bordeaux. Nursing political ambitions, he had run against the official candidate in the elections of 1863, then after his inevitable defeat entered the family business and toured the world selling cognac. He had developed a keen interest in art, amassing on his travels a large collection of Oriental *objets d'art* and befriending Gustave Courbet during the Realist's legendary wine- and cognac-fuelled sojourn at Rochemont in 1862. In comparison with Courbet's antics, Manet's odd behaviour must have struck Duret as positively benign. The two men swiftly became friends, visiting the Prado together and making a three-hour excursion by train to Toledo, where once more Manet made a fuss about the local cuisine.

Within days of their meeting, though, Manet had become too exasperated with Spanish food to remain in the country, and he boarded the train for the French frontier. He made a slight detour on his return, spending a few days near Le Mans, in the small town of Sillé-le-Guillaume, where his mother's family still owned substantial property. By the middle of September he was back in Paris. Despite the ordeals of travel and the supposedly unpalatable

food, the expedition had been a success, with Manet carrying back with him, besides his plans to paint bullfight scenes, the "enormous hope and courage" given to him by the canvases of *maître* Velázquez. His return to Paris had been ill-timed, however. He arrived in the city as a cholera epidemic was about to strike.

The summer and autumn of 1865 had been extremely hot and dry in Paris. The level of the Seine had dropped, the canals were closed to navigation, and ornamental fountains such as those in the Place de la Concorde stopped gushing on orders from the government. The practices of rinsing the gutters and hosing down the dusty macadam roads were likewise suspended. By the beginning of October the first spring water from the Dhuis Valley came to the rescue along a new eighty-one-mile aqueduct, passing through thirty-two tunnels en route and, to the applause of assembled onlookers, filling a fifteen-foot-deep reservoir at Belleville. But the water arrived too late to relieve the unsanitary conditions created by the water shortage. By the end of September, cattle reaching the Paris abattoirs showed signs of a "contagious typhus," prompting the Prefect of Police to quarantine all herds and ship the dead animals for disposal at the knacker's yard in the northern suburb of Aubervilliers.[11]

Parisians themselves were the next to suffer as a cholera epidemic that had begun in the south of France, in Marseilles and Toulon, arrived in the first week of October. By the middle of the month, the disease was claiming more than 200 lives each day, with most deaths occurring in the poorer areas on the north side of Paris, such as Montmartre and the Batignolles.[12] Thousands more fell ill with diarrhoea, vomiting, palpitations and leg cramps. Caused by a bacterium called *Vibria cholerae* and spread through contaminated water, cholera was still a deadly disease, killing 19,000 people in Paris in the epidemic of 1832 and returning in 1849 to claim 16,000 more.

As October progressed, the cholera wards and cemeteries both started to fill. On October 20, the Emperor Napoleon took time out from his other duties to pay a visit to victims in the Hôtel-Dieu on the Île-de-la-Cité. Though he was cheered by a large crowd gathered outside Notre-Dame, these were difficult days for the Emperor, who had just suffered a catastrophic setback in his foreign policy. With the end of the American Civil War six months earlier (word of General Lee's surrender at Appomattox Court House had reached Paris one week before the opening of the Salon of 1865) he had been obliged to agree, under threat from the Americans—who were arming the Juáristas, and who regarded the intervention as a violation of the Monroe Doctrine—to withdraw

all French troops from Mexico. This humbling retreat would inevitably expose Maximilian, his puppet emperor, to attacks from the Juáristas and, in a worst case, lead to his abdication.

By the end of the month, deaths from cholera halved to only a hundred per day, and a newspaper reported that the cholera wards were starting to empty as two thirds of the afflicted recovered from the disease.[13] Still, the epidemic was bad enough (altogether more than 6,000 people would succumb to the disease) that the cemeteries were thronged on All Souls' Day, when families laid beads, bouquets of flowers and garlands of yellow *immortelles* on the graves of their dead relations. So many people had tried to pay their respects at Père-Lachaise that guards were stationed at the entrances to keep the way clear and prevent carriages from colliding.[14] Manet narrowly avoided becoming one of the cholera victims. He fell ill with the disease in the middle of October, during the height of the epidemic, after contracting the bug from the infected water supply in the cholera-ridden Batignolles. Recovering at the end of the month, he wrote to Baudelaire that after returning from Spain he had "fallen victim to the current epidemic."[15]

Perhaps in order to keep a lower profile after so much public derision over *Olympia*, Manet switched his custom from the Café de Bade to another establishment, the Café Guerbois, found in the Grand-Rue des Batignolles,* a street ambling northwards from the Batignolles to the glasshouses and candle factories of Clichy. The café was run by a man named Auguste Guerbois and consisted of two large rooms and a small garden planted with shrubs at the back. The front room was furnished with gilded mirrors and marble-topped tables, while the room behind, a crypt-like space lit in the daytime by skylights cut into the roof, featured five billiard tables. Friends of Manet from the Café de Bade such as Astruc and Fantin-Latour quickly followed him to the Café Guerbois. Manet soon found himself presiding over the clacking of billiard balls in what became known to the locals as the Artists' Corner. To the art critics, the group quickly became known as the École des Batignolles.

Despite his brush with cholera, Manet dashed off three bullfight scenes in the autumn of 1865: one entitled *The Saluting Torero*, showing a matador in his suit of lights, and two others known as *The Bullfight* and *The Bull Ring in Madrid*, both panoramic action shots featuring the sanguinary scenes he had promised Astruc in his letter from Spain—horses being gored by angry bulls. He also began work on portraits of two "beggar-philosophers," a pair of six-

*Renamed the Avenue de Clichy in 1868.

foot, two-inch canvases, each depicting a shoddily dressed old man wrapped in a cloak: *A Philosopher (Beggar in a Cloak)* and *A Philosopher (Beggar with Oysters)*. These works had been inspired by two full-length portraits by Velázquez he had seen in the Prado, *Aesop* and *Menippus*, which pictured the eponymous philosophers looking aged and bedraggled. *Beggar in a Cloak* was a particularly arresting piece. Using the same stark lighting and cursory brushwork as Velázquez, he portrayed an old man with an expressive face stepping forward either to deliver an oracular pronouncement or make a request for money.

Altogether Manet painted more than a dozen canvases between his return to

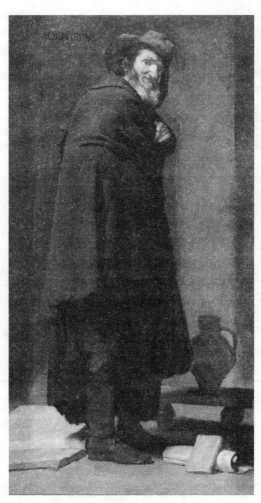

Menippus *(Diego Velázquez)*

Paris and the March 20 deadline for the Salon six months later. One of them was *The Tragic Actor*, a full-length portrait of an actor and painter named Philibert Rouvière; a second was *The Fifer*, a slightly smaller full-length portrait of a child dressed in a military uniform. Both had been inspired by the eerily luminous atmosphere of Velázquez's works in the Prado; and it was with these two works—the fruits of his Spanish journey—that Manet would attempt to redeem his reputation at the Salon of 1866.

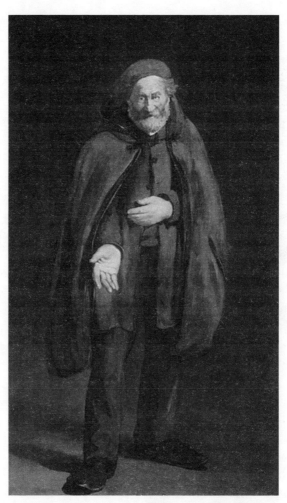

Beggar in a Cloak *(Édouard Manet)*

The Jury of Assassins

IF THE GROUNDS of the old abbey of Saint-Louis had once been a place of serenity, disturbed only by the tolling of bells and the whispering of nuns in the cloisters, the nineteenth century had brought a number of changes. By the 1860s the abbey enclosure was home to not only Ernest Meissonier and his family but also several other families—the Courants, the Gros and the Bezansons—who had likewise taken up residence in the grounds. Relations among them were for the most part congenial, no small outcome considering that the Protestant Courants and Gros were somewhat taken aback by the grandeur of Meissonier's style of living. Louis and Sarah Courant, further-more, had taken successful legal action against Meissonier when one of his nu-merous additions to the Grande Maison infringed on their vegetable garden, while Adolphe Bezanson, a lawyer, had been Meissonier's political opponent in the elections of 1848, defeating him for a seat in the Constituent Assembly.

Neighbourly harmony seems to have been preserved due to the happy coin-cidence that each of the four families had children (or grandchildren in the case of the Courants) of roughly the same age. Meissonier's children Charles and Thérèse became friends with Lucien and Jeanne Gros, Alfred and Elisa Bezanson, and (whenever they visited from Le Havre) Maurice, Claire and Jenny Courant. Together they swam in the river, unfurled the sails of Meis-sonier's yachts, or knocked croquet balls across the expansive lawns of the Grande Maison. They also went horseback riding together, accompanying Meissonier on his gallops through the countryside. And Charles and Lucien had another pursuit in common, training together under the eagle eye of *Le Patron*.[1]

Charles Meissonier was hoping to build on the modest success of *The Studio* a year earlier with another contribution to the Salon, and so in the middle of March 1866 he sent to the Palais des Champs-Élysées a domestic interior entitled *While Taking Tea*. Recently, however, Charles had become distracted from his studies. He had taken to painting *plein-air* landscapes in the orchard of the Grande Maison—sometimes, comically, late into the night—in hopes of catching a glimpse of his neighbour Jeanne Gros, the nineteen-year-old sister of Lucien, as she walked along a path skirting the property of the Grande Maison.[2] Having fallen in love with Jeanne two or three years earlier, he arranged his days around the possibility of seeing her. After he discovered that he could see the window of her bedroom in the Gros house from the terrace of his own bedroom, the opportunity of gazing at her from afar made him a reluctant participant in his father's early-morning jaunts through the countryside. "My father wanted to make me ride a horse this morning," he lamented in his diary in the spring of 1866. "He was unaware that this morning I wished to remain at the house in order to see Jeanne for a few minutes. One day without seeing her is so long, so tedious and so heavy to bear."[3]

On some mornings when Charles did accompany his father on long excursions, a frosty atmosphere prevailed. The reason was not Jeanne Gros, however, but another neighbour who often came along for the ride, twenty-six-year-old Elisa Bezanson, the daughter of Meissonier's old political opponent. One morning in 1866 Meissonier led his party of riders five miles into the Forest of Saint-Germain. "The weather was cold," Charles recorded in his diary. "Mademoiselle Elisa was with us. I was exquisitely courteous, but very cold. Seventeen words exchanged, I counted them by chance."[4]

By 1866 Elisa seems to have been the elder Meissonier's lover, in spirit, at least, if not yet in the flesh. Edmond de Goncourt later claimed that "La Bezanson" (as he called her) was indeed the painter's mistress.[5] Still, it seems unlikely that even a man as arrogant and self-centred as Meissonier would have paraded his mistress before his wife and children in quite so brazen a fashion. At this early stage of their relationship—and a relationship would certainly develop between them—the unmarried Elisa may simply have been in awe of the wealthy and famous Meissonier, who was as flattered by her attentions as he was no doubt vexed by the physical dolours that kept his wife confined for long periods to her bedroom.

Though they had been married for almost thirty years, Meissonier only rarely painted his wife. On one of the few occasions, *Portrait of Mme Meissonier and her Daughter*, done in 1855, he depicted Emma with bobbin and thread in hand, working at a piece of lace. The two Meissonier women are

shown tranquilly following their sedentary pursuits, Emma in a chair and Thérèse, then fifteen, at the table with a book. Emma has long fingers and an even longer face, with refined features set in a dull and expressionless gaze. The picture of Victorian domestic respectability, she sits beneath the Mount Parnassus tapestry that features in works such as *The Etcher*. But if in *The Etcher* the figure of Apollo with his garland of laurels seems to foretell artistic triumphs awaiting Charles, in *Portrait of Mme Meissonier and her Daughter* the presence of the god above a woman sedately doing her needlework seems more than a little incongruous—perhaps even a bit ironic.

Whatever the state of his relationship with Elisa Bezanson, in 1866 Meissonier had reached a juncture in his artistic career as well as in his personal affairs. Though not deliberately boycotting the Salon as in 1863, he had decided not to show any work in the Palais des Champs-Élysées. *Friedland* was still unfinished after three years of work, and despite occasional rumours that Meissonier was about to put the work on show or sell it to a wealthy collector for an exorbitant sum—breathless reports had mentioned an American senator—the painting failed to emerge from his studio. He continued to craft his masterpiece with an intensifying series of studies, making endless sketches of lunging horses and flying hooves. The painting itself was reworked relentlessly. "Love of truth often impels me to begin something over again, after finishing it completely," he once said with reference to his work on *Friedland*.[6]

Meissonier's obsessive labours over *Friedland* were not the only reason he was showing nothing at the Salon of 1866. He had completed a number of small works over the previous year, including one called *The Venetian Nobleman*, for which he himself had posed in a red velvet gown. But none of these works was sent to the Palais des Champs-Élysées. As a successful artist with numerous patrons, Meissonier did not need to advertise his wares at the Salon; however, his reasons for not showing work in Room M had more to do with his wish to elevate his art to more sublime heights. His ideal audience was no longer the gawping rabble who elbowed their way into the Salon or even the bankers and industrialists with their chequebooks at the ready. Rather, he was appealing to the generations to follow, who would recognise him, he hoped, as the foremost painter of his epoch. He would therefore exhibit at the Salon works such as *Friedland* and *The Campaign of France* or he would exhibit nothing at all.

The double act that controlled the Salon, Nieuwerkerke and Chennevières, forever experimented with their rules and regulations. In 1866 they made a major change, doubling the size of the jury for painting from twelve to twenty-four members, an enlargement that Chennevières explained would do away

with "accusations of camaraderie and favouritism" that had arisen after the Salon of 1865.[7] An expanded jury would cater to a wider range of tastes while ensuring that individual jurors would possess less influence than previously. But Chennevières and Nieuwerkerke were careful to ensure that this enlarged jury remained (to quote Castagnary) an "intolerant and jealous aristocracy" by stipulating that the only painters eligible to vote were, as usual, those with membership in the Institut de France and the Legion of Honour, together with winners of medals at previous Salons. Meanwhile they retained the privilege of appointing a quarter of the painting jury themselves.

Few surprises presented themselves when the ballot boxes were opened and the votes counted on March 21. The entire membership of the 1865 Selection Committee was re-elected, while new faces included Meissonier's landscapist friend Daubigny and a thirty-eight-year-old named Jules Breton, who had been enjoying popularity and acclaim with his paintings of peasants toiling in the fields. Alongside them were two history painters and muralists, Paul Baudry and Félix Barrias. The thirty-seven-year-old Baudry had won the Prix de Rome fifteen years earlier and had enjoyed immediate success after his return to Paris, titillating Salon-goers with what was to become his hallmark, female nudes in attitudes of voluptuous languor. In 1864 he had been awarded the most prestigious mural commission in France when he was selected to paint thirty-three scenes for the foyer of the new opera house that the architect Charles Garnier was building between the Boulevard Haussmann and the Boulevard des Capucines. Barrias had likewise won the Prix de Rome and then proceeded to paint ambrosial scenes from classical history onto the walls and ceilings of various public buildings. In 1866 he too was decorating Garnier's opera house, executing a scene called *The Glorification of Harmony* for the grand foyer.

In addition to the eighteen painters elected by their peers, Nieuwerkerke appointed six further jurors in order to bring the total number on the painting jury to twenty-four. They included, as usual, the critics Gautier and Saint-Victor, as well as the ornately named Jacques-Auguste-Gaston Louvrier de Lajolais. A former student of Gleyre, Louvrier de Lajolais was an interesting addition, since he had shown work at the Salon des Refusés in 1863 after the jury had rejected his work. A former *refusé* had therefore made it onto the painting jury.

Deliberations began at the end of March, and within a few days, in a repeat of 1863, word leaked out of the Palais des Champs-Élysées of mass rejections. One newspaper reported that Édouard Manet's two paintings had been refused, though it undermined its scoop by naming the works as *Imprudence* and *Father's Opinion*—titles that sounded quite unlike anything Manet was inclined to

paint.[8] When they were finally announced in the middle of April, the jury's decisions did not prove as unforgiving as three years earlier, with more than 3,000 works approved for the exhibition. But the rumour about Manet's rejection proved true as both of his works were rejected, a surprising turn of events since neither *The Tragic Actor* nor *The Fifer* seemed likely to foment controversy. Manet was apparently being punished for his work of a year earlier.

The sensation created by the rejection of the scandalous author of *Olympia* was rapidly overshadowed by an even more dramatic event: the suicide of another *refusé*, a forty-year-old painter from Strasbourg named Jules Holtzapffel. A former student of Léon Cogniet, Holtzapffel had shown work at every Salon for the previous ten years, even getting work into the Salon of 1863. Faced with rejection in 1866, he composed a despairing suicide note—"The members of the jury have rejected me, therefore I have no talent . . . I must die"— and shot himself in the head in his modest studio near the Gare du Nord.[9]

Holtzapffel's violent death, as well as the publication of his suicide note, created a backlash against the supposedly heartless jurors. Groups of artists poured along the boulevards chanting "Assassins! Assassins!" while articles appeared in the newspapers denouncing what became known as "the Jury of Assassins."[10] Some of the most forceful protests came from a notorious old buffoon, the Marquis de Boissy. Furious that a portrait of himself done by Giuseppe Fagnani had failed to impress the jury, Boissy rose to his feet in the Senate and demanded the return of the Salon des Refusés. He also published a letter in a newspaper, *L'Événement*, expressing his plan to exhibit the rejected portrait together with—if Holtzapffel's family proved willing—paintings by the dead artist.[11]

L'Événement ("The Event") had been launched the previous November by Hippolyte de Villemessant, owner of *Le Figaro*. Like *Le Figaro*, it dealt in scandal, intrigue, gossip, indiscretion and—if space permitted—the arts. In April 1866 it became a forum for debates over the Jury of Assassins, with Nieuwerkerke stooping to reply in its columns to the letter of Boissy and the charges of those who believed the painting jury guilty of bias, incompetence and even murder. The members were, Nieuwerkerke assured the paper's readership, "men of talent of whom France has the right to be proud and whom competent people of Europe know how to appreciate."[12]

Soon after Nieuwerkerke made this stout defence, the pages of *L'Événement* began running a remarkable series of broadsides against these "men of talent" composed by an energetic and articulate twenty-six-year-old force of nature named Émile Zola. Manet and the other *refusés* of 1866 could not have found a more capable or determined advocate, nor the jurors a fiercer opponent.

* * *

"One had to be blind not to sense the vigour of this man just by looking at him," the poet Armand Silvestre once wrote of Émile Zola.[13] Raised in Aix-en-Provence, Zola was the son of a brilliant Venetian civil engineer who had built a dam across the Infernets gorge in Provence and irrigated the drought-stricken countryside with a canal—christened the Canal Zola—that delivered water to the fountains of Aix. After catching a chill on the job, Francesco Zolla (as his surname was spelled) died of pleurisy in 1847, leaving seven-year-old Émile and his mother in dire financial straits. Eventually, in 1858, the pair moved to Paris, where Zola, having twice failed his baccalauréat, tried to make his mark as a poet. There followed a torrent of long alexandrine verses, including one in honour of his father entitled "Le Canal Zola" and another, "To the Empress Eugénie," celebrating in booming couplets the military exploits of Napoleon III. Unsuccessful in these pursuits, he was forced to pawn his clothing until he had nothing to wear but a bedsheet.

Zola was not a man to buckle under rejection or hardship. In 1862 he found work in a prestigious publishing company, the Librairie Hachette, first packing books into boxes and then, when his talent for publicity was spotted, in the advertising department (where he pioneered the use of sandwich boards). He also began publishing articles on art and politics in various newspapers. A collection of short stories appeared in October 1864, followed a year later by his first novel, *The Confession of Claude*, which proved something of a *succès de scandale* thanks to raunchy bedroom scenes that attracted a series of lurid headlines ("Grave Threat to Public Morality," "Pornographic Trash," "Sex Clinic for French Citizens") and eventually the attentions of Jules Baroche, the Minister of Justice. Baroche had Zola's rooms searched and the novel examined to see if it constituted "an outrage to public and religious morals," the offence with which both Flaubert and Baudelaire had been charged in 1857. Zola was found not guilty, though the report to Baroche concluded that the novel "inspires reservations from the point of view of good taste."[14] Zola could not have been more pleased with his sudden notoriety. "Today I am ranked among those writers whose works cause trepidation," he boasted in a letter to a friend.[15] He promptly left his job with Hachette and landed a position on the scandalmongering *L'Événement*.

"Pardon me, Monsieur le Comte," Zola thundered in *L'Événement* a few days after the newspaper printed Nieuwerkerke's article praising the "men of talent" on the jury. On April 30, the day before the Salon opened, he launched his first blistering tirade, naming and shaming the twenty-four jurors for their hostilities towards and prejudices against what he called "the new movement."

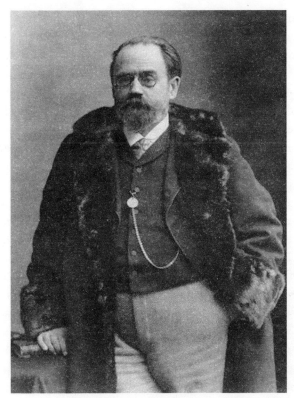

Émile Zola (Nadar)

Making what he described as "a somewhat daring comparison," Zola described the Salon as a "giant artistic *ragoût*" into which each painter poured his ingredients. But since the French public supposedly had a sensitive stomach, a team of cooks was deemed necessary to sample this eclectic stew in order to prevent "digestive disturbances" when it was dished up to the hungry public. Zola therefore proceeded to examine the qualifications and prejudices of these guardians of the public palate. "Nowadays a Salon is not the work of the artists," he claimed in the first instalment, "it is the work of a jury. I am therefore concerned first of all with the jurors."[16]

Zola blamed the malign interference of the jury's chairman, Robert-Fleury, a "relic of romanticism" who was both the Director of the École des Beaux-Arts and, since 1865, the Director of the Académie de France in Rome. But he also denounced the newer and younger jurors, such as Jules Breton, "a young and militant painter" who had supposedly said of Manet's canvases, "If we accept works like these, we are lost." Another first-time juror, a forty-six-year-old

portraitist named Édouard Dubufe, had also recoiled in horror when faced with Manet's work: "As long as I am part of a jury," Zola quoted him as saying, "I will not accept such canvases." As for another new juror, Louvrier de Lajolais, his experience of rejection in 1863 failed to make him a sympathetic judge: he supposedly boasted that only 300 of the more than 3,000 works accepted for the exhibition had received his personal seal of approval.

In the context of this tirade, Ernest Meissonier got off rather lightly. Zola claimed that the "painter of Lilliput"—an old nickname for Meissonier first coined by Gautier—skipped most of his jury duties due to his unremitting labours on his own work. "Nothing takes as long to make, it seems, as the *bonshommes*," wrote Zola, "since the painter of Lilliput, the homeopathic artist with his infinitesimally small doses, missed all the meetings. I was told, however, that Meissonier attended the judging of the artists whose surnames start with an M." The implication was that Meissonier had attended meetings only to guarantee the acceptance of his son Charles (*While Taking Tea* did indeed find favour with the jury) as well as to cast his vote against Manet.

Meissonier undoubtedly wished to see his son's painting accepted by the jury, but he was surely less appalled than Breton or Baudry by Manet's efforts. He was more likely to have taken the side of his old friend Daubigny, the one juror exempted by Zola from any blame for the débâcle. "He behaved as an artist and a man of heart," Zola proclaimed in *L'Événement*. "He alone fought against certain of his colleagues, in the name of truth and justice." Whatever his opinion of the "new movement," Meissonier would presumably have supported Daubigny against painters like Barrias, Baudry and Breton—men who shared the same artistic education as conservative *académiciens* such as Picot and Signol who had been shunted aside by the voters after the débâcle of 1863. But the fact that Zola made no attempt to exonerate him, or to put him on the side of "truth and justice," indicated that, in a few minds at least, Meissonier was coming to be identified with the forces of reaction. The association would eventually return to haunt him.

Monet or Manet?

CHARLES-FRANÇOIS DAUBIGNY had come a long way since the days when he shared a cramped apartment in the Marais district of Paris with four other struggling artists and, in concert with Ernest Meissonier, painted canvases for export to America for a wage of five francs per square metre. By 1866, at the age of forty-nine, Daubigny had won a handful of Salon medals, received a government commission to decorate an office in the Louvre, and been made a Chevalier in the Legion of Honour. He had travelled in Switzerland with his friend Camille Corot and, since 1861, occupied an idyllic house at Auvers-sur-Oise whose interior walls he decorated with scenes from the fables of La Fontaine and the Brothers Grimm. Nonetheless, he still liked to demonstrate his youthful, rebellious spirit by singing the *Marseillaise* as he painted.

In spite of his successes, Daubigny had always received a mixed reception from the critics. Their most common complaint was that his landscapes looked like sketches or preparations for future works rather than paintings in their own right. As one of them put it, though undoubtedly a great talent, he stubbornly insisted on hanging "rough sketches" on the walls of the Salon instead of more polished works.[1] Daubigny's taste for sketchiness meant he could appreciate the offerings of a number of the young painters rejected from the 1866 Salon, no matter how unorthodox their approaches. He preferred "paintings full of daring," he claimed, "to the nonentities welcome into each Salon."[2]

One of these "daring" painters unsuccessfully supported by Daubigny was the thirty-five-year-old landscapist Camille Pissarro. The son of a prosperous Jewish merchant who had emigrated to the Caribbean island of Saint Thomas,

Pissarro had been living in the insalubrious Bréda district since 1855. He had so far enjoyed little renown as a painter, though he did manage to exhibit landscapes at the Salon in 1859, 1864 and 1865, and three of his paintings had appeared at the 1863 Salon des Refusés. Like Daubigny, he specialised in river views. In 1866, however, *The Banks of the Marne in Winter* was refused by the jury despite pleas from Daubigny as well as from Corot, Pissarro's mentor and prime inspiration. Showing the atmospheric effects of grey clouds scudding above a dun-coloured winter terrain and an indistinct huddle of houses, this landscape, which looked to have been painted in a single afternoon, typified the breezy abandon of the "new movement" in painting.

Another painter backed to no avail by Daubigny was a twenty-five-year-old named Pierre-Auguste Renoir. The son of a tailor from Limoges, Renoir had shown talent in a number of fields. As a choirboy he possessed such an angelic voice that the composer Charles Gounod had urged him to turn professional. However, young Renoir's habit of scribbling with charcoal on the walls of the family home convinced his parents of the suitability of an artistic career, and he entered the École des Beaux-Arts in 1862 and began studying under Émile Signol. Like Daubigny, who as an adolescent had painted clock faces and jewellery boxes, young Renoir earned money by decorating coffee cups, ladies' fans and the awnings of butcher shops. But after finishing his studies at the École and entering the studio of Charles Gleyre he twice showed work at the Salon, including *La Esmeralda* (based on Victor Hugo's *Notre-Dame de Paris*) in 1864 and a landscape called *Summer Evening* a year later. To the Salon of 1866 he sent a pair of landscapes. When Daubigny was unable to sway the jury in his favour—six jurors voted for his works, the remainder against—he urged the young painter to demand another Salon des Refusés.[3]

Coincidentally, an appeal for a new Salon des Refusés had already landed on Nieuwerkerke's desk in the spring of 1866. It was composed by Paul Cézanne, a strange and obscure painter whose name was known, if at all, only because Émile Zola, his boyhood friend, had dedicated his scandalous *Confession of Claude* to him. A year older than Zola, Cézanne had yet to meet with anything remotely like success. He was the son of a haberdasher of hats in Aix-en-Provence whose tight-fistedness helped him to become so rich that in 1848 he bought a bank, amassed an even greater fortune, and became even more tight-fisted. Young Cézanne did not, however, either look or act like the son of a wealthy banker. He wore a *bandito* moustache, dressed sloppily, bathed infrequently and swore incessantly, while his studio near the Place de la Bastille was inches deep in dust, ashes and carelessly strewn piles of his meagre possessions. Having followed Zola to Paris in 1861, he stayed only long enough to

fail his entrance examination for the École des Beaux-Arts and become the butt of jokes at the Académie Suisse, where his fellow students found his efforts clumsy and incompetent. He reappeared in Paris a year later, at which point one of the more kindly painters working at the Académie Suisse, Camille Pissarro, took this "strange Provençal" (as Pissarro called him) under his wing.[4]

Cézanne had made several stabs at the Salon, all of them glacially rebuffed by the jurors. In 1866, in a spirit of vengeance, he submitted two works that he boasted would "make the Institut de France blush with rage and despair."[5] One of them, *Portrait of Antony Valabrègue*, showed the brusque, hasty style in which, in imitation of Courbet, he smeared paint onto his canvas with a palette

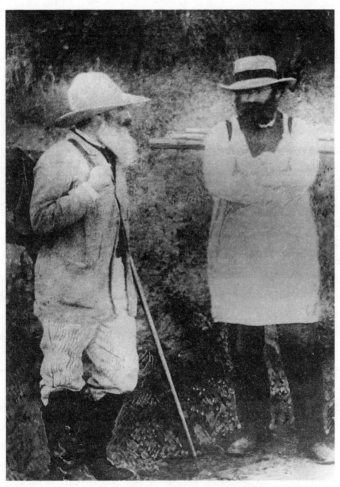

Paul Cézanne (right) and Camille Pissarro

knife instead of a brush. Even the sitter, a friend from Aix, had reservations about the work: "Paul is a horrible painter as regards the poses he gives people in the midst of his riots of colour," wrote Valabrègue. "Every time he paints one of his friends it seems as though he were revenging himself on him for some hidden injury."[6] The jurors did indeed recoil at the sight of the painting. One of them quipped that "it was not only painted with a knife but with a pistol as well."[7]

Finding himself rejected from the Salon yet again, Cézanne boldy penned a letter to Nieuwerkerke demanding the reinstatement of the Salon des Refusés, at which he had shown work in 1863. When Nieuwerkerke did not trouble himself with a reply—numerous such requests crossed his desk each year—Cézanne dashed off another letter. "Seeing that you have not answered me," he wrote impatiently, "I think I must emphasise the motives that made me appeal to you." He explained that he could not accept the "illegitimate judgment of colleagues whom I myself have not commissioned to appraise me," and that he wished to be judged by the public instead. "I ardently wish the public to know at least that I do not wish to be confused with the gentlemen of the jury," he loftily concluded, "any more than they seem to wish to be confused with me."[8]

This second letter still failed to produce the desired effect. Nieuwerkerke simply scrawled on Cézanne's letter: "What he asks is impossible. It has been recognised how little suitable the exhibition of the rejected was for the dignity of art, and it will not be re-established."[9]

One of Cézanne's few consolations was that he came to the attention, around this time, of his fellow *refusé* Édouard Manet, to whom he was introduced by Zola. He and Zola had admired Manet's paintings at the 1863 Salon des Refusés, and Zola himself was finally introduced to Manet, in February 1866, by Antoine Guillemet, a talented and amiable young landscape painter from Chantilly. Guillemet took the young writer, then revelling in his new-found infamy, to meet the equally infamous Manet at the Café Guerbois. Though the pair seem not to have crossed paths in the ensuing months, Zola leapt to his new friend's defence when the Salon of 1866 finally opened. Fresh from his attack on the jury, he devoted a laudatory article to the excluded Manet in *L'Événement*: "I feel it is my duty to devote as much space as possible to a man whose works have been wilfully rejected," he wrote, "and have not been thought worthy to appear among the fifteen hundred or two thousand ineffectual canvases which have been welcomed in with open arms."[10]

Zola's gallant defence of Manet was more than most readers of *L'Événement* could bear. Subscriptions were cancelled and copies of the newspaper were

shredded by angry readers in front of baffled newsagents. The publisher, Hippolyte de Villemessant, may have been a scandalmonger and sensation seeker, but these virulent diatribes were too much even for him. Before the month was out, Zola was clearing his desk.

Manet was delighted with the piece, however. "Dear Monsieur Zola," he wrote to its author, "I don't know where to find you to shake your hand and tell you how proud and happy I am to be championed by a man of your talent. What a splendid article. A thousand thanks!"[11] He proposed meeting at the Café de Bade. Zola agreed and, at some point, brought along Cézanne, some of whose still-life paintings Manet had already seen in Guillemet's apartment. Manet was complimentary about Cézanne's work to both Guillemet and Zola, but privately he wondered how anyone could bear to look at "such foul painting."[12] Cézanne's unrestrained brushstrokes and heavy-handed work with the palette knife, not to mention his rather grotesque visions, did not appeal. Manet later confessed that he found the younger artist uncouth and his work as sophisticated as something produced with a "bricklayer's trowel."[13]

Though the Salon of 1866 opened without any work from Manet on show, it did include paintings by the other bane of the artistic establishment, Gustave Courbet. In fact, the 1866 Salon was a rare triumph for Courbet following several troublesome years. After *Return from the Conference* was banned from both the Salon and the Salon des Refusés in 1863, Courbet had found himself exiled from the Palais des Champs-Élysées one year later when *Venus and Psyche*—a nude scene freighted with lesbian innuendo—offended the Empress Eugénie, who urged an obliging Chennevières to remove the canvas from view. He had made a return in 1865 with a landscape and a portrait of his late friend, the socialist firebrand Pierre-Joseph Proudhon, but both canvases were poorly received by the critics, even by those generally sympathetic to Courbet. One of his friends wrote witheringly that the two works "do not rise above the standard of a village stonemason who might, one fine day, take it into his head to be an amateur painter," while Théophile Thoré, writing about the portrait of Proudhon, claimed he had "never seen such a bad painting."[14]

Courbet had consoled himself over the failure of the paintings by departing in September for the seaside resort of Trouville and reinventing himself as a portrait painter to the idle rich. He executed portraits of the Countess Károlyi, wife of an Hungarian diplomat, and various other of the aristocrats and industrialists who flocked to the villas and casinos of Trouville. "I am gaining a

matchless reputation as a portrait painter," he boasted in a letter, in his usual self-aggrandising style. "I have doubled my reputation and have made the acquaintance of everyone who can be useful."[15] In between sessions in his studio—where more than one sitter was amazed at how he could talk, drink and paint at the same time—he bathed in the ocean and painted seascapes along the beach.

Courbet had soon been enchanted by the presence in Trouville of James McNeill Whistler and, even more agreeable to him, Whistler's copper-haired Irish mistress and model, Joanna Hiffernan. The daughter of an Irish immigrant to London, the beautiful Jo had met Whistler in 1860, when she was about seventeen, and had posed for various of his paintings and engravings. Her most famous appearance was in *The White Girl*, the seven-foot-high canvas that gave Whistler both public notoriety and a case of lead poisoning. She, Whistler and Courbet made a happy threesome in Trouville that October, eating shrimp salad, visiting the casino, and frolicking in the breakers. "This is a charming place," sighed Whistler in a letter to a friend in London.[16] He and Courbet assembled their easels along the beach, and Whistler finished at least five canvases; one of them, *Harmony in Blue and Silver: Trouville*, pictured the stocky, bearded Courbet in the foreground. Whistler had long admired Courbet's work, while Courbet quickly came to appreciate the charms of Whistler's "superb red-headed girl."[17] Smitten with Jo's Celtic beauty, he painted her in a portrait, *La Belle Irlandaise*, in which her abundant red-gold tresses were prominently featured.

Courbet's interest in Jo had not confined itself to aesthetics, and the two of them seem to have begun an affair, either in Trouville or a few months later, early in 1866, when Jo travelled on her own to Paris while Whistler, in a strange and baffling bit of derring-do, took himself off to South America with a boatload of torpedoes. Whistler claimed that he had decided "to go out to help the Chileans, and, I cannot say why, the Peruvians too."[18] Chile and Peru were at war with Spain at the time, but Whistler's motives may have had as much to do with escaping his creditors in London as with sinking the Spanish Pacific fleet. In any case, he had set sail for Valparaiso early in February, soon after which Jo began posing in Courbet's Paris studio for a work much more risqué than *La Belle Irlandaise*.

The commission for this work had come from a wealthy art collector and *bon viveur* named Khalil Bey, a thirty-five-year-old former Turkish ambassador to Greece and Russia who had moved to Paris and begun depleting his immense fortune on cards, canvases and courtesans.[19] Having heard about the deliciously indecent *Venus and Psyche*, he commissioned Courbet to paint a simi-

larly erotic scene to adorn his apartment, which ostentatiously included a number of Meissoniers. The result was *Le Sommeil* ("Sleep"), depicting a pair of intertwined female nudes asleep on a disordered bed; one of them, her hips rolled and posterior flaunted *à la* Cabanel, was the flame-haired Jo. Courbet, wisely, had not bothered to submit this work to the 1866 Salon. He sent instead a less explicit and more conventional nude showing a woman lolling on a bed with a parrot perched on her outstretched hand. This canvas, *Woman with a Parrot*, might have come from the studio of Cabanel; and, like one of Cabanel's works, it proved hugely popular with Salon-goers.

"I am the uncontested great success of the Salon," Courbet reported to a friend, and for once he was not exaggerating.[20] Cabanel personally complimented the preening Courbet on the work, as did another juror who knew something about the languorously draped female form, Paul Baudry. Courbet was less than gracious in accepting their regards: "I told you a long time ago," he wrote to a friend, "that I would find a way to give them a fist right in the face. That bunch of scoundrels . . . !"[21] The work was even popular with officialdom, for it was displayed prominently on direct orders from Nieuwerkerke, who had expressed an interest in purchasing it the previous summer after seeing it on the easel while visiting Courbet's studio. Nieuwerkerke also attempted to buy Courbet's second offering at the 1866 Salon, *Covert of Roe Deer*, only to discover that he had been pipped by another interested party, none other than Empress Eugénie.

In the space of three years, Courbet had gone from artistic pariah to darling of the Salon, with so many commissions that his drawers were, as a friend reported, "bulging with bank notes."[22] Such a turnabout in fortune must have been, to *refusés* from the Salon such as Édouard Manet, an enviable but inspiring sight. Perhaps not coincidentally, in 1866 Manet acquired an African grey parrot and, one year after the scandal of *Olympia*, invited Victorine Meurent back into his studio.

Another painter who managed to clear the hurdle of the 1866 jury and impress Salon-goers and critics was Claude Monet, whose seascapes had been such a draw one year earlier. Unfortunately, Monet had been unable to complete *Le Déjeuner sur l'herbe* (plate 5A). He had spent the summer of 1865 toiling away at the ambitious painting in the Forest of Fontainebleau, making sketches of his mistress Camille Doncieux and friend Frédéric Bazille enjoying a picnic lunch in fashionable dress. Work was interrupted, though, when he injured his leg in an incident involving a group of English painters, a bronze ball from the signboard of the Lion d'Or, and a game of football. Luckily Bazille, who had

trained as a doctor, took matters in hand, conducting Monet to his bed and treating the wound.

Monet's damaged leg was not the only reason *Le Déjeuner sur l'herbe* failed to appear at the 1866 Salon. The colossal size of the canvas meant he was unable to work on it exclusively out of doors, as he had hoped, especially when the weather turned at the end of summer. By mid-October, therefore, he had left Fontainebleau and, despite the cholera epidemic, returned to the studio he shared with Bazille in Paris. Over the next few months a number of visitors came to the Rue Furstemberg to inspect his progress on the work. His old friend and mentor from Le Havre, Eugène Boudin, arrived in December, reporting back to a mutual friend that Monet was "finishing his elephantine painting, which is costing him an arm and a leg."[23] Courbet, fresh from his invigorating spell at Trouville, commended the younger painter on the work, and Monet responded by painting Courbet into one of his studies for the scene. He placed him in exactly the same pose as that held by Ferdinand Leenhoff in Manet's *Le Déjeuner sur l'herbe*, insinuating that his own enormous canvas, with its showstopping size and uncompromisingly modern vision, would pay tribute to both Courbet and Manet.

As Boudin had noted, the enterprise was proving a costly one. Monet and Bazille, running short of funds, were evicted from their studio at the beginning of February, a situation made worse a short time later when Monet's aunt—who thus far had been bankrolling his artistic endeavours—decided to stop his allowance. "I'm utterly shaken," Monet wrote to a friend, Amand Gautier.[24] He also informed Gautier that he was "putting aside for the moment all the large things I have under way, which are only eating up my money and causing me great difficulties."[25] Despite having wrestled with the canvas in his studio for almost six months, he would be unable to finish it, he realised, on time for the Salon's March deadline. *Le Déjeuner sur l'herbe* was therefore, for the time being at least, rolled up and placed in storage.

Fortunately, Monet had been able to send two other works to the 1866 Salon: a landscape painted at Chailly-en-Bière and a portrait of Camille in a green-and-black striped dress. Both were accepted by the jury and reviewed favourably by the critics. Among the choristers of praise was Émile Zola: "Here is a man among eunuchs," he had managed to proclaim before getting the sack from *L'Événement*.[26] Monet made certain that cuttings of these reviews were dispatched forthwith to his aunt in Le Havre. "My aunt appears to be delighted," he was soon able to report to Amand Gautier. "She is congratulated at every turn."[27] Even more encouraging, the collectors began covetously eyeing his works; one of them, an art dealer, promptly commissioned further work from him. On the strength of his showing at the Salon, Monet

even managed to sell a number of his other paintings, pocketing a grand total of 800 francs in the bargain—a paltry amount by the standards of Meissonier or Gérôme, but a welcome relief for a man being dunned by creditors in both Paris and Fontainebleau.[28]

Édouard Manet no doubt took special interest in Monet, the man with a similar name who, on the evidence of *Camille (Woman in a Green Dress)*, shared something of his style of painting as well. "Monet or Manet?" the caricaturist Gill asked of the painting in *La Lune*, before concluding: "It is to Manet that we owe this Monet. Bravo, Monet! Thank you, Manet!"[29] Monet did indeed seem to owe a debt to Manet, since he had set Camille against a dark, blank background reminiscent of numerous of Manet's full-length portraits. He also arrayed Camille in modern costume—a fur-trimmed black coat over a long, billowing dress—similar to those represented by Manet in *Music in the Tuileries* and *The Races at Longchamp*. But where Manet's works had attracted public outrage and critical derision, Monet's efforts earned many plaudits. Camille was hailed in *L'Artiste*—the paper in whose columns Castagnary and Hector de Callias had both twitted Manet's work—as "the Queen of Paris."[30]

By the time the Salon opened, Monet and his "queen" had left Paris and were keeping a low profile in Sèvres, not far from where Corot lived at Ville-d'Avray. He had not quite learned his lesson, though, and by early summer he was at work on another massive *plein-air* scene with a similar modern-life subject. Entitled *Women in the Garden*, this new canvas, at eight feet high by six feet wide, was so large that Monet, according to legend, excavated a trench in his garden into which he lowered the canvas by means of a system of pulleys.[31] Once again his model for several of the figures was Camille Doncieux; and once again he outfitted her in the latest Second Empire fashions—expansive dresses, beribboned hats, a fawn-coloured parasol—as she posed under the boughs and among the shrubs and flower beds of his suburban garden. This time, more confident than ever of his abilities, Monet was determined not to fail to complete his canvas on time for the next Salon.

A Flash of Swords

A FEW DAYS AFTER the Salon des Refusés shut its doors in June 1863, Emperor Napoleon III had decreed that in four years Paris would host a Universal Exposition, a festival of arts and industry intended to attract visitors and exhibitors from all over the world. Such festivals had become popular ever since London hosted the Great Exhibition of Works of Industry of All Nations in 1851. More than six million people had visited the Crystal Palace in Hyde Park to view sights such as a steam hammer, a model of Niagara Falls, a twenty-five-ton lump of coal, and the Koh-I-Noor Diamond, newly arrived from India. Four years later, Napoleon III had hosted the Universal Exposition in Paris. Held in the Palais de l'Industrie (which was soon afterwards given its more dignified name, the Palais des Champs-Élysées), it included more than 20,000 exhibits, the most famous of which, after Prince Albert showed his enthusiastic appreciation for it, was Ernest Meissonier's *The Brawl*.

A number of other such fairs had followed: the Great London Exposition in South Kensington in 1862 (at which an inventor named Alexander Parkes unveiled "Parkesine," the world's first plastic); the International Exhibition of Arts and Manufactures in Dublin three years later; and the Exposição Internacional in Oporto, Portugal, in 1866. Louis-Napoleon hoped to outdo all of them with his second Universal Exposition, which was scheduled to open on the first of April in 1867. With four times the space of the Great Exhibition in the Crystal Palace and double the number of displays as the Universal Exposition of 1855, it was destined to be the greatest spectacle the world had ever seen.

An engineer named Jean-Baptiste-Sébastien Kranz was appointed to design a

special venue for the exhibition, the Palais du Champ-de-Mars. Assisted by an-other engineer who specialised in designing ironwork for railway bridges and viaducts, a talented thirty-four-year-old named Gustave Eiffel, Kranz produced an iron-framed oval structure with a domed roof that stretched 500 yards along the Champ-de-Mars and dwarfed the nearby Hôtel des Invalides. The hive of ac-tivity on the Left Bank of the Seine was witnessed in the months preceding the event by throngs of curious sightseers; every day as many as 5,000 people paid a franc each to watch the exotic structures—an American log cabin, a Chinese tea-house, an Inca palace, an English lighthouse—rise alongside Kranz's iron-and-glass cathedral.

The fine arts were to play an important part in this grand spectacle. A retro-spective of the arts since 1855, the International Exhibition of Fine Arts, would go on display in the Palais du Champ-de-Mars, showcasing modern master-pieces. To this end, French artists hoping to exhibit were invited to submit lists of their proposed works by December 15, 1866, while a Selection Committee was formed to choose among them. The Comte de Nieuwerkerke, as always, reserved the right to appoint a proportion of the jury himself, but provision was made for the artists themselves to elect sixteen of their peers. In the end, 147 artists gathered in the Louvre in the middle of November to cast their votes, which served as a sort of referendum on the Jury of Assassins. In the end, most of the names emerging from the ballot boxes had a familiar ring to them, though five members of the painting jury for the 1866 Salon were not elected.

The most striking absence was Daubigny, who had been the advocate for re-fusés such as Pissarro and Cézanne. His friend Corot, who had served on the past three Salon juries, likewise failed to garner enough votes. Despite the omission of France's two foremost landscapists, another, Théodore Rousseau, was not only elected to the jury but named its president. The fifty-five-year-old's sudden prominence was ironic in view of the fact that his works had once been rejected so frequently from the Salon that he became known as Le Grand Refusé. After being excluded from the Salons in 1836, 1838, 1839 and 1840, he had temporarily given up submitting work to the juries.

Ernest Meissonier was naturally elected to the jury. He also began preparing a list of his paintings that he wished to show at the Universal Exposition—more than a dozen of his finest works. He may have had ambivalent feelings about showing his work at the annual Salon, but the International Exhibi-tion of Fine Arts was another matter entirely. Included on his list, there-fore, was Friedland. With its millions of visitors from all over the world, the Universal Exposition would make the perfect venue for Meissonier to unveil

his masterpiece—if only he could complete the work on time. He had been persisting throughout 1866 with his endless studies for the painting, then almost four years in the making. But in the middle of December, just days before he was to submit his list of paintings, catastrophe struck at the Grande Maison.

Meissonier was forever adding to his collection of military paraphernalia. By the end of 1866, two entire rooms of the Grande Maison were filled with sabres, scabbards, bandoliers, shakos and tunics of various colours and materials— a veritable museum of military history. For *Friedland* he was obliged to depict the armour and uniform of Napoleon's cuirassiers. Napoleon had regarded these soldiers as the greatest weapon in the Grande Armée. They had been his shock troops, heavily armoured horsemen sent hurtling into battle in a terrifying attempt—usually successful—to break the enemy's line. Known as the *Gros Frères*, or "Big Brothers," troopers in cuirassier regiments were bigger and stronger, and mounted on faster and sturdier warhorses, than those in the other cavalry regiments. Their armour consisted of a cuirass, or breastplate, worn over a dark blue coat, together with a visored steel helmet decorated with a mane of black horsehair. Meissonier avidly put the entire uniform together piece by piece, including the buff-coloured trousers and knee-high riding boots.

As work on *Friedland* progressed, Meissonier's "Big Brothers" were almost undone by a weapon considerably less lethal than the thirty-eight-inch sabre with which Napoleon had equipped his cuirassiers. Besides the various weapons collected for *Friedland* and other paintings, Meissonier also owned a number of masks and foils. Fencing was, along with yachting and horseback riding, one of his favourite recreations. He had even built onto the Grande Maison a *salle d'armes*, a fencing room where he sparred with his son Charles in between sessions at the easel. Unfortunately he was ordered to demolish this extension after his neighbours, Louis and Sarah Courant, protested that it impeded access to their vegetable garden. Unwilling to relinquish the pleasures of his energetic pastime, Meissonier had begun constructing a new *salle d'armes* close to the Nouvelle Maison, the mansion he was having rebuilt for Charles. This extension was not yet finished by 1866, however, and so when Charles and Lucien Gros felt the need to practise their thrusts and parries, early one morning in the middle of December, they took their foils into the summer studio on the ground floor of the Grande Maison. The two young men then began lunging at one another a few feet from where *Friedland* sat on its easel.

"What a day, my pretty little girl," Charles wrote later that day to Jeanne in

a blow-by-blow account of the tragic events. "Several more like this one and my hair would quickly turn white."[1] He and Lucien had taken the precaution of protecting *Friedland*, he explained, by placing an enormous mirror in front of it. However, the fencing had barely started when the mirror tipped over, knocking Meissonier's masterpiece from the easel and tearing the canvas. The damage sustained was a hole some three inches long in the middle, where Meissonier had been painting a charging sorrel horse ridden by a cuirassier.[2] Charles was suitably horrified and despairing. "I wanted to run away, to kill myself," he wrote to Jeanne.

But Charles neither absconded nor fell upon his fencing sword. He climbed the stairs—"I don't know how"—to where his father was obliviously at work in the winter studio. He had good reason to fear the wrath of his father, the "maniac" who, according to Edmond de Goncourt, could be "as brutal as anything." But Meissonier received the news with uncharacteristic equanimity. At first, seeing his son so distraught, he feared some tragic accident had befallen a member of the family. But when Charles threw himself at his father's feet and tearfully confessed all, Meissonier simply raised him to his feet and said, quietly and calmly: "Oh well, it was a beautiful work and 100,000 francs lost. Dear me, it is finished, but do not cry I beg of you."[3]

Father and son descended the stairs together to witness the scene of destruction. Meissonier's initial examination concluded that the tear in the canvas was irreparable, but Charles was unwilling to abandon the painting to its tragic fate. He immediately caught the train to Paris, where he consulted with an expert in conservation, "an intelligent man," he reported to Jeanne, "who gave me a remedy that we will employ tomorrow." He then returned to Poissy, still in a state of enormous anxiety. The conservator (most probably one from the staff at the Louvre) had reassured the young man that all was not lost, "but I will be completely calm only tomorrow after the operation is done. I still have many torments and fears. You know me well, my dear little girl, and I am sure that you can imagine everything I suffered when I saw myself—me, his son—destroying my father's most beautiful work."

On the following day, at eleven o'clock in the morning on December 12, the expert from Paris arrived at the Grande Maison and then spent the next three hours repairing the damaged canvas as Charles hovered nervously at his elbow. More was at stake, of course, than the 100,000 francs that Meissonier evidently expected to earn from the painting. As Charles knew only too well, his father had expended almost four years of labour on the work,

which he hoped would consolidate his worldwide reputation at the International Exhibition of Fine Arts. "I was very afraid," wrote Charles, in something of an understatement. "Several times we believed it would never be finished." But the operation proved successful ("Victory, thank God"), and by two o'clock in the afternoon *Friedland* was salvaged. The conservator had glued to the back of the canvas a length of the finest French linen, a method allowing him to disguise both the hole in the painting as well as the seams where the original canvas had been fitted together.[4] Charles was brazen enough to claim credit for the procedure, writing triumphantly to Jeanne: "It was down to me, you see. I insisted on my method, and I am the one who succeeded."

The apparently imperturbable Meissonier went back to work on the canvas. He had fewer than four months to complete the painting on time to unveil it at the Universal Exposition.

Édouard Manet was also hoping to show samples of his work at the International Exhibition of Fine Arts in the Champ-de-Mars. To that end, he submitted his list of proposed works by the mid-December deadline and then awaited the response. He could not have been especially optimistic, even despite the presence on the jury of Thomas Couture, his old teacher. The shuffling of a few personnel notwithstanding, the painting jury still bore an eerie resemblance to the 1866 Jury of Assassins. Moreover, Manet's list consisted of all his most notorious paintings, including both *Le Déjeuner sur l'herbe* and *Olympia*, along with works rejected from previous Salons, such as *The Absinthe Drinker* and *The Tragic Actor*. He also hoped to exhibit a number of other controversial works, such as *Music in the Tuileries* and *The Dead Christ with Angels*, whose public displays had been greeted with both hostility and hilarity.

Many of the twenty-four jurors no doubt were exasperated by the sight of Manet's list of paintings, and few can have looked forward to the inevitable debates as once again they were forced to ponder their merits. But the problem simply could not be ignored. As a frustrated juror once remarked of Manet's submissions to the Salon: "Every year there is a Manet problem, just as there is an Orient problem or an Alsace-Lorraine problem."[5] In any case, the jurors needed to reach their decisions within two weeks. According to the regulations, successful applications would be acknowledged by the first of January, while those artists who heard nothing from the jury by that date could safely assume they had been passed over.

The *Jour de l'An*, New Year's Day, was a social occasion in Paris, with people

going from house to house for brief visits, exchanging sweetmeats and small gifts before setting off to browse the wooden stalls in the bazaars that opened for the day along the wide new boulevards on the Right Bank of the Seine. A light snow fell that day in 1867, powdering the trees (as Théophile Gautier observed at his home in Neuilly) "like marquesses in the days of Louis XV."[6] For Manet, the celebratory mood, with its high expectations for a year that would see Paris become the centre of the world's attention, seemed dismally inappropriate: no word had arrived from the Selection Committee, confirming the exclusion that he must already have been anticipating. He did receive more heartening tidings, however, in the form of a copy of *La Revue du XIX^e siècle*, a journal edited by Arsène Houssaye, previously the editor of *La Presse*. The journal's issue for the first of January 1867 included a long article entitled "A New Style in Painting: M. Édouard Manet." Its author was Émile Zola, tenacious champion of the "new movement" in French painting.

The two men had been meeting regularly since Zola's attack on the 1866 jury some nine months earlier, and the article in *La Revue du XIX^e siècle* had been preceded by a visit from Zola to the studio in the Rue Guyot. For the occasion Manet had displayed thirty of his finest works. Zola was enraptured. The paintings represented "an enormous totality of analysis and vigour," the pugnacious little writer informed his readers. "You begin to feel, do you not, that there's more to this man than black cats? The entirety of his work is one and complete. It enlarges itself with its sincerity and power. In every canvas, the artist's hand speaks with the same language, which is simple and precise."[7] Zola dared to express the hope that in the spring he would find these paintings on show at the International Exhibition of Fine Arts—but by the time the article appeared in print, the jurors had already spurned Manet's efforts.

Manet once again dashed off another letter of thanks: "What a splendid New Year's gift you've made me. I'm delighted by your remarkable article. It comes just at the right moment since I've not been deemed worthy of the benefits enjoyed by so many others." He then outlined to Zola plans he had already hatched to circumvent the Selection Committee by staging his own art exhibition during the Universal Exposition. In the summer of 1866, following his exclusion from the Salon, he had invited the public to his studio to see his rejected works for themselves. In 1867, he told Zola, he was determined to take this approach a step farther: "I've decided to hold a one-man exhibition. I have at least forty-odd pictures I can show, and have already been offered sites in very good locations near the Champ-de-Mars. I'm going to go all out and, with the support of people like you, it should be a success."[8]

Manet had approached the Prefect of Police, who granted him permission to

erect a temporary wooden building on the Right Bank of the Seine, near the Pont de l'Alma. The property on which Manet intended to build was a garden owned by the Marquis de Pomereu-d'Aligre, the forty-nine-year-old scion of a wealthy aristocratic family that had founded, among other enterprises, a spa in Burgundy and a lunatic asylum in Chartres.* One of the largest landowners in France, Pomereu-d'Aligre was also an art collector of discriminating tastes. The fact that he owned a number of landscapes by Gustave Courbet may have disposed him favourably towards Manet's unorthodox style of painting.

Manet's projected one-man art show during the Universal Exposition imitated the actions taken by Courbet in 1855 when, feeling himself slighted by Nieuwerkerke, he withdrew his paintings from the Universal Exposition and instead showed forty canvases in a private gallery specially constructed in the Avenue Montaigne, mere yards from where Manet proposed to show his own works. This one-man show had opened under the title of "Realism: Exhibition and Sale of Forty Canvases and Four Drawings by M. Gustave Courbet," with a catalogue put together by Champfleury. The exhibition was no great success, however, since even the presence of many of Courbet's most shocking works failed to garner much attention. Yet Courbet remained unbowed, and in 1867 he was planning a repeat performance. Though four of his works would be on show when the International Exhibition of Fine Arts opened, he decided the time was ripe to inaugurate what he called his own "personal Louvre," a permanent exhibition space in the Avenue Montaigne that would be christened "L'Exposition Courbet" and dedicated exclusively to his works. "I will astonish the entire world," he predicted with his usual modesty.[9]

If all went according to plan, therefore, visitors to the Universal Exposition in the Champ-de-Mars would only have a short walk across the Pont de l'Alma to study the works of what a newspaper called "the two ringleaders of Realism."[10] However, Manet faced a number of hurdles in getting his exhibition off the ground. He required the consent not only of Pomereu-d'Aligre and the

*The father of the Marquis de Pomereu-d'Aligre, Michel de Pomereu, who held the title Marquis de Ryceis, makes an appearance in Flaubert's *Madame Bovary*. In 1837 the fifteen-year-old Flaubert had been invited to the autumn ball hosted by the Marquis de Ryceis at the Château du Héron, near Rouen. Two decades later he immortalised the event by depicting his host as the Marquis d'Andervilliers, proprietor of La Vaubyessard, the Italianate château to which Charles and Emma Bovary are invited for a similarly memorable evening. The Château du Héron was destroyed by fire in 1945.

Prefect of Police but also, critically, of his mother. Courbet was planning to spend as much as 50,000 francs on his exhibition, but he could well afford this huge sum: following his triumphs in Trouville in 1865, he had enjoyed another lucrative spell on the Normandy coast, this time at neighbouring Deauville. But Manet, with no such commercial success behind him, was entirely dependent on his mother's purse strings. "Manetmaman" needed some persuading about the benefits of so costly an enterprise. She was no skinflint, living in grand style in her apartment in the Rue de Saint-Pétersbourg, where she hosted her own female guests at soirées on Tuesdays and received the friends of her three sons—earnest young men such as Fantin-Latour and Zacharie Astruc—on Thursdays. She also doled out enough money to allow Édouard to keep himself in the style to which he was accustomed. Recently she had calculated that between 1862 and 1866 she had paid him a total of 80,000 francs, an average of 20,000 per year—a truly immoderate sum considering that doctors earned an annual income between 6,000 and 15,000 francs and highly skilled engineers between 10,000 and 20,000.[11] "It seems to me high time to call a halt on this ruinous downhill path," she had wearily concluded after this depressing study of the account books.[12] Yet suddenly Édouard was demanding 18,000 francs to mount an exhibition of the very same canvases that had brought him, over the previous four years, little more than public humiliation and one corrosive review after another.

In an indication of her faith in the talents of her eldest son, Eugénie Manet agreed to finance the project. However, she handed over the funds on one condition: in order to save money, Édouard and Suzanne were to vacate their lodgings in the Boulevard des Batignolles and move into her apartment in the Rue de Saint-Pétersbourg. A short time after the *Jour de l'An*, Suzanne therefore found herself sharing living quarters with her formidable and disapproving mother-in-law. Suzanne's own generosity and faith in the talents of her husband were indicated by the fact that she too had consented to this plan.

CHAPTER TWENTY-ONE

Marvels, Wonders and Miracles

THE *JOUR DE L'AN* HAD not always been celebrated on the first of January. Under the Julian calendar used in Europe throughout the Middle Ages, New Year's Day had fallen around the time of the spring equinox, on March 25. In 1564, however, King Charles IX of France signed the Edict of Roussillon, declaring the first of January to be the start of the calendar year and, according to legend, causing much confusion among those accustomed to celebrating the *Jour de l'An* at the end of March. A folk tradition soon arose in which those caught unaware by the calendar switch became, on the first of April, the butts of practical jokes. This custom of playing pranks on the first of April continued long after everyone in France acclimatised to the new calendar; one of the most popular involved sticking a paper fish to the back of an unwary friend and, when the trick was discovered, shouting "Poisson d'Avril!"—a catchphrase that became synonymous with the day. The first of April was therefore a date when one needed to be on guard to avoid becoming the "April Fish," an expression that became to the French what "April Fool" was to the English.

The crowds assembled in the Champ-de-Mars on the first of April in 1867 could have been forgiven for suspecting themselves of having become April Fish, the victims of some cruel prank. For the previous few months the weather in Paris had been atrocious, with constant rains turning the Champ-de-Mars into a quagmire and preventing the 10,000 workmen on the site from completing their tasks. This dire weather, along with various other delays and impediments, meant barely half the goods to be exhibited at the Universal Exposition had reached Paris by the eve of its opening. Of those crates that had

arrived, only a fifth had actually been unpacked, let alone seen their contents assembled and displayed in the Palais du Champ-de-Mars. The opening ceremony, conducted by Emperor Napoleon on a muddy fairground amid packing cases, tarpaulin-shrouded exhibits, and crews of frantic workmen, therefore seemed something of a mockery. As one observer later wrote, the grand opening resembled the baptism of "a sickly child which seems born only to die."[1]

In the first nine days of the Universal Exposition only 38,000 people paid to enter the Palais du Champ-de-Mars. Over the ensuing weeks, however, hundreds of tons of goods from the far-flung corners of the earth arrived in Paris by river, road and rail, followed by visitors in their hundreds of thousands. In the following months, Paris played host to the Czar of Russia, the Emperor of Austria, the King of Prussia, the Sultan of Turkey, the Pasha of Egypt, the King of Portugal, and the brother of the Mikado of Japan. By early summer the Universal Exposition had become exactly what Louis-Napoleon had promised, the grandest spectacle the world had ever seen.

With 50,000 exhibits, the Universal Exposition of 1867 had more than double the number shown in Paris in 1855. Most of these were exposed in a series of galleries arranged in concentric ovals around the inside of the

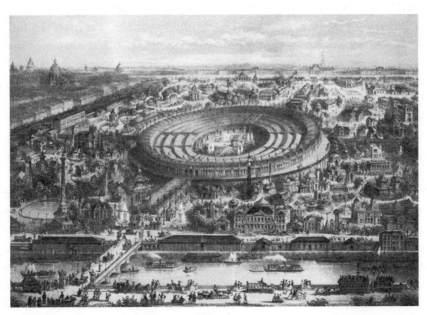

The Universal Exposition of 1867

Palais du Champ-de-Mars, which was bisected by long corridors radiating outwards from a central garden. Visitors entering through the main door, on the side closest to the Seine, passed along the 200-yard-long Grand Vestibule, with the numerous galleries of French exhibits on the left and those of Great Britain and Ireland on the right. Roughly a third of the space inside the oval was devoted to French exhibits, but room was also reserved for the wonders of countries such as Brazil, Tunisia, Egypt, Siam, Morocco, China and Persia. Many thousands of items were on display, from tooth powder and sewing-machine needles to steam boilers and combine harvesters.[2] The art critic Edmond About claimed that visitors could see "all the most astonishing things that men and gods have created, the marvels of nature, the wonders of industry, the miracles of art!"[3] Among the new inventions were a typewriter, a phonograph, a tyre made from rubber, a refined hydrocarbon oil called petroleum, and aluminium, a lightweight metal which so impressed the Emperor that he ordered a dinner service made from it. Other inventions included a high explosive called dynamite, created by a Swedish engineer named Alfred Nobel, and a new piece of furniture from America, the rocking chair. Displayed as well was a brass horn, *le saxophone*, invented by Napoleon III's Belgian-born Imperial Instrument Maker, Adolphe Sax.

The theme of the 1867 Universal Exposition was "objects for the improvement of the physical and moral condition of the masses"—a timely topic given that less than two weeks after the exhibition opened Karl Marx arrived at his publishers in Hamburg with the finished manuscipt of *Das Kapital* under his arm. However, only 769 of the items on display were actually dedicated to improving the condition of the masses; the remainder were given over to more frivolous sights. As the correspondent for *The Times* reported, sightseers were treated to "a collection of all that is old or new, all that is prodigiously big or infinitesimally small, the preciously rare or the merely odd—all that may be more or less worth seeing, and with it also not a little which many a man of taste would be anxious to avoid."[4] There were Oriental dancing girls, Chinese slaves with bound feet, the bones and teeth of extinct mammals, and an Egyptian mummy that was ceremonially unwrapped before a paying audience that included Théophile Gautier. Visitors could have their photographs taken in special booths, purchase exotic refreshments such as caviar from Russia and smoked beaver tails from Canada, or take a ride in a hydraulic lift that carried fair-goers to an observation platform sixty-five feet above the ground. Outside the hall, the *Céleste*, a balloon owned by Nadar, took paying passengers for as-

cents over the Champ-de-Mars, while new pleasure boats called *bateaux-mou ches* transported them on excursions along the Seine.

If they craved further entertainment, visitors to the Universal Exposition could simply have strolled the streets of Paris, transformed utterly since Louis-Napoleon came to power less than two decades earlier. Much broader than the twisted medieval streets they replaced, these new boulevards included the 140-yard-wide Avenue de l'Impératrice, which cut a majestic swath through the wealthy Sixteenth Arrondissement from the Arc de Triomphe to the Bois de Boulogne, an enormous park where, on orders of the Emperor, 400,000 new trees had been planted. An equally impressive attraction lay beneath the spacious boulevards. In the first half of the nineteenth century, rainwater and sewage had flowed freely through the streets of Paris, flooding cellars, polluting the Seine and promoting disease. To remedy the situation, Baron Haussmann and his chief engineer, Eugène Belgrand, had constructed 200 miles of sewers, an efficient new system of gravitational tunnels that conducted the waste safely out of Paris and discharged it into the Seine. Tickets to view these tunnels were in great demand during the Universal Exposition, with thousands of people passing through the entrance in the Boulevard de Sébastopol and descending into the eerie, echoing labyrinth.

For those who managed to exhaust these seemingly limitless pleasures, the Salon of 1867 opened in the Palais des Champs-Élysées on April 15, a fortnight earlier than usual. The annual exhibition had not been staged without the usual turbulence. Elections for the Selection Committee, held in March, produced a jury virtually identical to that responsible for the International Exhibition of Fine Arts. The results of the deliberations were therefore predictably harsh. "Never in the memory of artists has a jury been more severe," wrote Castagnary in *La Liberté*, a journal whose provocative motto was "Death to the Institut de France." "Out of 3,000 artists who sent their work," he reported, "2,000 have been refused."[5]

In fact, only 625 paintings were shown in the 1867 Salon. Édouard Manet had not bothered to submit any work, but many of his friends received the familiar bad news. Among the thousands of canvases returned to their owners with a red stamp on the back were ones by Renoir, Pissarro and Cézanne. The latter was cruelly mocked in *Le Figaro* (which dubbed him "Monsieur Sésame") as someone whose paintings were "worthy of exclusion from the Salon."[6] Undaunted, Cézanne (by this time sharing an apartment in the Batignolles with Émile Zola and his mother) began executing a canvas whose

subject was disconcerting even by his own standards. Called *L'Enlèvement* ("The Abduction"), it was a brutal reworking of Cabanel's *Nymph Abducted by a Faun*, a work owned by the Emperor.

Also among the 1867 *refusés* was Claude Monet. His eight-foot-high painting begun at Ville-d'Avray, *Women in the Garden*, was turned down by the jury, as was a seascape called *Port of Honfleur*. The rejection came as an unpleasant shock for Monet after his previous triumphs at the Salon in 1865 and 1866. However, one of the jurors, Jules Breton, explained that he had voted against Monet precisely because the young painter had been enjoying success. "Too many young people think only of pursuing this abominable direction," Breton complained. "It is high time to protect them and to save art."[7] The abominable direction to which Breton referred was Monet's lack of detail and finish. "It really is appallingly difficult to do something which is complete in every respect," Monet had written to Bazille a few years earlier, "and I think most people are content with mere approximations."[8] If this statement voiced the artistic creed for the Generation of 1863, many jurors desired something more than these "mere approximations"—something more than blurry impressions of gardens or beaches whose lack of fine detail mirrored, in the opinion of Breton and others, an absence of either moral integrity or narrative content.

Worse news was still to come for Monet as he fell afoul of his family as well as the Salon jury. Camille was with child, an unplanned and (for Monet at least) an unwanted pregnancy. Early in April, soon after learning of his rejection, Monet returned to Le Havre to confess to his father the full details of their relationship, and also, no doubt, to solicit financial assistance. Adolphe Monet was not amused. In a letter to Frédéric Bazille the elder Monet fumed that his son had taken "the wrong path" (a strange echo of Breton's objection) and needed to mend his ways if he hoped to remain in the good graces of his family.[9] He therefore ordered Claude to quit Paris and move to his aunt's house at Sainte-Adresse in Normandy.

But Monet, for the time being at least, did not wish to abandon either his pregnant mistress or the recreations of Paris. Instead, he obtained permission to set up his easel on a balcony of the Louvre, from where he painted *Garden of the Princess*, a cityscape with the Panthéon rising in the background. He sold the work to a dealer named Louis Latouche, who promptly placed it in the window of his small shop in the Rue Laffitte. Here it attracted the attention of passers-by, among them Honoré Daumier, a lithographer and political satirist who urged Latouche to remove such a "horror" from his window. *Garden of the Princess* also drew the adverse attentions of another artist. Édouard Manet likewise stopped in the street and, according to legend, remarked disdainfully

to a group of his friends: "Just look at this young man who attempts to do *plein-air*. As if the ancients had ever thought of such a thing!"[10] Despite his flirtations with *plein-air* painting at Longchamp and Boulogne, Manet apparently still believed that great art could only be produced in a studio, not under the open skies.

The stringency of the 1867 jury meant that, as usual, demand escalated for another Salon des Refusés. In early April the Comte de Nieuwerkerke received an anonymous letter purporting to come from a group of artists who stated, in threatening tones: "This injustice is revolting, and you had better believe that it's not a favour we're demanding, it's our right and we hope you will grant it."[11] Agitations by bands of rejected artists soon grew so heated in the vicinity of the Palais des Champs-Élysées that complaints against them were registered with the Prefect of Police.[12] A more considered protest came from Frédéric Bazille, who sent Nieuwerkerke a letter requesting the opportunity for the *refusés* to exhibit their work in a separate Salon. "Knowing your benevolent solicitude for our interests," Bazille finished, somewhat sarcastically, "we are hoping that you will be willing to take our request into consideration."[13] Attached was a five-page list of signatories that included Manet, Monet, Renoir, Pissarro and Daubigny. In the middle of April, when Bazille's petition bore no fruit, yet another letter featuring many of the same signatures landed on Nieuwerkerke's desk. At this point the beleaguered Superintendent of Fine Arts agreed to meet representatives of the disgruntled artists, though in the end he denied their requests for another Salon des Refusés. He had little enthusiasm for risking a repeat of the undignified events of 1863 at a time when the eyes of the world were fixed on Paris.

At the time of the petitions against the jury's decisions, Nieuwerkerke was busy curating not only the Salon and the International Exhibition of Fine Arts but also a retrospective of the works of Ingres, who had died three months earlier at the age of eighty-seven. The Superintendent could take great satisfaction in the fact that the exhibition of 600 of Ingres's paintings and drawings was a tremendous success, with more than 40,000 people filing into the École des Beaux-Arts to see masterpieces such as *The Apotheosis of Homer*, *The Vow of Louis XIII* and *Jupiter and Thetis*. Meanwhile, on the opposite bank of the Seine from the École, the exhibitions of Manet and Courbet were meeting with a quite different reception.

The poor weather that hampered the opening of the Universal Exposition likewise played havoc with Manet's plans for his one-man show. He had been hoping to open the doors of his pavilion on the first of April, but work had barely started on the project by that date as he found himself mired in both the mud of the Place de l'Alma and—much worse—unpleasant legal wrangles with his builders.

For the design of his thirty-foot-long wooden pavilion Manet had employed an architect recommended by the Marquis de Pomereu-d'Aligre. After drawing up a set of plans, the architect had entrusted the work to a contractor named Letellier, who subcontracted the work to another builder and promptly vanished. The subcontractor worked sporadically through the bad weather of February and March before downing tools altogether at the beginning of April with the job nowhere near complete. Having paid out a total of 18,305 francs, Manet was furious. Time was obviously of the essence since he needed to have his paintings exhibited in time to catch the attention of the millions of people pouring into Paris for the Universal Exposition. He therefore brought legal pressure to bear on the wayward contractor by engaging a solicitor named Chéramy. Legal summonses were promptly served on Letellier and a man named Belloir, the housepainter in charge of decorating the pavilion. The truant labourers arrived back on the site, where work finally resumed soon after the Salon opened in the middle of April.[14]

Manet was also involved at this time in more solemn and heart-rending affairs. By 1867 Baudelaire was back in Paris, in a special hydrotherapy clinic near the Arc de Triomphe, following a series of strokes and seizures caused by advanced syphilis. Newspapers in Paris had reported his death a year earlier, in April 1866, after he suffered a debilitating stroke in Belgium. While the obituaries had been premature, the poet was in an extremely serious condition, paralysed down his right side and virtually incapable of speech. His mother had brought him back to Paris in July, and Manet had paid frequent visits to the clinic, where to ease Baudelaire's sufferings Suzanne played excerpts from *Tannhäuser*, his favourite piece of music. Throughout the last half of 1866 and the early months of 1867, the garden in the hydrotherapy clinic became a place of pilgrimage for artists and writers such as Nadar, Gautier, Champfleury and the poet Théodore de Banville, all of whom gathered around the disabled Baudelaire. But it was Manet, apparently, whom the poet most wished to see. At the end of 1866 the painter received a letter from Nadar describing how he had discovered Baudelaire in the garden crying: "Manet! Manet!"[15]

These various anxieties kept Manet from his painting. At some point in the spring of 1867, however, he took a canvas and easel to the hill of the Trocadéro, a quarter-mile downstream from where his star-crossed pavilion was taking shape near the Pont de l'Alma. Though used as a refuse dump during the Universal Exposition, the Trocadéro provided a beautiful panorama of the Palais du Champ-de-Mars. Therefore, despite his supposed reservations about *plein-air* painting, Manet began a cityscape not unlike Monet's *Garden of the Princess*. He placed a series of figures in the foreground—a clutch of men in top hats, others

in military uniform, and a group of ladies wielding their ubiquitous parasols. He also added the fifteen-year-old Léon Koëlla, spiffily attired in a pearl-grey top hat and white trousers, walking a shaggy-looking dog along the path. Kranz's gigantic exhibition hall was shown at a distance, obscured by clouds of steam, while Nadar's *Céleste*, a small teardrop, hung in the sky above.

Had Manet's panorama of Paris continued a few more inches to the left it might have captured the Pont de l'Alma and his own small exhibition hall, which was nearing completion, at long last, around the time he began his *View of the Universal Exposition of 1867*. The Manet pavilion finally opened on May 24, with fifty-three canvases on show, including *Music in the Tuileries*, *The Absinthe Drinker*, *Le Déjeuner sur l'herbe* and *Olympia*. Manet had spared no expense to make his gallery a success. On the outside, pennants fluttered on flagpoles, while on the inside the walls were hung with red velvet and a divan in the centre of the room offered respite to weary visitors. "A perfume of gallantry floats on the air," wrote one of his friends.[16]

For good measure, Manet made available copies of Zola's article from the *Revue du XIXᵉ Siècle*, which he published in pamphlet form despite some initial reservations. "I think it might be in poor taste," he had written to Zola in March, "and strain our resources to no great advantage, to reprint such an outspoken eulogy of me and sell it at my own exhibition."[17] But he was won over by Zola, who understood a thing or two about publicity from his days at the Librairie Hachette. The pamphlet, handsomely attired in blue slipcovers, was therefore available in bookshops by the time the gallery opened to the public. Likewise on offer was a catalogue for Manet's exhibition, complete with a preface elucidating his motives in showing his work outside the Palais des Champs-Élysées.

Though no doubt composed with the help of Zola, this short article rehashed many of the points that Manet had put to the Comte de Walewski at their meeting in 1863. It explained that Manet's work had attracted criticism from those who followed (and here the preface alluded pointedly to the École des Beaux-Arts) "the traditional teachings concerning composition, technique and the formal aspect of a picture. Those who have been brought up on these principles," it asserted, "countenance no others." Constant rejection by Salon juries adhering to these conservative principles was obviously detrimental to the livelihood of an artist. Deprived of an audience, such an artist "would be obliged to stack up his canvases or roll them up and put them away in the attic." But Manet had decided, the preface stated, "to present a retrospective exhibition of his work directly to the public." Of course, the public had been even more hostile to many of his works than had most members of the Salon juries, but the preface urged

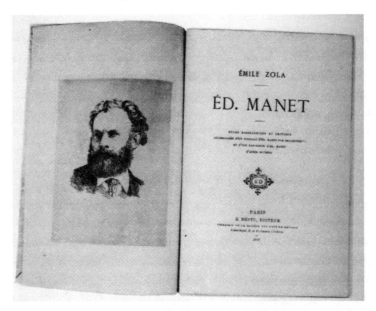

Title page of Zola pamphlet on Manet
(Manet portrait by Félix Bracquemond)

visitors to give the paintings a second look. With repeated viewing, the initial "surprise and even shock will give way to familiarity. Little by little," the preface confidently predicted, "understanding and acceptance will follow."[18]

Manet was fraught as the day of the opening approached. "He is in a frightful state," Claude Monet (not yet exiled to Normandy) reported to Bazille after a visit to the pavilion.[19] Despite his efforts and professed optimism, Manet's exhibition proved a comparative failure. He did receive a good notice in *L'Indépendance belge* from Jules Clarétie, who called him "a Velázquez of the boulevards" and a "Parisian Spaniard."[20] He also received a glowing report in the *Revue libérale* from Hippolyte Babou, an influential writer and critic who had immortalised himself a decade earlier by providing Baudelaire with the title for *Les Fleurs du mal*.[21] But these lines marked the full extent of the blandishments. The other Parisian papers completely ignored the exhibition: no reviews appeared in the *Gazette des Beaux-Arts, L'Artiste, Le Moniteur*, or any of the other journals that had previously humiliated him with their pungent comments. Critics like Gautier, Saint-Victor and Mantz, busily surveying the other art on show in Paris, all declined to set foot in his little pavilion. One of the few references to the exhibition was in the humourous *Journal amusant*, which dubbed it the "Musée Drôlatique"[22]—the Museum of Drolleries.

Nor was the public any more reliable, since most of the spectators apparently came to laugh. "Never at any time was seen a spectacle of such revolting injustice," fumed Manet's friend Antonin Proust, who claimed the public was "pitiless": "They laughed in front of these masterpieces. Husbands escorted their wives to the Pont de l'Alma. Wives brought their children. The entire world had to avail itself of this rare opportunity to shake with laughter."[23] As usual, Proust was exaggerating. In fact, Manet's pavilion was never really thronged. He began by charging an entrance fee of fifty centimes, half of what Salon-goers paid to get into the Palais des Champs-Élysées. This modest fee meant that in order to recoup his costs he needed to entice 36,000 paying customers into his pavilion, or to make up any shortfall in these numbers with sales of his canvases. The Ingres retrospective at the École des Beaux-Arts drew such crowds, but Manet's name did not possess the same magnetic properties. By the end of June, in a bid to inflate his receipts, he had doubled his entrance fee to a franc.[24]

Manet did at least have one celebrated visitor to his pavilion. Gustave Courbet took time out from superintending his "personal Louvre" in order to inspect the work of his fellow Realist. Alas, Manet could not count on a kind word even from Courbet. "What Spaniards!" was the older painter's only comment as he stalked from the pavilion.[25]

Courbet naturally entertained a higher opinion of his own efforts. "I have staggered the art world," he declared to a friend soon after his own pavilion opened, likewise at the end of May.[26] This was a gross hyperbole, since Courbet was scarcely any more successful with his exhibition than Manet. Visitors stayed away in droves, the press paid him little attention, and even friends and admirers such as Monet were distinctly unimpressed by many of the 130 works on show: "God, what horrors Courbet came up with," he confided to Bazille.[27] Though celebrated works such as *A Funeral at Ornans* and *The Stonebreakers* were part of the exhibition, Courbet had crammed the walls of his pavilion with lesser works, including many of the seascapes hurriedly knocked off during his boozily gregarious interludes at Trouville and Deauville. "Ugliness and more ugliness," sniffed Edmond and Jules de Goncourt after their visit.[28] Such a tepid reception was a letdown for a man who had been hatching grandiose plans of expanding his exhibition space into a gallery 220 yards in length and earning a million francs through the sales of his paintings.

But at least Courbet was able to sell a few of his works. A wealthy collector bought two of his paintings, including *The Stonebreakers*, while the widow of the Duc de Morny showed interest in another. Manet, on the other hand, failed to tempt a single buyer with any of his fifty-three canvases. Yet both of their travails were soon overshadowed by the rumours emanating from the Champ-

de-Mars: a wealthy American collector named Henry Probasco, visiting from Cincinnati, Ohio, had offered to buy a French painting for the unheard-of sum of 150,000 francs. The work in question was *Friedland*. As in 1855, Ernest Meissonier had once again become the talk of the Universal Exposition.

Visitors wishing to view the International Exhibition of Fine Arts needed a good deal of patience and persistence. On display at the centre of the vast exhibition hall, next to the Museum of the History of Work, this exhibition dedicated to paintings and sculptures from around the world could be seen only after one passed, among other attractions in the open air on the Champ-de-Mars, a Tunisian palace, an aquarium, two lighthouses, a prefabricated American schoolhouse, and a full-scale model of a Gothic cathedral in which religious artefacts had been placed on display. Nonetheless, more than a million people managed to thread their way through the cast-iron labyrinth to where hundreds of the most remark-able modern masterpieces were on show. The British section included paintings by Sir Edwin Landseer (who at the time was designing the enormous lions for the base of Nelson's Column in Trafalgar Square) and two co-founders of the Pre-Raphaelite Brotherhood, William Holman Hunt and John Everett Millais. The biggest star among the British was Millais. A former child prodigy, he was known for attacking his canvases with all of the industrious preparation and finicky appli-cation to detail of a Meissonier or a Gérôme. For one of his works, *Ophelia*, painted fifteen years earlier, he had dressed his model, Lizzie Siddal, in an expen-sive gown, placed her in a full bath of water, and toiled so long over his canvas that she caught a chill and required medical attention. For many years Millais had suffered at the hands of the critics what he called "such abuse as was never equalled in the annals of criticism"; but by 1867, at the age of thirty-eight, he had survived this invective to become the most commercially successful painter in En-gland, with earnings of 35,000 pounds per year. Equivalent to 175,000 francs, this huge sum made him, he boasted, "almost like Meissonier."[29]

 The American section in the International Exhibition of Fine Arts occupied a much smaller set of galleries between those dedicated to Mexico and Tunisia. The stellar attraction was the four paintings by Whistler, including *The White Girl*. Having survived his South American odyssey, Whistler had gone to Paris in March with a canvas from Valparaiso called *Twilight at Sea** and a destruc-tively violent spirit that saw him quarrel with the American delegation over the

*Whistler later changed the painting's title to *Crepuscule in Flesh Colour and Green: Valparaiso*.

hanging of his paintings, pummel a plasterer in the street, push his brother-in-law through the window of a café, and (in an incident that may explain the others) acrimoniously part company with Jo Hiffernan. Then, back in London in April, in an episode whose details were never properly explained—Whistler called it "the simple chastisement of a gross insult"[30]—he had thrashed his erstwhile friend Alphonse Legros so severely that the Frenchman had needed the services of a doctor. But if Whistler was becoming seriously unhinged, at least his paintings appeared to be finding favour. A French critic pronounced him "the only American worthy of attention," while, surprisingly, the Comte de Nieuwerkerke, who owned several of his etchings, made no secret of his admiration of Whistler, the only member of the Generation of 1863 for whom he had any taste.[31]

The largest and, to many visitors, the most impressive section in the International Exhibition of Fine Arts was dedicated to French painting. Cabanel and Gérôme both displayed thirteen of their finest works, the former thrilling viewers with his famous *Birth of Venus* and the latter with works such as *The Prisoner* and *Dance of the Almeh*. But most of the attention, along with most of the critical laurels, went to Ernest Meissonier, whose legions of admirers swarmed into the Palais du Champ-de-Mars. One English visitor to the International Exhibition of Fine Arts claimed the picture galleries were "rendered well-nigh impassable by curious sightseers expatiating over a Meissonier."[32] Émile Zola, for one, was irritated by the contrast between the frantic squash of people in front of Meissonier's paintings and the dearth of visitors to Manet's pavilion across the river. Mocking the popularity of Meissonier in an article published in a journal called *La Situation*, he bitterly condemned "the enthusiastic crowd that pressed around as though to crush me, exclaiming to each other and enumerating in lowered voices, with a religious astonishment, the fabulous prices of these bits of canvas."[33]

A total of fourteen Meissonier paintings were on view, including *The Battle of Solferino* and *The Campaign of France*. The catalogue for the International Exhibition of Fine Arts listed *Friedland* among their number, but Meissonier had not managed to finish the work. Though successfully repaired after its mishap the previous December, the canvas was still in Meissonier's Poissy studio. Meissonier seems to have been dissatisfied with his depiction of the horses; in any case, he had begun planning further studies into equine locomotion in order to make his cavalry horses as realistic as possible.

Meissonier's disappointment at not completing *Friedland* on time was offset by the rapturous reception given his fourteen other paintings. The Universal Exposition of 1867 witnessed his coronation as France's—and indeed

the world's—greatest living artist. Praise for him was unanimous and almost boundlessly extravagant. Scarcely a day passed in the spring and summer of 1867 without one critic or another declaring Meissonier's unsurpassed greatness. The respected art historian Charles Blanc, founder of the *Gazette des Beaux-Arts*, wrote that the painter "had no equal . . . either in France or anywhere else." "All things considered, there is only Meissonier in Europe, and he is ours," declared Paul Mantz, who proclaimed him "the hero of the French display." Even Théophile Thoré, a champion of "modern" art as well as the rediscoverer of Jan Vermeer, had no doubt that Meissonier was one of the few painters alive in France who would be "definitively consecrated" by future generations. "Let us prostrate ourselves with Europe," Léon Legrange simply urged his fellows, "at the feet of one of the glories of French art."[34]

These statements of Meissonier's pre-eminence, along with his fourteen paintings, caught the attention of Henry Probasco, a hugely wealthy forty-seven-year-old former hardware merchant. Probasco had just sold the company he had owned with his late brother-in-law and retired to spend his fortune covering the walls and stacking the shelves of his mansion outside Cincinnati with one of the world's finest collections of paintings and books. He had just commissioned from the Royal Bavarian Foundry in Munich, at a cost of 100,000 dollars, a forty-five-foot-high bronze fountain that he planned to ship back to America and unveil in downtown Cincinnati in honour of his brother-in-law.[35] He had also purchased a Shakespeare First Folio as well as various Bibles and rare manuscripts. But he wanted something more to show for his trawl through the auction rooms of Europe in 1867—namely, the greatest prize in modern art. The 150,000 francs he was rumoured to be offering for Meissonier's *Friedland* was unprecedented for a work by a living artist, eclipsing even the 99,000 francs paid to Horace Vernet by Czar Nicholas I of Russia in 1849.[36]

Soon, however, someone with even deeper pockets than Probasco let it be known that he, too, was interested in laying his hands on *Friedland*. The Marquess of Hertford, who already owned a half-dozen Meissoniers, approached the painter with a view to acquiring the unfinished masterpiece to adorn one of his Paris mansions. The competition for Meissonier's paintings at the Duc de Morny's auction in 1865 therefore looked set to pale into insignificance beside the tug-of-war for *Friedland*.

Still more honour was to come for Meissonier. The Awards Ceremony for the International Exhibition of Fine Arts, held on the first of July, took place before a crowd of 20,000 people in the Palais des Champs-Élysées, hung for

the occasion with banners and bunting. The ceremony was presided over by Emperor Napoleon, with numerous other dignitaries—including the Viceroy of Egypt and the Prince of Wales—in attendance. Having easily received more votes from the awards jury than any other painter, Meissonier was awarded the Grand Medal of Honour. His coronation as the king of painters was complete.

Funeral for a Friend

A LL HAD NOT been well with Emperor Napoleon as, dressed in his general's uniform and standing beside Abdul Aziz, the Turkish Sultan, he distributed the prizes for the International Exhibition of Fine Arts. The Universal Exposition had certainly been a great triumph, eventually attracting more than seven million paying customers. Yet this success could not allay Louis-Napoleon's various troubles.

During the previous year the Emperor's political fortunes had begun to suffer. One particular exhibit in the Palais du Champ-de-Mars, a fifty-ton Prussian cannon manufactured by Alfred Krupp, capable of firing shells weighing a thousand pounds, would have reminded him (and everyone else who laid eyes on it) of how in the summer of 1866 the Prussians under their Minister-President, Otto von Bismarck, had managed to vanquish the Austrians in a war lasting only seven weeks. The fifty-two-year-old Bismarck, an impressively tall and gluttonously corpulent Prussian *junker* with a walrus moustache and huge ambitions, had more than doubled the size of Prussia's army over the previous few years. He had started using this newfound muscle to hammer together from the various German-speaking dukedoms and princedoms— Mecklenberg, Thuringia, Saxony—a super-state that could rival its French neighbour. He had purchased Louis-Napoleon's neutrality in the war against Austria by promising to cede land along the Rhine to France, but he then proceeded to humiliate the Emperor (whom he mocked as "a sphinx without a secret") by showing no signs of handing over this territory. Meanwhile his own territories continued to grow as the Prussians annexed Hanover, Nassau and Frankfurt. A novel by Alexandre Dumas *père*, *The Prussian Terror*, serialised

in *La Situation* in 1867, was written to warn France of the dangers from the Prussian war machine.

In the summer of 1867 Louis-Napoleon had an even greater worry than Prussian militarisation and expansionism. Though he had done his best to conceal these anxieties as he presented the awards for the International Exhibition of Fine Arts on the first of July, several clues indicated that something had gone seriously wrong. Prince Richard von Metternich, the Austrian ambassador, had departed abruptly before the ceremony was finished, while the Count of Flanders, brother of Empress Charlotte of Mexico, was inexplicably absent. Then, before the ceremony had concluded, copies of *L'Indépendance belge* hit the news-stands with a dramatic story quoting official dispatches from the Austrian ambassador in Washington.

The news concerned the fate of Emperor Maximilian. It soon became clear that Louis-Napoleon's five-year-long Mexican adventure had gone horrifyingly awry. After 30,000 French troops evacuated Mexico a year earlier at the insistence of the United States, Benito Juárez and his men had promptly set about recapturing the territories they had lost in 1863. In the summer of 1866, as Juárez approached Mexico City, Louis-Napoleon had urged Maximilian to abdicate his throne and flee to Europe. Empress Charlotte had abandoned the hilltop palace of Chapultepec and set sail for friendlier shores, but Maximilian vowed—with an admirable courage— to remain in his adopted country and fight the Juáristas to the death. Though he was supported by an army of 8,000 Mexican loyalists, his fortunes looked bleak. As the 2,000 Guineas was run at the Hippodrome de Longchamp in the summer of 1866, Louis-Napoleon could not have missed an ironic coincidence: the winner was Puebla, a three-year-old colt named for the French victory in 1863.

The festivities of the Universal Exposition had been conducted under the dark shadow of further events implacably unfolding in Mexico. The last French troops had departed from Veracruz on the eve of the Exposition's opening; the inevitable occurred within a few short months, and by June news reached Paris that Maximilian was in the hands of the Juáristas. Since Juárez was known for taking bloody reprisals against his enemies, appeals for clemency—by figures such as Queen Victoria, King Wilhelm of Prussia and Czar Alexander II of Russia—were widespread, insistent and immediate. Even two grizzled radicals sympathetic to Juárez's cause, Victor Hugo and Giuseppe Garibaldi, pleaded with him to spare the Emperor's life. But these entreaties fell on deaf ears, and on June 19 the thirty-five-year-old Maximilian was executed by firing squad on the Cerro de las Campanas, the "Hill of Bells," in Querétaro, a hundred miles north of Mexico City.

Word of Maximilian's death had reached Louis-Napoleon on the morning of

the first of July, a few minutes before he left his palace in Saint-Cloud to attend the prize-giving ceremony at the Palais des Champs-Élysées. Even as he was making his speech extolling the greatness of France, a pro-Juárez newspaper in Mexico was taking a different perspective on his empire: "Napoleon III ought to be satisfied with his handiwork," reported the *Boletín Republicano*. "The death of the Archduke and of those who adhered to his cause ought to weigh heavily on the humbug who from the Imperial throne of France seeks to govern the world."[1]

The death of Maximilian did indeed weigh heavily on Louis-Napoleon, whose court immediately went into mourning. It weighed even more heavily on Empress Charlotte. She had come to Paris in the summer of 1866 in an attempt to persuade Louis-Napoleon to keep troops in Mexico in order to bolster her husband. "He is the principle of evil on earth," she declared when he refused.[2] Eventually she returned to Trieste, to her beloved Miramare, where the news of her husband's death deranged her mind. She was escorted by her brother back to Belgium, to the moated Château de Bouchout, where she lived for sixty more years, hopelessly insane, comforted by a doll she called Maximilian and consumed by a passionate hatred of Napoleon III as the devil incarnate.

Among the most popular canvases shown each year at the Salon were those dealing with recent historical events. Over the years Parisian audiences had crowded the space before depictions of contemporary episodes such as Jacques-Louis David's *Death of Marat*, Géricault's *Raft of the "Medusa,"* and Delacroix's *Massacre of Chios*. This latter canvas, winner of a gold medal at the Salon of 1824, portrayed the horrific genocide on the Aegean island of Chios in 1822, when as many as 20,000 islanders were slaughtered by Turkish troops at the start of the Greek War of Independence. More recently, at the 1866 Salon, Tony Robert-Fleury, the son of Joseph-Nicolas, had enthralled Salon-goers with his *Warsaw, 8 April 1861*, showing the massacre of Polish nationalists by Russian troops. The work was so compelling that it was said no Russian could pass through the Palais des Champs-Élysées without risking attack.

The execution of Emperor Maximilian at the hands of the Juáristas appeared to cry out for a similar treatment. The artistic possibilities of Maximilian's death were pointed out by, among others, the critic Jules Clarétie, writing in *L'Indépendance belge* less than a week after the news reached Paris: "What a terrible dénouement to the most incredible of adventures! Tragedy is certainly not dead, and the theatre of the future is there, bloody and outlined in full, a subject sombre and dramatic. Shakespeare could not have imagined a more shocking fifth act."[3]

Even as these avowals were being broadcast in the newspaper columns, at least one painter was busy crafting a scene recording Maximilian's bloody end. Édouard Manet took time away from his pavilion in the Place de l'Alma to begin his own version of the incident. He may have been hoping to finish *The Execution of Maximilian* (as he would call his work) on time to hang it in this ill-fated exhibition. A representation of such a topical event, the shocking deed about which all of Paris was talking, could not help but boost attendance figures in his lonely gallery. However, the work would be no half-measure, for he purchased a huge canvas, eight and a half feet wide—the largest he had ever tackled—and then set to work in his studio.

Details of the execution were still sketchy, but Manet began working from the available newspaper reports, including an account in *Le Figaro*, published on July 8, purporting to be a transcription of a report in a paper in New Orleans that had been transcribed, in turn, from a Mexican newspaper. These researches may have been risibly shoestring compared to those of Géricault or Meissonier, but Manet was prepared for the task in one vital respect: he had witnessed violent death at close quarters. During Louis-Napoleon's sanguinary coup d'état in December 1851, he and Antonin Proust had found themselves in the midst of the fighting, watching in horror as a cavalry charge swept along the Rue Laffitte and soldiers gunned down protesters outside the Café Tortoni. Afterwards the two young men had gone to the cemetery in Montmartre, where the victims were laid out under a covering of straw, with only their heads showing for purposes of identification. The scene, according to Proust, "left a terrible impression on us."[4]

Manet was inspired as well by one of the greatest of all examples of pictorial reportage, Francisco de Goya's *The Third of May, 1808*. Painted a half-dozen years after the fact, Goya's masterpiece captured the terror of the moment when French troops, having installed Napoleon's brother Joseph on the Spanish throne, executed by firing squad the *guerrillas* (as they came to be known) who had fought against the French occupation of Madrid. Manet had seen the painting in the Prado in 1865, and its ghastly and unnerving imagery—the merciless fusillade, the bodies sprawled on the barren hill outside the nocturnal city—was already scorched into his imagination before events in Mexico dramatically recalled it.

Manet began working swiftly and purposefully in the month of July, making a series of sketches and then rapidly spreading paint onto his immense canvas. He took his basic composition from Goya, placing the helpless victims on the left of the canvas and the members of the firing squad discharging their weapons on the right. A half-dozen Mexicans in sombreros and flared

trousers—his own interpretation of their clothing—were placed in a threatening huddle from which they dispatched Maximilian and his two faithful generals, Miramón and Mejía, in a great puff of smoke.

Work did not go as well as Manet might have hoped. He seems to have been uncertain how to portray the faces and gestures of Maximilian and his generals. He lacked photographic evidence of their features as well as—more critically—the ability (and also perhaps the desire) to communicate either physical movement or strong emotion. Goya's victims in *The Third of May, 1808* were shown bug-eyed with terror, clutching their hands in white-knuckled prayers or throwing their arms wide in desperate appeals to their executioners. But such emotional vehemence was not for Manet. The subjects of his paintings—the deadpan Victorine Meurent, his grim-looking parents, his meekly expressionless Christ—all did without melodramatic passions and frantic physical paroxysms. Such histrionic gestures were the hallmarks of great painters of the Romantic movement such as Goya or Delacroix; Manet favoured a greater subtlety. Most of his paintings possessed a static quality in which the blank facial expressions and minimum of physical movements betokened an emotional detachment on the part of painter and subject alike.

Manet's difficulties were soon compounded as more reliable reports of the execution making their way to Paris gave eyewitness testimony that contradicted his portrayal, which suddenly appeared fanciful and inaccurate. The Mexicans had not worn sombreros and flared trousers but—according to an authoritative account published in *Le Figaro* on August 11—a "uniform that looks like the French uniform." Subsequent reports revealed that the executioners wore grey képis and tunics, belts of white leather, and trousers of a dark material. This new information, combined with an account in *L'Indépendance belge* of how Maximilian and his two generals had held hands as the bullets ripped into them, persuaded Manet to abandon his gigantic canvas. He therefore bought an even larger canvas, one more than nine feet wide, and started all over again.

By the middle of August, Manet was distracted from his work—which he must have realised he could never complete in time for exhibition in his pavilion—when he left Paris for a holiday in Boulogne and then Trouville.[5] He visited the latter resort in the company of Antonin Proust, who for the previous three years had been publishing an anti-government newspaper called *La Semaine*. Manet may have been hoping to repeat the success Gustave Courbet had enjoyed in Trouville two years earlier, though unlike his visit to the seaside in 1864, on this visit he appears to have done no painting at all. In the event, his holiday abruptly ended on the first of September when a tele-

gram arrived from Paris reporting that Baudelaire had died the previous day. He and Proust immediately caught the train back to the capital for the funeral.

"I think there can be few examples of a life as dilapidated as mine," Baudelaire once wrote to his mother.[6] Few would have argued with the poet, and his death, when it finally came, must have been a release. He was laid to rest in the cemetery of Montparnasse on the second of September. A heat wave in Paris meant his body was interred after only two days, barely giving Manet time to return from the Normandy coast. He was buried in a family plot beside his stepfather, General Jacques Aupick, a successful and highly distinguished man whom a few horrified Belgians apparently believed Baudelaire had murdered and then consumed.

Two years earlier, in a self-pitying letter from Brussels, Baudelaire had complained that he was "alone and forgotten by everyone."[7] To be sure, many of his works were still unpublished at the time of his death, while all of his published poems, including *Les Fleurs du mal*, were out of print. Nonetheless, more than a hundred people attended the funeral mass; and most of them, despite the heat, followed the hearse to the cemetery, Manet, Nadar and Fantin-Latour among them. Théodore de Banville delivered the eulogy, but he was interrupted by a sudden thunderstorm triggered by the extreme heat. The ceremony concluded amid torrents of wind and rain.

Though long expected, Baudelaire's death was a heavy blow to Manet in what had already been a discouraging year. He must have glimpsed, in the poet's controversial and ultimately thwarted career, a tragedy threatening to repeat itself in his own frustrated artistic quest. Soon after his trip to the cemetery he took time away from *The Execution of Maximilian* to begin, perhaps as a tribute to his friend, or perhaps simply as a meditation on fame and death, a work entitled *Burial at La Glacière*. Probably painted at least partly *en plein air*, this smallish work, only twenty-eight inches wide, shows a huddle of black-clad figures following a hearse through La Glacière, a poor district a short distance south-east of Paris, named for a series of ponds that habitually froze in winter.[8] Manet placed in the background, in silhouette, a number of Latin Quarter monuments, such as the neoclassical domes of the Panthéon and the monastery of Val-de-Grâce, as well as the bell tower of the church of Saint-Étienne-du-Mont. He seems deliberately to have contrasted the humble cortège and anonymous grave in La Glacière with these grand architectural monuments housing (in the case of Saint-Étienne-du-Mont) a shrine to Sainte-Geneviève, the patron saint of Paris, and (in the case of the Panthéon) the tombs of Voltaire and Rousseau. He probably knew, furthermore, that interred in Val-de-Grâce were the hearts of twenty-six members of the French royal family, including those of the son and grandson of Louis XIV.

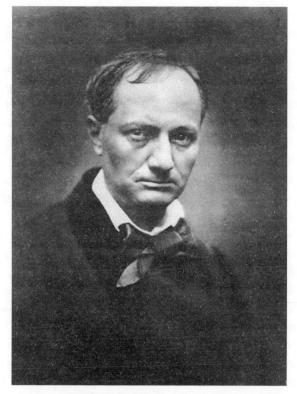

Charles Baudelaire (Nadar)

The scene is therefore ironic but also poignant, emphasising the dizzying chasm between worldly distinction and the nameless obscurity into which, like Baudelaire, the humble resident of La Glacière was about to be lowered. This polarity was actually engraved (as Manet would have been aware) on Baudelaire's tombstone: the plaque marking the family plot loftily proclaimed that Jacques Aupick was a General, a Senator, an Ambassador to Constantinople and Madrid, a member of the General Council of the *Département* of the North, and a Grand Officer of the Legion of Honour; meanwhile three terse lines inscribed beneath simply recorded that his stepson Charles Baudelaire had died in Paris at the age of forty-six. No mention was made of his career as a poet.*

* * *

*Baudelaire was eventually given a more fitting memorial in the cemetery of Montparnasse: a rather gruesome monument consisting of a flamboyantly forelocked bust contemplating a mummy-like figure that lies beneath a pedestal draped in the skeleton of a giant

Another work painted in the autumn of 1867 also showed Manet's intense pre-occupation with mortality. Léon Koëlla was working at this time as an errand boy for a banker named Auguste de Gas whose son Edgar, a painter, Manet had met in the Louvre in 1862. Edgar de Gas (he was not yet spelling his surname "Degas") had since become a regular if slightly incongruous presence in the Artists' Corner at the Café Guerbois. With an exotic genealogy that included a Neapolitan grandmother and a Creole mother from New Orleans, he had enjoyed a privileged upbringing in the wealthy First Arrondissement. But unlike that other son of a banker, the loutish Paul Cézanne, Degas, with his brittle wit and aloof, haughty manner, looked and acted the part of a plutocrat's offspring. Throughout his life, it was said, he used the informal *tutoiement*—the linguistic marker of intimacy and equality—with only three people. His charmed upbringing, however, together with his sharp tongue and love of the Old Masters in the Louvre, had quickly made him a natural friend and ally of Manet.

Degas was two years younger than Manet. Like many young Parisians predestined for greatness, he had studied at the Lycée Louis-le-Grand, the prestigious school in the Latin Quarter whose former pupils included Molière, Voltaire and Hugo. Most unusually for an aspiring artist, he had proved himself a superb student, reading voraciously and excelling at the classics in particular. He briefly studied law at the Sorbonne before moving on to the École des Beaux-Arts to train with a former pupil of Ingres—his artistic hero—named Louis Lamothe. His education had then continued in Italy, where the Neapolitan branch of his family owned a palazzo, and where he spent three years studying Renaissance paintings. He exhibited at the Salon for the first time at the age of thirty-one, in 1865, though his *War Scene in the Middle Ages*—which made allusions to the plight of women in the American Civil War—attracted no attention whatsoever. Due largely to Manet's influence he soon switched from historical scenes to subjects from modern-day Paris, such as racehorses, ballerinas and washerwomen.

Degas also painted portraits, including one of Manet and Suzanne, done in the summer of 1866. This picture was the cause of a serious but temporary fracture in their friendship. Posed at the apartment in the Boulevard des Batignolles, *Portrait of Monsieur and Madame Édouard Manet* appeared to show a crestfallen Manet lounging in a fit of boredom as his wife played the piano: Degas depicted him sprawled apathetically on a white sofa, one knee drawn awkwardly upwards,

bat. Sculpted by José de Charmoy, it was unveiled in 1902, thirty-five years after Baudelaire's death.

his hand thrust into his beard and his eyes raised vacantly upwards. If this like-
ness was unflattering, the one of Suzanne must have been far worse, since Manet
took such exception to Degas's depiction of his wife that he took a knife to the
canvas and expurgated her face and hands. Degas was enraged by this act of van-
dalism, and for several months the two men had refused to speak. The rift was
soon healed, however: Degas claimed that "one cannot stay vexed with Manet for
very long."[9] And shortly after their reconciliation, Degas seems to have found
Manet's fifteen-year-old godson employment at the Banque de Gas.

 Léon Koëlla was not living in the apartment in the Rue de Saint-Pétersbourg
that Manet and Suzanne were sharing with his mother. More modest lodgings
had been found for him in a ground-floor flat in the building next door. Manet
paid frequent visits to the boy, and most evenings the pair of them competed at
games of backgammon and bezique. Léon had posed for his godfather on a
number of occasions, most recently as the young dandy in *View of the Univer-
sal Exposition of 1867*. He was, in fact, Manet's favourite model, ultimately
posing for him more times even than Victorine Meurent, which suggests that
Manet, who always feared being let down by his models, found the boy a com-
pliant sitter. Therefore, when a new idea for a painting came to him in the
weeks following Baudelaire's death, he naturally turned to Léon; and in be-
tween running his errands at the Banque de Gas, the boy therefore found him-
self in the studio in the Rue Guyot, blowing soap bubbles.

 Soap bubbles had long been a source of fascination to scientists and artists
alike. Even as Manet was painting his canvas, a Belgian physicist named
Joseph-Antoine-Ferdinand Plateau was dipping wire frameworks into tubs of
soapy water in an attempt to describe the geometrical properties of bubbles, in-
cluding the precise angles at which they clustered together.[10] Manet's interest
in soap bubbles, like that of most artists, was rather different. The soap bubble
had been used for several centuries in what was known as a *vanitas*, a painting
whose purpose was to remind viewers (through symbols such as skulls, time-
pieces and snuffed-out candles and lanterns) of the vanity and brevity of
earthly life. With its intimations of the evanescence of life and inevitability of
death, Manet's *Boy Blowing Soap Bubbles* faithfully followed this genre. Never-
theless, if Manet was brooding on death and extinction, he also perhaps kept a
shrewd eye on his artistic career. Executed with a careful brushwork, *Boy
Blowing Soap Bubbles* was a beautiful and inoffensive painting of the sort
beloved by Salon juries and art collectors alike.

By some point in the autumn of 1867 Manet resumed work on *The Execution
of Maximilian*. In keeping with the stringent researches carried out by history

painters such as Meissonier, he arranged for a number of French infantrymen, Chasseurs à Pied from a nearby barracks—"foot soldiers" whom the Emperor had often called upon to put down various riots and insurrections—to come to his studio and pose with their muskets aloft.[11] This dedication resulted, however, in the anachronism of the Juáristas wielding French infantry muskets rather than the Springfield rifle muskets with which they had actually shot Maximilian. Manet also made the uniforms of the soldiers in his painting similar to those of the Chasseurs à Pied posing in his studio, though he gave them swords and made a few minor alterations, such as removing the epaulettes and adding white spats.[12]

These errors were not due simply to Manet's slipshod efforts at historical accuracy. By the time he recommenced work on his second version of the scene, information about the execution was suddenly exceedingly difficult to come by. In September the photographs described in the article in *Le Figaro* had been interdicted. Soon afterwards, a dealer of photographic prints named Alphonse Liébert was sentenced to two months in prison and slapped with a 200-franc fine for possessing copies of them with an intent to distribute.[13] Such censorship, so typical of the Second Empire's approach to the press, did not merely

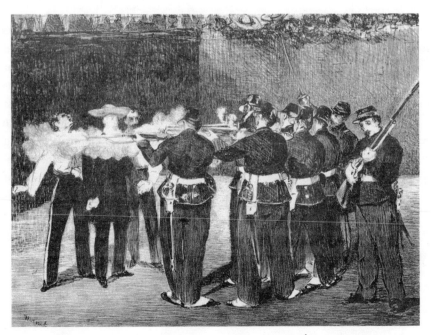

Lithograph of The Execution of Maximilian *(Édouard Manet)*

hinder Manet's researches; it also threatened to make his gigantic canvas illegal. Though he must have realised that his *Execution of Maximilian* could likewise be proscribed in order to spare Louis-Napoleon the embarrassment of witnessing how his foreign policy had concluded in a hail of bullets, Manet nonetheless carried on with the work. He may well have wished to use the painting to provoke Louis-Napoleon, a man for whom he and his friends, republicans to a man, had little love or respect. He had no doubt rehashed the Mexican episode at length during his stay in Trouville with Antonin Proust, who regularly assaulted the Imperial government in the pages of *La Semaine*, a journal so inflammatory that it was printed in Belgium in order to circumvent the censorship laws in France.

The soldiers from the Chasseurs à Pied who posed for Manet in the Rue Guyot might have had reason, once the painting was finished, to feel betrayed by *The Execution of Maximilian*. Manet seems deliberately to have changed the colour of the Juáristas' uniform from grey (as described in *Le Figaro*) to blue, thus making it more closely resemble the French uniform. The implication was that French troops, by retreating from Mexico, had been responsible for the death of Maximilian.[14]

That Manet held Louis-Napoleon to blame for the death of Maximilian appears to be suggested by the soldier on the right of the canvas who prepares, with menacing sangfroid, to deliver the *coup de grâce*. Manet had his facts right, since a Mexican soldier was indeed required to step in to finish off the Emperor as he lay bleeding on the ground after the first round of .58-calibre bullets failed to kill him. However, Manet gave this executioner a goatee beard that made him look uncannily like Louis-Napoleon. The clever and none-too-subtle touch illustrated what many people believed, not least the tragically distraught Empress Charlotte. Yet it was not one bound to endear Manet to an administration that already treated him as a reprobate and an outcast.

CHAPTER TWENTY-THREE

Manoeuvres

E RNEST MEISSONIER SOMETIMES rode all the way through the Forest of Saint-Germain, along the Route de la Reine, to emerge on the south side, in the ancient town of Saint-Germain-en-Laye. Only a few miles west of Paris, Saint-Germain-en-Laye was home to a cavalry garrison, the 10th Regiment Cuirassiers, whose commander, Colonel Dupressoir, was a friend of Meissonier. A portly man who loyally trimmed his beard and waxed his moustache in the style of Louis-Napoleon, the fifty-one-year-old Dupressoir was an experienced cavalry officer who had served in both the Dragoons and Carabiniers. During several of Meissonier's visits to Saint-Germain-en-Laye, Dupressoir obligingly put a company of his *Gros Frères* through their paces as the painter watched attentively from his saddle. Édouard Manet was therefore not the only painter for whom troops of soldiers were taking time away from their training to strike dramatic poses. More than four years after starting his work, Meissonier was still doing his best to capture the "flash of swords" at the Battle of Friedland.[1]

Unlike Manet, Meissonier had no subversive intentions with his painting. On the contrary, he wished to glorify Napoleon Bonaparte, the cuirassiers who had fought for him at Friedland, and by implication the fighting spirit of the French military across the decades. This lofty aim, together with Meissonier's reputation as France's greatest painter, made Colonel Dupressoir and his men only too happy to assist him in whatever way they could. Meissonier had already been studying charging horses with the help of his son Charles on their early-morning jaunts through the Forest of Saint-Germain. The pair would take their horses along the wide bridle path leading from Poissy to Maisons-Laffitte, five miles to the east.

"When we thought we had got far enough away and were alone," Charles later re-
called, "my father would say to me, 'Make your horse gallop.' Then, putting his
own horse at the same pace, and keeping on the opposite side of the road, he would
study each movement." Meissonier was attempting to capture, according to
Charles, "the rhythm and successive modifications of the horse's action."[2]

These experiments in equine locomotion were continued on the parade
ground at Saint-Germain-en-Laye. According to Charles, a witness to these
grand re-enactments, the cuirassiers were delighted to demonstrate "all the
massed movements that might furnish him with as close an image as possible

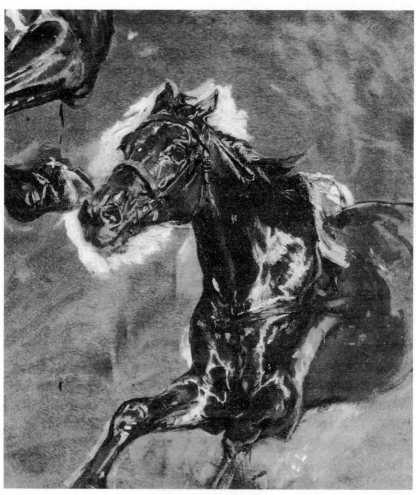

Study of horses in motion (Ernest Meissonier)

of war, with its furious bursts, its hand-to-hand encounters, its charges, its mêlées."[3] Meissonier may have earned their respect with his own adept horsemanship, since he rode his own steed alongside the charging cuirassiers, "gazing as if hypnotised," according to Charles Yriarte, and then frantically noting down everything he witnessed.[4]

Besides demonstrating their attack formations and the secrets of hand-to-hand combat, the cuirassiers had another task to perform for Meissonier: he requested that they and their horses trample a field of wheat. Just as *The Campaign of France* had required him to rake across the grounds of the Grande Maison vast quantities of flour to double as snow, his work on *Friedland* demanded a battered crop of ripening wheat—the landscape on which the incident depicted had taken place. Yriarte claims Meissonier purchased an entire field over which he hired horsemen from a cavalry company to tromp.[5] Another of Meissonier's friends, Albert Wolff, likewise a writer for *Le Figaro*, maintained that the painter actually planted the crop in his park at Poissy, then hired the horsemen to flatten it once June, the month of the battle, had arrived.[6] Whatever the exact circumstances, Meissonier had assembled his easel in the middle of the field and made *plein-air* sketches of the ears of wheat scattered across the ground.

These studies seem to have been completed in 1867 or the first half of 1868. Meissonier included one of them in a portrait he began early in 1868, that of Gaston Delahante, owner of *The Campaign of France*. The banker posed for the portrait not at his own mansion but, in what amounted to a kind of advertisement for Meissonier's taste in interior decoration, in one of Meissonier's antique Louis XIII chairs, with a carved trunk beside him and a tapestry on the wall behind. Also in the background was an easel with a sketch of *Friedland* clearly visible, while a piece of paper lying casually on the floor proclaimed: "Gaston Delahante. E. Meissonier, 1868." The cost to Delahante was 25,000 francs, one of the highest prices ever paid by a sitter for his portrait.[7]

Delahante naturally could not fail to notice how Meissonier's latest masterpiece was proceeding. But when he expressed an interest in acquiring *Friedland* he learned how the painting was already spoken for. The buyer was not Henry Probasco, who had returned to Cincinnati with tens of thousands of dollars' worth of books and other treasures but without, however, getting his hands on *Friedland*. His offer of 150,000 francs had been topped by a bid from Lord Hertford that seems to have been in excess of a stratospheric 200,000 francs.[8] At this price, *Friedland* cost more than double the amount ever paid for a painting by a living artist. To put this sum into perspective, twenty years earlier,

Alexandre Dumas *père* had spent 200,000 francs constructing his Château de Monte Cristo, a lavish Renaissance-style castle featuring a moated studio, statues by James Pradier, and a Moorish salon carved by a team of craftsmen specially imported from Tunisia; while *Le Moniteur* once reported that 200,000 francs could support a brigade of soldiers—some 2,000 men—for as long as six months.[9] The price tag of 200,000 francs was therefore an extravagance even for the man who owned Bagatelle, the beautiful château built for Marie-Antoinette in the Bois de Boulogne.

The Universal Exposition of 1867 and the months following its closure at the end of October comprised for Meissonier a kind of *annus mirabilis* in what had already been a miraculously successful career. If he entertained any worries about his finances (and his passion for aggrandising his property at Poissy certainly gave him a few anxious moments over the years), then the 200,000 francs would happily lay these to rest. And if he retained any worries about his critical reputation, he could rejoice in the assurances of the many critics who claimed he possessed, in the words of Charles Blanc, "no equal . . . either in France or anywhere else."[10] His career had reached a magnificent peak by the time he celebrated his fifty-third birthday in February. He also relished other domestic delights, since he would mark his thirtieth wedding anniversary later in the year, a few weeks before his son Charles—who had succeeded in winning the hand of Jeanne Gros—was due to marry. Charles himself seemed poised to become a great success as a painter, a worthy heir to his father. Not only had *While Taking Tea* been awarded a medal at the 1866 Salon, but Charles was celebrated by the reviewer for the *Revue du XIX^e Siècle* as an artist whose talent "seizes you with its lively charm, which harbours sharp and rigorous drawing, and which bursts with the right colour—youthful, stimulating, harmonious, virile and truthful."[11] Buoyed by so many accomplishments, Meissonier was unprepared for the rebuke he was about to receive as the Salon of 1868 approached.

The *règlement* for the 1868 Salon was published in *Le Moniteur universel* a little more than a week after the Universal Exposition closed at the end of October. The numerous protests over the previous two Salons—the chanting in the streets, the petitions, the violent threats—had convinced Nieuwerkerke that he could no longer avoid making alterations to how the jury was chosen. Four years earlier, the furores of 1863 had persuaded him to allow certain artists to elect three quarters of the jurors, effectively marginalising the most reactionary painters. But the artists casting their ballots had constituted an élite group who had either won medals at the Salon or been decorated with the Le-

gion of Honour. The controversies surrounding the Salons of 1866 and 1867 indicated that a noisy rump of artists had yet to be appeased by what they regarded as half-measures and token gestures.

The time had therefore come for Nieuwerkerke to surrender to the democrats: his new *règlement* announced that two thirds of the jury for the 1868 Salon would be elected by artists who had ever exhibited as much as a single work at the Salon, regardless of whether or not the work had been awarded a medal of any description. Hundreds of artists were thereby enfranchised. Perennially unsuccessful painters such as Paul Cézanne would still be excluded from the ballot box; but Manet, Fantin-Latour, Whistler, Monet, Renoir, Pissarro and Degas were suddenly eligible to vote for the first time. Cabanel, for one, was displeased with this new democracy: "It's just like in politics," he lamented, "it makes a fine mess of things."[12]

The deadline for submitting work to the 1868 Salon was March 20, with ballot papers due to be counted two days later. The first weeks of March therefore witnessed, besides the usual scenes in which hopeful masterpieces trundled down the boulevards on the tops of pushcarts, much frantic politicking on the part of the artists as the more savvy and ambitious among them recognised that in order to get themselves elected they needed to campaign as vigorously as any politician. Meetings were therefore convened, committees appointed, parties formed, manifestos composed, and slates of candidates thrust forward. Not surprisingly, Gustave Courbet, a veteran of so many previous battles, proved himself the most energetic politician; he wasted no time putting together a group called "The Committee of Non-Exempt Artists." Consisting of twelve candidates, his impressive roster encompassed two former jurors, Daubigny and Charles Gleyre, and a number of other successful and well-known painters.*

In the run-up to the election, the Committee of Non-Exempt Artists embarked on a well-organised campaign that left no one in any doubt about their intentions. Their slogan was "Liberty in Art," and their published manifesto—which came with a detachable ballot paper inscribed with the names of the twelve candidates—declared that they would follow "a frankly liberal course"

*Courbet's other candidates were Adolphe Yvon; Hugues Merle; Louis-Henri de Rudder; the journalist Jules-Antoine Castagnary; the Néo-Grec painter Auguste-Barthélémy Glaize, whose work had been appearing at the Salon since 1836; a former student of Glaize named Théodule-Augustin Ribot, who had been an exhibitor at the 1863 Salon des Refusés; two landscapists, Charles Jacques and Eugène Isabey; and the journalist Henri Rochefort (on whom, more below).

and "open the doors of the Salon to all artistic production, whatever its incli-
nation, which they agree unanimously not to reject."[13] They were therefore a
team of prospective jurors who planned, should they get elected, to abolish the
jury altogether. Nieuwerkerke must have held his breath as, on March 22, the
Palais des Champs-Élysées filled with artists clutching their ballot papers.

Manet did not put himself forward as a candidate for the painting jury; but
not having made a single sale from his 18,000-franc investment in the Place de
l'Alma, he decided to end his boycott of the Palais des Champs-Élysées and
send work to the 1868 Salon. He had failed to complete *The Execution of Max-
imilian* on time to hang it in his pavilion, which had closed on October 10; nor
was it ready by the time the deadline for Salon loomed. He had abandoned his
second version of the work some time in the autumn and commenced yet an-
other, this time on an even larger canvas, exactly ten feet wide. But since this
latest version of Maximilian's execution was likewise incomplete by the middle
of March, he submitted two portraits instead.

The first of these paintings, done some two years earlier, was of Victorine
Meurent. Placing before the jurors yet another image of Victorine may have
looked like a provocative stunt and a foolish temptation of fate. For this can-
vas, however, she had worn clothing; or at any rate she had donned a pink
peignoir and posed in Manet's studio with an African grey parrot. Begun
around the time of the Salon of 1866, the work was entitled *Young Lady in
1866*. Though Victorine struck a modest pose, little doubt could be left in
the mind of the spectator about the profession followed by this particular
"young lady": Manet had, as usual, cast Victorine as a prostitute. Parrots
were well known as a signature attribute of the courtesan, with Marie Du-
plessis, for instance, one of the most famous courtesans of the century, hav-
ing kept a parrot with brilliant feathers in a gilded cage in her apartment in
the Rue de la Madeleine. The bird, which she had taught to sing, was sold at
auction along with the rest of her possessions after she died in 1847 at the age
of twenty-three.*

The subject of Manet's second portrait was, if anything, more notorious

*Born Alphonsine Plessis, the daughter of a tinker, Marie Duplessis was the most famous
woman in Paris for a brief period in the 1840s. During her short career she would inspire
Franz Liszt, marry the son of King Louis-Philippe's banker (thereby acquiring the title
Comtesse de Perregaux), and become the lover of Alexandre Dumas *fils*, whose novel
(and subsequent play) about her, *La Dame aux Camélias*, inspired Giuseppe Verdi's *La
Traviata* in 1853.

than Victorine Meurent. Some time after closing his pavilion in the Place de
l'Alma he had begun a portrait of Émile Zola. Already infamous for his art
criticism, by the time the painting was under way Zola had become still more
ill-famed as his novel *Thérèse Raquin*, serialised in *L'Artiste* between August
and October, appeared in book form in December. A lurid tale of adultery and
murder among working-class Parisians, this work plunged even his scan-
dalous first novel, *The Confession of Claude*, into the shade.

Thérèse Raquin tells the story of an adulterous affair between the title charac-
ter, the wife of a lowly clerk in a railway company, and a would-be painter
named Laurent whose canvases (rather like those of Zola's friend Cézanne)
"defied all critical appreciation."[14] Zola evoked controversial Realist painters
such as Courbet, Manet and Cézanne not merely through his portrayal of Lau-
rent and his violent and ugly canvases layered thickly with paint. The milieu of
Manet's *Le Déjeuner sur l'herbe* was suggested in Chapter Eleven, in the novel's
murder scene, where Camille, the cuckolded clerk, goes on a day's outing with
his wife and her lover to Saint-Ouen, directly across the Seine from Asnières.
Here the three of them encounter among the fairground stalls and raucous
cafés the sorts of daytrippers typically found along this stretch of river: office
workers and their wives, people in their Sunday best, crews of oarsmen, and
"tarts from the Latin Quarter."[15] They find a shaded spot in the woods where
they sit on the grass, the two men in their coat-tails and Thérèse—in a kind of
homage to Victorine Meurent—provocatively baring a leg. This description
of a threesome reclining on the grass beside the river would undoubtedly have
put many readers in mind of Manet's *Le Déjeuner sur l'herbe*. And the violent
outcome of the scene—Camille is strangled and thrown into the Seine—may
have confirmed the suspicions of those visitors to the Salon des Refusés who
had found something immoral about Manet's ill-assorted grouping of figures.

Zola had confidently predicted to his publisher that *Thérèse Raquin* would
enjoy a "*succès d'horreur*."[16] The forecast proved accurate as the novel be-
came both hugely popular—the first edition sold out in less than four
months—and highly controversial. The novel was denounced as "putrid lit-
erature" by a writer in *Le Figaro*. "In the past several years," the critic ex-
claimed in outrage, "there has grown up a monstrous school of novelists
which pretends to replace carnal eloquence with eloquence of the charnel
house, which invokes the strangest medical anomalies, which musters plague
victims so that we can admire their blotchy skin . . . and which makes pus
squirt out of the conscience."[17] Zola could hardly have been more pleased
with the denunciation. Taking maximum advantage of the opportunities for
publicity, he fired off a defence of his so-called "cesspit of blood and filth" in

a preface to the second edition.[18] He claimed his motive was a scientific one and the novel itself merely a kind of experiment in which he scrupulously but dispassionately viewed the results of mixing together a powerful man and an unsatisfied woman. His efforts, he suggested, resembled those of a chemist with his test tubes or an anatomist with his scalpel and his corpse—or, better still, a painter with his paintbrush and a nude model. "I found myself in the same position," Zola wrote, "as those artists who copy the nude body without feeling the least stirrings of desire, and are completely taken aback when a critic declares himself scandalised by the living flesh depicted in their work."[19]

Manet was full of congratulations for his friend's robust defence. "I must say that someone who can fight back as you do must really enjoy being attacked," he wrote after the preface appeared in print.[20] He recognised, of course, that Zola's project was entwined with his own: "You are standing up not only for a group of writers," he wrote, "but for a whole group of artists as well."[21] But if Manet's portrait was to show both his gratitude to and his solidarity with Zola, his choice of a subject was a controversial one. He was proposing to place before the 1868 jurors—and then, if all went well, before the members of the public—the image of French literature's greatest *enfant terrible*.

Portrait of Émile Zola was made even more provocative by its conspicuous inclusion of a particular prop. Zola, who posed for the portrait over the course of several months in Manet's studio, was depicted sitting at a desk with a book in his hand and a number of pictures pinned to the wall. One of these pictures featured the unmistakable image of Victorine posing as *Olympia*—a sight bound to raise eyebrows during the jury sessions. In a witty visual joke, Manet altered Victorine's eyes so that they directed themselves at the seated figure of Zola, her defender and champion. He had therefore given his most controversial work a pride of place in both his studio and his portrait of Zola. And he proposed to smuggle back into the Palais des Champs-Élysées the inflammatory image of Victorine reclining naked on her pillows.

More than 800 painters gathered to cast their ballots for the 1868 jury, almost seven times the number who had voted a year earlier.[22] There was much frenzied politicking by the teams of candidates as campaigning continued right up to the door of the Palais des Champs-Élysées. The atmosphere was later described by Zola, who wrote that voters were "pounced upon by men in dirty smocks shouting lists of candidates. There were at least thirty different lists . . . representing all possible cliques and opinions: Beaux-Arts lists, lib-

eral, die-hard, coalition lists, 'young-school' lists, and ladies' lists. It was exactly like the rush at the polling booths the day after a riot."[23]

The result of the wider suffrage and the campaigns by painters such as Courbet produced a jury that, after the dust had settled, appeared to differ very little from those of the previous few years. Each of the twelve painters elected for service in 1868 had served on at least one previous jury, though Cabanel and Gérôme, who normally polled at the top of the list, were placed only seventh and twelfth respectively. The man who drew the most votes, by a substantial margin, was Daubigny, a member of Courbet's slate for whom more than half of all voters had ticked. He had been a popular choice among many of the younger artists, such as Pissarro and Renoir, who were voting for the first time, and who had appreciated the support of this "man of heart" against his more conservative colleagues on the Jury of Assassins in 1866. However, the only other member of Courbet's party to get himself elected was Charles Gleyre, and the voters returned several prominent members of the Jury of Assassins, including Baudry and Breton.

Perhaps the biggest surprise of the voting was that Meissonier failed to find special favour with the electorate, falling short of the 275 ballots required for elevation onto the jury. Despite his towering reputation, enhanced over the previous few months by both the Universal Exposition and the sale of *Friedland*, he finished only fifteenth, which gave him a position as one of the alternates. His disenchantment with the Salon, where he had not stooped from his Olympian heights to show work since 1865, coupled with his lack of enthusiasm for the invidious task of serving on the jury, meant he had not actively campaigned for votes. Even so, such a modest showing was a humiliation for the man hailed as Europe's greatest artist. Many of the younger artists who had been enfranchised for the first time, and who were struggling to get their work displayed, clearly did not regard the stupendously successful Meissonier as someone who might best understand their aims or represent their interests.

Meissonier's immediate response was to resign from his position as an alternate. This indignant rejection of the decision of his peers appears to have won him few friends, especially among the younger painters; in fact, it seems to have been a turning point in his career. By 1868 he was fast becoming a marked man. His enormous success and conspicuous prosperity meant that the younger generation—and in particular propagandists for the Generation of 1863 such as Zola and Zacharie Astruc—regarded him as a giant to be slain, together with the two other artistic leviathans of the age, Cabanel and Gérôme. The stratospheric prices fetched by Meissonier's paintings as well as

his abundant critical laurels jarred all too conspicuously with, for example, Manet's collection of grisly reviews and his stack of unsold canvases, while the painters of the Generation of 1863 found his painstaking technique diffi-cult to appreciate. Astruc had assailed him as early as 1860, disparaging his work for its supposed creative destitution. After seeing an exhibition of Meis-sonier's paintings in the Galerie Martinet, Astruc sneered that the work demonstrated "neither movement nor heat nor spirit nor imagination, but only cold-bloodedness, tenacity and, embroidering the whole, a patience for work verging on the phenomenal."[24]

The ground had begun subtly to shift beneath Meissonier's feet. He may have been more sympathetic than most of his colleagues on the jury to the techniques and styles of the *refusés* of 1863 and 1866; yet the "new movement" praised by Zola—the striving for an abstraction of visual effect through the apparently spontaneous application of paint—was as far removed as could be imagined from the severe precision of his own style. Gautier had once en-thused over how Meissonier painted so realistically that the viewer fancied he could see his figures' lips move.[25] By the middle of the 1860s this sort of finicky exactitude was suddenly, in the eyes of certain painters, merely the stock-in-trade of the technically flawless but creatively barren alumni of the École des Beaux-Arts. Even Delacroix had once admitted in his journal, with pointed reference to Meissonier, that "there is something else in painting be-sides exactitude and precise rendering from the model."[26] Meissonier suddenly found himself in danger of being assailed for the very techniques which had won him such fame in the first place.

A Salon of Newcomers

THE PROTESTS AND petitions launched in the spring of 1867 seemed to have borne fruit when the results of the 1868 jury's decisions were made public: more than 5,000 works of art—paintings, sculptures, engravings, photographs—had been submitted, of which more than eighty-three per cent were accepted, including 2,587 paintings.[1] The successful artists included Camille Pissarro, who had desperately needed some good news after his rejections in 1866 and 1867. With his riverbank views lingering unsold in his studio, and with two young children to feed, he had been forced to earn money by painting awnings and shop signs. In April, however, he received a letter from Daubigny reporting that both of his pictures had been admitted.[2] These canvases, both landscapes, were views of Pissarro's newly adopted home of Pontoise, a market town on the River Oise, eighteen miles north-west of Paris. Another *refusé* from the previous two Salons, Renoir, likewise found favour with the jury, as did Manet's elegant friend Edgar Degas. In keeping with his love of ballet and opera, Degas had submitted a dreamy costume-piece, *Mademoiselle Eugénie Fiocre in the Ballet "La Source,"* which was based on a scene from a ballet performed with much success at the Paris Opéra in 1866.

Both of Manet's submissions, *Young Lady in 1866* and *Portrait of Émile Zola*, were accepted without, apparently, either questions or confabulations. The jurors were perhaps reluctant to decline these works lest they bring down on their heads the wrath of the bellicose subject of the second portrait, since Zola had been engaged to cover the Salon for *L'Événement illustré*, a journal that had risen from the ashes of *L'Événement* following its suppression by the authorities at the end of 1866. In any case, Manet would make a return to

the Palais des Champs-Élysées for the first time since the controversy over *Olympia* three years earlier.

Despite the new munificence on the part of the jury, the results still managed to yield a few disappointments. Paul Cézanne, as ever, failed to have a canvas accepted. One of Cézanne's friends explained his failure by averring that he had "no chance of showing his work in officially sanctioned exhibitions for a long time to come. His name is already too well known; too many revolutionary ideas in art are connected with it; the painters on the jury will not weaken for an instant."[3] This perhaps overestimated Cézanne's notoriety, but his arrestingly unique style—combining Courbet's use of the palette knife with Manet's thick outlines and sharp juxtapositions of colour—produced undeniably brusque-looking canvases with bold but sometimes virtually indecipherable images. The subject matter of his work was frequently as alarming as the style. In 1868 he painted *The Murder*, a disturbingly brutal scene in which two figures, one wielding a dagger, are shown violently attacking a third. He had also made preparatory sketches for *The Autopsy*, featuring a man's naked corpse stretched on a mortuary slab as a bearded doctor prepares to set to work. Such eerie-looking scenes had little chance of finding a place on the walls of the Salon. But Cézanne had been persistent, going to the Palais des Champs-Élysées each March, as another friend wryly observed, "carrying his canvases on his back like Jesus with his cross"[4]—and then bearing them, stamped with a red R, back to his grubby studio. Such martyrdom began to grate. Cézanne's constant rejection made him even more bitter and cantankerous than usual on the rare occasions when he could be tempted to join the company in the Café Guerbois. Asked by Manet on one such circumstance whether he intended to submit anything to the Salon, Cézanne had retorted: "Yes, a pot of shit!"[5]

Claude Monet also faced disappointment. One of his offerings, a seascape called *Boats Leaving the Port of Le Havre*, was admitted by the jury only after impassioned insistence from Daubigny; but not even Daubigny's pleas could save his second entry, *The Jetty at Le Havre*. Nieuwerkerke, who served as president of the jury, and who was no admirer of landscapes, was at loggerheads with Daubigny not only over Monet's work but also over the submissions of many other young painters. The Superintendent regarded Daubigny as a "liberal" and a "freethinker" who wished indiscriminately to open the doors (in line with the Courbet manifesto) to all painters regardless of taste and talent. Nieuwerkerke therefore took a firm stand over *The Jetty at Le Havre*. "We have enough of that kind of painting," he informed Daubigny.[6]

The rejection of any of his paintings was inopportune in view of Monet's precarious domestic situation. Camille Doncieux had given birth to their

child, a son named Jean, the previous August. "Despite everything, I feel that I love him," Monet wrote to Bazille, adding: "It pains me to think of his mother having nothing to eat."[7] Monet had not been present for the birth of his son. Summoned back to Normandy earlier in the summer, he had been living with his aunt, in a kind of enforced exile, at her seafront home in Sainte-Adresse. He was able to make only the occasional swift trip into Paris to visit Camille, who suffered through the winter of 1867–68 with barely enough money for coal. These excursions were not without a certain risk: Monet had to be careful neither to arouse the suspicions of his father nor excite the attentions of his various creditors.

Still, despite the demurrals from Nieuwerkerke and more conservative jurors such as Baudry and Breton, almost 2,000 more paintings would be shown at the 1868 Salon than a year earlier. So many artists appeared for the first time, in fact, that Castagnary quickly dubbed it "the Salon of Newcomers."[8]

The liberalisation of the jury's selection process in 1868 was mirrored by another progressive measure taken by the government. The Salon of 1868 coincided with a relaxation in censorship laws as, on May 11, less than a fortnight after the Salon opened, the Emperor repealed many of the draconian restrictions under which newspapers had operated for most of the previous two decades.

"Liberty has never helped to found a lasting political edifice," Louis-Napoleon once wrote in defence of his policies. "Liberty crowns the edifice when time has consolidated it."[9] Louis-Napoleon's own political edifice, the Second Empire, had been consolidated through a military coup and the Law of General Security, as well as various censors, bans, imprisonments and deportations—the whole raft of measures that *The Athenaeum*, across the Channel, had claimed amounted to "political slavery."[10] The Emperor believed that these tyrannical methods had been necessary in order to forge the thriving, modern nation that France had finally become. He was so proud of his various accomplishments that he had even taken notes for a novel that he planned to write about a grocer named Benoît who returns to France after many years in America to discover the jaw-dropping wonders and utopian delights of the Second Empire. Expecting to find misery and poverty, Benoît is thrilled and impressed by France's universal suffrage, by its cheap consumer products, its telegraph and railway systems, its well-paid soldiers, convalescent homes, pensions for disabled priests, and by any number of other enlightened social policies overseen by the Emperor.[11]

With all of these improvements in place by 1868, the time was ripe, the Emperor believed, to unchain the press. Accordingly, stamp taxes were lowered and licences for journals abolished, which meant journals and newspapers

could be founded and published without authorisation from the government. As well, governmental officials lost their powers of warning and then suspending or suppressing journals (such as *L'Événement*) that they deemed subversive. The result of the press law of 1868 was that scores of new journals were immediately founded, both in Paris and the provinces—virtually all of them hostile to the Emperor. In the months following the promulgation of the new law, more than a hundred journals sprang up in Paris alone. "They are cramped for space in kiosks," one journalist claimed, "and newspaper dealers, positively overwhelmed, do not know where to tuck the latest arrivals."[12]

Most of these journals arrived in the kiosks too late to cover the 1868 Salon, and so Manet and other members of the so-called École des Batignolles faced the same familiar adversaries in the columns of the same familiar newspapers. Their cause was also thwarted by the Marquis de Chennevières, who, anxious as ever to impede the advance of the democrats, had ensured that their works were skyed. Pissarro's paintings of Pontoise, for example, had been hung near the ceiling on orders from the Hanging Committee, though Castagnary noted that even this lofty altitude failed "to prevent art lovers from observing the solid qualities that distinguish them."[13] Nor was it enough to put off the critics, many of whom singled out his work for special praise.[14] At the age of thirty-eight, Pissarro was finally beginning to win himself a reputation as a landscapist worthy of his two mentors, Corot and Daubigny.

Manet's two works received a more uneven press. As soon as the Salon opened, Zola dashed off an article for *L'Événement illustré* in which he declared that the "success of Manet is complete. I dared not believe it would be so rapid and deserving. . . . The necessary and inevitable reaction which I prophesied in 1866 is slowly taking place. The public is becoming acclimatised; the critics are growing calmer and consenting to open their eyes; success is on the way."[15] Castagnary likewise praised *Portrait of Émile Zola* as "one of the best portraits in the Salon,"[16] but on the whole Manet's paintings attracted chiding reviews. One critic claimed that the canvases showed his "coarse and ugly eccentricities, the fruit of vanity and impotence"; another, in the *Gazette des Beaux-Arts*, that he was stirring up controversy "quite voluntarily and uselessly." A reviewer in *La Presse* lamented that Realists such as Manet were "capable of anything!" In *L'Artiste*, the journal in which *Thérèse Raquin* had been serialised the previous year, Manet was taken to task for his lack of control, muffled hues and poor modelling; and in a provincial journal, *Le Gironde*, the young painter Odilon Redon, who had praised Pissarro, claimed that Manet's portrait of Zola, due to its lack of animation, was more like a still life than a portrait.[17]

Nonetheless, the hilarity and hostility that had accompanied the exhibitions

of his work in 1863 and 1865 was not repeated; and most critics recognised that his was a name to conjure with, if only because so many young painters had rallied around him. "The leader, the hero of Realism, is now Manet," wrote Théophile Gautier. "His partisans are frenzied and his detractors timid." Manet's work seemed to make Gautier—once the floppy-haired, hashish-smoking champion of "Young France," but now fifty-seven years old and nursing both gout and a heart ailment—feel his age and sense the final passing of the fabled Generation of 1830. "It would seem," he wrote with a wistful resignation in *Le Moniteur universel*, "that, if one refuses to accept Manet, one must fear being taken for a philistine, a bourgeois, a Joseph Prudhomme,* an idiot who cares for nothing but miniatures and painted porcelain. . . . One examines oneself with a sort of horror . . . to discover whether one has become obese or bald, incapable of understanding the audacities of youth." And Gautier frankly admitted that he was indeed incapable of understanding the audacities of this new generation. The paintings of Courbet, Manet and Monet held beauties, he claimed, "apparent to young people in short jackets and top hats"—the sort of conformist dress that Gautier despised—"but which escape the rest of us old Romantic greybeards."[18]

As the ailing Gautier recognised, the Salon of Newcomers marked an important juncture in French art. The occasion was marked by the prescient Zola. His weekly reviews in *L'Événement illustré* ignored the traditional heroes of the Salon in favour of singling out for evaluation and praise a new group of painters, members of the École des Batignolles, whose names he introduced to the public. To the thousands of Salon-goers who had never before heard the name Camille Pissarro, much less noticed his landscapes, Zola presented this "intense and austere personality" as "one of the three or four painters of our time" and ventured that public opinion would soon pronounce itself in his favour.[19] He also gave, week after week, well-versed introductions to, and shrewd appraisals of, Monet, Bazille, Renoir and Degas, as well as Manet and Courbet, calling them *naturalistes* and *actualistes*, and identifying them as a distinct group at the head of a new artistic movement. They were painters, he argued, who ignored traditional bourgeois tastes in favour of a courageous pursuit of the modern, the original, and the true.[20]

The medals at the 1868 Salon were collected not by any of these *actualistes*,

*Joseph Prudhomme, created by the caricaturist Henri Monnier (a contributor to *Le Charivari*), was a personification of the vulgar, well-heeled and self-satisfied bourgeoisie who grew up under the July Monarchy.

however. Works catering to what Zola called bourgeois tastes collected the majority of the prizes, with the roll call of winners featuring painters such as Jules Worms, Henri Klagmann, Victor Giraud, Pierre de Coninck, Alphonse Muraton and a forty-one-year-old named Pierre-Honoré Hugrel, who was rewarded for a Cabanelesque nude scene entitled *Nymph Playing with Cupid*. The Grand Medal of Honour, meanwhile, went to Gustave Brion, a member of the jury. Probably most famous for having done 200 illustrations for a popular 1863 edition of Victor Hugo's *Les Misérables*, Brion specialised in rural scenes featuring peasants whose quaint customs and antique costumes recalled the idyllic charm of many of Meissonier's lace-and-buckle period pieces. His prize-winning canvas in 1868, *Bible Reading: Protestant Interior in Alsace*, was typical of his work—and typical of the sort of sentimentalised scene that Zola claimed so delighted the bourgeoisie.

Not only did Manet and his fellow members of the École des Batignolles fail to receive either prizes or praise from the administration; further indignities befell them. Midway through the Salon, following the announcement of the medals, Nieuwerkerke and Chennevières always rearranged the paintings in the Palais des Champs-Élysées to highlight both the prize-winners and the dozens of works purchased by the government. In 1868 they took advantage of this reshuffle to remove paintings by many of the *actualistes* from the alphabetised rooms and place them in a room at the very back of the building known by the artists as the *dépotoir* ("rubbish dump")—an out-of-the-way room into which few Salon-goers ventured. Though Manet's paintings did not suffer this relegation, the contributions of Renoir, Bazille and Monet spent the last few weeks of the Salon in this humiliating obscurity, with Renoir's *Lise* and Bazille's *Family Gathering* skyed even in the *dépotoir*. For Castagnary, a critic sympathetic to the *actualistes*, this shabby treatment was a sure sign that the work of the newcomers praised by Zola had delighted the public as much as they had displeased Nieuwerkerke and Chennevières.[21]

Au Bord de la Mer

A NTIBES, IN THE south of France, was a sleepy fishing village fortified
by ramparts and surrounded by pine forests and stretches of sandy beach.
Olive trees shaded its winding roads and the star-shaped Fort Carré loomed
over the turquoise waters of the cove. In 1868 Antibes was home to a perfume
factory, a sardine fishery, and little else apart from a botanic garden founded a
decade earlier by Gustave-Adolphe Thuret, the biologist who had elucidated
the sexual reproduction of seaweeds. The railway from Paris had arrived at
Cagnes-sur-Mer, six miles from Antibes, in 1863, causing luxury hotels and an
esplanade to sprout in Cannes; and for several generations English aristocrats
had spent their winters close by at Nice, where each day, on orders of Sir
Thomas Coventry, a cannon was fired at twelve o'clock to remind them to eat
their lunch. But tourists had not yet arrived in Antibes, nor had the seaside re-
sort of Juan-les-Pins been founded. This stretch of the Midi, 400 miles from
the capital, was still terra incognita to most Parisians. Between 1814 and 1860 it
had belonged not to France but to the Kingdom of Sardinia. The people spoke
Provençal, a dialect that successive educational campaigns had failed to eradi-
cate; and they were believed by northerners to be indolent, superstitious, pas-
sionate and (in the words of one writer) "voluptuous to the point of
delirium."[1] Prosper Mérimée, when he arrived in the south of France, felt he
had entered a foreign land.

Its remoteness from Paris meant that painters were still a fairly uncommon
sight in the Midi. The landscapist Félix Ziem had opened a studio in Mar-
tigues, near Marseilles, in the late 1830s, and Paul Huet visited for the good of
his health on regular occasions between 1833 and 1845, taking the opportunity

to capture slices of the south of France on canvas. "I am completely dazzled by this light," Huet wrote, "so keen and so brilliant."[2] But French landscapists overwhelmingly preferred to exercise their talents in the more muted light of the north, so the charms of Provence and what was soon to become known as the Côte d'Azur had for the most part remained unexplored. Even painters born in the Midi showed little interest in its landscape. Frédéric Bazille, a native of Montpellier, confined his landscapes to the environs of Paris, while Paul Cézanne was too preoccupied with images of violent eroticism to worry about the sunlight or mountains around his home town of Aix-en-Provence.*

The people of Antibes could have been forgiven their surprise, therefore, when the most famous painter in France suddenly appeared in their midst. Ernest Meissonier arrived in Antibes, complete with canvas and easel, in June 1868. He took with him his wife, son and daughter, as well as two of his horses, Bachelier and Lady Coningham. Meissonier may have been drawn to the region for its historical associations. After the fall of Robespierre in 1794, Napoleon had been imprisoned in Fort Carré, and on his return from exile on Elba in 1815 he had come ashore a few miles away at Golfe-Jouan. A little out to sea, meanwhile, loomed the island of Sainte-Marguerite, in whose citadel the Man in the Iron Mask was imprisoned between 1686 and 1698. As he stared out to sea, Meissonier was also reminded of Homer. "Looking at that shining sea," he wrote, "as beautiful and as inimitable in colour as the sky itself, one dreams one sees the ships of Ulysses floating on it."[3]

In the end, though, landscape and light, rather than history, were what captivated Meissonier in Antibes. "It is delightful to sun oneself in the brilliant light of the South," he wrote, "instead of wandering about like gnomes in the fog. The view at Antibes is one of the fairest sights in nature."[4] He seems to have come to the Midi mainly to indulge his passion for landscapes, devoting himself to watercolours and oils of scenes such as Fort Carré perched on its promontory overlooking the water. Never in his life had he been so prolific with his brush. The man who had been labouring for five years on *Friedland* suddenly churned out, in the space of a few weeks, canvas after canvas, most of them painted *en plein air* and beautifully refulgent with Mediterranean light. "It is a delight to work in the open air," he wrote following his stay, "and the peaceful landscape painters are a happy race. They do not suffer from nerves like the rest of us."[5]

*Cézanne would of course paint many landscapes around Aix-en-Provence, including some sixty views of Mont Sainte-Victoire; but his interest in making these studies of the Provence landscape did not develop until the 1870s.

Meissonier wandered about the village and along the coast with his easel, raising it at various points to capture the locals playing *boules* or the view along the Route de la Salice. These outdoor scenes, spontaneously executed and awash in light and colour, come as a surprise from a man known to the public only as a laboriously accurate painter of military scenes and quaint *bonshommes*. Although Meissonier had already painted numerous landscapes in and around Poissy, his new passion for *plein air* probably had something to do with his response to the recent work of painters such as Monet and Pissarro.[6] For a painter struggling with *Friedland*, in which almost every brushstroke was infinitely rehearsed, the brisk and impulsive approaches of *plein-air* landscapists seem to have prompted Meissonier to abandon his traditional obsession with historical authenticity in favour of creating eye-catching visual effects by means of a few salient touches of the brush. If these Antibes landscapes never matched the casual brushstrokes and colourful dissolutions of natural form found in the work of Pissarro, they nonetheless revealed Meissonier as a painter of remarkable versatility whose ambitions were not entirely at odds with those of the École des Batignolles. In danger of attack from writers like Zola and Astruc, Meissonier may have used his Antibes sojourn to revamp his style in order to meet the challenges of the "new movement" in painting.[7]

With his great wealth and awesome self-regard, Meissonier was hardly a man of the people. Still, several of the Antibes paintings suggest that he was happy to mix with the locals. "We should take an interest in the poor people," he once wrote, "we should talk about their affairs with them. We should love them, and be beloved by them."[8] In keeping with this philosophy, Meissonier often performed small acts of charity to relieve the miseries of the poor. One day in Poissy, for example, he came across an old blacksmith whose goods had been seized and were to be sold to cover his debts. He promptly bought all of the tools, reinstated the blacksmith in his business, and paid his rent for a year.[9] He also performed a similar sort of charity at Antibes. One of his paintings, *Mère Lucrèce*, featured an old peasant woman sitting on her doorstep with a grandchild perched on her knee. Since Madame Lucrèce lived in great poverty, Meissonier arranged to pay her a pension for the rest of her life.[10] This pension may have amounted to a paltry sum for a man no doubt aware of how he could easily sell *Mère Lucrèce* for as much as 20,000 francs; but the episode shows that Meissonier, for some a monster of ambition and pride, possessed a softer side.

Meissonier returned to Poissy with more than a dozen paintings in hand. Fresh from executing these *plein-air* landscapes, he turned once again to the formidable labours of *Friedland*. He was still dissatisfied with his representa-

tion of horses in the work. The models sculpted in beeswax, the cavalry charges organised by Colonel Dupressoir, the endless studies that left his own horses on the verge of collapse—none of these measures had allowed him to portray equine movement in quite the way he desired. He therefore decided to take even more drastic measures: he began building a railway track in the grounds of the Grande Maison.

While Meissonier travelled south in the summer of 1868, Édouard Manet, like so many other Parisians, headed north for his vacation, returning with his family to Boulogne-sur-Mer. Having taken his sketchbook with him, as well as his palette and easel, he wandered about the town in search of likely subjects, executing rapid pencil (and sometimes watercolour) studies of steamboats, lighthouses, donkeys, women under parasols, men lounging on jetties and bathing machines lumbering out of the waves.[11] These sketches then became oil canvases such as *Jetty at Boulogne* and *Beach at Boulogne*, seascapes with boats in murky silhouette against horizontal bands of pale blue and gunmetal grey strikingly different from what Meissonier had depicted in Antibes.

Besides his *plein-air* seascapes, Manet also painted an interior scene on a five-foot-wide canvas. Called *The Luncheon*, it was posed in the dining room of their rented house, that of a retired sailor, and featured a portrait of Léon Koëlla standing in the foreground. Wearing a straw boater, a dark blazer and the same vacant expression familiar from so many of Manet's portraits, the young man stands before a table littered with the remains of a meal of oysters. Seated at the table behind him, smoking a cigar and enjoying both a coffee and an amber-coloured *digestif*, is the painter Auguste Rousselin, a regular visitor to Boulogne and one of Manet's friends from their days together in the studio of Thomas Couture. In the bottom left-hand corner of the canvas, looking very out of place in this domestic scene, is a medieval helmet and a pair of swords.

Manet may have been inspired to paint these bits of armour in part by the example of a friend, Antoine Vollon, who had just scored a success at the 1868 Salon with *Curiosités*, a still life of helmets and swords that had been commissioned by Nieuwerkerke. Yet Manet's painting was quite different from Vollon's crisp delineation of Nieuwerkerke's pieces of armour. In many respects it was, like *Le Déjeuner sur l'herbe* and *Olympia*, a defiant reworking of artistic tradition. Helmets such as the one depicted in the corner of his canvas were a staple of nineteenth-century French art. Many masterpieces of French Neo-classicism, such as those by David and Ingres, featured heroic male figures nude but for their helmets and the occasional strategic fold of toga. Through the first half of the nineteenth century the numerous students and imitators of

The Luncheon *(Édouard Manet)*

David and Ingres proceeded to paint so many helmet-clad heroes from ancient Greece and Rome that a new term, *pompier*, was born to describe them. *Pompier* literally meant "fireman"—derived from *pomper*, "to pump"—and the term made reference, supposedly, to how the antique helmets of these neo-classical heroes resembled the headgear worn by the French fireman of the period.[12] The term quickly became a derogatory one and, by dint of its similarity to the word *pompeux* ("pompous"), soon connoted the pretentious and the overblown. Nonetheless, in 1868 the *pompier* spirit was still alive and well at the École des Beaux-Arts, where the most recent topic for the Prix de Rome had been *The Death of Astyanax*. However, the style was one with which Manet, who favoured top hats over plumed helmets, had scant sympathy.

Manet placed the helmet and swords on the retired sailor's armchair, where they form a kind of historical and sartorial counterpoint to Léon's straw boater and Auguste Rousselin's pearl-grey top hat. Also on the chair, directly in front of the helmet, Manet painted a black cat—a sly allusion to the most famous and controversial black cat in the history of art. Rather than arching its back as in *Olympia*, though, the cat in *The Luncheon* turns its back on the heroic-looking helmet and goes about the business of industriously licking its privates. It is a whimsical touch in a painting otherwise filled with suggestions of

boredom and claustrophobia. Manet also took a poke at the conventions of *pompier* art. Just as the plumed helmet and shield from the engraving of Raphael's *Judgment of Paris* became, in *Le Déjeuner sur l'herbe*, a wickerwork picnic basket and a jumble of discarded clothing, so in *The Luncheon* the signatures of masculine bravery celebrated in *pompier* art became cast-off props in a provincial dining room, sharing the same dignity and distinction—no more, no less—as the potted plants, corked bottles and coffee urn.

Manet completed several other oil paintings during his two-month stay in Boulogne. One of them, entitled *Moonlight, Boulogne*—a view of the harbour with the blackened silhouettes of masts and rigging visible under a full moon—he considered one of his finest works. He also painted the Folkestone steam packet that ferried passengers back and forth across the English Channel. The Folkestone boat, which he had painted in 1864, seems to have had a certain attraction for Manet; and in the last week of July, before returning to Paris, he became a passenger on it. He had decided to make his first trip to London.

Victorian London was the largest city on earth. The journalist Henry Mayhew, ascending over it in a hot-air balloon, had been unable to tell where the "monster city" began or ended. The American Henry James, writing home to his sister in Boston, claimed he felt "crushed under a sense of the sheer magnitude of London—its inconceivable immensity."[13] Its population, at more than three million, was almost double that of Paris. Over the previous few decades hundreds of thousands of immigrants had arrived, many of them refugees from all across Europe and beyond. The city was "a reservoir," claimed the journalist George Augustus Sala, "a giant vat, into which flow countless streams of Continental immigration."[14] More Irish lived in London than in Dublin and more Catholics than in Rome.[15] There were exiled Polish nationalists, Italian followers of Garibaldi, Jews fleeing pogroms in Russia, as well as German radical philosophers, such as Karl Marx, escaping the attentions of the Prussian authorities. Also among these multitudes were as many as 20,000 Frenchmen, many of them in the area around Leicester Square.[16] Édouard Manet travelled to London to visit one of them in particular: his old friend, the painter and engraver Alphonse Legros.

Having left his family in Boulogne, Manet arrived in London following a two-hour journey from Folkestone on board the South-Eastern Railway only to find the city in the midst of a heat wave of unprecedented intensity and duration. Throughout the month of July the mercury had rarely dipped below the mid-80s Fahrenheit, and on July 21 a temperature of 101 degrees was recorded.[17] The country endured deaths from sunstroke, fires on the moorlands, dried-up springs, parched meadows and, on everyone's part, extreme

physical enervation. "We are not used to being roasted, melted, exhaled," wrote the editor of *The Illustrated London News* at the beginning of August, "and most of us find a dash of unpleasantness in the process."[18] The newspapers urged men to keep cool by drinking their tea cold and by wearing wet cabbage leaves inside their top hats.[19] Women meanwhile adopted French fashions: straw hats topped off dresses made of light materials such as muslin and "gauze de Chambéry," all in pale fawns and greys rather than the dark colours more familiar in London's streets and parks.[20]

Even with the theatres and opera houses closed for the season, London offered much for a painter of modern life to appreciate. Attractions included Cremorne Gardens in Chelsea, with its open-air dance floor, and the Zoological Gardens on the north side of Regent's Park. The famous Crystal Palace, moved by the Brighton Railway Company to its new home in the suburb of Sydenham, played host, in 1868, to an exhibition of the Aeronautical Society of Great Britain at which an inventor named John Stringfellow unveiled a triplane with a one-horsepower steam engine and two twenty-one-inch propellers. Most spectacular of all, perhaps, was the Metropolitan Railway, opened in 1863, which ran underground for four miles between Paddington Station and King's Cross. Passengers sat in open carriages as steam trains conducted them through brick-lined tunnels at speeds of twenty miles per hour. These were precisely the kind of inventions, the sooty and thronging emblems of modern life, that Thomas Couture had urged his students to take as the subjects for their paintings.

A good deal of art was also on offer in London, albeit few Spanish paintings. The most famous Velázquez in England, *The Toilet of Venus*, showing the nude goddess studying her reflection in a mirror held by Cupid, was at Rokeby Hall in Yorkshire. But at the National Gallery, founded in 1824, Manet could have seen two works by this "greatest artist of all," a portrait of King Philip IV and *La Tela Real*, a depiction of a boar hunt. Meanwhile the South Kensington Museum (later the Victoria and Albert Museum) displayed some of England's greatest art treasures, including the seven Raphael Cartoons for the tapestries in the Sistine Chapel in Rome. In the summer of 1868 the museum was also hosting an exhibition of portraits, featuring work by Holbein, Vandyke, Hogarth, Gainsborough and Romney, as well as a self-portrait by Turner.

One gallery that Manet almost certainly would have visited was that of Gustave Doré, the man with whom he had delivered the petition to the Comte de Walewski in the spring of 1863. Since then, Doré had enjoyed phenomenal success, mainly as a book illustrator. An exhibition of his engravings had proved a huge success in London in 1867, prompting him to move there in 1868. He had immediately opened a gallery in Mayfair and signed a contract to engrave some

200 scenes of London for a book to be called *London: A Pilgrimage*. The contract, due to run for five years, was worth the enormous sum of 10,000 pounds per year—the equivalent of almost 250,000 francs. Doré, who was exactly the same age as Manet, had entered the ranks of the Meissoniers and the Cabanels.

The gulf between Doré's fabulous success in London and Manet's disastrous failure in Paris was as vast as it must have been rankling for the visiting *actualiste*. Two of Manet's other friends, Whistler and Fantin-Latour, had likewise enjoyed bursts of good fortune in London, as had Alphonse Legros. After only moderate success in Paris, Legros had relocated to London in 1863, married an Englishwoman, then begun exhibiting regularly, and winning medals, at both the Salon and the Royal Academy. He was furthermore a teacher at the National Art Training-Schools of South Kensington, an art college with an enrolment of more than a thousand students.

Quite understandably, Manet was determined to see if he could make a similar impact across the Channel. "I think we should explore the terrain over there," he had written to Edgar Degas from Boulogne a few weeks before making his trip, "since it could provide an outlet for our products."[21] Manet seems to have recognised that England's extraordinary prosperity had created a new breed of art collector—men who had come from humble origins, enriched themselves through trade, then devoted themselves to covering the walls of their mansions with paintings by living artists. Despite their unpopularity with both the British art establishment and many of the critics, Dante Gabriel Rossetti and his fellow Pre-Raphaelites had been able to find patrons in men like James Leathart, a lead merchant from Newcastle, and Frederick Richards Leyland, a thirty-six-year-old Liverpool shipowner known because of his generous patronage of the arts as the "Liverpool Medici."

Little wonder that Manet, struggling to sell any of his canvases in Paris, had cast a covetous eye across the Channel, or that he returned to Boulogne filled with a rare optimism. "I believe there is something to be done over there," he wrote confidently to Fantin-Latour. "The feel of the place, the atmosphere, I liked it all and I'm going to try to show my work there next year."[22]

Mademoiselle Berthe

PIERRE-AUGUSTE RENOIR once wrote that while he regarded female writers as "monstrosities," female painters were "simply ridiculous."[1] Nonetheless, a good many female painters could be found in Paris in the 1860s. Some fifty women had exhibited at the Salon des Refusés in 1863, or thirteen per cent of the total number of participating painters, while more than a hundred showed work at the official Salon during any given year.[2] Few of them won medals or were household names, and of the 162 paintings bought by the government from the 1868 Salon, only four were by women.[3]

Over the previous decades, however, a number of women had managed to forge successful artistic careers for themselves, the most renowned being Rosa Bonheur. Daughter of a little-known landscapist, Bonheur had first shown her work at the Salon in 1841, at the age of nineteen, after which she went on to enjoy success with her animal paintings. By the 1860s she had won several Salon medals, received government commissions, been awarded the Legion of Honour (the first woman to receive it), and earned the admiration of numerous collectors and connoisseurs. She was especially popular in England, where in 1855 her most famous work, *The Horse Fair*, was sold for 40,000 francs. One of her greatest enthusiasts was Queen Victoria, who ordered a private viewing of *The Horse Fair* at Windsor Castle when the painting triumphantly toured the country.

Showing a horse market held in the Boulevard de l'Hôpital in Paris, *The Horse Fair*, at more than sixteen feet wide, was a massive canvas, and one that had obliged Bonheur to visit the fair dressed as a man in order to avoid unwelcome attention as she made her sketches. Most female painters restricted themselves to smaller and more unassuming works such as still lifes and portraits,

and they were circumscribed in their choice of subject matter for the simple reason that they were circumscribed in their daily lives. They were not allowed to study at the École des Beaux-Arts or to paint nudes, and they did not have the liberty, like their male counterparts, of roaming the boulevards or the bridle paths at will. Nonetheless, by the 1860s a few women did enjoy enough freedom of movement to work as landscapists; and one of those represented most consistently at the Salon, a specialist in light-suffused riverscapes and sun-dappled woodlands, was Berthe Morisot.

Twenty-seven years old in 1868, Morisot had an impeccable artistic pedigree, since the Morisot family was said to be distantly related to the eighteenth-century Rococo painter Jean-Honoré Fragonard.[4] Berthe's father had studied architecture at the École des Beaux-Arts before going on to a career in the civil service that saw him become, in 1864, the Chief Councillor of the Cour des Comptes, the government's audit office. Still unmarried, Berthe lived with her parents, sister and brother in the affluent Paris suburb of Passy, directly across the Seine from the Champ-de-Mars. She had begun her artistic career at the age of seventeen, when she and her elder sister Edma took painting lessons from a neighbour, Joseph-Benoît Guichard, a former student of Ingres. Guichard had taken his young charges to the Louvre and instructed them to copy Old Masters, but he became alarmed as what had begun as a pleasing pastime (Berthe's mother simply wished her daughters to take painting lessons so they could present a birthday gift to their father) quickly became an obsession. "Your daughters have such inclination," Guichard warned Madame Morisot. "They will become painters. Are you fully aware of what that means? It would be revolutionary—I might almost say catastrophic—in your bourgeois society."[5]

Guichard was exaggerating, since women from distinguished families had become professional painters without causing either revolutions or catastrophes. There had even been a female painter in the Bonaparte family, Princesse Charlotte, Napoleon's niece, who trained under Jacques-Louis David and then worked as a landscapist. But Guichard may have been thinking of the tragic and scandalous fate of another female artist from a respectable family, Constance Mayer-Lamartinière. The daughter of a high-ranking bureaucrat, she had studied under Jean-Baptiste Greuze and then gone on to become the mistress of the neoclassical painter Pierre-Paul Prud'hon before committing suicide, in 1821, by slashing her throat with a razor. Or Guichard may have been alluding to Rosa Bonheur's decidedly unconventional personal life. Besides dressing as a man to visit horse fairs and slaughterhouses, she smoked cigarettes in public, cut her hair short, maintained a sheep on the sixth-floor balcony of her Paris apartment, and had a female companion instead of a husband.

1A. *Remembrance of Civil War* (Ernest Meissonier)

1B. *Liberty Leading the People* (Eugène Delacroix)

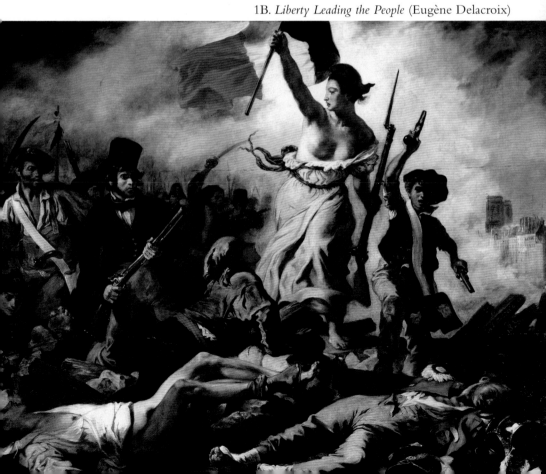

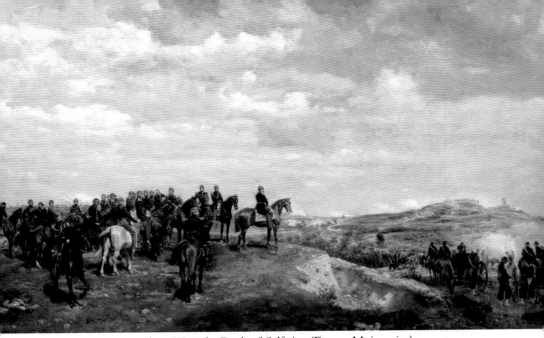

2A. *The Emperor Napoleon III at the Battle of Solferino* (Ernest Meissonier)

2B. *The Campaign of France* (Ernest Meissonier)

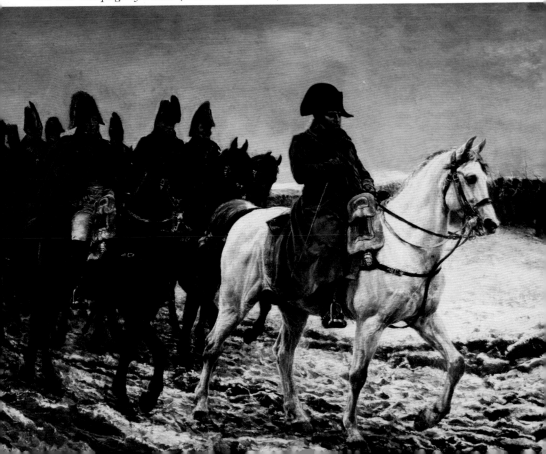

3A. *Music in the Tuileries* (Édouard Manet)

3B. *A Burial at Ornans* (Gustave Courbet)

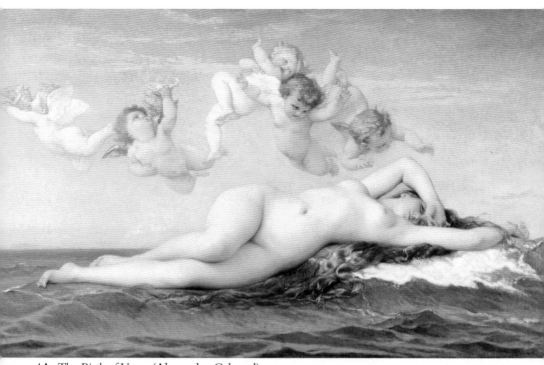

4A. *The Birth of Venus* (Alexandre Cabanel)

4B. *Olympia* (Édouard Manet)

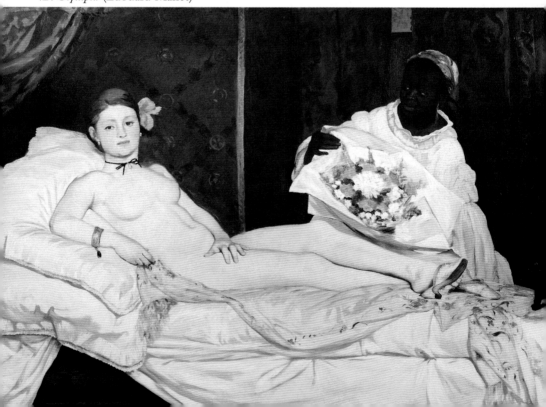

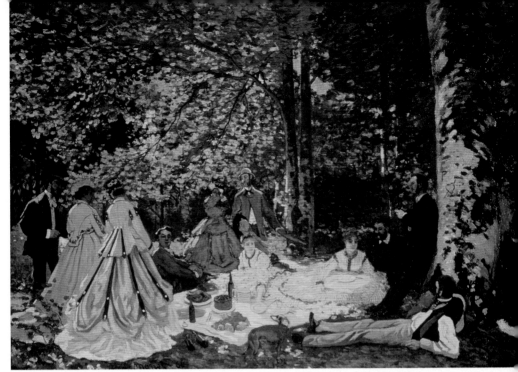

5A. *Le Déjeuner sur l'herbe* (Claude Monet)

5B. *Le Déjeuner sur l'herbe,* originally entitled *Le Bain* (Édouard Manet)

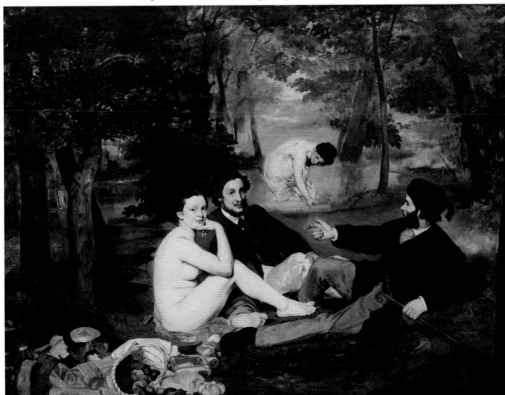

6A. *The Races at Longchamp* (Édouard Manet)

6B. *Friedland* (Ernest Meissonier)

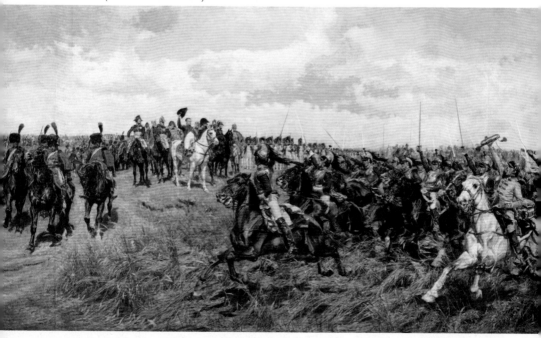

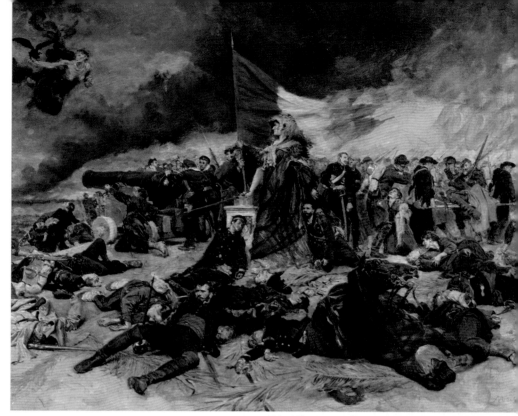

7A. *The Siege of Paris* (Ernest Meissonier)

7B. *The Railway* (Édouard Manet)

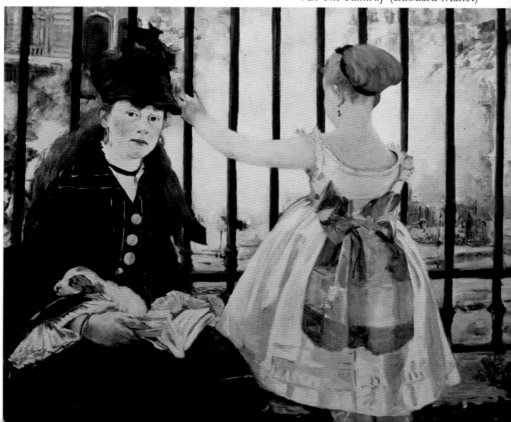

8A. *Le Bon Bock*
(Édouard Manet)

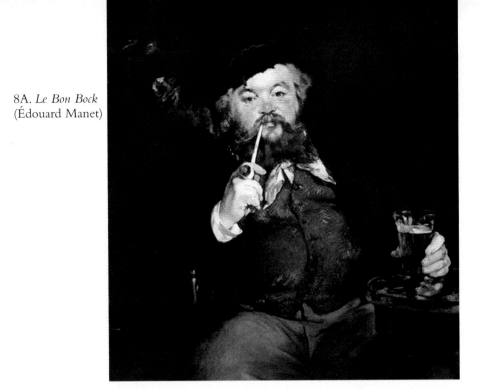

8B. *Bathers at La Grenouillère* (Claude Monet)

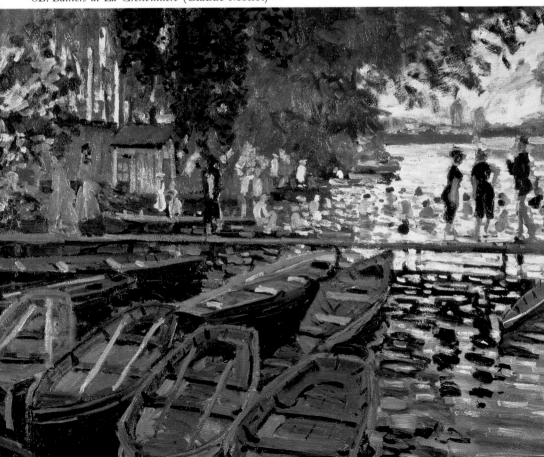

To her credit, Madame Morisot ignored Guichard's warnings, and soon afterward Berthe and Edma had become pupils of Camille Corot, a more benevolent and enlightened teacher. Berthe made her début at the 1864 Salon with two *plein-air* landscapes, after which she managed to exhibit her work at the next four consecutive Salons, even escaping the wrath of the Jury of Assassins to show a pair of landscapes in 1866. Her successes were not unqualified, since her paintings tended to be hung high on the walls, and in 1865 Paul Mantz dismissed her still life with the patronising observation that women could succeed at "domestic painting" since "it is not necessary to have spent a long time drawing at the École des Beaux-Arts in order to paint a copper pot, a candlestick and a bunch of radishes."[6] Yet by 1868, when she showed *The Pont-Aven River at Roz-Bras*, Morisot's reputation as a landscapist was lofty enough for Émile Zola to introduce her to readers of *L'Événement illustré* as one of the *actualistes* courageously pursuing truth and originality.

Édouard Manet was introduced to the Morisot sisters by Fantin-Latour in the spring or early summer of 1868. The bashful Fantin-Latour was secretly in love with Edma, who was engaged to a naval officer. But the younger sister, a slender, dark-eyed brunette, fascinated Manet. "I agree with you," he wrote jauntily to Fantin-Latour from Boulogne a few weeks after making the acquaintance, "the young Morisot girls are charming."[7] Manet was as impressed with Berthe's beauty and beguiled by her company at least as much as he was taken with her talents as a painter. He wasted no time in seeking her out after his return to Paris. By early autumn he had convinced her to model for a painting entitled *The Balcony*, an exterior view of two women and a man idling on a balcony with a boy in the background behind them. Morisot was therefore obliged to make regular visits to his studio. With Victorine Meurent apparently having vanished—Manet had neither seen nor heard from her since finishing *Young Lady in 1866* almost three years earlier—Morisot was about to become his favourite female model.

The Balcony was inspired both by a group of figures glimpsed by Manet on a balcony in Boulogne and by—as usual—an Old Master painting: Goya's *Majas on a Balcony*, which Manet had seen years earlier in the Galerie Espagnole in the Louvre.[8] But the real impulse for the canvas, one suspects, was the chance to paint the beguiling figure of the doe-eyed Morisot with her dark ringlets. The end result, however, was not especially flattering. Though friends described Morisot as having "powerfully dark" eyes that possessed "a deep magnetic force,"[9] Manet nonetheless gave her the same dully absent gaze as everyone else who had ever ventured before his easel. He portrayed her seated on an upholstered chair, wearing a voluminous white gown with bell-shaped sleeves—a gown of truly majestic dimensions—

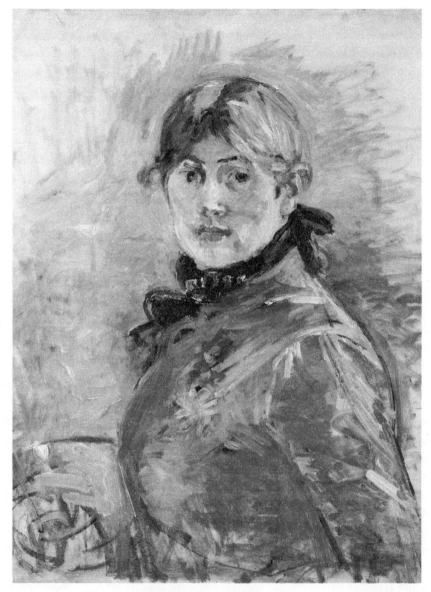

Berthe Morisot (self-portrait)

and staring vacantly beyond the frame of the canvas. Morisot herself did not quite know what to make of the work. "I am more strange than ugly," she later remarked.[10]

Manet eventually spent most of the autumn of 1868 toiling over his canvas. Posing in his studio was no easy business. If professional models like Jacob

Leuson and Victorine Meurent could hold their poses for long periods at a stretch, other sitters found the demands of portraiture excruciating. For Zola, the task of sitting for Manet had been exhausting both physically and mentally. His limbs, he claimed, went numb from long hours of forced inactivity; his eyes wearied from staring straight ahead; and he struggled to stay awake. He found the interminable sessions so tedious that he begged Théodore Duret to visit the studio and relieve the boredom with interesting conversation. Apparently Manet was not given to small talk as he worked, since he remained "engrossed in his work," wrote Zola, "with a concentration and artistic integrity that I have seen nowhere else."[11] Morisot, though, seems to have been a more compliant sitter. For reasons of propriety, her mother, Marie-Cornélie, was present for at least some of the sessions in which her daughter was involved, once more revealing her liberal inclinations, since not every mother in Paris would have allowed her unmarried daughter to pose for a man with a grisly reputation earned from a pair of shocking nudes. Still, Marie-Cornélie was not unduly taken with the painter. "Manet looks like a madman," she confided to Edma.[12]

Morisot, for her part, was much taken with Manet; but whether or not the relationship between the painter and his model developed into a more intimate one remains something of a mystery, not least because Berthe and Edma faithfully burned a number of the letters they wrote to one another, presumably in order to conceal incriminating sentiments. The few letters that survived these bonfires reveal that Edma—who confessed to a *toquade*, or crush, on Manet—was, despite her forthcoming marriage, no less intrigued by the dandyish painter than was her younger sister.[13] However, *The Balcony* appears to represent the impediments placed in the way of a deeper intimacy between the artist and his model, since Morisot is placed behind a barrier—the balcony's iron railing—and accompanied by a pair of chaperones.[14] Whatever the case, Manet clearly regarded Morisot as someone through whom he might revive his artistic fortunes. For no sooner was *The Balcony* completed than he began making plans to send it to the Salon.

Manet also had another work ready for the 1869 Salon. After three aborted attempts he had finally completed to his satisfaction a ten-foot-wide canvas showing Emperor Maximilian meeting his doom. Evidently undaunted by the fate of Alphonse Liébert, the print dealer imprisoned for two months and fined 200 francs for possessing photographs of the execution, he decided to send his enormous canvas to the Palais des Champs-Élysées, still showing the executioners in French uniforms as well as the soldier who looked like the Emperor Napoleon delivering the *coup de grâce*.

Early in 1869 Manet also began preparing a lithograph based on *The Execution of Maximilian*. He had done a few lithographs in his career, including one of *The Races at Longchamp*, though none had yet been published. Lithography literally means "drawing from stone." Invented in Munich by Alois Senefelder in about 1798, it consisted of making a drawing or design with a greasy crayon on a slab of polished stone; the stone was moistened first with a roller charged with water and then with another roller charged with either ink or an oil-based paint. Since grease and water do not mix, the ink or paint was repelled by the wet stone, adhering only to the marks left by the crayon. Impressions of these inky lines could then be taken on paper with a hand press. Lithography was highly efficient for the mechanical reproduction of works of art, since several hundred clear pulls could be made without any loss of definition. What Manet proposed, therefore, was to create dozens if not hundreds of lithographs of *The Execution of Maximilian* and then sell them through a publisher such as Adolphe Goupil.

With this project in mind, Manet prepared his slab of stone with a waxy crayon and then sent it to the foremost printer of lithographs in Paris, Rémond-Jules Lemercier, whose studios were in the Latin Quarter.[15] There the printer etched Manet's design into the stone by means of a chemical reaction precipitated with nitric acid. Brushed over the surface of the stone, the acid reacted with the grease to create oleomagnate of lime, in effect making the image, chemically speaking, part of the rock. The stone was then inked and four proofs were pulled from the press, three of which were sent to Manet for his approval. There was, however, a slight hitch. A law of 1852 stipulated that all prints needed to be submitted to the Dépôt Légal, where they were to be inspected for subversive content before they could be sold to the public. Lemercier duly sent the fourth proof to this government censor for registration. Despite the liberalisation of the press laws, censorship was still very much alive in the France of Napoleon III, and within days an official letter informed Manet that he was forbidden either to print or to publish his lithograph. The letter further stated that his canvas of *The Execution of Maximilian* would not be welcome at the 1869 Salon.

Manet's immediate reaction was to send the censor's letter to Émile Zola, denouncing "this ludicrously small-minded procedure" and suggesting that his friend "write a few lines" in his defence.[16] Zola needed no further encouragement, and the *Chronique des arts et de la curiosité* was soon carrying an article lamenting the repression of such an "excellent" work.[17] But the authorities were unbending, and within a few weeks the saga took a new twist as Lemercier refused to return the lithographic stone, which he was seeking permission to grind down. The infuriated Manet promptly had Lemercier & Co. served with

legal papers to prevent the firm from effacing the image. The stone was finally returned, but the victory was a small one since for all intents and purposes neither the lithograph nor the four canvases of *The Execution of Maximilian* were of any use to him. "What a pity Édouard took all that trouble with it," Suzanne would later dolefully reflect. "What a lot of nice things he could have painted in the time."[18] Still, one of the canvases did prove handy: Suzanne's brother Ferdinand cut the third version into strips, which he then used to light the fire.[19]

Balked in his plans for the 1869 Salon, Manet decided to enter *The Luncheon* along with *The Balcony*. He was particularly worried about the chances of the latter. "He hopes his picture will be a success," Madame Morisot wrote to Edma, "then all of a sudden he is filled with doubts that cast him down."[20] He may have been reassured by the composition of the jury. Once again the *règlement* provided for elections by means of a wide suffrage; and once again the ballots yielded a familiar crop of names. The only newcomer elected to the painting jury was Léon Bonnat, a thirty-six-year-old so squeamishly elegant (he was rumoured to paint with his gloves on) that he made even Manet look unkempt. Nieuwerkerke then named as one of his appointees Albert Lezay-Marnésia, the man who six years earlier had given the Emperor the idea for the Salon des Refusés.

The three stalwarts of the École des Beaux-Arts, Cabanel, Gérôme and Robert-Fleury, all were elected to the 1869 jury, but another familiar face was missing. For the second year in a row, Ernest Meissonier had failed to appeal to the expanded electorate. Nor did Meissonier have any plans to show his work in 1869, not even any of the beautiful views of Antibes painted the previous summer. He had recently sold one of them, *Promenade at Antibes*, for 25,000 francs; but such simple, sun-drenched landscapes lacked the *gravitas*, he seems to have felt, for a painter with his eminent reputation. *Friedland* took precedence over all else. And by 1869 his studies for this masterpiece had reached a critical new stage.

Flying Gallops

IN NOVEMBER 1868 Meissonier's son Charles married Jeanne Gros, and within weeks the new bride was pregnant with Meissonier's first grandchild. Charles and Jeanne took possession of the Nouvelle Maison, whose refurbishment Meissonier was still faithfully—and extravagantly—superintending. The 25,000 francs from *Promenade at Antibes*, sold a few weeks after the wedding, were a welcome infusion of cash as Meissonier attacked this new architectural enterprise with his customary gusto. Charles soon found himself on the end of relentless inquiries from his father regarding kitchen sinks and whether the house should feature a tower or a gable.[1]

Another construction project was also taking shape in the enclosure of the former abbey. Though Meissonier claimed to detest the modern industrial age, with his ever more adventurous studies of equine locomotion he was actually working at the cutting-edge of science. He was regarded by most critics in France as the greatest horse painter in history, having overcome all rivals, as Gautier once proclaimed, "in a single blow."[2] His skill in depicting horses had been gained through years of studying the equine form. He had even gone so far as to take courses in anatomy at the École Nationale Vétérinaire in Maisons-Alfort, a few miles south-east of Paris.[3] His dedication impressed not only the artistic but also the scientific community. "What efforts, what sketches, what lengths of precious time, what fatigue he incurred, to faithfully translate the living animal!" exclaimed the anthropologist Émile Duhousset.[4]

Meissonier regarded himself as something of a scientist in these matters, a

hippologist who was attempting to quantify the precise proportions and loco-
motions of the horse. He believed that the ancient Assyrians had grasped this
movement but that their knowledge had been lost until he, Meissonier, revived
it through his endless researches.[5] Equestrian experts were inclined to agree.
In one of his treatises on equine anatomy, Duhousset wrote that Meissonier's
motion studies for *The Campaign of France* had managed to differentiate, for
the first time in history, between a walk and a trot. He claimed Meissonier
showed how horses walked by moving in unison legs that were diagonally op-
posed to one another—right front and left back, for example—while flexing
their knees only slightly.[6]

Meissonier was nevertheless finding the horses in *Friedland* more difficult to
paint than those in *The Campaign of France*; the reason was that this latest work
called for galloping horses. Galloping horses were not usually a problem for
painters. Throughout history, the task of the artist had not necessarily been to
observe reality and then attempt to match it perfectly in his work. Instead, paint-
ers created their images by using various tried-and-trusted conventions—
ritualised gestures and symbolic expressions—that satisfied demands for
verisimilitude by assimilating the visual representation with the beholder's per-
ceptions.[7] Galloping horses were a case in point. Artists habitually showed them
performing what was known as a "flying gallop," a hobbyhorse pose in which
the forelegs stuck out front and the rear legs behind. People happily accepted
this depiction of a gallop because it seemed to match their impressions of what
they saw at, for example, the racecourse. Édouard Manet, a painter with no in-
terest in depicting motion, had used precisely this artistic cliché for his horses in
The Races at Longchamp.

Meissonier was not content with this convention, which he suspected did not
properly reflect how a horse actually galloped. The man who refused to paint
so much as a shoe buckle without first having a correct example before his eyes
would not execute something as complex as a charging horse unless he had an
image of its gait perfectly in his head. But the problem, he found, was compre-
hending the exact movement and disposition of the horse's legs as it
galloped—what Charles called "the rhythm and successive modifications of
the horse's action."[8] For instance, did all four hooves leave the ground simul-
taneously? If so, which was first to land, a foreleg or a hind leg? And were
both forelegs ever outstretched from the torso as depicted in the flying gallop?

Rosa Bonheur had spent eighteen months visiting horse markets and abattoirs
to create *The Horse Fair*, her masterpiece of equine muscle and movement.
Meissonier would ultimately go to even greater lengths in his quest to delineate

sequential movement. "Nature," he once wrote, "only gives up her secrets to those who press her closely."[9] He had therefore made sketches of Charles racing through the forest and of the 10th Regiment Cuirassiers charging in attack formation across the parade ground at Saint-Germain-en-Laye. But there were limitations to these approaches. "The rapidity of the motions made them difficult to seize," lamented Charles.[10] Meissonier found he needed a more effective method of ascertaining how a horse moved its legs as it galloped.

Unfortunately for Meissonier, the technology required for these motion studies, a multi-exposure camera, was still just out of reach in the late 1860s. A young surgeon and physiologist named Étienne-Jules Marey had recently set up a scientific laboratory in the Rue de l'Ancienne-Comédie where he used instruments to measure and then analyse the movements of amphibians, birds and insects.[11] He was particularly interested in flight, inventing a special girdle that allowed a bird to fly around in circles as the motions of its wings and torso were recorded. In 1864 he had been visited in his laboratory by the ingenious and inventive Nadar, who a year later began experimenting with moving pictures, taking a "revolving self-portrait" by photographing himself a dozen times as his chair was slowly rotated through 360 degrees. More promisingly, by 1869 an astronomer named Pierre-Jules-César Janssen was at work on what he called a "Revolver Photographique," a multi-exposure camera based on the principle of Samuel Colt's repeating pistol. Janssen envisaged a rotating wheel that could be "fired" at regular intervals in order to admit light into the shutter and allow a photographer to take as many as forty-eight exposures in seventy-two seconds. This sort of stop-action photography would have been absolutely invaluable to Meissonier in his researches into galloping horses. However, Janssen was not expected to have his invention ready before 1874, when he hoped to take it with him to Japan to photograph the transit of Venus. Meissonier was therefore forced to adopt other methods. And so he "turned his garden upside down," according to one visitor, and began building a railway through it.[12]

France had more than 11,000 miles of railway track in 1869.[13] In the previous three decades the railway had transformed the nation more than any other single invention. It had stimulated the economy, created new social relations, and transfigured the urban environment as metropolitan life began to revolve around the train station more than—as previously—the church or the town hall.[14] The railway had likewise influenced artists, in particular landscapists, by bringing the Forest of Fontainebleau and more remote destinations such as the coast of Normandy within easy reach of their Paris studios. It had also, like photography, caused a shift in visual perception by altering the relationship between the viewer

and the physical landscape, across which one could suddenly travel at speeds in excess of fifty miles per hour. It could be argued that the hasty-looking landscapes of Monet and Pissarro owed something to the brief vistas glimpsed as they loomed and then dissolved in the window of a train carriage. One critic of the Batignolles painters complained, at any rate, that Monet "paints as if from an express train."[15] Even so, the most eccentric contribution of railway technology to the history of art was surely Meissonier's miniature railway at Poissy.

Meissonier had a team of workmen lay a set of iron rails in grounds that had formerly featured only the bucolic delights of cherry trees and grazing livestock. He next installed on this track a small carriage, or what one witness called a "wagonette" and another "a rolling sofa."[16] Parallel to this length of track he fashioned a bridle path along which a horse could gallop. With these two lengths of course complete, he climbed into the wagonette, whose motive power was not steam or even horses but a pair of men. These two unfortunates were ordered to push the painter as quickly as possible along the rails in his wagonette as a horseman galloped full-pelt down the bridle path beside them. This bizarre feat was performed time and again as Meissonier, whisked along the track with pencil and paper in hand, "jotted down the action, the strain of the muscles, every detail of the motion and the different transitions."[17] Entire albums were filled with these scribbled observations. One of his friends claimed that Meissonier thereby "succeeded in decomposing and noting 'in a flash' the most rapid and complex actions" of the horse's flying legs.[18] Without a high-speed camera, however, Meissonier was like a naked-eye astronomer, a Tycho Brahe staring at the night sky and counting stars before the invention of the telescope. Not for another ten years, when Eadweard Muybridge finally managed to use a high-speed camera to capture a horse's motion photographically, would these "rapid and complex actions" truly be understood.[19] Nevertheless, that a man so bewitched by the past, a man who claimed to detest the sight of railway stations, should have spent so much time and effort hurling himself down a railway track in a quest for the latest scientific knowledge, provides a delicious irony.

Meissonier's researches into the articulation of a horse's leg as it cantered or galloped were nineteenth-century equivalents of Leonardo da Vinci's sketches of bats and birds or Michelangelo's dissections of the human body. In each case, scientific observation was pressed into the service of art, and art into the service of science, with Michelangelo, for instance, in his quest to depict physical perfection, mapping the anatomical structure of the human body more accurately and explicitly than anyone before him.[20] Meissonier was no less committed to his own task. He became the first painter in history, according to

one of his friends, to bring a "scientific knowledge of anatomy" to bear on the artistic treatment of the horse.[21]

The 1869 Salon took place, like the one in 1863, against the background of elections for the Legislative Assembly. The political climate in France had altered dramatically in the intervening six years. Not only had the Emperor's reputation been damaged by his ill-judged foreign policy initiative in Mexico, but the economy had begun to contract after years of growth. The silk industry was suffering from an epidemic of *pébrine*, the wine industry from *phylloxera*, and the banking industry from a *grève du milliard*, the "strike of the billions" whereby nervous financiers ceased to invest their wealth, causing the collapse of banks such as the Crédit Mobilier, the value of whose shares had tumbled, in 1867, from 1,982 francs to 140.[22] Even worse for the Emperor was the fact that the relaxation of the press laws in 1868 meant the republican opposition—always a powerful force in Paris—had at last been unmuzzled. *La Lanterne*, an inflammatory anti-government journal edited by Henri Rochefort, had become so provocative (and so successful) that the government took action after only a few issues and—liberal laws notwithstanding—closed it down. But dozens of other journalists also began whipping themselves into a vituperating frenzy. The result, in Paris at least, was that almost every night for weeks on end witnessed packed electoral meetings, followed by demonstrations, riots and the forceable scattering of the angry protesters with batons and cavalry charges.[23]

French artists, however, were more sedate in 1869, thanks largely to the fact that a wide majority had work accepted for the Salon. Many of the painters from the Salon of Newcomers returned in 1869. Camille Pissarro had two views of Pontoise accepted; Renoir a portrait of his mistress Lise Tréhot; and Degas that of a former ballerina, Joséphine Gaujelin. But Degas also had one of his canvases rejected; Berthe Morisot submitted nothing; while Cézanne and Alfred Sisley each had both of their works turned down.

The 1869 Salon had another notable absentee. Claude Monet had reached a low ebb following Nieuwerkerke's insistent rejection of one of his two paintings in 1868. He had moved that summer to Bonnières-sur-Seine, twenty-five miles north of Paris, where an unpaid bill resulted in his eviction from an inn and a half-hearted suicide attempt as he threw himself into the river. "Fortunately no harm was done," he wrote a day later to Bazille.[24] His fortunes then briefly waxed after he managed to show some of his canvases at an exhibition of maritime art in Le Havre and sell his portrait of Camille, shown at the 1866 Salon, to Arsène Houssaye, editor of *L'Artiste*, for 800 francs. However, the

authorities in Le Havre seized four of his paintings from the walls of the exhibition and auctioned them to pay his numerous creditors. These canvases were knocked down to a buyer for 80 francs each—an astonishing bargain considering that a new, unpainted canvas cost a little less than half that.

Monet had moved in the autumn to a rented house in Étretat, on the Normandy coast not far from Le Havre. There, buoyed by a visit from Gustave Courbet, his spirits quickly improved. "I'm very happy, very delighted," he wrote to Bazille. "I'm surrounded here by all that I love."[25] Despite being refused credit at the paint shop (his reputation had obviously preceded him) he managed a winter scene, *The Magpie*, which he painted out of doors on a day so cold that he was forced to bundle himself into three overcoats, light a brazier beside his easel, and wield his paintbrushes in gloved hands. A few months later, having moved back to Paris, he submitted *The Magpie* to the Palais des Champs-Élysées along with *Fishing Boats at Sea*, another product of his Étretat sojourn. This time both paintings were rejected. Monet was furious. "That fatal rejection has virtually taken the bread out of my mouth," he fumed in a letter. The dealers had all turned their backs on him, he noted bitterly, notwithstanding his extremely modest prices.[26]

Édouard Manet enjoyed more favour from the 1869 jury. Both *The Balcony* and *The Luncheon* were accepted, but he was anxious about their possible reception following so many discouraging experiences. On the first day of the Salon, Berthe Morisot discovered him loitering nervously in Room M, "with his hat on in bright sunlight, looking dazed."[27] Morisot, who had come to the Palais des Champs-Élysées with her mother, was not showing work in 1869. Though 130 women were exhibiting at this Salon, Morisot had been unable to join them since she was suffering from an eye infection that prevented her from completing her work on time. This infection made it difficult for her to see the paintings on the wall, but Manet begged her to gauge their effect, "as he did not dare move a step. I have never seen such an expressive face as his," she later wrote to her sister Edma. "He was laughing, then had a worried look, assuring everybody that his picture was very bad, and adding in the same breath that it would be a great success."[28]

Morisot made her way to where *The Balcony* was suspended on the wall. "It seems that the epithet *femme fatale* has been circulating among the curious," she reported to Edma about her own appearance in the work.[29] Manet, "in high spirits," then gallantly escorted her through the other rooms in the Palais des Champs-Élysées. The party soon became separated in the press of the crowd, at which point Morisot became sensible that it was not proper for a woman such

as herself "to walk around all alone. When I found Manet again, I reproached him for his behaviour. He answered that I could count on all his devotion, but nevertheless he would never risk playing the part of a child's nurse."[30]

With her sessions for *The Balcony* complete, Morisot's relations with the man she quickly came to regard as a mentor had become slightly fraught. "I think he has a decidedly charming temperament," she wrote to her sister following this particular encounter, "I like it very much."[31] But in many ways the gentle, insecure Morisot was ill-equipped to deal with a character such as Manet. Though he may have looked the part of the gentleman, with his lemon-yellow gloves and ubiquitous cane, Manet could sometimes be guilty of unpleasantly boorish behaviour. He dominated the Café Guerbois and his various other haunts with a kind of tyrannical wit. He was "naturally sarcastic in his conversation and frequently cruel," wrote one friend. "He had an inclination for punches, cutting and slashing with a single blow. . . . He was the strangest sight in the world, his elbows on the table, throwing about his jeers with a voice dominated by the accent of Montmartre, close to that of Belleville."[32] Clever insults delivered in an affected working-class accent may have gone down well in male company, but Morisot, more accustomed to tutelage from the genial, pipe-smoking "Papa" Corot, found them extremely hurtful. Manet, she once admitted to Edma, "has said many unpleasant things to me."[33] By the time of the 1869 Salon, moreover, the uneasiness between Manet and Morisot was exacerbated by the presence of another young female painter, a twenty-year-old named Éva Gonzalès who had become Manet's first and only student after entering his studio in February. The daughter of a Spanish-born novelist, Éva possessed beauty, elegance, breeding, intelligence—and even some talent as a painter. She swiftly became Morisot's rival for Manet's affections and attentions.

As it transpired, Manet had good reason to be nervous about the reception of his paintings. The attacks on the painter each spring in the French newspapers were becoming a regular event, an annual ritual like the Poisson d'Avril or the Grand Prix de Paris. The 1869 Salon brought yet another volley of abuse. Though Théophile Gautier wrote that the two works "are relatively sensible and will create no scandal," other reviewers found plenty of reasons to inveigh against them. A writer in the *Gazette de France* rather cruelly picked out the figure of Léon in *The Luncheon*: "The painter of Olympia and her cat seems to have laboriously plumbed the depths of human ugliness to extract the distressing figure which he shows us in the foreground of his *Luncheon*." Most severe of all was a thirty-four-year-old German playwright and journalist named Albert Wolff, recently appointed chief art critic of *Le Figaro*. "Manet thinks he is producing paintings, but in fact he does nothing but sketches," wrote Wolff,

voicing the familiar complaint against painters of the Generation of 1863. "He lacks imagination," Wolff added. "He will never accomplish anything else, you can count on it." Even Castagnary, one of the country's more progressive reviewers, found both paintings "meagre" and "sterile." His review in *Le Siècle*, a left-leaning paper with 40,000 readers, went so far as to suggest that Manet required more training in order to improve his technique.[34]

Having endured the humiliation of this latest batch of lacerating reviews, Manet lapsed into the usual depression. "Poor Manet, he is sad," Berthe Morisot wrote to her sister. "His exhibition, as usual, does not appeal to the public, which is for him always a source of wonder."[35] Such failure caused Manet embarrassment as well as wonder. Morisot's mother noted how he met in the street "people who avoid him in order not to have to talk about his painting, and as a result he no longer has the courage to ask anyone to pose for him."[36] Still, Manet did summon the courage to ask one person. Before the summer was out, he had begun, much to the annoyance of both Morisot and her mother, a portrait of Éva Gonzalès.

The elections for the Legislative Assembly took place on May 24, three weeks into the Salon. Though the candidates supporting the Emperor managed to win 216 of 292 seats, there were causes for concern in the Tuileries. Not only had twenty-five republicans been elected, including Adolphe Thiers, but forty-two per cent of the 7.8 million voters had cast their ballots in favour of candidates (ranging from socialists to monarchists) who opposed Louis-Napoleon's régime. Nor did the elections stop the civil unrest in Paris, which featured demonstrations by socialists in the Boulevard Montmartre and violent disturbances in the working-class suburb of Belleville. These riots quickly spread through Paris, night after night, with chants of "Vive Rochefort" (invoking the exiled editor of *La Lanterne*) and choruses of the *Marseillaise* leading to thrown bottles, broken glass and flailing police batons. More than a thousand demonstrators were thrown in jail over the course of a few nights in June. The government became even less popular when, on June 16, troops opened fire on striking coal miners in La Ricamarie, near Saint-Étienne, killing fourteen people, including a seventeen-month-old girl in her mother's arms. Immediately afterwards, the silk spinners in Lyon declared a strike. Hotels emptied as foreign tourists hastily left the country, while Rochefort, exiled to Belgium a year earlier, began plotting his return. France appeared to be on the brink of revolution.

Matters became even more troubling for Louis-Napoleon as his health declined. By this point his rheumatism was so excruciating that, according to one

of his wife's ladies-in-waiting, he would hold his arm to the flame of a candle before entering a room so that "a change of pain might bring a sort of relief."[37] Even more concerning was a bladder stone, which gave him sharp pains in the groin as well as troubles with urination. Great risks were associated with a lithotripsy, a procedure involving the insertion of a "urethrotome" into the bladder to crush the stone. The hazards were made chillingly clear on August 13 when, drugged with morphine and confined to his bed, Louis-Napoleon was given the distressing news that his most trusted military adviser, Adolphe Niel, the Minister of War, had died following a lithotripsy to remove his own bladder stone.

Two days after the catastrophe of Marshal Niel's death, Paris celebrated the hundredth anniversary of Napoleon's birth. A *Te Deum* was performed in the Invalides and a Mass at Notre-Dame. The Champ-de-Mars was filled with puppet theatres, clowns, acrobats, dwarfs, rope-dancers and men on stilts. Fireworks in the sky above the Trocadéro included 1,200 roman candles and 20,000 rockets. Finally, the word "Napoleon" was spelled in lights above the Arc de Triomphe. As these lights were extinguished a day later, many who watched may have felt the lights of Louis-Napoleon's régime were also fading. That, at any rate, was the conclusion soon reached by many foreign observers in the embassies lining the Rue du Faubourg Saint-Honoré. "The Second Empire," wrote Lionel Sackville-West, Chargé d'Affaires at the British Embassy, "has gone off the rails. It is no longer being guided. It is hurling itself at an accelerating speed towards the abyss."[38]

The Wild Boar of the Batignolles

EARLY IN SEPTEMBER 1869, as anxiety about his health spread through Paris, followed by rumours of his death, Emperor Napoleon made a queasy appearance in a carriage in the Champs-Élysées. The crowds turning out to see him were almost as large as those that had poured into the streets a day earlier for the opening of Le Bon Marché, the department store, in its grand new premises west of the Jardin du Luxembourg. Within a few weeks the Emperor was well enough to ride in a carriage in the Bois de Boulogne and to attend the theatre, though his hair had been dyed brown and his cheeks rouged to hide their pallor. Government bulletins simply reported that he had been suffering from a severe attack of rheumatism: no mention was made of the bladder stone.

Louis-Napoleon next attempted to heal the body politic. At the end of December, a few weeks after the Legislative Assembly convened, he summoned one of its deputies, a forty-four-year-old moderate reformer named Émile Ollivier, and ordered him "to designate the men who can form a homogenous cabinet with you, which will faithfully represent the majority in the Legislative Assembly."[1] This new cabinet marked the end of Louis-Napoleon's autocratic régime and the beginnings of what Ollivier christened the "Liberal Empire."[2] The transition from despotism to a form of parliamentary democracy was widely hailed in the press. "If this is not the greatest of all revolutions," claimed the *Revue des deux mondes*, "it is at least one of the most interesting, one of the most salutary and opportune."[3] Ollivier's government immediately began preparing legislation to establish trial by jury for press offences and to abolish both arbitrary arrest and the obligation of workers to carry identity

cards. But within days of taking office, Ollivier and his colleagues suddenly found themselves faced with a crisis even more grave than the strikes and riots of the previous summer. The architect of the crisis was the man whose name the republican crowds had been chanting in the streets of Montmartre: Henri Rochefort.

The Marquis Victor-Henri de Rochefort-Luçay had enjoyed a colourful career.[4] The son of a ruined aristocrat who had become a vaudevillian, he had begun work as a humble government clerk before moving on to write light comedies for the theatre, followed by drama criticism for satirical journals such as *Le Charivari*. Along the way he published several books and accumulated various wives, mistresses and illegitimate children. "He sought pleasure in every form," wrote a fellow journalist, "tracked down all the emotional thrills. He gambled at roulette, at the races, at cards, in the stock market."[5] But Rochefort's greatest thrill—and his greatest gamble—was baiting Louis-Napoleon. His wickedly barbed anti-government polemics got him sacked from *Le Figaro*, but a short while later he had returned to the fray with *La Lanterne*. Forced to decamp to Belgium after the paper's suppression, he returned in the aftermath of the 1869 elections and started a journal called, provocatively, *La Marseillaise*, from which flowed an even more profuse torrent of anti-Bonapartist abuse. And in order to protect himself against the victims of his calumnies, Rochefort hired a twenty-one-year-old playboy and bruiser, Yvan Salmon, a cobbler's son who went by the name Victor Noir.

Rochefort did not find the Emperor's liberal concessions in the least "salutary and opportune." He was sceptical of the Liberal Empire and, in particular, of the motivations of Louis-Napoleon. "Scratch a Bonapartist," he wrote in *La Marseillaise* on January 9, 1870, a week after Ollivier took office, "and find a ferocious beast." For his part, Louis-Napoleon was becoming tolerant of Rochefort, having quashed the one-year jail sentence and 10,000-franc fine imposed upon him after his flight to Belgium in 1868. But another Bonaparte, Prince Pierre, the Emperor's fifty-four-year-old cousin, took umbrage at the comment and immediately challenged Rochefort to a duel. Though duelling was more or less extinct in Britain, where the final combat had taken place in 1851, it was still common in France, where, according to one newspaper, it was "the stock-in-trade of adventurers in journalism, professional orators and parliamentary debaters."[6] Indeed, duelling was such an occupational hazard for journalists that some newspaper offices provided special rooms in which their writers and editors could hone their fencing skills.[7] These duels often served as publicity stunts, but occasionally they ended in tragedy, as in 1836, when the publisher of *La Presse*, Émile de Girardin, killed a fellow journalist with a bullet to the groin. More recently, in 1862 the editor of *Le Sport* had been slain in

a sword-duel with the Duc de Gramont-Caderousse. Rochefort himself had nearly become one of these statistics. Three years earlier he had fought a duel against Paul de Cassagnac, a journalist for *Le Pays* who had accused him of slandering Joan of Arc. He survived only because Cassagnac's bullet struck a consecrated medal of the Virgin that had been sewn (supposedly by his mistress) into the lining of his waistband.[8]

Rochefort remained undaunted by the experience. He eagerly accepted Prince Pierre's challenge, and on January 10 his two seconds, Victor Noir and an aeronaut named Ulric de Fonvielle, presented themselves at Prince Pierre's home in the Paris suburb of Auteuil. Precisely what happened next was the subject of some dispute, but harsh words were exchanged, followed by fisticuffs as Noir struck Prince Pierre in the face with a gloved hand. Prince Pierre, who was never without his pistol, even in bed, promptly discharged a bullet into Noir's chest. Noir staggered down the street and, minutes later, collapsed and died on the floor of a pharmacy.[9]

Prince Pierre, known as the "Wild Boar of Corsica," was an obscure but notorious member of the Bonaparte clan. His turbulent past encompassed a stint in an Italian prison for murdering a policeman, a tour of duty in the Colombian jungle with comrades of Simón Bolívar, and spells of aimless wanderings in London, New York and Greece. More recently, after allegedly killing a gamekeeper in Belgium, he had retired with his working-class mistress to a quieter life in Auteuil, where he lived in the former home of the eighteenth-century philosopher Helvétius. Here his days were spent polishing his numerous weapons and baiting anti-Bonapartists in the letter pages of right-wing newspapers. Louis-Napoleon had never so much as laid eyes on this infamous cousin, who was kept firmly at bay, according to one of Eugénie's ladies-in-waiting, because of his "low tastes and low habits."[10] Nonetheless, Prince Pierre was a Bonaparte, and the fact that a Bonaparte had slain a republican, an associate of Rochefort, was a call to arms for enemies of the Empire. "I have been so weak as to believe that a Bonaparte could be other than an assassin!" shrieked Rochefort in the pages of *La Marseillaise*. "For eighteen years now France has been held in the bloodied hands of these cut-throats who, not content to shoot down republicans in the streets, draw them into dirty traps in order to slit their throats in private. People of France, have we not had enough?"[11]

This seditious cry was followed, a day later, by the spectacle of Noir's funeral. Republicans wished to have the young man interred in the cemetery of Père-Lachaise, on the opposite side of Paris from his home in Neuilly-sur-Seine, which would have necessitated a funeral march through the centre of Paris. In the end, however, the funeral took place in Neuilly, with a tumultuous

procession and phalanxes of soldiers who had been sent into the streets to pre-serve order. Rochefort was soon afterwards jailed for inciting a riot and insult-ing the Imperial family; but Prince Pierre Bonaparte was likewise under lock and key, awaiting trial on a far more serious charge of murder. His trial was set for March.*

The rapid ascent of Émile Ollivier seemed to augur well for Édouard Manet. The two men had met by chance in Florence almost twenty years earlier, after which they became travelling companions; and by the 1860s the bespectacled, muttonchopped Ollivier was a regular visitor to the soirées hosted by Eugénie Manet each Thursday evening in the Rue de Saint-Pétersbourg. An intelligent and deeply cultured man, Ollivier had married the illegitimate daughter of Franz Liszt and was a staunch champion of the operas of Richard Wagner; in later years he would publish a volume on Michelangelo. Upon coming to power in 1870 he expressed a desire to end "the contempt for taste and intelligence" that had prevailed in the arts for the previous twenty years.[12] To that end, on the day he took office, January 2, he deprived the Comte de Nieuwerkerke of many of his powers by creating a Ministry of Fine Arts to be headed by Maurice Richard, a political liberal and personal friend. This new Ministry would take over control of the Salon (and also, curiously enough, of the government's stud farms) from what henceforth was to be known simply as the Ministry of the Imperial Household. Nieuwerkerke would still be in charge of the Imperial museums, but all his other responsi-bilities had been relinquished, together with his glorious apartments in the Louvre.

With Nieuwerkerke deprived of his influence, the 1870 Salon suddenly as-sumed an auspicious hue for painters such as Manet. It appeared all the more promising when the new *règlement* stated that the administration would forfeit its right to appoint members to the Selection Committee: all eighteen members of the painting jury would therefore be elected by a constituency of painters who had exhibited at the Salon. Richard furthermore granted to the painting

*Victor Noir did not stay for long in the cemetery at Neuilly. A few years later his remains were moved to Père-Lachaise, where in 1891 the sculptor Jules Dalou unveiled a bronze statue over his grave. It portrays Noir lying recumbent in a frock coat, a top hat at his feet and (in keeping with his reputation as a lady's man) his crotch bulging conspicuously. He has since become a fertility symbol, and female visitors to Père-Lachaise leave flowers on his grave and rub his protuberance for good luck in starting a family.

jury, instead of Chennevières, who had been dismissed from his post, the privilege of hanging the paintings in the Salon.

Manet was hoping to submit his portrait of Éva Gonzalès to the new Salon. He may have had a cynical motive in offering the portrait, since most critics would surely have thought twice about making flippant and offensive remarks about the daughter of Emmanuel Gonzalès, who possessed a good deal of influence and esteem as the president of the Société des Gens de Lettres. Whatever the case, Manet engrossed himself so deeply in the canvas that Marie-Cornélie Morisot, paying a visit to his studio, reported back to her daughter that Manet "has forgotten about you for the time being. Mademoiselle G. has all the virtues, all the charms, she is an accomplished woman."[13] At least the Morisot women had the consolation of knowing work on the canvas, which was to depict Gonzalès seated before her easel, did not advance to Manet's satisfaction. "She poses every day," Berthe wrote of her rival, "and every evening her head is washed out in soft soap."[14] By September, Gonzalès had sat a total of forty times for Manet, though the portrait was no nearer completion. "The head is again effaced," Berthe wrote to Edma with some satisfaction after seeing Manet at one of the Thursday soirées.[15]

Morisot had further consolation by this point, since Manet asked her to pose for her own portrait, an arduous task to which she readily agreed despite the unflattering comments about her appearance in *The Balcony*. Entitled *The Repose*, the new canvas showed her idling on an upholstered sofa, enfolded in acres of white muslin and extending a slippered foot. Her languid demeanour conveys something of her mood at a time when she was depressed, uncertain and unable to paint. "I am overcome by an insurmountable laziness," she confessed to her older sister Yves. "I feel sad . . . I feel alone, disillusioned and old into the bargain."[16] Manet, who constantly found fault with Morisot's work, seems to have done little to buoy her self-confidence. "Manet has been lecturing me and sets up that eternal Mademoiselle Gonzalès as an example to me," she wrote bitterly to Edma. "She has poise, perseverance and makes a proper job of things, whereas I am not capable of anything."[17] Adding to Morisot's crisis was the fact that Marie-Cornélie was determinedly seeking a husband for her daughter, whose twenty-eighth birthday had passed in January with no prospect of marriage in sight. Various unsuitable young men had since been presented to her, the most recent of whom, a "Monsieur D.," she found "completely ludicrous."[18] Morisot had reservations about marriage in any case after witnessing the fate of Edma, who had put away her brushes following her marriage in February and abandoned all aspirations for a career in art.

Work on *The Repose* came easily to Manet as, in a kind of reprise of *The Balcony*, he gave Morisot the same fan, the same abundant dress, and the same vacuous expression. The canvas was completed before the portrait of Gonzalès, but Manet was determined to exhibit this latter portrait at the Salon. He was within reach of finishing it on time for delivery to the Palais des Champs-Élysées when, like the Wild Boar of Corsica, he got himself involved in a duel.

The cause of the duel was an unflattering review of a pair of canvases that Manet exhibited in February at the Cercle de l'Union Artistique in the Place Vendôme. This venue, often known as Mirlitons, had been founded a decade earlier by a painter named Ludovic-Napoléon Lepic, a friend of both Edgar Degas and the Morisot family. Lepic had envisaged a private club in which painters and collectors could come together in elegant rooms to view works of art or listen to musical performances, and to this end Mirlitons mounted an unjuried art exhibition each February, a "petit Salon" staged in an intimate setting that was restricted to an élite audience. In 1870 Manet elected to show two paintings in these gentlemanly quarters: the Velázquez-inspired canvas painted after his trip to Madrid called *A Philosopher (Beggar with Oysters)* and a watercolour study for *The Dead Christ with Angels*. Though accustomed to negative reviews, he became enraged after reading in the pages of the *Paris-Journal* a notice by a friend named Edmond Duranty. "Monsieur Manet has exhibited a philosopher trampling over oyster shells and a watercolour of Christ supported by angels," wrote Duranty. "Mirlitons really ought to try harder. Among the exhibitors there is more of a feeling of a boring duty to be performed than of a little artistic context to entertain the public."[19]

Manet had read far more disobliging comments, but such casual insolence, from a friend no less, seems to have been too much. Encountering Duranty a day or two later in the Café Guerbois, Manet struck him in the face and loudly demanded satisfaction. Seconds were quickly assembled, with Émile Zola agreeing to represent Manet. The duel was set for four days later, at eleven o'clock in the morning on February 23, in the wild privacy of the Forest of Saint-Germain.

The thirty-six-year-old Duranty had existed for some time on the fringes of the worlds of art and journalism. Blue-eyed and balding, he was the illegitimate son of a former mistress of the novelist Prosper Mérimée. In 1856, under the spell of Courbet, he had edited a short-lived journal, *Le Réalisme*, in which he proposed that the Louvre should be burned to the ground. He wrote criticism for *Le Figaro* and *La Gazette des Beaux-Arts*, while his novel, *The Misfortunes of Henriette Gérard*, had appeared in 1861. He had also turned his hand to

such enterprises as a puppet theatre in the Jardin des Tuileries. He was described by a fellow critic, Armand Silvestre, as a "likeable, distinguished person, with a touch of bitterness . . . One sensed a lot of disillusionment behind his quiet little jokes."[20] Gentle and soft-spoken, his characteristic gesture, according to Silvestre, was his sad smile, while his physical exertions were limited to the billiard table. Manet could scarcely have found himself with a less intimidating opponent.

Given the French passion for duelling, together with the vitriolic tone of so much French art criticism, it is a wonder that more painters had not marched their persecutors into the woods in hopes of finding satisfaction. But in this, as in so many other things, Manet seems to have been in the avant-garde. With admirable sangfroid, he went out on the eve of the duel to buy a new pair of boots—"a pair of really broad, roomy shoes in which I would feel quite comfortable"—and casually informed Suzanne, on the morning of the duel, that he was off for a spot of *plein-air* sketching.[21] The Wild Boar of the Batignolles then made his way to the Forest of Saint-Germain.

Unlike the swashbuckling Ernest Meissonier, with his rapiers and his *salle d'armes*, neither Manet nor Duranty had any experience with a fencing sword. Unsure, therefore, of quite how to proceed, they flung themselves at one other with "such violence" (as the police report later observed) that they bent their swords.[22] The clumsy altercation left Duranty slightly wounded in the chest, at which point the horrified seconds stepped in to stop the fight. Honour apparently having been served, the parties were reconciled with a shaking of hands. In a bizarre gesture, Manet then attempted to give his erstwhile opponent, as a token of his consideration, his new pair of boots, "but he refused," Manet later recalled, "because his feet were larger than mine."[23]

The preposterous stunt thus complete, the combatants repaired to their homes with stories of their derring-do: Manet informed Suzanne that he had "run his sword through the wag's shoulder," while Duranty boasted in a letter that "I would have killed him if my sword had been straight."[24] However, Manet later confessed to Antonin Proust that he and Duranty "have wondered ever since how we could have been silly enough to want to run each other through."[25] For her part, Madame Eugénie Manet, when she learned of the fight, blamed the incident on the evil influence of the Café Guerbois. At one of her soirées, a short time later, she begged Fantin-Latour to help keep her son away from the establishment, "which is so dangerous for someone of his lively, spontaneous temperament."[26]

* * *

Soon after his duel, Manet involved himself in the election campaign for the

1870 painting jury. He had agreed to join a slate of eighteen candidates put forward by Julien de La Rochenoire, a forty-five-year-old painter who specialised in portraits of animals, and who was proposing to reform the Salon by handing over complete control to a committee composed entirely of the artists themselves. He also advocated doing away with all medals and prizes.[27] Naming himself president of what he called the *Comité d'initiative*, La Rochenoire chaired a number of meetings, composed a manifesto, and recruited painters to campaign with him for seats on the jury. In addition to Manet, an impressive group came forward, including Corot, Daubigny, Chintreuil and Millet.

Manet had not become so actively involved in the politics of the Salon since 1863, and he took to the task with relish. "I will take care of the newspapers," he wrote to La Rochenoire, "where I have friends."[28] He meant, of course, Émile Zola, whom he importuned to state their case in various anti-government journals. He also advised La Rochenoire that they needed to "strike a big blow" by sending to the studio of every artist, on the eve of the elections, the following notice, to which the names of the eighteen candidates would be affixed: "Every artist who fears being rejected should vote for the following men, who support the right of all artists to exhibit their work, and to do so under the most favourable conditions."[29]

When the elections for the 1870 jury were held on March 24, the most liberal selection process in the history of the Second Empire produced some surprising results. La Rochenoire's "Committee of Initiative" did manage to place a number of its candidates on the jury, including Daubigny, Corot and Millet. But neither La Rochenoire nor Manet managed to get himself elected. Manet may have held influence and esteem among his friends at the Café Guerbois, but the majority of French artists evidently did not trust him to represent their interests. Even some of the other members of La Rochenoire's slate had reservations, with Corot striking Manet's name from his ballot.[30] In comparison to 1868 and 1869, the ballots actually showed a slight swing to the conservatives. Emblematic of this trend was the election of one of the most well-known conservatives of all, Chennevières himself, who had sufficiently overcome his horror of democracy to toss his hat into the ring. He later claimed that in 1870, in stark contrast to La Rochenoire, he had hoped to turn the jury into "an aristocratic corporation, based on the élite and on recognised merit, on the election of the best by the best."[31] As the 1870 jury convened, it was therefore far from certain that the new liberalism of Louis-Napoleon would find its way into the Palais des Champs-Élysées.

Vaulting Ambitions

ANOTHER FAMILIAR NAME graced the list of the 1870 painting jury. Despite not having participated in the politicking and manoeuvring in the weeks immediately preceding the elections, Ernest Meissonier managed to place fourteenth in the voting. He had been absent for most of the election campaign since he left Paris at the beginning of March, with plans to be back in time for the jury sessions. Once again he travelled south, spending a few days painting landscapes in Antibes, but his primary destination was Italy. In a whirlwind trip of only two or three weeks, he made visits to Florence, Siena, Genoa and Parma.

Italy had been a place of artistic pilgrimage for Meissonier no less than for so many other artists. He had threatened to run away to Naples when his father at first refused to support his artistic career, and in one of his first excursions he set off, as an aspiring young painter in 1835, to visit the land of Michelangelo and Raphael—though on that occasion an outbreak of typhus meant he got no farther than Grenoble. He had since visited Italy a number of times, most recently in 1860 when, after making his sketches for *The Battle of Solferino*, he had gone on to Venice and Milan; in the latter, in the Biblioteca Ambrosiana, he had become "drunk with pure beauty" at the sight of Raphael's cartoon for his fresco *The School of Athens*.[1] Meissonier's return to Italy in 1870 no doubt had much to do with fresco painting—and with his long-standing desire to elevate his reputation among his fellow *académiciens*, with whom he had pledged to keep faith by producing "works perhaps more worthy" of their attention.

Meissonier was known as the "king of easel painters,"[2] but he knew that all

artists pretending to greatness in nineteenth-century France had worked on murals. Ingres had executed *The Apotheosis of Homer* on a ceiling in the Louvre and *The Apotheosis of Napoleon* in the Hôtel de Ville. The handiwork of Delacroix covered various walls and cupolas in the Hôtel de Ville, the Palais Bourbon, the Louvre, and churches such as Saint-Sulpice. However, aside from his bits of graffiti—his doodlings in the corridors of the Grande Maison or on the whitewashed walls of Poissy—Meissonier had never attempted a mural. Indeed, his troubles securing a chair in the Institut de France had owed much to the fact that, unlike most of the other members, he had no mural to his name, no grand public commission that looked down from the vault of some impressive public building.

A man who laboured for many years on paintings only a few feet square would surely have been an eccentric choice to decorate a huge surface such as the entire underside of a dome or the wall of a church. Still, Meissonier believed that only a major mural project of this sort could make unassailable his position at the head of French art. Minuscule paintings of musketeers had made Meissonier hugely popular with the public, the collectors and most of the critics, but they had done little for his reputation at the Académie, where Raphael still reigned supreme, and where "real painting" (as Géricault had called it) meant adorning the walls of public buildings with grand religious and historical subjects, not manufacturing for private consumption tiny easel paintings of cavorting cavaliers.

Meissonier therefore dreamed of exchanging his easel for a ladder and scaffold. He coveted one commission in particular: the decoration of the Panthéon, the church built on the site of the tomb of Sainte-Geneviève, the patron saint of Paris. As long before as 1848, a friend named Paul Chenavard had been given an immense commission to decorate the interior of the building with sixty-three scenes depicting the evolution of human society. This project was, according to a later commentator, "one of the most ambitious mural plans ever worked out by one man in the entire history of art."[3] Chenavard had gathered together a team of thirty assistants and created at least seventeen large cartoons; but two decades later, distracted by other astoundingly ambitious projects—including one to excavate a canal between Paris and Dieppe in order to turn the capital into a seaport—he had yet to produce more than a few brushstrokes. Meissonier therefore hoped to relieve his friend of the gargantuan task, apparently offering his services at some point in the early 1870s. "This little man," Chenavard later recalled, "burdened with so many troubles, actually wanted to replace me free of charge to finish the Panthéon. . . . Is that not marvellous?"[4]

It is marvellous, yet also droll. After making his name by executing works that had won for him the title of "the painter of Lilliput," Meissonier dreamed

of painting "with buckets of colour on hundred-foot walls"—and of tackling one of the largest decorative projects in the history of art. Charles Yriarte could see the funny side of these vaulting ambitions: "It would indeed have been a curious sight to watch this wonderful little short-sighted man, with his blinking eyes, armed with his enormous brushes, attacking this great wall with those colossal heroes."[5] But the depiction of these colossal heroes on the walls of the Panthéon was what Meissonier believed would secure his reputation for all time.

Meissonier had returned from Italy before the end of March, in time to participate in the jury sessions for the 1870 Salon. Despite the presence of Chennevières and other conservatives, the jury actually proved rather lenient, admitting almost 3,000 canvases. Manet's *Portrait of Éva Gonzalès* was accepted along with his second submission, *The Music Lesson*, in which he had posed Zacharie Astruc with a guitar in a kind of rehash of *The Spanish Singer*. Other Batignolles painters fared equally well. Renoir's two canvases passed muster with the jury, as did paintings by Pissarro and Sisley. Berthe Morisot's *The Harbour at Lorient* and a portrait of her sister Edma were likewise accepted. As for Cézanne, he had been in a bombastic mood when a journalist encountered him carrying his canvases to the Palais des Champs-Élysées in the week before judging started. "Yes, my dear sir," Cézanne airily informed him, "I painted as I see, as I feel—and I have very strong sensations . . . I dare, sir, I dare. I have the courage of my opinions—and he who laughs last laughs best."[6] The jurors responded in their usual fashion: "I have been rejected as in the past," Cézanne, in a less buoyant frame of mind, wrote a few weeks later to a friend in Aix.[7]

Also rejected, more controversially, was Claude Monet, marking the second year in a row in which he had been excluded from the Salon. "The worst thing is that I can no longer even work," a furious Monet had written a year earlier, following the jury's wholesale rejection of his work.[8] But he had in fact managed to work in the summer of 1869—and he had produced, at this low point in his life, his most dazzling canvases.

Before the 1869 Salon closed, Monet had taken Camille Doncieux and their son Jean to the hamlet of Saint-Michel, on the Seine eight miles west of Paris. There the family lived with (so Monet claimed) "no bread, no kitchen fire, no light—it's horrible."[9] He was soon joined on his *plein-air* painting excursions by Renoir, who was staying nearby with his parents at Louveciennes. Together the pair of them would visit an island in the Seine at Bougival, the Île de Croissy,[10] where a fashionable entertainment complex known as La Grenouillère ("The Frogpond") had operated for the previous two decades. Situated on

the south side of the island, La Grenouillère consisted of a bathing pond and, floating on pontoons, a restaurant fashioned from an old barge. As early as 1854 a book called *Le Sport à Paris* related that La Grenouillère had become popular with "men and women belonging to the artistic life of Paris," including, the author reported, Ernest Meissonier, who helped popularise swimming, fishing and rowing in the area.[11] The restaurant was even frequented by the Emperor and Empress, who stopped for a visit during a steamboat ride along the Seine in the summer of 1869.

Monet and Renoir had positioned themselves side by side on the riverbank at this fashionable pleasure spot. They assembled their easels a few yards away from a small artificial island, some fifteen feet in diameter, that was joined by footbridges to the restaurant and shore, and that was known (after wheels of the famous Normandy cheese) as Le Camembert. Painting sketches of the scene before them—the figures grouped on the miniature island, a corner of the restaurant, the trees on the opposite bank at Bougival—they concentrated most of all on the waters of the Seine sparkling in the foreground, conjuring vivid optical effects by dissolving solid forms into dazzling patches of colour.

Monet in particular excelled at the task of capturing the light shimmering on the waves. He worked on the same pale ground favoured by Manet but further heightened his luminous tones by painting with vibrant pigments, some of them newly invented, which he added to his canvas in small commas and dashes. Advances in chemistry during the Industrial Revolution meant nineteenth-century painters possessed a much wider range of pigments than artists of earlier centuries. Oddly, however, many painters were reluctant to expand their chromatic horizons, largely due to the prejudice against colour enforced, for example, at the École des Beaux-Arts. Rather than exploiting the properties of these radiant new pigments, artists learned to tone down their works by coating them with transparent brownish glazes made from ingredients such as bitumen. As a collector had once informed John Constable: "A good picture, like a good fiddle, should be brown."[12] Painters who challenged this prejudice against colour—most notably Delacroix, who used as many as twenty-three pigments on a single canvas—found themselves reviled by conservative critics.

Monet was happy to avail himself of advances in paint technology. The coruscating reflections in his La Grenouillère canvases owed much to his use of pigments such as chromium oxide green and cobalt violet. The former, a yellowish green produced from a chemical reaction involving chromium salts and boric acid, was manufactured as a pigment by a Parisian colour merchant only in 1862. Cobalt violet, invented in 1859 by a French chemist named Jean Salvétat, was almost as new. Monet blended it with Prussian blue to create the shimmer-

ing water in the foreground. He would eventually come to regard this particular pigment as an essential for capturing the effects of light and shade: "I have finally discovered the colour of the atmosphere," he later declared. "It is violet."[13] Though he possessed as profound and instinctual a grasp of colour as anyone who ever held a brush, Monet might never have discovered the true nature of the atmosphere without the help of chemists like Salvétat.

Both Monet and Renoir began hatching plans to turn their sketches into studio paintings. "I really have a daydream," Monet had written to Bazille at the end of September, "a painting of bathing at La Grenouillère, for which I've done a few bad sketches, but it's a daydream. Renoir, who just spent two months here, also wants to do this picture."[14] Monet accordingly began turning his hasty, paint-dappled sketches of Le Camembert into a larger canvas intended for the 1870 Salon (plate 8B). He encountered problems only when he and Renoir ran short of money for pigment, food and wine. "We don't eat every day," Renoir wrote to Bazille, adding pluckily: "Yet I am happy in spite of it, because, as far as painting is concerned, Monet is good company."[15] The only other problem, he claimed, was the dead donkeys that came floating down the river.

Despite his various privations, Monet managed to complete a studio version of his La Grenouillère scene which the following March he submitted to the Palais des Champs-Élysées along with *The Luncheon*, an interior scene (reminiscent of Manet's interior of the same name) painted a year earlier at Étretat. Monet undoubtedly expected a better result than in 1869 since the new jury included Daubigny and Corot. But the votes, when they were tallied, went against both paintings. This rejection led to the immediate resignation of Daubigny, who, as in 1868, pleaded with his colleagues to take a more tolerant view of Monet's canvases. "I wouldn't allow my opinion to be contradicted," Daubigny later claimed. "You might as well say that I don't know my trade."[16] In the minds of most jurors, however, Monet had simply gone too far in his "abominable direction" (as one juror, Jules Breton, had phrased it). With their seemingly slipshod facture, his paintings looked like mere preparatory sketches, not works of art finished to the standard of Salon paintings. Monet, in their opinion, required chastisement; and with five of his last six paintings rejected from the Salon, he had become the newest *Grand Refusé*.

The 1870 Salon opened, like its predecessor a year earlier, against the background of a fierce political campaign. In the third week of April the Emperor had called for a plebiscite on the following point: "The people approve the liberal reforms carried out in the Constitution by the Emperor with the assistance

of senior institutions of the State." Louis-Napoleon was hoping to strengthen his hand against the political opposition by seeking ratification from the French people for the transformation of his régime into a "Liberal Empire."

In the months before the plebiscite, due to be held on May 8, several events indicated that Louis-Napoleon could expect a rough political ride. At the end of March, Prince Pierre Bonaparte had been acquitted of Victor Noir's murder, leading to outrage in many newspapers and riots in the streets of the working-class districts of Paris. A month later an assassination plot against the Emperor was uncovered as a twenty-three-year-old army deserter named Camille Beaury was arrested in the Rue des Moulins carrying a loaded pistol with which he claimed he was intending to shoot Louis-Napoleon. The plot was supposedly the work of the AIT, the French section of the International Association of Working Men, founded in London in 1864 by Karl Marx. Ollivier immediately took the convenient precaution of arresting hundreds of Socialists and closing down left-wing newspapers.[17]

The Palais des Champs-Élysées must almost have seemed an oasis of calm in the midst of this turbulence. For Manet, however, the experience was as unpleasant as ever, with his paintings attracting the usual enmity and ridicule. If he expected his portrait of Éva Gonzalès to be spared derision because of the sitter's father, he was disabused of the notion as soon as he opened the pages of Le Figaro. Its chief reviewer, Albert Wolff, the man who predicted that Manet would never accomplish anything, scorned the portrait as a "flat and abominable caricature in oils" and claimed Manet was producing "coarse images for the sole purpose of attracting attention." Coverage in La Presse was no better, with an article entitled "Manet's Horrors" describing the two canvases as exceeding "the most ridiculous things you could imagine," while L'Illustration asserted that Manet's work "provokes only laughter or pity." If Manet was hoping to please Théophile Gautier with The Music Lesson, a work that recalled The Spanish Singer—which Gautier had praised in 1861—he was sorely disappointed. Gautier wrote in Le Journal officiel that Manet was painting "in defiance of art, the public and the critics," adding: "None of the early promises has been fulfilled."

Once again even Castagnary, a progressive critic, could find nothing good to say. Believing the sole aim of art to be the reproduction of nature in all its "maximum power and intensity," for the past decade Castagnary (like Baudelaire) had been urging artists to offer dynamic images of modern life—both the "uncouth force" of the countryside and the "beautiful triumphs" of city life.[18] He believed that Manet's two canvases, which he saw as a pair of sterile and undistinguished portraits, revealed nothing of this energy. Castagnary could appreciate neither Manet's allusive subjects that

owed as much to the galleries of the Louvre as the boulevards outside, nor the novel style that led him to experiment with, for instance, planar compositions and impasted shadows. Blind to the painter's unique vision of modern life, he simply charged Manet with failing in his mission to reflect "the society in which we live." In his particularly wounding review in Le Siècle, he argued that the two canvases gave "proof neither of extensive intellectual preoccupations nor of powerful faculties of observation." The only flattering words, in the end, came from Manet's antagonist on the field of honour, Edmond Duranty, who made up for his harsh words in February by heralding Manet, in the same journal, as "one of the first painters of the age."[19]

A full seven years after Le Déjeuner sur l'herbe made its appearance, most critics had not budged an inch in their appraisals. They still faulted Manet for inelegant brushwork, flawed perspective, undignified subjects, and a supposed insincerity of purpose that raised suspicions of an elaborate jape. Over the past few years he had even failed, in Castagnary's view, to produce forceful and convincing visions of modern life. As a frustrated Gautier complained, Manet seemed to be perpetrating the same outrages in Salon after Salon. A number of critics who had encouraged his efforts earlier in his career, like Castagnary and, to a lesser extent, Gautier, had by 1870 thrown their hands in the air. Each new Salon, Gautier despaired, "seems to prove that Monsieur Manet has resolved to die impenitent."[20]

The gulf between Manet's canvases and the desires and expectations of many critics and jurors could clearly be seen in the choice of the Grand Medal of Honour for 1870. Tony Robert-Fleury, the thirty-three-year-old son of the Director of the École des Beaux-Arts, was given the Salon's highest award for The Last Day of Corinth, a sprawling scene from the pages of the Greek historian Polybius. A painter of historical episodes, often massacres, Robert-Fleury impressed the jurors with his depiction of what Polybius had called "the consummation of the misfortunes of Greece," the sack of Corinth by the Romans in 146 B.C. "The incidents of the capture of Corinth were melancholy," Polybius, an eyewitness to these events, had reported.[21] The men were murdered, the women sold into slavery, the city walls turned to rubble, the buildings torched and—most disconcerting to Polybius—the works of art looted or destroyed. Robert-Fleury showed this tragedy unfolding amid weeping women sprawled before their mounted conquerors as a pall of black smoke rose over the devastated city. Though he was anything but a painter of modern life, his magnificent but terrifying canvas, with its depiction of a refined and resplendent civilisation put to the sword, would bear a horrible relevance in 1870. The admiring visitors who clustered before The Last Day of Corinth could not have known that in this image of the past lay an appalling vision of their future.

The Prussian Terror

TO BE SURE, Paris in the early summer of 1870 did not look like a city on the brink of disaster. In May a new ballet, *Coppélia*, featuring music by Léo Delibes, was staged at the Théâtre Impérial de l'Opéra. In June the Grand Prix de Paris was run for the eighth time; the winner by a length was Sornette, a mare whose name translates as "nonsense" or "idle chitchat." The women attending the races in Chantilly and Longchamp had paraded the latest fashions, including the "Chapeau Pomponnette," a bonnet adorned with roses and secured beneath the chin with a large bow. Pale turquoise soon became popular in homage to the livery of Sornette's owner, Charles Laffitte. Horseracing was not the only sport causing excitement. An eighty-three-mile road race from Paris to Rouen was inaugurated, with the competitors riding rubber-wheeled, pedal-powered contraptions known as *vélocipèdes*, for which a Frenchman named Pierre Lallement had received a patent in 1866. Victory went to an Englishman, James More, who completed the course in under eleven hours.

However, a few dark clouds appeared on the horizon in the summer of 1870. There was an outbreak of smallpox in Paris and a drought that led to a fire in the Forest of Fontainebleau, a rise in the price of bread, and the sight of congregations of the faithful carrying holy relics around their churches and praying for rain. Strikes afflicted an iron foundry in Le Creusot, north of Lyon, while riots in Paris resulted in overturned omnibuses, mass arrests and several deaths. Nonetheless, despite the unrest, the Emperor and Émile Ollivier had reason to feel encouraged since the plebiscite on his reforms

had been won on May 8 by an overwhelming 7.5 million to 1.5 million. "I'm back to my old score," gloated Louis-Napoleon.[1] When the results were formally proclaimed in the Salle des États in the Louvre, the Emperor, dressed in his general's uniform, delivered a speech declaring that the plebiscite revealed "a striking token of confidence" in his leadership.[2] Many of the newspapers concurred, and across the Channel the editor of *The Times* praised him as "a wise, firm and provident leader."[3] Huge crowds turned out in the Rue de Rivoli and the Champs-Élysées to cheer *"Vive l'Empereur!"* as his carriage passed.

The Emperor's poor health, however, was still a cause of concern. In May he had been visited by his old friend Lord Malmesbury, who was shocked to find him "prematurely old and broken."[4] In the first week of June the papers were reporting that he was "slightly indisposed with a touch of rheumatism," and a few days later gout was disclosed.[5] A specialist in bladder diseases confirmed the secret diagnosis of a bladder stone. Then on the first of July a team of five doctors, including an eminent surgeon who had once operated on Garibaldi's foot, examined the patient to decide if he was fit enough to risk a lithotripsy. Chastened by the recent death of Adolphe Niel, they quickly decided against it.

With the Emperor ill and infirm, the events of the next fortnight unfolded with astonishing speed and a dreadful implacability. On July 2, the day following the examination, the Spanish Prime Minister, Juan Prim, announced that he had found a replacement for the unpopular Queen Isabella II, deposed in the "September Revolution" of 1868. After scouring the royal houses of Europe, Prim had decided to offer the Spanish crown to a Hohenzollern prince named Leopold von Hohenzollern-Sigmaringen, brother of the King of Romania and a distant relative of King Wilhelm of Prussia. The choice did not sit well with Louis-Napoleon. Though he too was distantly related to Prince Leopold, who was the grandson of Napoleon Bonaparte's niece, Stéphanie de Beauharnais, he was worried that the Prussians, with a Hohenzollern ensconced on the Spanish throne, together with their recent territorial advances in Central Europe, would in effect have France surrounded. As the French Foreign Minister, the Duc de Gramont, phrased it, the coronation would "disturb the European equilibrium to our disadvantage."[6]

On July 9, therefore, the French ambassador to Prussia, Comte Vincent Benedetti, met four times with King Wilhelm, who was taking the waters at the resort town of Ems, near Koblenz. Prince Leopold could not accept the throne without first asking permission from the head of the Hohenzollern family— namely, King Wilhelm—and Louis-Napoleon made it clear, through Benedetti,

that he wished the King to withhold his consent. When Wilhelm politely acceded to his wishes, Prince Leopold withdrew his candidature on July 12, a move hailed by Ollivier as a triumph for France and a humiliation for Prussia. Yet not everyone in France was delighted at this peaceful outcome, in large part because of the way Otto von Bismarck had affronted the French by refusing to hand over territories along the Rhine as payment for French neutrality in the war that Prussia fought against Austria in 1866. "The country will be disappointed," Louis-Napoleon cabled Ollivier, "but what can we do?"[7] The Emperor was correct. The press, the public, the politicians, even the Empress Eugénie (who had supposedly exclaimed "This is my war")—all were not a little disgruntled that there would be no war to check the territorial advance of what Alexandre Dumas *père* had called the "Prussian Terror." Almost the only person in France who did not desire a war with Prussia was, it seems, the Emperor himself.[8]

Louis-Napoleon nevertheless agreed with the decision taken by Ollivier and his cabinet to have Benedetti—in a deliberately provocative move—press the King of Prussia for a further guarantee. On July 13, accordingly, Benedetti approached the seventy-three-year-old Wilhelm on the promenade at Ems, asking him to repudiate for ever the possibility of a Hohenzollern accepting the Spanish crown. Wilhelm sternly refused, then gave instructions for a telegram recounting this latest twist—the famous "Ems Telegram"—to be sent to Bismarck, his Minister-President. Bismarck was as eager for a war with France as the French were for a war with Prussia. Having over the past four years given a burly embrace to most of Germany's thirty-eight disparate duchies, princedoms and city-states, he believed a crisis such as a Franco-Prussian conflict would unite the remaining states, including Bavaria and Württemberg, into a single power under the leadership of Prussia. He therefore seized on the strategy of editing the telegram to make the King's words seem more defiant and insulting than in the original, then publishing the doctored text in the newspapers. Wilhelm's original telegram had stated that he had nothing further to say to Benedetti because word had arrived in Ems that Prince Leopold was withdrawing his candidature. Bismarck cunningly omitted this reference to news of Leopold's withdrawal, thus making the King's refusal to grant a further audience to Benedetti look like a direct result of Benedetti's request—and an insult to France. Bismarck predicted that the amended telegram would serve as "a red rag to the Gallic bull."[9] He could not have judged his prospective enemy more astutely. "Everyone wants to eat Prussians," Théophile Gautier observed of the jingoistic crowds in Paris following the telegram's publication. "If anyone spoke

in favour of peace, he would be killed on the spot."[10] Within days the Duc de Gramont was announcing that a state of war existed between France and Prussia.

In 1806 the French under Napoleon had defeated the Prussians in a six-week campaign, trouncing them with such aplomb at the Battle of Jena that the philosopher Hegel had been moved to celebrate Napoleon as the "world soul." In 1870 all signs indicated that the outcome would be otherwise. The French military attaché in Berlin had recently made a chilling observation: "Prussia is not a country which has an army. Prussia is an army which has a country."[11] King Wilhelm, a professional soldier who spent his adolescence fighting the Grande Armée, was able to field an army of 500,000 men with 160,000 reserves, numbers that could virtually be doubled when he called on the other German states in the Confederation.[12] Louis-Napoleon, on the other hand, had at his disposal only 350,000 men, 60,000 of whom were occupied in Algeria with 6,000 more protecting the pope in Rome.[13] Yet despite the size and strength of the Prussian war machine, the French were strangely confident of victory. Their soldiers were equipped with the *chassepôt*, the most advanced rifle of the day, a weapon unveiled at the Universal Exposition in 1867. They also had a more secret—and deadly—invention called the *mitrailleuse*, a machine gun with twenty-five rotating barrels that could fire 150 rounds a minute.

Ollivier had announced in the Legislative Assembly that he was declaring war "with a light heart."[14] The Minister of War, Marshal Edmond Leboeuf, assured his countrymen that the war against the Prussians would be a "mere stroll, walking stick in hand."[15] In the days following the announcement, Parisians marched along the boulevards chanting *"Vive la guerre."* A soprano named Madame Sasse sang the *Marseillaise* in the streets dressed in the costume of the "Goddess of France," while another singer, Mademoiselle Thérèse, belted it out in the Théâtre-Gaieté in the costume of a waitress. Crowds besieged the enlisting offices, and a troop of soldiers paraded with a parrot trained to squawk "To Berlin!"

"It is in this frivolous spirit," an English newspaper reported, "that the nation which pretends to consider itself the most civilised in the world enters upon a war the terrible consequences of which few dare trust themselves to contemplate."[16] One of the few who dared was Gautier. "Who knows," he asked nervously, "what measureless conflagration will devour Europe?"[17]

The French headquarters for the war against the Prussians became Metz, a city on the River Moselle that lay within striking distance of the Rhineland. Its attractions included a Roman aqueduct and a Gothic cathedral. More to the

point, it had thick defensive walls and a powerful fortress known, because it had never been captured, as La Pucelle ("The Virgin"). Metz had not been taken by the enemy, in fact, since it was plundered in the middle of the fifth century by the forces of Attila the Hun. In the summer of 1870 its residents prepared themselves for battle with the modern-day Huns led by Otto von Bismarck.

Ernest Meissonier arrived in Metz at the end of July, within a fortnight of the declaration of war. He had abandoned both *Friedland*—which he believed himself close to finishing at last—as well as his studio in Poissy and, in a repeat of his expedition to the Italian front in 1859, set off on Lady Coningham, his beloved mare, for the 175-mile journey. In his luggage was a supply of sketching materials as well as official papers impressively announcing him as "Monsieur Meissonier, on special service."[18] He was hoping to record a French victory such as Solferino or, better yet, Jena or Friedland. Emma had been very

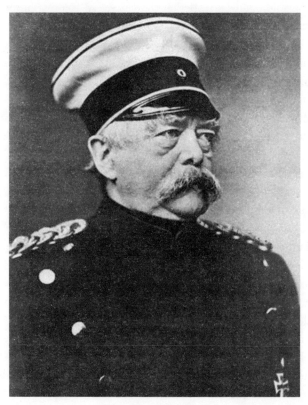

Otto von Bismarck

much against the enterprise, attempting to dissuade her husband, by then a fifty-five-year-old grandfather, from risking his neck for the sake of a painting. But Meissonier was adamant. "Don't worry that I will let myself get intoxicated by the smell of powder," he wrote home to her. "It isn't the horrible things of war that I want to paint, it's the life of the soldier, the strange and picturesque behaviour of which one cannot have any idea when one hasn't seen it."[19]

Meissonier was received by the staff at the Emperor's headquarters in Metz "almost as a herald of victory,"[20] but very soon he became aware that French preparations were not everything they might have been. The 200,000 troops gathered in the region—Meissonier's students Maurice Courant and Lucien Gros among them—were dismally provisioned. The trains carrying them to the front had been overcrowded and running late, and when they finally arrived in Metz the men found themselves short of tents, kettles, sugar, coffee and cooking pots, as well as maps and ammunition. Even horses were in short supply because Marshal Leboeuf, in a staggering display of short-sightedness and sheer stupidity, had sold many of them due to the lack of fodder caused by the summer's drought.[21] The soldiers did manage to find alcohol, however, and many quickly became insensible and, as a natural matter of course, undisciplined and indisposed—drunken antics that were not quite the "strange and picturesque behaviour" Meissonier had been hoping to capture on canvas. He also discovered, to his own inconvenience, a shortage of billets. He had been expecting to stay with "a friend of friends of mine," an engineer named Prooch, but due to some oversight Prooch had no quarters to offer him. The most eminent painter in France thereby found himself occupying "a humble room" in the riverside home of a family of "poor but decent people."[22]

The Emperor had been accommodated in a more befitting style. His headquarters in Metz, to which he had come to assume personal command of the forces, was a private train appointed with oak panelling, Aubusson tapestries and Louis XV furniture. But he too felt his spirits sink at the sight of his ill-provisioned and ill-disciplined troops. "Nothing is ready," he wrote to Empress Eugénie soon after arriving. "We do not have sufficient troops. I regard us already as lost."[23] This pessimism was born of his superstition as much as his growing awareness of the idiocy and incompetence of his various generals. Before departing from Paris he had paid a visit to his most recent mistress, a golden-haired Belgian countess named Louise de Mercy-Argenteau, who was surprised to see him extract from his pocketbook a scrap of paper covered in mysterious hieroglyphics. It was a horoscope, he told her, that had been discovered among his mother's possessions after her death, and that predicted the entire course of his life. "So my reign is to finish," Louis-Napoleon had

informed the startled countess on the eve of his departure for Metz, "and the Prussians are to be victorious."[24]

The Emperor's horoscope swiftly assumed a grim air of infallibility. As battle was joined at the beginning of August, the dash of the French officers and their gorgeous uniforms—the bearskin shakos, the gold braid, the tasselled turbans and stylish cutaway tunics—proved themselves no match for ruthless Prussian steel, especially the fifty-ton cannon manufactured by Alfred Krupp and menacingly displayed at the Universal Exposition three years earlier. The French troops were defeated on August 4 at Wissembourg and then two days later at battles in Forbach and Wörth; at the latter battle, in Alsace, the legendary cuirassiers showed themselves dismally ineffective against the awesome long-range Prussian firepower. "Farewell for ever to military pictures!" sighed a disconsolate Meissonier, packing away his paints and brushes.[25]

The Emperor too despaired at these defeats. He began making plans for a hasty return to Paris, but Eugénie, sensing the hostile mood of the capital, informed him he could not show his face without a victory. Already angry crowds were encircling the Palais Bourbon, which housed the Legislative Assembly, and noisily demanding a republic. On the twelfth, the Emperor handed command of the army to François-Achille Bazaine, a general who had the dubious distinction of having led the French exodus from Mexico in 1867. He then retreated in a third-class railway carriage to Châlons-sur-Marne, midway between Paris and Metz. Bazaine and his troops were promptly defeated at the Battle of Vionville and then a few days later at Gravelotte-Saint-Privat, a few miles west of Metz. Cowardice as well as incompetence had by then infected the French ranks, since several cavalry regiments were reported to have wheeled and taken flight at the cry "The Prussians are coming!"[26] Clearly French military valour had wilted since the days when Napoleon's *Gros Frères* bestrode the continent. Otto von Bismarck, in the Prussian camp, gleefully wrote home to his wife Johanna that the war was "as good as ended, unless God should manifestly intervene for France, which I trust will not happen."[27]

Soon after the defeats of August 6, Meissonier retreated from Metz, "with my heart like lead." On the morning following the disaster at Wörth, he had come across Marshal Leboeuf, the man who had claimed the war would be a "mere stroll, walking stick in hand." His obvious dejection and defeatism left Meissonier "overflowing with sadness and despair" and determined to get out of Metz while he still could. "How right you were to try to prevent my starting!" he wrote despondently to Emma. He set forth at three o'clock in the morning, encountering only a column of defeated soldiers making for

the safety of the city's fortress. "I was dressed in the queerest fashion," he later wrote. Leaving all his luggage in the care of the unreliable Prooch, he had set off on Lady Coningham wearing a grey cloak, a straw hat and a pair of holsters into which, for want of weapons, he had thrust several bars of soap. His Cross of the Legion of Honour was around his neck. "In this strange getup," he wrote, "I might easily, in the disturbed state of men's minds, have been taken for a spy." In fact, a day later, halting at an inn near Gravelotte, he was subjected to the "distrustful eyes" and suspicious murmurs of the other patrons. A sergeant of gendarmes was promptly summoned, and Meissonier escaped arrest, or worse, only when he produced his "on special service" papers. Thirty miles from Metz, at the citadel in Verdun, he met an old friend, Colonel Dupressoir, who had since been promoted to the rank of general. Dupressoir promptly arranged for his evacuation from the theatre of war on a cattle train. Meissonier's war was thereby ended, along with any aspirations to paint a heroic French victory.[28]

On August 30 the French met with yet another defeat, this time at Beaumont-sur-Meuse. The Emperor, who had returned to the front, was forced to fall back on Sedan, a small citadel town on the right bank of the River Meuse. With him were Marshal Patrice MacMahon, a hero of the Crimean War, and 100,000 troops.* MacMahon was promptly wounded in the leg by Prussian gunfire. He turned over his command to General Ducrot, who, realising that the hills surrounding Sedan would make excellent emplacements for the deadly Prussian cannons, uttered the memorable words: "We're in a chamberpot and about to be shat upon."[29] It was a statement displaying a foresight thitherto alien to the French military command.

The Battle of Sedan commenced on the first of September, with the Prussian artillery blasting the city as the French cavalry, heroically but suicidally redeeming itself, charged to its inevitable destruction. "Ah! The brave fellows!" exclaimed King Wilhelm as he witnessed the carnage.[30] Among them was the Emperor himself, who spent five hours in the saddle. He was suffering excruciating pain not only from his bladder stone but also (like his uncle at Waterloo) from haemorrhoids. Towels had to be stuffed into his breeches to sop up

*The Celtic surname of Marshal MacMahon (1808–93) is explained by the fact that he was descended from an Irish Catholic family from County Clare that went into French exile with King James II of England following the Glorious Revolution of 1688. MacMahon was given his marshal's baton and created Duc de Magenta by Napoleon III for distinguished service in the war against Austria in 1859.

the blood. "The agony must have been constant," one of his doctors later claimed. "I cannot understand how he would have borne it."[31] Realising that all was lost, the Emperor repeatedly exposed himself to the fire of enemy guns, doing his best to die in the battle. When even that tactic failed—he lamented bitterly that he was "not even able to get himself killed"[32]—he ordered the white flag of surrender to be raised above the citadel at three fifteen in the afternoon.

The Second Empire of Napoleon III had reached its inglorious end. A day later, Louis-Napoleon turned over his sword to King Wilhelm at the Château de Bellevue and then, escorted by a troop of black-caped Death's Head Hussars, went as a prisoner to Wilhelmshöhe, a château near Cassel that was once owned—in an ironic twist of fate—by one of his uncles, King Jérôme of Westphalia. "Poor Emperor!" wrote Théophile Gautier. "What a lamentable end to a dazzling dream!"[33]

The Last Days of Paris

T HREE DAYS AFTER the defeat at Sedan, Ernest Meissonier visited a
friend who lived in the Rue de Rome, Louis-Joseph-Ernest Cézanne, an
engineer who until recently had served as Director of the Ottoman Railway.
"We were broken down," wrote Meissonier, "completely demoralised by the
terrible news of the surrender of the whole army at Sedan." The news was ter-
rible indeed: 83,000 French soldiers were in Prussian hands at Sedan, while an-
other 17,000 lay dead or wounded on the battlefield. Meanwhile the Army of
the Rhine was pinned down at Metz and the city of Strasbourg was under siege.

Meissonier was therefore surprised, on leaving the house with Cézanne, to
find crowds marching through the streets around the Gare Saint-Lazare show-
ing their "enthusiasm" and "wild delight." "The contrast with our own state
of mind," he wrote of this blithe company, "astounded us at first." But Meis-
sonier's republican instincts were rapidly stirred as he heard the mobs chanting
"Vive la République!"[1] For on that day, a new republic—the so-called Third
Republic—had been declared at the Hôtel de Ville.

"Bliss was it in that dawn to be alive," an English visitor to France, William
Wordsworth, had written about the birth of the First Republic.[2] Some eighty
years later, republican bliss in Paris was undimmed. Crowds gathered outside
the Hôtel de Ville had cheered wildly as Léon Gambetta, the new Minister of
the Interior, declared from the window that "Louis-Napoleon Bonaparte and
his dynasty have for ever ceased to reign in France."[3] That evening, a throng
of 200,000 people surrounded the Tuileries to sing the *Marseillaise*. The city
received a republican revamp as lamp-posts along the boulevards were decked
with red crêpe and statues of the Emperor were vandalised and tossed into the

Seine. The name of the Avenue de l'Empereur was changed, with the help of placards and a bucket of paint, to "Avenue Victor Noir" and a stretch of the Boulevard Haussmann to "Boulevard Victor Hugo." Hugo himself appeared in Paris on September 5, following a nineteen-year exile and a seven-hour train ride from Belgium. At the Gare du Nord he shook thousands of hands, delivered speeches to the cheering multitudes, and issued defiant proclamations to the Prussians. He then installed his mistress, Juliette, in the Hôtel Rohan in the Rue de Rivoli and moved himself into the house of the dramatist Paul Meurice, where he began democratically entertaining compliant young fe-males of all social classes and harbouring dreams of hearing himself ac-claimed incontestable head of the republic.[4]

The political jollities did not last long, since Parisians began preparing to de-fend themselves against the invaders, who were scything their way across east-ern France, bent on reaching Paris. Bridges over the Seine were blown up and houses demolished in what became a military zone near the Point du Jour, south-west of the Champ-de-Mars. The *bateaux-mouches* that had carried visi-tors along the Seine during the Universal Exposition were fitted with guns to form a flotilla on the river. Charles Garnier's half-finished opera house was turned into an infirmary for the wounded; its rooftop became a semaphore sta-tion, beaming messages by means of electric searchlights to other stations atop the Arc de Triomphe, the Panthéon and, in Montmartre, the Moulin de la Galette. All of the theatres were closed by order of the Prefect of Police. Bar-racks tents appeared in the Jardin des Tuileries, and soldiers could be seen bathing in the fountains in the Place de la Concorde. Pedlars walked among them, selling papers and pencils with which to write wills. In Montmartre, mass graves were excavated to make room for the dead.

Meissonier was determined to take his own part in resisting the invasion. "Chance, necessity rather, has made me a soldier," he wrote proudly as he donned a uniform of the popular militia, the National Guard.[5] After sending his wife and daughter to Le Havre and a store of his paintings to England, he received an audience with General Louis-Jules Trochu, the Military Governor of Paris and head of the provisional Government of National Defence. Meis-sonier possessed some experience marching in uniform and shouldering a rifle, having served as a captain in the National Guard in 1848. He therefore hoped to lead a battalion at Poissy. "Give me the National Guard and I will be respon-sible for the whole place," he boldly informed Trochu.[6] Soon, however, he thought better of this assignment, since Poissy, having neither guns nor fortifi-cations, would make easy pickings for the Prussians, who he worried "might wish perhaps to treat me courteously"—an abhorrent possibility—when they

overran the town. He therefore got himself reassigned to Paris, where he moved into the house of his picture dealer, Francis Petit, on the Right Bank, near the church of Notre-Dame-de-Lorette. He was given the exalted rank of lieutenant-colonel in the National Guard and the task of inspecting the ring of walls and fortresses protecting Paris.

Meissonier was far from the only artist to down brushes and take up a weapon as the Prussians approached. Maurice Courant and Lucien Gros both had been taken prisoner, but Meissonier's other young pupil, Édouard Detaille, joined the Eighth Battalion. Other artists in National Guard uniform were numerous: Edgar Degas, Paul Baudry, Charles Garnier, William Bourguereau, the engraver Félix Bracquemond, the sculptor Jean-Alexandre-Joseph Falguière, a promising young painter named Henri Regnault, along with scores of others. Some units were composed almost entirely of artists, such as the Seventh Company of the Nineteenth Battalion, which included nine painters, seven sculptors and a couple of engravers.[7] Many Parisians were pleasantly surprised by the patriotic duty of these men, who were more generally associated in the popular imagination with laziness, hedonism and trouble-making. "All of the artists conduct themselves admirably," wrote one observer, "with a simplicity and good humour, with a devotion that elicits the tenderness of the people of Paris."[8] A military pride seized even Gustave Courbet, a lifelong pacifist who had once cleverly avoided his military service by downing a bottle of cognac and smoking twenty pipes on the eve of his army medical, for which he turned up, to the alarm of the doctor, reeking of booze and tobacco. Though not a member of the National Guard, he stitched a red stripe onto his trousers to give himself a martial bearing. "When I have my chassepôt," he wrote jovially to a friend, "watch out."[9]

Édouard Manet also joined the National Guard, sending his family to stay with friends in Oloron-Sainte-Marie, a hilltop town in the Pyrenees. Like Meissonier, he attempted to safeguard his paintings, taking a dozen of what he considered his most important canvases—including Le Déjeuner sur l'herbe and Olympia—to Théodore Duret's home near the church of the Madeleine, where they were placed in the cellar. His other paintings he deposited in the cellar of the family home in the Rue de Saint-Pétersbourg, where he remained with his brothers Gustave and Eugène, both of whom had joined the Garde Mobile, a force of untrained conscripts attached to the regular army. "I am glad I made you leave. Paris is bleak," he wrote to Suzanne on September 10, reporting that the theatres had closed. "I find the house very sad. I hope this won't last a long time."[10] Two days later he went with Eugène to Passy to visit the Morisots, who had soldiers from the National Guard billeted in their house.

Manet tried to persuade Berthe to leave the capital, graphically describing the horrors that lay in store. "You will be in a fine way," he informed her, "when you are wounded in the legs or disfigured."[11] Berthe was undaunted by this grim scenario, but Manet's visit "has had a bad effect on your father," Madame Morisot wrote to Edma. "The tales that the Manet brothers tell us are almost enough to discourage the most stout-hearted."[12]

If Berthe Morisot was determined, like Manet, to remain in Paris, other members of the École des Batignolles took the opportunity of removing themselves to safer environs. The outbreak of the Franco-Prussian War had found Claude Monet on his honeymoon at the Hôtel Tivoli in Trouville. He and Camille had been married at the end of June in a civil ceremony in the Batignolles, with Courbet as a witness. The newlyweds remained in Trouville and the surrounding area for the month of August, with Monet painting on the beaches and making an occasional excursion to Le Havre in a bid to extract money from his father. After the fall of Sedan, he hastily left Trouville on a boat bound for England without (naturally) paying his bill at the Hôtel Tivoli. He also left without Camille and Jean. By a strange coincidence, he was followed across the Channel from Trouville, one day later, by Empress Eugénie. She had fled the Tuileries and, in the company of her American dentist, Dr. Thomas Evans, travelled incognito to Trouville, where she arrived on the sixth. She then crossed to England after throwing herself on the mercy of a stranger, Sir John Burgoyne, whose yacht was moored in the harbour. After a rough passage, she began her exile at Chislehurst, a dozen miles outside London in the Kent countryside. As for Monet, he made his way to London, to a flat in Bath Place, Kensington. He would eventually be reunited with two other refugees, Daubigny and Pissarro, and then with his wife and son.

Another newlywed who took the precaution of keeping out of harm's way was Émile Zola. At the end of May, with Cézanne as a witness, he too had married his mistress in a civil ceremony in the Batignolles. The outbreak of the Franco-Prussian War two months later was most inopportune for Zola, interrupting as it did the newspaper serialisation of *La Fortune des Rougon*, the first novel in his ambitious project of mapping out in a series of novels what he called the "natural and social history of a family under the Second Empire." Zola had celebrated the Emperor's expedition to Italy in 1859 in clunky, jingoistic verse: "Go! Our Emperor leaves us for glory!/As, in former days, soldiers, our anthem of victory."[13] But by 1870 he was much less supportive. He spent the war attacking the Emperor and the French army in the radical journal *La Cloche*, an act for which he would have been prosecuted had not the Second Empire collapsed at Sedan. He then made plans to escape Paris. "My wife is so

frightened that I must take her away," he wrote to Edmond de Goncourt in early September.[14] He duly departed for Marseilles with his mother and his new wife. He was followed south, soon afterwards, by Cézanne, who went to L'Estaque with his mistress Hortense Fiquet.

Zola and Cézanne, along with thousands of others, had escaped the capital with only days to spare. Little more than a fortnight after the Third Republic was declared, on September 19, the siege of Paris began. The city was encircled by 200,000 Prussian troops who, after a few skirmishes in the suburbs, hunkered down to wait for their siege artillery to arrive. The Prussian commanders had decided on a siege rather than an invasion, reckoning they could starve the Parisians into submission within six weeks. Bismarck had insolently predicted that "eight days without *café au lait*" would be enough to break the will of the pleasure-loving Parisians.[15]

The Government of National Defence had made preparations for feeding its besieged citizens. The iron pavilions of Les Halles, newly built, were filled with sacks of wheat and flour, while the Gare du Nord was turned into a flour mill. Livestock had been brought into the city to graze in the squares, and shepherds could be seen tending their flocks in the Bois de Boulogne, which had also become a pasture for 25,000 oxen. But food and other luxuries quickly began running short as the city was severed from the outside world. "We now can no longer get *café au lait*," Manet wrote to Suzanne on the last day of September, adding that people began queuing at the butcher shops—which were open only three days a week—at four o'clock in the morning.[16] "Horse meat is sneaking slyly into the diet of the people of Paris," noted Edmond de Goncourt one day later.[17] After a few more weeks, Manet was reporting to Suzanne that even mules were regarded as "royal fare."[18]

Manet's letters were sent to Suzanne by means of the "Balloon Post," a service started, on the advice of the intrepid Nadar, in the first week of the siege. With Paris encircled by the Prussians, with its roads and rails blockaded and its telegraph lines cut, the only way to communicate with the outside world was through the air. On the second day of the siege, Nadar had ascended above the Prussian line of investment in a hot-air balloon, not to deliver post but to shower the enemy soldiers with leaflets castigating them for attacking Paris, the pinnacle of civilisation. Unable to steer his balloon back to Paris, he touched down in the countryside beyond, from where it was impossible to get back into the city. For Nadar at least, the siege was over. The next balloon left Paris two days later, floating over the heads of the Prussian soldiers with 275 pounds' worth of dispatches in its gondola. This

vessel, the *Neptune*, landed safely at Evreux, seventy-five miles to the west, after a three-hour flight, effectively breaking the blockade. Four more balloons left in quick succession, and soon the Gare d'Orléans and several other venues, including a former dance hall in Montparnasse, were turned into factories for making more of them.

One of these new vessels, the *Armand Barbès*, named for a republican and revolutionary who had died the previous June, was used to transport Léon Gambetta out of Paris so he could organise resistance in the provinces. Wearing a sealskin cap and fur-lined boots, and looking distinctly queasy as he climbed into the gondola, Gambetta was launched in the first week of October from a spot in Montparnasse as the assembled crowd shouted *"Vive la République!"* He was carrying—as if more hot air were needed—several letters from Victor Hugo, one addressed "To the Germans!" and another "To Frenchmen!"[19]

Since balloons could not be flown back into Paris due to their erratic and uncontrollable flight patterns, the only means of getting information into the capital from the outside world was the carrier pigeon. Pigeons had been used to convey messages since antiquity, and a pigeon post between Germany and Belgium had been operated as late as 1850 by Paul Julius Reuter, the founder, in 1865, of the Reuter's Telegraph Company. Reuter's fleet of forty-five carrier pigeons had actually proved themselves swifter than the railway in carrying stock prices between Brussels and Aachen. The carrier pigeons used in the Siege of Paris were able to carry much more information thanks to a new process of microphotography invented by René Dagron. In 1859 Dagron had received a patent for microfilm, and over the next decade he produced such novelties as photographs shrunk to fit inside jewels, signet rings and other trinkets. He also developed, like so many other photographers, a profitable sideline in pornography, producing on microfilm works with titles such as *The Surprised Bathers* and *The Joyful Orgy*. Illegible to the naked eye—and therefore difficult for the police to apprehend—his shrunken images of gaily disporting lovelies could be enjoyed with the assistance of a special magnifying viewer.[20]

During the siege, Dagron turned his talents to more patriotic endeavours. He and his equipment were flown out of Paris on a pair of balloons, one of them christened, fittingly, the *Daguerre*. Despite an ill wind, a crash and one of the balloons falling into the clutches of the Prussians, Dagron eventually made his way to Tours, where Gambetta and the machinery of government were based. He set to work photographing government dispatches, shrinking them to a minute size, printing them on lightweight collodion membranes, then rolling them up and fitting as many as 40,000 of them into a canister

strapped to the legs of a single carrier pigeon. The pigeons were then released, encountering on their return to Paris, besides all the usual perils, falcons specially trained by the Prussians.[21]

As well as the official dispatches sent to General Trochu and the other military authorities in Paris, the pigeons also carried personal communications, short messages from anxious relatives to their loved ones inside Paris. Manet finally received one of these from Suzanne in the middle of November. "You can imagine my emotion on opening it," he wrote back to her via the Balloon Post. "It is the first time in two months that I have had any sign of life from you. It will restore a little of my courage, and plenty is needed here."[22] Little wonder that the pigeon quickly became for besieged Parisians a symbol of freedom and hope. A play called *The Pigeon of the Republic* was performed on the stage, and a former student of Couture, Pierre Puvis de Chavannes, painted in his studio in the Place Pigalle a work entitled *Le Pigeon voyageur*, showing a heroic little bird dodging a vicious-looking Prussian hawk and arriving safely in the arms of its keeper. There were even arguments made in favour of putting the pigeon on the coat of arms of Paris. But perhaps the most sincere tribute was the fact that, even as winter drew nigh and starving Parisians began to experiment with ever more exotic cuisine, the pigeon remained safe from their cooking pots.

By November the situation in Paris had become grim. "They are starting to die of hunger here," Manet wrote to Suzanne in the middle of the month, informing her three days later that "there are now cat, dog and rat butchers in Paris. We no longer eat anything but horse meat, when we can get it."[23] A much-loved cat mysteriously disappeared from the apartment of one of Manet's neighbours. "Naturally it was for food," he observed.[24] One hungry Parisian pronounced cats "a very dainty dish" when broiled with pistachio nuts, olives, gherkins and pimentos.[25] Rats such as those purchased from the "rat market" in front of the Hôtel de Ville also had their advocates. "This morning I regaled myself with a rat *pâté*," Gautier wrote to a friend in Switzerland, "which wasn't bad at all."[26] Another diner pronounced it "excellent—something between frog and rabbit."[27]

The capacity of Parisians to stomach dainties such as rat was possibly assisted by an adventurous national gastronomy that already encompassed snails, frogs, calves' udders, pigs' lungs and the testicles of roosters. Horse meat was already popular with the French, since 2,421 horses—the equivalent of more than a million pounds of meat—had been butchered for food in 1868.[28] Even rats were not unknown to the dinner tables of the French, with

people in Bordeaux regarding them as something of a delicacy, cutting them in half and then grilling them with herbs and spices.[29] In any case, few people could afford to disdain a rat *pâté* as the siege continued and supplies became ever scarcer.

Neither the privations of the besieged metropolis nor his military duties stopped Manet from working. He wrote to Éva Gonzalès, who had fled to Dieppe, that his paintbox and portable easel were "stuffed into my military kit-bag, so there's no excuse for wasting my time."[30] One of the pictures he executed, an etching done in bister on ivory laid paper, showed a queue at a butcher shop—a line of people standing under umbrellas in the rain. He also made rough pencil-and-watercolour sketches of his képi-wearing and rifle-bearing comrades in the National Guard. Circumstances had turned Manet (who had given up his studio in the Rue Guyot) into a *plein-air* painter. Such vignettes, he told Suzanne, were "souvenirs that will one day have value."[31] His most remarkable work was an oil sketch, no doubt painted outdoors, called *Effect of Snow at Petit-Montrouge*, a hasty impression of a church on the southern edge of Paris whose tower had served as a lookout post.[32]

Manet's fellow Guardsman, Lieutenant-Colonel Meissonier, likewise kept his sketching materials in his knapsack. Prussian guns were not enough to keep a compulsive worker like Meissonier from his brushes and paints. He had brought to Francis Petit's house the materials he needed to complete *Friedland*, including the canvas itself, which he believed was only six months from completion. But after Sedan he found himself unable to touch the work on which he had spent much of the previous seven years. In September he had therefore set *Friedland* aside in favour of beginning—in his spare moments away from military duties—a work of quite a different sort, an allegorical scene to be called *The Siege of Paris*.[33] He began sketches for the painting on (apparently for want of other material) Petit's headed notepaper; his first doodles showed a female figure standing tall and defiant in the midst of the dead and dying. Taking his paintbox and brushes to the ramparts, he painted watercolours called *A Battery of Artillery* and *A Cannon in an Embrasure on a Rampart*. He also made a watercolour sketch of his own head after coming home from an outpost, after a frigid shift in December, and seeing in the mirror the "tragic expression" on his face.[34] If circumstances had turned Manet into a *plein-air* painter, Meissonier had become, through the same exigencies, a painter of modern life.

To conserve fuel for inflating balloons, gas supplies to all buildings in Paris had been stopped at the end of November, plunging the cafés and residences into a darkness that could be relieved only by candles. Coal grew scarce as

snow fell and the temperatures plummeted to as low as -14 Celsius (7 degrees Fahrenheit) during what became the coldest winter in living memory. Sentries froze to death on the ramparts, hundreds of National Guardsmen suffered frostbite, and ice floes drifted down the Seine. People began burning their doors and furniture, and even their pianos, as firewood. Soon the city was denuded of hundreds of trees, including the chestnuts and plane trees along the Champs-Élysées, as gangs of desperate, frigid citizens appeared in the streets carrying stepladders and wielding axes. Smallpox raged through the city, claiming hundreds of lives.

Food became ever more scarce. "I shan't even talk about the food," Manet wrote to Suzanne on Christmas Day, the hundredth day of the siege.[35] The bread, made from a barely palatable mixture of rye, rice and straw, was said to taste like a Panama hat. But an enticingly different fare was available for those with both money and venturesome tastes. At a butcher shop in the Boulevard Haussmann the proprietor, a Monsieur Deboos, was selling, according to Edmond de Goncourt, "all sorts of weird remains," including "the skinned trunk of young Pollux, the elephant at the Zoo."[36] Castor and Pollux, the two elephants in the Jardin des Plantes, had been cruelly and bunglingly dispatched with a *chassepôt* firing steel-tipped .33-calibre bullets. Elephants had long been the most esteemed and well-loved residents at the Jardin des Plantes. They were fed honey cakes known as *plaisirs* by visitors to the zoo, and were said to enjoy the singing of patriotic songs. Their keeper, Monsieur Devisme, had protested at the execution (which was watched by several famous big-game hunters and other interested Parisians) and afterwards fell sobbing into the snow, hugging the trunk of one of his dead charges. Elephant steak promptly found its way onto the plate of Victor Hugo, who was further satisfying his gastronomic curiosity by tucking into bear and antelope (he complained that horse meat gave him indigestion).[37] Wealthy Parisians such as Hugo were able to choose from an extensive menu of zebra, reindeer, yak and kangaroo, all from the Jardin des Plantes, the adjunct of the National Museum of Natural History that had been founded in 1793 to house animals regarded as "national treasures."

But horses provided the main source of meat for Parisians as the siege continued. Some 65,000 of them were butchered for food, so many that Manet observed there were "hardly any carriages now; all the horses are being eaten."[38] Meissonier had to fight to keep his own horses—Lady Coningham and a second horse named Blocus—out of the abattoir and off the menu. When both animals were requisitioned for food, he appealed to the highest authority, General Trochu. "I beg that my poor horses, which are useful to me for my military duty, and indispensible for the completion of my unfinished pictures,

may not be taken from me," he pleaded, "except in the case of the direst extremity." He added that one of the horses was "particularly dear to me—my mare Coningham. She is an old friend who carried me all day at Solferino."[39] For the meantime, both horses were spared.

After smallpox and starvation came pneumonia. "It's getting tough," Manet admitted to Suzanne three days after Christmas. "Many weak people have succumbed."[40] His own health had begun to decline. He had been sleeping in straw while on guard duty along the ramparts, and the ankle-deep mud had given him, in all probability, a case of trench foot, since as early as October he was complaining about his feet and wearing Suzanne's cotton socks for protection. He had taken to keeping himself warm—and creating a kind of bulletproof vest for protection against Prussian bullets—by stuffing hundreds of layers of silk paper down the front of his Guardsman's cloak.[41] But he was finding military life both demanding and dangerous. At the end of November he had been present at a fierce battle fought at Champigny, eight miles south-east of the centre of Paris. "What a bacchanalia!" he wrote to Suzanne. "The shells went off over our heads from all sides."[42] He was, understandably, badly shaken by the sight of so much bloodshed, since the French suffered massive casualties, with one regiment alone losing 400 men.[43] He decided to leave the artillery in which he had been serving and find another, preferably safer, position. Fortunately for him, in December he was promoted from enlisted man to the rank of lieutenant and transferred to the General Staff, which was based at the Élysée Palace. His benefactor—and his new commanding officer—was none other than Lieutenant-Colonel Meissonier.[44]

Nothing indicates that Manet and Meissonier knew one another personally, or ever had met, before 1870. According to Manet's friend Théodore Duret, "There had never passed between them the least relation, occupying as they did the two opposite poles of art."[45] However, Duret was writing thirty-six years after the fact, and relations may well have passed between them in the 1860s. Manet and Meissonier shared a number of friends, including Delacroix, Daubigny and Philippe Burty. Furthermore, the pair of them may have worked together on the petition presented by Manet to the Comte de Walewski in 1863. But even if they had never met, Meissonier was well aware of both Manet's paintings and his reputation as an artist. Between 1864 and 1870 he served on four different Salon juries to which Manet had offered his work, including the controversial Jury of Assassins in 1866. Though four of his eight paintings had been rejected from those Salons, Manet is unlikely to have held Meissonier responsible for his misfortunes. He saw his persecutors elsewhere,

in characters such as Nieuwerkerke and Chennevières, the outspoken jurors Jules Breton and Édouard Dubufe, critics like Gautier and Albert Wolff, and even the censor at the Dépôt Legal who had forbidden the printing of *The Execution of Maximilian*.

Still, Manet must have been rankled by the older painter's success, which threw into a dispiritingly sharp relief his own unhappy career. As Duret pointed out, the relationship between the two men in the National Guard was a vastly unequal one: "Military service brought them suddenly together, and put the one, a young and combative artist, under the orders of the other, in his full glory and superior in age and rank." Yet their service together does not seem to have been marked by too great an animosity. Manet, in his letters to Suzanne, made no complaints about his new commanding officer, though in Duret's account Meissonier was guilty of a lordly self-regard (a believable enough complaint) that supposedly left his junior officer feeling "very ruffled." Manet resented how Meissonier treated him "with a kind of polite formality from which, however, any idea of confraternity was banished." No opportunity arose for the two men to talk about "Art with a capital A," since Duret claimed that Meissonier "never showed an awareness that Manet was a painter."[46] Meissonier's lofty indifference must have been extremely galling to a man who dominated conversations at the Café Guerbois with his sarcastic wit and luxuriated in his reputation as the leader of the group of younger artists who clustered around him. Manet exacted his revenge, according to Antonin Proust, by showing scorn for the sketches that Meissonier, the obsessive doodler, produced on scraps of paper during meetings at the Élysée Palace—"something that strongly chagrined the painter of *The Campaign of France*," Proust claimed, "but amused his shrewder neighbours at the table."[47]

Manet soon had more to worry about than Meissonier's haughty disregard: he was painfully ill-equipped for his duties on the General Staff, which required him to ride a horse. While Meissonier was a superbly adept horseman, Manet had little experience in the saddle, with the result that within days of taking up his new position he was suffering from one more discomfort to go with the cold and the hunger. "For the past two days I've had to stay in my room," he wrote to Suzanne early in January 1871. "Riding horseback has given me piles, and with the abominable cold we are having here, one must look after one's health."[48]

Conditions soon became even more disagreeable. For the previous four months, long Prussian trains had been pushing steadily westwards from the Rhine, their carriages laden with hundreds of tons of cannon and shot. Included among the Prussian ordnance were Krupp's massive doomsday

weapons as well as heavy cannons with nine-inch calibres and 300-pound mortars. The weight and mass of these projectiles far surpassed anything ever used in military history, even at the siege of Sebastopol. Finally, on January 5, all of these massive guns had been rolled into position on the heights south of Paris. "We shall soon be at the mercy of those savages," Meissonier bitterly observed.[49]

A Carnival of Blood

THE BOMBARDMENT OF Paris by the Prussians lasted for almost three weeks. Some 400 shells fell on the city each evening as the Prussians fired their guns after ten o'clock at night in order to starve the besieged Parisians of sleep as well as food. Since the bulk of the artillery was positioned on the heights of Châtillon, five miles south of where the Seine flowed through the centre of Paris, virtually all of the mortars fell on the Left Bank. "The Prussian shells have already reached as far as the Rue Soufflot and the Place Saint-Michel," Manet wrote to his wife a week after the bombardment started.[1] The Chapel of the Virgin in Saint-Sulpice was struck by a mortar. So were the Gare d'Orléans, with its balloon factory; the Jardin des Plantes, where a collection of orchids was destroyed; and a school in the Rue de Vaugirard, where a single shell killed five young children.

Residents of the Left Bank hastily fled across the river, clutching a few meagre possessions and looking, as Gautier observed, like "a migration of Indians carrying their ancestors rolled in bison skins."[2] Gautier himself was in the firing line, having fled from his house in Neuilly to what he thought was the greater safety of the Faubourg Saint-Germain. Both Manet and Meissonier, however, occupied securer quarters on the Right Bank, more than a mile away from where the nearest shells had fallen. Even so, the noise was deafening. "The cannonade was so heavy during the night," Manet wrote to Suzanne, "that I thought the Batignolles was bombarded." Three days later he added, plaintively: "The life I am leading is unbearable."[3]

The Prussian guns finally fell silent on January 27, when the Government of National Defence agreed to an armistice. The Siege of Paris had lasted a total of

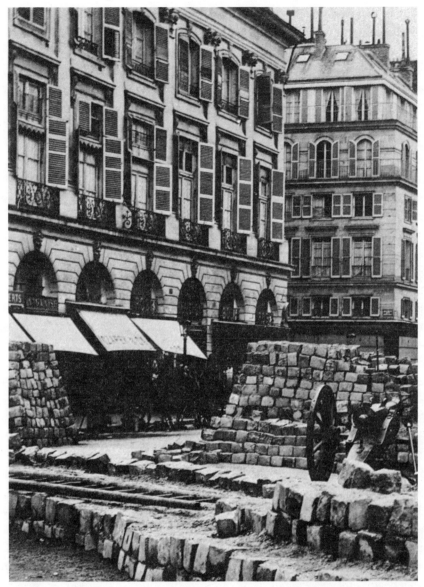

Rue Castiglione during the siege of Paris, 1871

130 days. "Holding out was no longer possible," Manet wrote to Suzanne. "People were starving to death and there is still great distress here. We are all as thin as rails."[4] The armistice was officially signed at the Palace of Versailles on the twenty-eighth, where less than two weeks earlier another ceremony had

taken place. The south German states of Bavaria, Baden and Württemberg had agreed to join the German Confederation, which thereafter became known as the Deutsches Reich, or German Empire, a federal state governed by Wilhelm. This unification of Germany was celebrated on January 18 as Wilhelm was proclaimed Emperor, or Kaiser, in a ceremony staged—humiliatingly for the French—in the Hall of Mirrors at Versailles. "That really marks the end of the greatness of France," despaired Edmond de Goncourt after reading of Wilhelm's coronation in a newspaper.[5]

Manet observed the end of the siege by treating himself to a choice cut of beef—for which he paid seven francs a pound—and cooking a *pot-au-feu*, the nourishing dish of boiled beef and vegetables ("but naturally with no vegetables," he complained)[6] known as *le plat qui fait la France* ("the dish that made France"). He then began preparations for the 400-mile journey south to the Pyrenees for a reunion with Suzanne, his mother and Léon. His joy at being able to see his family again was tempered by the sad news, received early in February, that Frédéric Bazille, the great friend of Claude Monet, had been killed at the end of November while serving with the Zouaves. Dying a few months short of his thirtieth birthday, Bazille was tragically denied the chance to further explore his brilliant talents.

Meissonier had a much shorter journey to make, but he too was in mourning as he left Paris. He arrived at the Grande Maison, some time early in February, suffering from "the bitterest sorrow I have ever felt."[7] A young friend and protégé, Henri Regnault, winner of the Prix de Rome in 1866 and of gold medals at the Salons of 1869 and 1870, had been killed in a disastrous sortie by the National Guard at Buzenval, seven miles west of Paris, on January 19. Meissonier, who spoke to the young painter on the night before his death, had seen in Regnault the future of French art. He had personally recovered his body from the muddy battlefield and then a few days later delivered the funeral oration. His words were inspirational: "Let us work again," he had exclaimed. "The time is short. We have no eternity in which to re-create our country."[8] But the young man's death left him consumed by a furious hatred for the Prussians. He was therefore displeased in the extreme to discover, upon returning to Poissy, that the Grande Maison had been turned into a barracks for Prussian soldiers. Sixty of them had been living in the house since the start of the siege, with no plans to depart. Meissonier thereby found himself compelled to share his accommodation with the despised enemy.

Other unpleasant surprises awaited Meissonier's return. Though he had been able to save Blocus and Lady Coningham from the slaughterhouse, one of his

horses had been appropriated by the Prussians, who had furthermore taken, and presumably butchered, his cows. Several of his other horses had been requisitioned by the French army; among them was Bachelier, the grey stallion that had appeared in so many of his paintings and sketches. He never saw Bachelier again, and some time after his return to Poissy he inscribed on one of his 1865 sketches of the animal the words: "My poor Bachelier, taken by the Army of the Loire, 27 January 1871."[9]

One of the few consolations for Meissonier as he returned to Poissy was a re-union with Elisa Bezanson, by then thirty years old, still unmarried, and still completely devoted to him. And, for what seems to be the first time, he began a painting that featured her. To escape from the Prussians occupying his house, Meissonier shut himself away in his studio and, in the words of the critic Jules Clarétie, "threw upon the canvas the most striking, the most vivid, the most avenging of allegories."[10] Having begun sketches for *The Siege of Paris* while staying with Francis Petit, he portrayed the tall, robust Elisa as the figure of Paris standing enveloped, in the words of Clarétie, "in a veil of mourning, de-fending herself against the enemy, with her soldiers and her dying grouped around a tattered flag." Victims of the siege lay sprawled at her feet—soldiers, National Guardsmen, women, children, a horse—while a Prussian eagle, with "wan and haggard Famine" at its side, hovered in the air above them. "I will put all our sufferings, all our heroism, all our hearts—my very soul into it," de-clared Meissonier, who described the painting as an act of revenge against the conquering Prussians.[11]

Passionate he may have been about his new work, but Meissonier approached *The Siege of Paris* (plate 7A) with his typical painstaking devotion. He made a wax model for the dying horse, while for the figure of Henri Regnault, whom he depicted leaning against the allegorical figure of Paris, he borrowed the greatcoat which the painter had been wearing when he was shot in the head. And likewise for the figure of Brother Anselme, one of the Brothers of the Christian Doctrine whose job was to retrieve bodies from the field of battle, he borrowed the black gown worn by the cleric when he was killed by a Prussian bullet.[12]

The Siege of Paris recalls *The Last Day of Corinth*, Tony Robert-Fleury's tri-umph from the 1870 Salon. But it also evokes Meissonier's own earlier work, *Remembrance of Civil War*, the painting (so admired by Delacroix) that had been removed from the 1850 Salon on orders from the government because its "omelette of men" showed the horrors of warfare in such scarifying detail. *The Siege of Paris* emphasised, even more than *Friedland*, Meissonier's turn from his lucrative but—in light of recent political events—irrelevant musketeer sub-

jects to a style of painting that would be grander in both physical scale and emotional impact. This was no time, he claimed, "to paint little figures."[13] Artistic monumentality was, he believed, the order of the day. "I want to execute this painting large as life!" he said of *The Siege of Paris*, even going so far as to entertain hopes of executing it as a mural: "Who knows? Perhaps this is the picture that will be in the Panthéon some day."[14] But Meissonier still had a very long way to go before he could project his noble vision on such elevated walls, since the sketch over which he laboured in the months following his return to the Grande Maison measured—in typical Meissonier fashion—less than a foot square.

Manet was reunited with Suzanne, his mother and Léon on February 12, 1871, five months after he had bade them farewell. Oloron-Sainte-Marie, where the family had spent their exile, was an old wool town, famous for manufacturing berets, that perched on a wooded bluff overlooking the junction of two swift-flowing rivers. Suzanne seems to have spent much of her time there arguing with her mother-in-law. The two women had never enjoyed cordial relations, and their enforced exile only led to further mutual aggravation. According to Eugénie Manet, Suzanne had written dozens of letters to Édouard during the siege, documenting "a thousand complaints about me. . . . Her jealousy was always there, against me!"[15] Luckily for Manet, none of these missives made it through the Prussian blockade.

Manet did not remain for long in Oloron-Sainte-Marie. After less than two weeks in the Pyrenees he made the 110-mile trip north to Bordeaux, where, craving the sea rather than the mountains for his recuperation, he arranged the rental of a villa on the coast. Bordeaux was, temporarily at least, France's new seat of government, with the National Assembly having convened in the city's Grand Théâtre following national elections in the first week of February.* These elections showed the divisions between Paris and much of the rest of the country. More than 400 of the 768 seats were won by monarchists—deputies who wished to restore to the throne of France one of the two Pretenders, either the Comte de Chambord (the grandson of King Charles X) or the Comte de Paris (the grandson of King Louis-Philippe). The voters of Paris, on the other hand, had elected a number of deputies with strong republican and socialist credentials, such as Victor Hugo, Henri Rochefort

*The legislating body from the Second Empire, the Corps Législatif (Legislative Assembly), was renamed the Assemblée Nationale (National Assembly) by the Third Republic.

and Louis Blanc, the man who coined the phrase "to each according to his needs." The brother of the art critic Charles Blanc, he was known in England, to which he had been exiled by Napoleon III, as the "Red of the Reds."[16]

Adolphe Thiers, likewise elected in Paris, was named "chief of the executive power of the French Republic" and given the authority to negotiate the terms of the surrender with Otto von Bismarck. These terms proved extremely harsh. On February 26, hours before the armistice was due to expire, Thiers agreed to cede most of Alsace and part of Lorraine to the Germans; to pay an indemnity of five billion francs; to permit 500,000 German troops to remain on French soil until this indemnity was paid; and to allow the Germans a victory parade through the streets of Paris. When Thiers presented the treaty for ratification in the National Assembly two days later, many deputies, especially the socialists and republicans elected in Paris, were outraged by what they saw as a betrayal by Thiers and a humiliation by Bismarck. Manet was equally unimpressed with Thiers. After witnessing the proceedings of this new National Assembly, he wrote biliously to Félix Bracqúemond about "that little twit Thiers, who I hope will drop dead one day in the middle of a speech and rid us of his wizened little person."[17] The crushing terms of the treaty were ratified on the first of March.

Manet was reunited in Bordeaux with Émile Zola. Since escaping to Marseilles in September, Zola had launched a newspaper, *La Marseillaise*, which he intended to serve as a voice of the proletariat. However, this organ ceased publication in December when, ironically, the printers struck for higher wages, an action that Zola, turning strike-buster, tried unsuccessfully to overcome by engaging a team of cut-rate printers from Arles. With his career as a newspaper proprietor thwarted, he began cultivating plans to secure for himself the post of Subprefect for Aix-en-Provence, and to that end he had gone to Bordeaux to lobby officialdom. He was offered a lesser plum, Subprefect of Quimperlé in Brittany, which he imperiously declined as being "too far away and too grim."[18] Eventually he accepted the post of secretary to an elderly and reputedly senile left-wing deputy in the National Assembly. He was also reporting on the National Assembly for *La Cloche* and fretting about the refugees occupying his apartment in Paris. "Are there any broken dishes?" he wrote to a friend in Paris. "Has anything been ransacked or stolen?"[19]

Manet stayed in Bordeaux long enough to paint a sketch, *Port of Bordeaux*, showing masts bristling in the harbour and the twin towers of the cathedral. After a few days, however, he went with his family to a villa in Arcachon, forty miles to the south-west, a seaside resort with mountainous sand dunes and huge Atlantic breakers. Despite his weakened condition, he prowled the beach

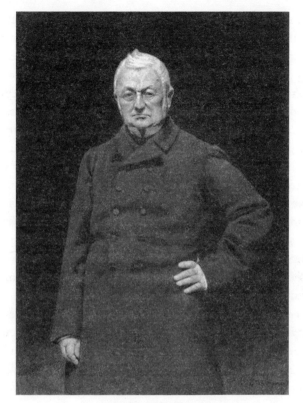

Adolphe Thiers

with his canvas and paints, working on at least a half-dozen pictures. Included among them was an image of Léon sitting astride a *vélocipède* with the blue bay looming in the background. Most fittingly for a painter of modern life, *Le Vélocipédiste* was one of the first-ever images on canvas of one of these popular new machines.

Manet was, uncharacteristically, in no mood to return to Paris. The family had been urged to stay in Arcachon by Manet's brother Gustave, who wrote from Paris warning that "the state of the sanitation in the city is far from reassuring."[20] And then, within a few weeks of arriving in Arcachon, Manet had another even more compelling reason for keeping away from the capital. One writer had called the Prussian bombardment of Paris a "carnival of blood" and a "massacre of the innocents."[21] But even the worst horrors of the bombardment would pale in comparison with the bloodbath that was about to take place in the spring of 1871.

* * *

On March 18, a Saturday, Ernest Meissonier was passing along the Avenue de l'Opéra in Paris, in the wealthy district north of the Tuileries, when he encountered a group of workmen "shouting out all sorts of wild absurdities and insults." Stopping to "reason a little" with these agitators, he was subjected to further torrents of abuse until one of the workers suddenly recognised him and shouted down the others, protesting: "Leave that man alone. Don't you know that he earns a hundred thousand francs by the work of his hands?" The very name Meissonier was apparently enough to soothe the raw and violent tempers of these labourers, who identified the meticulous craftsman as one of their own. "I certainly did not expect to be recognised in such a company," Meissonier later observed.[22] He had next made his way from the affluent First Arrondissement to the impoverished Eighteenth, the heights of Montmartre. In 1871 Montmartre was a semirural enclave with gypsum mines, windmills for grinding corn, and a notorious shantytown, the Maquis, that was home to, in the words of one Montmartre resident, "ragpickers and other less desirable characters,"[23] many of whom had been ejected from the centre of Paris when Baron Haussmann razed the slums in order to build his grand boulevards. Undaunted by these environs, Meissonier went straight to what in a short time would be the most notorious spot in Paris, the Rue des Rosiers.

Around the time of Meissonier's arrival, the twenty-nine-year-old mayor of Montmartre, a radical young doctor named Georges Clemenceau, was witnessing horrifying scenes in the Rue des Rosiers: a mob "in the grip of some kind of frenzy" had begun "shrieking like wild beasts" and "dancing about and jostling each other in a kind of savage fury."[24] The cause of the violence, the sight of which caused Clemenceau to burst into tears, was a botched attempt by the National Guard, under orders from Adolphe Thiers, to reclaim from Montmartre 227 cannons that had been used for the defence of Paris.

Montmartre and neighbouring Belleville possessed a history of political agitation. Among their winding streets were establishments bearing names such as the Club de la Révolution, the Club de la Vengeance and—most alarming of all—the Women's Club, where Louise Michel, the "Red Virgin," could whip the masses into a frenzy with her fiery rhetoric.[25] Thiers wished to disarm their local National Guard regiments, regarding them as potential threats to the government, which had relocated from Bordeaux to Versailles following the German departure from the latter city on March 12. Thiers claimed the 227 cannons belonged to the government; the people of Montmartre believed the guns belonged to them, since all had been purchased with funds raised by the

poor people of the Eighteenth Arrondissement. (One of the cannons was known as *Le Courbet* after it was purchased with funds raised from the sale of a seascape donated by Gustave Courbet.) Various attempts at negotiation had come to nothing, mainly because the people of Montmartre viewed the National Assembly, with its hundreds of monarchists, as dangerously conservative, while Thiers regarded the people of Montmartre, with their hundreds of "Reds," as dangerously revolutionary. The German troops, still occupying the city's eastern perimeter, waited to see what would transpire. Kaiser Wilhelm's son, Crown Prince Friedrich, noted in his diary: "We must be prepared to see a fight in Paris between the Moderates and the Reds. . . . How sad is the fate of this unhappy people."[26]

Thiers finally sent government troops into Montmartre on March 18, before sunrise, to capture and remove the cannons. The guns were successfully seized, but the operation came unstuck when the soldiers realised that, in an astounding piece of incompetence, they had neglected to bring teams of horses to tow them away. The citizens of Montmartre therefore awoke to find their guns in the hands of Thiers's rather hapless troops. Several hours of pitched battles were followed by the capture and then execution by firing squad in the Rue des Rosiers of the commanding officer, General Claude-Martin Lecomte, together with General Jacques Clément-Thomas, the former commander-in-chief of the National Guard.* Panic and jubilation ensued in equal measure. On orders from Thiers, the government troops hastily retreated from Paris to Versailles, effectively leaving the city beyond the control of the government. By the next morning the *tricoloure* had been removed from the Hôtel de Ville and replaced by the Red Flag, symbol of the "Republic of Labour."

This violent skirmish in Montmartre, followed by the speedy evacuation of the French army, was clearly far more serious than the countless riots of the Second Empire, in which a few omnibuses had been overturned and windows smashed before the Emperor's Chasseurs à Pied arrived to scatter the participants on the points of their bayonets. Many Parisians reacted in horror to the shootings, with as much as a third of the population leaving the capital in the days that followed. Learning the news in Arcachon, Manet was appalled by the behaviour of those who had murdered the two generals,

*Since one of the bullets that killed General Clément-Thomas was fired by a *chassepôt*, with which the government troops (but not the National Guard) were armed, there is good reason to suspect that elements in the French army were involved in the Montmartre uprising against the government.

denouncing them as "cowardly assassins."[27] Meissonier was even more in-dignant. He had arrived in the Rue des Rosiers a short while before the exe-cutions but did not stay to witness the proceedings. He was livid when he learned of the killings, not least because during the Siege of Paris he had served under the command of Clément-Thomas, whom he regarded as "the purest republican that ever there was." Joining the exodus from Paris, he re-turned a few days later to Poissy, where his hatred of the executioners threat-ened to eclipse even his hatred of the Prussians. "The rascals!" he wrote to his wife, whom he had sent to Antibes. "I would like to think up the most horrible tortures and yet I would find them too gentle for these parricides, these murderers of our dear country, these monsters who assassinate her when, all bloody and lacerated, she calls for the aid of all her children."[28]

Meissonier's *Siege of Paris* was intended to show the French standing uni-fied before the Prussian threat, with government soldiers, National Guards-men, the people of Paris and those in the country beyond fighting together for a common cause beneath the *tricoloure*, which he showed fluttering defi-antly above the head of Elisa Bezanson. But, as the February elections had shown, this patriotic image was merely a fiction. The events of March 18 only further emphasised the split between Paris and the provinces, since be-hind the dispute over the cannons was a feeling among many Parisians—and not just those in Montmartre—that their heroism and suffering during the siege had been betrayed by both Thiers and their fellow Frenchmen. Not the least of their grievances was the fact that, under the terms of the peace nego-tiated by Thiers, the Germans had been allowed to stage a victory parade in Paris, with 30,000 of their soldiers marching before Kaiser Wilhelm at Longchamp before—to the fury and humiliation of the Parisians—a smaller contingent marched through the Arc de Triomphe and along the Champs-Élysées. Even Bismarck had put in an appearance, puffing on a cigar beneath the Arc de Triomphe and idly surveying the scene from the back of his horse. "Shame has been consummated," wrote an enraged Gustave Manet to his family.[29]

The fracture between Paris and the rest of the country became official eight days after the execution of Lecomte and Clément-Thomas as the city became an autonomous state. On March 26, Parisians went to the polls in free elections to elect a Communal Assembly of eighty-five deputies—soon proclaimed as the Paris Commune—that would administer the city in the absence of Thiers's government. Thiers promptly denounced these "Communards" as "a handful of criminals," while Karl Marx, following developments with great interest from London, celebrated them as "a working-class government."[30]

The elections had produced a varied lot of deputies, including doctors, lawyers, teachers, several dozen manual workers, a billiards player, a brothel-keeper, and three self-proclaimed mystics.[31] Many well-known socialists and radicals gave the Commune a wide berth: Rochefort chose not to stand for election; Hugo retreated to Brussels; and Louis Blanc found himself unable to support the Commune since he believed in a strong centralised state and disliked democratic institutions.[32] Even so, few among the Communards, no matter how bourgeois, shared any common political ground with the monarchists in the National Assembly who wished to offer the crown to the Comte de Chambord.

The eighty-five deputies in the Communal Assembly set immediately to work. Most unusually for politicians, in one of their first acts they voted to keep their salaries low. They then proceeded to pass legislation aimed at improving conditions for the poor. A minimum wage was established, night work for bakers was abolished, and the pawnshops were closed. Pensions were awarded to the widows of soldiers killed in the war against the Prussians, and all unpaid rents pertaining to the months of the siege were cancelled. A few other Communard policies were not so generous. Church property was confiscated, and Raoul Rigault, a journalist who had become the new Prefect of Police, began boasting about issuing a warrant for God's arrest. Unable to arraign the Almighty, Rigault settled for his representative on earth, arresting and imprisoning the Archbishop of Paris, Monseigneur Georges Darboy, together with ten Dominican monks. Memories of the French Revolution were revived as the Communards ordered the demolition of the Chapel of Atonement, built in 1816 as an expiation for the execution of King Louis XVI. They did stage a ceremonial burning of the guillotine in front of a statue of Voltaire, but they also set fire to Thiers's house in the Place Saint-Georges. And then, on May 16, in an act that more than anything else would symbolise their rule, they toppled the Vendôme Column.

Along with the Arc de Triomphe, the Vendôme Column was the most visible symbol in Paris of Napoleonic power. Modelled on Trajan's Column in Rome, it reared 138 feet above the Place Vendôme, on the north side of the Tuileries. This "giant bronze exclamation point,"[33] as Théophile Gautier called it, had been constructed between 1806 and 1810. It was cast from 1,200 cannons captured from the Russian and Austrian armies at the Battle of Austerlitz and fitted with more than 400 bronze plaques commemorating Napoleon's exploits in a spiralling bas-relief frieze. Originally the column had been topped by a giant statue of Napoleon in the dress of a Roman emperor, but after Waterloo this statue was replaced by a flag featuring the

fleur-de-lis. In 1833, when he was Minister of the Interior, Thiers had over-seen the restoration of Napoleon's statue, only this time the Little Emperor became the Little Corporal, since he was given a military uniform instead of a toga. Thirty years later, in November 1863, Napoleon III had replaced this statue of his uncle, and once again Napoleon was given his toga and laurel leaves.

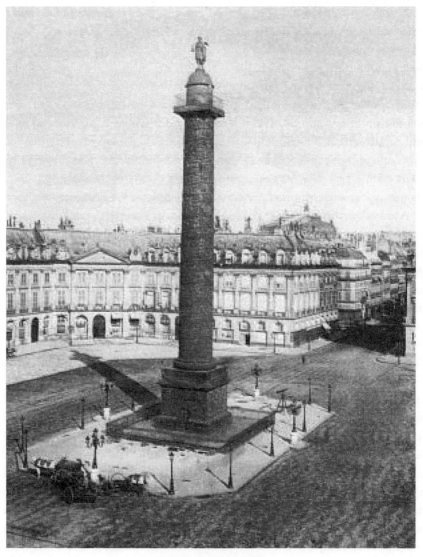

The Vendôme Column

The idea of destroying the Vendôme Column had been put forward many months earlier by Gustave Courbet, who served the Government of National Defence during the siege of Paris as "President of the Arts in the Capital."[34] This post gave "Citizen" Courbet (as he took to signing his letters) responsibility not only for the Louvre but also for, among others, the museum in the Palace of Versailles, the Musée du Luxembourg, and the ceramics museum at Sèvres. Under his direction, masterpieces from the Louvre were removed from their frames, rolled up and then transported by train, in boxes marked "Fragile," to the prison in Brest, far from the advancing Prussian armies. Other works of art were taken into the museum's basement, and the *Venus de Milo* was smuggled, under the cover of night, to a vault at the Prefecture of Police on the Île-de-la-Cité. Meanwhile, the Louvre itself was turned into an arsenal and fortified with sandbags.

With the art treasures of Paris thus preserved, Courbet had next turned his attentions to the Vendôme Column, which was, he claimed, "a monument devoid of any artistic value, tending by its character to perpetuate the ideas of wars and conquests."[35] When enthusiasm grew for tearing down the column, Courbet quickly published a letter in *Le Réveil* insisting that he was not actually proposing its destruction, merely the unbolting of the bas-relief frieze and the removal of the column itself to a less conspicuous location. Nonetheless, the seeds of the monument's destruction had been planted, and when the Communards took power the following spring they passed a decree, on April 12, denouncing the Vendôme Column as "a monument of barbarism, a symbol of brute force and false glory." Their decree thunderously concluded: "The Column in the Place Vendôme shall be demolished."[36]

The Communards had hoped to knock down the column on May 5, the anniversary of Napoleon's death and the day on which veterans of the Napoleonic Wars traditionally laid wreaths at the column's foot. However, as the equipment necessary for the demolition—a system of cables, pulleys and winches—was not ready on time, the date was moved to the middle of the month. The shaft had been given a bevel cut into which wedges of wood were driven, and then, on the afternoon of May 16, after the singing of the *Marseillaise*, the capstan was tightened and, following an initial miscue, the column crashed to the ground amid cheers from a crowd of 10,000 onlookers. According to one eyewitness, the head of Napoleon "rolled like a pumpkin into the gutter."[37] As the crowd scrambled for souvenirs, the Red Flag was planted on the empty pedestal.

Courbet had not been a deputy in the Communal Assembly at the time of the decree of April 12 that sealed the column's fate. However, he was victorious

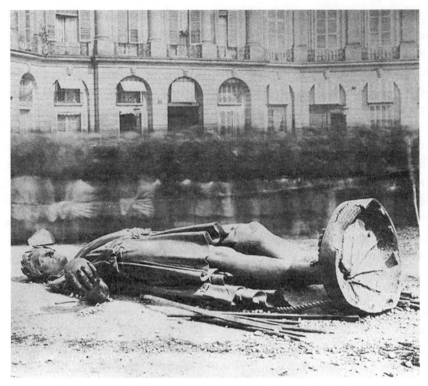

The statue of Napoleon after the toppling of the Vendôme
Column, May 16, 1871

several days later in a by-election in the Sixth Arrondissement—a con-
stituency that included, ironically enough, the École des Beaux-Arts—and on
April 27, as a fully fledged Communard, he had spoken in favour of demolish-
ing the column and replacing it with a statue "representing the Revolution of
March 18."[38] In the public imagination, he therefore came to be associated with
the toppling of the column. Not the least of his critics was Meissonier, who was
outraged by this act of destruction. Having spent the previous decade of his
career assiduously celebrating Napoleon's military exploits in works such as
Friedland and *The Campaign of France*, only to see such heroism be dismissed
as "false glory" by Courbet and the Communards and then quite literally
turned to rubble in the Place Vendôme, Meissonier saw the desecration of what
he regarded as the greatest glory of French history as little short of treason. He
condemned Courbet as a "monster of pride" and a "madman," even going so
far as to fantasise, in a letter to his wife, about devising the cruellest possible
punishment: he would chain Courbet to the base of the column and give him

the task of copying its bas-reliefs, "while having always in front of him, but beyond his reach, beer mugs and pipes."[39]

One witness to the events of May 16 claimed the toppling caused "no concussion on the ground" since the pavement of the Place Vendôme had been prepared with a bed of sand, branches and manure.[40] In the world of French art, however, the fall of the Vendôme Column would reverberate for many years to come.

Adolphe Thiers was known to his enemies as "Père Transnonain." The nickname alluded to how in 1834, as King Louis-Philippe's Minister of the Interior, he had ordered the brutal suppression of a working-class insurrection in Paris, an act leading to a bloody massacre in the Rue Transnonain. Almost forty years later, his determination to annihilate the Paris Commune was every bit as strong. To that end, since the beginning of April 130,000 government troops had been preparing at secret camps for a second siege of Paris. Thiers was confident of the outcome. "A few buildings will be damaged," he predicted, "a few people killed, but the law will prevail."[41] His friend Meissonier was much less optimistic. For the man who had painted *Remembrance of Civil War* twenty years earlier, the spectacle of the French fighting among themselves in the streets of Paris did not bear contemplation. "If the battle is engaged," he wrote gloomily, "whatever the result, it will be disastrous. Torrents of blood will be spilled and our wounds will be so great that they will be mortal."[42]

Meissonier's worst fears were realised soon enough. The carnival of blood—or, as it came to be known, *La Semaine Sanglante* ("Bloody Week")—began on a Sunday, May 21, as government troops surged through the undefended Porte de Saint-Cloud, less than four miles south-west of the centre of Paris. The Communards had prepared themselves for the inevitable onslaught by raising barricades throughout the city, hacking at Haussmann's new boulevards with pickaxes and prising free the stones. Sandbags, upturned omnibuses, pieces of furniture, empty casks and piles of books were also used to build barricades. One at the Porte de la Chapelle, north of Montmartre, was even built—very much against his wishes—from the lumber out of which Courbet's 1867 pavilion had been constructed. But these barriers did little to check the inexorable advance of the government troops under the command of Marshal MacMahon, anxious to redeem himself for the disaster at Sedan.

Thiers's prediction that "a few buildings will be damaged" proved, in the days that followed, a spectacular understatement. On May 23 the Palais des Tuileries, the former residence of Napoleon III, was set alight by the Communards as both a smoke screen and a rebuke to French imperial power. As the

palace exploded and burned, the central cupola collapsed inwards—an even more shocking symbol of destruction than the toppling of the Vendôme Column one week earlier. A wing of the Louvre also went up in flames, with the loss of 100,000 books; and over the next few days ever more buildings were torched: the Palais-Royal, the Palais de Justice, the Cour des Comptes, the Prefecture of Police (where only the accident of a burst waterpipe saved the *Venus de Milo* from incineration), and the Hôtel de Ville, where murals by Ingres, Delacroix and Cabanel were turned to ash. Strong winds whipped the flames higher, sweeping them along the Rue de Rivoli and the Boulevard de Sébastopol; dozens of houses were burned. Edmond de Goncourt could see from his home in the suburb of Auteuil "a fire which, against the night sky, looked like one of those Neapolitan gouaches of an eruption of Vesuvius."[43]

Thiers's forecast of "a few people killed" was even more grotesquely understated. On the evening of May 24 the Archbishop of Paris was executed by firing squad in the prison where he had been held hostage for almost two months. His death was soon afterwards followed by those of the ten Dominican monks who had been held with him, all of whom were shot, along with thirty-six gendarmes, in reprisal for the execution by government soldiers of Communard prisoners. From Rome, Pope Pius IX denounced the Communards as "men escaped from Hell," while Thiers solemnly announced to the National Assembly

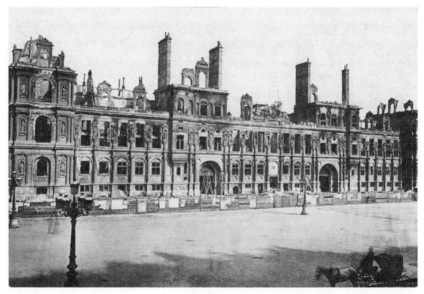

The Hôtel de Ville after it was burned during the suppression of the Commune

in Versailles: "I shall be pitiless. The expiation will be complete."[44] He was true to his word. On May 27, the last Communard forces were defeated in their stronghold inside the cemetery of Père-Lachaise. From there, only thirty yards from Delacroix's tomb, they had been firing on the Versailles troops from a gun emplacement before the grandiose tomb of the Duc de Morny, which had been converted into a munitions depot. The government soldiers lined up against a wall in the south-east corner of the cemetery 147 of the surrendering Communards and, in a foretaste of Thiers's pitiless method of expiation, turned on them a *mitrailleuse* that fired 150 rounds per minute. One day later, Marshal MacMahon announced that Paris had been delivered.

Though the Commune was at an end, the carnival of blood continued. The carnage was horrific even for a city that had witnessed the murderous excesses of the French Revolution. "The French," wrote a shocked correspondent from England, "are filling up the darkest page in the book of their own or the world's history."[45] The Seine literally ran red with blood—a long red streak could be seen in the current beside the blackened shell of the Tuileries—as soldiers acting on orders from Thiers executed, in the days that followed, as many as 25,000 Communards.[46] The prisoners were marched into parks, cemeteries and railway stations, where the *mitrailleuses* mercilessly dispatched them. By this point, many of the Communard leaders were already dead, including Rigault, who was shot in the head while defiantly shouting *"Vive la Commune!"* at the advancing troops. Courbet, too, was reported dead, supposedly having swallowed poison to escape falling into Thiers's clutches. When word of his death reached Ornans, his mother died of a heart attack. In fact, rumours of Courbet's death were greatly exaggerated. He was arrested, alive and well, on June 7, three days shy of his fifty-second birthday, and escorted to Versailles to face a military court.

Days of Hardship

MEISSONIER RETURNED TO Paris a few days after the fighting had ceased. The stench of bodies was everywhere. As another visitor noted, there were "corpses in the streets, corpses in doorways, corpses everywhere."[1] Yet, incredibly, the city was already starting to return to normal as the many residents who had fled after the events of March 18 returned in the first weeks of June. All were staggered by the sight of so many famous landmarks in ruins, but many found themselves moved, despite everything, by the eerie beauty of the devastation. Théophile Gautier was "saturated with horror" at so much death and destruction, yet confessed himself "struck, most of all, by the beauty of these ruins." His friend Edmond de Goncourt, a virulent anti-Communard, waxed poetical over the sight of the Hôtel de Ville, "a splendid, a magnificent ruin" that reminded him of "a magic palace, bathed in the theatrical glow of electric light." Jules Clarétie was equally impressed. "Ruined, burned and devastated, the Hôtel de Ville remains," he wrote, "the most superb of the Parisian ruins. Its primitive harmony has given way to a picturesque and funerary disorder which wrings one's heart, while offering to one's eyes one of those horribly beautiful spectacles that comes from such destruction."[2] Within a fortnight of Bloody Week an English travel agency, Thomas Cook, was organising special tours of the ruins. Photographers did a brisk trade, their stark images of the charred landmarks appearing in the windows of shops and even embarking on tours of cities as far afield as London and Liverpool.[3]

Meissonier toured the ruins with a friend, the architect Hector Lefuel. A favourite of Napoleon III, the sixty-one-year-old Lefuel had built, among

other things, the new Baroque-style addition to the Louvre that opened in
1857—and that would have become one more scorched tourist attraction had
not rains fallen on May 26, extinguishing the fires that had consumed the Lou-
vre's library. As the two men walked past the fire-gutted Tuileries, Meis-
sonier's attention was caught by an arresting sight. Facing eastwards, looking
through the rubble of the Tuileries towards the Louvre, he could see, framed
in the wreckage, the bronze sculptural group on top of the Arc de Triomphe
du Carrousel. This sixty-three-foot-high triumphal arch had been built at the
same time as the Vendôme Column and, like the column, was intended to com-
memorate Napoleon's military victories. Originally it had been crowned with
the four bronze horses looted by Napoleon from the Basilica of San Marco in
Venice, but after the horses were returned to Venice in 1815 the sculptor
François-Joseph Bosio was commissioned to make a replacement—the tri-
umphal chariot that Meissonier could glimpse through the burned-out wreck-
age. Below this chariot, in the remains of the Tuileries, he could see a poignant
but inspiring sight in the Salle des Maréchaux, the grand room that one of the
Empress Eugénie's ladies-in-waiting had called "the finest in the palace."[4] It
had been the venue for the balls held each winter in the Tuileries during the
Second Empire, and included among its lavish decorations were a series of
shields bearing the names of Napoleon's victories. Two of these had survived
the incineration that destroyed much of the rest of the palace. "I was suddenly
struck," wrote Meissonier, "by the sight of the words, Marengo and Austerlitz,
the names of two incontestable victories, which appeared, shining and intact.
In an instant, I saw my picture."[5]

Meissonier promptly installed himself in a nearby sentry box and went to work
on a watercolour sketch of this symbolically charged scene. On a piece of paper
sixteen inches wide he painted the piles of rubble, the precarious walls, the distant
chariot and, at the very top, the two shields commemorating resplendent French
victories. This *plein-air* work took a week, during which he also found time to in-
dulge his passion for doodling on walls, sketching the figure of a horseman onto
the side of the sentry box. A passing souvenir-hunter then helped himself to a
genuine Meissonier, since the graffito "was cut out by someone," he later com-
plained, "and taken I know not where." The sentry box had also served another
purpose, that of protecting the painter from falling debris. He returned to the site
one morning to have the watchman tell him: "Ah, Monsieur Meissonier! You had
a narrow escape. You had scarcely left the place yesterday when this stone fell
down, just where you had been standing." The stone, Meissonier observed, was
"a huge fragment of the cornice, which would certainly have killed me."[6]

Returning to his studio in Poissy, Meissonier turned his watercolour sketch into an oil painting entitled *The Ruins of the Tuileries*. At the bottom of the work he painted a foundation stone on which he inscribed the words GLORIA MAJORUM PER FLAMMAS USQUE SUPERSTES ("The glory of our forefathers survives the flames"). The meaning of the work was abundantly clear.[7] It was not, like *Remembrance of Civil War*, a frank record of the bloody horrors of civil strife, displaying broken barricades and heaps of bodies. Meissonier wished to show, instead, that the glories of French history were undimmed and the potency of its symbols and monuments unsullied by these same sort of bloody horrors—and by events such as the felling of the Vendôme Column and the torching of the Tuileries and the Hôtel de Ville. The spirit of Napoleon, and of the French people, had survived Bloody Week, a survival epitomised by the words "Marengo" and "Austerlitz" emblazoned across the ruins and the triumphal chariot rising above them. This might have been wishful thinking in the dark aftermath of the Commune; but the vision, together with a passionate hatred of Gustave Courbet, was one that would guide and console Meissonier in the months to come.

Édouard Manet returned to Paris at the end of May or beginning of June, after some fifteen weeks away from the capital.[8] He arrived with Suzanne, Léon and his mother by train from Tours, in the Loire Valley, following a leisurely progress up the Atlantic coast that included stops in La Rochelle, Nantes and Saint-Nazaire. He had clearly been dallying along the coast, reluctant to return to Paris while the Communards were still in power. "I'm not looking forward to the return to Paris at all," he had written to Bracquemond from Arcachon a few days after the events of March 18.[9] Upon his return, he was profoundly distressed by everything he saw. "What terrible events," he wrote to Berthe Morisot, who had left Paris for Cherbourg. "Will we ever recover from them? Everyone blames his neighbour, but the fact is that we're all responsible for what has happened."[10]

Manet discovered that his studio in the Rue Guyot had been badly damaged during Bloody Week, though all his canvases, both in Théodore Duret's cellar and in the apartment in the Rue de Saint-Pétersbourg, remained intact. He immediately transported all of them to a new studio next door to his mother's apartment and, in the weeks that followed, began work on a lithograph entitled *Civil War* and a watercolour called *The Barricade*.

According to legend, these two works were based on scenes he had personally witnessed after his return to Paris. *Civil War* depicted, in a scene reminiscent of Meissonier's *Remembrance of Civil War*, an overrun barricade beneath which a képi-wearing National Guardsman lay dead, while *The Barricade* featured a firing squad blasting away at several captured Communards. Duret

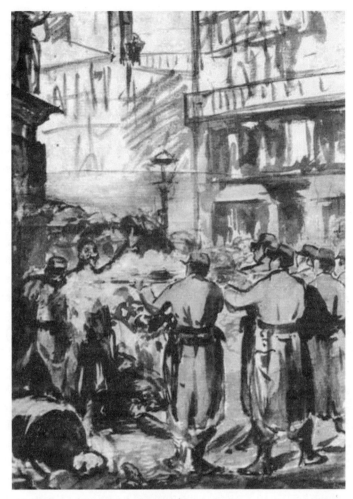

The Barricade *(Édouard Manet)*

claimed this first work was based on a corpse Manet had seen sprawled at the corner of the Rue de l'Arcade and the Boulevard Malesherbes. "He made an on-the-spot sketch of it," declared Duret.[11] However, Duret was in America at the time and so could hardly have known first-hand what Manet did or did not see or sketch. His claim is highly dubious unless one can believe the corpse somehow arranged itself, through an astonishing coincidence, into exactly the pose Manet had used for his *Dead Toreador*, the figure excised seven years earlier from *Incident in a Bull Ring*. Rather than being an "authentic" piece of artistic reportage, Manet's *Civil War* was an obvious reworking of this earlier scene. Exactly the same can be said of *The Barricade*, an even more blatant

revamping of *The Execution of Maximilian*. Manet clearly used artistic licence rather than eyewitness observation or on-the-spot sketches in order to depict the horrors of Bloody Week and condemn political violence.[12]

These were disillusioning days for Manet. Émile Zola, who had returned to Paris to find his apartment blessedly intact, wrote at this time to Cézanne: "Paris is being reborn. As I have often told you, our reign has begun!"[13] But Manet could feel no such optimism. Even before the Commune he had complained to Bracquemond that there were "no disinterested people around, no great citizens, no true republicans, only party hacks and ambitious types."[14] The civil strife brought on by the Commune and its brutal suppression made him even more angry and depressed about the state of French politics. His hatred of Adolphe Thiers—"a demented old man"[15]—was unbounded. The only politician in whom he put any store was Léon Gambetta, the lawyer and populist orator who had heroically organised the resistance against the Prussians following his white-knuckle balloon ride out of Paris. After resigning in March over the terms of the peace treaty negotiated by Thiers and then spending the weeks of the Commune in Spain, Gambetta returned to the National Assembly in a July by-election.

Manet took to riding the train with Gambetta each morning to Versailles, where the National Assembly was still sitting. The two men had known one another for a number of years, since Gambetta, a thirty-three-year-old bachelor and dedicated bohemian, was no less than Manet an enthusiastic habitué of café society. In 1871 he was a radical revolutionary in the process of mellowing into a moderate and articulate spokesman for social equality. He was opposed to what he called "intriguers, adventurers, dictators, ruffians"— that is, the class of swashbuckling bankers, aristocrats and Bonapartists that, in his opinion, had ruled France for the years of the Second Empire. But he was equally against what he called "something even more grave, the unforeseen explosion of the inflamed masses, who suddenly obey their blind fury."[16]

Gambetta's moderate political opinions, with their suspicion of both the radical left and the authoritarian right, no doubt reflected Manet's own convictions at this time. Manet made sketches of him on the train, trying to persuade him to sit for a portrait; but Gambetta politely declined the offer. Notoriously ugly and un-kempt, he was known as "Cyclops" after his right eye, injured in an accident in 1849, was surgically removed in 1867 and replaced with a glass one. He may have felt that a portrait of him executed by Manet would almost have been guaranteed to draw gibes from the critics and gleeful squirts of ink from the caricaturists.

When not travelling with Gambetta to Versailles, Manet spent the summer of 1871 wandering aimlessly from one café to another. Gradually friends such as Degas and Éva Gonzalès had returned to Paris, though Berthe Morisot, whose

health suffered badly during the siege, remained in Cherbourg. Manet contin-
ued to see her mother, who found his behaviour and opinions "insane" but,
following a soirée at the Manet home, was able to report the good news to
Berthe that "Mademoiselle Gonzalès has grown ugly."[17]

By August, Manet's doctor diagnosed a nervous depression and urged him
to leave Paris for the seaside. He seems to have required little urging and
promptly departed with Suzanne and Léon for Boulogne-sur-Mer, where he
spent the month of September. He did little work apart from a number of pen-
cil and watercolour sketches of crinoline-clad figures playing croquet. These
studies were eventually worked into a canvas called *Croquet at Boulogne* show-
ing three women and two men (one of them posed by Léon) in the midst of a
match at the Établissement des Bains. Like his painting of Léon astride a
vélocipède, the work captured an image of modern life, a genteel sport that had
recently become popular following its introduction from across the English
Channel. Croquet had been described by one exponent in England as, oddly
enough, a healthy substitute for war but a moral danger zone because—and
this was one of the main reasons for its popularity—it was played by men and
women together.[18] But Manet's canvas suggests neither moral impropriety nor
war continued by other means. A picture of a middle-class leisure activity, it
was strikingly different in its subject matter from either *Civil War* or *The Bar-
ricade*, offering no hint of the horrors its author had undergone.

The Comte de Nieuwerkerke, the man who had ruled the French art world for al-
most two decades, had fled Paris in September 1870, disguised, humiliatingly, as
a valet. By 1871 he was living in exile in England, on the seafront at Eastbourne.
Yet Nieuwerkerke's replacement did not give Manet and the painters in the Café
Guerbois any particular cause for cheer. Under the Third Republic the fine arts
became the responsibility of what was called the Ministry of Public Instruction,
Cults and Fine Arts; and in November 1870 Charles Blanc, the fifty-eight-year-
old founder of the *Gazette des Beaux-Arts*, became Director of Fine Arts. Manet's
father had known Blanc many years earlier, but this friendship was about the
only thing that could possibly have recommended the two men to each other.

Though his brother was Louis, the "Red of the Reds," Charles Blanc was,
if anything, even more conservative in his views than Nieuwerkerke.
Chennevières described him, in a grand understatement, as "more a sup-
porter of Ingres and the Académie des Beaux-Arts than of Courbet and the
Commune."[19] In fact, Blanc had published a biography of Ingres, whom he
idolised, a year earlier, and for several decades he had been the most prolific
and articulate exponent of the sort of Neoclassicism celebrated at the École

des Beaux-Arts. In his lofty conception of art, Eve was the original represen-
tative of ideal beauty, but by plucking the forbidden fruit from the Tree of
Knowledge she had plunged the world into a catastrophic state, a sort of Pla-
tonic world of appearances in which the ideal was obscured by the humdrum
and ugly material world. Blanc believed that the ability to see through the
veil of appearances, and glimpse the ideal beyond, was "obscure, latent and
sleeping" among the majority of men. However, great artists—by whom he
meant especially Ingres and the painters of the Italian Renaissance—"carry
within themselves this idea of the beautiful in a state of light."[20] The true
mission of art was therefore to show the "idea of the beautiful" that con-
cealed itself behind the flickering shadows of the fallen world. "Art is the in-
terpretation of nature" was his motto,[21] by which he meant that art should
not portray nature in all its warts but should idealise it instead. Not surpris-
ingly, he was vehemently opposed to Realism and paintings of *la vie mod-
erne*, believing that artists who imitated nature and everyday life were slaves
to appearance.

 Blanc was especially anxious about the role that art should perform at the
Salon of 1872 since the eyes of the world would, he knew, inevitably turn to
Paris to witness the artistic response to the tragedies of the previous two years.
The October issue of the *Gazette des Beaux-Arts* accordingly called on French
artists to play their part in the national recuperation, urging them to "revive
France's fortunes" and help to "rebuild the economic, intellectual and moral
grandeur of France."[22] Two months later, Blanc exhorted them to create stirring
works of art by finding "even in the spectacle of our disasters" heroic episodes
and "gripping motifs" that could adorn the walls of the Palais des Champs-
Élysées.[23] This was precisely the kind of scene to which Meissonier—who
Blanc believed had no equal "either in France or anywhere else"—had turned
his attentions with *The Siege of Paris* and *The Ruins of the Tuileries*, two paint-
ings that attempted to depict French honour and pride even in the hour of defeat.

 Blanc's appeal for patriotic art was played out against a wider binge of na-
tional self-scrutiny. The French entered a period of self-doubt, and breast-
beating and finger-pointing became popular pastimes as they tried to
understand how the events of the previous few years could have occurred.[24]
Many people, conveniently, blamed the Emperor for everything. A resolution in
the National Assembly declared Louis-Napoleon "to be responsible for all our
misfortunes and the ruin, the invasion and the dismemberment of France."[25] It
was carried by 691 votes to 6—the dissenting votes belonging to the half-dozen
Bonapartists who had managed to get themselves elected. By this time Louis-
Napoleon himself was safely in England, having spent only six months as a

prisoner of war in Germany. He had passed his time by reading *The Three Mus-keteers* and composing two short books about the Franco-Prussian War. Released in March 1871, he was reunited with Eugénie and Loulou at Camden Place, an elegant eighteenth-century mansion in Chislehurst. Few people in France believed him when he claimed, in an interview with *The Times* in October 1871, that he had no wish to regain his imperial throne. Indeed, he was watched closely by secret agents of the French government, who scaled trees on the village green in order to peer into the grounds of his house.[26]

Despite the many fingers of blame pointing in his direction, most people agreed that Louis-Napoleon could not be faulted for everything, least of all the horrific butchery of Bloody Week. Suspicions arose that the French themselves had been to blame for their afflictions. As early as September 1870 the Prussian Crown Princess Vicky wrote primly to her mother, Queen Victoria, regarding the defeated French: "It would be well if they would pause and think that immoderate frivolity and luxury depraves and ruins and ultimately leads to a national misfortune."[27] This theme of French decadence was soon taken up by many others. In 1871 a German doctor named Karl Starck published *The Physical Degeneration of the French Nation*, which argued that the French character and morals had become enfeebled by the sexual and materialistic excesses of the Second Empire. The French themselves did not deny these charges. Ernest Renan published in the same year *The Intellectual and Moral Reform of France*, asserting that France, unlike Prussia, lacked "scientific spirit" and had fallen victim to "presumption, puerile vanity, indiscipline, a want of seriousness, application and honesty."[28] Scapegoats were naturally found for the spread of this frivolity, vanity and sexual excess. The suspects were the usual ones: homosexuals, women (especially prostitutes) and abusers of absinthe. Bohemian artists in their Left Bank garrets were likewise singled out for blame. Elme Caro, a lecturer in philosophy at the Collège de France, would publish in 1872 a work called *Jours d'épreuve* ("Days of Hardship") in which he held bohemianism responsible for the Commune. The romanticisation of Latin Quarter poets and artists had, in Caro's opinion, turned young people against good, honest bourgeois values. Caro did not specifically name members of the École des Batignolles in his diatribe against artistic depravity in Paris. Even so, the winds did not seem auspicious for a painter such as Manet to relaunch his career.

The Apples of Discord

"THE YEAR THAT has just ended," declared *L'Opinion nationale* in an editorial published on the *Jour de l'An* in 1872, "will have been for France one of the saddest and most painful." In keeping with the national mood, winter fashions were sober and restrained. Dresses were made from wool instead of velvet, while their colours—dark blues, browns, myrtle greens—verged on the funereal. Elaborate and expensive gowns were an irrelevance since for the second year in a row no winter balls were held. Salons in fashionable neighbourhoods such as the Faubourg Saint-Germain opened for simple afternoon and evening receptions, "from which," a newspaper reported, "dancing has been rigorously excluded." Even a favourite winter festival, the *Boeuf Gras* ("Fat Ox"), was cancelled in 1872. Normally taking place on Shrove Tuesday, the festival saw an enormous ox paraded through the streets of Paris, garlanded with laurels and followed by capering attendants costumed as wild beasts and Roman soldiers. But in 1872 such merrymaking was considered to be in poor taste.[1]

Nonetheless, a few signs of life stirred in the capital. The Emperor and Empress of Brazil, arriving in January, were entertained by Adolphe Thiers at a grand reception in Versailles. They were followed soon afterwards by the King and Queen of Naples, who, like any other tourists to Paris, requested a tour of the city's charred ruins. New music by Offenbach, the court minstrel of the Second Empire, could be heard at the Théâtre-Gaieté; and Victor Hugo's *Ruy Blas*, banned for thirty years, was staged at the Odéon. In addition, buildings steadily began rising from the ashes as Paris sheathed itself in scaffolding. The dome of the Panthéon, struck by a Prussian shell, was under repair, as were

buildings burned by the Communards, such as the Palais-Royal and the Palais de Justice. Funds had been raised by means of a national subscription to rebuild the devastated Hôtel de Ville, and a competition to design the new structure was won by the architects Théodore Ballu and Édouard Deperthes. Only the Tuileries, scorched and crumbling, was to be left in ruins—a grim memento of civil strife.

The Palais des Champs-Élysées had come through the siege and the Commune miraculously unscathed. It had been used as a hospital during the Siege of Paris and then suffered the indignity, in March 1871, of serving as a billet for Prussian soldiers briefly occupying the capital. By early 1872 it was accommodating the Ministry of Finance, whose offices in the Louvre had been burned during Bloody Week. But there were still plans to hold the 1872 Salon on the premises. Space would be restricted, though, not only because of encroachment from the Ministry of Finance but also due to Charles Blanc's determination to inaugurate his Museum of Copies in the building.

This museum was one of Blanc's long-standing ambitions—a gallery that would encompass full-scale copies of the great masterpieces of European painting and sculpture. He planned to include among the exhibits a bronze reproduction of Lorenzo Ghiberti's "Doors of Paradise" from the Baptistery of San Giovanni in Florence, copies of Michelangelo's frescoes in the Sistine Chapel, as well as line-by-line imitations of frescoes and altarpieces by Masaccio, Raphael and dozens of other Old Masters. Blanc hoped the Museum of Copies would instil in young French artists a love of the great art of the past, in particular that of the artists and sculptors of the Italian Renaissance—and wean them, at the same time, from what he saw as the false paths of Realism and the "new movement" in painting. The moral and artistic decadence of the Second Empire could be purged, Blanc believed, by a healthy injection of the "idea of the beautiful." Witnessing these plans take shape, many artists, according to Zola's friend Paul Alexis, "began to regret the passing of the Empire and Monsieur de Nieuwerkerke."[2]

Blanc managed to make himself even more unpopular with his artistic constituency when he published his regulations for the 1872 Salon. Rolling back Nieuwerkerke's reforms from the 1860s, he decreed that jurors would not be selected by means of universal suffrage but rather by a select group of artists meeting certain rigorous requirements, such as having won either a Salon medal or the Prix de Rome. These criteria, a throwback to the old days, drastically reduced the number of eligible voters. This new regulation was received with such widespread dismay that petitions—another throwback to the 1860s—began doing the rounds even before the elections were held. One of

them, addressed to Thiers, exclaimed: "It is with most painful astonishment and a truly patriotic chagrin that the vast majority of artists have read the new regulations."[3]

But Blanc was uncompromising. The deadline for submissions to the 1872 Salon, March 23, arrived with no change in his position. The jury produced by the new regulations was, unsurprisingly, top-heavy with painters associated with the École des Beaux-Arts: Baudry, Robert-Fleury, and a former winner of the Prix de Rome, Isidore Pils, who had been a teacher at the École des Beaux-Arts since 1864. Also elected were other notable conservatives from previous juries, including Breton and Dubufe, along with Antoine Vollon, a former exhibitor at the 1863 Salon des Refusés and a friend of Daubigny, Manet and Fantin-Latour. Vollon, a painter of still lifes, had come a long way since his days as a *refusé*. In 1869 he had won a Salon medal, in 1870 he had been decorated with the Legion of Honour, and in the spring of 1872 he had been paid 10,000 francs to paint a reproduction of a Frans Hals painting for Blanc's Museum of Copies. Even so, Vollon was an unconventional painter who astounded his friends by adding pigments to his canvases with his fingers, palms and sometimes even the sleeves of his coat.[4]

When the ballot boxes were opened, Ernest Meissonier found himself returned to the jury, finishing in the top five for the first time since 1866. However, Meissonier had changed since his days as one of the moderates on the Jury of Assassins. If in the early 1860s he had presented himself to the electorate as a friend of Daubigny and Delacroix, a liberal opponent of the "old Académie," and a lover of landscapes and *plein-air* painting, by 1872 his profile had altered. His attitudes had begun to harden even before the Siege and the Commune; his obsession with artistic grandeur and his own exalted reputation made him as reluctant to exhibit his dainty musketeers and Antibes landscapes as he was eager to paint heroic scenes on the vaults and walls of the Panthéon. The disasters of the past few years only confirmed his opinion that French art, like French society as a whole, was in need of moral and patriotic regeneration. He showed his newfound aesthetic conservatism by endorsing Blanc's controversial Museum of Copies, stating that it was "an excellent thing for artists," and he took very much to heart Blanc's idea that French artists had to play an important part in the national renovation. "An exhibition," Meissonier proclaimed, "is a work of patriotism."[5] Yet his patriotism could not induce him to show work at the Salon, since neither *The Siege of Paris* nor *The Ruins of the Tuileries* was destined to appear.

Meissonier's influence on the jury was boosted with his appointment as its

Vice-President; Robert-Fleury would serve as President. The judging then commenced at the start of April. The weather outside the Palais des Champs-Élysées was unpleasantly cold, with hard frosts, heavy snowfalls, and ice on the Seine. Conditions inside were even stormier: proceedings were quickly brought to a halt when the jurors, as they made their way through the maze of canvas, found themselves shocked by a piece of what they called "senseless impudence."[6] Two paintings by Gustave Courbet had just appeared before them.

The previous year had been, for Courbet, one of startling contrasts. "Paris is a true paradise!" he wrote at the height of the Commune.[7] Besides toppling the Vendôme Column, he had also dismantled the entire edifice of the French artistic establishment. Taking charge of artistic affairs for the Commune, he had abolished the École des Beaux-Arts, the Académie de France in Rome, and the Académie des Beaux-Arts. "We are avenged!" he wrote in an open letter to French artists. "Genius will soar!"[8] His delight was made wondrously complete as he began a passionate affair with a beautiful woman calling herself, with dubious entitlement, Comtesse Mathilde Montaigne Carly de Svazzena. But within months he was languishing in prison.

Courbet was fortunate to escape the firing squad that awaited so many of his fellow Communards. Following his arrest, he had appeared before a military court at Versailles in September. He was convicted of being a "toppler" (*déboulonneur*), fined 500 francs, and sentenced to six months' confinement in Sainte-Pélagie, a prison on the Left Bank. Here he had passed the next three months, sleeping "amid the rabble on vermin-infested ground."[9] Making his confinement even worse was, as he put it, "a haemorrhoidal condition."[10] He had suffered dreadfully from haemorrhoids throughout his trial, and the gallery at Versailles did not fail to peal with laughter as he planted his ample posterior wincingly on a leather cushion. Desperate for relief, he began petitioning the governor of Sainte-Pélagie to allow him sitz baths and, to ease his constipation, bottles of beer. But his sufferings continued, and by the end of the year he had lost so much weight—more than fifty pounds—that he was transferred to a clinic in Neuilly. Surgery was successfully performed at the end of January 1872, after which he was allowed to serve the remainder of his sentence in the clinic. So congenial did he find this establishment that he elected to occupy his room even after his term expired at the beginning of March.

Courbet had managed to paint numerous canvases during his confinement.

He finished at least fifty works in Sainte-Pélagie, many of them still lifes of the fruit and flowers brought to him by his sisters. At Neuilly, in the month of January alone, he completed eighteen more. As his prison term ended, he submitted two of his recent efforts to the 1872 Salon, one a female nude, the other a still life of apples, at the bottom of which he had inscribed, in bright vermilion, "Sainte-Pélagie"—even though this particular work had actually been painted in Neuilly.

The effrontery of this Communard and convicted *déboulonneur* proposing to show work at the Salon—and work that apparently advertised and even glorified his status as a prisoner—was simply too much for the jurors, and particularly for Meissonier, to countenance. Courbet's apples were all the more provocative since the canvas arrived in the Palais des Champs-Élysées against the grim backdrop of a series of trials and executions. In February, five men were condemned to death for the murder of the Dominican monks; a week later three men found guilty of killing Lecomte and Clément-Thomas were shot by firing squad; and in April a Communard named Fimbert was convicted of "incendiarism"—a lesser charge than the one faced by Courbet—and condemned to death. Henri Rochefort, meanwhile, was sentenced to deportation to a penal colony in New Caledonia.

By comparison with these sentences, the toppler of the Vendôme Column seemed to have escaped rather lightly. Meissonier, still seething over the episode, therefore took the lead in proposing that Courbet should be excluded from the Salon, not on aesthetic grounds but because of his political activities. The deliberations of the jury were reported in *Le Figaro*, whose correspondent described how Meissonier, "whose canvases are better than his judgments," declared that he would never agree to serve on a jury for which "questions of honour" did not take precedence over all else. "We must reject Monsieur Courbet with all our hearts," Meissonier was reported as telling his fellow jurors. "He must be dead for us."[11]

When a vote was taken, the show of hands went overwhelmingly against Courbet, with only two of the twenty jurors—Robert-Fleury and Fromentin—protesting against his exclusion. Robert-Fleury made a spirited defence, scolding his colleagues for "banishing one of their own, the first among them in talent and perhaps in character."[12] The seventy-five-year-old Robert-Fleury commanded enormous authority, not just as President of the jury but also as the Director of both the École des Beaux-Arts and the Académie de France in Rome. Yet his words had little effect in the face of Meissonier's angry determination, and the other jurors, including even Antoine Vollon, voted to banish Courbet. A second vote produced exactly the

same result. Courbet's apples therefore became the forbidden fruit of the 1872 Salon, or the "apples of discord," as one newspaper promptly dubbed them[13] —a witty allusion to the golden apple thrown by Eris, the Goddess of Strife, that led to the Judgment of Paris and ultimately started the Trojan War.

Courbet himself, the cause of the strife, was strangely unconcerned by this development, in part because he had a much greater worry in the spring of 1872: 200,000 francs' worth of his paintings and other possessions had been stolen from his lodgings during his spell in Sainte-Pélagie, prior to which his parents' house had been ransacked by the Prussians. Against these misfortunes, his status as a *refusé* from the Salon seemed of little consequence. Indeed, Courbet revelled in the publicity. "The attention I get is tremendous," he wrote before treating himself to a new vehicle, an eight-seat brig for which he paid 1,300 francs.[14]

In the end, Meissonier, rather than Courbet, came to suffer from the latter's exclusion. There was very little support among the newspapers for the banishment, still less from the artistic community. A Catholic journal, *L'Univers*, supported the exclusion, as did, writing in *Le Figaro*, Jules-Amédée Barbey d'Aurevilly, a flamboyant dandy and the founder of the right-wing *Revue du monde catholique*. Barbey d'Aurevilly claimed to see a direct link between the "brutality" of Courbet's canvases and the atrocities of the Commune, as if naked bathers and thick layers of paint had led inexorably to the assassination of the Archbishop of Paris.[15] On the whole, though, even conservative journals such as *Le Pays* supported Courbet's right to show his work even as they deplored his actions as a Communard.[16]

Most vehement in Courbet's defence was his friend Castagnary. He launched a blistering attack on Meissonier in the pages of *Le Siècle*, implicating him in what he regarded as the decadence, corruption and general tastelessness of the Second Empire. Meissonier, he claimed, had spent his entire career catering to the whimsies of "bankers and prostitutes" with tiny pictures adapted to "the proportions of contemporary apartments." Courbet, on the other hand, was a far more unique and inventive artist; he had never imagined, according to a sarcastic Castagnary, "that to make figures interesting it would suffice to dress them in Louis XV costume." He concluded that the two painters occupied—as Duret later claimed of Manet and Meissonier—the two opposite poles of art: "Obviously these two artists cannot live together. They are polar opposites."[17]

Ironically, Meissonier had suddenly become identified, like his old foes Picot, Signol and Ingres, with the forces of reaction. Though Meissonier's overriding concern had undoubtedly been to punish Courbet for destroying

the Vendôme Column, his vendetta may also have been motivated, on some level, by a distaste for Realism. Courbet's rustic figures and his thick application of pigment with a palette knife—not to mention, as well, his often crude and sensual subject matter—had nothing in common with Meissonier's dainty figures and his fastidious applications of paint. Meissonier's fellow juror, Jules Breton, described this difference in style by observing that Meissonier was "in contrast with Courbet" because of his "absolute conscientiousness and marvellous clearness of vision."[18] These qualities may have pleased jurors like Breton, but by 1872 many younger artists and critics had little truck with such optical subtleties or dexterous sleights-of-brush. Meissonier's intransigence over Courbet would provide further ammunition to critics such as Zola and Astruc who felt his technical facility could not disguise the fact that he was destitute of the original creative impulses that motivated painters such as Courbet and Manet.

The exclusion of Gustave Courbet was not to be the only controversy at the 1872 Salon as widespread rejections by the Selection Committee caused a clamour for a Salon des Refusés. A petition did the rounds accusing the jurors of "a favouritism and prejudice that are without precedent" and requesting space for an alternative exhibition.[19] But Charles Blanc showed himself as impervious as Nieuwerkerke to all such demands.

A number of artists had declined to submit work to the 1872 Salon. Claude Monet and Camille Pissarro had both come back from London, Monet bringing with him canvases of Hyde Park and the River Thames, Pissarro views of the south London suburbs of Norwood and Sydenham. But no longer did they possess the desire to precipitate themselves into the unforgiving artistic fray that was the Salon. Monet and Paul Cézanne—who was back from the south of France with Hortense Fiquet—had good reason to be disillusioned with the process, since in the last years of the Second Empire their works had constantly been rejected. Edgar Degas had likewise decided to turn his back on a system that looked no more encouraging under the Third Republic than it had when Napoleon III was in power. Renoir, however, broke ranks with the Batignolles painters to submit a pair of canvases, *Parisiennes in Algerian Costume* and *The Riders in the Bois de Boulogne*. The actions of his friends no doubt seemed justified when both were returned unceremoniously stamped with a red R.

Another painter who broke rank, albeit with more success, was Édouard Manet. The last few months had been remarkable ones for Manet. In the decade before the Siege and the Commune he had managed to sell only a couple of his paintings. These had gone to close friends, one of whom, Théodore Duret, paid

for his portrait in 1868 by giving Manet a case of cognac. This lack of commercial success had become more acutely dismaying to Manet as his fortieth birthday approached: one of the reasons for his depressive illness in the summer of 1871 seems to have been the precarious state of his finances. In August, shortly before his doctor sent him to Boulogne, he had found himself obliged to ask Duret for a loan of 700 francs. "You can imagine how dire my need has been," he wrote to his friend.[20]

Yet one day in the middle of January 1872, less than two weeks before observing his fortieth birthday, Manet was visited in his studio by Paul Durand-Ruel, a picture dealer who owned a gallery in the Rue Laffitte. Durand-Ruel promptly purchased two of his canvases, paying Manet 1,600 francs. He then returned the following day and, to Manet's astonished pleasure, took away twenty-three more canvases for which he arranged to pay 35,000 francs. "On the spot," Durand-Ruel later recalled, "I bought everything he had."[21] He thereby became the proprietor of, among others, *The Absinthe Drinker*, *The Street Singer*, *The Spanish Singer*, *Young Man in the Costume of a Majo*, *Mlle V . . . in the Costume of an Espada*, *The Dead Toreador*, *The Dead Christ with Angels*, *The Fifer*, *The Tragic Actor* and *The Repose*. Several days later, Durand-Ruel returned once more to the Rue de Saint-Pétersbourg and paid Manet 16,000 francs for yet another cartload of canvases; included among this third batch was *Music in the Tuileries*.

Durand-Ruel was in many ways an unlikely champion for the rebel angel of French painting.[22] He was an extreme political conservative who feared and detested both democracy and republicanism. A friend and supporter of the Comte de Chambord, he believed that only the restoration of a hereditary monarchy could save France. Yet he was, above all, a practical businessman. He had taken control of the family firm at the age of thirty-four, following the death of his father in 1865, and then begun vigorously to expand. He had specialised in landscapists, acquiring a virtual monopoly on Théodore Rousseau when, in 1866, he purchased seventy paintings directly from Rousseau's studio. When his business was threatened by the Franco-Prussian War, he escaped with his collection of canvases to London and opened a gallery in New Bond Street. There he staged exhibitions that introduced the English public to the work of Corot, Courbet, Daubigny, Rousseau and Millet, as well as to two members of the new generation of French landscapists whose acquaintance he made in London: Monet and Pissarro. He also opened a gallery in Brussels, where in the aptly named Place des Martyrs he began impressing Belgian connoisseurs with works that had been on the receiving end of so many critical brickbats in Paris. He had then returned to France at the end of 1871 to reopen

his gallery in the Rue Laffitte and acquire more works by the new generation of painters.

Delighted with his sales to Durand-Ruel, Manet had sauntered into the Café Guerbois and mischievously inquired: "Can you name an artist who can't flog fifty thousand francs' worth of paintings in a year?" To which a chorus of his comrades replied, predictably: "You!" Manet then happily disabused them of their misapprehension.[23] These sales did not seem to have inspired him to go back to work, however, and so when the March 23 deadline arrived he had no new Salon painting to offer. He had obviously decided that his canvases of Léon riding a *vélocipède* and playing croquet were too frivolous in a year when the Salon was meant to showcase the greatness of France. Unlike so many of his contemporaries, though, he was still determined to exhibit work. He therefore arranged to enter *The Battle of the U.S.S. "Kearsarge" and the C.S.S. "Alabama,"* for which Durand-Ruel had paid 3,000 francs. Painted in 1864, the work had received a good press, notably from Philippe Burty, when it had appeared in the window of Alfred Cadart's shop.

Manet may have chosen the painting for another reason as well. Its subject matter was topical because, though the famous naval battle was eight years old, the United States had begun seeking reparations from Great Britain for the damage inflicted on its shipping by the *Alabama*, which had been built at the shipyard of John Laird & Sons in Liverpool despite the fact that Britain was supposedly neutral during the American Civil War. In 1871 the U.S. Secretary of State, Hamilton Fish, had signed the Treaty of Washington, which provided for arbitration between Britain and America over what became known as the "Alabama Claims." As Manet submitted his work to the 1872 jury, a panel that included the Emperor of Brazil was convening in Geneva to discuss the reparations. It would eventually find in favour of the United States, which was awarded reparations of more than $15 million in gold. The Salon jury, in the meantime, found in favour of Manet, whose battle scene was accepted for the exhibition.

A Ring of Gold

"THE SKY STAYS a funereal grey. Between two dirty clouds a yellow sun sometimes risks an arrow of gold; but the rain blunts the flaming dart and sudden downpours sweep the roadways and the pavements, rolling in torrents of water along the Champs-Élysées. The chestnut trees drip on your head, and you must leap across the wide puddles that turn the asphalt into maps of seas and continents."[1]

Such were the inauspicious conditions under which, according to Émile Zola, the Salon of 1872 opened its doors. Worse still, the Salon opened ten days later than usual, on May 11, because of delays in getting the Palais des Champs-Élysées cleaned and decorated following the equestrian exhibition, itself held for the first time in two years. But worst of all, the two thousand paintings on show were, in the opinion of most critics, decidedly substandard. An English newspaper reported that the Salon "has no picture of exceeding merit to boast of; besides which, the general run of works exhibited is unquestionably below the average." Most French critics found themselves regretfully obliged to agree. One reviewer, bemoaning the meagre contributions, asked a question guaranteed to send chills down the spine of every Frenchman: "Have we lost supremacy on the field of fine arts, as we have lost it on the field of battle? Are our artists, like our generals, the victims of a treacherous illusion in believing themselves invincible?" It was a hideous question to contemplate in a year when the French hoped, as *L'Opinion nationale* had declared, "to show jealous Europe all that the genius of France could produce in the aftermath of its defeat."[2] On the evidence of the 1872 Salon, genius seemed in as short supply among French painters as it had been among French commanders.

The dearth of notable works at the Salon meant that Manet's naval battle, with its sinking ship and billows of black smoke, turned out to be an unexpected crowd-pleaser. Manet was in any case the talk of the Salon thanks to the much-publicised purchase of his paintings by Durand-Ruel a few months earlier. The Salon's critical pariah soon found himself on the receiving end of several column inches of generous praise. *The Battle of the U.S.S. "Kearsarge" and the C.S.S. "Alabama"* was singled out by a critic in *La Rappel* as "a strong, beautiful seascape," while Armand Silvestre, in *L'Opinion nationale*, extolled it as "one of the most interesting things in the Salon." The loudest applause came from Barbey d'Aurevilly, the reactionary Catholic and erstwhile friend of Baudelaire who, several months earlier, had defended Courbet's exclusion. "Édouard Manet, according to his critics, possesses no talent," he wrote in *Le Gaulois*. "He is said to be a persistent and headstrong dauber, and in recent years he has been pitilessly ridiculed. But that does not imply he is ridiculous—no, far from it." He went on to cite Baudelaire's approval of Manet before celebrating the "very simple and very powerful" battle scene with a poetic conceit that implied the artist's mastery of seascape. "Monsieur Manet," he wrote, "has made like the Doge of Venice: he cast a ring, which I swear was a ring of gold, into the sea."*

Barbey d'Aurevilly was an old friend of Manet, as for that matter was Armand Silvestre; but these enthusiastic reviews were no less gratifying for a man who had indeed been pitilessly ridiculed by the critics. Even his old nemesis, Albert Wolff, declined to savage the work. Wolff concentrated more on Manet's appearance, reassuring readers of *Le Figaro* that although his canvases may sometimes have conjured images of a long-haired, beret-wearing, pipe-smoking bohemian, in fact Manet was "a man of the world, with a refined and ironic smile."[3] Here was an artist, Wolff seemed to be saying, who was safe for bourgeois consumption.

All in all, Manet could scarcely have hoped for a better result. He also had other reasons for celebrations that summer. A sportsman and art collector named Barret commissioned him to paint a view of the horse races at the Hippodrome de Longchamp for the enticing sum of 3,000 francs.[4] Then, two days before Barbey d'Aurevilly's review, he moved into a new studio. With his old atelier in the Rue Guyot badly damaged, he had spent the previous year working in rented accommodation not far from the apartment he shared with Suzanne and his mother. But on the first of July, fresh from his Salon triumph, he signed a nine-year lease on

*The image refers to how each year on Ascension Day the Doge of Venice would symbolically marry the sea by tossing a gold ring into the Adriatic from his galley, the *Bucentaur*, while saying: "We espouse thee, O sea, as a token of our perpetual dominion over thee."

an imposing studio down the street at 4 Rue de Saint-Pétersbourg. Formerly used as a fencing school, the premises consisted of four rooms, including a kitchen and toilet facilities. The vast main room featured high ceilings, oak-panelled walls, a balcony, and an impressive fireplace whose looming overmantel was decorated with Corinthian pilasters. Parting with more of Durand-Ruel's cash, he furnished the room such that it began to look more like a fashionable salon than the studio of a painter known for his shocking canvases. Up the stairs and into the oversize room came a piano, a cheval-glass, a Louis XV console table, a tapestry, some porcelain vases, crimson curtains, a crimson sofa covered with cushions, and a ceramic statue of a cat. More than simply an expression of Manet's own personal taste, this elegant décor was intended to impress prospective clients with his status and sophistication—to prove to wealthy men such as Barret that he was indeed safe for bourgeois consumption.

At least one visitor, an art critic, was utterly charmed by Manet's impeccable refinement, effusing over the studio as "a truly agreeable environment: very beautiful, charming, luxurious even. . . . With a little imagination, we might believe ourselves to be in a room at the Louvre."[5] Or, indeed, one might almost have believed oneself inside Meissonier's baronial halls in the Grande Maison. In fact, to some of Manet's friends from the Café Guerbois, this stately and self-important studio smacked of a creeping conservatism, of a commitment more to the artistic ideals and ambitions of the *pompiers* than the *actualistes*.[6] In any case, it certainly did not look like the workplace of a man about to devote himself to painting *en plein air*. Nonetheless, the studio did include among its elegant *objets* two jarringly dissident souvenirs of the painter's old days as a critical abomination. Hanging proudly on the walls were both *Le Déjeuner sur l'herbe* and *Olympia*, two works that not even Durand-Ruel had mustered the courage to purchase.

In many ways, Ernest Meissonier had been lucky during the Franco-Prussian War. Thanks to his Europe-wide reputation, his studio in the Grande Maison was treated with far more deference than those of numerous other painters. Camille Pissarro had returned to Louveciennes to discover how the enemy soldiers were using his house as a butcher shop and his canvases as aprons on which to wipe their hands after they slit the throats of rabbits and chickens; his studio was heaped with dung, and only forty of his 1,500 paintings remained intact. Thomas Couture had lost more than a hundred paintings and drawings after his house at Villiers-le-Bel, twelve miles north of Paris, was expropriated by the invaders. Meissonier, on the other hand, may have lost a number of his cows and horses, but his unwelcome guests had neither damaged nor looted his paintings. The fact that none of

his works vanished under mysterious circumstances during the occupation indicated a certain level of discipline on the part of the Prussian soldiers in view of the fact that many of Meissonier's tiny masterpieces could easily have fitted inside a kitbag or overcoat.

Meissonier nonetheless had a difficult time settling in the Grande Maison after its occupation by the Prussians. He had developed an almost pathological hatred of all Germans. In the weeks following the siege, polite and ingratiating Prussian officers hoping to engage the master in idle conversation were treated to rude replies and slamming doors.[7] Meissonier became a recluse in his studio, and even when the Prussians finally departed the memory of their presence was so obnoxious to him that he began contemplating a move from Poissy. To that end, therefore, he acquired a plot of land in the Boulevard Malesherbes, in the heart of the Batignolles.

The Batignolles may have seemed an unlikely spot for France's wealthiest painter to build himself a house. The district was home, of course, to members of the so-called École des Batignolles. It was also home to a large population of working-class Parisians, many of whom had been, like their neighbours in Montmartre, staunch supporters of the Commune. The women of the Batignolles had been especially active, forming a Women's Union for the Defence of Paris and raising barricades from the tops of which they flew the Red Flag. Still, the area was beginning to change. Meissonier had bought the land for his house from the brothers Émile and Isaac Pereire, wealthy railway developers and financiers who were hoping to transform this working-class neighbourhood into one of the most fashionable in Paris. He quickly set about planning a Renaissance-style château whose grandeur and opulence—it was to include a loggia, a courtyard and a spiralling staircase—would put even the Grande Maison to shame.[8]

Besides his new home, Meissonier was also busy with an old project, namely the seemingly interminable *Friedland*. By the spring of 1872, he had not touched the painting for more than eighteen months. He had temporarily abandoned it during the siege of Paris, after which, with a house full of conquering Prussians, he had not had the heart to work on what he called "this picture of Victory."[9] The man who had arranged to buy the work, Lord Hertford, had died of bladder cancer in August 1870. The work therefore had no owner until, more than a year later, Sir Richard Wallace agreed to buy it. Supposedly Lord Hertford's illegitimate son, but more probably his illegitimate half-brother, Wallace inherited the marquess's houses in London and Paris, his sprawling Irish estates, and his extraordinary art collection, which included among its treasures more than a dozen Meissonier paintings. If Lord Hertford went to his grave with the consolation of knowing he had never rendered any-

one a service, Wallace was determined to use his wealth more generously. Opportunities immediately presented themselves during the siege, and "Monsieur Richard," as he was known to Parisians, rose heroically to the challenge. He funded two hospitals for the sick and wounded, provided food and coal for the poor, and in the end spent an estimated 2.5 million francs assisting the besieged and starving Parisians in one way or another.

Wallace quickly demonstrated that he would be no less enthusiastic a Meissonier collector than Lord Hertford. Early in 1872 he bought *A Visit to the Burgomaster*—Meissonier's first-ever Salon painting—and soon afterwards agreed to purchase *Friedland* for 200,000 francs. This extravagant price matched the going rate for a work by the artist revered above all others in nineteenth-century France, since only a year later the French government would spend 207,500 francs buying for the Louvre a fresco that Raphael had executed for La Magliana, the papal villa outside Rome.[10]

After paying Meissonier an advance of 100,000 francs, Wallace shipped all fourteen of his Meissonier paintings across the Channel, together with most of the rest of his art collection, for an exhibition at the Bethnal Green Museum in London.* This exhibition drew the usual complimentary reviews. One of the most enthusiastic came from the studiously elegant pen of a twenty-nine-year-old American named Henry James, whose first novel, *Watch and Ward*, had made its appearance a year earlier. The young novelist had picked his way through what he called an "endless labyrinth of ever murkier and dingier alleys and slums" in order to describe the show for readers of *The Atlantic Monthly*. Among the paintings by Watteau, Rembrandt, Gainsborough and Vernet, he singled out Meissonier for special praise. Meissonier's "diminutive masterpieces," he wrote, "form a brilliant group. They have, as usual, infinite finish, taste, and research, and that inexorable certainty of hand and eye which probably has never been surpassed."[11]

That inexorable certainty would soon test the reaction of critics everywhere. Meissonier estimated that *Friedland* had been some six months from completion when the Franco-Prussian War erupted. Resuming work in the summer of 1872, he found his optimism had been well founded. He would therefore be ready to unveil the painting in 1873, a full ten years after he had first started work.

*Wallace deposited his paintings in the Bethnal Green Museum in 1872 while waiting for his London home, Hertford House in Manchester Square, to be made ready to receive them. This stock of paintings, together with Nieuwerkerke's pieces of armour, today forms the core of the Wallace Collection in Hertford House.

Pure Haarlem Beer

DESPITE HIS GRAND studio and newfound success, in the autumn of 1872 Édouard Manet could still be found warming a bench every evening in the artists' corner of the Café Guerbois. By the early 1870s the Café Guerbois was crowded with, besides the regular group of painters, a motley band of dandies and bohemians. Included among them, until he absconded to Brussels with the seventeen-year-old Arthur Rimbaud, was Paul Verlaine, the absinthe-addicted poet and former Communard; an eccentric musician named Ernest Cabaner, who collected old boots to use as flower pots and lived on nothing but bread and milk; and the Comte de Villiers de l'Isle-Adam, a penniless and dissolute poet and dramatist. But Manet was particularly taken with another of these fellow drinkers, a red-faced, beer-drinking, pipe-smoking engraver named Émile Bellot. "I must do your portrait some time," Manet had often told Bellot; and in the autumn of 1872 the engraver finally agreed to visit the Rue de Saint-Pétersbourg.[1]

Manet's inspiration for this portrait was almost certainly a visit he and Suzanne had made to Holland the previous June, immediately before he took possession of his new studio. It was Manet's first visit to Holland since his marriage in 1863; and while he may have had little desire to visit his in-laws, his enthusiasm for Dutch museums made the journey worthwhile. Accompanied by his brother-in-law Ferdinand Leenhoff, he had made a visit to the Frans Hals Museum in Haarlem, a town of canals and gabled houses that was famous for growing flower bulbs and brewing beer. Opened ten years earlier in a former home for indigents where the painter had died in 1666, the museum held more than a dozen of Hals's portraits of worthy Haarlem burghers dressed in

millstone collars and dark suits. Yet besides these respectable Dutch mer-
chants, Hals had also painted more light-hearted portraits of bosomy wenches
and cheery, round-faced cavaliers. One of the best of these, *The Merry
Drinker*, was in the Rijksmuseum in Amsterdam, which Manet likewise visited.
Painted in the 1620s, the work showed a rosy-cheeked gentleman in a ruff col-
lar and wide-brimmed hat gesticulating amiably with his right hand and rais-
ing a glass of Haarlem's finest with his left.[2]

This convivial *bonhomme* seems to have put Manet in mind of his friend Bellot,
and within a few weeks of returning to Paris he began work on a Hals-like paint-
ing called *Le Bon Bock* ("The Good Pint," plate 8A). The honour of posing for
Manet was, as ever, greater than the pleasure, and Bellot was obliged to visit the
studio on at least eighty occasions. In keeping with the lordly style of his new
studio, Manet instructed the concierge to admit Bellot—humiliatingly for the
engraver—through the tradesmen's entrance.[3] At least the pose was by no
means a demanding one. Bellot was merely required to don an otter-skin cap
and sit at a table holding a glass of beer while puffing happily on his long-
stemmed pipe. His twinkly-eyed contentment is wonderfully captured—a rare
example of Manet depicting animation and emotion in a subject. Manet himself
was evidently pleased with the work, which he decided to send to the 1873 Salon.

Manet was also working on several other paintings in between his relentless
sessions with Bellot. One of them, quite different in flavour from *Le Bon Bock*,
was entitled *The Railway* (plate 7B)—a portrait of a mother and child that in-
cluded in the background the tracks and platforms of the Gare Saint-Lazare as
seen from the back garden of a house in the Rue de Rome. The garden, which
belonged to an artist friend named Hirsch, looked east across the tracks towards
Manet's new studio, one of whose balustraded windows makes a sly cameo in
the top left-hand corner of the painting.[4] The work satisfied Couture's old de-
mands for paintings of *la vie moderne*, since it featured huge clouds of locomo-
tive steam rising above the railway cutting and the Pont de l'Europe, a
star-shaped bridge with iron latticework that had been completed only in 1868.
Manet seated the fashionably attired young mother on a concrete ledge, holding
in her lap a clasped fan, an open book and a sleeping puppy; the child stands
beside her, back turned as she clutches the iron railing at the foot of Hirsch's
garden and looks down into the vaporous void of the railway station.

The little girl was posed by his friend's daughter, and the young woman—
surprisingly, perhaps, for such an image of bourgeois motherhood—by none
other than Victorine Meurent. Victorine had only recently returned to Paris
after six or seven years in America, to which she had emigrated to pursue a
love affair. She may have been surprised at the pose she was ordered to adopt in

Hirsch's garden, since this most notorious *femme fatale* of the 1860s Salons suddenly found herself playing a maternal role. Even so, the painting would have been unsettling for anyone expecting an intelligible narrative or an unambiguous moral imperative. Victorine's nonchalant expression; the child turning her back; the prison-like bars of the railing; the smoking chasm of the railway tracks; the inexplicable bunch of grapes in the right foreground—as so often whenever Manet and Victorine came together, numerous enigmatic touches seemed deliberately to frustrate any clear reading of the work.[5]

Louis-Napoleon's exile in England had been a reasonably pleasant one. Camden Place, his rented mansion in Chislehurst, was staffed by fifty servants and host to numerous visitors. Both the Prince of Wales and Queen Victoria had come to pay their respects. The former then invited Louis-Napoleon to his club in London, the latter by private train to Windsor Castle. The deposed Emperor gratefully accepted both offers. He also made excursions to the Brighton Aquarium, and in the summer of 1871 he had holidayed on the Isle of Wight, where he went yachting with a party that included a young American, Jennie Jerome, who three years later would become the mother of Sir Winston Churchill. He even began working on a new invention, a cylindrical stove that would provide, he hoped, a cheap source of central heating for the poor.

In addition to these recreations, Louis-Napoleon had been—despite his protestations to the contrary—plotting his return to France. In a repeat of his exploits of three decades earlier, he planned to cross into France from Switzerland; he would then mobilise loyal elements in the army and march triumphantly on Versailles to overthrow Adolphe Thiers. His scheme was compromised, however, by the fact that he was too debilitated to ride a horse. Jennie Jerome had found him "old, ill and sad,"[6] and indeed he was still suffering from both rheumatism and his bladder stone. Throughout the autumn of 1872 the pain from the stone became so excruciating that his physician, Sir Henry Thompson, decided to risk an operation. A thorough examination was conducted on Christmas Eve, followed by a crushing operation soon afterwards. Over the next week, two further operations were performed to break up the remains of what turned out to be the largest bladder stone Sir Henry had ever seen. A fourth procedure was scheduled, but Louis-Napoleon's condition had begun rapidly to deteriorate. He died on the morning of January 9, 1873, three months short of his sixty-fifth birthday.

The Emperor's body lay in state—ironically for a man who had little appreciation for art—in the picture gallery on the ground floor in Camden Place, with the funeral taking place at Saint Mary's Catholic Church in Chislehurst.

The tiny building had seating for fewer than 200 people, but some 30,000 more gathered in the grounds outside, the majority of them French. Hundreds of *immortelles* were sold, and mourners clipped sprigs from the yew and holly trees for souvenirs. There was "weeping and sobbing from men as well as women," reported *The Illustrated London News*, which declared: "The late Emperor was a great man, and a great ruler of men."[7] In France, the newspapers expressed far less sympathetic opinions. Though Bonapartist organs such as *L'Ordre* announced the death on front pages bordered in black, the left-wing journals were jubilant. "*Requiescat in pace* in the oblivion of history," sneered one, while another suggested that 200,000 Frenchmen would be alive and five billion francs saved if only Louis-Napoleon had died a few years earlier. Meanwhile the official government newspaper, *Le Journal officiel*, did not bother to report the death until two days later, and then it deemed the Emperor worthy of only a single line: "Napoleon III died on January 9 at Chislehurst."[8]

Determined that her husband should not rest in the oblivion of history, Eugénie immediately began constructing a memorial for Louis-Napoleon. No sooner was he interred in the sacristy of Saint Mary's than she commissioned a neo-Gothic chapel to enshrine his tomb, the granite for which had been donated by Queen Victoria. The small chapel attached to Saint Mary's would be completed early in 1874, in time for a Requiem Mass on the first anniversary of his death. Above its door was a stained-glass window that featured, among other scenes, a portrait of Saint John the Evangelist holding a poisoned chalice. The image was an apt one for a man whose long reign had been brimful of both splendour and tragedy.*

A few days after the newspapers announced Louis-Napoleon's death, Charles Blanc published the regulations for the 1873 Salon. He demanded such stringent qualifications from voters that only 149 painters were eligible to receive a ballot, compared with more than a thousand in 1870. As a result, the jurors for the 1873 Salon turned out to be virtually identical to those elected the previous year. However, one member of the 1872 jury was conspicuously absent in 1873: the

*In 1881 Eugénie left Camden Place and moved to Farnborough Hill, a neo-Gothic mansion in Hampshire. Here she founded Saint Michael's Abbey and commissioned a chapel to whose crypt, in 1888, she transferred her husband's sarcophagus. Louis-Napoleon's remains were joined by those of the Prince Imperial, who had died fighting for the British army in South Africa in 1879, aged twenty-three. Eugénie herself would die in 1920, at the age of ninety-four.

voters emphatically rejected Ernest Meissonier, denying him a place on the jury as chastisement for his persecution of Gustave Courbet. The exclusion of Meissonier itself then caused a rumpus, since several jurors, including Baudry and Breton, promptly resigned in a show of support—though the rest of the artistic community seems to have endorsed the punishment of the belligerent and overbearing Meissonier.

Meissonier was not especially troubled by his reproof from the voters because in 1873 he was involved in what he regarded as a grander mission. Almost six years had passed since Napoleon III had opened the Universal Exposition in 1867. A number of large industrial exhibitions had been held since then, though nothing on the same scale as the Emperor's spectacular display in Paris. In 1870, however, the Lower Austrian Trade Association had proposed the staging of what became known as a *Weltausstellung*, or World Exhibition—a showcase, explained the organisers, "that would embrace every field on which human intellect has been at work."[9] A huge exhibition hall named the Rotunda, complete with a 440-foot-wide dome, began rising over Prater Park in Vienna, while nearby a 2,000-foot-long Machinery Hall started taking shape. To the east of the Rotunda, beside the Danube, was the Fine Arts Gallery, a 600-foot-long brick-and-stucco construction in which the most recent masterpieces of world art were due to be shown when the Emperor Franz Josef opened the exhibition on May 1, 1873. It was in this building, on the largest stage the world could provide, that Meissonier planned to unveil *Friedland*.

Meissonier may have been *persona non grata* among many of his fellow artists in France, but abroad his name still carried enough weight and prestige that Charles Blanc chose him to head the International Jury for the Fine Arts, in which capacity he would oversee the display of French paintings in Vienna. Meissonier naturally took to this task with relish, seeing a chance to demonstrate to the world—and in a German-speaking nation—that the genius of France was still alive and well. The critic Edmond About summed up the aspirations of many Frenchmen when he wrote that "a French masterpiece, exploding amid the mediocrity of arts in Europe, would do us as much honour as a victory on the battlefield."[10] To that end, Meissonier planned to send to Vienna masterworks of French painting from the Louvre, the Luxembourg and other French museums. Besides the mighty *Friedland*, Meissonier also planned to dispatch some nine or ten others of his works.

This artistic expedition soon encountered problems when Adolphe Thiers, citing possible damage en route to Vienna, refused to allow any paintings to be removed from the walls of French museums. Meissonier was furious at his

friend's casual attitude to the exhibition, which recalled the ineptness and com-
placency with which the French generals had prosecuted the war against the
Prussians. He sent a telegram to Thiers requesting an audience. "We had a
long conversation," Meissonier later reported. "I told him over and over again
that he was sending us out to battle with only half our arms, the best of which
he was keeping back in the arsenal."[11] Thiers eventually relented. The French
would go into battle fully equipped with masterpieces.

So long as Meissonier was in charge, one artist would have nothing to do
with the French expeditionary force. Over the past two decades, Gustave
Courbet's work had been shown in London, Brussels, Amsterdam, Antwerp
and Ghent, and even as far afield as New York and Boston. Courbet was espe-
cially popular among his Teutonic neighbours. He had spent several happy
months in Frankfurt at the end of 1858, doing a lucrative trade in portraits; and
in 1869 he had spent a few weeks painting and socialising in Munich, where
King Ludwig II of Bavaria made him a Knight of the Order of Saint Michael.
He was therefore a natural choice to represent France in Vienna, but Meis-
sonier would have none of it. Not only was he impenitent about having ex-
cluded Courbet from the 1872 Salon; in 1873 he began pressing to have him
banned from the World Exhibition as well. Vainglorious and self-centred as al-
ways, he seems not to have appreciated just how swiftly he was becoming
more unpopular than the man he was persecuting.

The jury for the 1873 Salon followed a predictable pattern, rejecting more
than half of the five thousand submissions. This harsh treatment was fol-
lowed in turn by the usual response from the rejected artists, who began agi-
tating for a Salon des Refusés. For once, Charles Blanc acceded to their
wishes, making provisions for what was named an Exposition Artistique des
Oeuvres Refusées. The works of hundreds of rejected artists would there-
fore go on show on the tenth anniversary of the infamous Salon des Refusés
of 1863.

Courbet had submitted nothing to the 1873 Salon because he feared, with
good reason, that the authorities might seize his canvases from the Palais des
Champs-Élysées. At his 1871 trial in Versailles he had stated, much to his
subsequent regret, that he would pay for the rebuilding of the Vendôme Col-
umn, and by 1873 the government was ready to hold him to his word. In Jan-
uary his friend Castagnary warned him to get as many of his canvases as
possible out of France lest they fall into the hands of the authorities.[12]
Though Courbet claimed his notoriety guaranteed even higher prices for his
work, by this time much of his bravado had been replaced by worry and

grief. "I am in a state of inexpressible anxiety," he wrote to his sister Lydie.[13] His fourteen-year-old son by a former mistress had died in the summer of 1872; and he himself was once again in poor health, with rheumatism and an enlarged liver—though this latter ailment did not prevent him from buying a forty-gallon cask of Beaune wine with which to celebrate a particularly lucrative sale.

Claude Monet was also absent from the Palais des Champs-Élysées. After returning from London he had moved with Camille to Argenteuil, a picturesque town directly across the Seine from Gennevilliers. Here sails could be seen scudding along the river and chimney stacks puffing their clouds of smoke into the sky—all of which Monet painted over and over again. He had finished nearly sixty canvases in 1872, thirty-eight of which he found himself able to sell, fetching a total of 12,000 francs and putting his income for 1872 on a par with that of doctors and lawyers. Gone were the days when he could no longer afford a fire for his kitchen. With these sales to his credit, he did not require exposure at the Salon, and so in 1873 he once again declined the humiliating ritual of sending work before the jury.[14]

Most other members of the Batignolles group likewise abstained. More significantly, Pissarro, who had sold a number of his canvases to Paul Durand-Ruel, was setting in motion plans for an alternative exhibition that would bypass the Salon jury altogether. He had already been recruiting potential exhibitors in the autumn of 1872. A painter friend named Ludovic Piette, a former pupil of Couture, summed up the sentiments of many fellow artists when he wrote to Pissarro in December: "If a certain nucleus of painters plans not to exhibit at all in the Salon of 1873, above all if Courbet is excluded, and if the jury is still composed of reactionaries or Bonapartists, I would also join with pleasure."[15]

However, one notable *actualiste* did appear at the 1873 Salon, as he had the previous year. Both of Manet's submissions, *Le Bon Bock* and *The Repose*, his 1868 portrait of Berthe Morisot, were accepted by the jury of "reactionaries." Ten years after the original Salon des Refusés, Manet would be the only member of the Generation of 1863 still flying the flag in the Palais des Champs-Élysées.

"The annual Salon has been opened," an English correspondent reported from Paris in the first week of May, "with a somewhat disappointing result. . . . Very few out of the 1,500 pictures exhibited call for any special notice."[16] As in 1872, the critics were distinctly underwhelmed, with the English reviewer registering his disappointment that nothing by Ernest Meissonier was on show—"a fact

much commented upon."[17] So many pieces of soft-focus eroticism hung on the walls that another English reviewer, the correspondent for *The Times*, observed disapprovingly that each room included "from six to eight examples of staring nudity."[18] Landscapes by Corot and Daubigny were also present, the latter taking a merciless critical drubbing for the supposedly sketchy and unfinished look of his *Effect of Snow*.

When the reviews for *The Repose* appeared in the papers, Berthe Morisot found herself stepping into Victorine's role as the most ridiculed and reviled woman in the Salon as the canvas received abuse all too familiar to Manet. The portrait was denounced as a "horror"; it was dubbed "Seasickness" and "The Woman Who Squints"; it was lampooned as a portrait of a woman resting after having swept the chimney; and it was said to depict "the goddess of slovenliness." A critic in the *Revue des deux mondes* summed up the portrait by declaring it "a confusion defying all description."[19] These insults, together with the fact that her own works had been rejected by the jury, seem to have convinced Morisot that her future lay not in the Salon but with the "nucleus of painters" taking shape around Pissarro.

Nonetheless, in 1873 Manet was in for an even bigger triumph than he had enjoyed with *The Battle of the U.S.S. "Kearsarge" and the C.S.S. "Alabama"* a year earlier. Sending a painting of a drinker to the Salon may have looked unwise in 1873 given how alcoholism and working-class insurgency had become virtually synonymous in the public mind since the end of the Commune. The term *alcoolisme* had been coined as a diagnosis as recently as 1865, and the French Temperance Society was founded immediately after the suppression of the Commune with a view to battling this perceived problem—one thought by many to have explained not only the outrages of the Commune but also the French defeat by the Prussians.[20]

However, the public and the critics saw no indication of working-class dissent in Émile Bellot's contented beer-drinker, and *Le Bon Bock* quickly became the most popular painting in the entire Salon. Praise flowed from all quarters. The front page of *Le Soir* declared the painting "a marvel of life and colour . . . amazing and excellent." *Le Gaulois* called it "an indisputable success," announcing that "Manet has found a curious and interesting style, and the public will follow his new efforts with pleasure." Even critics normally hostile to Manet found themselves charmed by the work. "This supposed demon come forth from the pit to frighten women and children is in fact an interesting painter," wrote Paul Mantz in *Le Temps*, "and a peaceful and distinguished man." Like many spectators, he saw something soothingly nostalgic in the work,

which seemed to feature a sturdy Frenchman blissfully unruffled by the multiple horrors of the previous few years. "In our present troubled times," wrote Mantz, "this placid drinker symbolises eternal serenity. . . . His rosy cheeks and portly frame say so well that he knows no sadness." Even Albert Wolff was able to find words of approval, avouching that Manet "has put water in his beer. He has renounced his violent and outlandish effects to explore a more pleasing harmony." "Water?" quipped Manet's friend Alfred Stevens after reading the review. "It's pure Haarlem beer!"[21]

Stevens was correct. The way for Manet's merry drinker had been paved by Frans Hals and the generation of Haarlem painters who followed him—men who did quaint and humourous scenes of sloshed, stuporous peasants. But someone else besides Manet had been inspired by this genre and paved the way for the success of *Le Bon Bock*. Even before his visit to Holland in 1850, Ernest Meissonier had been busily conjuring to life his own little pipe-smokers and beer-drinkers. He exhibited a work called *A Smoker* at the 1842 Salon, *A Man Smoking* in 1849, and in 1854 he painted *A Smoker in Black*, a portrait of a young man puffing on a long-stemmed pipe in the corner of a tavern, a glass of beer at his elbow. Meissonier's exalted reputation had been built on precisely this sort of scene, and the congenial reception accorded *Le Bon Bock* no doubt had much to do, ironically, with a taste for bibulous *bonshommes* formed by Meissonier a quarter of a century earlier.

Le Bon Bock gave Manet an unaccustomed celebrity. His fame increased as a newspaper reported in the middle of June that an offer of 120,000 francs had been made for the painting—an incredible sum that Meissonier alone could command. Alas for Manet, the report proved to be a typographical error. Two weeks later the paper described how Manet had come to the newspaper's offices demanding to know "the name of the madman offering 120,000 francs." The report, admitted the sheepish editor, "should have read 12,000."[22] In the end, the painting would be sold for a more modest sum of 6,000 francs, though this price was nevertheless double that paid by Durand-Ruel for any of Manet's previous works. The buyer was a famous baritone named Jean-Baptiste Faure, the Professor of Singing at the Paris Conservatoire and a well-known connoisseur of painting.

The impact of Manet's painting was nothing short of sensational. "You are as famous as Garibaldi," Degas told Manet that summer, surveying the astonishing success of the painting.[23] Its fame radiated outwards from the Palais des Champs-Élysées as Paris was swept by a "Bon Bock" craze. Reproductions of the painting went on sale in bookshops and tobacconists. A shopkeeper in the Rue Vivienne, beside the Bourse, displayed in his window what he claimed was

Manet's palette, beside which he placed a mug of beer; and a restaurant in the Latin Quarter, in a clever bid to increase its custom, changed its name to Le Bon Bock. But the greatest beneficiary of this fame, besides Manet, was Émile Bellot, who revelled in his own newfound celebrity and developed a reputation as a connoisseur of beer. Two years later he would capitalise on this reputation by founding the Bon Bock Society, a social club for artists and intellectuals that hosted boozy, boisterous dinners each month in Montmartre. Active for almost fifty years, the society would do much to make Montmartre, before then a sub-urb known for windmills and working-class radicalism, into a centre of Pari-sian cultural life.

Manet was finally enjoying the popular, critical and financial success that had eluded him for so long. But had the public and the critics matured in the years since *Le Déjeuner sur l'herbe* and *Olympia*, or had Manet changed his style? Only three years earlier, Gautier had written that Manet was deter-mined to die impenitent; but suddenly the troublingly provocative pictures had given way to a cuddly *bonhomme* in an otter-skin cap deemed fit to adorn shop windows and tavern signs; to sell beer and tobacco; to becalm and amuse a tormented nation. Accused in 1863 of terrorising the bourgeoisie, a decade later Manet appeared to be enchanting them in the style of Meissonier or Gérôme.

Yet one critic in particular could appreciate *Le Bon Bock* for something other than the jolly charms of Émile Bellot—a discerning twenty-four-year-old re-viewer named Marie-Amélie de Montifaud, who wrote under the masculine pseudonym Marc de Montifaud. A budding novelist, historian, feminist and art critic, Montifaud had just published her first book, *The History of Héloïse and Abélard*, and her study of the poetry of Anatole France was forthcoming in Oc-tober. In 1873 she reviewed the Salon for *L'Artiste*, and her comments on *Le Bon Bock* were almost singular in their perspicacity. While most people admired the painting for its content, she concentrated on its technique. Manet's loose brush-work and broad patches of pigment, maligned by so many critics, were actually an attempt, Montifaud recognised, to use shape and colour to compose an en-tirely new visual experience by means of a kind of optical fusion. "One per-ceives at a first glance in his *Bon Bock*," she wrote, "coloured areas laid one next to the other with a crude simplicity and without any shading. But stand back a little. Relations between masses of colour begin to be established. Each part falls into place, and each detail becomes exact."[24] A more acute insight into the aesthetic effects of the École des Batignolles had never been produced.

Beyond Perfection

THE UNIVERSAL EXHIBITION of Arts and Industry in Vienna was not a disaster, but neither did it bear comparison to the Great Exhibition in London in 1851 or the Universal Exposition in Paris in 1867. The enormous Rotunda and its adjoining galleries had been finished on time, providing almost twenty acres of exhibition space—amazingly, some four times as much as had been available in Paris. But many displays were not actually in place by the middle of June, let alone for the grand opening in May. A few days after the opening, on May 9, the Vienna stock market collapsed in what became known as *Der Krach*. And, to cap it all, the weather was atrocious. The grand opening took place amid chilly showers, and the ankle-deep quagmires of mud in Prater Park were succeeded by dust storms as downpours throughout May turned to a stifling heat in June. The adverse conditions kept the visitors away, as did the high prices charged by Vienna's innkeepers, who had greedily doubled their rates. Then, in July, a cholera outbreak was reported. The exhibition's Director-General, Baron Wilhelm von Schwarz-Senborn, eventually slashed the admission charge in half.

The Vienna Exhibition was therefore a less than perfect forum for the French to restore their international reputation—and for Ernest Meissonier to unveil *Friedland*. Still, France's display was widely regarded as by far the most impressive in the entire exhibition. The French had been given more than 6,000 square metres of exhibition space, or almost an acre and a half, second only to the Germans; and their galleries were filled with elegant attractions such as Aubusson and Gobelins tapestries, fans by Duvelleroy, silks from Lyon, and such crowd-pleasers as photographs by Nadar and a Bible illustrated by Gustave Doré.

"France has reason to feel satisfied with the results of her efforts," wrote an English correspondent, "for her display at Vienna is a surprise even to those acquainted with the energy of her people and the resources of the country."[1] The standard of their goods was so high that, incredibly, the French were awarded a quarter of all the prizes, easily eclipsing those of any other country, Germany included.

The French truly surpassed themselves, however, in the Fine Arts Gallery. Housing some 6,500 works of art, this building was opened by Emperor Franz Josef on May 15, in a ceremony performed beneath Alexandre Cabanel's *The Triumph of Flora*, an oval-shaped mythological scene finished a short while earlier. Painters and sculptors from twenty-six countries had sent works of art to Vienna, but the French, with 1,527 pieces on display, comprised a quarter of the entire exhibition. Eight rooms in the gallery, as well as half the central hall, were dedicated to the finest examples of French art—sculptures by Jean-Baptiste Carpeaux, canvases by Ingres, Delacroix, and Théodore Rousseau. The effect was overwhelming. Most critics and spectators were agreed that the French outclassed the opposition in quality as well as quantity. France, one English critic proclaimed, "carries off the palm"; another made a welcome comparison between the French and the Germans, praising the "fidelity to nature" shown by the former and castigating the "harsh colouring and severe drawing" of the latter. Even an Italian visitor, the architect Camillo Boito, grudgingly admitted that the French were "ever so far ahead in the disciplines of beauty."[2]

The greatest interest, though, was reserved for Meissonier, who had dispatched nine of his own paintings into this artistic combat, none of which, except for *End of a Gambling Quarrel*, had ever been seen in public. In addition to a couple of musketeer scenes, he chose three of his Antibes landscapes, one a watercolour, providing visitors to the Fine Arts Gallery with a glimpse of a possibly unexpected versatility in dealing with colour and light. They were predictably well received, with the critic for *The Times* exclaiming over the beauties of these light-saturated landscapes.[3] But watercolours and musketeers nonetheless made odd choices for a man obsessed with artistic grandeur as well as with the moral and patriotic regeneration of France. In 1871 Meissonier had claimed the aftermath of the war against Prussia was no time to paint "little figures"—and yet, try as he might to drive his repertoire into Olympian realms, he could never quite abandon his musketeers.

Absent from the Fine Arts Gallery were Meissonier's two patriotic allegories from 1871, *The Siege of Paris* and *The Ruins of the Tuileries*. He likely left these two works back in Poissy to avoid stirring up memories of the shameful

and tragic episodes in the Franco-Prussian War and the Commune. The failure of painters at the 1872 Salon to pull artistic victories from the jaws of military defeats no doubt convinced him to dwell, instead, on an incontestable triumph; and for that reason his hopes in Vienna rode on another work. This, of course, was the masterpiece calculated to explode amid "the mediocrity of arts in Europe" with all the devastating force of a battlefield victory. On May 15, 1873, following a short speech by Emperor Franz Josef, the world therefore got its first glimpse of *Friedland*.

Few works in the history of art have consumed as much labour, generated as much rumour and anticipation, been showered with as much money, or simply taken as long to complete, as Meissonier's *Friedland*. The canvas had been the product of exhaustive studies and researches, bizarre experiments, real-life cavalry charges, and as many as a hundred separate studies of everything from the crook of a soldier's arm to the joint of a horse's foreshortened leg. It had survived a skewering from a fencing sword, bombardment by the Prussians, and the flames of Bloody Week. In the ten years he had spent on this work, Meissonier had metamorphosed from a painter whose election to the Institut de France had been celebrated by progressive newspapers as a victory for youth over the "old Académie," to a painter reviled by those same progressive newspapers as an appalling reactionary. He had turned from an artist known for exquisite little paintings of musketeers and other *bonshommes* into a man possessed by Michelangelesque visions of covering the Panthéon with sprawling murals—of appealing to posterity from hundred-foot walls. And his opponents, finally, had changed from the diehards found in the Académie des Beaux-Arts to the younger generation of artists who gathered at the Café Guerbois.

Despite his incredible hauteur and colossal self-regard, even Meissonier must have wondered how long he could possibly keep his grasp on the vertiginous summit to which he had climbed. For the previous two decades he had been celebrated as the "incontestable master" who would be venerated, according to Delacroix, long after his contemporaries disappeared into the shades. Yet he knew from his historical studies, as well as from witnessing the collapse of the Second Empire, that power, fame and glory were the most transient of properties. One of his favourite stories concerned a comment made by Napoleon while at the height of his powers. The Emperor had gathered with several close friends at the Château de Malmaison when talk turned to the blazing glory of his reign. "Yes," Napoleon had soberly told his listeners, "but some day I shall see the abyss open before me, and I shall not be able to stop myself. I shall climb so high that I shall turn giddy."[4]

The year 1873 was not perhaps the best time to unveil a work such as *Friedland*. The historic victory on Prussian soil commemorated by the painting was made to look somewhat hollow by the Germans' gleaming display, only a few yards from the Fine Arts Gallery, of the giant Krupp cannons that had shredded the modern-day French cuirassiers with such brutal efficiency. Equally inauspicious was the work's celebration of Napoleon. Ten years earlier, as Meissonier set to work on his masterpiece, Adolphe Thiers wrote that Napoleon was "the man who has inspired France with the strongest emotions she has ever felt."[5] But by 1873 these emotions were not so strong. The cult of Napoleon, so lustrous and potent throughout the 1860s, had been damaged with the fall of Napoleon III and the transition of France from an imperial power to a republic constituted in the ignominy of military defeat and civil war. Indeed, the Bonapartes were derided in one republican newspaper, following the death of Louis-Napoleon, as "that sinister and cursed race."[6] Rather than trumpeting the glories of France, Meissonier appeared to have created an elegy for a lost empire and a testimonial to fugitive and meretricious grandeur.

Friedland (plate 6B) was prominently displayed in the central hall of the Fine Arts Gallery. It was an arresting sight, a full-pelt cavalry charge magically frozen in time, every bunched muscle and flying hoof—and every stalk of ripening wheat—captured with a precision that no photographer, and no other painter, could hope to replicate. Not even *The Campaign of France*, Meissonier's master-class in heaving human and equine bodies into motion, could have prepared viewers for the thundering gallop across the canvas of the triumphant cuirassiers.

The composition was a thrilling one, plunging spectators headlong into the scene. Here, for the first time on a broad canvas, were all the extraordinary virtuosities with which Meissonier had made his name—the trademark dexterities of brush, the microscopically precise details, the rigorously anatomical and exquisitely choreographed movements of horses and riders. The painting repaid the closest inspection, yielding up such infinitesimal details as the bulging veins on the legs of Napoleon's white charger and the poppies—a few dashes of red—crushed beneath the hooves of the stampeding cuirassiers. For anyone who knew to look for it, there was also evidence of Charles Meissonier's mishap with the fencing sword, since the flank of the sorrel horse in the middle foreground betrayed both an ever-so-slight wrinkling of the canvas and a thick and apparently clumsy application of paint altogether unlike Meissonier's usual elegant brushwork.

Most viewers were enthralled by the astonishing level of detail, with critics

exclaiming over Meissonier's "scrupulous exactitude," his "conscientious-ness," and the unparalleled means by which he gave a vivid impression of "na-ture seized from life."[7] The critic for *The Times* wrote that "the composition is remarkably bold and the execution at once vigorous and minute."[8] A Viennese paper, the *Tageblatt*, proclaimed him "the ace of spades" in French art and called his paintings "a constellation of stars in the Fine Arts Gallery."[9] Mean-while a French critic writing in the *Journal officiel* noted with satisfaction that his glory was still "without eclipse."[10]

And yet not everyone was convinced by the painting. A few years later Meis-sonier would complain about the "many (among the thousands of viewers) who have done it injustice with a certain malevolent appreciation."[11] He was exaggerating, though a minority of critics did take the view that the whole of *Friedland* was something less than the sum of its parts. One of the most trenchant was Arsène Houssaye's son Henry, a masterful young art critic and classical historian who reviewed the painting for the *Revue des deux mondes*. His argument was one Meissonier must have found damaging for the simple reason that it was undeniably—and embarrassingly—accurate. Meissonier believed the painter's task was to come to the aid of history; he had once claimed, in fact, that had he not become a painter he would have been a histo-rian like Adolphe Thiers. He purported to be a student of Thiers in matters Napoleonic, keeping beside his bed volumes of *The History of the Consulate and the Empire of France under Napoleon* and on occasion inviting Thiers to Poissy to discuss the finer points of French military history. With *Friedland*, Meissonier had hoped to achieve a perfect historical reconstruction by trans-lating onto canvas what Thiers had put onto the page.

Houssaye, however, uncovered a troublesome lapse in Meissonier's historical appreciation, one suggesting that *Friedland* was actually a fiction. A keen scholar of Napoleon, Houssaye would later publish a two-volume history of the First Empire that ran through forty-six editions. He knew whereof he spoke, therefore, when he pointed out that the episode portrayed—Napoleon reviewing his charging cuirassiers—had never actually occurred: the 3,500 *Gros Frères* had made their dramatic assault against the enemy columns long before Napoleon made his appearance on the battlefield at Friedland. Hous-saye then went on to explicate the farcical nature of the composition by point-ing out how the particular trajectory of the charge—which sent the cuirassiers looping around to the Emperor's right—invited spectators logically to con-clude that either Napoleon had turned his back on the enemy or the cuirassiers were in the process of fleeing from battle. Meissonier was thereby exposed as

someone defective in both historical knowledge and military tactics— devastating assaults on a man who prided himself on his absolute fidelity to history.

Houssaye also voiced what was ultimately, perhaps, an even more serious criticism, one that further struck at the root of Meissonier's artistic project. Specifically, he felt Meissonier had gone overboard in his laborious attempts to represent the movement and musculature of his horses. The work's mind-boggling complexity of detail, far from heightening the realism, actually detracted from it. Meissonier's fixation on anatomical exactitude merely resulted in horses that looked like they had been flayed of their skin. "He wanted to go beyond perfection," wrote Houssaye, "to show everything, to not let a single muscle relax, nor hide a single vein beneath the skin." He argued, in effect, that Meissonier failed to see the forest for the trees: though his horses were anatomically correct in every last detail, they were not actually true to life. "A galloping horse," he pointed out, "cannot be painted with the minute meticulousness and patience that one employs for a figure at rest. . . . Such figures must be executed with vigorous touches, otherwise they will be frozen and immobilised in their movement."[12]

Meissonier's all-engrossing scrutiny of his subject, combined with his almost mesmeric style of delineating the results, ultimately made for a dubious and unrealistic scene. The canvas was zootomically impeccable but, for spectators such as Houssaye, visually unconvincing. What Meissonier saw as he watched anatomical dissections or rode alongside Colonel Dupressoir's galloping cuirassiers did not tally with the blurry and indistinct impressions of equine locomotion gained, for example, by spectators positioned beside the finishing post at Longchamp. Meissonier's attempts to press technological advances into the service of art had produced animals that belonged less in the École des Beaux-Arts than in the École Nationale Vétérinaire.

Someone considerably more important to Meissonier than Henry Houssaye likewise entertained reservations about the painting. Among the hundreds of notable visitors to the International Exhibition in Vienna was Sir Richard Wallace, who made his way to the Fine Arts Gallery in a distinguished company that featured the Prince of Wales and several English politicians. Also in the party were the critic Charles Yriarte and the art dealer Francis Petit, both close friends of Meissonier. Naturally, they made straight for *Friedland*.

The Prince of Wales and his companions were suitably awed by the painting. "At first sight," Yriarte remembered, "this admirable work drew a cry of admiration from our whole party." Petit then turned to the Prince of Wales

(whose father, Prince Albert, had been such an enthusiast for Meissonier) and informed His Royal Highness that he could congratulate Sir Richard "on being its fortunate owner." But to the surprise of Yriarte and the others, Sir Richard, who only a year earlier had parted with an advance of 100,000 francs, "modestly declined the honour," an announcement that must have shocked Petit, who had personally arranged the sale. *Friedland* was suddenly, and somewhat inexplicably, without an owner, and Meissonier was without the promised second instalment of 100,000 francs.[13]

This unexpected renunciation of ownership had little to do with aesthetic disagreements of the sort advanced by Houssaye and everything to do with a childish misunderstanding. Wallace had advanced Meissonier 100,000 francs for *Friedland* on the understanding "that later the final conditions could be settled according to the work's importance." But these final conditions were never settled. By 1873 virtually all communication had lapsed between patron and painter as Wallace moved more or less permanently to London, having become, among other things, the Member of Parliament for Antrim in Ireland. According to Yriarte, Wallace was "somewhat offended by the artist's protracted silence," while Meissonier, for his part, was miffed that the connoisseur for whose collection the work was destined "should never have displayed any curiosity about it."[14] This standoff culminated with Wallace disowning *Friedland* in front of the Prince of Wales and Meissonier obliged to return his advance of 100,000 francs.

Despite favourable reviews and the admiring throngs, Meissonier was therefore left looking to his laurels as it became clear that the triumphs of 1855 and 1867 were not to be repeated in Vienna. As a student of history, he could have glimpsed the possibility of a grisly parallel between Napoleon's military endeavours and his own artistic career. In Meissonier's opinion, Napoleon's greatest triumph had been the Battle of Friedland, not simply because of the virtuoso tactics and crushing finality of the victory but because prior to 1807 the Emperor, as Meissonier wrote, "made no mistakes."[15] Perfection had followed perfection. But Friedland was also, Meissonier believed, the beginning of the end, the setting of the course that would lead Napoleon inescapably to the abyss of Waterloo.

Meissonier returned to Poissy in the summer of 1873 and, in a gesture typical of the almost maniacal craftsman that he was, restored *Friedland* to his easel. Despite his years of effort, the painting was still, in his opinion, something less than perfect; and it was perfection, he always claimed, that lured him forward.

The Liberation of Paris

FRANCE HAD A new President by the time Meissonier returned from Vienna. Adolphe Thiers resigned on May 24, 1873, following a no-confidence motion in the National Assembly prompted by monarchist opposition to his appointment to the cabinet of three republicans. A day later the Assembly's conservative majority elected a man much more to their tastes: Marshal Patrice MacMahon, the general who two years earlier had crushed the Commune.

In his inaugural address, delivered on May 26, the sixty-five-year-old MacMahon stated that the aim of his government was "the restoration of a moral order in our country."[1] A religious revival was already under way in France. Over the previous year, dozens of trainloads of pilgrims had travelled south to Lourdes, where in 1858 visions of the Virgin Mary had been revealed to a fourteen-year-old named Bernadette Soubirous; and the first national pilgrimage to Lourdes, complete with a torchlight procession, was planned for July 21, 1873.[2] The Virgin Mary and Joan of Arc had been appearing to young women throughout the country, while the sculptor Emmanuel Frémiet was working on a bronze equestrian statue of Saint Joan, clad in armour and holding a standard, that was destined for the Place des Pyramides.

In keeping with this "moral order," MacMahon's administration launched plans for a number of large architectural projects. A new church, the basilica of the Sacré-Coeur, would be built in Montmartre, on the spot where Generals Lecomte and Clément-Thomas had been executed. Funded by public subscription, it would serve, as the deputies in the National Assembly affirmed, "as witness of repentence and as a symbol of hope." The government also

announced plans to rebuild the Vendôme Column. This latter project, expected to cost hundreds of thousands of francs, would be funded not by public subscription but rather—very much against his wishes—by Gustave Courbet. To that end, the government ordered the sequestration of his property in both Paris and Ornans, at which point Courbet fled into exile in Switzerland. There, according to a friend, he began "drowning himself" in white wine.[3]

The government of moral order also had plans for yet another grand artistic project. Charles Blanc was dismissed as Director of Fine Arts in December 1873, a victim, according to Le Temps, of "malice and political prejudice." His crime, the newspaper maintained, was to be a republican, "and the presence of a republican at the head of the fine arts was, it would seem, a scandal that the government of the moral order could no longer support."[4] His replacement was a man with irreproachable conservative credentials, the Marquis de Chennevières. Deprived of his responsibilities at the Salon early in 1870, Chennevières had spent the previous few years working as a curator at the Musée du Luxembourg and raging in the newspapers against socialism, atheism and the evils of the Commune.[5] Returned to a position of power, he immediately set about commissioning artists to work on his pet project: the decoration of the church of Sainte-Geneviève, otherwise known as the Panthéon.

Sainte-Geneviève possessed a confusing history that oscillated between the sacred and the profane. Commissioned in the 1750s by King Louis XV, it was raised on the site of a shrine dedicated to the patron saint of Paris, a nun who had averted an attack on the city by Attila the Hun. However, construction had not been completed until 1791, at which point the revolutionaries seized the church, incinerated the remains of Sainte-Geneviève, and transformed the building into a secular temple, the Panthéon, under whose neoclassical dome the great men of France, such as Voltaire and Rousseau, could be buried. The building was reconsecrated as a church in 1821, only to be secularised again in 1831. It then reverted back to the Catholic Church in 1852, one year after the physicist Jean-Bernard-Léon Foucault suspended a 220-foot-long pendulum from its dome in order to demonstrate the rotation of the earth on its axis. In 1871 the church was damaged by a shell during the Prussian bombardment; two months later the Communards replaced the cross on its dome with the Red Flag, vandalised the remaining relics, and turned the building back into a temple.

Though by 1873 it was known once more as the church of Sainte-Geneviève, Chennevières was anxious to imprint an indelibly and unmistakably Christian identity on the building in order to forestall any future attempts at secularisation. Since Paul Chenavard's proposed mural decorations, begun in 1848, had

come to nothing, Chennevières immediately ordered a series of religious murals for the church's walls and vaults. Painters involved in the project were Cabanel, Gérôme and Baudry, all experienced muralists. Also receiving a commission was Meissonier, who possessed no experience whatsoever in the medium. He had become obsessed with murals, however, to the point where as his new mansion rose on the Boulevard Malesherbes he began fantasising about covering its ceilings and walls with historical and allegorical scenes. "Last night I could not sleep," he wrote, "and I lay awake thinking of the paintings I would put on the walls of my house. Over one door, *Painting* and *Music*; over the other, *Sculpture* and *Architecture*. . . . Won't my staircase be magnificent, with an allegory of *The Poet* on one wall and *Homer Appearing to Dante* on the other?"[6]

Learning of the plans for Sainte-Geneviève, Meissonier had approached Chennevières to let him know of his wish to participate. Chennevières later recalled how Meissonier's name was therefore put forward for consideration: "I can assure you," he claimed, "that no one began to laugh, and no one thought of the size of his paintings."[7] Meissonier thereby found himself, in the spring of 1874, engaged to decorate a thirty-nine-foot-high wall on the left side of the high altar with a scene entitled *The Liberation of Paris by Sainte-Geneviève*. He was duly given a history lesson by the church's abbot, who recounted the tale of how a barge loaded with bread destined for starving Parisians besieged by the Huns was miraculously saved from destruction after Sainte-Geneviève waved her arm and turned a jagged rock in the middle of the Seine into a serpent.

The story of Sainte-Geneviève and Attila the Hun had obvious resonances after the siege of Paris by the Prussians—all the more so given that General Trochu, the Military Governor of Paris during the siege, claimed Sainte-Geneviève had come to him in a vision, offering to save the city once again. Meissonier was less than enthused, however, about the pictorial possibilities of the episode of the rock and the serpent: "It really is impossible to get up any enthusiasm for such a theme!"[8] He was delighted, even so, at the prospect of decorating the wall of such an important building, and of proving himself in the most prestigious of all painting techniques. Yet the commission did raise a few eyebrows. Chennevières and his colleagues may not have laughed, but not everyone was so restrained at the thought of the "painter of Lilliput" tackling such a grand design. "Can one imagine a more absurd fantasy?" scoffed Pierre Véron, editor of *Le Charivari*, who predicted a disastrous outcome.[9]

Mural painting presented enormous challenges to an artist. Working on the surface of a high wall or curved vault, where the design needed to be incorporated into the architecture, was a more complex and demanding operation than

even the largest easel painting. More challenging still was a mastery of technique. Italian Renaissance masters such as Michelangelo had worked in the medium known as *buon fresco*. The word *fresco*, meaning "fresh," refers to the fact that the artist painted on a patch of wet plaster that was trowelled onto the surface of the wall each day as he began work. The frescoist was forced to complete his scene, necessarily only a few feet square, in the eight or twelve hours in which this patch of plaster would dry. The technique had the advantage of durability, since the pigments would be, in effect, locked in stone once the plaster had dried. Yet it had the considerable disadvantage of requiring great speed and accuracy, since once the plaster dried the painter was unable to make corrections to his work, short of chipping it from the wall and starting again. For these reasons fresco was, according to one Italian Renaissance artist, "the most manly, most certain, most resolute and most durable" method of painting.[10]

Few nineteenth-century mural painters worked in fresco, however. The exact technique, transmitted from master to pupil in Renaissance workshops, was no longer completely understood, especially outside Italy. When monumental frescoes were ordered in the 1840s for the embellishment of the rebuilt Houses of Parliament in London, the Commissioners on the Fine Arts were obliged to send the painter William Dyce to Italy to investigate the lost techniques of the Old Masters. Nor was the medium understood any better in France. When Delacroix received a commission to decorate a room in the Palais Bourbon, he understood so little of fresco painting that he went to a former Benedictine abbey in Normandy and conducted a series of experiments on its walls. The upshot of his investigations was a method very different from that practised by Michelangelo and Raphael, whose technique did away with the need for binders such as oils, glues or egg whites. Delacroix, in contrast, developed a procedure by which he suspended his pigments in melted wax before adding them to the dry masonry. Better suited than fresco to the damper, cooler French climate, this wax emulsion allowed him the luxury of revising and retouching his mural. Likewise, when Ingres worked on his mural *The Golden Age* at the Château de Dampierre in the 1840s, he mixed his pigments with oil—something his idol Raphael would never have done—before adding them to dried plaster.[11]

A proud and superlative craftsman, Meissonier no doubt looked forward to the numerous manual and technical stages of mural painting. Like any nineteenth-century muralist, however, he needed to experiment with techniques before going to work on his wall in Sainte-Geneviève. He also needed to bring together a team of painters to help him prepare designs and, when the time came, to assist him on the scaffold. Help was at hand, fortunately, as he conscripted into service both his son Charles and his pupil Lucien Gros. He then set about making the

first studies and drawings for *The Liberation of Paris*. The elaborate preparations must have been daunting even for the painter of *Friedland*, since murals required not only scores of compositional sketches but also cartoons—full-scale drawings that served as the templates from which the final design was transferred to the wall. Murals were always, therefore, a labour of years. Ingres had executed as many as 500 separate drawings for *The Golden Age*, which consumed six years of work. Delacroix had spent seven years on his murals in the church of Saint-Sulpice, while Baudry's thirty-three scenes for Garnier's new opera house were almost ten years in the making. Hundreds, even thousands, of hours of work would therefore be required before the first brushstroke of paint could be added to the wall of Sainte-Geneviève, the thirty-nine-foot-high canvas across which Meissonier believed he would inscribe his magnificent legacy.

At the end of December 1873, four days after the appointment of Chennevières as Director of Fine Arts, a group of artists banded together to launch a new artistic enterprise that would coincide almost exactly with the mural commissions for Sainte-Geneviève. Courbet's exclusion from the 1872 Salon and his subsequent exile from France, as well as their prolonged disenchantment with the Salon system in general, had finally determined Camille Pissarro and his "nucleus of painters" to test their fortunes elsewhere.

Despite the onset of the moral order, by the end of 1873 the signs looked favourable for at least a few members of the École des Batignolles. Édouard Manet sold paintings worth 22,000 francs in the months following his success at the 1873 Salon, while Claude Monet had earned 24,800 francs from sales of his paintings over the previous twelve months, double his income for 1872. These sales had been possible in part because in 1873 the French economy was in remarkably rude health considering the events of the previous three years. In September 1873 the Germans, who had been occupying sixteen *départements*, finally left the country. Showing remarkable resilience, the French had discharged the entire five-billion-franc indemnity in a little more than two years. These reparations had been paid so promptly thanks largely to the profits from a booming wine industry, since Louis Pasteur had discovered that pasteurising wine—briefly heating it to fifty-five degrees Celsius to kill off the microscopic organisms—made it last longer and travel better. The result was an increase in exports to countries such as Britain and America.

French art as well as French wine looked like it was beginning to travel well. Paul Durand-Ruel had published a catalogue of his collection and, in the first week of November, opened in his London gallery an exhibition of what one English newspaper called "the latest phases of Parisian fashion in art."[12]

Among them were canvases by Pissarro, Monet, Daubigny, Courbet and Whistler. The relative success of this exhibition was followed by the formation at the end of December of a cooperative venture called the *Société anonyme coopérative à capital variable des artistes, peintres, sculpteurs, graveurs et lithographes* ("Joint Stock Company of Artists, Painters, Sculptures, Engravers and Lithographers"). The company's charter, composed by Pissarro, was based on that of a baker's organisation in Pontoise, while the aim of the members, according to an article in *Le Chronique des arts*, was "the organisation of free exhibitions, without a jury or honorific awards; the sale of the works in question; and the publication, as soon as possible, of a newspaper devoted to the arts."[13] The society's first step would be the staging of an independent exhibition, or what quickly became known as the "Realist Salon." It was scheduled to open in April 1874, two weeks before the official Salon.

Besides Pissarro, members of this cooperative society included Monet, Renoir, Degas, Cézanne and Morisot. The membership did not, however, despite various overtures, include Manet. The success of *Le Bon Bock* had convinced him that he was on the verge of making his reputation in the official Salon. His letters at this time were even inscribed on notepaper headed with the jauntily optimistic slogan TOUT ARRIVE ("everything arrives"). An equally compelling reason for his refusal to join the Realist Salon was his low opinion of much of the work produced by its prospective exhibitors. Though he was fond of Renoir and even owned one of his works, he was not especially impressed by the younger man's paintings. He regarded him, a mutual friend later claimed, as "a decent sort of chap who had taken up painting by mistake."[14] Much worse, he believed, was Cézanne. Though Cézanne greatly admired Manet's work, the feeling was far from mutual. "I will never commit myself with Monsieur Cézanne," he stubbornly declared as plans for the Realist Salon progressed.[15]

Manet's disgust for Cézanne's paintings may have been partly fed by the younger man's uncouth appearance and charmless personality. But he seems genuinely to have been appalled by Cézanne's canvases, which, despite the debt they owed his own, were profoundly different in their inspiration. If Manet wished to represent his own visual impressions of the external world, whether of modern life or Old Master paintings, Cézanne at this stage of his career was obsessed with transferring onto canvas his own morbid and tormented inner world. As Castagnary wrote (disapprovingly) of Cézanne's work, the natural world was "merely a pretext for dreams" and for "subjective fantasies without any general echo in reason."[16] The result of these fantasies had been a series of disconcertingly macabre scenes, such as *The Strangled*

Woman. Painted in 1872, it showed a woman in a white dress being throttled by a figure of indeterminate sex whose face is a cruel and sinister mask. Cézanne had also created a number of unsettling images of violent and unrestrained sexuality, including *The Banquet of Nebuchadnezzar*, an orgiastic vision of indistinct nudes writhing together amid the remains of a feast.

Recently Cézanne appeared to have tamed his wilder visions by turning his hand to *plein-air* landscapes at Auvers-sur-Oise, the thatched village northeast of Paris to which he had moved, on the advice of Pissarro, in 1873. Nonetheless, Manet was convinced that throwing in his lot with such a pariah would be a grave mistake. Instead, he planned to submit four paintings, including *The Railway*, to the 1874 Salon. "I will never exhibit in the shack next door," he claimed, spurning the advances of Degas and ignoring the fact that he had exhibited outside the official Salon in 1863 and 1867. "I enter the Salon through the main door," he protested, "and fight alongside all the others."[17]

The venue for the Realist Salon was to be Nadar's former photographic studio in the Boulevard des Capucines, a short walk from both the Café Tortoni and the Galerie Martinet. Though he had abandoned it a year earlier, Nadar still owned the lease on the studio, which consisted of a magnificent set of top-floor rooms with cast-iron pillars, skylights and floor-to-ceiling windows. He generously lent the use of the rooms free of charge despite the fact that their annual rent, at 30,000 francs, had virtually bankrupted him. Inspired by the location, Degas tried to persuade the group to call itself La Capucine ("The Nasturtium"), even going so far as to design a stylised nasturtium, a plant with bright yellow or red flowers, as an emblem. The other members vetoed the idea, and in the end the works would go on show under the long and prosaic title—the *Société anonyme coopérative à capital variable*—that had appeared on the charter.

A catalogue for the exhibition was quickly prepared by Renoir's younger brother Edmond, a budding journalist, while Renoir himself oversaw the hanging of 165 paintings, pastels and engravings by thirty artists. Among them were ten works by Degas, including depictions of dancers and laundresses; nine by Monet; and five by Pissarro. Cézanne chose to show three works, among them a view of Auvers-sur-Oise entitled *The House of the Hanged Man* and a curious phantasmagoria of blazing colour and shimmering forms called *A Modern Olympia*. This latter canvas, a pastiche of Manet's *Olympia*, showed a black maid unveiling a nude woman who lies curled on a bed as a bearded man in a frock coat—possibly Cézanne's self-portrait—watches from a sofa, a black cat at his feet. Not a canvas destined to calm the worries of those members of the society, including even Degas and Monet, who had been entertaining doubts about the

wisdom of exhibiting alongside Cézanne, its appearance was secured only after much pleading by Pissarro.

The doors of Nadar's studio opened to the public, as planned, on April 15, with visitors paying one franc as an entrance fee (the same as for the Salon) and fifty centimes for the catalogue. Despite notices in as many as fifty newspapers, the Realist Salon did not attract anything like the same numbers that visited the Salon des Refusés in 1863. Yet opening day still saw 175 people ascend the stairs to the studio, and the show's four-week run averaged more than a hundred visitors per day, ultimately attracting 3,500 members of the public. Predictably, the exhibition was greeted by some with mockery and distaste. A number of critics compared the paintings unfavourably with those shown in the Salon des Refusés, which was, sneered the reviewer for *La Presse*, "a Louvre in comparison to the exhibition on the Boulevard des Capucines." Cézanne in particular was singled out for censure and derision. "Monsieur Cézanne," complained the reviewer for *L'Artiste*, "seems no more than a kind of madman, painting while suffering from *delirium tremens*." He was accused of attacking his canvases while under the influence of "oriental vapours"—that is, opium—and jokes circulated that he and many of his fellow painters accomplished their work by loading pistols with tubes of paint and discharging them at their canvases.

Nonetheless, even critics repelled by the paintings could appreciate the point of the exhibition itself. Despite declaring indignantly that "the debaucheries of this school are nauseating and revolting," the reviewer for *La Presse* still acknowledged that the Realist Salon represented "not just an alternative to the Salon, but a new road . . . for those who think art, in order to develop, needs more freedom than that granted by the administration." These exhibitors were, he proclaimed, "the pioneers of the painting of the future."[18]

These pioneers found themselves christened with a memorable name on April 25, following a satirical review by Louis Leroy in *Le Charivari*. While compiling the exhibition catalogue, Edmond Renoir had been exasperated by the somewhat monotonous titles, such as *Le Havre: Fishing Boat Leaving Port*, with which Monet labelled his canvases. Faced with yet another Le Havre seascape, a hazily indistinct sketch painted by Monet in the spring of 1872, he demanded a more alluring title, to which Monet replied: "Why don't you just put *Impression!*"[19] Renoir duly named the canvas *Impression: Sunrise*. This title amused and irritated Leroy, for whom, as for so many other critics and Salongoers, a picture was meant to be a story told in paint, not a fuzzy "impression" of the weather conditions. He therefore dubbed the painters in the Boulevard des Capucines with a pejorative nickname, entitling his article "Exhibition of

the Impressionists." The name was immediately seized on by other critics, including those sympathetic to the artists' cause. "If one must characterise them by a word that explains them," wrote Castagnary four days after Leroy's article, "we will have to invent the new term 'impressionists.' They are 'impressionists' insofar as they render not the landscape itself, but the sensation produced by the landscape."[20]

The "pioneers of the painting of the future" had just been baptised—and no one who entered Nadar's old studio in the spring of 1874 was in any doubt as to who was the godfather. The scathing review in *La Presse* had called the group "disciples of Monsieur Manet," and by June a journal entitled *Les Contemporains* featured on its cover a caricature of Manet wearing a crown and wielding a paintbrush as his sceptre. The caption read "Manet, King of the Impressionists."

Manet's decision to send his paintings to the Palais des Champs-Élysées instead of the Boulevard des Capucines had been based partly on the fact that each of his offerings since 1868 had been accepted for the Salon. He was exasperated and dismayed, therefore, when the 1874 jury turned down two of the four works that, under the terms of the new regulations, he was allowed to submit. His rejected paintings were a scene of modern life called *A Masked Ball at the Opera* and a landscape, *Swallows*, painted the previous summer during a family holiday at Berck-sur-Mer, near Boulogne. Added to the humiliation of rejection was the fact that, since both works had already been sold, they would be returned to their owners ignominiously imprinted with a red R.

Manet's two accepted paintings, *The Railway* and a watercolour of a Polichinelle, went on show when the 1874 Salon opened at the beginning of May. The success of *Le Bon Bock* proved a false dawn as *The Railway* attracted blanket coverage in the press, virtually all of it unfavourable. The enigmatic scene of Victorine Meurent sitting before a cast-iron railing—a much more difficult scene to interpret and appreciate than *Le Bon Bock*—was relentlessly lampooned in journals such as *La Vie parisienne* and *Le Journal amusant*. The satirists variously pretended to believe it depicted lunatics in an asylum, a mother and daughter confined in a prison, or a woman inexplicably clutching a baby seal.[21] The reviewers were equally unsparing. All the usual complaints were registered: the clumsy facture, the ignoble subject matter, the general unintelligibility. Even critics well disposed towards Manet struggled to appreciate *The Railway*. Zola, covering the Salon for *Le Sémaphore de Marseille*, passed over the work in silence, while Philippe Burty lamented Manet's incompetence at painting hands (not the first time someone had murmured about this perceived shortcoming) and Ernest Chesneau allowed that Manet's "summary

methods may look brutal at times." Still, Chesneau argued that this brutal style constituted a bold and honest attempt on the part of Manet to free his art from "technical conventions" and to "express modern life exactly as it is."[22]

The problem for Manet, as ever, was that the jurors, the critics and the public did not, on the whole, wish to see either expressions of modern life or violations of technical conventions. Their tastes were much better represented by the 1874 Salon's greatest attraction, Gérôme's *L'Éminence grise* ("The Grey Eminence"), which was awarded the Grand Medal of Honour and sold to an American collector for 60,000 francs. A highly wrought historical tableau of flowing robes and plumed hats, it depicted Cardinal Richelieu's influential and secretive confessor, a grey-frocked Capuchin priest named Tremblay, descending a palatial staircase, his nose obliviously in a breviary as a dozen obsequious courtiers bow before him in one long, cascading flurry. Accomplished with Gérôme's usual virtuoso brushwork, it perfectly answered the public's demands for a painting to tell a comprehensible story and to beguile them with its visual charms. *L'Éminence grise* therefore provided a bracing antidote for all those disturbed by either *The Railway* or the canvases in the Boulevard des Capucines. It also suggested just how far the "King of the Impressionists" was from deposing the reigning deities and prevailing tastes of the Salon.[23]

Manet's disappointments at the 1874 Salon led him to a kind of show of solidarity with his fellow outcasts, the Impressionists, and in particular with Claude Monet. Manet and Monet had come a long way since 1865, when the former had angrily refused to make the acquaintance of the latter. They got to know one another some time in the late 1860s, when Manet invited the younger painter to the Café Guerbois, "at which point," Monet later recalled, "we immediately became firm friends." Monet was to look back on these evenings in Manet's company at the Café Guerbois as vital to his artistic development. "Nothing could have been more interesting than our discussions," he claimed, "with their constant clashes of opinion. They kept our wits sharpened, encouraged us to press forward with our own experiments, and gave us the enthusiasm to work for weeks on end."[24] Manet had provided material as well as intellectual support, since in 1871 he had found Monet a house in Argenteuil when the latter returned from England.

Though he still had a studio in Paris, by 1874 Monet was firmly established at Argenteuil. He failed to sell any of the works exhibited in Nadar's studio— where *Impression: Sunrise* languished on the wall despite a modest price tag of 1,000 francs—but his paintings continued to find enough favour in the marketplace that he planned to move into a larger house. In the middle of June, he signed the lease on a newly built house, complete with a large garden, next

door to the one where he had lived for the previous eighteen months. The rent was a not inconsiderable 1,200 francs per month, but Monet was determined to enjoy the fruits of his labours. He hired a maid and a gardener, and he took to drinking fine wines from Bordeaux instead of the local vintage. Finally, he allowed himself one more luxury, a small rowboat in which he began plying the arms of the Seine in the wide stretch of the Argenteuil basin. Following the example of Daubigny, he took his canvas and paintbox on board for expeditions, dropping anchor at likely vantage points and painting scenes of regattas and riverbanks. This suburban idyll suited him so well that he was more productive than ever in the summer of 1874, completing forty canvases in the space of a few short months.[25]

Monet's happiness that summer was further boosted by the regular presence of a visitor from Paris. Manet had decided to forgo his traditional trip to the seaside in favour of remaining in the environs of Paris. Choosing to stay for a few weeks in the family home at Gennevilliers, he found himself back in the environment—in the vibrantly modern world of bathers, boaters and casual pleasure-seekers—that a dozen years earlier had inspired *Le Déjeuner sur l'herbe*. On this occasion, though, his style of painting had changed. He may not have esteemed the efforts of Cézanne and Renoir, but Monet was a different matter. Seven years earlier Manet had disdained *The Garden of the Princess*, one of Monet's *plein-air* cityscapes, when he saw it in a dealer's window. At that time he believed paintings of *la vie moderne* were best realised in a studio, not under the open skies. Slowly, however, he had come to accept—largely on the evidence of Monet's canvases—that the fashionable and fugitive world of what Baudelaire called "modernity" could be captured *in situ*. He had painted *en plein air* on previous occasions, most notably during his seaside vacations. But he seems to have come to the Argenteuil basin in the summer of 1874 with the express aim of abandoning what he would call the "false shadows" of the studio in favour of joining Monet in the "true light" of the outdoors.[26]

For the first time in his career, Manet tried to catch the effects of natural light. He carried his canvases to the same riverbank that Monet had been painting so prolifically and, following Monet's lead, replaced the sombre colours and sharp contrasts of so many of his earlier canvases with a lighter palette of blues, yellows and ochres, which he added to his canvas in strokes of pure, unmixed colour. He even painted, as a kind of tribute, *Claude Monet and his Wife on his Floating Studio*, a portrait of his friend at work, his easel propped on the gunwale and Camille inside the boat's makeshift cabin.

Nautical pursuits along this reach of the Seine had become fashionable in the

previous two decades, and anyone hoping to witness the picturesque amuse-
ments of modern Parisians could do no better than to visit—as Manet made
sure to do that summer—the Cercle de la Voile, or Sailing Club, at Argen-
teuil.[27] Besides the portrait of Monet in the boat, he painted four further
scenes of sailors and boaters at Argenteuil. In one of these canvases, simply
entitled *Boating*, Manet posed his brother-in-law Rudolphe Leenhoff, then
thirty-one, in the stern of a skiff, a young woman in a blue dress beside him.
Another canvas, *Argenteuil*, showed Rudolphe and another young woman
seated on a bench beside the marina, the luminous blues of the river frac-
tured by the white of the sails in the middle distance. The stiff postures and
blank expressions of these two figures, as well as the whiff of moral delin-
quency, recalled numerous of Manet's earlier paintings, but they also indi-
cated the enduring appeal for him, even outdoors, of the human form. This
fascination would make his work distinct from that of Monet, whose only
real pictorial concern was the incidental effect on a landscape of the weather,
the hour or the season. The lighter tones and saturated colours of both *Boat-
ing* and *Argenteuil* show how Manet had left the studio and stepped res-
olutely into the sunshine.

Manet also painted one other canvas that summer at Argenteuil. Visiting
Monet's house in the Boulevard Saint-Denis one afternoon, he began paint-
ing *The Monet Family in their Garden at Argenteuil*. The work portrayed
Camille and Jean, then seven years old, seated on the grass amid the sprawl
of her white dress; nearby a blue-smocked Monet stooped over one of the
borders in his beloved garden, a watering can at his feet. Monet ceased gar-
dening at some point that afternoon and then he, too, started painting. Turn-
ing his attention to his guest, he began working on *Manet Painting in Monet's
Garden*, showing Manet seated before his easel in a long coat and a wide-
brimmed hat. Hardly had he begun painting than Renoir arrived at the house
and, finding the two men so engaged, borrowed paints and a canvas from
Monet and started his own work, *Madame Monet and her Son*, with Camille
and Jean reclining on the lawn as in Manet's canvas. The day ended with
Manet and Renoir making gifts of their paintings to Monet.

The pioneers of the painting of the future: three men working outdoors in
a suburban garden, their canvases catching reflections from one another like
rays of the sun.

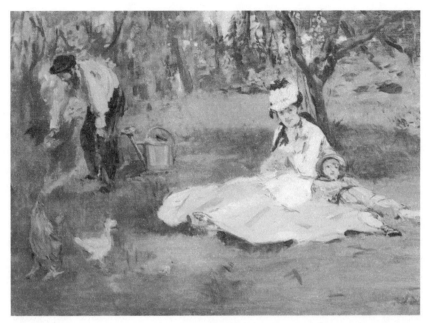

The Monet Family in Their Garden at Argenteuil *(Édouard Manet)*

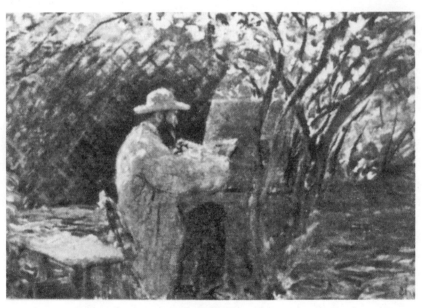

Manet Painting in Monet's Garden *(Claude Monet)*

Epilogue: Finishing Touches

THE *SOCIÉTÉ ANONYME coopérative à capital variable des artistes, peintres, sculpteurs, graveurs et lithographes* was dissolved in December 1874, after its members failed to sell many paintings from their exhibition or make much in the way of profit from their enterprise. However, in 1876 many of the same painters regrouped for a second show, this time at Durand-Ruel's Paris gallery, under the prosaic banner "Exhibition Made by a Group of Artists." Fewer visitors attended than in 1874 and the reviews—particularly one by Albert Wolff that denounced the painters as "a group of unfortunate creatures stricken with the mania of ambition"[1]—were even worse. Nonetheless, the art critic for *The New York Tribune*, Henry James, wrote that this exhibition by the "Irreconcilables" (as he christened them) was "decidedly interesting."[2]

The following year, in April, a third show was held in a vacant apartment on the third floor of a building in the Rue Le Peletier. On this occasion a dwindling number of participants—only eighteen braved the exhibition—finally took ownership of Louis Leroy's term of abuse, calling themselves Impressionists and even publishing a short-lived journal called *L'Impressioniste* to defend their efforts against their critics. The results were much the same as on the two previous occasions.

Five more such exhibitions would follow. By the time of the eighth and last Paris show, in 1886, Durand-Ruel had mounted successful retrospectives of paintings by "the Impressionists of Paris" in both London (in 1882 and 1883) and New York (1886). The exhibition in New York was staged at the American Art Galleries and continued due to popular demand at the National Academy

of Design. Organised under the auspices of the American Art Association, it featured 289 works of art and proved particularly gratifying in terms of both sales and reviews. According to *The New York Tribune*, American collectors of Meissonier, Cabanel and Gérôme, hoping to protect the value of their investments, had tried to queer the pitch for the Impressionists by denouncing them in the press as "utterly and absolutely worthless."[3] The tactic ultimately failed as the American public remained unmoved by the prevailing tastes and long-standing prejudices in France. "Do not believe the Americans are savages," Durand-Ruel wrote to Fantin-Latour in 1886. "On the contrary, they are less ignorant, less bound by routine than our French collectors."[4] Unencumbered by the dogma of conservative institutions such as the École des Beaux-Arts, the Americans happily embraced what the French had been reviling for two decades as scandalous profanations of art. Paintings of modern life—ballet dancers, Parisian street scenes, and the sunlit, willow-draped riverbanks at Pontoise or Argenteuil—endeared themselves to a new generation of American collectors and museum-goers much more than did moralistic interpretations of Greek myths, Roman history, or indeed Napoleonic battle scenes.

In the decade following Durand-Ruel's New York exhibition, increasingly more American money was invested in Impressionist paintings. One of the primary American collectors was Louisine Havemeyer, a friend of the American Impressionist painter Mary Cassatt and the wife of Henry O. Havemeyer, owner of the American Sugar-Refining Company. By the 1890s she had begun buying works by Monet, Pissarro, Degas and Cézanne, ultimately putting together an unsurpassed collection of more than a hundred Impressionist paintings to adorn her Tiffany-encrusted, Romanesque-style mansion on the corner of Fifth Avenue and East Sixty-sixth Street in Manhattan. American painters had also taken note of the work of the Impressionists. Numerous American artists had trained in Paris in the second half of the nineteenth century, and in 1887 a journal reported that an "American colony" had gathered at Giverny, the village on the Seine to which Claude Monet had moved in 1883: their pictures, noted the correspondent, revealed "that they have got the blue-green colour of Monet's Impressionism and 'got it bad.' "[5] One of these painters, Theodore Earl Butler, married Monet's stepdaughter Suzanne at Giverny in 1892—an event charmingly commemorated by one of the great examples of American Impressionism, Theodore Robinson's *The Wedding March*. By the first years of the twentieth century the style had taken such a firm root in American soil that many local varieties—Connecticut Impressionism, California Impressionism, Pennsylvania Impressionism—had been produced. As

Germain Bazin, Chief Conservator of the Louvre during the 1950s, was later to write, exaggerating only slightly: "The Impressionists entered America without resistance."[6]

Seventeen canvases by Édouard Manet were included in Durand-Ruel's watershed exhibition in New York in 1886. However, Manet cannot properly be called an Impressionist, not only because he refused to take part in any of the Impressionist exhibitions in Paris but also because of his different stylistic preoccupations, such as his fondness for the Old Masters and for rendering the human form rather than (his Argenteuil canvases notwithstanding) the effects of open-air light. Throughout the 1870s he had remained determined to show his work at the Palais des Champs-Élysées rather than in "the shack next door." As in the 1860s, neither the jurors nor many of the critics treated him kindly. Unveiling his sun-drenched new style at the 1875 Salon, he received appalling reviews for *Argenteuil*, while in the following year—the tenth anniversary of the Jury of Assassins—history repeated itself as both of his canvases were spurned by the jury. Not until the Salon of 1881 did he enjoy any real success, when he was awarded a Salon medal, albeit only a second-class one, for *Portrait of Henri Rochefort*.* The Grand Medal of Honour was claimed that year by Paul Baudry. At the close of that year, thanks to his friend Antonin Proust, who had become Minister of Fine Arts in a government formed by Léon Gambetta, he received the Legion of Honour. Much to Manet's disgust, a letter of congratulations arrived from Italy, from his old adversary the Comte de Nieuwerkerke, who had retired to a villa near Lucca. "Tell him I appreciate his good wishes," Manet wrote to a mutual friend, Ernest Chesneau, "but that he could have been the one to decorate me. He would have made my fortune and now it's too late to compensate for twenty lost years."[7]

In 1882 Manet exhibited the remarkable *A Bar at the Folies-Bergère*, one of the finest works in his entire *oeuvre*, but found himself disillusioned, as ever, with the bewildered public reaction. It was to be his final Salon. He was seriously ill by this time, having finished the painting despite suffering pains and problems with his physical coordination caused by a syphilitic infection contracted many years earlier. In April 1883, his gangrenous left leg was ampu-

*Rochefort had returned to France, after an amnesty, in 1880. Six years earlier he had escaped from his captivity on New Caledonia by boarding a boat bound for San Francisco—an episode portrayed by Manet in *The Escape of Henri Rochefort* (1881). Before returning to Paris he lived for a number of years in London and Geneva.

tated below the knee. He died less than a fortnight later, on April 30, at the age of fifty-one, almost twenty years to the day after *Le Déjeuner sur l'herbe* was first revealed at the Salon des Refusés. He was buried at the Cimetière de Passy, with Émile Zola and Claude Monet among the pallbearers. Edgar Degas, walking behind the coffin, expressed sentiments that much of the rest of France needed some time to appreciate: "He was greater than we thought."[8]

Manet was indeed greater than many people thought—greater, in particular, than the critics and the Fine Arts administrators of the 1860s and 1870s had dared to consider. As early as eight months after his death a retrospective exhibition of his work was mounted at, of all places, the École des Beaux-Arts—the institution in which, twenty years earlier, Gérôme had tried to ban all mention of his name. This "Exposition Manet" was treated to the sort of favourable reviews that the painter had so often been denied during his lifetime. Then, in February 1884, a large selection of his work, including ninety oil paintings, went to auction. A respectable if unspectacular 116,000 francs was raised. *A Bar at the Folies-Bergère* was one of the pricier lots, going to a friend, the composer Emmanuel Chabrier, for 5,850 francs. But the most expensive—to the guffawing of many spectators at the auction—proved to be *Olympia*, which was purchased by Manet's brother-in-law Ferdinand Leenhoff for 10,000 francs.[9]

The fortunes of *Le Déjeuner sur l'herbe* and *Olympia* served as barometers for Manet's reputation in the decades after his death. The latter canvas, easily the most notorious painting of the nineteenth century, became, surprisingly, the first of his works to enter the Louvre, albeit not without the usual controversy. The painting's museological beatification occurred only thanks to the untiring efforts of Claude Monet. In a feat of almost unexampled selflessness in an artist, Monet spent the entire year 1889 organising a public subscription to purchase the canvas from Manet's family for installation in the Louvre. Nearly 20,000 francs was raised from subscribers who included Degas, Pissarro, Renoir, Fantin-Latour, Antonin Proust and Philippe Burty. However, the work was sent by the government not to the Louvre but to the Musée du Luxembourg—the "Museum of Living Artists." Here it was joined in 1897 by two more of Manet's works, including *The Balcony*, which had been bequeathed to the nation by the Impressionist painter, patron and collector Gustave Caillebotte. However, two more of Manet's works from Caillebotte's collection, *Croquet at Boulogne* and a small sketch of racehorses, were refused by the Luxembourg, whose curator, Léonce Bénédite, would later publish a biography of Meissonier. From the same bequest Bénédite turned down some thirty paintings by Monet, Pissarro, Renoir, Degas and Sisley.[10] *Olympia* was

consecrated by the French artistic establishment only in 1907, when it entered the Louvre on orders of Georges Clemenceau, at the time the President of the Council of Ministers as well as a long-standing friend of Monet (and the subject of an 1880 Manet portrait). The work was afforded the honour of hanging on the wall beside Ingres's *Grand Odalisque*, another work that had once been savaged by the critics.

Coincidentally, also in 1907 Pablo Picasso, then twenty-six, painted *Les Demoiselles d'Avignon*, his first Cubist painting, which featured a stunning new approach to representing the nude female form. Two years earlier, a number of other young artists, including Henri Matisse and Maurice de Vlaminck, outraged the French public with works whose flat compositions and splodges of vivid, clashing colour—a shocking style that won them the pejorative nickname *les Fauves* ("the Wild Beasts")—recalled the Wild Boar of the Batignolles. And *Olympia* entered the Louvre two years before Filippo Martinetti published his "Futurist Manifesto" in *Le Figaro*, praising "courage, audacity and revolt," and asserting—in art history's ultimate tribute to modern life—that a speeding motorcar was more beautiful than the *Winged Victory of Samothrace*.[11]

A generation after his death, Manet had left behind a vibrant cultural legacy, not simply through scandalising the public—an option that artists of the past century have found all too expedient—but by recasting artistic tradition in his own idiosyncratic vision in order to forge entirely new forms. Within this context, Charles Oulmont, a professor at the Sorbonne, was able to declare, as early as 1912, that *Olympia* "marks a momentous date in the history of nineteenth-century painting and art generally."[12] Or as a more recent art historian, Professor T. J. Clark, has written, *Olympia* is "the founding monument of modern art."[13]

Le Déjeuner sur l'herbe, meanwhile, has staked its own claim as a foundation of modern art. Few serious artists have managed to escape its spell. It inspired Claude Monet's own *Le Déjeuner sur l'herbe* as well as Cézanne's numerous paintings of male and female nudes bathing in streams and lounging on riverbanks. Most transfixed of all, though, was Picasso, who was born just eighteen months before Manet died. *Le Déjeuner sur l'herbe* inspired him more than any other painting. "One can see the intelligence in each of Manet's brushstrokes," he once wrote to a friend.[14] Ultimately Picasso would produce some 200 versions of the work: 150 drawings, twenty-seven oil paintings, and even a number of cardboard models from which thirteen-foot-high statues were created from sand-blasted concrete and sent to adorn the sculpture garden of the Moderna Museet in Stockholm. He was attempting to dissect this most enigmatic of paintings, probing at it from every angle with his pencil and brush, repeatedly

taking it apart and putting it back together in a struggle to divine the secrets of its power and mystique.[15]

Picasso had first seen *Le Déjeuner sur l'herbe* in 1900, when it was shown at the Universal Exposition in Paris, in a room in the Grand Palais that the Fine Arts administration grudgingly dedicated to Impressionism. The seventy-six-year-old Gérôme had tried to prevent Émile Loubet, the French president, from entering the room by exclaiming: "Stop, sir, for in there France is dishonoured!"[16] Thirty-seven years after its appearance at the Salon des Refusés, paintings by the members of the École des Batignolles still had the power to provoke and offend.

Le Déjeuner sur l'herbe had a much longer wait than *Olympia* for its consecration. It had first been bought in 1878, for 3,000 francs, by Jean-Baptiste Faure, the singer who had acquired *Le Bon Bock* five years earlier for double that price. Two decades later it was purchased for 55,000 francs by the collector and art historian Étienne Moreau-Nélaton, who willed the work to the French nation in 1906. The canvas was deposited not in the Louvre proper but rather—in a bizarre act that revealed lingering official hostilities—in a room in the Louvre then occupied by the Ministry of Finance. Not until 1934 did the officials of the Louvre see fit to place *Le Déjeuner sur l'herbe* in the part of the building concerned with the fine arts rather than fiscal policy. Both works were subsequently moved, in 1947, to what became known as the "Impressionist Museum," the Musée du Jeu de Paume, situated in the north-west corner of the Jardin des Tuileries, in a building Napoleon III had constructed to house tennis courts. This new museum was, as the Louvre's Chief Conservator declared, a "triumphant temple" to a style of art that by then had gained a worldwide popularity.[17] In that year an admiring American art historian, Robert Goldwater, declared of *Le Déjeuner sur l'herbe*: "No other painter of the century managed to get so much into a canvas."[18]

In 1986 the two paintings were again moved, this time to another newly founded "Impressionist Museum," the Musée d'Orsay. By this time, dozens of Manet paintings had found their way into museums all over the world, from Russia and Poland to Australia and Japan, and into every corner of America. Most spectacular, perhaps, had been the entry of ten of his canvases into the Metropolitan Museum of Art in New York in 1929, as part of the bequest of Louisine Havemeyer. Prices for Manet's paintings have risen in accordance with his collection in museums. As early as the 1920s examples of his work were selling for more than 400,000 francs; by the 1950s a number of his canvases had exceeded a million francs; and by the 1970s they had sur-

passed a million U.S. dollars. In 1983 a work painted in the early 1880s, *La Promenade*, showing a woman strolling in a park, sold for $3.6 million; six years later it fetched $14,850,000. More recently, in May 2004, Sotheby's in New York sold *The Races in the Bois de Boulogne*—the canvas for which Barret paid 3,000 francs in 1872—for just over $26 million. But the record price for a Manet painting is still the $26.4 million paid in 1989 by the J. Paul Getty Museum in Los Angeles for *The Rue Mosnier with Flags*, a street scene that Manet painted in 1878 from the window of his studio in the Rue de Saint-Pétersbourg. Anyone managing to locate one of Manet's lost paintings, especially *Croquet at Boulogne*—a far more exemplary work once described by a connoisseur as a "delicious painting"[19]—could reasonably expect to receive a good deal more.

Manet's vital statistics have been equally healthy on the turnstiles of the world's museums. Three major shows featuring his work were mounted in the year 2003 alone. *Manet at the Prado*, in Madrid, averaged almost 6,000 visitors per day, or more than 439,000 altogether, making it the second most successful exhibition ever staged at the museum. *Manet/Velázquez*, at the Metropolitan Museum of Art in New York, drew more than 553,000 viewers following an equally impressive outing at the Musée d'Orsay. Finally, an exhibition dedicated to his maritime painting, *Manet and the Sea*, opened at the Art Institute of Chicago before travelling to the Philadelphia Museum of Art. In 2004 it moved to the Van Gogh Museum in Amsterdam, where, in the country of Suzanne Manet's birth, it proved the most successful exhibition of the year. A poll conducted by BBC Radio 4 in the summer of 2005 testified to the widespread appeal of Manet's work, with *A Bar at the Folies-Bergère* (in London's Courtauld Institute of Art) attracting the third-highest tally of votes for the public's favourite painting in a British museum. Only works by twin titans of British art, Constable and Turner, finished higher.

"Time gives every human being his true value," Ernest Meissonier once wrote. "The real worth of a man cannot be gauged until he is dead, until the clamour of friendship dies down over his ashes, until the farewell speeches, official or kindly, have been delivered. Then the edifice either crumbles away, or endures in glory, flooded with light and fame."[20]

Few artists can have brooded over their posthumous reputation as much as Meissonier. After dominating his own era so completely, nothing remained for him but the conquest of future generations. His obsession with mural painting was a symptom of his anxieties about this rendezvous with posterity. In the end, though, despite his grand designs, he would not spread a single brush of paint on his wall in the Panthéon. A man who took an entire decade to paint a

few square yards of canvas was never going to be a good bet to finish a colossal mural, plans for which did indeed prove—as the sceptics had predicted—an "absurd fantasy." This failure nonetheless did little to undermine his cosmic pre-eminence. In 1878 he showed sixteen paintings at the third Universal Exposition held in Paris, and for the third time he was given the Grand Medal of Honour—an award that simply reconfirmed his stature as Europe's most celebrated painter. Then in 1889 he became the first artist ever to receive the Grand Cross, the highest order of the Legion of Honour.

Two years after its unveiling in Vienna, Meissonier had finally completed *Friedland* more or less to his own satisfaction, signing "EMeissonier 1875" in black paint in the lower left-hand corner. He was suitably compensated for the snub by Sir Richard Wallace when, in 1876, another buyer was found: Alexander T. Stewart, an Irish-born American dry-goods millionaire known as "The Merchant Prince." The single largest taxpayer in America, Stewart paid 380,000 francs for *Friedland*, almost double the price originally offered by the Marquess of Hertford. The work was shipped to America early in 1876—though not before Meissonier, on the eve of its departure, scraped down and then repainted the central group of horsemen. Once in New York, *Friedland* became one of the grandest trophies of the Gilded Age, adorning the sky-lit picture gallery in Stewart's $1.5 million mansion on West Thirty-fourth Street. Henry James would exult in *The New York Tribune* that Stewart had claimed one of "the highest prizes in the game of civilization."[21]

Stewart did not enjoy his prize for long. He died in April 1876, only a few weeks after taking delivery of *Friedland*. The work remained in Stewart's mansion (which occupied the site where the Empire State Building would eventually be built) until it was sold at auction in New York in 1887. Judge Henry Hilton, the executor of Stewart's estate, purchased it for $69,000—the equivalent of more than 300,000 francs—and immediately donated it to the Metropolitan Museum of Art. More than a century later, *Friedland* is still in the museum, where it hangs in a corridor beside another great equestrian canvas, Rosa Bonheur's *The Horse Fair*. Visitors to the Metropolitan Museum can admire it immediately before passing into the "Manet Room" (featuring nine of Manet's canvases) only a few yards away. The "two opposite poles of art" have been brought together within steps of one another.

Stewart and Hilton were not the only American tycoons with a taste for Meissonier. William H. Vanderbilt, the shipping and railway magnate, would purchase seven of his paintings and also sit for a portrait; all were shipped to New York to grace his block-long Greek Renaissance townhouse, "The Triple

Palace," on Fifth Avenue. The most exalted estimate of Meissonier's worth was offered, though, by a Frenchman. In 1890, the year before Meissonier's death, Alfred Chauchard, owner of the Grands Magasins du Louvre, an enormous department store in the Rue de Rivoli, paid a staggering 850,000 francs when *The Campaign of France*, formerly owned by Gaston Delahante, came onto the market. To get some perspective, the entire annual budget for the Paris Opéra was 800,000 francs, a sum sufficient to maintain an eighty-piece orchestra along with seventy ballet dancers and sixty choristers.[22] This stratospheric price made *The Campaign of France* the most expensive painting ever purchased during the nineteenth century, by a painter either living or dead. Almost two decades after the Universal Exhibition in Vienna, Meissonier's signature had still been worth that of the Bank of France.

Meissonier died at his Paris mansion in the Boulevard Malesherbes on January 31, 1891, a few weeks shy of his seventy-sixth birthday. He was survived by his children and by Elisa Bezanson, whom he had married two years earlier, following Emma's death in 1888. After a Requiem Mass at the church of the Madeleine, his body was taken for burial to the cemetery of La Tournelle in Poissy. The following year Henri Delaborde, a distinguished art historian, delivered Meissonier's eulogy at the annual meeting of the Académie des Beaux-Arts. "Meissonier's life flowed on for half a century," claimed Delaborde, "in the splendour of a glory without eclipse, in the confident possession of success of every kind, and homage in every form . . . Everything was exceptional in that brilliant career, from the constant chorus of admiration which acclaimed it, to the universal emotion with which the news of its close has been greeted, both in France and abroad."[23]

 Meissonier had the good fortune to die while his reputation was still intact and unsurpassed. But within a decade or two, his reputation—and his prices—had collapsed. "Many people who had great reputations," he once gravely observed, "are nothing but burst balloons now"[24]—and he himself provides the most cautionary and startling example. By 1926 the art historian André Michel, a professor at the Collège de France, was able to write: "The case of Meissonier is one that gives us pause to reflect about the variations of taste and the vicissitudes of glory. No painter was more adulated during his lifetime . . . His reputation was global. But what remains today of all this magnificence?"[25] Two decades later, Lionello Venturi's two-volume history of nineteenth-century French art, *Modern Painters*, made no mention of him whatsoever: Meissonier had vanished from the history of French art like a murdered enemy of Stalin airbrushed from an official Soviet photograph.

When not expurgated from the history of French art, Meissonier has been cast as one of its villains, an evil genius who, among his various sins, frustrated the career of Édouard Manet—the man praised by Michel as someone "who played the role of the heroic annunciator, the initiator of a new art."[26] Meissonier's place has thus become an invidious one, that of the counterpole to more progressive artistic movements of the second half of the nineteenth century. Forty years after Michel, a French writer named Jean-Paul Crespelle, author of numerous popular guides to Impressionism, even managed to make Meissonier an opponent of Delacroix, who was in fact one of his best friends and supporters.[27] But loathing of Meissonier has known few boundaries, including that of historical accuracy. As Jacques Thuiller, a modern-day professor at the Collège de France, wrote in 1993: "Rare is the artist on whom more prejudice—and even hatred—has accumulated than Meissonier. Not long ago the mere act of looking at one of his works was considered worthy of excommunication."[28] Meissonier was even despised by a staunch aesthetic conservative like John Canaday, the chief art critic for the *New York Times* during the 1960s and a bitter opponent of the Abstract Expressionists and other exponents of modernism. Canaday confessed himself enraged at the thought that "while this mean-spirited, cantankerous and vindictive little man was adulated, great painters were without money for paints and brushes."[29] In 1983 a French connoisseur was even heard advocating the incineration of Meissonier's canvases.[30]

In two generations, Meissonier went from the most revered painter in Europe—and one of the world's most famous Frenchmen—to an artist who caused such embarrassment to the French establishment that in 1964 a marble statue of him unveiled four years after his death was unceremoniously removed from the Louvre on orders from André Malraux, Charles de Gaulle's Minister of State for Cultural Affairs. Even more demeaning was the fate of another statue of Meissonier, cast by Emmanuel Frémiet in 1894 and unveiled near the church in Poissy: it was melted down for scrap.

Thuiller has claimed that Meissonier's excesses—his enormous wealth as well as the excruciating conscientiousness of his paintings—became "a target for the new generations." The art critic Gustave Coquiot, who was born in 1865, the year of *Olympia*, summed up the opinion of many younger artists appalled by the extravagant prices paid for Meissonier's works by men such as Stewart, Vanderbilt and Chauchard. Author of books on Van Gogh and Toulouse-Lautrec, and a man who once posed for the young Pablo Picasso, Coquiot claimed that Meissonier was "the representative choice of the limitless stupidity of the bourgeoisie and the *nouveaux riches*. . . . He possessed in

exact proportions the ignominies of his time; and he threw into the face of the *nouveaux riches* of two hemispheres his low smears, a puerile and silly tedium that they found so agreeable. Thus we have Meissonier, a bad painter for businessmen and vulgar upstarts! Yes, all of that, and nothing more."[31]

Coquiot's hateful shrieks ring a little false when set against the *nouveau riche* adulation of the Impressionists: in 1912 Louisine Havemeyer purchased Degas's *Dancers Practising at the Barre* for 435,000 francs, or a little more than $95,000, which made it 55,000 francs more expensive than *Friedland*. The difference between Meissonier and Manet was actually over artistic aims and techniques, not side issues such as fat bank balances and great painters (in Canaday's melodramatic scenario) "without money for paints and brushes." The decade between 1863 and 1874—the years between the Salon des Refusés and the First Impressionist Exhibition—had witnessed a struggle between the votaries of the past and those of *la vie moderne*. This struggle concerned rival ways of painting as well as, ultimately, rival ways of seeing the world, and it would result in the greatest revolution in the visual arts since the Italian Renaissance. The contest was shot through with amusing ironies as well as questions about our most confident value judgments. It is superbly ironic, in the first place, that at a time when a group of artists began experimenting with new methods of capturing their "sensations" of objects through slurred colours and summary brushwork, the most celebrated painter in France should have been constructing his own railway track for the purposes of understanding with micrometric accuracy the precise motions of a galloping horse's legs— and then attempting faithfully to convey this movement on his canvas with one of the steadiest and most deliberating paintbrushes in the history of art. That the cultural gatekeepers condemned the first procedure as roundly as they celebrated the second seems perversely unthinkable from a point of view—the one that has prevailed for the past century—that takes for granted that what one sees is not as important in the visual arts as how one sees or expresses it.

To these gatekeepers, however, our reversal of their aesthetic judgments, and the collapse of Meissonier's reputation at the expense of those of Manet and the Impressionists, would have been equally unthinkable. Meissonier is far from alone, though, in suffering a posthumous reputation that cruelly gainsays his contemporary acclaim. Numerous other artists and writers have paid for the applause of their lifetimes with silence and obscurity after their deaths. Removing the idols of the previous generation from their pedestals has long been a favourite pastime of cultural historians—though rarely does it happen quite as literally as in the case of the two statues of Meissonier. The French offer a striking literary parallel to Meissonier in Anatole France, their most popular

writer in the two or three decades before his death in 1924, yet someone now devoid of an influence or a following.[32] Such harsh re-evaluations provide a matter for sober reflection not only for today's cultural icons but to all those who realise that posterity will always have the last word.

There is perhaps a final irony in Manet's and Meissonier's careers. Before we mock the seemingly inexplicable appeal for nineteenth-century Salon-goers of Meissonier's *bonshommes* in their quaint costumes, it is worth considering whether some of the more recent admiration for Impressionist portrayals of "modern life" may be steeped in something of the same yearning for a bygone time. Meissonier's spurred and booted cavaliers being served drinks outside a country tavern spoke to nineteenth-century Parisians in the same language of gentle nostalgia that Monet's parasol-clutching woman wading through a field of poppies, or Manet's barmaid under a chandelier at the Folies-Bergère, speak to many museum-goers today. The painters of modern life created, in the end, the same consoling visions of the past.

More than a century after their deaths, Manet "endures in glory, flooded with light and fame" while Meissonier gathers dust in museum storerooms. Yet for all his self-regard and swollen sense of artistic destiny, Meissonier may well have been resigned to his obscure and dismal place in history. "Life," he once sighed. "How little it really comes to."[33] One of the few places that still commemorate him is, suitably enough, Poissy. Here, in what is now an industrial town where automobiles have been manufactured since 1902, Meissonier's well-tended grave, planted in summer with cyclamen, can be found in the cemetery of La Tournelle. The gravestone features a bas-relief bronze portrait and an inscription that proudly announces him as the winner of the Grand Medal of Honour in 1855, 1867 and 1878. A short distance away, a quarter-mile-long stretch of road has been christened the Avenue Meissonier. To its west, in the grounds of the former abbey, thirty acres of wooded slopes and gravel paths have been known since 1952 as the Parc Meissonier. Frémiet's bronze statue of Meissonier may have been knocked from its pedestal and melted down for scrap, but in the park the painter's image endures in the form of the enormous marble statue that Malraux banished from the Louvre. Brought to Poissy in 1980 and placed in the middle of a flower bed, it shows the artist sitting cross-legged in one of his antique armchairs, his left hand holding his palette and his right supporting his head.

Carved in 1895 by Antonin Mercié, this statue is curiously revealing. The base of the pedestal, inscribed "MEISSONIER 1815–1891," features a disconcerting paraphernalia: an empty breastplate, a fallen standard, and a wreath of laurels that seems to have tumbled from the artist's head and landed on the ground.

From his armchair, Meissonier himself gazes glumly at a modern world that rushes heedlessly past his stern marble glare. The monument is, more than anything else, an image of acquiescence and defeat, of an artist grimly accepting his unhappy encounter with posterity.

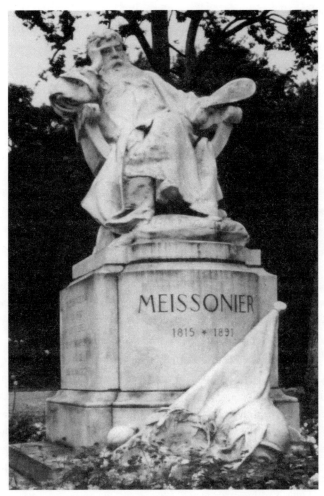

Statue of Ernest Meissonier in Poissy

POLITICAL TIMELINE

1804 (December) Napoleon Bonaparte is crowned Emperor of the French, assuming the dynastic title Napoleon I.

1805 (October) Napoleon is defeated by Britain's Royal Navy at the Battle of Trafalgar.

1806 (October) Napoleon's Grande Armée defeats the Prussians at the Battle of Jena.

1807 (June) The French defeat the Russians at the Battle of Friedland in East Prussia.

1808 (December) Napoleon invades Spain.

1809 (July) Napoleon defeats the Austrians at the Battle of Wagram, near Vienna.

1812 (June) Napoleon begins his invasion of Russia.
 (September) Napoleon enters Moscow after defeating the Russians at the Battle of Borodino; soon afterwards the Grande Armée begins its long retreat.

1813 (October) The French are defeated by Coalition forces at the Battle of Nations near Leipzig.

1814 (April) Napoleon abdicates following the invasion of France by Coalition forces that now consist of the British, the Russians, the Spanish, the Portuguese and the Prussians. He is exiled to Elba and the Bourbon monarchy is restored under Louis XVIII, the younger brother of the guillotined Louis XVI.

1815 (March) Beginning of the Hundred Days as Napoleon, escaping from Elba, returns to France. Louis XVIII flees to Ghent.

(June) Defeat of Napoleon at Waterloo.

(October) Napoleon exiled to Saint-Helena.

1821 (May) Death of Napoleon on Saint-Helena.

1824 (September) Death of King Louis XVIII. He is succeeded by his brother the Comte d'Artois, who reigns as King Charles X.

1830 (July) The "July Monarchy" is born as Charles X is deposed when artisans and workers take to the barricades in Paris. The Duc d'Orléans (descended from a younger brother of Louis XVI) is invited to take the throne as King Louis-Philippe.

1834 (April) Massacre in the Rue Transnonain in Paris as government forces ruthlessly suppress working-class insurrection.

1836 (October) Louis-Napoleon Bonaparte, nephew of Napoleon, makes an unsuccessful coup attempt against King Louis-Philippe.

1840 (August) Louis-Napoleon stages a second unsuccessful attempt to overthrow Louis-Philippe. Captured at Boulogne-sur-Mer and sentenced to life in prison, he will escape to England in 1846.

1848 (February) Riots and revolution in Paris (partly due to bad harvests) are followed by the abdication of King Louis-Philippe and the proclamation of the Second Republic at the Hôtel de Ville, with the poet Alphonse de Lamartine at its head.

(June) Further riots, with barricades in the east and centre of Paris. Some 1,500 of the insurgents are killed and 12,000 placed under arrest during what become known as the "June Days."

(December) Louis-Napoleon Bonaparte, returning from exile in London, is elected to a four-year term as President of the Second Republic, with a majority of four million votes.

1850 (August) Death in England of the deposed King Louis-Philippe.

1851 (December) Backed by the army, Louis-Napoleon seizes personal control of the government in a coup d'état.

1852 (January) Louis-Napoleon promulgates a new constitution which confirms him in office for a period of ten years and gives him executive powers to command the armed forces, declare war and make laws.

(March) Decree banning gatherings of more than twenty persons.

(December) Exactly one year after his coup d'état, Louis-Napoleon proclaims himself Emperor of the French, reigning under the dynastic title Napoleon III. The Second Empire is declared.

1854 (March) The Crimean War begins as France and Britain declare war on Russia.

1855 (May–November) Universal Exposition held in Paris.

1856 (March) The Treaty of Paris ends the Crimean War.

1859 (May) France declares war on Austria.
 (June) French troops defeat the Austrians at the Battle of Solferino.
 (July) France and Austria sign a peace treaty at the Conference of Villafranca.

1861 (April) American Civil War begins.

1862 (April) France declares war on Mexico.
 (May) French troops defeated at Puebla.
 (August) Confederate forces under Stonewall Jackson defeat the Union Army at the Second Battle of Bull Run.
 (September) Otto von Bismarck becomes Minister-President of Prussia.

1863 (May) French troops capture Puebla after a two-month siege; Robert E. Lee's Army of Northern Virginia is victorious at the Battle of Chancellorsville; candidates supporting Napoleon III win 250 of 282 seats in elections for the Legislative Assembly.
 (June) French troops enter Mexico City.
 (July) Confederate forces defeated at the Battle of Gettysburg.

1864 (May) General Ulysses S. Grant begins his summer campaign against the South with the Battle of the Wilderness and the Battle of Spotsylvania.
 (June) Union forces suffer heavy casualties at the Battle of Cold Harbor in Virginia; naval battle off Cherbourg between the U.S.S. *Kearsarge* and the C.S.S. *Alabama*; Austrian Archduke Maximilian arrives in Mexico City.
 (September) The Franco-Italian Convention stipulates the withdrawal of all French troops from Rome, where they have been safeguarding the papacy; the International Working Men's Association is founded in London.

1865 (April) Civil War ends as General Lee surrenders at Appomattox Court House; Abraham Lincoln is assassinated.
 (October) The United States demands the withdrawal of French troops from Mexico.

1866 (July) Prussia defeats Austria in the Seven Weeks' War; French troops begin their retreat from Mexico.
 (December) Under the terms of the Franco-Italian Convention, all French troops leave Rome except for a garrison of volunteers protecting the pope.

1867 (January) Napoleon III announces a series of liberal reforms.
 (February) The last French troops evacuate Mexico.

(April) Opening of the Universal Exposition in Paris.

(June) The Emperor Maximilian is executed by Mexican republicans led by Benito Juárez.

(September) Giuseppe Garibaldi escapes from custody and marches on the Papal States.

(November) French troops, dispatched into Italy to protect the pope, defeat Garibaldi at Mentana.

1868 (May) Napoleon III relaxes laws on the censorship of the press; new journals, hostile to his régime, abound.

1869 (June) Elections for the Legislative Assembly result in opponents of Louis-Napoleon claiming more than forty per cent of the vote; strikes and violence at La Ricamarie.

1870 (January) Émile Ollivier becomes Minister of Justice in what he christens the "Liberal Empire"; Victor Noir is killed by Prince Pierre Bonaparte.

(May) Napoleon III wins a plebiscite on his reforms by a wide margin.

(July) The Spanish Prime Minister Juan Prim announces that Leopold von Hohenzollern-Sigmaringen, a distant relative of Kaiser Wilhelm I of Prussia, will assume the Spanish throne; the Ems Telegram; France declares war on Prussia.

(September) Napoleon III surrenders after defeat at Sedan; the Third Republic is declared; the Italian army enters Rome after French troops are forced to withdraw; the Siege of Paris begins.

1871 (January) Kaiser Wilhelm is crowned Emperor of Germany at Versailles; France surrenders to Prussia.

(February) Following national elections, Adolphe Thiers becomes Chief of State (and later President) of the Third Republic.

(March) Execution in Montmartre of Generals Lecomte and Clément-Thomas; founding of the Paris Commune.

(May) Treaty of Frankfurt officially ends the Franco-Prussian War; defeat of the Communards during "Bloody Week."

(July) Rome becomes capital of a unified Italy.

1872 (July) Death of Mexican President Benito Juárez.

(September) The so-called "Alabama Claims" are settled as a tribunal meeting in Geneva orders Britain to pay $15.5 million to the United States as reparations for the damages inflicted on American shipping by British-built raiders such as the C.S.S. *Alabama*.

1873 (January) Death of Louis-Napoleon in England.

(May) Adolphe Thiers resigns as President, to be succeeded by Marshal MacMahon, the Duc de Magenta.

(September) The last German troops leave French soil.

ACKNOWLEDGEMENTS

My thanks to the many people who assisted me with my research and writing. Charlotte Hale, Paintings Conservator at the Metropolitan Museum of Art in New York, provided information about the damage done to *Friedland* by Charles Meissonier's fencing sword. Dr. Ivan Gaskell at Harvard University informed me about the location of Vermeer's *The Astronomer* in the 1860s. Philip J. Dempsey supplied me with a number of books and arranged for me to view some of the paintings in the collection at Wildenstein & Co. in New York. Michele Lee Amundsen did a superb job of tracking down the illustrations for the book. Russell Ash and Andrew Roberts responded to my queries about, respectively, museum attendance and Napoleon's health. Assistance with a number of translations was gratefully received from Anne-Marie Rigard. Earlier versions of the manuscript were read and critiqued by Susan Adams, Mark Asquith, Michael Sims, and my agent Christopher Sinclair-Stevenson.

Special thanks must go to George Gibson, my editor in New York, who was a source of unfailing support as well as of numerous stimulating inquiries and wise observations. He and my editor in London, Rebecca Carter, with whom I've also had the good fortune to work on three consecutive books, were instrumental in helping the manuscript find its shape. I can only hope their patient labours have been requited.

I am grateful to a number of scholars and art historians from whose researches I have benefited enormously. In particular, I wish to acknowledge Albert Boime, Marc J. Gotlieb, Robert H. Herbert, Constance Cain Hungerford, Patricia Mainardi, Jacqueline du Pasquier, Agnès du Pasquier-Guignard, Jane Mayo Roos, Paul Hayes Tucker, and Juliet Wilson-Bareau.

Finally, I wish to thank my wife Melanie for her love and support over the course of the past three years.

Chapter One: Che*ₓ* Meissonier

1 For Poissy's population and industry, see the entry in volume 12 (1874) of Pierre Larousse, ed., *Grand dictionnaire universel du XIX^e siècle*, 16 vols. (Paris, 1866–77).

2 Stéphanie Tascher de la Pagerie, quoted in Constance Cain Hungerford, *Ernest Meissonier: Master in His Genre* (Cambridge: Cambridge University Press, 1999), p. 121.

3 Quoted in John W. Mollett, *Meissonier* (London, 1882), p. 8.

4 For Meissonier's indefatigable working habits, see Vassíli Verestchagín, "Reminiscences of Meissonier," *Contemporary Review* 75 (May 1899), p. 664; and Valéry C. O. Gréard, *Meissonier: His Life and Art*, trans. Lady Mary Loyd and Miss Florence Simmonds (London, 1897), p. 85.

5 Henri Delaborde, quoted in Gréard, *Meissonier*, p. 345.

6 Charles Yriarte, "E. Meissonier: Personal Recollections and Anecdotes," *The Nineteenth Century* 43 (May 1898), p. 825.

7 Ibid., p. 826.

8 Albert Wolff, *La Capitale de l'art* (Paris, 1886), p. 182.

9 Quoted in Marc J. Gotlieb, *The Plight of Emulation: Ernest Meissonier and French Salon Painting* (Princeton: Princeton University Press, 1996), p. 9.

10 Quoted in Yriarte, "E. Meissonier," p. 839. An author in his own right, Alexandre Dumas *fils* (1824–95) was the son of Alexandre Dumas *père* (1802–70), creator of *The Three Musketeers*.

11 *L'Illustration*, February 7, 1891, quoted in Hungerford, *Ernest Meissonier*, p. 1.

12 For information on Meissonier's property I am indebted to Agnès du Pasquier-Guignard, "La 'Grande Maison' de Poissy: L'Installation à Poissy," in *Ernest Meissonier: Rétrospective* (Lyon: Musée des Beaux-Arts de Lyon, 1993), pp. 64–70. Pasquier-Guignard reports that Meissonier had his Paris apartment at least as late as October 1860; however, it is probable that he maintained the residence during the early 1860s.

13 Gréard, *Meissonier*, p. 191.

14 Quoted in ibid., p. 133.

15 Flaubert, *Correspondance, 1857–1863*, ed. Maurice Nadeau (Lausanne: Éditions Rencontre, 1965), p. 263. For Flaubert's use in this passage of the term *sens historique*, as well as his own historical fascination in the context of nineteenth-century historiography, see Gisèle Séginger, *Flaubert: Une Poétique de l'histoire* (Strasbourg: Presses Universitaires de Strasbourg, 2000).

16 Quoted in Hungerford, *Ernest Meissonier*, p. 34.

17 For the status and sales of *The Three Musketeers* (*Les Trois Mousquetaires*) in nineteenth-century France, see Anatole France, "M. Thiers as Historian," in *On Life and Letters*, vol. 1, trans. A. W. Evans et al. (London: Bodley Head, 1911), p. 209.

18 On which matters, see Guy P. Palmade, *French Capitalism in the Nineteenth Century*, trans. Graeme M. Holmes (Newton Abbot: David & Charles, 1972).

19 *Reflections on the Revolution in France*, ed. Conor Cruise O'Brien (London: Penguin, 1969), p. 170. Burke published this work in 1790.

20 *La Presse*, April 16, 1845.

21 Prosper Haussard, *Le Temps*, March 20, 1840.

22 *La Presse*, April 16, 1845.

23 *La Presse*, August 11, 1857; *Revue française*, no. 10 (1857). For further examples of the critical carping that caused Meissonier to revise his style, see Hungerford, *Ernest Meissonier*, pp. 112–14; and Gotlieb, *The Plight of Emulation*, pp. 15–16.

24 Gréard, *Meissonier*, pp. 339–40.

25 Ibid., p. 126.

26 Kenyon Cox, "The Paintings of Meissonier," *The Nation*, December 24, 1896.

27 Gréard, *Meissonier*, p. 267–8.

28 Quoted in ibid., p. 18; translation slightly modified.

29 Quoted in Hungerford, *Ernest Meissonier*, p. 112.

30 The epithet "French Metsu" was first used by Eugène Fromentin (quoted in Gotlieb, *The Plight of Emulation*, p. 101).

31 Gréard, *Meissonier*, p. 214.

32 For the story of Meissonier posing as Napoleon on horseback on his rooftop on "a gloomy day in winter," see Mollett, *Meissonier*, p. 6.

33 Gréard, *Meissonier*, p. 63.

34 For the commercial success of Thiers's work, see Anatole France, "M. Thiers as Historian," in *On Life and Letters*, vol. 1, p. 209.

35 Quoted in Timothy Wilson-Smith, *Napoleon and His Artists* (London: Constable, 1996), p. 70. Delacroix's nominal father was Charles Delacroix, but the painter has long been rumoured to have been the illegitimate son of the great French statesman Talleyrand, i.e., Charles Maurice de Talleyrand-Périgord (1754–1838).

36 Philippe Burty, "Meissonier," *Croquis d'après nature* (Paris, 1892), p. 18.

37 This anecdote—which might just possibly be apocryphal—is recounted by Edmond de Goncourt: see Edmond and Jules de Goncourt, *Journal: Mémoires de la vie littéraire*, 3 vols., ed. Robert Ricatte (Paris: Robert Laffont, 1989), vol. 2, pp. 892–3. According to the entry in volume 10 (1964) of the *Grand Larousse encyclopédique*, 10 vols. (Paris: Librairie Larousse, 1960–64), the *suspensoir* is a medical binding intended to support the scrotum

and its contents. It is used in cases of hernia, hydrocele (accumulation of fluid), varico-
cele (a tumour composed of varicose veins of the spermatic cord), and gonorrhea.

38 *History of the Consulate and the Empire of France under Napoleon*, 20 vols. (London, 1845–62), vol. 17, p. 470.

39 Gréard, *Meissonier*, p. 243.

40 *History of the Consulate and the Empire of France under Napoleon*, vol. 17, p. 445.

Chapter Two: Modern Life

1 Quoted in *The Westminster Review*, April 1, 1873.

2 Émile Zola, *La Bête Humaine*, trans. Leonard Tancock (London: Penguin, 1977), p. 45.

3 Armand Silvestre, *Au Pays des souvenirs* (Paris, 1892), p. 161.

4 Quoted in Beth Archer Brombert, *Édouard Manet: Rebel in a Frock Coat* (New York: Little, Brown, 1996), p. 42.

5 Quoted in Françoise Cachin, *Manet*, trans. Emily Read (New York: Henry Holt, 1991), p. 18.

6 Eric Darragon, *Manet* (Paris: Fayard, 1989), p. 12.

7 Quoted in Brombert, *Édouard Manet*, p. 15.

8 For the Daumier reference, see ibid., p. 46. Thomas Couture frequently receives bad press from Manet's hagiographers, most notably Antonin Proust. For an absurd distortion of the facts, see the entry on Manet in volume 8 of André Michel's *Histoire de l'Art depuis les premiers temps chrétiens jusqu'à nos jours* (Paris: Librairie Armand Colin, 1926). Michel attempts, ludicrously, to make of the young Manet a determined *plein-air* painter who, against the tenets of Couture, eschews the "false shadows" of the studio for the "true light" of the great outdoors (pp. 581–2). For more balanced accounts of Couture and his atelier, see Albert Boime, *Thomas Couture and the Eclectic Vision* (New Haven: Yale University Press, 1980), pp. 441–56; and idem., *The Academy and French Painting* (London: Phaidon, 1971), pp. 65–78. Boime argues that the reported conflicts between Manet and Couture "reflect the attempts of apologists to create historical cleavage between master and pupil in the interests of establishing the latter's unbridled originality" (*Thomas Couture and the Eclectic Vision*, p. 446).

9 For Manet's journeys to Italy as well as his studies there, see Peter Meller, "Manet in Italy: some newly identified sources for his early sketchbooks," *Burlington Magazine* (February 2002), pp. 68–84.

10 The father's name was listed on the birth certificate as "Koëlla" and his occupation as "artiste." The mysterious Koëlla has never been identified, and speculation about Léon's paternity has settled on Édouard, not unreasonably, perhaps, in view of the fact that he and Suzanne eventually became lovers and set up home together. But speculation has also turned to Auguste Manet, Édouard's father. In 1981 Mina Curtiss gave readers of *Apollo* the tantalising piece of gossip that a "highly distinguished and reliable writer, a relation by marriage of the Manet family, confided in recent years to a close friend that Manet *père* was actually Léon's father." "Letters of Édouard Manet to his Wife during the Siege of Paris: 1870–71," *Apollo* 113 (June 1981), p. 379. This theory has recently been championed by Nancy Locke, who points out that Édouard, later in life, never legitimised Léon, even though the Napoleonic Code made provisions for the legitimation of a child whose

parents married after their birth. See *Manet and the Family Romance* (Princeton: Princeton University Press, 2001), pp. 47 and 115. Manet's biographer, Brombert, refutes these assertions, claiming that Édouard was in fact the father: see *Édouard Manet*, p. 98. It may be relevant that both Locke's and Brombert's intriguing psychoanalytic readings of Manet's paintings depend, at least in part, on whether he was Léon's half-brother or biological father.

11 *L'Artiste*, September 6, 1857.

12 Quoted in Cachin, *Manet*, p. 26.

13 *Poems of Baudelaire*, trans. Roy Campbell (New York: Pantheon Books, 1952).

14 *Gazette des Beaux-Arts*, July 1, 1861. The critic was Léon Lagrange.

15 Albert de la Fizelière, in *L'Union des arts*, May 21, 1864.

16 *Le Moniteur universel*, July 3, 1861.

17 Fernand Desnoyers, *Le Salon des Refusés* (Paris, 1863), p. 41.

18 The fact that Auguste Manet received treatment, following his stroke, from Dr. Jacques Maisonneuve, a renowned expert on venereal diseases, suggests that his debilitating medical condition may in fact have been tertiary syphilis, presumably contracted from either a prostitute or a mistress. Locke, for example, speculates that the "cerebral congestion" suffered by Auguste Manet could have been "a euphemism for what we would now call tertiary syphilis": see *Manet and the Family Romance*, p. 48.

19 I have calculated the worth of land based on the fact that in 1863 sixteen acres were sold for 60,000 francs. For this sale, see Brombert, *Édouard Manet*, p. 135.

20 Edmond and Jules de Goncourt, *Manette Salomon* (1867), quoted in Robert L. Herbert, *Impressionism: Art, Leisure, and Parisian Society* (New Haven: Yale University Press, 1988), p. 199. For Herbert's excellent description of the delights of Asnières, see pp. 198–200.

21 Kenneth Clark writes that by the nineteenth century the predominance of the female nude over the male "was absolute": *The Nude: A Study of Ideal Art* (London: John Murray, 1956), p. 343.

22 The term has since entered popular culture, since today the French will describe a woman with a comely shape as *une belle académie*.

23 *The Journal of Eugène Delacroix*, trans. Walter Pach (New York: Hacker Art Books, 1980), p. 293.

24 *Le Concert champêtre*, painted about 1508, was thought in Manet's time to be by Giorgione. It is now believed to have been the work of Titian.

25 Antonin Proust, *Édouard Manet: souvenirs* (Paris: H. Laurens, 1913), p. 43.

26 Ibid.

27 Stendhal was writing about the 1824 Salon in a series of articles in the *Journal de Paris*. A translation can be found in Elizabeth Gilmore Holt, ed., *From the Classicists to the Impressionists: Art and Architecture in the Nineteenth Century* (New York: Doubleday, 1966), pp. 40–51.

28 Thomas Couture, *Méthode et entretiens d'atelier* (Paris, 1867), pp. 251–2. Though this work was not published until 1867, there is no reason to believe it does not represent Couture's views in the 1850s, when Manet was under his tutelage.

29 *Les Chantes modernes* (Paris, 1858), p. 5.

30 The critic was Walter Benjamin in "Das Passagen-Werk," his massive but unfinished study of architecture, politics and capitalism in nineteenth-century Paris, researched from 1927 until his death in 1940. The work has recently been translated by Howard Eiland and Kevin Mclaughlin as *The Arcades Project* (Cambridge, Mass.: Harvard University Press, 2002). For studies of Haussmann's transformation of Paris, see J. M. and Brian Chapman, *The Life and Times of Baron Haussmann: Paris in the Second Empire* (London: Weidenfeld & Nicolson, 1957); David H. Pinkney, *Napoleon III and the Rebuilding of Paris* (Princeton: Princeton University Press, 1958); Howard Saalman, *Haussmann: Paris Transformed* (New York: George Braziller, 1971); and David P. Jordan, *Transforming Paris: The Life and Labors of Baron Haussmann* (Chicago: University of Chicago Press, 1996).

31 Baudelaire originally wrote *The Painter of Modern Life*, a study of the artist and illustrator Constantin Guys, at the end of 1859. He published it four years later, in November and December 1863, in three instalments in *Le Figaro*. For a modern translation, see *Baudelaire: Selected Writings on Art and Literature*, trans. P. E. Charvet (New York: Viking, 1972), pp. 395–422.

Chapter Three: The Lure of Perfection

1 Gréard, *Meissonier*, p. 82.

2 Ibid., p. 254.

3 Ibid. The references to "Penelope's webs" and the palimpsesting are found on p. 83.

4 Ibid., pp. 70–1.

5 Ibid., p. 69. Accounts of Meissonier's studies for *1814: The Campaign of France* may be found in Verestchagín, "Reminiscences of Meissonier," p. 662; Ambrose Vollard, *Recollections of a Picture Dealer*, trans. Violet M. MacDonald (New York: Little, Brown, 1936), pp. 159–61; and Yriarte, "E. Meissonier," pp. 832–4.

6 This expanse of snow, coupled with a grim-looking Napoleon, led a number of earlier commentators to call the painting "The Retreat from Russia," identifying the painting, mistakenly, with the French retreat from Moscow. See, for example, Vollard, *Recollections of a Picture Dealer*, p. 161, and Mollett, *Meissonier*, p. 6.

7 Quoted in Vollard, *Recollections of a Picture Dealer*, p. 161.

8 Quoted in ibid.

9 These details come from an account by the writer Edmond Duranty, who was—it should be noted—both writing long after the fact and relying on hearsay: see *Le Pays des artistes* (Paris, 1881), p. 141. Duranty ascribes these efforts to the painting of *Friedland*, but given that there is no snow in this latter work, the most likely candidate is obviously *The Campaign of France*.

10 Yriarte, "E. Meissonier," p. 832.

11 Philippe Burty, "Meissonier," *Croquis d'après nature* (Paris, 1892), p. 18.

12 This account, that of Meissonier's son Charles, is given in Yriarte, "E. Meissonier," p. 834.

13 Ibid.

14 Ibid.

15 For the "extreme artificiality" of the conditions under which Géricault painted, see Lorenz Eitner, *Géricault's "Raft of the Medusa"* (London: Phaidon, 1973), pp. 32–3.

16 Gréard, *Meissonier*, p. 105. For Meissonier's work as a landscapist, see Dominique Brach-
 lianoff, "Heureux les paysagistes!" in *Ernest Meissonier: Rétrospective*, pp. 148–9.

17 On *plein-air* landscape in France, see the discussion in Lorenz Eitner, *An Outline of
 19th-Century European Painting: From David through Cézanne* (New York: Harper &
 Row, 1987), pp. 212–13; Anna Ottani Cavina et al., *Paysages d'Italie: Les peintres du
 plein air (1780–1830)* (Milan: Electa, 2001); and the exhibition catalogue *Impressions of
 Light: The French Landscape from Corot to Manet*, ed. George T. M. Shackleford and
 Fronia Wissman (Boston: Museum of Fine Arts, 2002).

18 For the way in which such inventions made *plein-air* painting possible, see James Ayres,
 The Artist's Craft: A History of Tools, Techniques and Materials (London: Guild Publish-
 ing, 1985), pp. 110–11. Ayres writes that metal tubes were not patented before 1841, when
 an American named John Goffe Rand received a patent in London for collapsible metal
 tubes for oil paints. However, such tubes were in use before then, since in 1824 an
 Englishman was awarded a prize of twenty-four guineas from the Royal Society of Arts
 in London for inventing tin tubes for the preservation of colours.

19 Yriarte, "E. Meissonier," p. 834.

20 Gréard, *Meissonier*, pp. 13 and 15.

21 Ernest and Jules de Goncourt, *Pages from the Goncourt Journal*, ed. and trans. Robert
 Baldick (London: The Folio Society, 1980), p. 101. Where possible I quote from this work
 rather than the three-volume French edition published by Robert Laffont.

22 On Nieuwerkerke's life and career, see Suzanne Gaynor, "Count de Nieuwerkerke: A
 Prominent Official of the Second Empire and His Collection," *Apollo* 122 (1985),
 pp. 372–9; Fernande Goldschmidt, *Nieuwerkerke, le bel Émilien: Prestigieux directeur du
 Louvre sous Napoléon III* (Paris: Art International Publishers, 1997); and Goldschmidt et
 al., *Le Comte de Nieuwerkerke: Art et pouvoir sous Napoléon III* (Paris: Réunion des
 Musées nationaux, 2000), the catalogue for an exhibition held at the Musée National du
 Château de Compiègne. Regarding Nieuwerkerke's links to the House of Bourbon, his
 mother seems to have been the illegitimate granddaughter of Louis-Philippe I de Bour-
 bon, Duc d'Orléans (1725–85), who was the father of Philippe Égalité and the grandfa-
 ther of King Louis-Philippe. Nieuwerkerke's father, who once served as King Charles
 X's Gentleman of the Bedchamber, was a descendant of William the Silent, the
 sixteenth-century founder of Dutch independence.

23 This statement, possibly apocryphal, is quoted in Patricia Mainardi, *Art and Politics of the
 Second Empire: The Universal Expositions of 1855 and 1867* (New Haven: Yale University
 Press, 1987), p. 184.

24 For Nieuwerkerke's 1863 *règlement* and the artists' response to it, see Albert Boime, "An
 Unpublished Petition Exemplifying the Oneness of the Community of Nineteenth-
 Century French Artists," *Journal of the Warburg and Courtauld Institutes* 33 (1970),
 pp. 345–53.

25 Quoted in Boime, "An Unpublished Petition," p. 353.

26 Quoted in ibid.

27 Gréard, *Meissonier*, p. 62.

Chapter Four: Mademoiselle V.

1 According to Henri Perruchot, Manet had painted eighteen canvases in 1862 alone. See *Manet*, trans. Humphrey Hare (London: Perpetua, 1962), p. 102.

2 Manet later painted out the satyr and renamed the work *The Surprised Nymph*. For the evidence for this change, see Beatrice Farwell, "Manet's *Nymphe Surprise*," *Burlington Magazine* 97 (April 1975), pp. 224–9.

3 Albert Boime, *Thomas Couture and the Eclectic Vision*, p. 465.

4 Much light has been shed on the formerly shadowy Victorine. See Margaret Siebert, "A Biography of Victorine-Louise Meurent and Her Role in the Art of Édouard Manet," Ph.D. dissertation, Ohio State University, 1986. See also Eunice Lipton's entertaining account of her scholarly sleuthing, *Alias Olympia: A Woman's Search for Manet's Notorious Model and her Own Desire* (New York: Penguin, 1992).

5 Jacques Lethève, *Daily Life of French Artists in the Nineteenth Century*, trans. Hilary E. Paddon (London: George Allen and Unwin, 1968), p. 77.

6 Susan Waller, "Professional Poseurs: The Male Model in the École des Beaux-Arts and the Popular Imagination," *Oxford Art Journal* 25 (2002), p. 56.

7 Waller, "Professional Poseurs," p. 56.

8 Ibid., pp. 41 and 56. Female models would be admitted to the École des Beaux-Arts at the end of 1863.

9 Quoted in ibid., p. 59.

10 Quoted in Pierre Courthion and Pierre Cailler, eds., *Portrait of Manet by Himself and His Contemporaries*, trans. Michael Ross (London: Cassell, 1960), p. 10.

11 Ibid., p. 54.

12 Juliet Wilson-Bareau, "Le Déjeuner sur l'herbe," in Juliet Wilson-Bareau, ed., *The Hidden Face of Manet: An Investigation of the Artist's Working Processes* (London: Burlington Magazine, 1986), p. 37.

13 Eugène Manet is sometimes identified as the brother who posed for the work. For this debate, see Paul Hayes Tucker, "Making Sense of Édouard Manet's 'Le Déjeuner sur l'Herbe,'" in Paul Hayes Tucker, ed., *Manet's "Le Déjeuner sur l'Herbe"* (Cambridge: Cambridge University Press, 1998), p. 35, note 37.

14 For the copies of Raphael's work in the École des Beaux-Arts, see Paul Duro, " 'Un Livre Ouvert à l'Instruction': Study Museums in Paris in the Nineteenth Century," *Oxford Art Journal* 10 (1987), p. 48.

15 Quoted in Gary Tinterow, "Raphael Replaced: The Triumph of Spanish Painting in France," in Gary Tinterow et al., eds., *Manet/Velázquez: The French Taste for Spanish Painting* (New Haven: Yale University Press, 2003), p. 14.

Chapter Five: Dreams of Genius

1 Quoted in Gotlieb, *The Plight of Emulation*, p. 21. For the prestige of fresco in nineteenth-century France, see ibid., pp. 19–21.

2 Henri Delaborde, *Ingres: Sa vie, ses travaux, sa doctrine* (Paris, 1870), p. 373.

3 Quoted in Gotlieb, *The Plight of Emulation*, p. 21.

4 Gréard, *Meissonier*, p. 162.

5 Ibid., pp. 103–4.

6 Ibid., p. 238. For a good discussion of *Remembrance of Civil War*, see Hungerford, *Ernest Meissonier*, pp. 52–63. See also the comments of Robert Rosenblum and H. W. Janson, *Art of the Nineteenth Century: Painting and Sculpture* (London: Thames & Hudson, 1984), p. 219. Their passage is worth quoting: "Even the precedent of Goya's *Disasters of War* or Daumier's *Rue Transnonain* offers inadequate preparation for the close-up scrutiny of the facts of modern military death that Meissonier insists on here. . . . The ignoble truths of violated flesh and blood, of grotesque foreshortenings, and ripped clothing are presented with the chilling veracity of a modern news photo that might document anything from the corpses of the Crimean War to those of a Nazi concentration camp" (p. 219). Rosenblum and Janson, together with Hungerford, provide a welcome correction to the view expressed by T. J. Clark that Meissonier's "deliberate deadpan in the face of horror" implied "a sober warning to the rebels of the future": see his discussion in *The Absolute Bourgeois: Artists and Politics in France, 1848–1851* (London: Thames & Hudson, 1973), pp. 24–9, which is based on a nonlinear reading of Meissonier's politics that unfairly presses him into service as a conservative straw man. For a good discussion of the June Days, which points out that the battle was not a simplistic or straightforward one between workers and their masters, see Theodore Zeldin, *Politics and Anger: France 1848–1945* (Oxford: Oxford University Press, 1979), pp. 125–6, as well as the classic study by Rémi Gossez, *Les Ouvriers de Paris: L'Organisation, 1848–1851* (Paris: Société d'histoire de la révolution de 1848, 1968).

7 Gréard, *Meissonier*, p. 238.

8 *The Journal of Eugène Delacroix*, p. 689.

9 On this matter, see *Ernest Meissonier: Rétrospective*, p. 34. See also the excellent discussion of Meissonier's election in Hungerford, *Ernest Meissonier*, pp. 92–4.

10 *The Journal of Eugène Delacroix*, p. 689. For celebrations of Meissonier's victory over the "old Académie," see *Ernest Meissonier: Rétrospective*, p. 34, and Hungerford, *Ernest Meissonier*, p. 94.

11 Gréard, *Meissonier*, p. 297.

12 Quoted in Hungerford, *Ernest Meissonier*, p. 92.

13 Ingres's decision to sign the petition may have been motivated in part by his vendetta against Nieuwerkerke. In the early 1860s Ingres had criticised Nieuwerkerke's conservation of a number of paintings in the Louvre, including ones by Raphael, denouncing the Directeur an "assassin." Nieuwerkerke responded with the unworthy gesture of removing some of Ingres's paintings from their prominent positions in the Luxembourg Gallery. On these matters, see the discussion in Mainardi, *Art and Politics of the Second Empire*, pp. 123–4.

14 Quoted in John Rewald, *The History of Impressionism* (New York: Museum of Modern Art, 1961), p. 79.

15 Quoted in Boime, "An Unpublished Petition," p. 347.

16 On this boycott, see Hungerford, *Ernest Meissonier*, p. 50.

Chapter Six: Youthful Daring

1 Juliet Wilson-Bareau maintains that the show at Martinet's gallery, which opened a month before the deadline for Salon paintings, was "part of Manet's strategy to gain sup-

port for his Salon pictures": *Manet by Himself* (London: Macdonald Illustrated, 1991), p. 16. For a similar argument, see George Heard Hamilton, *Manet and His Critics* (New Haven: Yale University Press, 1954), p. 38.

2 Theodore Zeldin reports that in 1861 there were 104 picture dealers in Paris: *Taste and Corruption: France 1848–1945* (Oxford University Press, 1980), p. 116.

3 Gérôme received 20,000 francs in 1852 for his *Age of Augustus*, first shown in 1855; and he was paid another 20,000 francs for his *Reception of the Siamese Ambassadors*, painted between 1861 and 1863. For his relationship with Adolphe Goupil—whose daughter he married in 1863—see *Gérôme & Goupil: Art and Enterprise*, trans. Isabel Ollivier (New York: Dahesh Museum of Art, 2000).

4 For a discussion of Manet's experimentation with technique, see Anthea Callen, *Techniques of the Impressionists* (London: Tiger Books International, 1993), especially pp. 10–45.

5 *L'Artiste*, April 1, 1863.

6 *Gazette des Beaux-Arts*, April 1, 1863.

7 Edmond and Jules de Goncourt, *Pages from the Goncourt Journal*, p. 138.

8 *La Presse*, April 27, 1863.

9 Émile Zola, *The Masterpiece*, trans. Roger Pearson (Oxford: Oxford University Press, 1993), p. 140.

10 See Lee Johnson, *Eugène Delacroix (1798–1863): Paintings, Drawings, and Prints from North American Collections* (New York: Harry N. Abrams, 1991), p. 16.

11 Callen, *Techniques of the Impressionists*, pp. 16 and 22.

12 On this matter, see Theodore Zeldin, *Taste and Corruption*, pp. 83–4.

13 See Baudelaire, *Oeuvres complètes*, 2 vols., ed. Claude Pichois (Paris: Bibliothèque de la Pléiade, 1975–6), vol. 2, p. 494.

14 Quoted in Linda Nochlin, *Realism* (London: Penguin, 1971), p. 28.

15 See, for example, his articles in *Le Moniteur universel*, December 24, 1855 and June 4, 1868.

16 Wilson-Bareau, ed., *Manet by Himself*, p. 29.

17 *Courrier artistique*, April 15, 1863.

Chapter Seven: A Baffling Maze of Canvas

1 Zola, *The Masterpiece*, p. 324.

2 Ibid., p. 318.

3 A juror from later in the century, Tony Robert-Fleury, claimed that jurors could be forced to view as many as 600 works per day, "and sometimes they refuse out of distaste what they have seen in a bad mood": quoted in John Milner, *The Studios of Paris: The Capital of Art in the Late Nineteenth Century* (New Haven: Yale University Press, 1988), p. 49.

4 Boime, "An Unpublished Petition," p. 346.

5 The winners of the Prix de Rome in the Académie des Beaux-Arts at this time were: Ingres (1801), François Heim (1807), Jean Alaux (1815), Léon Cogniet (1817), Signol (1830), and Hippolyte Flandrin (1832).

6 Rewald, *The History of Impressionism*, p. 79.

7 This at least is the claim of one of Signol's students, Pierre-Auguste Renoir, quoted in

Vollard, *Renoir: An Intimate Portrait*, trans. Harold Van Doren and Randolph T. Weaver (New York: Greenberg, 1925), p. 31.

8 *Correspondance générale de Eugène Delacroix*, 5 vols., ed. André Joubin (Paris: Plon, 1937), vol. 3, p. 369.

9 Dr. Gachet would later have, as his most famous patient, Vincent Van Gogh, who was treated at Gachet's house in Auvers-sur-Oise in the weeks before his suicide in 1890. Van Gogh immortalised his physician in *Portrait of Doctor Gachet*.

10 An example of such a rejection—that of Fantin-Latour—is reproduced in Daniel Wildenstein, "Le Salon des Refusés de 1863: Catalogue et Documents," *Gazette des Beaux-Arts*, ser. 6 (September 1965), p. 131.

11 For a discussion of the contribution of cafés to the artistic life of Paris in the nineteenth century, see Georges Bernier, *Paris Cafés: Their Role in the Birth of Modern Art* (New York: Wildenstein & Co., 1985). The discontented drinker, J.-K. Huysmans, is quoted on p. 37.

12 George Du Maurier, quoted in Stanley Weintraub, *Whistler: A Biography* (London: Collins, 1974), p. 66.

13 James McNeill Whistler, *The Correspondence of James McNeill Whistler*, ed. Margaret F. MacDonald et al. (Glasgow: Centre for Whistler Studies, University of Glasgow), no. 08033. This collection may be found online at http://www.whistler.arts.gla.ac.uk/letters.

14 Quoted in David Baguley, *Napoleon III and His Regime: An Extravaganza* (Baton Rouge: Louisiana State University Press, 2000), p. 110.

15 For lists of candidates for Louis-Napoleon's father, see Baguley, *Napoleon III and His Regime*, pp. 114–16; and Jasper Ridley, *Napoleon III and Eugénie* (London: Constable, 1979), pp. 14–15.

16 Ridley, *Napoleon III and Eugénie*, p. 23.

17 Quoted in Zeldin, *Politics and Anger*, p. 188. For the booming economy of the Second Empire, see ibid., pp. 188–92; and Alfred Cobban, *A History of Modern France: From the First Empire to the Second Empire, 1799–1871* (Harmondsworth, Middlesex, U.K.: Penguin, 1984), pp. 164–71.

18 Quoted in Baguley, *Napoleon III and His Regime*, pp. 12 and 151.

19 Quoted in Ridley, *Napoleon III and Eugénie*, p. 120.

20 Quoted in Baguley, op. cit., p. 1.

21 *The Illustrated London News*, January 18, 1873.

22 Anna L. Bicknell, *Life in the Tuileries under the Second Empire* (London, 1895), p. 171.

23 James Howard Harris, First Earl of Malmesbury, *Memoirs of an Ex-Minister* (London, 1884), vol. 2, p. 282.

24 Quoted in Roger Bellet, *Presse et Journalisme sous le Second Empire* (Paris: Armand Colin, 1967), p. 18.

25 Quoted in Ridley, *Napoleon III and Eugénie*, p. 508.

26 Ibid., p. 510.

27 Quoted in Zeldin, *Politics and Anger*, p. 147. Zeldin writes that Louis-Napoleon's "mystical communion with public opinion made him—when he was successful—a kind of wizard" (ibid., p. 149). For Louis-Napoleon's reliance on public opinion, see also Cobban, *A History of Modern France*, p. 180.

28 For the Emperor's visit to the Palais des Champs-Élysées, see Wildenstein, "Le Salon des Refusés de 1863: Catalogue et Documents," p. 128.

29 For Lezay-Marnésia's involvement in the Salon des Refusés, see Boime, *Thomas Couture and the Eclectic Vision*, p. 473. Antoine-Albert Lezay-Marnésia (1819–79), whose father had been Prefect of the Rhône, was related to Louis-Napoleon through the Grand Duchess of Bade, Stéphanie de Beauharnais (1789–1860), whose mother had been a Lezay-Marnésia. Albert was the nephew of Adrien Lezay-Marnésia (1759–1814), the translator of Schiller, friend of Madame de Staël and Prefect of the Lower Rhine who died after accidentally skewering himself with his ceremonial sword. Albert Lezay-Marnésia's wife, a lady-in-waiting to Eugénie, is depicted in Franz Xaver Winterhalter's famous *Portrait of the Empress Eugénie Surrounded by her Maids of Honour* (1855), now in the Musée National du Château de Compiègne.

30 Quoted in Matthew Truesdell, *Spectacular Politics: Louis-Napoleon Bonaparte and the Fête Impériale, 1849–1870* (New York: Oxford University Press, 1997), p. 67.

31 *The Athenaeum*, November 8, 1862.

32 On these matters, see Truesdell, *Spectacular Politics*, passim.

33 *Le Moniteur universel*, April 24, 1863.

34 *L'Artiste*, May 1, 1863.

35 *The Correspondence of James McNeill Whistler*, no. 08035.

36 Quoted in Shackelford and Wissman, eds., *Impressions of Light*, p. 76.

37 *Fine Arts Quarterly Review*, October 1863.

38 *The Correspondence of James McNeill Whistler*, no. 08035.

Chapter Eight: The Salon of Venus

1 Jules Janin, *L'Été à Paris* (Paris, 1844), p. 148.

2 Philippe de Chennevières-Pointel, *Souvenirs d'un directeur des Beaux-Arts*, 5 vols. (Paris, 1889), vol. 1, p. 37. For information about Chennevières and his tasks in readying the Palais des Champs-Élysées for the Salon, see Jane Mayo Roos, *Early Impressionism and the French State (1866–1874)* (Cambridge: Cambridge University Press, 1996), pp. 4–5 and 40–1; and idem., "Aristocracy in the Arts: Philippe de Chennevières and the Salons of the Mid-1870s," *Art Journal* 48 (Spring 1989), pp. 53–62.

3 *Souvenirs d'un directeur des Beaux-Arts*, vol. 4, p. 2.

4 Quoted in Roos, *Early Impressionism and the French State*, p. 135.

5 Quoted in Roos, "Aristocracy in the Arts," p. 54.

6 For Chennevières's aesthetic conservatism, see ibid., p. 55.

7 Quoted in Rewald, *The History of Impressionism*, p. 20.

8 Quoted in Lethève, *Daily Life of French Artists in the Nineteenth Century*, p. 120.

9 For discussions of the art critics, or *salonniers*, of the Second Empire, see Zeldin, *Taste and Corruption*, p. 119; and Claudine Mitchell, "What is to be done with the Salonniers?" *Oxford Art Journal* 10 (1987), pp. 106–14.

10 Quoted in *Gérôme & Goupil: Art and Enterprise*, p. 117.

11 *Moniteur universel*, June 13, 1863.

12 *Gazette des Beaux-Arts*, June 1863.

13 Maxime du Camp, *Les Beaux Arts à l'Exposition Universelle et aux Salons de 1863–1867* (Paris, 1867), p. 30.

14 For discussions of the issues involved in painting the nude at this time, see Jennifer L. Shaw, "The Figure of Venus: Rhetoric of the Ideal and the Salon of 1863," *Art History* 14 (December 1991), pp. 540–67; and T. J. Clark, *The Painting of Modern Life: Paris in the Art of Manet and His Followers* (Princeton: Princeton University Press, 1984), pp. 121–31.

15 For an example, see Geoffrey Wall, *Flaubert: A Life* (London: Faber and Faber, 2001), p. 172.

16 *Revue des deux mondes,* June 15, 1863.

17 Arthur Stevens, *Le Salon de 1863* (Paris, 1866), p. 57; Alan Bowness et al., *Gustave Courbet (1819–1877)* (London: Arts Council of Great Britain, 1978), p. 39.

18 Quoted in Elizabeth Anne McCauley, "Sex and the Salon: Defining Art and Immorality in 1863," in Tucker, ed., *Manet's "Le Déjeuner sur l'Herbe,"* p. 49.

19 *Le Correspondant,* June 18, 1863.

20 *Revue des races latines,* June 1863; *Fine Arts Quarterly Review,* October 1863.

21 Quoted in Baguley, *Napoleon III and His Regime,* p. 243.

22 Much work has been done on prostitution in nineteenth-century France. See, for example, Jill Harsin, *Policing Prostitution in Nineteenth-Century Paris* (Princeton: Princeton University Press, 1985); Alain Corbin, *Women for Hire: Prostitution and Sexuality in France after 1850* (Cambridge, Mass.: Harvard University Press, 1990); and Hollis Clayson, *Painted Love: Prostitution in French Art of the Impressionist Era* (New Haven: Yale University Press, 1991).

23 *La Pornacratie, ou les femmes dans les temps modernes* (Paris, 1875), p. 13.

24 On this loan, see Ridley, *Napoleon III and Eugénie,* pp. 285–6.

Chapter Nine: The Tempest of Fools

1 For the preface, see Wildenstein, "Le Salon des refusés de 1863," p. 132.

2 For the Marquis de Laqueuille's involvement with the Salon des Refusés, see Adolphe Tabarant, *Manet et ses oeuvres* (Paris: Gallimard, 1947), p. 66.

3 Quoted in James H. Rubin, *Courbet* (London: Phaidon Press, 1997), p. 4.

4 Quoted in ibid., p. 51.

5 Quoted in Bowness et al., *Gustave Courbet,* p. 31.

6 For Courbet's sojourn in Saintes, see Rubin, op. cit., pp. 186–7.

7 *The Letters of Gustave Courbet,* ed. and trans. Petra ten-Doesschate Chu (Chicago: University of Chicago Press, 1992), p. 221.

8 Ibid.

9 Ibid., p. 222.

10 Quoted in Rubin, op. cit., p. 108.

11 Tabarant, *Manet et ses oeuvres,* p. 65.

12 Ibid., p. 67.

13 Zola, *The Masterpiece,* p. 327.

14 *Fine Arts Quarterly Review,* October 1863.

15 Tabarant, op. cit., p. 67.

16 *Le Salon de 1863,* May 20, 1863.

17 *Fine Arts Quarterly Review*, October 1863.

18 *Le Boulevard*, May 31, 1863; *Le Figaro*, May 31, 1863. Stevens's review was not without a certain bias: he was the brother of the painter Alfred Stevens, a good friend of Manet and his companions at the Café de Bade.

19 Wilson-Bareau, ed., *Manet by Himself*, p. 16.

20 Théodore Duret, *Histoire de Édouard Manet et de son oeuvre* (Paris: Charpentier et Fasquelle, 1906), p. 38.

21 *Le Courrier artistique*, May 30, 1863.

22 *Le Siècle*, July 19, 1863; *La Patrie*, May 21, 1863.

23 *Le Constitutionnel*, May 18, 1863. Similar complaints about the figures were voiced in *Le Figaro* (July 19, 1863) and *L'Artiste* (August 15, 1863).

24 Quoted in Hamilton, *Manet and His Critics*, p. 45.

25 *L'Artiste*, August 15, 1863. The notion of *Le Déjeuner sur l'herbe* as a practical joke has persisted. For a discussion of the work as a huge prank, see Linda Nochlin, *The Politics of Vision: Essays on Nineteenth-Century Art and Society* (London: Thames & Hudson, 1991), pp. 13 ff. She claims the painting "must have seemed as full of protest and constituted as destructive and vicious a gesture as that of Marcel Duchamp when, in 1919, he painted a moustache on the Mona Lisa" (p. 14).

26 *Le Constitutionnel*, May 18, 1863.

27 Alan Krell has argued that "there are no positive grounds to believe that the public considered the *Déjeuner* a moral affront verging on the scandalous": see "Manet's *Déjeuner sur l'herbe* in the Salon des Refusés: A Re-appraisal," *Art Bulletin* 65 (June 1983), p. 319. Nor, it seems, were the critics, apart from Chesneau, troubled by the painting's moral implications. As Krell writes elsewhere, "What we can say with some degree of certainty . . . is that the critics were not unanimous in declaring the juxtaposition of a naked woman with clothed men singularly offensive": *Manet and the Painters of Contemporary Life* (London: Thames & Hudson, 1996), p. 45.

28 *Le Siècle*, July 19, 1863.

29 This connection has been pointed out by John House, "Manet and the De-Moralised Viewer," in Tucker, ed., *Manet's* Le Déjeuner sur l'Herbe, p. 86.

30 *Fine Arts Quarterly Review*, October 1863.

31 *L'Indépendance belge*, June 11, 1863.

32 Alan Krell has made a convincing case that Manet's painting received a better critical reception at the Salon des Refusés than has previously been recognised. See "Manet's *Déjeuner sur l'herbe* in the Salon des Refusés: A Re-appraisal," pp. 316–20.

33 *Le Salon de 1863*, May 20, 1863.

34 *Le Petit journal*, June 11, 1863.

35 *Le Courrier artistique*, May 16, 1863.

36 Quoted in Georges Vigne, *Ingres*, trans. John Goodman (New York: Abbeville, 1995), p. 137.

37 *Le Figaro*, September 16, 1855. The author of this review was Manet's friend Nadar, the photographer and aeronaut.

38 Quoted in Lorenz Eitner, *An Outline of 19th Century European Painting: From David through Cézanne* (New York: Harper & Row, 1987), p. 186.

39 Tabarant, *Manet et ses oeuvres*, p. 67.

40 Ibid.

41 *Le Figaro*, May 24, 1863.

42 Quoted in Tabarant, op. cit., p. 68. Pelloquet (a pseudonym of Frédéric Bernard) was writing in a biweekly publication called *L'Exposition: Journal du Salon de 1863*.

43 Quoted in Albert Boime, "The Salon des Refusés and the Evolution of Modern Art," *The Art Quarterly* 32 (1969), p. 414. Boime provides an excellent discussion of this battle between the "sketchers" and the "finishers" on pp. 414–15.

44 Quoted in ibid., p. 414.

Chapter Ten: Famous Victories

1 Burty, "La Vie de Meissonier," in Gustave Larroumet, *Meissonier* (Paris, 1895), p. 85.

2 Yriarte, "E. Meissonier," p. 829.

3 Verestchagín, "Reminiscences of Meissonier," p. 664.

4 Quoted in Gotlieb, *The Plight of Emulation*, p. 155.

5 For Dumas *fils*'s gift, see *Ernest Meissonier: Rétrospective*, p. 79.

6 Yriarte, "E. Meissonier," p. 829.

7 *History of the Consulate and the Empire of France Under Napoleon*, vol. 7, p. 362.

8 Ibid., p. 360.

9 Gréard, *Meissonier*, p. 41.

10 This scene is described in Thiers, *History of the Consulate and the Empire of France Under Napoleon*, vol. 7, p. 331.

11 Edmond and Jules de Goncourt, *Journal*, vol. 1, p. 138.

12 For elections during the Second Empire, see Alain Plessis, *The Rise and Fall of the Second Empire, 1852–1871*, trans. Jonathan Mandelbaum (Cambridge: Cambridge University Press, 1985), p. 23; and Theodore Zeldin, *The Political System of Napoleon III* (London: Macmillan, 1958), p. 87.

13 *The Civil War in France*, in Karl Marx and Frederick Engels, *Collected Works*, 37 vols., ed. Eric Hobsbawm et al. (London: Lawrence & Wishart, 1975–1998), vol. 22, p. 316.

14 *Le Moniteur universel*, August 2, 1863.

15 *Salons (1857–1879)*, 2 vols. (Paris, 1892), vol. 2, p. 135.

16 A full discussion of these reforms and the motives behind them can be found in Albert Boime, "The Teaching Reforms of 1863 and the Origins of Modernism in France," *The Art Quarterly*, vol. 1, new series (1977), pp. 1–39. He argues that Nieuwerkerke was acting in part out of his personal animosity towards the members of the Académie, with whom he had been quarrelling throughout 1863 over the conservation of the Old Master paintings in the Louvre (see ibid., p. 27, note 16).

17 For Meissonier's regret at never gaining a post at the École des Beaux-Arts, see Gréard, *Meissonier*, p. 55.

18 Quoted in Timothy Wilson-Smith, *Delacroix: A Life* (London: Constable, 1992), p. 220. Wilson-Smith does not identify the offending member of the Institut.

Chapter Eleven: Young France

1 Quoted in Raymond Escholier, *Delacroix: Peintre, Graveur, Écrivain*, 3 vols. (Paris: H. Floury, 1929), vol. 3, p. 266. For Delacroix's funeral, see also René Huyghe, *Delacroix*, trans. Jonathan Griffin (London: Thames & Hudson, 1963), pp. 7–8.

2 For the "Generation of 1830," see M. C. Sandhu, "Le Romantisme: Problème de Génération," *Nineteenth-Century French Studies*, vol. 8 (Spring–Summer 1980), pp. 206–17. Sandhu argues that the "Generation of 1830" was the first to have perceived itself as a generation, to have organised itself in a revolt against the existing society—i.e., the older generation—and, in doing so, to have developed a kind of counterculture. The Generation of 1830 is also discussed at length in Arnold Hauser, *The Social History of Art*, 2 vols., trans. Stanley Godman (London: Routledge & Kegan Paul, 1951), vol. 2, pp. 714–68.

3 Quoted in Huyghe, *Delacroix*, p. 8.

4 Gréard, *Meissonier*, p. 9.

5 For Meissonier's intoxication with Alfred de Vigny et al., see ibid., p. 8. *Les Jeunes-France* is the title of Gautier's collection of stories published in 1833.

6 On this transaction, see Brombert, *Édouard Manet*, p. 120.

7 *A Tramp Abroad* (Cologne: Könemann, 2000), p. 406.

8 *La Lumière*, November 29, 1856.

9 On these matters, see Elizabeth Anne McCauley's superb study, *Industrial Madness: Commercial Photography in Paris, 1848–1871* (New Haven: Yale University Press, 1994).

10 On Nadar, see McCauley, *Industrial Madness*, pp. 105–48, as well as Nadar's autobiography, *Quand j'étais photographe*, ed. Jean-François Bory (Paris: Éditions du Seuil, 1994).

11 Quoted in Alan Krell, "The Fantasy of *Olympia*," *Connoisseur* 195 (August 1977), p. 298.

12 Quoted in Tabarant, *Manet et ses oeuvres*, p. 79.

13 For Manet's progress in painting Olympia, see Juliet Wilson-Bareau, *The Hidden Face of Manet*, pp. 44–5.

14 Krell, *Manet and the Painters of Contemporary Life*, p. 59.

15 For the literary allusions in the name Olympia, see Theodore Reff, *Manet: "Olympia"* (London: Allen Lane, 1976), pp. 111–12.

16 Work remains to be done in this area, but for discussions of the possible influences of photography on Manet's work, see ibid., pp. 79 ff.; and Aaron Scharf, *Art and Photography* (London: Allen Lane, 1968), pp. 42–9.

17 For a discussion of the Japanese influence in Manet's work, see Klaus Berger, *Japonisme in Western Painting from Whistler to Matisse*, trans. David Britt (Cambridge: Cambridge University Press, 1992), pp. 20–33.

18 *The Illustrated London News*, October 10, 1863.

19 For this stipulation, see Brombert, *Édouard Manet*, p. 135.

20 Quoted in ibid., p. 136.

21 For Jules Vibert, see E. Bénézit, ed., *Dictionnaire critique et documentaire des Peintres, Sculpteurs, Dessinateurs et Graveurs*, 14 vols. (Paris: Grund, 1999), vol. 14.

22 Vollard, *Recollections of a Picture Dealer*, p. 154.

23 *Correspondance de Baudelaire*, 2 vols., ed. Claude Pichois (Paris: Gallimard, 1973), vol. 2, p. 323.

Chapter Twelve: Deliberations

1 For the "subtle conspiracy" whereby Louis-Napoleon fashioned a visual style sympathetic to his régime through the inducement of such purchases, many of them made by the Duc de Morny, see Albert Boime, "The Second Empire's Official Realism," in Gabriel P. Weisberg, ed., *The European Realist Tradition* (Bloomington: Indiana University Press, 1983), pp. 31–123.

2 Quoted in Gréard, *Meissonier*, p. 88.

3 For contemporary reviews of Meissonier's *Remembrance of Civil War*, see Hungerford, *Ernest Meissonier*, pp. 52–63.

4 For the argument that Morny deliberately co-opted Meissonier, I am indebted to the discussion in Boime, "The Second Empire's Official Realism," pp. 102–4. Boime argues that the Meissonier of *Remembrance of Civil War* "was a potential threat to the Second Empire ideology and had to be brought into the fold" (p. 103).

5 For this work, see Gréard, *Meissonier*, p. 378.

6 Quoted in Tabarant, *Manet et ses oeuvres*, p. 82. On this matter, see the discussion in Boime, "The Salon des Refusés and the Evolution of Modern Art," p. 416. Boime argues that the administration manipulated the adjudication process and the Salon des Refusés of 1864 "so as to forestall critical comment from press and public" (p. 416).

7 Gréard, *Meissonier*, p. 291.

8 Ibid., p. 100. Valéry Gréard was elected to the Institut de France in 1875.

9 *Journal*, vol. 1, p. 138.

10 For an English translation of the poems, see *Le Spleen de Paris: City Blues*, trans. F. W. J. Hemmings (Melton Mowbray, Leicestershire: Brewhouse Private Press, 1977).

11 *Correspondance de Baudelaire*, vol. 2, p. 350.

12 Quoted in F. W. J. Hemmings, *Baudelaire the Damned: A Biography* (London: Hamish Hamilton, 1982), p. 18.

Chapter Thirteen: Room M

1 *The Illustrated London News*, May 7, 1864.

2 For the Emperor's children by Marguerite and Valentine, and the controversies surrounding their paternity, see Joanna Richardson, *The Courtesans*, pp. 81–3. Valentine's son, born in 1865, was Jules Hadot.

3 Quoted in Roger L. Williams, *The Mortal Napoleon III* (Princeton: Princeton University Press, 1971), p. 54.

4 *The Illustrated London News*, June 27, 1863.

5 Malmesbury, *Memoirs of an Ex-Minister*, vol. 2, p. 321.

6 See the excellent discussion of Eugénie, bullfighting and animal welfare issues found in Ridley, *Napoleon III and Eugénie*, pp. 410–11.

7 *Moniteur universel*, June 4, 1864.

8 Quoted in Jean Paladilhe and José Pierre, *Gustave Moreau*, trans. Bettina Wadia (London: Thames & Hudson, 1972), p. 25.

9 Quoted in Hungerford, *Ernest Meissonier*, p. 121.

10 Quoted in ibid., p. 135.

11 *Le Figaro*, June 2, 1864; *Le Nain Jaune*, May 11, 1864.

12 *Journal des Débats*, August 15, 1864; *Les Beaux Arts*, July 15, 1864; *L'Union*, June 13, 1864.

13 *La Presse*, June 2, 1864.

14 *Westminster Review*, July 1864.

15 *Le Salon de 1864* (Paris, 1864), p. 74.

16 Ibid.

17 *Le Journal amusant*, May 21, 1864.

18 *Le Monde illustré*, June 18, 1864.

19 *L'Artiste*, June 1, 1864; *Petit-Journal*, June 3, 1864.

20 *Le Charivari*, June 15, 1864.

21 *Le Moniteur universel*, June 25, 1864.

22 *Gazette des Étrangers*, June 7, 1864.

23 *La Vie Parisienne*, May 1, 1864.

24 Ibid.

25 Ernest Renan, *The Life of Jesus*, trans A. D. Howell Smith (London: Watts & Co., 1935), p. 215.

26 Recent critics have certainly read the painting in this way: see the discussion in Brombert, *Édouard Manet*, pp. 151–2. "Manet," she writes, "made graphic his acceptance of Renan's explanation: Mary Magdalen was hallucinating" (p. 152).

27 *Le Moniteur universel*, June 25, 1864.

28 *Correspondance de Baudelaire*, vol. 2, p. 408.

Chapter Fourteen: Plein Air

1 *The Illustrated London News*, July 11, 1863. For Manet's sojourn in Boulogne in 1864, see Wilson-Bareau and Degener, "Manet and the Sea," in *Manet and the Sea* (New Haven: Yale University Press, 2003), pp. 61–7.

2 For an excellent overview of the history of seaside vacations in nineteenth-century France, see Herbert, *Impressionism: Art, Leisure, and Parisian Society*, pp. 265–302.

3 Quoted in ibid., p. 265.

4 *The Times*, June 7, 1864.

5 For a good discussion of the history of this painting, see Theodore Reff, *Manet and Modern Paris: One Hundred Paintings, Drawings, Prints and Photographs by Manet and His Contemporaries* (Washington: National Gallery of Art, 1982), pp. 129–31.

6 *Gazette des Beaux-Arts*, May 1862. Gautier wrote these words after a private viewing of the painting.

7 *Manet by Himself*, p. 31.

8 Quoted in Juliet Wilson-Bareau and David Degener, *Manet and the American Civil War* (New York: Metropolitan Museum of Art, 2003), p. 54.

9 Quoted in ibid.

10 On Burty, see Gabriel P. Weisberg, *The Independent Critic: Philippe Burty and the Visual Arts of Mid-Nineteenth-Century France* (New York: P. Lang, 1993).

11 *Manet by Himself*, p. 31.

12 Gréard, *Meissonier*, p. 185.

13 For details of Meissonier's sketches and his working method on *Friedland*, see Hungerford, *Ernest Meissonier*, pp. 168–70.

14 Gotlieb, *The Plight of Emulation*, p. 155.

15 Quoted in Pasquier-Guignard, "L'Installation à Poissy," p. 68.

16 Quoted in ibid., p. 66. For Meissonier's spending habits, see Gréard, *Meissonier*, p. 116.

17 Gréard asserts that Meissonier spent more than a million francs on his property in Poissy (*Meissonier*, p. 115).

18 See Pasquier-Guignard, "L'Installation à Poissy," p. 66.

19 On these matters, see ibid.

20 This anecdote is told by Edmond de Goncourt in *Journal*, vol. 1, p. 138.

21 Ibid.

22 Ibid.

23 Gréard, *Meissonier*, p. 125.

24 Ibid., p. 126.

25 For a discussion of Meissonier's paintings of artists in their studios, see Gotlieb, *The Plight of Emulation*, pp. 188–95.

26 See "Extraits de l'agenda de Charles Meissonier," in *Ernest Meissonier: Rétrospective*, p. 73.

27 Ibid.

28 Ibid.

Chapter Fifteen: A Beastly Slop

1 Quoted in William Gaunt, *The Pre-Raphaelite Tragedy* (London: Cardinal, 1975), p. 29.

2 *Letters of Dante Gabriel Rossetti*, ed. Oswald Doughty and John Robert Wahl, 5 vols. (Oxford: Clarendon Press, 1965–7), vol. 2, p. 527.

3 *Dante Gabriel Rossetti and Jane Morris: Their Correspondence*, ed. John Bryson and Janet Camp Troxell (Oxford: Clarendon Press, 1976), p. 174. This particular comment dates from 1881, but there is no doubt that it represents Rossetti's opinion in 1864.

4 *Letters of Dante Gabriel Rossetti*, vol. 2, p. 530.

5 Quoted in Tabarant, *Manet et ses oeuvres*, p. 100.

6 Wilson-Bareau, ed., *Manet by Himself*, p. 32. The price paid by Chesneau is not recorded.

7 Ibid.

8 See Brombert, *Édouard Manet*, p. 167. See also the ingenious argument made by Theodore Reff that, in sending these two particular paintings to the Salon, Manet was imitating the example of Titian, who had once presented Emperor Charles V with a Venus and a derided Christ: "The Meaning of Olympia," *Gazette des Beaux-Arts* 63 (1964), p. 116.

9 See Louis Leroy's comments in *Le Charivari*, May 5, 1865.

10 Wilson-Bareau, ed., *Manet by Himself*, p. 32.

11 Ibid., p. 33.

12 *Le Temps*, November 27, 1900.

13 Quoted in Rewald, *The History of Impressionism*, p. 50.

14 *Gazette des Beaux-Arts*, July 1865.

15 This anecdote is repeated in Rewald, *The History of Impressionism*, p. 123.

Chapter Sixteen: The Apostle of Ugliness

1 Wilson-Bareau, ed., *Manet by Himself*, p. 33.

2 *Correspondance de Baudelaire*, vol. 2, pp. 553, 437.

3 Ibid., p. 500.

4 Ibid., p. 496.

5 Louis Auvray, *Exposition des beaux-arts: Salon de 1865* (Paris, 1865), p. 59.

6 *Le Moniteur des arts*, May 5, 1865; *Le Monde illustré*, May 13, 1865; *L'Époque*, May 17, 1865.

7 Jules Clarétie, *Le Figaro*, June 20, 1865.

8 *Le Moniteur universel*, June 24, 1865; *La Presse*, May 28, 1865; *Le Grand Journal*, May 21, 1865; *L'Illustration*, June 3, 1865; *Le Siècle*, June 2, 1865; *La Gazette de France*, June 30, 1865. For an excellent overview of the critical responses to *Olympia*, see the discussion in Clark, *The Painting of Modern Life*, pp. 83–98. I am indebted to Clark for his gleaning of so many reviews as well as for his discussion of the place of both nudes and prostitutes in French art and society (see especially pp. 100–46).

9 *La Presse*, May 28, 1865.

10 *L'Époque*, May 17, 1865; *Le Grand Journal*, May 21, 1865; *Le Siècle*, June 2, 1865; Félix Jahyer, *Étude sur les beaux-arts: Salon de 1865* (Paris, 1865), p. 23.

11 Quoted in Clark, *The Painting of Modern Life*, p. 96.

12 *Le Journal Littéraire de la Semaine*, May 29–June 4, 1865.

13 *Le Grand Journal*, May 21, 1865; and A.-J. Lorentz, quoted in Clark, *The Painting of Modern Life*, p. 289, note 69.

14 Quoted in McCauley, *Industrial Madness*, p. 155. I am indebted to this work for its account of the "flesh trade" on pp. 153–85.

15 Quoted in ibid., p. 158.

16 Jacques-Émile Blanche, *Manet* (Paris: F. Rieder & Cie, 1924), pp. 36–7.

17 Quoted in Courthion and Cailler, eds., *Portrait of Manet*, trans. Michael Ross, p. 55.

18 Quoted in ibid., p. 51.

19 *L'Artiste*, April 1, 1865.

20 For a good discussion of Meissonier's manipulation of interior light in *The Etcher*, see Hungerford, *Ernest Meissonier*, p. 88.

21 *The Astronomer* is now in the Louvre, *The Geographer* in the Städel Museum in Frankfurt. How and where Meissonier may have seen *The Astronomer*—if indeed he was familiar with the work—is something of a mystery. According to Dr. Ivan Gaskell, a Vermeer scholar at Harvard University, the painting appears to have been in England by 1804, and by 1857 it may have been owned by Henry Tate. No reliable information indicates when it returned to France. Thoré claimed in his 1866 article in the *Gazette des Beaux-Arts* that the painting was offered by Christie's in London in 1863, but the details of this sale have not been traced. It is known, however, that *The Astronomer* was not among the eleven paintings in the 1866 exhibition of Vermeer's work in Paris. Meissonier may well have

been familiar with the work through a 1784 engraving by Louis Garreau. This reproduction was included by Jean-Baptiste-Pierre Le Brun (the dealer who owned the painting and commissioned the engraving) in his three-volume illustrated publication, *Galérie des peintres flamands, hollandais et allemands* (Paris, 1792–96), vol. 2, p. 49. On Le Brun, see Ivan Gaskell, "Tradesmen as Scholars: Interdependencies in the Study and Exchange of Art," *Art History and Its Institutions: Foundations of a Discipline*, ed. Elizabeth Mansfield (London and New York: Routledge, 2002), pp. 146–62. For the 1866 Vermeer exhibition in Paris, see Gaskell's *Vermeer's Wager* (London: Reaktion, 2000), p. 123. I am grateful to Dr. Gaskell for supplying this information.

22 Quoted in Hungerford, *Ernest Meissonier*, p. 35.

23 Zeldin, *Taste and Corruption*, p. 112.

24 *La Presse*, June 2, 1865.

25 Edmond and Jules de Goncourt, *Pages from the Goncourt Journal*, p. 172.

26 Ibid.

27 See John Ingamells, *The Wallace Collection Catalogue of Pictures*, vol. 2, *French Nineteenth Century* (London: The Wallace Collection, 1986), p. 14.

28 For the prices paid for works at the Morny auction, see Hungerford, *Ernest Meissonier*, pp. 106–8; and Ingamells, op. cit., pp. 163, 168 and 172.

Chapter Seventeen: Maître Velázquez

1 Wilson-Bareau, ed., *Manet by Himself*, p. 34.

2 Ibid.

3 Quoted in Wilson-Bareau, "Manet and Spain," in Tinterow et al., eds., *Manet/Velázquez*, p. 230.

4 Quoted in ibid., p. 231.

5 Wilson-Bareau, ed., *Manet by Himself*, pp. 34 and 36.

6 Quoted in Tinterow, "Raphael Replaced," in *Manet/Velázquez*, p. 56.

7 Quoted in Erika Langmuir and Norbert Lynton, eds., *The Yale Dictionary of Art and Artists* (New Haven: Yale University Press, 2000), p. 711.

8 Quoted in Wilson-Bareau, "Manet and Spain," p. 235.

9 Wilson-Bareau, ed., *Manet by Himself*, p. 36.

10 For Duret's account, see *Histoire de Édouard Manet et de son oeuvre*, pp. 44–7.

11 *The Times*, October 5, 1865.

12 See the reports in *The Times*, October 5 and 16, 1865.

13 *Gazette des Hôpitaux*, October 31, 1865.

14 *The Times*, November 4, 1865.

15 Wilson-Bareau, ed., *Manet by Himself*, p. 37.

Chapter Eighteen: The Jury of Assassins

1 See Pasquier-Guignard, "L'Installation à Poissy," pp. 66–70; and Pasquier, "La Vie à la 'Grande Maison,'" p. 71–2.

2 Pasquier, "La Vie à la 'Grande Maison,'" p. 72.

3 "Extraits de l'agenda de Charles Meissonier," p. 73.

4 Ibid.

5 *Journal*, vol. 3, p. 1180. A recent scholar is more cautious in her speculations about the early relationship between Meissonier and Elisa Bezanson. Hungerford calls her Meissonier's "attentive friend from the later 1860s" (*Ernest Meissonier*, p. 5) and his "intimate friend and confidante" (*Ernest Meissonier: Rétrospective*, p. 173).

6 Gréard, *Meissonier*, p. 253.

7 Quoted in Roos, *Early Impressionism and the French State*, p. 10.

8 Ibid., pp. 61 and 237, note 32.

9 Holtzapffel's suicide note was reproduced in several newspapers, including *La Petite Revue* (April 21, 1866).

10 Tabarant, *Manet et ses oeuvres*, p. 123.

11 *L'Événement*, April 23, 1866.

12 *L'Événement*, April 25, 1866.

13 Quoted in Rewald, *History of Impressionism*, p. 200.

14 Quoted in Frederick Brown, *Zola: A Life* (London: Macmillan, 1996), p. 124.

15 Quoted in ibid.

16 *L'Événement*, April 30, 1866. The article is also reproduced in Zola, *Salons*, ed. F. W. J. Hemmings and Robert J. Neiss (Geneva: E. Droz, 1959), pp. 53–60.

Chapter Nineteen: Monet or Manet?

1 Quoted in Madeleine Fidell-Beaufort and Janine Bailly-Herzberg, *Daubigny: La Vie et l'oeuvre* (Paris: Éditions Geoffroy-Dechaume, 1975), p. 45.

2 Quoted in ibid., p. 57.

3 Rewald, *The History of Impressionism*, p. 142.

4 Quoted in John Rewald, *The Ordeal of Paul Cézanne* (London: Phoenix House, 1950), p. 26.

5 *The Ordeal of Paul Cézanne*, p. 38.

6 Ibid., p. 65.

7 Ibid., p. 39.

8 This letter is reproduced in Roos, *Early Impressionism and the French State*, p. 65.

9 *The Ordeal of Paul Cézanne*, p. 40.

10 *L'Événement*, May 7, 1866.

11 Wilson-Bareau, ed., *Manet by Himself*, p. 38.

12 Quoted in Roos, op. cit., p. 56.

13 Vollard, *Recollections of a Picture Dealer*, p. 18.

14 Quoted in Bowness et al., *Gustave Courbet*, p. 40; and Rewald, *The History of Impressionism*, p. 125.

15 *Letters of Gustave Courbet*, pp. 267–8.

16 *The Correspondence of James McNeill Whistler*, no. 11310.

17 Quoted in Weintraub, *Whistler*, p. 116.

18 Quoted in ibid., p. 118.

19 For Khalil Bey, see Francis Haskell, "A Turk and His Pictures in Nineteenth-Century Paris," *The Oxford Art Journal*, vol. 5 (1982), pp. 40–7. Khalil Bey was also the owner, at this time, of Ingres's *Turkish Bath*, which he purchased in 1865.

20 *Letters of Gustave Courbet*, p. 276.

21 Ibid.

22 Quoted in Rewald, *The History of Impressionism*, p. 144.

23 Quoted in Georges Jean-Aubry, *Eugène Boudin* (Paris: Bernheim-Jeune, 1922), p. 62. The word used by Boudin to describe the painting was *tartine*, which literally means a slice of bread and butter but also has the figurative sense of a long-winded discourse.

24 *Monet by Himself: Paintings, drawings, pastels, letters*, ed. Richard Kendall, trans. Bridget Strevens Romer (London: Macdonald Orbis, 1989), p. 23.

25 Quoted in Joel Isaacson, *Monet: "Le Déjeuner sur l'herbe"* (London: Allen Lane, 1972), p. 30.

26 *L'Événement*, May 11, 1866.

27 *Monet by Himself*, p. 23.

28 On these sales, see Paul Hayes Tucker, *Claude Monet: Life and Art* (New Haven: Yale University Press, 1995), p. 24.

29 *La Lune*, May 13, 1866.

30 *L'Artiste*, June 15, 1866.

31 Paul Hayes Tucker claims that this story is probably apocryphal since "the trench would have to have been a veritable canal—the picture is eight feet tall! Even if he had done such excavation, we know that the unfinished painting was shipped to him after he left Sèvres for Honfleur in the later summer or early fall of 1866 and that he completed it in his studio there on the coast" (*Claude Monet*, p. 31).

Chapter Twenty: A Flash of Swords

1 For this episode, see "Extraits de l'agenda de Charles Meissonier," p. 73.

2 This damage was noted on December 4, 1894, by the American art restorer George H. Storey. For Storey's report on the condition of *Friedland* I am indebted to Charlotte Hale, Paintings Conservator at the Metropolitan Museum of Art, New York.

3 "Extraits de l'agenda de Charles Meissonier," p. 73.

4 I am grateful to Charlotte Hale for providing this information from Storey's 1894 report on *Friedland*.

5 Quoted in Brombert, *Édouard Manet*, p. 353. This remark comes from 1875.

6 Quoted in Richardson, *Théophile Gautier: His Life and Times* (London: Max Reinhardt, 1958), p. 215.

7 *La Revue du XIXᵉ Siècle*, January 1, 1867.

8 Wilson-Bareau, ed., *Manet by Himself*, p. 41.

9 Quoted in Mainardi, *Art and Politics of the Second Empire*, p. 139.

10 *L'Artiste*, May 1, 1867.

11 Brown, *Zola*, p. 315.

12 Wilson-Bareau, ed., *Manet by Himself*, p. 12.

Chapter Twenty-one: Marvels, Wonders and Miracles

1 Quoted in Brian and J. M. Chapman, *The Life and Times of Baron Haussmann*, p. 202.

2 For the full catalogue, see *Paris Universal Exhibition, 1867: Complete Official Catalogue*, 2nd edition (London and Paris, 1867).

3 *Le Temps*, May 22, 1867.

4 *The Times*, April 1, 1867.

5 *La Liberté*, April 1, 1867.

6 *Le Figaro*, April 5, 1867.

7 Quoted in Rewald, *History of Impressionism*, p. 168.

8 *Monet by Himself*, p. 20.

9 Quoted in Tucker, *Claude Monet*, p. 34.

10 Quoted in Rewald, *The History of Impressionism*, p. 150. For the various sources of this story, a number of which attribute Manet's remark to different paintings, see ibid., p. 193, note 19.

11 Quoted in Mainardi, *Art and Politics of the Second Empire*, p. 137.

12 Boime, "The Salon des Refusés and the Evolution of Modern Art," p. 418.

13 Quoted in Mainardi, op. cit., p. 136.

14 Tabarant, *Manet et ses oeuvres*, pp. 135–6.

15 Ibid., p. 132.

16 *Revue libérale*, June 1867.

17 Wilson-Bareau, ed., *Manet by Himself*, p. 42.

18 The text of this preface may be found in ibid., p. 43.

19 *Monet by Himself*, p. 24.

20 *L'Indépendance belge*, June 15, 1867.

21 *Revue libérale*, June 1867.

22 *Le Journal amusant*, June 29, 1867.

23 Proust, *Manet: souvenirs*, p. 55.

24 This, at least, is the price quoted in *Le Journal amusant* for June 29, 1867.

25 Quoted in Courthion and Cailler, eds., *Portrait of Manet*, trans. Michael Ross, p. 61.

26 *Letters of Gustave Courbet*, p. 315.

27 *Monet by Himself*, p. 24.

28 *Pages from the Goncourt Journal*, p. 149.

29 Quoted in Gaunt, *The Pre-Raphaelite Tragedy*, pp. 82 and 140.

30 *The Correspondence of James McNeill Whistler*, no. 11312.

31 Quoted in Weintraub, *Whistler*, p. 125. For Nieuwerkerke's admiration for Whistler's work, see *The Correspondence of James McNeill Whistler*, nos. 09216, 02644 and 09191.

32 *Notes and Sketches of the Paris Exhibition* (London, 1868), p. 79.

33 *La Situation*, July 1, 1867.

34 Charles Blanc, "Exposition Universelle de 1867," quoted in ibid., *Les Artistes de mon temps* (Paris, 1876), p. 321; *L'Illustration*, November 23, 1867; *Gazette des Beaux-Arts*, October 1, 1867; *L'Artiste*, May 1, 1867; *Salons de W. Bürger*, quoted in Hungerford, *Ernest Meissonier*, p. 95; *Le Correspondant*, August 1867.

35 This work, the Tyler Davidson Fountain, was completed in 1871 and now stands in Fountain Square (formerly Probasco Square) in downtown Cincinnati.

36 For Probasco's bid of 150,000 dollars, see Mollett, *Meissonier*, p. 56. Writing in 1882, fifteen years after the fact, Mollett identifies the work in question not specifically as *Friedland*—discussed elsewhere in his text—but as "Cavalry Charge," which he claims Probasco successfully acquired in 1867. However, there is no record (e.g., in Gréard) of Meissonier ever having painted a work named "Cavalry Charge." The Probasco collection was dispersed in 1887, and I have been unable to determine the

identity of this painting—if, indeed, it ever existed. I suspect that Probasco's bid—ultimately unsuccessful—was actually for *Friedland*, the only painting for which Meissonier expected compensation of more than 100,000 francs. *Friedland* was sometimes known by varying names, including "Cavalry Charge." For example, Théodore Duret (writing in 1906) called it "Charge des cuirassiers" (*Histoire de Édouard Manet et de son oeuvre*, p. 124).

Chapter Twenty-two: Funeral for a Friend

1 Quoted in Ridley, *Napoleon III and Eugénie*, p. 532.
2 Quoted in ibid., p. 526.
3 *L'Indépendance belge*, July 6, 1867.
4 Courthion and Cailler, *Portrait of Manet*, p. 40.
5 This visit is confirmed in Wilson-Bareau and Degener, eds., *Manet and the Sea*, p. 258.
6 *Correspondance de Baudelaire*, vol. 2, p. 253.
7 Ibid., p. 460.
8 For a discussion of this painting and its relation to Paris's topography and monuments, see Nancy Locke, "Unfinished Homage: Manet's Burial and Baudelaire," *The Art Bulletin* (March 2000), pp. 68–82.
9 Quoted in McMullen, *Degas*, p. 119.
10 Plateau would publish his study in 1873. For a discussion of the surprisingly long and important scientific history of soap bubbles, see Michele Emmer, "Architecture and Mathematics: Soap Bubbles and Soap Films," in *Nexus: Architecture and Mathematics*, ed. Kim Williams (Florence: Edizioni dell'Erba, 1996), pp. 53–65.
11 This account seems to have originated with Manet's friend Théodore Duret: see *Histoire de Édouard Manet et de son oeuvre*, p. 115. However, Juliet Wilson-Bareau argues that this story "may have been a picturesque invention of the kind often used to catch the imagination of the public and enhance the 'veracity' of a history painting": see "Manet and *The Execution of Maximilian*," in Wilson-Bareau et al., *Manet: "The Execution of Maximilian": Painting, Politics, Censorship* (London: National Gallery Publications, 1992), p. 55.
12 Wilson-Bareau, "Manet and *The Execution of Maximilian*," p. 55.
13 Ibid., p. 52.
14 See Henri Loyrette's review, in the September 1992 *Burlington Magazine*, of a 1992 exhibition at the National Gallery, London, entitled *Manet: The Execution of Maximilian*. Loyrette makes the case that Manet's "clear and straightforward purpose was to denounce the French attitude to the incident" (p. 613).

Chapter Twenty-three: Manoeuvres

1 Gréard, *Meissonier*, p. 185. For Colonel Dupressoir ordering his cuirassiers to perform manoeuvres for Meissonier, see Yriarte, "E. Meissonier," p. 835.
2 Yriarte, "E. Meissonier," p. 835.
3 Quoted in Hungerford, *Ernest Meissonier*, p. 166.
4 "E. Meissonier," p. 835.
5 Ibid.
6 Wolff, *La Capitale de l'art* (Paris, 1886), p. 181.

7 For a description of this work, see Gréard, *Meissonier*, p. 378. For the price paid by Dela-hante, see Hungerford, *Ernest Meissonier*, p. 259, note 11.

8 For the price of *Friedland*, see the report in *Paris-Artiste*, January 25, 1872, cited in Hungerford, *Ernest Meissonier*, p. 160. Hungerford states that Meissonier agreed to sell *Friedland* to Lord Hertford some time around 1867 (ibid.)—that is, at the time of the Universal Exposition or shortly thereafter.

9 The author of the article in *Le Moniteur* was no less an authority than Napoleon Bona-parte: see D. M. Tugan-Baranovsky, "Napoleon as Journalist," in *Napoleonic Scholarship: The Journal of the International Napoleonic Society* 1 (December 1998), online at www.napoleonicsociety.com.

10 Blanc, *Les Artistes de mon temps*, p. 321.

11 *Revue du XIXᵉ Siècle*, June 1866.

12 Quoted in Philip Nord, *Impressionists and Politics: Art and Democracy in the Nineteenth Century* (London and New York: Routledge, 2000), p. 48.

13 Quoted in Roos, *Early Impressionism and the French State*, p. 103. For these activities of Courbet et al., see ibid., pp. 103–4, and Mainardi, *Art and Politics of the Second Empire*, pp. 187–8.

14 *Thérèse Raquin*, trans. Andrew Rothwell (Oxford: Oxford University Press, 1992), p. 28.

15 Ibid., p. 62.

16 Quoted in Brown, *Zola*, p. 156.

17 *Le Figaro*, January 23, 1868. Since the author of the review has been identified as Zola's friend Louis Ulbach, it has been suggested that Zola, hoping to enhance his notoriety, was himself directly responsible for this campaign against "putrid literature." Certainly Zola was not above such practices. When his first book, *Les Contes à Ninon*, came out in 1864, he took the liberty of writing favourable reviews which he then obligingly sent to various newspapers (for this episode, see Brown, *Zola*, p. 119).

18 For this Preface, see *Thérèse Raquin*, pp. 1–6.

19 Ibid., p. 2.

20 Wilson-Bareau, ed., *Manet by Himself*, p. 45.

21 Ibid.

22 In total, 839 painters cast ballots in 1868, against only 125 in 1867 (Roos, *Early Impres-sionism and the French State*, p. 104).

23 This description comes from Zola's novel *L'Oeuvre*, first published in 1886; see *The Mas-terpiece*, trans. Thomas Walton, pp. 314–15.

24 Astruc, *Le Salon intime: Exposition au boulevard des Italiens* (Paris, 1860), p. 91.

25 *L'Artiste*, September 6, 1857.

26 *The Journal of Eugène Delacroix*, p. 187.

Chapter Twenty-four: A Salon of Newcomers

1 Roos, *Early Impressionism and the French State*, p. 251, note 15.

2 Rewald, *The History of Impressionism*, p. 185.

3 Quoted in Rewald, *The Ordeal of Paul Cézanne*, p. 59.

4 Ernest d'Hervilly, *Le Rappel*, April 17, 1874. D'Hervilly is here describing Cézanne's typ-ical appearance in the 1860s.

5 Quoted in Brombert, *Édouard Manet*, p. 228.

6 Quoted in Roos, op. cit., p. 117.

7 *Monet by Himself*, p. 25.

8 Quoted in Roos, op. cit., p. 117.

9 Quoted in Roger L. Williams, *The French Revolution of 1870–1871* (London: Weidenfeld & Nicolson, 1969), p. 45.

10 *The Athenaeum*, November 8, 1862.

11 Though this novel never made it into print, a recent historian has suggested that Napoleon III's contribution to the history of the novel was twofold: "to have confounded the view that we all have a novel in us and to have confirmed the view that there are very many novels that are better for never having been written" (Baguley, *Napoleon III and His Regime*, p. 337).

12 Quoted in Brown, *Zola*, p. 172. See also Zeldin, *Politics and Anger*, p. 175; and David Thomson, *Europe Since Napoleon* (Harmondsworth, Middlesex: Penguin, 1966), p. 268.

13 Quoted in Ralph E. Shikes and Paula Harper, *Pissarro: His Life and Work* (London: Quartet Books, 1980), p. 75.

14 For the positive reception of Pissarro's work in 1868, see ibid.

15 *L'Événement illustré*, May 10, 1868.

16 Quoted in Hamilton, *Manet and his Critics*, p. 123.

17 *Le Nain Jaune*, June 5, 1868; *Gazette des Beaux-Arts*, June 1, 1868; *L'Artiste*, May 1868. For samples of the other reviews, see Hamilton, *Manet and His Critics*, p. 129.

18 *Le Moniteur universel*, May 11, 1868.

19 *L'Événement illustré*, May 10, 1868.

20 These reviews have been reprinted in Zola, *Écrits sur l'art*, ed. Jean-Pierre Leduc-Adine (Paris: Gallimard, 1991), pp. 191–223. For the importance of Zola's articles in *L'Événement illustré* for identifying this avant-garde, and for the importance of the 1868 Salon more generally, see the excellent discussion in Roos, *Early Impressionism and the French State*, pp. 122–3.

21 For the *dépotoir* in the 1868 Salon, see Roos, op. cit., p. 119.

Chapter Twenty-five: Au Bord de la Mer

1 Quoted in Theodore Zeldin, *Intellect and Pride: France 1848–1945* (Oxford: Oxford University Press, 1980), p. 45. The writer quoted is Alphonse Daudet, who was born in Nîmes in 1840. For Zeldin's excellent discussion of the place of Provençals in the French imagination, see ibid., pp. 43–54.

2 Quoted in Shackleford and Wissman, *Impressions of Light*, p. 63.

3 Gréard, *Meissonier*, p. 49.

4 Ibid., p. 302.

5 Ibid., p. 195.

6 On this matter, see Dominique Brachlianoff's argument that Meissonier, at the time of his stay in Antibes, was influenced by the future Impressionists: "Meissonier reveals in his landscapes the concerns and qualities close to those of the Impressionists whose influence

he incontestably absorbed" ("Heureux les Paysagistes!," in *Ernest Meissonier: Rétrospective*, p. 149).

7 Meissonier's efforts eventually won the plaudits they deserved: one of these works, *La Route de la Salice*, was recently declared "one of the great successes of landscape painting in the nineteenth century" (quoted in *Ernest Meissonier: Rétrospective*, p. 150).

8 Gréard, *Meissonier*, p. 99.

9 Ibid.

10 Ibid., pp. 98–9.

11 This sketchbook, only recently rediscovered, is held in the Département des Arts graphiques in the Musée du Louvre; for some illustrations—as well as for an account of Manet's Boulogne sojourn in 1868—see Wilson-Bareau and Degener, "Manet and the Sea," pp. 67–70 and 112–16.

12 On the genesis of the term *pompier*, see James Harding, *Artistes Pompiers: French Academic Art in the 19th Century* (London: Academy Editions, 1979), p. 7.

13 Quoted in Peter Ackroyd, *London: The Biography* (London: Chatto & Windus, 2000), pp. 587–8. James was writing in 1869.

14 *Gaslight and Daylight* (London, 1859), p. 165.

15 Ackroyd, op. cit., p. 576.

16 Quoting the Service National des Statistiques, Zeldin finds 12,000 French permanently in Britain—the vast majority presumably in London—in 1861, and 26,600 in 1881 (*Intellect and Pride*, p. 89). For Sala's description of the French in London, see Sala, *Gaslight and Daylight*, p. 169.

17 *Annual Register: A Review of Public Events at Home and Abroad, for the Year 1868* (London, 1869), p. 86.

18 *The Illustrated London News*, August 8, 1868.

19 *The Times*, July 30, and August 1, 1868.

20 *Illustrated London News*, July 4, 1868.

21 Wilson-Bareau, ed., *Manet by Himself*, p. 47.

22 Ibid.

Chapter Twenty-six: Mademoiselle Berthe

1 Quoted in Kathleen Adler and Tamar Garb, *Berthe Morisot* (Oxford: Oxford University Press, 1987), p. 10.

2 As noted above, forty-six women are listed in the Salon des Refusés catalogue reproduced in Wildenstein, "Le Salon des refusés de 1863," pp. 132–52. For the participation of women in the regular Salons, see Roos, *Early Impressionism and the French State*, pp. 18–19.

3 See *Oeuvres exposées au salon annuel organisé par le Ministère de la Maison de l'Empereur et des beaux-arts* (Paris, 1868).

4 For a sceptical treatment of this legend, see Margaret Shennan, *Berthe Morisot: The First Lady of Impressionism* (Stroud, Gloucestershire: Sutton Publishing, 1996), p. 5.

5 Quoted in ibid., p. 38.

6 *Gazette des Beaux-Arts*, July 1865.

7 Wilson-Bareau, ed., *Manet by Himself*, p. 49.

8 On these influences, see Tinterow and Lacambre et al., eds., *Manet/Velázquez*, p. 499.

9 Quoted in Shennan, op. cit., p. 39.

10 *The Correspondence of Berthe Morisot*, ed. Denis Rouart, trans. Betty W. Hubbard (London: Lund Humphries, 1957), p. 31.

11 *L'Événement illustré*, May 10, 1868.

12 *The Correspondence of Berthe Morisot*, p. 29.

13 Brombert, *Édouard Manet*, p. 237. On the possible nature of the relationship between Manet and Morisot, see ibid., pp. 235–40; and Shennan, op. cit., pp. 90–1.

14 For this interpretation, see Shennan, op. cit., p. 90.

15 The distinguished lithographic printer Lemercier, born in 1802, winner of numerous international medals and an officer in the Legion of Honour, is identified as "Rémond-Jules Lemercier" in Pierre Larousse's *Grand Dictionnaire Universel du XIXᵉ Siècle*, vol. 10 (Paris, 1873); but ninety years later, in vol. 16 of the *Grand Larousse encyclopédique*, he has mutated into "Rose-Joseph Lemercier" (1802–87) and become a student of Senefelder.

16 Wilson-Bareau, ed., *Manet by Himself*, p. 50.

17 *Chronique des arts et de la curiosité*, February 7, 1869.

18 Vollard, *Recollections of a Picture Dealer*, p. 54.

19 For this story, see ibid., p. 55. The remnants of this version are now in the National Gallery, London.

20 *The Correspondence of Berthe Morisot*, p. 29.

Chapter Twenty-seven: Flying Gallops

1 Pasquier-Guignard, "L'Installation à Poissy," p. 68.

2 *Gazette des Beaux-Arts*, May 1862.

3 Gréard, *Meissonier*, p. 78.

4 Émile Duhousset, *Le Cheval: Études sur les allures, l'extérieur et les proportions du cheval* (Paris, 1874), p. 13, quoted in Gotlieb, *The Plight of Emulation*, p. 165. For Gotlieb's excellent discussion of Meissonier's studies of equine locomotion, see ibid., pp. 165–84.

5 On these matters, see Gréard, *Meissonier*, p. 77.

6 See Gotlieb, *The Plight of Emulation*, p. 165.

7 On these matters, see the essays in Ernest Gombrich, *The Image and the Eye: Further Studies in the Psychology of Pictorial Representation* (Oxford: Phaidon Press, 1982). Gombrich provides a brief account of the flying gallop on p. 44. See also his discussion of "minimum models" on pp. 78–9.

8 Yriarte, "E. Meissonier," p. 835.

9 Gréard, *Meissonier*, p. 78.

10 Yriarte, "E. Meissonier," p. 835.

11 See Marta Braun, *Picturing Time: The Work of Étienne-Jules Marey* (Chicago: University of Chicago Press, 1992), which also examines Marey's work with photography later in his career.

12 Yriarte, "E. Meissonier," p. 835.

13 Zeldin, *Taste and Corruption*, p. 289.

14 On these matters, see ibid., pp. 290–2.

15 Albert Wolff, quoted in Milner, *The Studios of Paris*, p. 102.

16 Yriarte, "E. Meissonier," p. 835; Gréard, *Meissonier*, p. 78; and Gérôme, quoted in Gotlieb, *The Plight of Emulation*, p. 172. Yriarte claims that these studies began in 1869 (see p. 835).

17 Yriarte, "E. Meissonier," p. 835.

18 Gréard, *Meissonier*, p. 78.

19 Much work has been done on the flying gallop as it was ultimately captured on film by Eadweard Muybridge in the late 1870s. For an interesting recent example, see Rebecca Solnit, *River of Shadows: Eadweard Muybridge and the Technological Wild West* (New York: Penguin, 2003), pp. 179–98. For the implications of Muybridge's photographs for Meissonier's work, see Gréard, *Meissonier*, p. 77; and more particularly Gotlieb, *The Plight of Emulation*, pp. 175–84.

20 See James Elkins, "Michelangelo and the Human Form: His Knowledge and Use of Human Anatomy," *Art History* (June 1984), pp. 176–85.

21 Gréard, *Meissonier*, p. 77.

22 Alfred Cobban, *A History of Modern France*, pp. 192–3.

23 For the political climate during the 1869 elections, see Zeldin, *The Political System of Napoleon III*, pp. 139–40.

24 *Monet by Himself*, p. 26.

25 Ibid.

26 Ibid., p. 27.

27 Morisot, *Correspondence*, p. 30.

28 Ibid., pp. 30–1.

29 Ibid., p. 31.

30 Ibid.

31 Ibid.

32 Armand Silvestre, quoted in Rewald, *The History of Impressionism*, p. 198.

33 Morisot, *Correspondence*, p. 39.

34 *L'Illustration*, May 15, 1869; *Gazette de France*, May 17–18, 1869; *Le Figaro*, May 20, 1869; *Le Siècle*, June 11, 1869.

35 Morisot, *Correspondence*, p. 35.

36 Ibid.

37 Bicknell, *Life in the Tuileries Under the Second Empire*, p. 201.

38 Quoted in Ridley, *Napoleon III and Eugénie*, p. 550.

Chapter Twenty-eight: The Wild Boar of the Batignolles

1 Quoted in Williams, *The French Revolution*, p. 61.

2 See Theodore Zeldin, *Émile Ollivier and the Liberal Empire of Napoleon III* (Oxford: Clarendon Press, 1963).

3 Quoted in ibid., p. 120.

4 See Roger L. Williams, *Henri Rochefort: Prince of the Gutter Press* (New York: Charles Scribner's Sons, 1966).

5 Quoted in ibid., p. 130.

6 *Illustrated London News*, July 28, 1888.

7 Zeldin, *Taste and Corruption*, p. 156.

8 For this duel, see E. A. Vizetelly, *The Court of the Tuileries, 1852–1870* (London: Chatto
 & Windus, 1907), pp. 218–19.

9 On the Noir case, see Roger L. Williams, *Manners and Murders in the World of Louis-
 Napoleon* (Seattle: University of Washington Press, 1975), pp. 127–50.

10 Bicknell, *Life in the Tuileries Under the Second Empire*, p. 63.

11 *La Marseillaise*, January 11, 1870.

12 Quoted in Zeldin, *Politics and Anger*, p. 187.

13 Morisot, *Correspondence*, p. 37.

14 Ibid., p. 38.

15 Ibid., p. 39.

16 Ibid., p. 40.

17 Ibid., p. 38.

18 Ibid., p. 33.

19 *Paris-Journal*, February 19, 1870.

20 Quoted in McMullen, *Degas*, p. 142.

21 Wilson-Bareau, ed., *Manet by Himself*, p. 51; Vollard, *Recollections of a Picture Dealer*,
 p. 150.

22 See the official statement quoted in Courthion and Cailler, eds., *Portrait of Manet*, p. 66.

23 Wilson-Bareau, ed., *Manet by Himself*, p. 51.

24 Vollard, *Recollections of a Picture Dealer*, p. 150; Bernier, *Paris Cafés*, p. 42.

25 Wilson-Bareau, ed., *Manet by Himself*, p. 51.

26 Ibid., p. 12.

27 For La Rochenoire's proposal, see Roos, *Early Impressionism and the French State*,
 pp. 136–7.

28 Quoted in ibid., p. 136.

29 Quoted in ibid., p. 137.

30 Tabarant, *Manet et ses oeuvres*, p. 175.

31 Quoted in Roos, *Early Impressionism and the French State*, p. 135. For the election of
 Chennevières, with whom many of the artists had sympathy, see ibid., p. 138.

Chapter Twenty-nine: Vaulting Ambitions

1 Gréard, *Meissonier*, p. 58.

2 Ferdinand de Lasteyrie, *La Peinture à l'Exposition universelle de 1855* (Paris, 1863), p. 149.

3 Joseph C. Sloane, *French Painting Between the Past and the Present* (Princeton: Princeton
 University Press, 1951), p. 134. On this commission, see two other works by Sloane: *Paul-
 Marc Chenavard: Artist of 1848* (Chapel Hill: University of North Carolina Press, 1962);
 and "Paul Chenavard's Cartoons for the Mural Decoration of the Panthéon," *The Art
 Bulletin* (December 1951), pp. 240–58; as well as Gotlieb, *The Plight of Emulation*,
 pp. 37–44.

4 Quoted in Gotlieb, op. cit., p. 44. According to Gotlieb: "The Panthéon offered Meis-
 sonier what even the Napoleonic subjects could not, a site whose appropriateness and
 manifest significance were beyond question. Here was a supreme opportunity to secure
 his position as leader of the French school" (ibid., p. 19). Gotlieb states that Meissonier

made the offer to Chenavard "sometime around" 1874 (p. 44), but no doubt he had coveted the project for several years at least.

5 Yriarte, "E. Meissonier," p. 828.

6 Quoted in Rewald, *The History of Impressionism*, p. 246.

7 Quoted in Rewald, *The Ordeal of Paul Cézanne*, p. 68.

8 *Monet by Himself*, p. 27.

9 Quoted in Rewald, *The History of Impressionism*, p. 226.

10 Now the Île de la Chaussée.

11 Eugène Chapu, *Le Sport à Paris* (Paris, 1854), p. 208; quoted in Herbert, *Impressionism: Art, Leisure and Parisian Society*, p. 211. For Herbert's account of Manet and Renoir at La Grenouillère, see ibid., pp. 202–19.

12 Quoted in Philip Ball, *Bright Earth: The Invention of Colour* (London: Viking, 2001), p. 153.

13 Quoted in Simon Jennings, *The Collins Artists' Colour Manual* (London: HarperCollins, 2003), p. 55. For Monet's pigments at this time, see Ashok Roy et al., "Monet's *Bathers at La Grenouillère*," *National Gallery Technical Bulletin* (1981), pp. 14–25.

14 Quoted in Herbert, *Impressionism: Art, Leisure and Parisian Society*, p. 312.

15 Quoted in ibid., p. 226.

16 Quoted in ibid., p. 240.

17 On this plot, which may have been a fabrication by the government, see Ridley, *Napoleon III and Eugénie*, pp. 555–6; and the report in *The Illustrated London News*, May 14, 1870.

18 Quoted in Rewald, *The History of Impressionism*, p. 150.

19 *Le Figaro*, May 13, 1870; *La Presse*, June 23, 1870; *L'Illustration*, May 21, 1870; *Le Journal officiel*, July 18, 1870; *Le Siècle*, June 3, 1870; *Paris-Journal*, May 5, 1870.

20 *Le Journal officiel*, July 18, 1870.

21 For Polybius's account, see *The Histories of Polybius*, trans. Evelyn S. Shuckburgh (London, 1889), Book 38.

Chapter Thirty: The Prussian Terror

1 Quoted in Plessis, *The Rise and Fall of the Second Empire*, p. 166.

2 Quoted in *The Illustrated London News*, May 28, 1870.

3 *The Times*, May 23, 1870.

4 Malmesbury, *Memoirs*, vol. 2, p. 415.

5 *The Times*, June 7, 1870; *The Illustrated London News*, June 18, 1870.

6 *The Illustrated London News*, July 16, 1870.

7 Quoted in Ridley, *Napoleon III and Eugénie*, p. 561.

8 Many have written that Louis-Napoleon went to war with Prussia in order to prop up his corrupt and failing regime. For correctives to this view, see Plessis, *The Rise and Fall of the Second Empire*, p. 69; and Baguley, *Napoleon III and His Regime*, pp. 375–6. For the Empress Eugénie's actions and opinions, see Bicknell, *Life in the Tuileries Under the Second Empire*, pp. 214–15.

9 Quoted in D. W. Brogan, *The Development of Modern France, 1870–1939* (London: Hamish Hamilton, 1940), p. 14.

10 Quoted in Richardson, *Théophile Gautier*, p. 245.

11 Quoted in S. C. Burchell, *Upstart Empire: Paris During the Brilliant Years of Louis-Napoleon* (London: Macdonald, 1971), p. 321.

12 Plessis, *The Rise and Fall of the Second Empire*, p. 169; Alistair Horne, *The Fall of Paris: The Siege and the Commune, 1870–71* (New York: St. Martin's Press, 1965), p. 40.

13 Malmesbury, *Memoirs*, vol. 2, p. 414.

14 Quoted in Ridley, *Napoleon III and Eugénie*, p. 562.

15 Quoted in Williams, *The French Revolution*, p. 78.

16 *The Illustrated London News*, July 23, 1870.

17 Quoted in Richardson, *Théophile Gautier*, p. 245.

18 Gréard, *Meissonier*, p. 313.

19 Quoted in Hungerford, *Ernest Meissonier*, p. 137.

20 Gréard, *Meissonier*, p. 90.

21 *The Illustrated London News*, July 2, 1870.

22 Gréard, *Meissonier*, p. 312.

23 Quoted in Williams, *The Mortal Napoleon III*, p. 150.

24 Quoted in Baguley, *Napoleon III and His Regime*, p. 134.

25 Gréard, *Meissonier*, p. 310.

26 *Le Temps*, August 17, 1871.

27 Quoted in Otto Pflanze, *Bismarck and the Development of Modern Germany*, 3 vols. (Princeton: Princeton University Press, 1990), vol. 1, p. 474.

28 For Meissonier's account of his exodus from Metz, see Gréard, *Meissonier*, pp. 309–15.

29 Quoted in Horne, *The Fall of Paris*, p. 51.

30 Quoted in ibid.

31 Quoted in Williams, *The Mortal Napoleon III*, p. 166.

32 Quoted in Williams, *The French Revolution*, p. 80.

33 Quoted in Richardson, *Théophile Gautier*, p. 248.

Chapter Thirty-one: The Last Days of Paris

1 Gréard, *Meissonier*, pp. 315–16. For Louis-Joseph-Ernest Cézanne (1830–76), see *Larousse du XXᵉ Siècle*, 6 vols. (Paris: Librairie Larousse, 1928–33), vol. 2, p. 99.

2 William Wordsworth, *The Prelude*, ed. Jonathan Wordsworth (New York: W. W. Norton & Co., 1979), Book Tenth, line 692.

3 Quoted in Williams, *The French Revolution*, p. 81.

4 For Hugo's amorous dalliances at this time, see Horne, *The Fall of Paris*, p. 188. For his political aspirations, André Maurois, *Victor Hugo*, trans. Gerard Hopkins (London: Chatto & Windus, 1956), p. 413.

5 Gréard, *Meissonier*, p. 318.

6 Ibid., p. 93.

7 Hollis Clayson, *Paris in Despair: Art and Everyday Life Under Siege (1870–71)* (Chicago: University of Chicago Press, 2002), pp. 14–15. Clayson offers a superb account of the response to the siege, both artistic and military, of French painters and sculptors.

8 Quoted in ibid., p. 15.

9 *Letters of Gustave Courbet*, p. 402.

10 Mina Curtiss, ed. and trans., "Letters of Édouard Manet to his Wife," p. 379.

11 Morisot, *Correspondence*, p. 48.

12 Ibid., pp. 47–8.

13 Quoted in Brown, *Zola*, p. 61.

14 Quoted in ibid., p. 196.

15 Quoted in Horne, *The Fall of Paris*, p. 177.

16 Curtiss, ed., "Letters of Édouard Manet to his Wife," p. 381.

17 *Pages from the Goncourt Journal*, p. 193.

18 Curtiss, ed., "Letters of Édouard Manet to his Wife," p. 383.

19 For the balloon service during the siege of Paris, see Horne, *The Fall of Paris*, pp. 121–34.

20 McCauley, *Industrial Madness*, pp. 160–1.

21 See Jacques Fromaigeat, *La Poste par Pigeons, 1870–71* (Paris: Le Monde des Philatélistes, 1966); and Horne, *The Fall of Paris*, pp. 128–9.

22 Curtiss, ed., "Letters of Édouard Manet to his Wife," p. 384.

23 Ibid.

24 Ibid.

25 Quoted in Rebecca L. Spang, " 'And They Ate the Zoo': Relating Gastronomic Exoticism in the Siege of Paris," *MLN* (1992), p. 760.

26 Quoted in Richardson, *Théophile Gautier*, p. 252.

27 Quoted in Horne, *The Fall of Paris*, p. 136.

28 *The Illustrated London News*, August 28, 1869.

29 Zeldin, *Taste and Corruption*, p. 399.

30 Wilson-Bareau, ed., *Manet by Himself*, p. 60.

31 Curtiss, ed., "Letters of Édouard Manet to his Wife," p. 384.

32 For a discussion of this work, see Edward Lilley, "Manet's 'Modernity' and *Effet de Neige à Petit-Montrouge*," *Gazette des Beaux-Arts*, series 6, 118 (September 1991), pp. 107–10.

33 For the dating of the beginnings of this work to September 1870, see Hungerford, *Ernest Meissonier*, p. 141.

34 Gréard, *Meissonier*, p. 386.

35 Curtiss, ed., "Letters of Édouard Manet to His Wife," p. 386.

36 *Pages from the Goncourt Journal*, p. 199.

37 See Spang, " 'And They Ate the Zoo,' " p. 772.

38 Curtiss, ed., "Letters of Édouard Manet to His Wife," p. 388.

39 Gréard, *Meissonier*, p. 319.

40 Curtiss, ed., "Letters of Édouard Manet to His Wife," p. 386.

41 Ibid., p. 381.

42 Ibid., p. 385.

43 Horne, *The Fall of Paris*, p. 153.

44 For Meissonier's role in Manet's promotion to the General Staff, see Françoise Cachin, *Manet*, trans. Emily Read (New York: Henry Holt & Co., 1991), p. 96; and Clayson, *Paris in Despair*, p. 214. Art historians over the years have sometimes tried to suggest an antagonistic relationship between Manet and Meissonier in the National Guard. Curtiss, for example, in an otherwise excellent article, erroneously states that Meissonier had been Manet's commanding officer in the artillery, an occupation which Manet admitted that he

found "too demanding" ("Letters of Édouard Manet to His Wife," p. 385). Her implication, presumably, is that Meissonier was a harsh taskmaster who drove the hapless younger artist from his ranks.

45 *Histoire de Édouard Manet et de son oeuvre*, p. 124.

46 Ibid.

47 Proust, *Manet: souvenirs*, pp. 57–8. Like all of Antonin Proust's stories, this one must be taken with several grains of salt.

48 Curtiss, ed., "Letters of Édouard Manet to His Wife," pp. 386–7.

49 Gréard, *Meissonier*, p. 322.

Chapter Thirty-two: A Carnival of Blood

1 Curtiss, ed., "Letters of Édouard Manet to His Wife," p. 387.

2 Quoted in Horne, *The Fall of Paris*, p. 214.

3 Curtiss, ed., "Letters of Édouard Manet to His Wife," p. 387.

4 Ibid., p. 389.

5 *Pages from the Goncourt Journal*, p. 202.

6 Curtiss, ed., "Letters of Édouard Manet to His Wife," p. 389.

7 Gréard, *Meissonier*, p. 320.

8 Ibid., p. 95.

9 *Ernest Meissonier: Rétrospective*, p. 151.

10 Quoted in Mollett, *Meissonier*, p. 5.

11 Gréard, *Meissonier*, p. 112.

12 For the cast of characters in *The Siege of Paris*, including the portrayal of Henri Regnault, see Hungerford, *Ernest Meissonier*, pp. 141–3.

13 Gréard, *Meissonier*, p. 114.

14 Clarétie, *Peintres et sculpteurs contemporains*, 2 vols. (Paris, 1881), vol. 2, p. 5; Gréard, *Meissonier*, p. 114.

15 Quoted in Brombert, *Édouard Manet*, p. 261.

16 *Westminster Review*, October 1867.

17 Wilson-Bareau, ed., *Manet by Himself*, p. 160.

18 Quoted in Brown, *Zola*, p. 202.

19 Quoted in ibid., p. 208.

20 Quoted in Brombert, *Édouard Manet*, p. 288.

21 Quoted in Horne, *The Fall of Paris*, p. 214.

22 Gréard, *Meissonier*, p. 316.

23 Quoted in Milner, *The Studios of Paris*, p. 155.

24 Horne, *The Fall of Paris*, p. 273.

25 John Milner, *Art, War and Revolution in France, 1870–1871: Myth, Reportage and Reality* (New Haven: Yale University Press, 2000), p. 140.

26 Quoted in Horne, *The Fall of Paris*, p. 265.

27 Wilson-Bareau, ed., *Manet by Himself*, p. 161.

28 Quoted in Hungerford, *Ernest Meissonier*, pp. 144–5.

29 Quoted in Brombert, *Édouard Manet*, p. 288.

30 *Le Rappel*, April 29, 1871; Marx, quoted in Zeldin, *Politics and Anger*, p. 372.

31 For the political persuasions of the Communards, see Zeldin, *Politics and Anger*, pp. 371–4.

32 For Blanc's political opinions, see Zeldin, *Politics and Anger*, p. 85.

33 *Tableaux de siège: Paris 1870–1871* (Paris, 1871), p. 318.

34 *Letters of Gustave Courbet*, p. 385.

35 Ibid., p. 388.

36 Quoted in Milner, *Art, War and Revolution in France*, p. 154.

37 Quoted in Stewart Edwards, ed., *The Communards of Paris* (Ithaca: Cornell University Press, 1973), p. 148.

38 *Journal officiel de la Commune*, April 28, 1871, quoted in Roos, *Early Impressionism and the French State*, p. 155.

39 Hungerford, *Ernest Meissonier*, p. 148; *Ernest Meissonier: Rétrospective*, p. 175.

40 Quoted in Horne, *The Fall of Paris*, p. 351.

41 Quoted in Boime, *Art and the French Commune*, p. 205.

42 Quoted in Hungerford, *Ernest Meissonier*, p. 145.

43 *Pages from the Goncourt Journal*, p. 209.

44 Zeldin, *Politics and Anger*, p. 380; *Journal officiel*, May 25, 1871.

45 *The Times*, May 31, 1871.

46 For speculation as to the numbers of the dead, see Horne, *The Fall of Paris*, p. 418.

Chapter Thirty-three: Days of Hardship

1 Quoted in Rupert Christiansen, *Tales of the New Babylon* (London: Sinclair-Stevenson, 1994), p. 367.

2 Gautier, *Tableaux de siège*, p. 327; *Pages from the Goncourt Journal*, p. 212; *L'Illustration*, July 22, 1871.

3 On the commercialisation of the ruins, see Alisa Luxenberg, "Creating *Désastres*: Andrieu's Photographs of Urban Ruins in the Paris of 1871," *The Art Bulletin* 80 (March 1998), pp. 113–37.

4 Bicknell, *Life in the Tuileries under the Second Empire*, p. 85. For the balls in the Salle des Maréchaux during the Second Empire, see Vizetelly, *The Court of the Tuileries*, pp. 255–7.

5 Gréard, *Meissonier*, p. 266.

6 Ibid.

7 For a good discussion of *The Ruins of the Tuileries*, see Hungerford, *Ernest Meissonier*, pp. 145–8. For an argument that Meissonier's painting is profoundly anti-Commune, see Gen Doy, "The Camera Against the Paris Commune," in Victor Burgin, ed., *Photography/Politics* (London: Photographic Workshop, 1979), pp. 13–26. Doy's argument is capably refuted in Luxenberg, "Creating *Désastres*," pp. 130–1. Luxenberg points out that Meissonier's work cannot be seen as anti-Commune propaganda aimed at a bourgeois audience (as Doy claims) for the simple reason that he kept the work in his private possession, declining to exhibit the work until more than a decade after the Commune's suppression.

8 The precise date of Manet's return to Paris has never been reliably fixed, although Antonin Proust implies that he was present in Paris during the end of Bloody Week. He

states—incorrectly—that Manet "spent the Commune in the Pyrenees" and then re-turned to Paris "before the last battle of May" (*Édouard Manet: souvenirs*, p. 64).

9 Wilson-Bareau, ed., *Manet by Himself*, p. 161.

10 Ibid.

11 *Histoire de Édouard Manet et de son oeuvre*, p. 166.

12 For a good study of Manet's lithograph, see Jacquelynn Baas, "Édouard Manet and Civil War," *Art Journal* (Spring 1985), pp. 36–42, which points out Manet's debt to Gérôme's *Dead Caesar*. Rosenblum and Janson argue that other artistic precedents for Manet's *Civil War* include Goya's *Disasters of War*, Meissonier's *Remembrance of Civil War*, and Dau-mier's *Rue Transnonain* (*Art of the Nineteenth Century*, p. 327).

13 Rewald, *The Ordeal of Paul Cézanne*, p. 72.

14 Jean-Paul Bouillon, ed., "Les Lettres de Manet à Bracquemond," *Gazette des Beaux-Arts*, series 6 (April 1983), p. 151.

15 *The Correspondence of Berthe Morisot*, p. 63.

16 Quoted in Zeldin, *Politics and Anger*, p. 251. For Gambetta and his political ideology, see ibid., pp. 246–57.

17 Morisot, *Correspondence*, pp. 63 and 71.

18 Thomas Mayne Reed, *Croquet: A Treatise and Commentary* (London, 1863). For the game's history, see D. M. C. Prichard, *The History of Croquet* (London: Cassell, 1981).

19 *Souvenirs d'un directeur des beaux-arts*, vol. 1, p. 88.

20 *Grammaire des arts du dessin* (Paris, 1867), p. 7. Blanc originally published this work in serial form in the *Gazette des Beaux-Arts*. For discussions of his aesthetics, see Misook Song, *The Art Theories of Charles Blanc* (Ann Arbor: University of Michigan Press, 1984); and Shaw, "The Figure of Venus: Rhetoric of the Ideal and the Salon of 1863," pp. 549–53.

21 *Grammaire des arts du dessin*, p. 10.

22 *Gazette des Beaux-Arts*, October 1871. For discussions of the patriotic injunctions to artists in the early Third Republic, as well as of the artistic responses themselves, see Paul Hayes Tucker, "The First Impressionist Exhibition and Monet's *Impression, Sunrise*: A Tale of Timing, Commerce and Patriotism," *Art History* 7 (December 1984), pp. 465–76; and Christopher Robinson, "The Artist as 'Rénovateur': Paul Baudry and the Paris Opéra," *Art Journal* 46 (Winter 1987), pp. 285–9.

23 *Journal officiel*, December 19, 1871.

24 For reactionary responses to the Commune, see Christiansen, *Tales of the New Babylon*, pp. 380–7.

25 Quoted in Ridley, *Napoleon III and Eugénie*, p. 580.

26 Ibid., p. 584.

27 Quoted in Christiansen, *Tales of the New Babylon*, p. 162.

28 Quoted in ibid., p. 386.

Chapter Thirty-four: The Apples of Discord

1 Reports in *The Illustrated London News*, January 6, 1872; February 3, 1872; and February 17, 1872.

2 *L'Avenir nationale*, May 15, 1873. For Blanc's Museum of Copies, see Albert Boime, "Le

Musée des copies," *Gazette des Beaux-Arts*, series 6, 64 (1964), pp. 238–47; and Duro, " 'Un Livre Ouvert à l'Instruction,' " pp. 44–58.

3 Quoted in Roos, *Early Impressionism and the French State*, p. 168. For Blanc's intransigence in 1872, see ibid., pp. 165–9.

4 For Vollon's career, see Carol Forman Tabler et al., *Antoine Vollon, 1833–1900: A Painter's Painter* (New York: Wildenstein & Co., 2004).

5 Gréard, *Meissonier*, pp. 195, 290.

6 Quoted in Bowness et al., *Gustave Courbet*, p. 188.

7 *Letters of Gustave Courbet*, p. 416.

8 Ibid., p. 409. For a full list of Courbet's reforms, see ibid., pp. 410–11.

9 Ibid., p. 443.

10 Ibid., p. 440.

11 *Le Figaro*, April 10, 1872. For discussions of Meissonier's role in Courbet's exclusion, see Roos, *Early Impressionism and the French State*, pp. 171–4; and Hungerford, *Ernest Meissonier*, pp. 152–5.

12 Quoted by Jules-Antoine Castagnary in *Le Siècle*, April 9, 1872.

13 *Le Journal amusant*, May 18, 1872.

14 *Letters of Gustave Courbet*, p. 459.

15 *Le Figaro*, April 11, 1872.

16 For samples of how the newspapers rose to defend Courbet, see Roos, op. cit., pp. 173–4 and p. 267, notes 56–61; and Hungerford, *Ernest Meissonier*, pp. 154–5.

17 *Le Siècle*, April 9, 1872. On Castagnary, see Palomba Paves-Yashinsky, "Castagnary, le Naturalisme et Courbet," *Nineteenth-Century French Studies* (Spring 1976), pp. 332–43.

18 Breton, *The Life of an Artist*, trans. M. V. Sefrano (London, 1891), p. 188.

19 Quoted in Roos, op. cit., p. 175. On these demands, see also Boime, "The Salon des Refusés and the Evolution of Modern Art," p. 421.

20 Quoted in Tabarant, *Manet et ses oeuvres*, p. 191.

21 Quoted in ibid., p. 196.

22 For a recent study of Durand-Ruel, see Pierre Assouline, *Grâces lui soient rendues: Paul Durand-Ruel, le marchand des impressionistes* (Paris: Gallimard, 2004).

23 Quoted in Tabarant, op. cit., p. 196.

Chapter Thirty-five: A Ring of Gold

1 *La Cloche*, May 12, 1872.

2 *The Illustrated London News*, May 25, 1872; *La Revue de France*, May 30, 1872; *L'Opinion nationale*, May 11, 1872.

3 *Le Rappel*, May 11, 1872; *L'Opinion nationale*, June 29, 1872; *Le Gaulois*, July 3, 1872; *Le Figaro*, June 16, 1872.

4 Tabarant, *Manet et ses oeuvres*, p. 202.

5 *Le Figaro*, December 25, 1873. The visitor was Léon Duchemin, who used the pseudonym Fervacques. For a description and photographs of the studio, see Juliet Wilson-Bareau, *Manet, Monet, and the Gare Saint-Lazare* (Washington, D.C.: National Gallery of Art, 1998), pp. 145–6.

6 For this unfavourable reaction, see Perruchot, *Manet*, p. 190.

7 Gréard, *Meissonier*, p. 325.

8 For Meissonier's dealings with the Pereire brothers, who owned two of his paintings, see Hungerford, *Ernest Meissonier*, pp. 102–3. The transformation of the Batignolles into one of Paris's most fashionable districts is discussed—albeit with no reference to the Pereire brothers—in Milner, *The Studios of Paris*, pp. 171–2. On the Pereire brothers' lives, careers and speculative ventures, see Jean Autin, *Les Frères Pereire: Le Bonheur d'entreprendre* (Paris: Perrin, 1983).

9 Quoted in Hungerford, *Ernest Meissonier*, p. 160.

10 For the Raphael sale, see *The Illustrated London News*, May 10 and August 2, 1873. This work, *God the Father Blessing among the Angels*, a fresco transferred to canvas, is now thought to have been the work of Raphael's collaborators rather than of the master himself.

11 Henry James, *The Painter's Eye: Notes and Essays on the Pictorial Arts*, ed. John L. Sweeney (London: Rupert Hart-Davis, 1956), pp. 67 and 75.

Chapter Thirty-six: Pure Haarlem Beer

1 Tabarant, *Manet et ses oeuvres*, p. 203.

2 For the influence on Manet of both this particular work and the trip to Holland in general, see Brombert, *Édouard Manet*, pp. 309–11.

3 Cachin, *Manet*, p. 23.

4 For the topography described in this painting, see the discussion in Wilson-Bareau, *Manet, Monet, and the Gare Saint-Lazare*, pp. 44–9. Wilson-Bareau corrects a number of long-standing misapprehensions about the painting's viewpoint.

5 For an interesting discussion of how various details in the painting compromise the image of bourgeois domesticity, see Carol Armstrong, *Manet Manette* (New Haven: Yale University Press, 2002), pp. 203–6.

6 Quoted in Ridley, *Napoleon III and Eugénie*, p. 583.

7 *The Illustrated London News*, January 18, 1873.

8 Ridley, *Napoleon III and Eugénie*, pp. 590–1; *Le Journal officiel*, January 11, 1873.

9 Quoted in Robert Henry Thurston, *Reports of the Commissioners of the United States to the International Exhibition held at Vienna, 1873* (Washington, D.C., 1867), p. 87.

10 *Le XIX Siècle*, August 29, 1874.

11 Gréard, *Meissonier*, p. 290.

12 On this matter, see *Letters of Gustave Courbet*, pp. 471–2.

13 Ibid., p. 473.

14 For the classic study of Monet at this time, see Paul Hayes Tucker, *Monet at Argenteuil* (New Haven: Yale University Press, 1983).

15 Ludovic Piette, *Mon cher Pissarro: Lettres de Ludovic Piette à Camille Pissarro* (Paris: Valhermeil, 1985), p. 78.

16 *The Illustrated London News*, May 10, 1873.

17 Ibid.

18 *The Times*, May 6, 1873.

19 For samples of these reviews, see Hamilton, *Manet and the Critics*, p. 163; Brombert, *Édouard Manet*, p. 314; and Shennan, *Berthe Morisot*, p. 141.

20 On these matters, see Susannah Barrows, "After the Commune: Alcoholism, Temperance and Literature in the Early Third Republic," in John M. Merriman, ed., *Consciousness and Class Experience in 19th-Century Europe* (New York: Holmes & Meier, 1980), pp. 205–18.

21 *Le Soir*, May 6, 1873; *Le Gaulois*, May 13, 1873; *Le Temps*, May 24, 1873 ; *Le Figaro*, May 12, 1873. Stevens is quoted in Rewald, *History of Impressionism*, p. 302. For a fuller sample of the reviews, see Tabarant, *Manet et ses oeuvres*, pp. 205–12.

22 Quoted in Tabarant, op. cit., p. 212.

23 Quoted in Brombert, *Édouard Manet*, p. 314.

24 *L'Artiste*, June 1, 1873. On Montifaud's career, see Laurence Brogniez, "Marc de Montifaud: une femme en procès avec son siècle," *Sextant*, vol. 6 (1996), pp. 55–80.

Chapter Thirty-seven: Beyond Perfection

1 *The Illustrated London News*, September 20, 1873.

2 *The Illustrated London News*, November 8, 1873; *The Times*, August 23, 1873. For accounts of the French display in Vienna, as well as the 1873 exhibition more generally, see Elizabeth Gilmore Holt, ed., *The Art of All Nations: The Emerging Role of Exhibitions and Critics* (Princeton: Princeton University Press, 1982), pp. 545–72.

3 *The Times*, August 23, 1873.

4 Gréard, *Meissonier*, p. 294.

5 Quoted in Zeldin, *Politics and Anger*, p. 245.

6 Quoted in *The Times*, January 11, 1873.

7 For these reviews, see Hungerford, *Ernest Meissonier*, p. 174.

8 *The Times*, November 8, 1873.

9 Quoted in Mollett, *Meissonier*, p. 72.

10 Roger Ballu, quoted in Hungerford, *Ernest Meissonier*, p. 174.

11 Quoted in ibid.

12 *Revue des deux mondes*, February 15, 1876, as translated in Gotlieb, *The Plight of Emulation*, pp. 173–4. Houssaye was writing his critique after the painting had returned from Vienna to Paris.

13 Yriarte, "E. Meissonier," p. 837.

14 Ibid., p. 838.

15 Gréard, *Meissonier*, p. 294.

Chapter Thirty-eight: The Liberation of Paris

1 Quoted in Jean-Marie Mayeur, *Les Débuts de la Troisième République, 1871–1898* (Paris: Éditions du Seuil, 1973), p. 27.

2 For the pilgrims travelling to Lourdes in 1872, see *The Nation*, October 3, 1872.

3 Quoted in Bowness et al., *Gustave Courbet*, p. 48.

4 *Le Temps*, December 25, 1873.

5 Roos, "Aristocracy in the Arts," pp. 55–6.

6 Gréard, *Meissonier*, p. 266. Like most of the autobiographical reflections reproduced by Gréard, this one is difficult to date, but given its context—Meissonier speaks immediately before about the Panthéon commission and immediately afterwards about the

Commune—it appears to be from the early 1870s, when his house was under construction. Further evidence pointing to a date in the early 1870s is an allegorical sketch of the Arts, Science and Poetry which is dated 1873 (Gotlieb, *The Plight of Emulation*, p. 186).

7 Quoted in Gotlieb, *The Plight of Emulation*, p. 19.

8 Gréard, *Meissonier*, p. 263.

9 Quoted in Gotlieb, op. cit., p. 19.

10 Charles Seymour, ed., *Michelangelo: The Sistine Chapel Ceiling* (New York: W.W. Norton, 1972), p. 150.

11 For Delacroix's mural technique, see the essays in the exhibition catalogue *Eugène Delacroix à l'Assemblée Nationale*, ed. Arlotte Serullaz et al. (Paris: Assemblée Nationale, 1995). The results of his fresco experiments at the abbey of Valmont—*Anacréon, Leda and the Swan*, and *Bacchus and the Tiger*—are on display in Paris at the Musée National Eugène Delacroix.

12 *The Illustrated London News*, November 15, 1873.

13 *Le Chronique des arts*, January 17, 1874.

14 Vollard, *Recollections of a Picture Dealer*, p. 152. For Manet's relations with Renoir, see also Rewald, *The History of Impressionism*, pp. 341–2.

15 Quoted in Rewald, *The History of Impressionism*, p. 314.

16 *Le Siècle*, April 29, 1874.

17 Quoted in Darragon, *Manet*, p. 236.

18 *La Presse*, April 29, 1874 and *L'Artiste*, May 1, 1874. Paul Hayes Tucker argues that "we have generally overlooked the fact that while a few critics gave the exhibition scathing reviews, more liked it than not": of fourteen reviews, he notes, six were very positive, three mixed, and five negative ("The First Impressionist Exhibition," p. 465). For other positive reviews, see ibid., pp. 469ff., and Tucker, *Claude Monet*, p. 77.

19 Quoted in Rewald, *The History of Impressionism*, p. 316.

20 *Le Siècle*, April 29, 1874.

21 For a sample of these caricatures, see Wilson-Bareau, *Manet, Monet, and the Gare Saint-Lazare*, pp. 50–5.

22 *La Republique française*, June 9, 1874; *La Revue de France*, July 1874.

23 Not everyone was pleased with *L'Éminence grise*. Murmurs of complaint about the work's trivial and merely anecdotal subject matter were voiced by a few critics when the painting was awarded the Grand Medal of Honour. Gérôme, who was in Holland at the time, tried to decline the medal when he learned of this adverse reaction. The jury refused to rescind the medal, and so he donated it towards a student fund at the École des Beaux-Arts, raising 4,000 francs. On this matter, see Gerald Ackerman, *The Life and Work of Jean-Léon Gérôme* (London: Sotheby's Publications, 1986), p. 96. The painting is now in the Museum of Fine Arts, Boston.

24 *Le Temps*, November 1900.

25 For Monet at Argenteuil in 1874, see Tucker, *Claude Monet: Life and Art*, pp. 79–92; and idem, *Monet at Argenteuil*, passim.

26 Quoted in Michel, *Histoire de l'Art depuis les premiers temps chrétiens jusqu'à nos jours*, vol. 8, p. 581.

27 Herbert, *Impressionism: Art, Leisure, and Parisian Society*, pp. 234–6; Tucker, *Monet at Argenteuil*, pp. 90–7.

Epilogue: Finishing Touches

1 Quoted in Rewald, *The History of Impressionism*, p. 369.
2 Quoted in ibid., p. 370.
3 *New York Tribune*, April 11, 1886.
4 Quoted in Rewald, *The History of Impressionism*, p. 531.
5 *Art Amateur*, October 1887.
6 *Impressionist Paintings in the Louvre*, trans. S. Cunliffe-Owen (London: Thames & Hudson, 1963), p. 67. For good introductions to Impressionist painting in America, see the catalogues of two recent exhibitions: Nicolai Cikovsky, ed., *American Impressionism and Realism: The Margaret and Raymond Horowitz Collection* (Washington, D.C.: National Gallery of Art, 1998); and Elizabeth Prelinger, ed., *American Impressionism: Treasures from the Smithsonian American Art Museum* (New York: Watson-Guptil, 2000). On the collection of Henry and Louisine Havemeyer, see Sylvie Patin, et al., *La Collection Havemeyer: Quand l'Amerique découvrait l'impressionisme* (Paris: Éditions de la Réunion des musées nationaux, 1997). The Havemeyer mansion on Fifth Avenue has been demolished.
7 *Manet by Himself*, p. 264.
8 Quoted in Brombert, *Édouard Manet*, p. 453.
9 For the 1884 auction, see Tabarant, *Manet et ses oeuvres*, pp. 499–501.
10 On the controversies over the Caillebotte bequest, see Bazin, *Impressionist Paintings in the Louvre*, pp. 44–8; and Anne Distel et al., *Gustave Caillebotte: The Unknown Impressionist* (London: Royal Academy of Arts, 1996), pp. 22–3, and Appendix III, pp. 218–36, which attempts to reconstruct the entire collection. To give Bénédite his proper due, he cannot fairly be portrayed—as he often has been—as a backward-looking aesthetic conservative. He contributed to the catalogues for an 1897 Bracquemond exhibition at the Luxembourg, an 1899 Fantin-Latour exhibition at the Luxembourg, and a 1905 Whistler exhibition at the École des Beaux-Arts. He also published work on Alphonse Legros (1900) and Gustave Courbet (1911). The whereabouts of the two Manet paintings rejected from the Luxembourg are presently unknown.
11 *Le Figaro*, February 20, 1909.
12 Oulmont, "An Unpublished Watercolour Study for Manet's *Olympia*," *Burlington Magazine* (October 1912), p. 47.
13 Clark, *The Painting of Modern Life*, p. 79.
14 Quoted in Susan Grace Galassi, *Picasso's Variations on the Masters: Confrontations with the Past* (New York: Harry N. Abrams, 1996), p. 185.
15 See ibid., pp. 185–203.
16 Quoted in Bazin, *Impressionist Paintings in the Louvre*, p. 49.
17 Ibid., p. 77.
18 Robert Goldwater, "A French Nineteenth-Century Painting: Manet's Picnic," *Art in America* 34 (October 1947), p. 328.
19 Gustave Geffroy, quoted in Distel et al., *Gustave Caillebotte*, p. 222.

20 Gréard, *Meissonier*, p. 269.

21 James, *The Painter's Eye*, p. 180.

22 Spire Pitou, *The Paris Opera: An Encyclopedia of Operas, Ballets, Composers and Perform-ers* (Westport, Conn.: Greenwood Press, 1983), pp. 47–8.

23 Gréard, *Meissonier*, p. 345.

24 Ibid., p. 166.

25 *Histoire de l'Art depuis les premiers temps chrétiens jusqu'à nos jours*, vol. 8, part 2, p. 567.

26 Ibid., p. 581.

27 *Maîtres de la Belle Époque* (Paris: Hachette, 1966), pp. 49–55. For a good summary of Meissonier's unfavourable place in the art history of the twentieth century, see Hunger-ford, *Ernest Meissonier*, p. 3.

28 "Préface: Éloge d'Ernest Meissonier," p. 17.

29 *Mainstreams of Modern Art* (New York: Holt, Rhinehart & Winston, 1981), p. 127.

30 Thuiller, "Préface: Éloge d'Ernest Meissonier," in *Ernest Meissonier: Rétrospective*, p. 17. Thuiller does not identify the critic.

31 Quoted in ibid.

32 For the collapse of Anatole France's reputation, see Zeldin, *Taste and Corruption*, pp. 65–8.

33 Gréard, *Meissonier*, p. 341.

About, Edmond. *Salon de 1864* (Paris, 1864).

Ackerman, Gerald M. "Gérôme and Manet," *Gazette des Beaux-Arts*, series 6, 70 (1967), pp. 163–76.

———. *The Life and Work of Jean-Léon Gérôme* (London: Sotheby's Publications, 1986).

Ackroyd, Peter. *London: The Biography* (London: Chatto & Windus, 2000).

Adler, Katherine, and Tamar Gelb. *Berthe Morisot* (Oxford: Oxford University Press, 1987).

Albistur, Maité, and David Armogathe. *Histoire du Féminisme Français* (Paris, 1866).

Annual Register: A Review of Public Events at Home and Abroad, for the Year 1867 (London, 1868).

Annual Register: A Review of Public Events at Home and Abroad, for the Year 1868 (London, 1869).

Armstrong, Carol. "To Paint, to Point, to Pose: Manet's *Le Déjeuner sur l'herbe*," in Paul Hayes Tucker, ed., *Manet's* Le Déjeuner sur l'Herbe (Cambridge: Cambridge University Press, 1998), pp. 90–118.

Assouline, Pierre. *Grâces lui soient rendues: Paul Durand-Ruel, le marchand des impressionistes* (Paris: Gallimard, 2004).

Astruc, Zacharie. *Le Salon intime: Exposition au boulevard des Italiens* (Paris, 1860).

Auvray, Louis. *Exposition des beaux-arts: Salon de 1865* (Paris, 1865).

Ayres, James. *The Artist's Craft: A History of Tools, Techniques and Materials* (London: Guild Publishing, 1985).

Baas, Jacquelynn. "Édouard Manet and *Civil War*," *Art Journal* (Spring 1985), pp. 36–42.

Baguley, David. *Napoleon III and His Regime: An Extravaganza* (Baton Rouge: Louisiana State University Press, 2000).

Ball, Philip. *Bright Earth: The Invention of Colour* (London: Viking, 2001).

Barrows, Susannah. "After the Commune: Alcoholism, Temperance and Literature in the Early Third Republic," in John M. Merriman, ed., *Consciousness and Class Experience in 19th-Century Europe* (New York: Holmes & Meier, 1980), pp. 205–18.

Baticle, Jeannine. "The Galerie Espagnole of Louis-Philippe," in Gary Tinterow et al., eds.,

Manet/Velázquez: The French Taste for Spanish Painting (New Haven, Conn.: Yale University Press, 2003), pp. 175–89.

Baudelaire, Charles, *Correspondance*, 2 vols., ed. Claude Pichois and Jean Ziegler (Paris: Bibliothèque de la Pléiade, 1973).

————. *Lettres à Charles Baudelaire*, ed. Claude Pichois (Neuchâtel: Baconnière, 1973).

————. *Oeuvres complètes*, 2 vols., ed. Claude Pichois (Paris: Bibliothèque de la Pléiade, 1975–6).

————. *Selected Letters of Charles Baudelaire: The Conquest of Solitude*, trans. and ed. Rosemary Lloyd (London: Weidenfeld & Nicolson, 1986).

Bazin, Germain. *Impressionist Paintings in the Louvre*, trans. S. Cunliffe-Owen (London: Thames & Hudson, 1958).

Bazire, Edmond. *Manet* (Paris, 1884).

Bellet, Roger. *Presse et Journalisme sous le Second Empire* (Paris: Armand Colin, 1967).

Bénédite, Léonce. *Meissonier* (Paris: Librairie Renouard, n.d.).

Benjamin, Walter. *The Arcades Project*, trans. Howard Eiland and Kevin Mclaughlin (Cambridge, Mass.: Harvard University Press, 2002).

Berger, Klaus. *Japonisme in Western Painting from Whistler to Matisse*, trans. David Britt (Cambridge: Cambridge University Press, 1992).

Bergerat, Émile. *Peintures Décoratives de Paul Baudry au Grand Foyer de l'Opéra* (Paris, 1875).

Bernier, Georges. *Paris Cafés: Their Role in the Birth of Modern Art* (New York: Wildenstein & Co., 1985).

Beulé, Charles-Ernest. *Cours d'archéologie: La Peinture décorative et le grand art* (Paris, 1860).

Bicknell, Anna L. *Life in the Tuileries under the Second Empire* (London, 1895).

Bigot, Charles. *Peintres français contemporains* (Paris, 1888).

Billy, André. *La Présidente et ses amis* (Paris: Flammarion, 1945).

Bizardel, Yvon. "Théodore Duret: An Early Friend of the Impressionists," trans. Francine Yorke, *Apollo* (August 1974), pp. 146–55.

Blake, Robert. *Disraeli* (New York: St. Martin's Press, 1967).

Blanc, Charles. *Les Artistes de mon temps* (Paris, 1876).

————. *Grammaire des arts du dessin* (Paris, 1867).

————. *Ingres: Sa vie et ses ouvrages* (Paris, 1870).

Blanchard, Marcel, ed. "Journal de Michel Chevalier (1856–1869)," *Revue des deux mondes* 12 (November 1, 1932), p. 180.

Blanche, Jacques-Émile. *Manet* (Paris: F. Rieder & Cie, 1924).

————. *Portraits of a Lifetime: The Late Victorian Era and the Edwardian Pageant, 1870–1914*, ed. and trans. Walter Clement (New York: Coward-McCann, Inc., 1938).

Boime, Albert. *The Academy and French Painting in the Nineteenth Century* (London: Phaidon, 1971).

————. *Art and the French Commune: Imagining Paris after War and Revolution* (Princeton, N.J.: Princeton University Press, 1995).

————. "Le Musée des copies," *Gazette des Beaux-Arts*, series 6, 64 (1964), pp. 238–47.

————. "New Light on Manet's *Execution of Maximilian*," *The Art Quarterly* (Autumn 1973), pp. 172–208.

————. "The Salon des Refusés and the Evolution of Modern Art," *The Art Quarterly* 32 (1969), pp. 411–26.

————. "The Second Empire's Official Realism," in Gabriel P. Weisberg, ed., *The European Realist Tradition* (Bloomington, Ind.: University of Indiana Press, 1982), pp. 31–123.

————. "The Teaching Reforms of 1863 and the Origins of Modernism in France," *The Art Quarterly*, new series 1 (1977), pp. 1–39.

————. *Thomas Couture and the Eclectic Vision* (New Haven, Conn.: Yale University Press, 1980).

————. "An Unpublished Petition Exemplifying the Oneness of the Community of Nineteenth-Century French Artists," *Journal of the Warburg and Courtauld Institutes* 33 (1970), pp. 345–53.

Bouillon, Jean-Paul. "Les Lettres de Manet à Bracquemond," *Gazette des Beaux-Arts*, series 6 (April 1983), pp. 145–58.

Bowness, Alan, and Marie-Thérèse de Forges et al., *Gustave Courbet, 1819–1877* (London: Arts Council of Great Britain, 1978).

Brachlianoff, Dominique. "Heureux les Paysagistes!" in *Ernest Meissonier: Rétrospective* (Lyon: Musée des Beaux-Arts de Lyon, 1993), pp. 148–9.

Braun, Marta. *Picturing Time: The Work of Étienne-Jules Marey* (Chicago: University of Chicago Press, 1992).

Briais, Bernard. *Grandes courtisanes du Second Empire* (Paris: Jules Tallandier, 1981).

Brogan, D.W. *The Development of Modern France, 1870–1939* (London: Hamish Hamilton, 1940).

Brogniez, Laurence. "Marc de Montifaud: une femme en procès avec son siècle," *Sextant*, vol. 6 (1996), pp. 55–80.

Brombert, Beth Archer. *Édouard Manet: Rebel in a Frock Coat* (Boston: Little, Brown, 1996).

Brown, Frederick. *Zola: A Life* (London: Macmillan, 1996).

Brown, Marilyn R. "Manet, Nodier, and 'Polichinelle,' " *Art Journal* (Spring 1985), pp. 43–8.

Burchell, S. C. *Upstart Empire: Paris During the Brilliant Years of Louis-Napoleon* (London: Macdonald, 1971).

Burty, Philippe. "Meissonier," *Croquis d'après nature* (Paris, 1892), pp. 15–27.

Camp, Maxime du. *Les Beaux Arts à l'Exposition Universelle et aux Salons de 1863–1867* (Paris, 1867).

————. *Le Salon de 1857* (Paris, 1857).

————. *Le Salon de 1861* (Paris, 1861).

Castagnary, Jules-Antoine. *Salons (1857–1879)*, 2 vols. (Paris, 1892).

Champfleury, Jules. *Souvenirs et portraits de jeunesse* (Paris, 1872).

Chapman, J. M., and Brian Chapman. *The Life and Times of Baron Haussmann: Paris in the Second Empire* (London: Weidenfeld & Nicolson, 1957).

Chennevières-Pointel, Philippe de. *Souvenirs d'un directeur des Beaux-Arts*, 5 vols. (Paris, 1889).

Chesneau, Ernest. *Les Nations rivales dans l'art* (Paris, 1868).

Christiansen, Rupert. *Tales of the New Babylon* (London: Sinclair-Stevenson, 1994).

Chu, Petra ten-Doesschate. *French Realism and the Dutch Masters: The Influence of Dutch Seventeenth-Century Painting on the Development of French Painting between 1830 and 1870* (Utrecht: Haentjens Dekker & Gumbert, 1974).

Cikovsky, Nicolai, ed. *American Impressionism and Realism: The Margaret and Raymond Horowitz Collection* (Washington, D.C.: National Gallery of Art, 1998).

Clairet, Alain. "Le Bracelet de l'Olympia: genèse et destinée d'un chef-d'oeuvre," *L'Oeil* 333 (1983), pp. 36–41.

Clarétie, Jules. *Peintres et sculpteurs contemporains*, 2 vols. (Paris, 1881).

———. *La Vie à Paris* (Paris, 1881).

Clark, Kenneth. *The Romantic Rebellion: Romantic versus Classic Art* (London: John Murray, 1973).

Clark, T. J. *The Absolute Bourgeois: Artists and Politics in France, 1848–1851* (London: Thames & Hudson, 1973).

———. *The Painting of Modern Life: Paris in the Art of Manet and His Followers* (Princeton, N.J.: Princeton University Press, 1984).

Clayson, Hollis. *Painted Love: Prostitution in French Art of the Impressionist Era* (New Haven, Conn.: Yale University Press, 1991).

———. *Paris in Despair: Art and Everyday Life Under Siege (1870–71)* (Chicago: University of Chicago Press, 2002).

Collingwood, W. G. *The Life of John Ruskin* (London: Methuen & Co., 1900).

Collins, Bradford R. "Manet's *Rue Mosnier Decked with Flags* and the Flâneur Concept," *Burlington Magazine* 97 (November 1975), pp. 709–14.

Corbin, Alain. *Women for Hire: Prostitution and Sexuality in France after 1850* (Cambridge, Mass.: Harvard University Press, 1990).

Courbet, Gustave. *The Letters of Gustave Courbet*, ed. and trans. Petra ten-Doesschate Chu (Chicago: University of Chicago Press, 1992).

Courthion, Pierre, and Pierre Cailler. *Portrait of Manet by Himself and His Contemporaries*, trans. Michael Ross (London: Cassell, 1960).

Crespelle, Jean-Paul. *Maîtres de la Belle Époque* (Paris: Hachette, 1966).

Curtiss, Mina, ed. and trans. "Letters of Édouard Manet to his Wife during the Siege of Paris: 1870–71," *Apollo* 113 (June 1981), pp. 378–89.

Darragon, Eric. *Manet* (Paris: Fayard, 1989).

Delaborde, Henri. *Ingres: Sa vie, ses travaux, sa doctrine* (Paris, 1870).

Delacroix, Eugène. *Correspondance générale de Eugène Delacroix*, 5 vols., ed. André Joubin (Paris: Plon, 1935–8).

———. *The Journal of Eugène Delacroix*, trans. Walter Pach (New York: Hacker Art Books, 1980).

Delécluze, Étienne. *Louis David: son école et son temps* (Paris, 1855).

Desnoyers, Fernand. *Le Salon de Refusés* (Paris, 1863).

Distel, Anne, et al. *Gustave Caillebotte: The Unknown Impressionist* (London: Royal Academy of Arts, 1996).

Dolan, Therese. "Skirting the Issue: Manet's Portrait of *Baudelaire's Mistress, Reclining*," *Art Bulletin* (December 1997), pp. 611–29.

Dorival, Bernard. "Meissonier et Manet," *Art de France* (1962), pp. 223–6.

Dorment, Richard. "James McNeill Whistler," in Juliet Wilson-Bareau and David Degener, eds., *Manet and the Sea* (New Haven, Conn.: Yale University Press, 2003), pp. 187–93

Duret, Théodore. *Histoire de Édouard Manet et de son oeuvre* (Paris: Charpentier et Fasquelle, 1906).

Duro, Paul. "'Un Livre Ouvert à l'Instruction': Study Museums in Paris in the Nineteenth Century," *Oxford Art Journal* 10 (1987), pp. 44–58.

Edwards, Stewart, ed. *The Communards of Paris* (Ithaca, N.Y.: Cornell University Press, 1973).

Eitner, Lorenz. *An Outline of 19th Century European Painting: From David through Cézanne* (New York: Harper & Row, 1987).

———. *Géricault's "Raft of the Medusa"* (London: Phaidon, 1972).

Elam, Caroline. "Editorial: Édouard Manet, the old-masterly modernist," *Burlington Magazine* (February 2002), p. 67.

Engels, Frederick, and Karl Marx. *Collected Works*, 37 vols., ed. Eric Hobsbawm et al. (London: Lawrence & Wishart, 1975–98).

Escholier, Raymond. *Delacroix: Peintre, Graveur, Écrivain*, 3 vols. (Paris: H. Floury, 1926–9).

Farwell, Beatrice. "Manet's *Nymphe Surprise*," *Burlington Magazine* 97 (April 1975), pp. 224–9.

Feller, Robert L., et al., eds. *Artists' Pigments: A Handbook of their History and Characteristics*, 3 vols. (Washington: National Gallery of Art, 1986–97).

Fidell-Beaufort, Madeleine, and Janine Bailly-Herzberg. *Daubigny: La Vie et l'oeuvre* (Paris: Éditions Geoffroy-Dechaume, 1975).

Flaubert, Gustave. *The Letters of Gustave Flaubert*, ed. and trans. Francis Steegmuller (Cambridge, Mass.: Harvard University Press, 1982).

———. *A Sentimental Education*, trans. Douglas Parmée (Oxford: Oxford University Press, 1989).

Flescher, Sharon. "More on a Name: Manet's *Olympia* and the Defiant Heroine in Mid-Nineteenth-Century France," *Art Journal* (Spring 1985), pp. 27–35.

Fosca, François. *Renoir: His Life and Work* (London: Thames & Hudson, 1961).

France, Anatole. *On Life and Letters*, 4 vols., trans. A.W. Evans et al. (London: Bodley Head, 1911–24).

Franquet, Charles, le Comte de Franqueville. *Le Premier Siècle de L'Institut de France*, 2 vols. (Paris, 1895–6).

Fried, Michael. *Manet's Modernism, or The Face of Painting in the 1860s* (Chicago: University of Chicago Press, 1996).

Gaskell, Ivan. *Vermeer's Wager* (London: Reaktion, 2000).

Gaunt, William. *The Pre-Raphaelite Tragedy* (London: Cardinal, 1975).

Gautier, Théophile. *Tableaux de siège: Paris 1870–1871* (Paris, 1871).

Gaynor, Suzanne. "Count de Nieuwerkerke: A Prominent Official of the Second Empire and His Collection," *Apollo* 122 (1985), pp. 372–9.

Geffroy, Gustave. *Claude Monet: Sa vie, son oeuvre*, 2 vols. (Paris: Crès, 1922–4).

Goldschmidt, Fernande, et al. *Le Comte de Nieuwerkerke: Art et pouvoir sous Napoléon III* (Paris: Réunion des Musées nationaux, 2000).

Goldschmidt, Fernande. *Nieuwerkerke, le bel Émilien: Prestigieux directeur du Louvre sous Napoléon III* (Paris: Art International Publishers, 1997).

Gombrich, Ernst. *The Image and the Eye: Further Studies in the Psychology of Pictorial Representation* (Oxford: Phaidon Press, 1982).

Goncourt, Edmond de, and Jules de Goncourt. *Journal: Mémoires de la vie littéraire*, 3 vols., ed. Robert Ricatte (Paris: Robert Laffont, 1989).

———. *Pages from the Goncourt Journal*, ed. and trans. Robert Baldick (London: The Folio Society, 1980).

Gossez, Rémi. *Les Ouvriers de Paris: L'Organisation, 1848–1851* (Paris: Société d'histoire de la révolution de 1848, 1968).

Gotlieb, Marc J. *The Plight of Emulation: Ernest Meissonier and French Salon Painting* (Princeton, N.J.: Princeton University Press, 1996).

Gould, Roger V. *Insurgent Identities: Class, Community and Protest in Paris from 1848 to the Commune* (Chicago: University of Chicago Press, 1995).

Gréard, Valéry C. O. *Meissonier: His Life and Art*, trans. Lady Mary Loyd and Miss Florence Simmonds (London: William Heinemann, 1897).

Green, Nicholas. *The Spectacle of Nature: Landscape and Bourgeois Culture in Nineteenth-Century France* (Manchester: Manchester University Press, 1990).

Guest, Ivor. *Napoleon III in England* (London: British Technical & General Press, 1952).

Hamilton, George Heard. *Manet and His Critics* (New Haven, Conn.: Yale University Press, 1954).

Harding, James. *Artistes Pompiers: French Academic Art in the 19th Century* (New York: Rizzoli, 1979).

Harsin, Jill. *Policing Prostitution in Nineteenth-Century Paris* (Princeton, N.J.: Princeton University Press, 1985).

Hauser, Arnold. *The Social History of Art*, 2 vols., trans. Stanley Godman (London: Routledge & Kegan Paul, 1951).

Hemmings, F.W.J. *Baudelaire the Damned: A Biography* (London: Hamish Hamilton, 1982).

Herbert, Robert L. *Impressionism: Art, Leisure, and Parisian Society* (New Haven, Conn.: Yale University Press, 1988).

Holt, Elizabeth Gilmore, ed. *The Art of All Nations: The Emerging Role of Exhibitions and Critics* (Princeton, N.J.: Princeton University Press, 1982).

Honour, Hugh. *Neo-Classicism* (London: Penguin, 1968).

―――. *Romanticism* (London: Penguin, 1979).

Horne, Alistair. *The Fall of Paris: The Siege and the Commune, 1870–71* (New York: St. Martin's Press, 1965).

House, John. "Manet and the De-Moralised Viewer," in Paul Hayes Tucker, ed., *Manet's* Le Déjeuner sur l'Herbe (Cambridge: Cambridge University Press, 1998), pp. 75–89.

―――. "Manet's Maximilian: History Painting, Censorship and Ambiguity," in Juliet Wilson-Bareau et al., *Manet: "The Execution of Maximilian": Painting, Politics, Censorship* (London: National Gallery Publications, 1992), pp. 87–113.

Houssaye, Arsène. *Man About Paris: The Confessions of Arsène Houssaye*, trans. and ed. Henry Knepler (London: Victor Gollancz, 1972).

Hungerford, Constance Cain. *Ernest Meissonier: Master in His Genre* (Cambridge: Cambridge University Press, 1999).

―――. "Meissonier's *Souvenir de guerre civile*," *Art Bulletin* (June 1979), pp. 277–88.

Hutton, John. "The Clown at the Ball: Manet's *Masked Ball of the Opera* and the Collapse of Monarchism in the Early Third Republic," *Oxford Art Journal* 10 (1987), pp. 76–94.

Huyghe, René. *Delacroix*, trans. Jonathan Griffin (London: Thames & Hudson, 1963).

Ingamells, John. *The Wallace Collection Catalogue of Pictures*, vol. 2, *French Nineteenth Century* (London: Trustees of the Wallace Collection, 1986).

Isaacson, Joel. *Monet: "Le Déjeuner sur l'herbe"* (London: Allen Lane, 1972).

Jahyer, Félix. *Étude sur les beaux-arts: Salon de 1865* (Paris, 1865).

James, Henry. *The Painter's Eye: Notes and Essays on the Pictorial Arts*, ed. John L. Sweeney (London: Rupert Hart-Davis, 1956).

Jamot, Paul. *"Le Fifre* et Victorine Meurent," *Revue de l'art ancient et moderne*, 51 (1927), pp. 31–41.

Jamot, Paul, and Georges Wildenstein. *Manet*, 2 vols. (Paris: Les Beaux-Arts, 1932).

Janin, Jules. *L'Été à Paris* (Paris, 1844).

Jean-Aubry, Georges. *Eugène Boudin* (Paris: Bernheim-jeune, 1922).

Jennings, Simon. *Artist's Colour Manual* (London: HarperCollins, 2003).

Johnson, Douglas. "The French Intervention in Mexico: A Historical Background," in Juliet Wilson-Bareau et al., *Manet: "The Execution of Maximilian": Painting, Politics, Censorship* (London: National Gallery Publications, 1992), pp. 15–33.

Johnson, Lee. *Eugène Delacroix (1798–1863): Paintings, Drawings, and Prints from North American Collections* (New York: Harry N. Abrams, 1991).

Jordan, David P. *Transforming Paris: The Life and Labors of Baron Haussmann* (Chicago: University of Chicago Press, 1996).

King, Edward. *My Paris: French Character Sketches* (Boston, 1868).

Kinney, Leila W. "Genre: A Social Contract?" *Art Journal* 46 (Winter 1987), pp. 267–77.

Krell, Alan. *Manet and the Painters of Contemporary Life* (London: Thames & Hudson, 1996).

———. "Manet's *Déjeuner sur l'herbe* in the *Salon des Refusés:* A Re-appraisal," *Art Bulletin* 65 (June 1983), pp. 316–20.

Lafont-Couturier, Hélène, et al., *Gérôme & Goupil: Art and Enterprise*, trans. Isabel Ollivier (New York: Dahesh Museum of Art, 2000).

Lamb, Lynton. *Preparation for Painting: The Purpose and Materials of the Artist* (London: Oxford University Press, 1954).

Larroumet, Gustave. *Meissonier* (Paris, 1895).

Lavergne, Claudius. *Exposition Universelle de 1855: Beaux-Arts* (Paris, 1855).

Lefort, Paul. *La Peinture française actuelle* (Paris, 1891).

Lemonnier, Camille. *Le Salon de Paris 1870* (Paris, 1870).

Lethève, Jacques. *Daily Life of French Artists in the Nineteenth Century*, trans. Hilary E. Paddon (London: George Allen and Unwin Ltd., 1968).

Lilley, Edward. "Manet's 'Modernity' and *Effet de Neige à Petit-Montrouge*," *Gazette des Beaux-Arts*, series 6, 188 (September 1991), pp. 107–10.

Lindsay, Jack. *Cézanne: His Life and Art* (New York: New York Graphic Society, 1969).

Lipton, Eunice. *Alias Olympia: A Woman's Search for Manet's Notorious Model and Her Own Desire* (New York: Meridian, 1994).

Locke, Nancy. *Manet and the Family Romance* (Princeton, N.J.: Princeton University Press, 2001).

———. "Manet's *Le Déjeuner sur l'herbe* as a Family Romance," in Paul Hayes Tucker, ed., *Manet's* Le Déjeuner sur l'Herbe (Cambridge: Cambridge University Press, 1998), pp. 119–51.

———. "Unfinished Homage: Manet's *Burial* and Baudelaire," *The Art Bulletin* (March 2000), pp. 68–82.

Lowry, Bates. *Muse or Ego: Salon and Independent Artists of the 1880s* (Claremont, Calif.: Pomona College, 1963).

Luxenberg, Alisa. "Bueno días, Señor Courbet: The Artist's Trip to Spain," *Burlington Magazine* (November 2001), pp. 690–4.

———. "Creating *Désastres:* Andrieu's Photographs of Urban Ruins in the Paris of 1871," *Art Bulletin* 80 (March 1998), pp. 113–37.

Mack, Gerstle. *Gustave Courbet* (New York: Knopf, 1951).

Mainardi, Patricia. *Art and Politics of the Second Empire: The Universal Expositions of 1855 and 1867* (New Haven, Conn.: Yale University Press, 1987).

———. *The End of the Salon: Art and the State in the Early Third Republic* (Cambridge: Cambridge University Press, 1993).

———. "The Political Origins of Modernism," *Art Journal* 45 (Spring 1985), pp. 11–17.

Malmesbury, James Howard Harris, First Earl of Malmesbury. *Memoirs of an Ex-Minister*, 2 vols. (London, 1884).

Marx, Karl. *The Civil War in France*, in Karl Marx and Frederick Engels, *Collected Works*, 37 vols., ed. Eric Hobsbawm et al. (London: Lawrence & Wishart, 1975–98), vol. 22, pp. 309–55.

Maurois, André. *Victor Hugo*, trans. Gerard Hopkins (London: Chatto & Windus, 1956).

Mayeur, Jean-Marie. *Les Débuts de la Troisième République, 1871–1898* (Paris: Éditions du Seuil, 1973).

McCauley, Elizabeth Anne. "Sex and the Salon: Defining Art and Immorality in 1863," in Paul Hayes Tucker, ed., *Manet's* Le Déjeuner sur l'Herbe (Cambridge: Cambridge University Press, 1998), pp. 38–74.

———. *Industrial Madness: Commercial Photography in Paris, 1848–1871* (New Haven, Conn.: Yale University Press, 1994).

McMillan, James F. *Napoleon III* (London: Longman, 1991).

McMullen, Roy. *Degas: His Life, Times and Work* (London: Secker & Warburg, 1985).

McPhee, Peter. *A Social History of France* (London: Routledge, 1992).

McPherson, Heather. "Manet: Reclining Women of Virtue and Vice," *Gazette des Beaux-Arts*, series 6 (January 1990), pp. 34–44.

Meissonier, Charles. "Extraits de l'agenda de Charles Meissonier," in *Ernest Meissonier: Rétrospective* (Lyon: Musée des Beaux-Arts de Lyon, 1993), p. 73.

Meixner, Laura L. *French Realist Painting and the Critique of American Society, 1865–1900* (Cambridge: Cambridge University Press, 1995).

Meller, Peter. "Manet in Italy: Some Newly Identified Sources for Manet's Sketchbooks," *Burlington Magazine* (February 2002), pp. 68–84.

Mendès, Catulle. *Les 73 Jours de la Commune* (Paris, 1871).

Milner, John. *Art, War and Revolution in France, 1870–1871: Myth, Reportage and Reality* (New Haven, Conn.: Yale University Press, 2000).

———. *The Studios of Paris: The Capital of Art in the Late Nineteenth Century* (New Haven, Conn.: Yale University Press, 1988).

Mitchell, Claudine. "What is to be done with the Salonniers?" *Oxford Art Journal* 10 (1987), pp. 106–14.

Mollett, John W. *Meissonier* (London, 1882).

Monet, Claude. *Monet by Himself: Paintings, drawings, pastels, letters*, ed. Richard Kendall, trans. Bridget Strevens Romer (London: Macdonald Orbis, 1989).

Moore, George. *Memoirs of My Dead Life* (New York: Boni & Liveright, 1920).

———. *Modern Painting* (New York: Brentano, 1910).

Morisot, Berthe. *The Correspondence of Berthe Morisot*, ed. Denis Rouart, trans. Betty W. Hubbard (London: Lund Humphries, 1957).

Moskowitz, Ira, ed. *Berthe Morisot* (New York: Tudor Publishing, 1961).

Moss, Armand. *Baudelaire et Madame Sabatier* (Paris: A. G. Nizet, 1975).

Nadar [Gaspard-Félix Tournachon]. *Quand j'étais photographe*, ed. Jean-François Bory (Paris: Éditions du Seuil, 1994).

Nochlin, Linda. *The Politics of Vision: Essays on Nineteenth-Century Art and Society* (London: Thames & Hudson, 1991).

————. *Realism* (London: Penguin, 1971).

Nord, Philip. *Impressionists and Politics: Art and Democracy in the Nineteenth Century* (London and New York: Routledge, 2000).

Oulmont, Charles. "An Unpublished Watercolour Study for Manet's *Olympia*," *Burlington Magazine*, vol. 22 (October 1912), pp. 44–7.

Paladilhe, Jean, and José Pierre. *Gustave Moreau*, trans. Bettina Wadia (London: Thames & Hudson, 1972).

Palmade, Guy P. *French Capitalism in the Nineteenth Century*, trans. Graeme M. Holmes (Newton Abbot, Devon: David & Charles, 1972).

Paris Universal Exhibition, 1867: Complete Official Catalogue, 2nd edition (London and Paris, 1867).

Pasquier, Jacqueline de. "La Vie à la 'Grande Maison,'" in *Ernest Meissonier: Rétrospective* (Lyon: Musée des Beaux-Arts de Lyon, 1993), pp. 71–2.

Pasquier-Guignard, Agnès du. "L'Installation à Poissy," in *Ernest Meissonier: Rétrospective* (Lyon: Musée des Beaux-Arts de Lyon, 1993), pp. 64–70.

Patin, Sylvie, et al. *La Collection Havemeyer: Quand l'Amerique découvrait l'impressionisme* (Paris: Éditions de la Réunion des musées nationaux, 1997).

Perruchot, Henri. *Manet*, trans. Humphrey Hare (London: Perpetua, 1962).

Pflanze, Otto. *Bismarck and the Development of Modern Germany*, 3 vols. (Princeton, NJ.: Princeton University Press, 1990).

Piette, Ludovic. *Mon cher Pissarro: Lettres de Ludovic Piette à Camille Pissarro*, ed. Janine Bailly-Herzberg (Paris: Valhermeil, 1985).

Pinkney, David H. *Napoleon III and the Rebuilding of Paris* (Princeton, N.J.: Princeton University Press, 1958).

Pitou, Spire. *The Paris Opera: An Encyclopedia of Operas, Ballets, Composers and Performers* (Westport, Conn.: Greenwood Press, 1983).

Plessis, Alain. *The Rise and Fall of the Second Empire, 1852–1871*, trans. Jonathan Mandelbaum (Cambridge: Cambridge University Press, 1985).

Polybius. *The Histories of Polybius*, trans. Evelyn S. Shuckburgh (London, 1889).

Poulain, Gaston. *Bazille et ses amis* (Paris: La Renaissance du livre, 1932).

Prelinger, Elizabeth, ed. *American Impressionism: Treasures from the Smithsonian American Art Museum* (New York: Watson-Guptil, 2000).

Proudhon, Pierre-Joseph. *La Pornacratie, ou les femmes dans les temps modernes* (Paris, 1875).

Proust, Antonin. *Édouard Manet: souvenirs* (Paris: H. Laurens, 1913).

Queen Victoria. *Leaves from a Journal* (New York: Farrar Strauss and Cudahy, 1961).

Reff, Theodore. *Manet: "Olympia"* (London: Allen Lane, 1976).

————. *Manet and Modern Paris: One Hundred Paintings, Drawings, Prints and Photographs by Manet and His Contemporaries* (Washington, D.C.: National Gallery of Art, 1982).

————. "The Meaning of *Olympia*," *Gazette des Beaux-Arts* 63 (1964), pp. 111–22.

Renan, Ernest. *The Life of Jesus*, trans A. D. Howell Smith (London: Watts & Co., 1935).

Rewald, John. *The History of Impressionism* (New York: Metropolitan Museum of Art, 1961).

————. *The Ordeal of Paul Cézanne* (London: Phoenix House, 1950).

Richardson, Joanna. *The Courtesans: The Demi-Monde in 19th-Century France* (London: Weidenfeld & Nicolson, 1967).

————. *Théophile Gautier: His Life and Times* (London: Max Reinhardt, 1958).

Ridley, Jasper. *Napoleon III and Eugénie* (London: Constable, 1979).

Rishel, Joseph, et al. *The Second Empire: Art in France under Napoleon III* (Philadelphia: Philadelphia Museum of Art, 1978).

Robinson, Christopher. "The Artist as 'Rénovateur': Paul Baudry and the Paris Opéra," *Art Journal* 46 (Winter 1987), pp. 285–9.

Roos, Jane Mayo. *Early Impressionism and the French State (1866–1874)* (Cambridge: Cambridge University Press, 1996).

Rosenblum, Robert, and H. W. Janson. *Art of the Nineteenth Century: Painting and Sculpture* (London: Thames & Hudson, 1984).

Rosenthal, Léon. *Manet: Aquafortiste et lithographe* (Paris: Le Goupy, 1925).

Rossetti, Dante Gabriel. *Dante Gabriel Rossetti and Jane Morris: Their Correspondence*, ed. John Bryson and Janet Camp Troxell (Oxford: Clarendon Press, 1976).

————. *Letters of Dante Gabriel Rossetti*, ed. Oswald Doughty and John Robert Wahl, 5 vols. (Oxford: Clarendon Press, 1965–7).

Roy, Ashok, et al. "Monet's *Bathers at La Grenouillère*," *National Gallery Technical Bulletin* (1981), pp. 14–25.

Rubin, James H. *Courbet* (London: Phaidon Press, 1997).

Saalman, Howard. *Haussmann: Paris Transformed* (New York: George Braziller, 1971).

Sala, George Augustus. *Gaslight and Daylight* (London, 1859).

————. *Notes and Sketches of the Paris Exhibition* (London, 1868).

Sand, George. *Letters of George Sand*, 2 vols., trans. R. Ledos de Beaufort (London, 1886).

Sandhu, M. C. "Le Romantisme: Problème de Génération," *Nineteenth-Century French Studies*, vol. 8 (Spring–Summer 1980), pp. 206–17.

Scharf, Aaron. *Art and Photography* (London: Allen Lane, 1968).

Séginger, Gisèle. *Flaubert: Une Poétique de l'histoire* (Strasbourg: Presses Universitaires de Strasbourg, 2000).

Serraute, Gabriel. "Contribution à l'étude du *Déjeuner sur l'herbe* de Monet," *Bulletin du laboratoire du Musée du Louvre*, no. 3 (June 1958), pp. 46–51.

Shackleford, George T. M., and Fronia E. Wissman. *Impressions of Light: The French Landscape from Corot to Monet* (Boston: Museum of Fine Arts, Boston, 2002).

Shaw, Jennifer L. "The Figure of Venus: Rhetoric of the Ideal and the Salon of 1863," *Art History* 14 (December 1991), pp. 540–70.

Silvestre, Théophile. *Histoire des artistes vivants, français et étrangers: Études d'après nature* (Paris, 1856).

Sloane, Joseph C. *French Painting Between the Past and the Present* (Princeton, N.J.: Princeton University Press, 1951).

——. "Paul Chenavard's Cartoons for the Mural Decoration of the Panthéon," *The Art Bulletin* (December 1951), pp. 240–58.

——. *Paul-Marc Chenavard: Artist of 1848* (Chapel Hill, N.C.: University of North Carolina Press, 1962).

Solkin, David H. "Philibert Rouvière: Édouard Manet's *L'Acteur Tragique*," *Burlington Magazine* 97 (November 1975), pp. 702–9.

Solnit, Rebecca. *River of Shadows: Eadweard Muybridge and the Technological Wild West* (New York: Penguin, 2003).

Song, Misook. *The Art Theories of Charles Blanc* (Ann Arbor, Mich.: University of Michigan Press, 1984).

Spang, Rebecca L. "'And they ate the zoo': Relating Gastronomic Exoticism in the Siege of Paris," *MLN* (1992), pp. 752–73.

Swinburne, Algernon Charles. *The Swinburne Letters*, 6 vols., ed. Cecil Y. Lang (New Haven, Conn.: Yale University Press, 1959–62).

Tabarant, Adolphe. *Manet et ses oeuvres* (Paris: Gallimard, 1947).

——. *Vie artistique au temps de Baudelaire* (Paris: Mercure de France, 1942).

Thiers, Adolphe. *History of the Consulate and the Empire of France under Napoleon*, 20 vols. (London, 1845–62).

Thomson, David. *Europe Since Napoleon* (London: Pelican, 1966).

Thuiller, Jacques. "Préface: Éloge d'Ernest Meissonier," in *Ernest Meissonier: Rétrospective* (Lyon: Musée des Beaux-Arts de Lyon, 1993), pp. 17–23.

Tinterow, Gary, and Henri Loyrette. *Origins of Impressionism* (New York: Metropolitan Museum of Art, 1994).

Tinterow, Gary. "Raphael Replaced: The Triumph of Spanish Painting in France" in Gary Tinterow et al., eds., *Manet/Velázquez: The French Taste for Spanish Painting* (New Haven, Conn.: Yale University Press, 2003), pp. 3–65.

Toutain, J. C. *La Population de la France de 1700 à 1959* (Paris: Institut de Science Économique Appliqué, 1963).

Truesdell, Matthew. *Spectacular Politics: Louis-Napoleon Bonaparte and the* Fête Impériale, *1849–1870* (New York: Oxford University Press, 1997).

Tucker, Paul Hayes, *Claude Monet: Life and Art* (New Haven and London: Yale University Press, 1995).

——. "The First Impressionist Exhibition and Monet's *Impression, Sunrise:* A Tale of Timing, Commerce and Patriotism," *Art History* 7 (December 1984), pp. 465–76.

——. "Making Sense of Édouard Manet's *Le Déjeuner sur l'Herbe*," in Paul Hayes Tucker, ed., *Manet's* Le Déjeuner sur l'Herbe (Cambridge: Cambridge University Press, 1998), pp. 1–37.

Venturi, Lionello. *Modern Painters*, 2 vols., trans. Francis Steegmuller (New York: Charles Scribner's Sons, 1947–50).

Verestchagín, Vassíli. "Reminiscences of Meissonier," *Contemporary Review* 75 (May 1899), pp. 660–6.

Verlaine, Paul. *Oeuvres en prose complètes*, ed. Jacques Borel (Paris: Gallimard, 1972).

Véron, Pierre. *Les Coulisses artistiques* (Paris, 1876).

Vigne, Georges. *Ingres*, trans. John Goodman (New York: Abbeville, 1995).

Vizetelly, E. A. *The Court of the Tuileries, 1852–1870* (London: Chatto & Windus, 1907).

Vollard, Ambroise. *Recollections of a Picture Dealer*, trans. Violet M. MacDonald (Boston: Little, Brown & Co., 1936; reprinted New York: Dover Publications, 2002).

———. *Renoir: An Intimate Portrait*, trans. Harold Van Doren and Randolph T. Weaver (New York: Greenberg, 1925).

Wall, Geoffrey. *Flaubert: A Life* (London: Faber and Faber, 2001).

Waller, Susan. "Professional Poseurs: The Male Model in the École des Beaux-Arts and the Popular Imagination," *Oxford Art Journal* 25 (2002), pp. 41–64.

Weintraub, Stanley. *Whistler: A Biography* (London: Collins, 1974).

Weisberg, Gabriel P. *The Independent Critic: Philippe Burty and the Visual Arts of Mid-Nineteenth-Century France* (New York: P. Lang, 1993).

Whistler, James McNeill. *The Correspondence of James McNeill Whistler*, ed. Margaret F. MacDonald et al. (Glasgow: Centre for Whistler Studies, University of Glasgow).

White, Harrison C., and Cynthia A. White. *Canvases and Careers: Institutional Change in the French Painting World* (Chicago: University of Chicago Press, 1965).

Wilcox, Timothy. *Alphonse Legros, 1837–1911* (Dijon: Musée des Beaux-Arts, 1988).

Williams, Roger L. *The French Revolution of 1870–1871* (London: Weidenfeld & Nicolson, 1969).

———. *Gaslight and Shadows: The World of Napoleon III* (New York: Macmillan, 1957).

———. *Manners and Murders in the World of Louis-Napoleon* (Seattle: University of Washington Press, 1975).

———. *The Mortal Napoleon III* (Princeton, N.J.: Princeton University Press, 1971).

Willis, Deborah, and Carla Williams. *The Black Female Body: A Photographic History* (Philadelphia: Temple University Press, 2002).

Wilson-Bareau, Juliet. *The Hidden Face of Manet: An investigation of the artist's working processes* (London: Courtauld Gallery, 1986).

———. "Manet and Spain," in Gary Tinterow et al., eds., *Manet/Velázquez: The French Taste for Spanish Painting* (New Haven, Conn.: Yale University Press, 2003), pp. 203–51.

Wilson-Bareau, Juliet, with David Degener. *Manet and the American Civil War* (New York: Metropolitan Museum of Art, 2003).

Wilson-Bareau, Juliet. "Manet and *The Execution of Maximilian*," in Juliet Wilson-Bareau et al., *Manet: "The Execution of Maximilian": Painting, Politics, Censorship* (London: National Gallery Publications, 1992), pp. 35–85.

Wilson-Bareau, Juliet, and David Degener. "Manet and the Sea," in Juliet Wilson-Bareau and David Degener, eds., *Manet and the Sea* (New Haven, Conn.: Yale University Press, 2003), pp. 55–101.

Wilson-Bareau, Juliet, ed. and trans. *Manet by Himself: Correspondence and Conversation* (London: Macdonald & Co., 1991).

Wissman, Fronia E. *Bouguereau* (San Francisco: Pomegranate Artbooks, 1996).

Wolff, Albert. *La Capitale de l'art* (Paris, 1886).

Yriarte, Charles. "E. Meissonier: Personal Recollections and Anecdotes," *The Nineteenth Century* 43 (May 1898), pp. 822–40.

Zeldin, Theodore. *Intellect and Pride: France 1848–1945* (Oxford: Oxford University Press, 1979).

————. *The Political System of Napoleon III* (London: Macmillan, 1958).

————. *Politics and Anger: France 1848–1945* (Oxford: Oxford University Press, 1979).

————. *Taste and Corruption: France 1848–1945* (Oxford: Oxford University Press, 1980).

Zola, Émile. *La Bête Humaine*, trans. Leonard Tancock (London: Penguin, 1977).

————. *The Masterpiece*, trans. Thomas Walton and Roger Pearson (Oxford: Oxford University Press, 1993).

————. *Salons*, ed. F. W. J. Hemmings and Robert J. Niess (Geneva and Paris: E. Droz, 1959).

INDEX

Note: Page numbers in *italics* refer to illustrations.

About, Edmond, 127, 128, 194, 336
Abstract Expressionism, 371
Académie de France, 42n, 321
Académie des Beaux-Arts, 8, 22, 41, 49, 95,
 266, 321
 and Institut, 43–47
 and Salons, 32, 34, 54, 56, 72, 91, 98–99, 113,
 127, 315
Alaux, Jean, 58
Albert, Prince, 5, 184, 348
Alma-Tadema, Lawrence, 125
American Art Association, 363
American Art Galleries, 362
Anselme, Brother, 296
Astruc, Zacharie, 60, 70, 86, 89, 148, 150, 160,
 161, 164, 191, 225–26, 235, 267, 324
Attila the Hun, 276, 350, 351
Augier, Émile, 11, 108
Aupick, Jacques, 211, 212

Babou, Hippolyte, 200
Ballu, Théodore, 319
Balzac, Honoré, 10
Banville, Théodore de, 14, 198, 211
Barbey d'Aurevilly, Jules-Amédée, 323, 328
Baroche, Jules, 172
Barrias, Félix, 170, 174
Baudelaire, Charles, 2, 51, 131, 172, *212*

Les Fleurs du mal, 16, 18, 19, 200
 illness and death of, 103, 117, 198, 211–12, 214
 and Manet, 112, 130, 151, 161
 modernism promoted by, 54, 86, 103, 133, 359
 The Painter of Modern Life, 23, 25
 and Salons, 117, 151, 328
Baudry, Paul, 170, 174, 181, 225, 229, 283, 320,
 336, 351, 353, 364
Bazille, Frédéric, 149, 181–82, 196, 197, 231,
 232, 234, 252, 295
Bazin, Germain, 364
Beaury, Camille, 270
Bellanger, Marguerite, 79, 97, 122
Bellot, Émile, 332, 333, 339, 341
Benedetti, Comte Vincent, 273, 274
Bénédite, Léonce, 365
Bernadotte, Jean-Baptiste, 15
Bezanson, Elisa, 167, 168, 169, 296, 302, 370
Bida, Alexandre, 146
Bismarck, Otto von, 206, 274, *276*, 278, 285,
 298, 302
Blanc, Charles, 204, 298, 315–16, 319–20, 324,
 335–36, 337, 350
Blanc, Louis, 298, 303, 315
Bonaparte, Napoleon, *see* Napoleon Bonaparte
Bonaparte, Prince Pierre, 258–60, 270
Bonheur, Rosa, 242
 The Horse Fair, 241, 249, 369

Bonnat, Léon, 247
Botticelli, Sandro, *Birth of Venus*, 104
Boudin, Eugène, 148, 182
Bouguereau, William, 283
Bourgeois, Hortense, 69
Bracquemond, Félix, 36, 131, 137, 283, 298, 314
Brascassat, Jacques-Raymond, 46, 58n
Breton, Jules, 170, 173, 174, 196, 225, 229, 269, 291, 320, 324, 336
Brion, Gustave, 232
Burke, Edmund, 6
Burty, Philippe, 92, 138, 290, 326, 357, 365
Butler, Theodore Earl and Suzanne, 363

Cabanel, Alexandre, 86, 124, 308, 351, 363
 The Birth of Venus, plate 4A, 77–80, 88, 89, 99, 108, 203
 Nymph Abducted by a Faun, 78, 80, 196
 and Salons, 77, 78, 80, 91, 113, 146, 157, 221, 225, 247
 style of, 85, 91, 105, 153, 161, 181
 The Triumph of Flora, 343
Cabaner, Ernest, 332
Cadart, Alfred, 137, 326
Caillebotte, Gustave, 365
Callias, Hector de, 128, 183
Camp, Maxime du, 23, 78, 125
Canaday, John, 371, 372
Carpeaux, Jean-Baptiste, 343
Cassatt, Mary, 363
Castagnary, Jules-Antoine, 88, 98, 170, 183, 195, 221n, 230, 232, 255, 270, 323, 337, 354, 357
Cazin, Charles, 86
Cézanne, Paul, *177*, 179, 213, 223, 234, 285, 363, 366
 and Realist Salon, 354–56
 and Salons, 82, 176–78, 185, 195–96, 221, 228, 252, 267, 324
Cézanne, Paul, works by:
 The Autopsy, 228
 The Banquet of Nebuchadnezzar, 355
 The House of the Hanged Man, 355
 L'Enlèvement (The Abduction), 196
 A Modern Olympia, 355
 The Murder, 228
 Portrait of Antony Valabrègue, 177–78
 The Strangled Woman, 354–55
 style of, 354–55, 359
Chabrier, Emmanuel, 365
Chambord, Comte de, 297, 303, 325

Champfleury, Jules, 54, 160, 198
Charles IX, king of France, 192
Charles X, king of France, 101, 297
Charlotte, Empress, 207, 208, 216
Charlotte, Princess, 242
Chauchard, Alfred, 370, 371
Chavannes, Pierre Puvis de, 287
Chenavard, Paul, 266, 350
Chennevières-Pointel, Philippe de, 73–75, 77, 81, 84, 116, 117, 152, 169–70, 179, 230, 231, 261, 264, 267, 291, 315, 350–51, 353
Chesneau, Ernest, 51, 70, 88, 90, 147, 357–58, 364
Chintreuil, Antoine, 59, 70–72, 81–82, 113, 116, 119, 264
Churchill, Sir Winston, 334
Civil War, U.S., 68, 123, 136, 163, 326
Clarétie, Jules, 200, 208, 296, 310
Clark, T. J., 366
Clemenceau, Georges, 300, 366
Clément-Thomas, Jacques, 301, 302, 322, 349
Cogniet, Léon, 58, 59, 113, 145
 Helen Delivered by Her Brothers Castor and Pollux, 8
 Meissonier's apprenticeship with, 8, 45
Colt, Samuel, 250
Coninck, Pierre de, 232
Constable, John, 30, 268, 368
Coquiot, Gustave, 371–72
Corot, Camille, 34, 91, 175, 325
 and landscapes, 30, 70–71, 113, 126, 150, 339
 as mentor, 70, 230, 243, 254
 and Salons, 113, 126, 146, 176, 185, 264, 269
Couder, Auguste, 58n, 113
Courant, Louis and Sarah, 167, 186
Courant, Maurice, 167, 277, 283
Courbet, Gustave, 52, 82–85, *83*, 86, 114, 148, 201, 210, 301, 312
 and Commune, 305, 309, 315, 321, 322, 323
 in exile, 350, 353
 and Monet, 149, 182, 253, 284
 personal traits of, 85, 337–38
 and Realism, 22, 41, 50, 59, 74, 162, 190, 223, 324
 and Salons, 22, 59, 82, 83–85, 179–81, 221, 225, 228, 321–24, 328, 336, 337, 353
 and Vendôme Column, 305–6, 321, 322, 324, 337, 350
 and war with Prussia, 283
Courbet, Gustave, works by:
 After Dinner at Ornans, 83

The Bathers, 22, 66, 78, 80, 84
La Belle Irlandaise, 180
A Burial at Ornans, plate 3B, 84, 85
Covert of Roe Deer, 181
critical responses to, 83–84, 88, 179
exhibitions of, 49, 325, 337, 354
Fighting Stags, 84
Fox Hunt, 84
A Funeral at Ornans, 201
Return from the Conference, 84–85, 179
Le Sommeil (Sleep), 181
The Stonebreakers, 84, 201
style of, 85, 177, 228, 231, 324
Venus and Psyche, 179, 180
Woman with a Parrot, 181
Young Ladies of the Village, 114–15
Couture, Thomas, 15–16, 18, 23, 25, 38, 52, 54, 69, 133, 142, 160, 188, 236, 239, 329, 333, 338
Crystal Palace, London, 184, 239, 342
C.S.S. *Alabama* vs. U.S.S. *Kearsarge*, 135–39, 326, 328, 329
Cubism, 366

Dagron, René, 286
Daguerre, Louis, 105
Darboy, Georges, Archbishop of Paris, 303, 308, 323
Daubigny, Charles-François, 30, 230, 284
exhibitions of work, 49, 325, 339, 354
and Meissonier, 94, 175, 290, 320
and Salons, 170, 174, 175–76, 185, 197, 221, 225, 227, 228, 264, 269
Daumier, Honoré, 16, 74, 196
David, Jacques-Louis, 10, 236–37, 242
The Coronation of Napoleon, 27n
Death of Marat, 208
The Oath of the Horatii, 8
Degas, Edgar, 240, 283, 314, 340, 365
collectors of work by, 363
critical reviews of work, 231
Dancers Practising at the Barre, 372
Mademoiselle Eugénie Fiocre in the Ballet "La Source," 227
Manet's portrait by, *118*
Portrait of Monsieur and Madame Édouard Manet, 213–14
and Realist Salon, 354, 355
and Salons, 221, 227, 252, 324
War Scene in the Middle Ages, 213

Delaborde, Henri, 370
Delacroix, Eugène, 10, 19, 22, 55, *102*, 106, 146, 266, 308, 309, 343
death of, 99–100, 101–3
Fantin-Latour's *Homage* to, 103, 120, 130–31, 145
and Meissonier, 2, 44–45, 59, 226, 290, 296, 320, 344, 371
and petition, 34, 46, 47
and Romanticism, 44–45, 51, 210
and Salons, 58, 59, 153
Delacroix, Eugène, works by:
Apollo Slaying Python, 45
Death of Sardanapalus, 52, 53
Liberty Leading the People, plate 1B, 101–2, 115
Massacre of Chios, 90, 208
Odalisque Reclining on a Divan, 105
style of, 52, 210, 268, 353
Woman with a Parrot, 105
Delahante, Gaston, 10, 219, 370
Delibes, Léo, 272
De Nittis, Giuseppe, 14
Deperthes, Édouard, 319
Desbrosses, Jean, 71, 81, 91
Desnoyers, Fernand, 70
Detaille, Édouard, 283
Doncieux, Camille (Monet), 150, 181–82, 183, 196, 228–29, 252, 267, 284, 338, 359, 360, *361*
Doré, Gustave, 47, 239–40, 342
Dubufe, Édouard, 173–74, 291, 320
Duhousset, Émile, 248, 249
Dumas, Alexandre *fils*, 2, 37, 94, 107, 222n
Dumas, Alexandre *père*, 6, 47, 206–7, 220, 274
Duplessis, Marie, 222
Dupressoir, Colonel, 217, 236, 279, 347
Durand-Ruel, Paul, 325–26, 328, 338, 340, 353–54, 362–63, 364
Duranty, Edmond, 262–63, 271
Duret, Théodore, 162, 245, 283, 290, 291, 312–13, 323, 324–25
Durieu, Eugène, 106
Dyce, William, 352

École des Batignolles, 164, 230, 231–32, 235, 267, 284, 317, 330, 338, 341, 353, 367
École des Beaux-Arts, 15, 38, 41, 59, 71, 88, 91, 98–99, 161, 226, 237, 247, 268, 315–16, 320, 321, 363, 365
École de Septeuil, 71

Eiffel, Gustave, 185
Eugénie, Empress, 69, 79, 121–22, 124, 179, 181, 274, 278, 284, 317, 335

Fagnani, Giuseppe, 171
Falguière, Jean-Alexandre-Joseph, 283
Fantin-Latour, Henri, 60, 211, 240
 Homage to Delacroix, 103, 120, 130–31, 145
 and Manet, 145, 161, 164, 191, 263, 365
 and Salons, 36, 71, 117, 120, 130–31, 221
 Scene from Tannhäuser, 131
 and Whistler, 70, 71, 86
Faure, Jean-Baptiste, 340, 367
Fauvism, 366
Ferdinand VII, king of Spain, 161
Fiquet, Hortense, 285, 324
Flandrin, Hippolyte, 58, 101, 113, 124
Flaubert, Gustave, 6, 20, 74, 107, 172
Fonvielle, Ulric de, 259
Foucault, Jean-Bernard-Léon, 350
Fragonard, Jean-Honoré, 158, 242
France:
 censorship in, 67, 215–16, 229–30, 246, 270, 291
 Liberal Empire, 257–58, 269–70, 272–73
 religious revival in, 349–51
 seaside resorts in, 132–34
 Second Empire, 6, 64–65, 67, 80, 115, 215, 229, 256, 280, 284, 314, 317, 319, 323, 344
 Third Republic, 281–83, 297–98, 302, 315
 wine industry in, 353
 see also Paris
France, Anatole, 372–73
Franco-Prussian War, 273–80, 281–95, 325, 329, 331, 337
 armistice, 293–94
 French surrender, 280, 281, 298
 Siege of Paris, 281–92, 293–95, 351
Franz Josef, Emperor, 122, 336, 343, 344
Frémiet, Emmanuel, 349, 371, 373
French Revolution, 6, 31, 74, 303, 309
Fromentin, Eugène-Samuel-Auguste, 322

Gainsborough, Thomas, 28
Galerie Martinet, Paris, 49, 51, 52–55, 62, 71, 88, 147, 226
Gambetta, Léon, 281, 286, 314, 364
Garibaldi, Giuseppe, 123, 207
Gariot, Paul-César, 68–69
Garnier, Charles, 170, 282, 283, 353

Gautier, Amand, 59, 182
Gautier, Théophile, 19–20, 20, 65, 84, 101, 103, 189, 303, 310
 on Manet's work, 19, 20, 127, 128, 130, 152, 160, 231, 254, 270, 271, 291, 341
 and Meissonier, 6–7, 19, 34, 134, 140, 174, 226, 248
 in *Music*, 51, 54
 and Salons, 20, 77, 114, 125, 127, 128, 146, 152, 170, 254, 271
 and Universal Exposition, 194, 198, 200
 and war with Prussia, 274, 275, 280, 287, 293
Generation of 1830, 101, 103
Generation of 1863, 103, 130–31, 196, 203, 225–26, 231, 255, 338
Géricault, Théodore, 44, 50
 The Raft of the "Medusa," 26–27, 30, 208, 209
Germany, unification of, 295
Gérôme, Jean-Léon, 106, 351, 363
 and École des Beaux-Arts, 99, 146, 155, 161, 247, 365
 and Salons, 76–77, 91, 113, 125, 146, 225, 247, 358
Gérôme, Jean-Léon, works by:
 Age of Augustus, 56, 95
 Dance of the Almeh, 125, 203
 Greek Interior, 76
 L'Eminence grise, 358
 prices of, 48–49, 158, 183
 The Prisoner, 76–77, 203
 style of, 85, 89, 91, 161
J. Paul Getty Museum, Los Angeles, 368
Giraud, Victor, 232
Glaize, Auguste-Barthélémy, 221n
Gleyre, Charles, 145, 149, 176, 221, 225
Goldwater, Robert, 367
Goncourt, Edmond de, 116, 141, 161, 168, 187, 201, 285, 289, 295, 308, 310
Goncourt, Jules de, 201
Gonzalès, Éva, 255, 261, 262, 288, 314, 315
Gounod, Charles, 176
Goupil, Adolphe, 48–49, 246
Goya, Francisco de, 209, 210, 243
Gramont, Antoine-Afred Agénor, Duc de, 273, 274
Grant, Ulysses S., 136
Greville, Charles, 65
Gros, Baron, 27n, 90
Gros, Jeanne, *141*, 167, 168, 220, 248

Gros, Lucien, *141*, 142, 155, 167–68, 186–87, 277, 283, 352
Guichard, Joseph-Benoît, 242, 243
Guillemet, Antoine, 178, 179

Habsburg, Maximilian von, Archduke of Austria, 122–23, 164, 207–10, 215
Hals, Frans, 332–33, 340
Hamerton, Philip, 71, 79, 85, 86, 89
Haussmann, Baron Georges, 23, 24, 122, 195, 300, 307
Haussmann, Valentine, 122
Havemeyer, Henry O., 363
Havemeyer, Louisine, 363, 367, 372
Hegel, Georg Wilhelm Friedrich, 275
Heim, François, 58, 113, 145
Hertford, Richard Seymour-Conway, Marquess of, 158, 204, 219, 330–31, 369
Hesse, Nicolas-Auguste, 44, 100
Hetherington, John, 53
Hiffernan, Joanna, 86, 180–81, 203
Hilton, Henry, 369
Hippodrome de Longchamp, 96, 134–35, 159, 207, 272, 328, 347
Hohenzollern-Sigmaringen, Leopold von, 273–74
Holtzapffel, Jules, 171
Houssaye, Arsène, 51, 86, 189, 252
Houssaye, Henry, 346–47, 348
Howard, Lizzie, 64, 80
Huet, Paul, 101, 233–34
Hugo, Victor, 10, 19, 67, 101, 207, 213, 232, 282, 286, 289, 297, 303, 318
Hugrel, Pierre-Honoré, 232
Hunt, William Holman, 202

Impressionism:
 American audiences for, 362–64
 early examples of, 91
 exhibitions of, 356–58, 362–64, 367, 372
 L'Impressioniste of, 362
 name of, 356–57, 362
 as "the new movement," 172–73, 176, 189, 226, 319, 356
 see also École des Batignolles
Ingres, Jean-Auguste-Dominique, 2n, 42, 158, 213, 323
 and Académie, 44, 46, 99, 315
 The Comte de Nieuwerkerke, 33
 death of, 197

exhibitions of work, 197, 201, 343, 366
 Grande Odalisque, 90, 366
 Martyrdom of Saint-Symphorian, 90
 murals by, 266, 308, 352, 353
 and Salons, 34, 46, 47, 58, 74–75, 90, 145
 style of, 89, 105, 153, 236–37
Ionides, Alexander, 131
Isabella II, queen of Spain, 273
Isabey, Eugène, 34, 221n
Italian Renaissance, *see* Renaissance

Jacques, Charles, 221n
James, Henry, 238, 331, 362, 369
Jerome, Jennie, 334
Jongkind, Johan Barthold, 59, 72
Joséphine, Empress, 62, 63n
Jouffroy, François, 101
Juárez, Benito, 68, 207

Khalil Bey, 180–81
Klagmann, Henri, 232
Koëlla, Léon-Édouard, 16–17, 111, 132, 148, 199, 213, 214, 295, 299, 315
Kranz, Jean-Baptiste-Sébastien, 184–85, 199
Krupp, Alfred, 206, 278, 291, 345

Lamartine, Alphonse de, 101, 103, 115
Landseer, Sir Edwin, 202
Laqueuille, Marquis de, 81–82, 126
La Rochenoire, Julien, 264
Latouche, Louis, 196
Leboeuf, Edmond, 275, 277, 278
Lecomte, Claude-Martin, 301, 302, 322, 349
Lee, Robert E., 60, 123, 163
Leenhoff, Carolus Antonius, 111–12
Leenhoff, Ferdinand, 39, 40, 111, 182, 247, 332, 365
Leenhoff, Rudolphe, 360
Leenhoff, Suzanne, *see* Manet, Suzanne Leenhoff
Lefuel, Hector, 310–11
Legrange, Léon, 204
Legros, Alphonse, 60, 131, 203, 238, 240
Lemercier, Rémond-Jules, 246
Leonardo da Vinci, 49, 52, 105, 251
Lepic, Ludovic-Napoléon, 262–63
Leroy, Louis, 128, 356–57, 362
Leuson, Jacob, 244–45
L'Événement, 171, 172–74, 178–79, 182, 230
L'Événement illustré, 227, 230, 231, 243

Lezay-Marnésia, Albert, 69–70

Liébert, Alphonse, 215, 245

Liszt, Franz, 222n, 260

Louis XVI, king of France, 6, 303

Louis-Napoleon, *see* Napoleon III

Louis-Philippe, king of France, 53–54, 63, 64–65, 101, 115, 297

Louvrier de Lajolais, Jacques-Auguste-Gaston, 170, 174

MacMahon, Patrice, 279, 307, 309, 349–50

Malraux, André, 371, 373

Manet, Auguste, 15, 16, 18, 21

Manet, Édouard, 13–23, *14*, *118*, 196–97, 211, 301

 in Boulogne, 132–35

 death of, 365

 in duel, 262–63

 early years of, 15–16

 family background of, 21, 103

 and Fine Arts Exhibition, 188–91

 health problems of, 290, 298, 315, 325, 364–65

 in Holland, 332–33

 and Impressionists, 357–58, 364

 influences on, 104–5, 108–9, 118–19, 130, 147, 181, 209, 243, 262, 340

 legacy of, 366–68

 in London, 238–40

 marriage of, 111–12

 and Monet, 148, 150, 200, 358–60, *361*, 365

 and Morisot, 243–45, 247, 253–54, 255, 261–62, 338

 personal traits of, 13–14, 254

 and *plein-air* painting, 133–35, 137, 138, 147, 197, 198–99, 211, 288, 359–60, *361*

 portraits of, 103, 130

 reputation of, 55, 103, 130–31, 231, 264, 290, 291, 340, 353, 354, 365, 367–68, 372–73

 return to Paris, 312–15

 and Salons, 17, 18, 20–21, 22, 34, 36, 37, 47, 48, 49, 50, 51, 55, 58–60, 62, 72, 74, 86–90, 104, 107, 117–18, 127–29, 134, 145, 147–48, 151–55, 166, 170–71, 173, 188, 197, 199, 221, 222, 227–28, 232, 245–47, 253, 260–61, 262, 264, 270–71, 290–91, 324–25, 326, 328, 338, 354, 355, 357–58, 364, 365

 in Spain, 159–62, 166

 studios of, 13, 21, 312, 328–29, 333

 and war with Prussia, 283–84, 285, 287–91, 293–94, 295, 297

and Zola, 178–79, 189, 199, *200*, 203, 223–24, 230, 245, 262, 264, 357, 365

Manet, Édouard, works by:

 The Absinthe Drinker, 18, *19*, 25, 50, 55, 188, 199, 325

 Argenteuil, 360

 Le Bain / Le Déjeuner sur l'herbe, plate 5B, 25, 36–37, 39–42, 49–50, 52, 58, 62, 70, 72, 86–89, 104, 105, 107–8, 109, 111, 117, 131, 138, 151, 153, 161, 182, 188, 199, 223, 236, 238, 271, 283, 329, 341, 359, 365, 366–67

 The Balcony, 243–45, 247, 253–54, 261, 262, 365

 A Bar at the Folies-Bergère, 364, 365, 368

 The Barricade, 312–14, *313*, 315

 The Battle of the U.S.S. "Kearsarge" and the C.S.S. "Alabama," 137–38, 326, 328, 339

 Beach at Boulogne, 236

 Beggar in a Cloak (A Philosopher), 165, *166*

 Beggar with Oysters (A Philosopher), 165, 262

 Boating, 360

 Le Bon Bock, plate 8A, 333, 338, 339–41, 354, 357, 367

 Boy with a Sword, 54

 Boy Blowing Soap Bubbles, 214

 Boy with Cherries, 49

 The Bullfight, 164

 The Bull Ring in Madrid, 164

 Burial at La Glacière, 211–12

 Civil War (lithograph), 312–13, 315

 Claude Monet and His Wife on his Floating Studio, 359

 critical responses to, 18–19, 51–54, 88–90, 104, 109, 127–29, 138, 152–54, 183, 191, 199, 200, 226, 230, 231, 254, 262, 270–71, 291, 328, 339–40, 341, 357–58, 365

 Croquet at Boulogne, 315, 326, 365, 368

 The Dead Christ with Angels, 118–19, 120, 127, 128–30, 131, 147, 188, 325; watercolour study for, 262

 The Dead Toreador, 147, 313, 325

 Departure of the Folkestone Boat, 137

 Effect of Snow at Petit-Montrouge, 288

 The Escape of Henri Rochefort, 364n

 The Execution of Maximilian, 209–10, 214–16, 222, 245, 314; lithograph, *215*, 246–47, 291

 exhibitions of, 49, 51, 54–55, 189–91, 197–201, 203, 364, 365, 367, 368

 The Fifer, 166, 171, 325

Fishing at Saint-Ouen, 25
Incident in a Bull Ring, 104, 117–18, 120, 127–28, 131, 134, 147, 162, 313
Jesus Mocked by the Soldiers, 147–48, 154, 159, 210
Jetty at Boulogne, 236
The "Kearsarge" at Boulogne, 138, 147
The Luncheon, 236, 237–38, *237*, 247, 253, 254, 269
A Masked Ball at the Opera, 357
Mlle V . . . in the Costume of an Espada, 37, 50, 325
The Monet Family in Their Garden at Argenteuil, 360, *361*
Moonlight, Boulogne, 238
The Music Lesson, 267, 270
Music in the Tuileries, plate *3A*, 51, 52–54, 72, 117, 135, 151, 160, 183, 188, 199, 325; study for, *53*
Nymph and Satyr, 39
The Old Musician, 25
Olympia, plate *4B*, 105–9, 117, 138, 147, 148, 151–55, 157, 159, 164, 171, 188, 199, 224, 228, 236, 283, 329, 341, 365–66; study for, *106*
Polichinelle, 357
Port of Bordeaux, 298
Portrait of Émile Zola, 223–24, 227, 230, 245
Portrait of Éva Gonzalès, 267
Portrait of Henri Rochefort, 364
Portrait of M. and Mme. Manet, 18–19, 210
prices of, 367–68
La Promenade, 368
public reactions to, 51–54, 55, 71, 72, 87–89, 145, 152–53, 157, 159, 164, 183, 201, 230–31, 364
The Races at Longchamp, plate *6A*, 134–35, 137, 147, 183, 249; lithograph, *135*, 246
The Races in the Bois de Boulogne, 368
The Railway, plate *7B*, 333–34, 355, 357
The Reader, 49
The Repose, 261, 262, 325, 338, 339
The Rue Mosnier with Flags, 368
The Saluting Torero, 164
Seascape at Boulogne, 137
self-portrait, 51
The Spanish Singer, 18–19, 20–21, 36, 49, 55, 127, 152, 267, 270, 325
The Street Singer, 37, 51, 325
style of, 18, 20–21, 49–51, 118–19, 190, 215, 228, 271, 324, 339, 341, 359, 364, 372
Swallows, 357
The Tragic Actor, 166, 171, 188, 325
Le Vélocipédiste, 299, 315, 326
View of the Universal Exposition of 1867, 198–99, 214
Women at the Races, 159
Young Lady in 1866, 222, 227, 243
Young Man in the Costume of a Majo, 50, 325
Young Woman Reclining in a Spanish Costume, 37, 51
Manet, Eugène, 21, 283
Manet, Eugénie, 111, 132, 191, 263, 295, 297
Manet, Gustave, 21, 39–40, 50, 89, 132, 283, 299, 302
Manet, Léon, *see* Koëlla, Léon
Manet, Suzanne Leenhoff, 16–17, 37, 39, 111–12, 132, 160, 191, 198, 213–14, 247, 263, 283, 287–88, 295, 297
Mantz, Paul, 7, 51, 150, 157, 200, 204, 243, 339–40
Marey, Étienne-Jules, 250
Marochetti, Carlo, 32
Martinet, Louis, 49, 62, 147
Martinetti, Filippo, 366
Marx, Karl, 97, 194, 238, 270, 302
Mathilde, Princess, 32, 34, 97
Matisse, Henri, 366
Mayer-Lamartinière, Constance, 242
Meissonier, Charles (father), 7–8, 31
Meissonier, Charles (son), 9, *141*, 167
 and *The Etcher*, 155–56
 and *Friedland*, 186–88, 345
 marriage of, 248
 as model, 30, 31, 169
 and mural painting, 352
 riding with his father, 94, 217–18, 250
 and Salons, 143, 168, 174, 220
 The Studio, 142–43, *143*, 146, 155, 168
 While Taking Tea, 168, 174, 220
Meissonier, Emma Steinheil, 8, 141–42, *141*, 168–69, 276–77, 278, 370
Meissonier, Ernest, 1–12, *3*, 102–3, *141*, *143*
 in Antibes, 234–36, 247, 343
 death of, 370
 early years of, 7–8, 16, 103
 and Fine Arts Exhibition, 185–86, 188
 Grande Maison of, 1–2, 3–4, 93–94, 140–41, 167, 186, 295–96, 329–30

Meissonier, Ernest (*continued*)
 gravesite of, 373–74, *374*
 on history, 5, 26–27, 139, 346–47, 348
 honours and awards to, 35, 43, 204–5, 226, 369
 influence of, 155, 320, 340
 influences on, 235
 and Institut de France, 43–47
 in Italy, 265
 and June Days, 45, 95, 115
 and Montmartre uprising, 300, 302, 306
 and mural painting, 266–67, 351–53, 368–69
 and Paris in ruins, 310–12
 as perfectionist, 6–7, 10, 18, 26–31, 52, 96,
 125, 140, 169, 209, 235, 249–50, 344, 345,
 347, 348, 368–69, 371, 372
 personal traits of, 4, 13, 116, 291, 337, 344
 and petition, 34–35, 43, 46, 47, 116
 and *plein-air* painting, 30–31, 96, 219, 234–35
 popularity of, 5, 35, 46, 47, 203–5, 266
 railway built by, 236, 250–51, 372
 reputation of, 2, 7, 46, 89, 116, 134, 204, 217,
 225, 247, 248, 265–67, 320, 329, 340, 344,
 368–69, 370–73
 and Salons, 2, 5, 16, 34–35, 47, 56, 58n, 59,
 94, 113–16, 120, 125–27, 145–46, 152,
 155–57, 169, 174, 225, 247, 267, 290,
 320–21, 322–24, 336, 338
 studios of, 4, 296, 329
 success of, 3, 6, 7, 9, 203–4, 225, 291
 and Vienna exhibition, 336–37, 342, 343–44
 and war with Prussia, 276–79, 281, 282–83,
 288, 289–92, 293, 295–97, 302, 329
 wealth of, 2, 7, 140, 167, 168, 220, 371
Meissonier, Ernest, works by:
 An Artist Showing His Work, 158
 A Battery of Artillery, 288
 Bravoes, 115, 158
 The Brawl, 5
 The Campaign of France, plate 2B, 9–12,
 28–31, 95, 116, 126–27, 128, 134, 139, 140,
 169, 203, 219, 249, 291, 306, 345, 370
 A Cannon in an Embrasure on a Rampart, 288
 collectors of, 2, 157–58, 202, 204, 219,
 330–31, 348, 363, 369–70, 371
 critical responses to, 2–3, 6–7, 126–27, 204,
 220, 226, 331, 343, 345–47, 370
 *The Emperor Napoleon III at the Battle of
 Solferino, plate 2A,* 27–28, 31, 46, 94, 95,
 115, 116, 124, 125–26, 127, 134, 140, 203,
 265

End of a Gambling Quarrel, 139, 156, 343
The Etcher: Portrait of Charles Meissonier,
 155–56, 169
Friedland, plate 6B, 95, 116, 139–40, 142, 155,
 169, 185–88, 202, 203, 204, 217–19, 225,
 234, 235–36, 247, 249, 276, 288, 296, 306,
 330–31, 336, 342, 344–48, 369, 372
Halt at an Inn, 5, 158
of horses, 94, 96, 134–35, 139, 217–19, *218,*
 236, 248–52, 345, 347, 372
Laughing Man, 139
The Liberation of Paris by Sainte-Geneviève,
 351–53
A Man Smoking, 340
Mère Lucrèce, 235
Peter the Hermit Preaching the Crusade, 8
Polichinelle, 92, *93,* 158
Portrait of Mme Meissonier and her Daughter,
 168–69
prices of, 2, 48, 157–58, 175, 183, 203, 204,
 219–20, 225, 331, 340, 369–70, 371
Promenade at Antibes, 247, 248
Remembrance of Civil War, plate 1A, 45, 115,
 296, 307, 312
The Ruins of the Tuileries, 311–12, 316, 343
The Siege of Calais, 8
The Siege of Paris, plate 7A, 288, 296–97,
 302, 316, 343
sketches and drawings, 92–93, 311
A Smoker, 340
A Smoker in Black, 340
style of, 4–7, 18, 23, 45, 89, 116, 232, 235,
 266–67, 323–24, 341, 343, 346–47, 372
The Venetian Nobleman, 169
A Visit to the Burgomaster, 125, 331
Meissonier, Thérèse, 141, 168–69
Mercié, Antonin, 373
Mérimée, Prosper, 233, 262
Merle, Hugues, 221n
Metropolitan Museum, New York, 367, 368,
 369
Metsu, Gabriel, 9
Metternich, Prince Richard von, 65, 207
Meurent, Victorine, 37–40, 49–50, 51, 87, 89,
 105, 106–7, *106,* 108–9, 117, 147, 152–54,
 156, 181, 210, 214, 222–23, 224, 243, 245,
 333–34, 339, 357
Meurice, Paul, 282
Mexico:
 Cinco de Mayo in, 68

Napoleon's war in, 68, 96–97, 122–23,
 163–64, 207–8, 216
Michel, André, 370–71
Michelangelo, 28, 40, 42, 44, 104, 105, 251, 260,
 352
Michelet, Jules, 133
Millais, John Everett, 202
Millet, Jean-François, 47, 77, 78, 125, 150, 153,
 264, 325
Monet, Adolphe, 196
Monet, Camille, see Doncieux, Camille
Monet, Claude, 148–50, 149, 228–29, 325
 and Manet, 148, 150, 200, 358–60, 361, 365
 marriage of, 284–85
 and paint technology, 268–69
 and plein-air painting, 150, 359
 and Realist Salon, 354, 355
 and Renoir, 267–69, 360
 and Salons, 148, 150, 181–83, 197, 221, 228,
 232, 252, 253, 267, 269, 324, 338
Monet, Claude, works by:
 Bathers at La Grenouillère, plate 8B, 269
 Boats Leaving the Port of Le Havre, 228
 Camille (Woman in a Green Dress), 183
 collectors of, 182, 363
 critical response to, 150, 182, 231
 Le Déjeuner sur l'herbe, plate 5A, 150, 181–82,
 366–67
 Fishing Boats at Sea, 253
 Garden of the Princess, 196–97, 198, 359
 Impression: Sunrise, 356, 358
 The Jetty at Le Havre, 228
 The Luncheon, 269
 The Magpie, 253
 Manet Painting in Monet's Garden, 360, 361
 The Mouth of the Seine at Honfleur, 148,
 150
 The Pointe de la Hève at Low Tide, 148
 Port of Honfleur, 196
 sales of, 353
 Women in the Garden, 183, 196
Monroe Doctrine, 123, 163
Montifaud, Marie-Amélie (Marc) de, 341
Moreau, Gustave, 125, 155
Moreau-Nélaton, Étienne, 367
Morisot, Berthe, 242–45, 312, 354
 The Harbour at Lorient, 267
 and Manet, 243–45, 247, 253–54, 255,
 261–62, 338
 Old Path at Auvers, 126

The Pont-Aven River at Roz-Bras, 243
and Salons, 126, 243, 252, 339
self-portrait, 244
and war with Prussia, 283–84, 314–15
Morisot, Edma, 243, 261, 267
Morisot, Marie-Cornélie, 245, 261, 315
Morny, Auguste Duc de, 5, 114–15, 116, 146,
 157–58, 201, 309
Muraton, Alphonse, 232
Muybridge, Eadweard, 251

Nadar, 106, 109, 198, 211, 250, 342, 355
 and ballooning, 109–11, 110, 114n, 194, 199
 portraits by, 3, 14, 20, 61, 66, 83, 102, 149,
 212
Napoleon Bonaparte, 234, 275, 344
 artistic portrayals of, 1, 9–12, 28–30, 95–96,
 126–27, 128, 139, 217, 303–4, 306, 345,
 348
 veneration of, 9–10, 101, 256, 305, 311, 345
Napoleon II, 63
Napoleon III, 66
 as absolute ruler, 66–67, 68
 assassination attempt against, 270
 birth and childhood of, 62–63
 coup attempts by, 63–64, 67, 114, 115, 209
 death of, 334–35
 elections, 96–97, 255, 272–73
 end of reign, 277–80, 281, 284, 345
 exile of, 316–17, 334
 and fine arts, 5, 22, 27, 31, 62, 65–66, 68–70,
 79, 80, 97–98, 121, 124, 196, 205, 206, 246,
 334, 336
 health problems of, 255–56, 257, 273, 279–80
 and his uncle, 9, 63
 and Mexican war, 68, 96–97, 122–23,
 163–64, 207–8, 216
 personal traits of, 65, 121
 and Second Republic, 64–65, 67, 115, 229,
 280, 284
 and Universal Exposition, 184–85
 and war with Prussia, 207, 273–75, 277–80,
 281
 and women, 64, 79, 97, 122, 277
Napoleon-Jérôme, Prince, 76
National Academy of Design, New York,
 362–63
Neoclassicism, 99, 236–37, 315
Nicholas I, Czar, 204
Niel, Adolphe, 256, 273

Nieuwerkerke, Alfred-Émilien O'Hara, Comte
 de, *33*, 101, 203
 exile of, 315, 364
 and Fine Arts Exhibition, 185
 loss of power of, 260
 and petition, 34, 46–47, 94, 116
 and Salons, 32–35, 57–60, 65, 69, 77, 81,
 97–99, 114, 116, 120, 145, 152, 169–70,
 172, 197, 220–22, 228, 231, 236, 252, 291,
 319, 324
Nobel, Alfred, 194
Noir, Victor, 258, 259, 270

Ollivier, Émile, 257–58, 260, 270, 272, 274, 275
Orcagna, Andrea, 144
Oulmont, Charles, 366

Paris:
 art auctions in, 157–58
 as autonomous state, 302–3
 Bloody Week in, 307–9, 312, *313*, 314, 317
 cafés of, 60
 civic improvements in, 195
 civil unrest in, 255, 272–73, 300–301, 307,
 314
 Commune, 302–9, 314, 315, 317, 319, 321,
 322, 323, 330, 349, 350
 disease in, 163–64, 182, 272, 290
 expositions in, 184–86, 188–91, 192–95, *193*,
 198, 200, 202–3, 206, 207, 220, 225, 336,
 342, 367, 369
 galleries in, 48–49
 horse racing in, 96, 134, 159, 207, 272, 328
 Jour de l'An (New Year's Day) in, 188–89,
 192, 318
 June Days, 45, 95, 115
 models in, 38–39, 245
 Montmartre culture, 341
 Montmartre uprising, 300–302, 306
 Museum of Copies, 319–20
 opera house, 170
 "petit Salon," 262–63
 pornography in, 153–54, 157, 286
 prostitution in, 79–80, 107, 108
 rebuilding, 316, 318–19
 ruins of, 307–9, *308*, 310–14, 318
 Sainte-Geneviève murals, 350–53, 368–69
 Siege of, 281–92, 293–95, *294*, 299, 302, 305,
 319, 351
 streets of, 23, *24*, 195, 300, 307, *313*

trials and executions in, 322
 Vendôme Column, 303–7, *304, 306*, 311, 312,
 321, 322, 324, 337, 350
Pelloquet, Théodore, 90–91
Pereire, Émile and Isaac, 330
Petit, Francis, 46, 283, 296, 347–48
photography, 105–6, 108–9, 153–54, 250–51,
 286
Picasso, Pablo, 366–67
Picot, François, 58–59, 77, 83, 98, 99, 113, 125,
 145, 174, 323
Pils, Isidore, 99, 320
Pissarro, Camille, 284, 329, 363, 365
 and Cézanne, 177, *177*
 exhibitions of work, 338, 354, 355
 landscapes by, 235, 251, 324, 325
 and "nucleus of painters," 339, 353, 354, 356
 and Salons, 82, 113, 175–76, 185, 195, 197,
 221, 225, 227, 230, 231, 252, 267, 324
Pius IX, Pope, 76, 308
Pomereu-d'Aligre, Marquis de, 190, 198
pompier art, 237–38
Pradier, James, 56, 220
Prado, Madrid, 160–61, 209
Pre-Raphaelite Brotherhood, 144, 202, 240
Prim, Juan, 273
Prix de Rome, 42n
Probasco, Henry, 202, 204, 219
Proudhon, Pierre-Joseph, 80, 179
Proust, Antonin, 22, 23, 36, 155, 201, 209, 210,
 216, 263, 291, 364, 365
Prussia:
 aggressive actions by, 206–7, 273–74
 and "Ems Telegram," 274
 and French surrender, 280, 281, 298
 in German Empire, 295
 war with France, *see* Franco-Prussian War

Raimondi, Marcantonio, *The Judgment of
 Paris*, 40, *41*
Raphael, 16, 41–42, 44, 51, 58, 79, 98, 129, 144,
 266, 331, 352
 The Judgment of Paris, 40, 41, 49–50, 238
 The School of Athens, 265
Realism, 22, 36, 41, 50, 54, 59, 74, 128, 160, 162,
 190, 223, 230–32, 243, 316, 319, 324
Realist Salon, 354–57
Redon, Odilon, 230
Regnault, Henri, 283, 295, 296
Rembrandt van Rijn, 70

Renaissance, 41–42, 44, 51, 52, 105, 118–19, 316, 319, 352, 372

Renan, Ernest, 129–30, 317

Renoir, Edmond, 355, 356

Renoir, Pierre-Auguste, 241, 359, 365
 critical reviews of work, 231
 La Esmeralda, 176
 Lise, 232
 Madame Monet and her Son, 360
 and Monet, 267–69, 360
 and Realist Salon, 354, 355
 and Salons, 71, 176, 195, 197, 221, 225, 227, 232, 252, 267, 324
 Summer Evening, 176

Reuter, Paul Julius, 286

Ribot, Théodule-Augustin, 221n

Richard, Maurice, 260

Rigault, Raoul, 303, 309

Rimbaud, Arthur, 332

Robert-Fleury, Joseph-Nicolas, 58n, 99, 113, 146, 173, 247, 320, 321, 322

Robert-Fleury, Tony, 208, 271, 296

Robinson, Theodore, 363

Rochefort, Henri, 221n, 252, 258–60, 297, 303, 322

Romano, Giulio, 16

Romanticism, 44–45, 51, 101, 210, 231

Rossetti, Dante Gabriel, 144–45, 240

Rousseau, Théodore, 47, 114, 150, 185, 325, 343

Rousselin, Auguste, 236, 237

Rouvière, Philibert, 166

Rubens, Peter Paul, 25, 39

Rudder, Louis-Henri de, 221n

Ruskin, John, 7, 52

Sainte-Geneviève murals, Paris, 350–53, 368–69

Saint-Victor, Paul Bins, Comte de, 7, 51–52, 110, 114, 125, 126, 127, 152, 170, 200

Salingre, Eugène-Édouard, 69, 80

Salon des Refusés (1863), 70–72, 81–82, 84, 85–91, 94, 105, 113, 131, 161, 170, 176, 178, 223, 226, 241, 337, 356, 365, 367, 372

Salon des Refusés (1864), 97–99, 116, 145

Salon of Newcomers, 229, 230–32, 252

Salons:
 1819, 90
 1824, 90, 208
 1828, 52
 1831, 102
 1833, 59
 1834, 90
 1835, 90
 1843, 78
 1844, 83
 1847, 47
 1849, 83
 1850, 45, 76, 115, 296
 1852, 115
 1853, 22
 1855, 5, 35
 1857, 35, 59
 1859, 18, 34, 49, 60
 1861, 18–19, 20–21, 27, 35, 36, 49, 84
 1863, 31–35, 37, 47, 55, 56–62, 68–70, 71, 75–80, 114, 116, 124, 174, 197; *see also* Salon des Refusés
 1864, 113–20, 124–31, 145, 146, 243
 1865, 139, 143, 145–47, 151–55, 156–57, 170, 213
 1866, 166, 169–71, 172–74, 178, 179–81, 182–83, 185, 188, 189, 208, 221, 226, 252, 290
 1867, 195–96, 221
 1868, 220–22, 224–25, 227–32
 1869, 245–47, 252–55
 1870, 260, 262, 264, 265, 267, 269–71, 350
 1872, 316, 319–24, 326, 327–28, 344
 1873, 335–36, 337–41, 353, 355
 1874, 354, 357–58
 1875, 364
 1881, 364
 1882, 364
 administration of, 31–35, 73, 260
 chiaroscuro technique for, 49
 commercialisation of, 74–75
 Exposition Artistique des Oeuvres Refusées (1873), 337–38
 Jury of Assassins, 171, 185, 188, 225, 243, 290, 320, 364
 military imagery in, 10, 125–26, 208
 nudes in, 22, 77–79, 88, 170
 at Palais des Champs-Élysées, 17–18, 73–74, 75, 76, 184, 195, 201, 319, 327
 règlements of, 31, 32–35, 47, 57, 98, 145, 169–70, 220–21, 260, 319–20, 335
 Selection Committees of, 17, 57–62, 69, 70, 74, 81, 98, 113, 114, 116, 126, 145, 169–71, 173, 195, 220, 227, 260, 265, 319, 324
 women artists in, 241, 242, 243, 253
 see also specific artists

Salvétat, Jean, 268–69

Schnetz, Victor, 58
Senefelder, Alois, 246
Signol, Émile, 43, 45, 58, 71, 98, 113, 145, 174,
 176, 323
Silvestre, Armand, 172, 263, 328
Sisley, Alfred, 252, 267, 365
Société anonyme coopérative, 354, 362
Soubirous, Bernadette, 349
Stendhal, 10, 23
Stevens, Alfred, 36, 160, 340
Stevens, Arthur, 78, 86
Stewart, Alexander T., 369, 371
Swinburne, Algernon Charles, 145

Taine, Hippolyte, 75, 85
Thiers, Adolphe, 44, 103, 299, 304, 314, 318
 and elections, 67, 97, 255, 298, 349
 and fine arts, 320, 336–37
 and Friedland, 95, 139, 345
 History by, 10, 11, 346
 and Meissonier, 28, 44, 307
 and Montmartre uprising, 300–301.
 and Napoleon III, 64, 67, 97, 334
 and Paris Commune, 302, 303, 307–9
 and surrender of France, 298
Thompson, Sir Henry, 334
Thoré, Théophile, 78, 89, 91, 147, 157, 161, 179,
 204
Thuiller, Jacques, 371
Thuret, Gustave-Adolphe, 233
Tintoretto, 118–19, 130
Titian, 16, 52, 118
 Christ Derided, 147
 Le Concert champêtre, 22
 Venus of Urbino, 104–5, 107–8, 153, 154
Trochu, Louis-Jules, 282, 287, 289, 351
Turner, J. M. W., 30, 133, 368
Twain, Mark, 104, 153

Universal Exposition, Paris, 184–85, 193, 194,
 198, 200, 220, 225, 275, 278, 336, 342, 367,
 369

Vanderbilt, William H., 369, 371
Van Gogh, Vincent, 61n
Velázquez, Diego, 16, 19, 160–63, 165–66, 239,
 262
Vendôme Column, Paris, 303–7, 304, 306, 311,
 312, 321, 322, 324, 337, 350
Venturi, Lionello, 370

Venus Pudica genre, 104, 153
Verdi, Giuseppe, 222n
Verlaine, Paul, 332
Vermeer, Jan, 4, 156, 204
Verne, Jules, 109
Vernet, Horace, 10, 58, 99, 134, 204
Vibert, Marthe (Martina), 111
Victoria, queen of England, 5, 241, 317, 335
Vienna, World Exhibition, 336–37, 342–44,
 370
Viollet-le-Duc, Eugène-Emmanuel, 6
Vlaminck, Maurice de, 366
Vollon, Antoine, 236, 320, 322

Wagner, Richard, 151, 260
Walewska, Maria, 47
Walewska, Marianne de, 79
Walewski, Comte de, 34–35, 47, 72, 84, 116,
 199, 239, 290
Wallace, Sir Richard, 330–31, 347–48, 369
Whistler, James McNeill, 60–62, 61, 70, 71, 103,
 120, 130–31, 180, 202–3, 221, 240, 354
 The Blue Wave: Biarritz, 61
 exhibitions of work, 202–3, 354
 Harmony in Blue and Silver: Trouville, 180
 and Salons, 61–62, 70, 71, 120, 131, 221
 Twilight at Sea, 202
 The White Girl, 61, 62, 86, 87, 180, 202
Wilhelm, king of Prussia/German Kaiser,
 273–74, 279, 280, 295, 301, 302
Wolff, Albert, 219, 254–55, 270, 291, 328, 340,
 362
Women's Union for the Defence of Paris, 330
Wordsworth, William, 281
Worms, Jules, 232

Yriarte, Charles, 92, 219, 267, 347–48
Yvon, Adolphe, 126, 221n

Ziem, Félix, 233
Zola, Émile, 171–74, 173, 243
 and Cézanne, 176, 178, 195, 314
 and Manet, 178–79, 182, 199–200, 262, 365
 Manet's portrait of, 223–24, 227, 230, 245
 on Meissonier's work, 203, 235, 324
 on the "new movement," 172–73, 189, 226
 on Salons, 172–74, 178, 182, 199, 203,
 224–25, 227, 231–32, 246, 264, 327, 357
 Thérèse Raquin, 223–24, 230
 and war with Prussia, 284–85, 298